Herausgeber, Editor. iF International Forum Design GmbH, Messegelände, Hannover, Germany; Sandstr. 33, München, Germany Phone: +49.511.8932402, Fax: +49.511.8932401, www.ifdesign.de, info@ifdesign.de iF Geschäftsführung, Managing Director: Ralph Wiegmann iF Team. Dirk Bartelsmeier, Anne-Kathrin Aumann, Sabine Böhmer, Korinna Gramsch, Hans Pflueg, Andrea Schewior, Anja-Martina Kirschning, Carmen Wille, Heike Meier, Rainer Schwarz, Frank Zierenberg, Sandra Fischer, Birgit Schultz, Gabriele Bertemann, Annegret Wulf-Pippig, Rylana Büter, Louisa Erbguth, Petra Nordmeier, Anna Reissert, Yvonne Tamme iF Taiwan Branch. Sean C.K. Lee, Joan Wu, Tobie Lee, 3F., Bldg. G, 3–1 Park Street, Nangang Taipei 115, Taiwan iF Representative. Sowon Koo, Design House Inc., Taekwang Building, 162-1 Jangchung-Dong 2-GA, Jung-Gu, Seoul 100-855, Korea iF Press Office. Claudia Neumann Communication GmbH, Claudia Neumann, Silke Becker, Sandy Pfeßdorf, Eigelstein 103–113, 50668 Köln, Germany, Phone: +49.221.9139490, Fax: +49.221.91394919, iF@neumann-luz.de Projektmanagement iF, Project management. Korinna Gramsch Projektmanagement Birkhäuser, Project management. Elena Dinter Produktion Birkhäuser, Production. Marion Plassmann Gestaltung aktuelle Ausgabe, Design current Edition. Muriel Comby, Basel Satz und Lithografie, Typesetting and Lithograph. Jung Crossmedia Publishing GmbH, Lahnau Druck, Print. Kösel, Altusried-Krugzell Fotografie Jury, Jury Photography. Dirk Meußling, Isernhagen, KB Textredaktion, Copy Editing. Kristina Irmler, Großburgwedel; Daphne Johnson, Hannover Übersetzung, Translation. Lennon.de Language Services, Düsseldorf; Corporate Design iF product design award. helke brandt communication, Hannover

© 2009 iF International Forum Design GmbH
Verlag, Publisher. Birkhäuser Verlag AG
Basel · Boston · Berlin
P.O. Box 133, 4010 Basel, Switzerland
Member of Springer Science+Business Media
www.birkhauser.ch
Printed in Germany
ISBN: 978-3-7643-8981-9

Bibliographic information published by the Deutsche Nationalbibliothek. The Deutsche Nationalbibliothek lists this publication in the Deutsche Nationalbibliografie; detailed bibliographic data are available on the Internet at http://dnb.d-nb.de

iF yearbook product 2009

Birkhäuser
Basel · Boston · Berlin

Volume 1

6	Introduction
16	The Jury in 2009
38	iF gold selection 2008
42	Transportation Design
64	Leisure/Lifestyle
148	Audio/Video
246	Telecommunications
286	Computers
358	Office/Business
378	Lighting
422	Furniture/Home Textiles
480	Index

Volume 2

6	Kitchen/Household
160	Bathroom/Wellness
204	Buildings
238	Public Design/Interior Design
266	Medicine/Health + Care
316	Industry/Skilled Trades
408	Special Vehicles/Construction/Agriculture
418	Advanced Studies
440	iF Industrie Forum Design e.V.
450	Index

Barbara Schmidt

Zu den schönsten Seiten der Arbeit als Designer gehört es, Menschen das Leben erleichtern zu können. Der Wunsch, lästige Hausarbeit zu verringern und Genuss zu vermehren, ist eine wesentliche Triebkraft des menschlichen Fortschritts.

Wir haben es mit einem Paradox zu tun: Nie waren etwa unsere Küchen besser ausgestattet als heute, und nie haben wir weniger Zeit mit der Zubereitung unserer Mahlzeiten verbracht, nicht nur, weil sie dank hervorragender Hilfsmittel schneller geht, sondern vor allem, weil wir viel weniger selbst kochen. Andererseits gibt es eine starke Tendenz, die Küche als Wohnraum zurückzugewinnen. Die in ihr verwendeten Geräte werden als Einrichtungsgegenstände wahrgenommen: Entweder indem sie wie Einbaumöbel hinter einer glatten, vorzugsweise weißen Front verschwinden (ein Kochlabor mit perfektem Werkzeugarsenal), ihre Typologie dabei allerdings unscharf wird (Mikrowelle? Dampfgarer? Spülmaschine oder Kühlschrank?), oder indem sie sich als Einzelobjekte um das wärmende Feuer wenigstens eines Gasherds gruppieren, und dabei unterschiedlichste Materialien, Neu und Alt, Handwerk und Technik aufeinandertreffen.

Die Zahl der eingereichten Produkte war außerordentlich hoch. Auf sehr hohem technischem Niveau wurden vielfach Sortimentsdifferenzierungen vorgenommen, an deren bereichernder Wirkung für die Nutzer leise Zweifel angemeldet werden dürfen. Hin und wieder gab es auch kleine schöne Erfindungen, oder Erfrischungen aus nichteuropäischen Kulturkreisen. Nicht einfach war es, den sehr unterschiedlichen Produkten der Kategorie, von Geräten mit vor allem technischer Innovation bis hin zu Tischaccessoires mit Betonung der ästhetischen Qualität gerecht zu werden. Jeweils zwei Juroren waren für je die Hälfte der Entscheidungen verantwortlich.

Making people's lives easier is one of the best things about being a designer. The desire to minimize tedious household chores and maximize pleasure is one of the main drivers of human progress.

We are dealing with a paradox: Never before have our kitchens been equipped as well as they are today, and never before have we spent less time preparing our meals – not only because the process takes less time thanks to outstanding equipment, but mainly because we cook far fewer meals ourselves. On the other hand, there is a pronounced tendency to reclaim the kitchen as living space. The devices used in the kitchen are perceived as fixtures: Either by hiding them behind a smooth and preferable white front like built-in furniture (a cooking laboratory with a perfect arsenal of tools), which unfortunately conceals their typology (Microwave? Steamer? Dishwasher or refrigerator?), or at least by grouping them as individual pieces around the warming fire of a gas range causing a wide variety of materials, new and old, craftsmanship and technology to meet.

A huge number of products was submitted. While product range differentiation often took place at a very high technological level, slight doubt may be expressed regarding the actual enrichment for users. Occasional lovely little inventions and refreshing ideas from non-European cultures were also found. Doing justice to this variety of products within the category, from appliances with mainly technical innovations to table-top accessories focusing on aesthetic qualities, was by no means easy. Two jurors, respectively, were responsible for each half of the decisions.

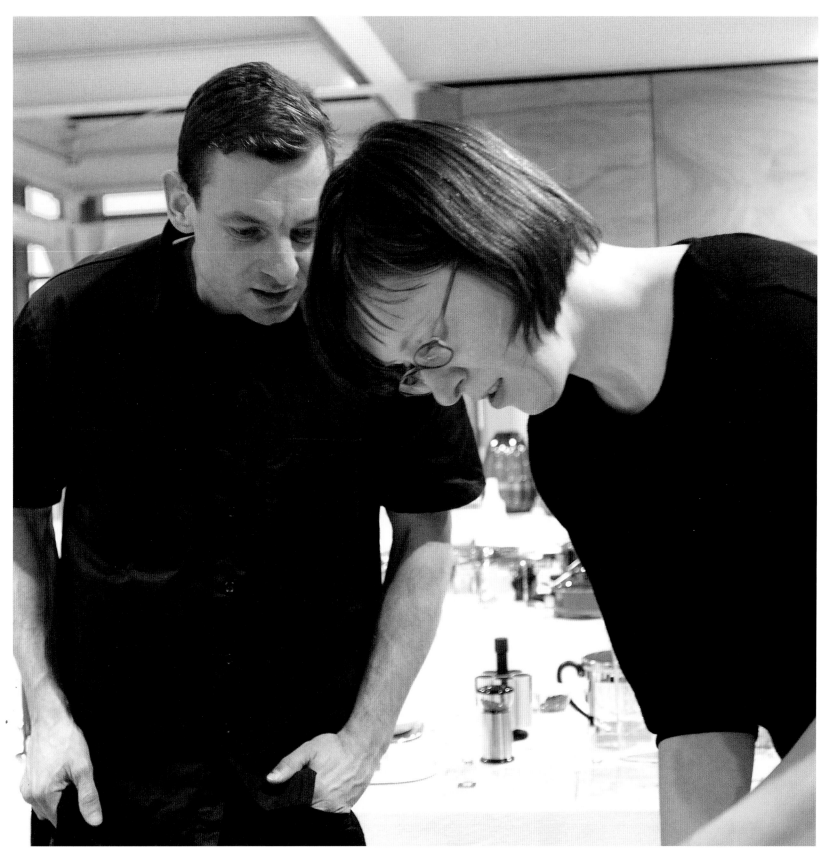

Die Formgebung der Küche ist tendenziell beständig und orientiert sich weiterhin an der professionellen Anmutung der Großgastronomie. Metallische Oberflächen wie Edelstahl und Aluminium lassen die Küchenmöbel und Küchengeräte hochwertig und langlebig anmuten, das Qualitäts- und Gestaltungsniveau ist allgemein sehr hoch.

Im Vordergrund steht nicht Originalität sondern Systemgedanke. Dieser wird konsequent weiterverfolgt mit dem Ziel, die einzelnen Gerätegruppen formal aufeinander abzustimmen und Produktfamilien zu bilden die beliebig miteinander kombiniert werden können.

(Das Bestreben Ofen, Abzugshaube und Kochfeld formal aufeinander abzustimmen ist aber noch nicht überall konsequent umgesetzt und so konnten skurrile Details wie Zierleisten in Ceranfeldoptik an der Dunstabzugshaube die Jury nicht wirklich überzeugen.)

Innovative Lösungen zur Verbesserung der Mensch-Maschine-Schnittstelle und intelligent gestaltete Details zeigen Wirkung – es macht Spaß, die Geräte zu bedienen und mit ihnen umzugehen.

Die Produktgruppe der Großgeräte wird bestimmt durch die Internationalisierung des Marktes. Die Plattformstrategie hat zu einer Uniformierung des Marktes geführt, in dem die Produkte durch das Interface und interessant gestaltete Detaillösungen charakterisiert werden, nicht aber durch die grundlegende Konzeption der Geräte.

Positiv hervorzuheben ist das Bestreben der Hersteller die Energieeffizienz der Produkte im Sinne der Nachhaltigkeit zu steigern.

Die Gestaltung im Bereich Porzellan / Keramik knüpft an die Entwicklungen und Trends der vergangenen Jahre an. Die Formgebung wird unter anderem bestimmt durch den Einfluss der asiatischen Esskultur, das Crossover unterschiedlicher Kulturen, dem spielerischen Umgang mit Traditionen wie z. B. dem Dekor und dem Trend zur Collage: der Kombination von Produkten mit unterschiedlichen Formensprachen zu einer Serie.

Positiv anzumerken ist, dass immer mehr leicht erschwingliche Produkte und Produktfamilien einem breiten Publikum den Zugang zu gut gestalteter Funktionalität originärer Designentwürfe ermöglichen.

Kitchen design tends to be consistent and is largely based on the professional appearance in the gastronomy field. Metallic surfaces such as stainless steel and aluminum give kitchen furnishings and appliances a high-end, durable appearance. The level of quality and design is generally high.

Rather than originality, the focus is on the system concept. This concept is consistently pursued with the goal of formally coordinating individual appliance groups and forming product families that can be combined as desired.

(However, the attempt to formally coordinate ranges, range hoods and hobs has not been consistently realized in all cases, so that odd details such as decorative trim with a ceramic hob look on the range hood didn't really convince the jury.)

Innovative solutions to improve the human-machine interface and intelligent details are effective – operating and using the appliances is fun.

The major appliance product group is defined by market internationalization. As a result of the platform strategy, the market has become more uniform so that products are defined by the interface and detailed solutions with interesting designs, but not by the underlying appliance concept.

Efforts made by manufacturers to make products more energy efficient and therefore sustainable are extremely positive.

Designs in the porcelain/ceramic field are based on developments and trends of the last few years. Among other things, the styling is defined by the influence of Asian cuisine, the crossover of various cultures, the playful exploration of traditions such as décor and the collage trend: Combining products with different design vocabularies into a series.

It is positive to note that more and more affordable products and product families are providing access to the well-styled functionality of original designs for a large audience.

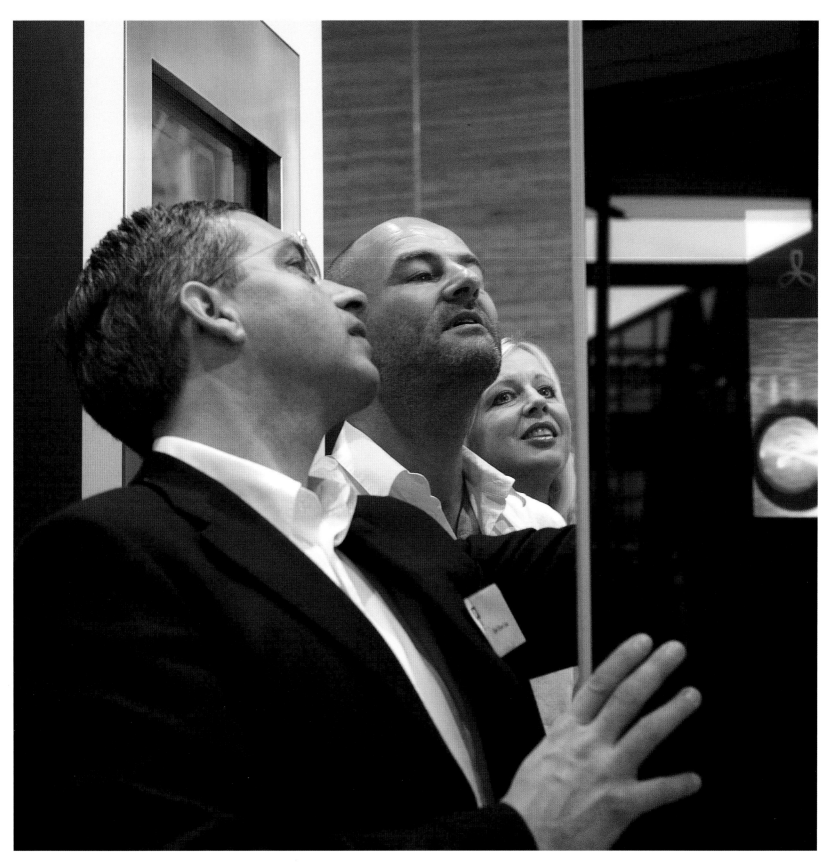

Product
T9800 / T9820
Wäschetrockner
Tumble dryer

Design
Miele & Cie. KG
Werksdesign
Gütersloh, Germany

Manufacturer
Miele & Cie. KG
Gütersloh, Germany

Mit der neu entwickelten Baureihe T9800 / T9820 konnte die Miele Schontrommel erfolgreich auf Wäschetrockner, speziell für den nordamerikanischen Markt, übertragen werden. Die großvolumige Trommel ist leicht einzusehen, zu befüllen und zu entladen. Durch Greifen in die umlaufende Fase ist es dem Benutzer möglich, an der ergonomisch günstigsten Stelle die Tür zu öffnen. Das stabile Flusensieb lässt sich dann sehr einfach entnehmen und reinigen. Dank mittiger Blendengestaltung, der Kombination aus geneigter Anordnung, Klartext und textilbezogener Programme ist eine leichte Bedienung gewährleistet.

Equipping tumble dryers from the new T9800 / T9820 series with Miele's honeycomb drum, specifically for the North American market, proved successful. The interior of the large-volume drum is fully visible, making the machine easy to load and unload. The door can easily be opened by first pressing the door-button and then gripping the door by the concealed recess, which runs around the entire door at the most convenient point. The sturdy fluff filter is very easy to remove and clean. Thanks to a centred, inclined fascia design and a combination of slope structure, plain-text and fabric-related programmes, the machine is easy to operate.

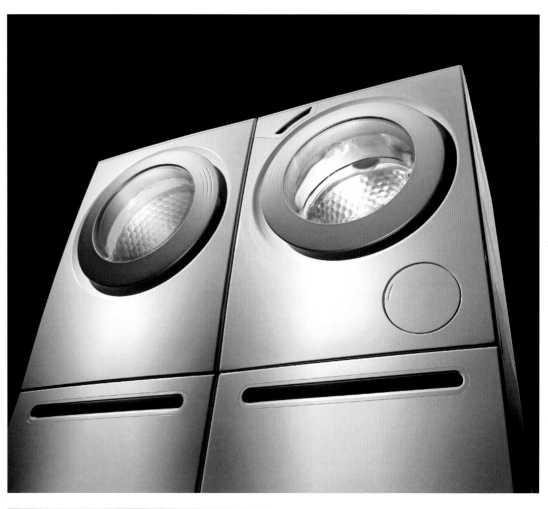

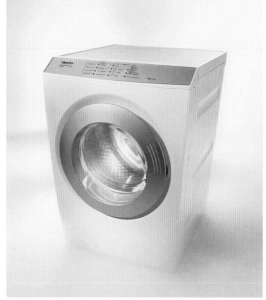

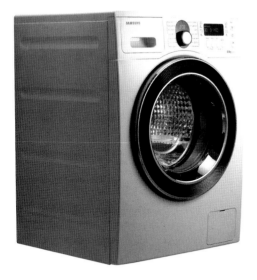

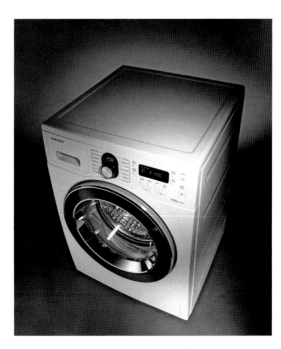

Product
WF8804
Trommelwaschmaschine
Drum washing machine

Design
Samsung Electronics
Gyoosang Choi, Sehun Oh, Eunsun Lim
Seoul, South Korea

Manufacturer
Samsung Electronics
Seoul, South Korea

Die Waschmaschine WF8804 verfügt über eine neuartige Benutzeroberfläche, die das Einstellrad mit Display kombiniert. Diese neue Oberfläche verbessert die Bedienbarkeit; der Nutzer kann ein bestimmtes Waschprogramm anwählen und die verbleibende Waschzeit feststellen. Die Verwendung einer Diamanttrommel schützt die Kleider, und die größere Tür gestattet ein bequemes Be- und Entladen der Wäsche. Eine Frischluftfunktion entfernt auf einfache Weise Gerüche ohne die Verwendung von Wasser.

The WF8804 is a drum washing machine that offers a new type of user interface that combines an display with the jog dial. The new interface further enhances convenience by allowing the user to choose a certain course for washing the clothes and ascertain the remaining time. A diamond drum has been applied to protect the clothes, and the door size has been increased so that the user can conveniently place and remove laundry. It offers an air refresh function that conveniently removes smell without the use of water.

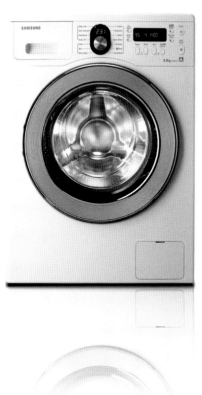

Product
3 VS 300 BA
Geschirrspüler
Dishwasher

Design
B / S / H
Ralph Pietruska, Ulrich Goss
München, Germany

Manufacturer
B / S / H
München, Germany

Der neuste Geschirrspüler 3 VS 300 BA der spanischen Topmarke Balay verbindet moderne Gestaltung und Technik mit einem hohen Bedienkomfort. Die aufgeräumte und charakteristische Erscheinung verdankt er dem „Smart Edge Design", der Blende und dem seitlich angebrachten Drehknebel mit integriertem Startknopf. Der Drehknebel ist in die seitliche Bedienzone perfekt eingebunden und bildet zusammen mit dieser einen definierten Interface-Bereich.

The latest dishwasher 3 VS 300BA of the Spanish top brand Balay meets the high demands of a modern yet simple design with high ease of use. The structured and characteristical appearance is achieved by the "Smart Edge design" of the panel and the turning knob with its integrated start button. The knob blends perfectly into the lateral interaction area and defines an integral interface zone.

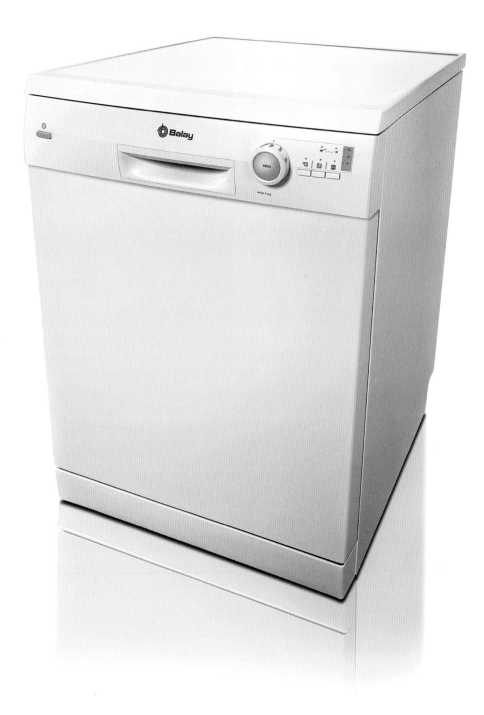

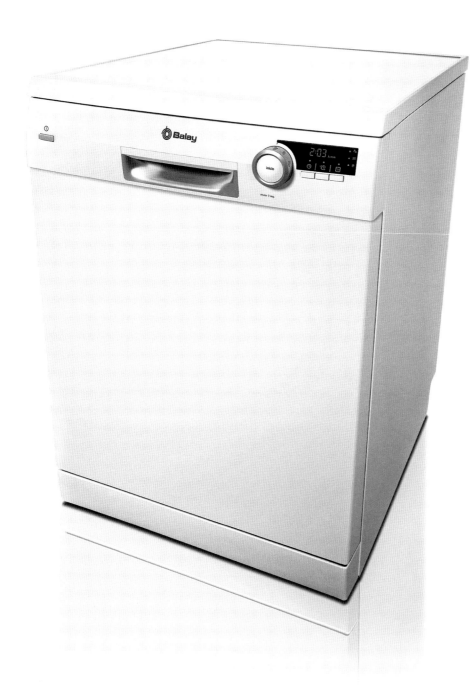

Product
3 VS 500 BA
Geschirrspüler
Dishwasher

Design
B / S / H
Ralph Pietruska, Ulrich Goss
München, Germany

Manufacturer
B / S / H
München, Germany

Der Geschirrspüler 3 VS 500 BA ist ein hochwertiges Produkt der neusten Spüler-Generation unter der spanischen Topmarke Balay. Die klare und charakteristische Erscheinung verdankt er dem „Smart Edge Design", der Blende und dem seitlich angebrachten Drehknebel mit mittigem Startknopf. Das seitlich angegliederte Displayfenster vereint übersichtlich alle Anzeigen des Gerätes. Wichtige Griff- bzw. Interaktionszonen wie Türöffnung bzw. Programmeinstellung sind im Metallic-Look gekennzeichnet. Ein Gerät, das die Ansprüche an moderne Gestaltung und Technik mit einem hohen Bedienkomfort verbindet.

The dishwasher 3 VS 500 BA is a high quality product of the latest dishwasher generation of the Spanish top brand Balay. The clear and characteristical appearance is achieved by the "Smart Edge design" of the panel and the turning knob with its centric start button. The lateral display window combines the well arranged indication area of the appliance. Important interaction zones to open the door and to adjust the programs are marked in a metallic-look. The appliance meets the high demands of a modern yet simple design with a high ease of use.

Product
SN 58 M 250 DE
Geschirrspüler
Dishwasher

Design
Siemens Electrogeräte GmbH
Wolfgang Kaczmarek
München, Germany

Manufacturer
Siemens Electrogeräte GmbH
München, Germany

Ein Einbau-Geschirrspüler mit in der Mitte ange-ordneten Bedientasten und deutscher Klartextbe-druckung. Eine automatische „3in1"-Funktion, d. h. Selbsterkennung von allen Tabs und Pulverreinigern. „VarioSpeed" spart bis 50% Zeit bei optimalem Rei-nigungsergebnis. Der höhenverstellbare Oberkorb mit Vollauszug (RACKMATIC) erhöht die Variabilität der Beladung und kann auch in beladenem Zustand problemlos in der Höhe verstellt werden. Das Gerät ist extrem leise (nur 44 dB) und dadurch für offene Küchengrundrisse geeignet. Das Gerät verfügt über eine „Extra trocken Funktion".

A built-in dishwasher with a control panel in the center and the buttons with a German clear text label. The automatic 3-in-1function recognizes all dishwashing tabs and powders. "VarioSpeed" shortens running time by up to 50% with optimal cleaning results. The height-adjustable top basket with full extension rails (RACKMATIC) enhances loading variability and can be adjusted without difficulty, even when the basket is fully loaded. The dishwasher is extremely quiet (only 44 dB) and suitable for open kitchen designs. It also has an extra dry function.

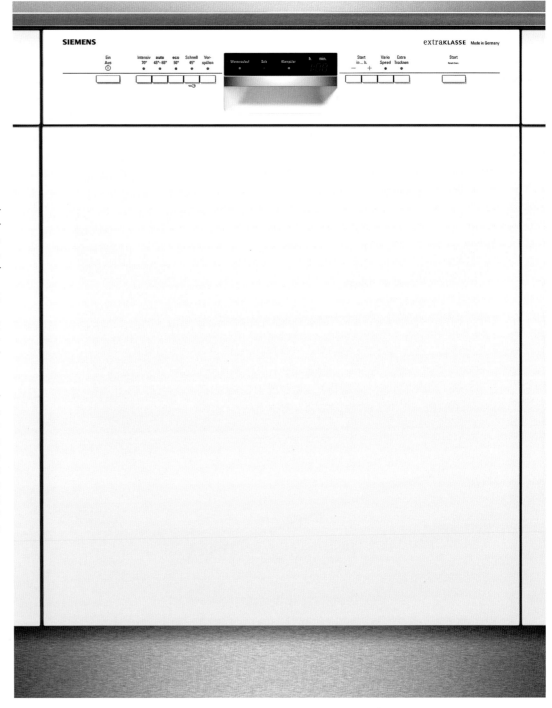

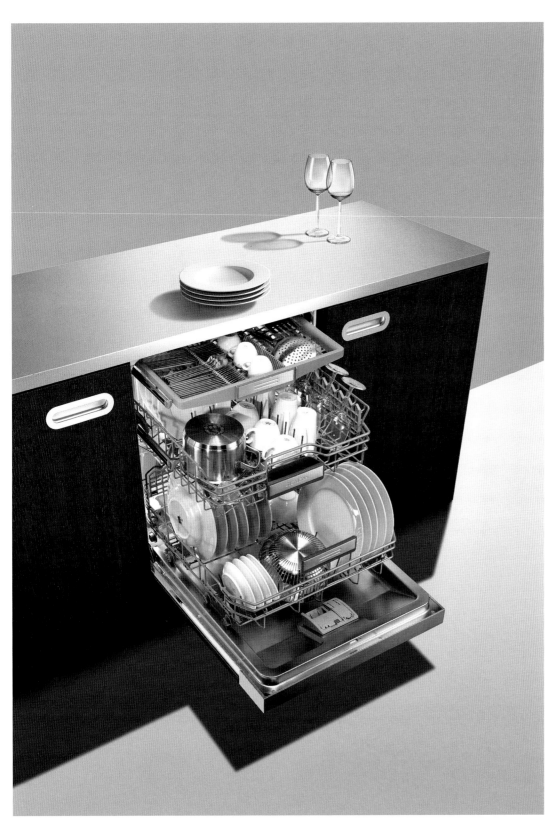

Product
SN 56 M 591 EU
Geschirrspüler
Dishwasher

Design
Siemens Electrogeräte GmbH
Wolfgang Kaczmarek
München, Germany

Manufacturer
Siemens Electrogeräte GmbH
München, Germany

Einbau-Geschirrspüler in Edelstahl-Ausführung mit Bedientasten, die in der Mitte angeordnet sind. Front-display mit Programmstatus-Anzeige. Die automatische „3in1"-Funktion erkennt Tabs und Pulverreiniger. „VarioSpeed" spart bis 50 % Zeit bei optimalem Reinigungsergebnis. Intensiv-Zone im Unterkorb für stark verschmutztes Geschirr. Hygiene-Programm und halbe Beladungsoption für sparsames Spülen bei geringer Beladung. Der höhenverstellbare Oberkorb mit Vollauszug (RACKMATIC) erhöht die Variabilität der Beladung und kann auch in beladenem Zustand problemlos in der Höhe verstellt werden. Der Geschirrspüler ist extrem leise (nur 42 dB).

Built-in dishwasher in stainless steel design with a control panel in the center. Front display with program status indicator. The automatic 3-in-1 function recognizes all dishwashing tabs and powders. "Vario-Speed" shortens running time by up to 50% with optimal cleaning results. High-intensity zone in the bottom basket for heavily soiled dishes. Sanitary program and half load option for efficient cleaning of lighter loads. The height-adjustable top basket with full extension rails (RACKMATIC) enhances loading variability and can be adjusted without difficulty even when the basket is fully loaded. The dishwasher is extremely quiet (only 42 dB).

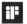
Product
SN 56 T 590 EU
Geschirrspüler
Dishwasher

Design
Siemens Electrogeräte GmbH
Wolfgang Kaczmarek
München, Germany

Manufacturer
Siemens Electrogeräte GmbH
München, Germany

Einbau-Geschirrspüler in Edelstahl. Ein Bedienfeld
mit „piezo-touch-Bedienung". Das zweite Display an
der Tür zeigt den Programmablauf an. Lichtdesign
in „weiß/blau" und eine Besteckschublade. Die auto-
matische „3in1"-Funktion erkennt alle Tabs und Pul-
verreiniger. Drei automatische Programme für alle Tem-
peraturbereiche. „VarioSpeed" spart bis 50% Zeit.
Intensiv-Zone im Unterkorb für stark verschmutztes
Geschirr. Hygiene Programm und halbe Beladungs-
option. Der höhenverstellbare Oberkorb mit Vollaus-
zug erhöht die Variabilität. Der Geschirrspüler ist ex-
trem leise (nur 44 dB).

Built-in dishwasher in stainless steel. A control panel
with piezo touch controls. The second display in the
door indicates the program status. Light design "white/
blue" and a cutlery drawer. The automatic 3-in-1 func-
tion recognizes all dishwashing tabs and powders.
Three automatic programs for all temperature ranges.
"VarioSpeed" saves up to 50% running time. High-
intensity zone in bottom basket for heavily soiled
dishes. Sanitary program and half-load option. Fully
accessible, height-adjustable upper basket for more
variability. The dishwasher is extremely quiet (only
44 dB).

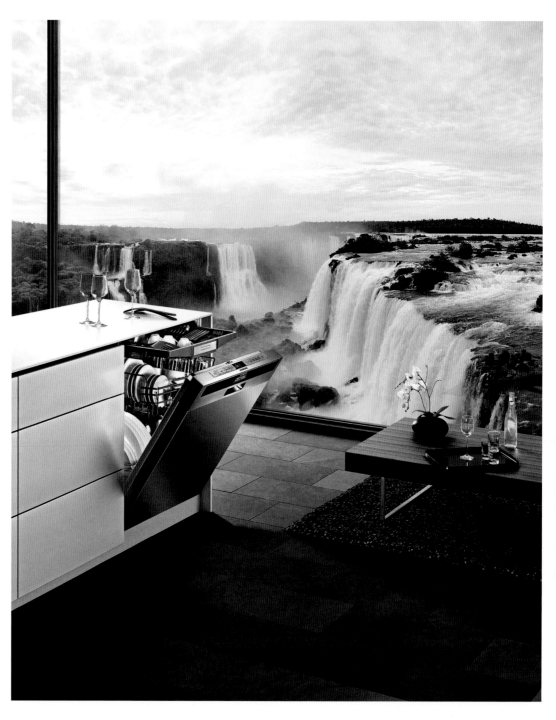

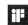

Product
SMS69T08EU
Solo-Geschirrspüler
Freestanding dishwasher

Design
Robert Bosch Hausgeräte GmbH
Thomas Ott, Robert Sachon
München, Germany

Manufacturer
Robert Bosch Hausgeräte GmbH
München, Germany

Das Gesicht des freistehenden Geschirrspülers wird durch die schlanke Blende mit der charakteristischen Einheit aus Klartext-Anzeige- und Bedienelement geprägt. Das Edelstahlfinish und die „MetalTouch-Bedienung" unterstreichen den qualitativen Anspruch der Marke. Insgesamt drei individuell einstellbare Beladungsebenen mit hochwertigen Metallgriffen bieten allen Geschirr- und Besteckteilen Platz. „DosierAssistent", „ReinigerAutomatik", Aqua- und Beladungssensor ergänzen die innovative Wärmetauscher-Technologie zu einem der sparsamsten Geräte überhaupt. Dabei wird jeder Liter Wasser im Gerät so effektiv wie umgerechnet 4.100 Liter Wasser eingesetzt.

The appearance of the freestanding dishwasher is characterised by the slimline control panel and typical complex of word display and controls. The stainless steel finish and "MetalTouch controls" emphasise the brand's superior quality. A total of three individually adjustable loading levels with exclusive metal handles provide space for all dishes and items of cutlery. The "DosageAssistant", "AutoRinseAid", Aqua and load sensor enhance the innovative heat exchanger technology to create one of the most economical appliances ever. As such, each litre of water in the appliance is used as effectively as the equivalent of 4,100 litres of water.

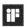
Product
SMS69M08EU
Solo-Geschirrspüler
Freestanding dishwasher

Design
Robert Bosch Hausgeräte GmbH
Thomas Ott, Robert Sachon
München, Germany

Manufacturer
Robert Bosch Hausgeräte GmbH
München, Germany

Enorme Variabilität, höchste Effizienz und riesiges Fassungsvermögen bietet der freistehende „Active-Water-Geschirrspüler" in Silver-Inox mit „AntiFingerprint"-Oberflächen. Die Bedienung der sechs Programme und vier Sonderfunktionen erleichtert die klare Gliederung der Funktionen. „DosierAssistent" und „ReinigerAutomatik" sorgen für optimale Wirkung und Verbrauch aller Reinigerarten. Aqua- und Beladungssensor ergänzen die innovative Wärmetauscher-Technologie zur Erzielung bester Verbrauchs- und Energiewerte. Das vielfach einstellbare Korbsystem wird durch eine Vario-Schublade als dritte Beladungsebene für Besteck und kleinere Geschirrteile ergänzt.

The freestanding "ActiveWater" dishwasher in Silver-Inox with "AntiFingerprint" surface offers immense variability, maximum efficiency and a huge capacity. Operation of the six programs and four special functions is facilitated by the clear structuring of functions. The "DosageAssistant" and "AutoRinseAid" feature assure optimum effectiveness and consumption for all rinse aid types. The aqua and load sensor complement the innovative heat exchanger technology to achieve premium consumption and energy rates. The highly adjustable basket system is complemented by a VarioDrawer as third loading level for cutlery and small items.

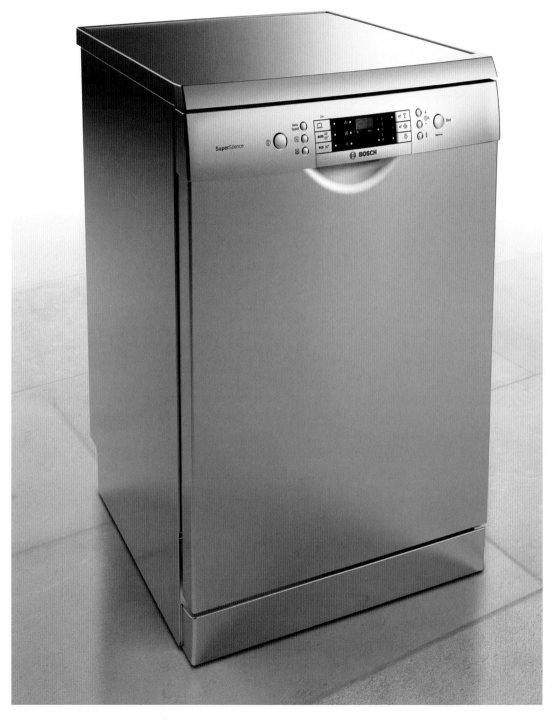

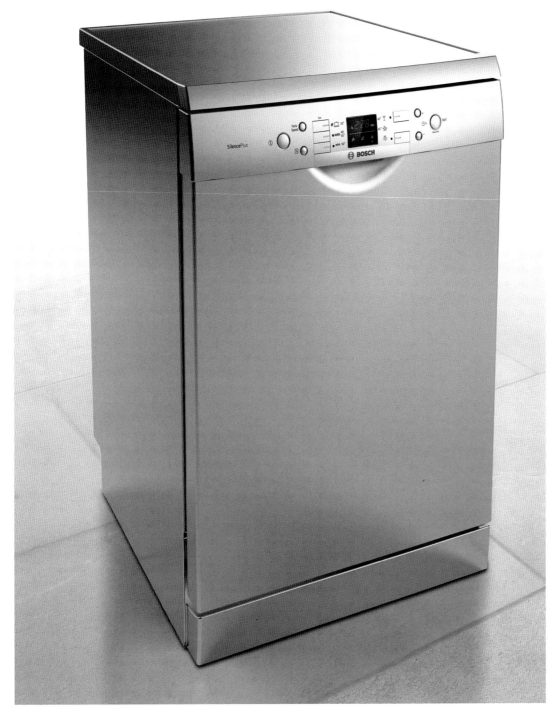

Product
SMS60M08EU
Solo-Geschirrspüler
Freestanding dishwasher

Design
Robert Bosch Hausgeräte GmbH
Thomas Ott, Robert Sachon
München, Germany

Manufacturer
Robert Bosch Hausgeräte GmbH
München, Germany

Der freistehende Spüler der Edelstahlreihe von Bosch erreicht mit modernster Technik Spitzenwerte bei allen Kriterien. Sechs Programme und sinnvolle Zusatz-optionen wie „Halbe Beladung" und „VarioSpeed" bieten ein Maximum an Spülqualität. Bedien- und Anzeigeelemente sind in Form und Funktion deutlich gegliedert. Das Vario-Korbsystem mit dreistufiger „Rackmatic"-Höhenverstellung, Klappstacheln und Oberkorb-Besteckablage bieten ein hohes Maß an An-passungsmöglichkeiten. „DosierAssistent" und „Rei-nigerAutomatik" optimieren Reinigerverbrauch und -wirkung. Das „ActiveWater-System" nutzt das Was-ser eines Spülganges so effektiv, als hätte man über 4.000 l verwendet.

Underpinned by the latest technology, the freestand-ing dishwasher in the Bosch steel series achieves top rates in all categories. Six programms and practical additional options like the "HalfLoad" and "Vario-Speed" achieve maximum dishwashing quality. Con-trol and display elements are clearly structured in form and function. The vario basket system with three-way "Rackmatic" height adjustment, folding racks and top basket cutlery compartment offers a gamut of positioning options. The "DosageAssistant" and "AutoRinseAid" features optimise rinse aid con-sumption and effectiveness. The "ActiveWater sys-tem" uses the water from one cycle as effectively as 4,000 l.

Product
SBI69T05EU
Integrierter Einbau-Geschirrspüler
Integrated built-in dishwasher

Design
Robert Bosch Hausgeräte GmbH
Thomas Ott, Robert Sachon
München, Germany

Manufacturer
Robert Bosch Hausgeräte GmbH
München, Germany

Der integrierbare Edelstahlspüler arbeitet mit modernster Technologie und hocheffizient. Die Relation von Wasser- und Energieverbrauch bei kurzen Laufzeiten ist Weltspitze. Eine Einheit aus Anzeige- und Griffelement prägt das Gesicht des Gerätes nach Außen. Innenliegende „MetalTouch-Bedienung" und Edelstahl-Griffschalen unterstreichen seine Wertigkeit. „DosierAssistent" und „Reiniger-Automatik" garantieren optimalen Einsatz von Tab- und Pulverreinigern. Flexible Körbe für 14 Maßgedecke bieten ein hohes Maß an Individualität. Die spezielle Gestaltung der dritten Beladungsebene erlaubt nicht nur die Aufnahme von Besteck, sondern auch von Kleingeschirr.

Underpinned by the latest technology, the integrated steel dishwasher performs with outstanding efficiency. The water and energy consumption ratio paired with short cycle times is world-beating. Together, the display and handle element characterise the outer appearance of the appliance. Interior "MetalTouch" controls and steel recessed handles emphasise its exclusiveness. The "DosageAssistant" and "AutoRinseAid" feature assure the optimum use of tab and powder cleaners. Flexible baskets for 14 place settings permit a high level of individualised loading. The special design of the third loading level means that both cutlery and small items fit.

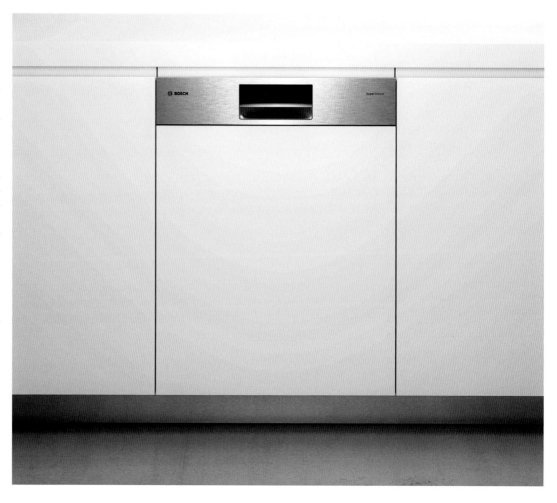

Product
SBI68M05EU
Integrierter Einbau-Geschirrspüler
Integrated built-in dishwasher

Design
Robert Bosch Hausgeräte GmbH
Thomas Ott, Robert Sachon
München, Germany

Manufacturer
Robert Bosch Hausgeräte GmbH
München, Germany

Das Design der Bedienblende des integrierbaren und äußerst energieeffizienten (Triple-A) Geschirrspülers besticht durch die symmetrische Anordnung und die klare Gliederung der Funktionen wie z.B. der sechs Programme und Zusatzoptionen wie „VarioSpeed" oder „Halbe Beladung". Vielfache Verstellmöglichkeiten der Körbe sowie die dritte Beladungsebene für Besteck- und andere Kleinteile bieten viel Platz, auch für spezielle Beladungsanforderungen.

The control panel design of the integrated and exceptionally energy-efficient (Triple A) dishwasher impresses with its symmetrical layout and clear structuring of functions, e.g. the six programs and additional "VarioSpeed" or "HalfLoad" options. Various adjustment options for the baskets, as well as the third loading level for cutlery and small items provide plenty of space, even for special loading scenarios.

Product
SBI69M15EU
Integrierter Einbau-Geschirrspüler
Integrated built-in dishwasher

Design
Robert Bosch Hausgeräte GmbH
Thomas Ott, Robert Sachon
München, Germany

Manufacturer
Robert Bosch Hausgeräte GmbH
München, Germany

Mit sechs Programmen und Optimierungsmöglich-keiten wie „Halbe Beladung", „VarioSpeed", „Hy-gienePlus" und „IntensivZone" bietet der integrier-bare sehr leise Spüler mit Edelstahlblende für jeden Nutzer maximalen Komfort. Die klare Gliederung der Funktionen erschließt sich intuitiv: Hauptschalter und Starttaste liegen ganz außen. Programm- und Op-tionstasten sind symmetrisch um das mittige Display angeordnet. Beste Effizienzwerte und höchste Varia-bilität durch „Rackmatic"-Höhenverstellung, „Vario-Schublade" als dritte Beladungsebene für Bestecke und Kleingeschirr, Klappstacheln und riesiges Fas-sungsvermögen steigern seine Attraktivität.

With six programs and optimisation options like "HalfLoad", "VarioSpeed", "HygienePlus" and "In-tensiveZone" this integrated, extremely quiet dish-washer with stainless steel control panel affords all users maximum convenience. The clear structure of the functions can be grasped intuitively: the main switch and start button are at the very outside. Pro-gram and option buttons are symmetrically arranged around the central display. Premium efficiency rates and maximum variability with "Rackmatic" height adjustment, "VarioDrawer" as third loading level for cutlery and small items, folding racks and a huge capacity enhance its appeal.

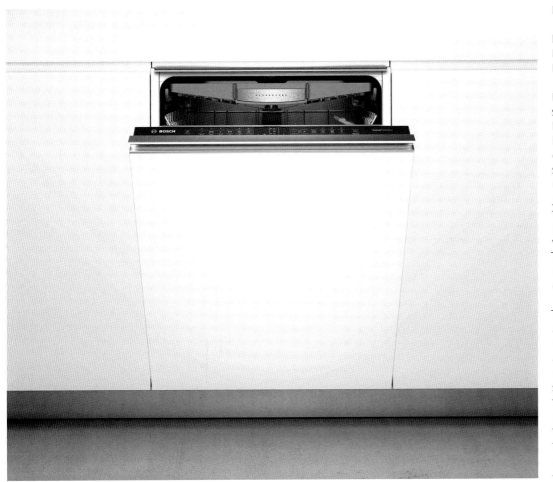

Product
SBV69T10EU
Vollintegrierter Einbau-Geschirrspüler
Fully integrated built-in dishwasher

Design
Robert Bosch Hausgeräte GmbH
Thomas Ott
München, Germany

Manufacturer
Robert Bosch Hausgeräte GmbH
München, Germany

Der vollintegrierbare Spüler bietet ein riesiges Fassungsvermögen und hohe Vielseitigkeit: Das „VarioFlexPlus"-Korbsystem mit „Oberkorb-Rackmatic"-Höhenverstellung und die flexiblen XXL-Geschirrkörbe erlauben eine individuelle Anpassung an die Geschirrteile. Die Schublade der dritten Beladungsebene nimmt Besteck und Kleingeschirr auf. Metallgriffe auf jeder Ebene bieten Komfort und zeugen von qualitativem Anspruch. Sechs Programme mit Aqua- und Beladungssensor, Wärmetauscher-Technologie sowie vier Sonderfunktionen steuern Sie über die schwarze TouchControl-Bedienung. Das „ActiveWater-System" nutzt das Wasser pro Spülgang so effektiv, als wären es 4.100 Liter.

This fully integrated dishwasher offers a huge capacity and outstanding versatility: the "VarioFlexPlus" basket system with top basket "Rackmatic" height adjustment and flexible XXL baskets permits individual loading. The third level drawer holds cutlery and small items. Metal handles on every level offer comfort and underline the high standard of quality. Six programs with aqua and load sensor, heat exchanger technology and four special options are controlled via the black touch controls. The "ActiveWater system" uses the water in each cycle as effectively as if it were 4,100 litres.

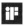
Product
SBV65T20EU
Vollintegrierter Einbau-Geschirrspüler
Fully integrated built-in dishwasher

Design
Robert Bosch Hausgeräte GmbH
Thomas Ott
München, Germany

Manufacturer
Robert Bosch Hausgeräte GmbH
München, Germany

Der „SuperSilence"-Spüler integriert sich vollständig
in moderne Einbauküchen. Bei 42 dB ist er auch kaum
zu hören. Dafür überzeugen seine inneren Werte:
„EmotionLight" leuchtet den gesamten Innenraum
taghell aus. Die innovative „Zeolith"-Technologie bie-
tet beste Trocknungsergebnisse bei noch weniger
Energiebedarf. Automatikprogramme, Sonderfunk-
tionen sowie „ActiveWater"- und Wärmetauscher-
technologie betonen seinen Wert ebenso wie die
XXL-Geschirrkörbe in extra stabiler Ausführung mit
wertigen Metallgriffen. Der „DosierAssistent" im Ober-
korb bietet durch gezielte Sprühstrahlen eine kon-
trollierte und vollständige Auflösung aller Reiniger-
arten.

The "SuperSilence" dishwasher can be fully integrated
into modern fitted kitchens. At 42 db it can hardly be
heard either. Its inner qualities are impressive: "Emo-
tionLight" illuminates the whole interior as bright as
daylight. The innovative "Zeolith" technology offers
top drying results for even less energy. Automatic
programs, special functions, "ActiveWater" and heat
exchanger technology emphasise its superior quality
as do the XXL baskets in an ultra-stable design with
exclusive metal handles. The "DosageAssistant" in
the top basket assures controlled, complete dissolv-
ing of all types of cleaning products by means of
targeted spraying.

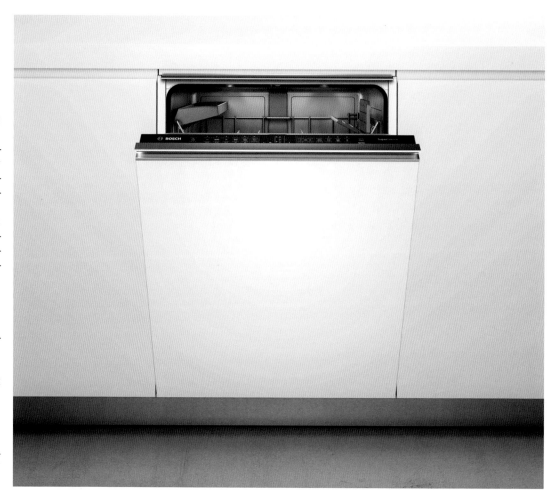

Product
DF 461 161
Vario-Geschirrspüler
Vario dishwasher

Design
Gaggenau Hausgeräte GmbH
H. Reinhard Segers, Sándor Klunker
München, Germany

Manufacturer
Gaggenau Hausgeräte GmbH
München, Germany

Der Vario-Geschirrspüler DF 461 von Gaggenau: Die neuen Vario-Geschirrspüler stehen für ein Maximum an Variabilität. Das gilt für die Technik ebenso wie für die Innenausstattung. Alles geht, kein Wunsch bleibt offen. Dafür sorgen neben der serienmäßig großen Funktionsvielfalt auch die Sonderausstattungen. Sie ermöglichen bedarfsgerechte Erweiterungen, die bei Gaggenau Methode haben. Der vollintegrierbare Geschirrspüler DF 461 kann mit einer Vollglastür kombiniert werden, die mit Edelstahl oder Aluminium hinterlegt ist und sich so in das Design der Backofen-Serie 200 einfügen.

The Vario dishwasher DF 461 from Gaggenau: The new Vario dishwasher offers maximum flexibility, in terms of interior configuration as well as technology. Anything's possible and nothing left to be desired, thanks to the wide range of standard functions and many optional features. These permit the well thought-out customization extras you are accustomed to from Gaggenau. The fully-integrated dishwasher DF 461 can be combined with a glass door backed with stainless steel or aluminium to blend in perfectly with the design of the 200 series oven range.

Product
Mega SHW 4674 N
Elektro Einbaubackofen
Built-in electric oven

Design
Constructa-Neff Vertriebs GmbH
Gerhard Nüssler, Ralf Grobleben
München, Germany
Tesseraux+Partner
Potsdam, Germany

Manufacturer
Constructa-Neff Vertriebs GmbH
München, Germany

Emotional anregend das neue faszinierend klare Design des Backofens Mega SHW 4674 N. Im Zentrum der geprägten Bedienblende der innovative „NeffNavigator", die neuartige und komfortable Einknopf-Bedienung und der darüber liegende leicht geschwungene Glaseinleger mit „Klartext-Elektronik". Spannend das Zusammenspiel von feiner Facettierung der Kanten als markantem und der Ellipse als hintergründigem Designelement. Die Highlights: der ergonomisch mitdrehende Türgriff SLIDE®, die voll versenkbare Backofentür HIDE® und die helle Backofenbeleuchtung NeffLight®. Mit 14 Betriebsarten gelingt die Zubereitung komfortabel und perfekt.

Emotionally stimulating: the new fascinatingly clear design of the Mega SHW 4674 N oven. At the centre of the embossed control panel is the "NeffNavigator", the innovative and convenient solitary control, above it the slightly curved glass insert with "ClearText electronics". Exciting: the interplay of fine faceting of the edges as a distinctive feature and the ellipse as a background design element. The highlights: the ergonomically revolving SLIDE® handle, the fully retractable HIDE® oven door and the bright NeffLight® oven lighting. With 14 settings, convenient and perfect preparation is guaranteed.

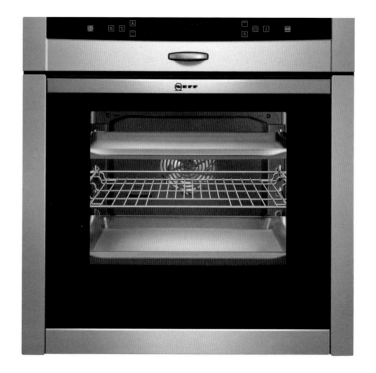

Product
Mega SHE 4674 N
Elektro Einbaubackofen
Built-in electric oven

Design
Constructa-Neff Vertriebs GmbH
Gerhard Nüssler, Ralf Grobleben
München, Germany
Tesseraux+Partner
Potsdam, Germany

Manufacturer
Constructa-Neff Vertriebs GmbH
München, Germany

Das neue faszinierende Design des Backofens Mega SHE 4674 N weckt Begeisterung. Ein nach oben offener Rahmen als Matrix, an dem sich alles ausrichtet. Spannend das Zusammenspiel von feiner Facettierung der Kanten als markantem und der Ellipse als hintergründigem Designelement. Herausragend die geprägte Bedienblende mit der zentral platzierten Finknopf-Bedienung und darüber dem Glaseinleger mit „Klartext-Elektronik". Die Highlights: der ergonomisch mitdrehende Türgriff SLIDE®, die voll versenkbare Backofentür HIDE® und das NeffLight®. Das „DUO-Backofensystem" mit zwölf Betriebsarten ermöglicht eine komfortable und perfekte Zubereitung.

The new fascinating details of the Mega SHE 4674 N oven meet with an enthusiastic response. A frame open at the top as a matrix dictates the overall alignment. Exciting: the interplay of fine faceting of the edges and the ellipse as a background design element. A striking feature is the embossed control panel with the central placement of the solitary control and, above it, the glass insert with "ClearText electronics". The highlights: the ergonomically revolving SLIDE® handle, the fully retractable HIDE® oven door and NeffLight®. The "DUO oven system" with twelve settings facilitates convenient and perfect preparation.

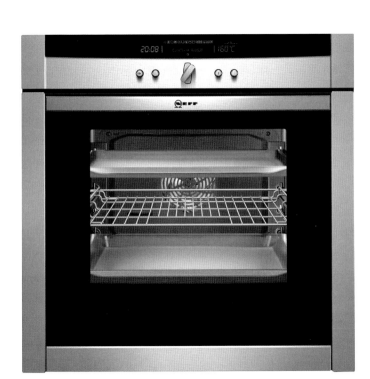

Product
Mega SHM 4542 N
Elektro Einbaubackofen
Built-in electric oven

Design
Constructa-Neff Vertriebs GmbH
Gerhard Nüssler, Ralf Grobleben
München, Germany
Tesseraux+Partner
Potsdam, Germany

Manufacturer
Constructa-Neff Vertriebs GmbH
München, Germany

Das neue Design des Backofens Mega SHM 4542 N
zieht die Blicke an: einheitlich und klar, verbunden mit
einem durchgängigen Bedien- und Anzeigenkonzept.
Auffallend die Facettierung der Kanten als wieder-
kehrendes, die Ellipse als dezentes Designelement.
Im Focus: die geprägte Bedienblende mit dem nach
unten leicht geschwungenen Glaseinleger und den
facettierten voll versenkbaren Bedienknebeln. Die
Highlights: der ergonomisch mitdrehende Türgriff
SLIDE® und die voll versenkbare Backofentür HIDE®.
Das „DUO-Backofensystem" mit acht Betriebsarten
ermöglicht die komfortable und perfekte Zuberei-
tung.

The new design of the Mega SHM 4542 N oven draws
all eyes: uniform and clear, together with a consistent
operating and display concept. Striking: the faceting
of the edges as a recurring design element and the
ellipse as an understated feature. In focus: the em-
bossed control panel with the slight downward curve
of the glass insert and the faceted, fully retractable
controls. The highlights: the ergonomically revolving
SLIDE® handle and the fully retractable HIDE® oven
door. The "DUO oven system" with eight settings
facilitates convenient and perfect preparation.

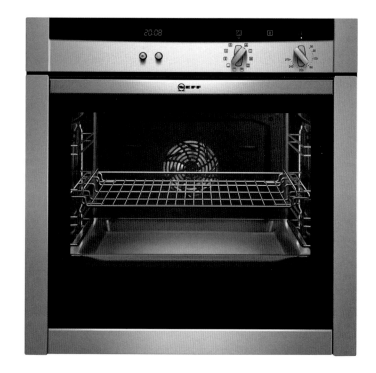

Product
Mega SHE 4554 N
Elektro Einbaubackofen
Built-in electric oven

Design
Constructa-Neff Vertriebs GmbH
Gerhard Nüssler, Ralf Grobleben
München, Germany
Tesseraux+Partner
Potsdam, Germany

Manufacturer
Constructa-Neff Vertriebs GmbH
München, Germany

Das neue beeindruckend klare Design des Backofens Mega SHE 4554 N, verbunden mit einem durchgängigen Bedien- und Anzeigenkonzept, weckt Emotionen. Fein die Facettierung der Kanten als wiederkehrendes Designelement und die Form der Ellipse als hintergründiges Designelement. Elegant ist die geprägte Bedienblende mit dem leicht geschwungenen Glaseinleger und der zentral platzierten, voll versenkbaren Einknopf-Bedienung. Die Highlights: der ergonomisch mitdrehende Türgriff SLIDE® und die voll versenkbare Backofentür HIDE®. Das „DUO-Backofensystem" mit zwölf Betriebsarten ermöglicht eine komfortable und perfekte Zubereitung.

The new impressively clear design of the Mega SHE 4554 N oven, together with the consistent operating and display concept arouses emotions. The fine faceting of the edges as a recurring design element and the ellipse form as a background design feature. Elegant: the embossed control panel with the lightly curved glass insert and the central placement of the fully-retractable solitary control. The highlights: the ergonomically revolving SLIDE® handle and the fully retractable HIDE® oven door. The "DUO oven system" with twelve settings facilitates convenient and perfect preparation.

Product
Mega SHE 4542 N
Elektro Einbaubackofen
Built-in electric oven

Design
Constructa-Neff Vertriebs GmbH
Gerhard Nüssler, Ralf Grobleben
München, Germany
Tesseraux+Partner
Potsdam, Germany

Manufacturer
Constructa-Neff Vertriebs GmbH
München, Germany

Einfach faszinierend ist das neue klare Design des
Backofens Mega SHE 4542 N, verbunden mit einem
durchgängigen Bedien- und Anzeigenkonzept. Anre-
gend die Facettierung der Kanten als wiederkehren-
des und die Ellipse als dezentes Designelement im
Hintergrund. Elegant: die geprägte Bedienblende mit
dem nach unten leicht geschwungenen Glaseinleger.
Im Zentrum befindet sich der facettierte voll versenk-
baren Einknopf-Bedienknebel. Die Highlights: der er-
gonomisch mitdrehende Türgriff SLIDE® und die voll
versenkbare Backofentür HIDE®. Das „DUO-Back-
ofensystem" mit neun Betriebsarten ermöglicht eine
komfortable und perfekte Zubereitung.

Simply fascinating – the new clear design of the Mega
SHE 4542 N oven together with a consistent operat-
ing and display concept. Exciting: the faceting of the
edges as a recurring design element and the ellipse
as an understated background feature. Elegant: the
embossed control panel with the slight downward
curve of the glass insert and the faceted, fully-re-
tractable solitary control at the centre. The highlights:
the ergonomically revolving SLIDE® handle and the
fully-retractable HIDE® oven door. The "DUO oven
system" with nine settings facilitates convenient and
perfect preparation.

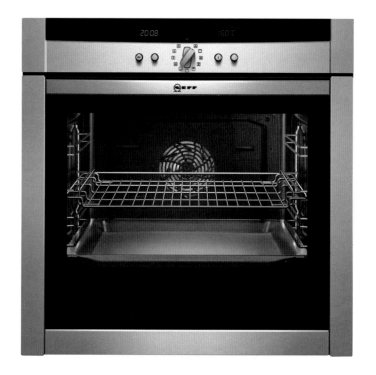

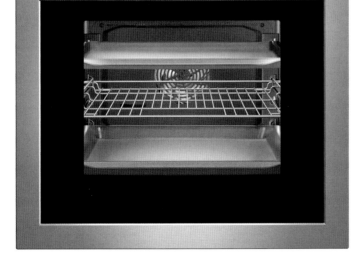

Product
Mega BW 1674 N
Elektro Einbaubackofen
Built-in electric oven

Design
Constructa-Neff Vertriebs GmbH
Gerhard Nüssler, Ralf Grobleben
München, Germany
Tesseraux+Partner
Potsdam, Germany

Manufacturer
Constructa-Neff Vertriebs GmbH
München, Germany

Der Backofen Mega BW 1674 N sorgt für Aufsehen. Beeindruckend sein neues klares Design. Es ist verbunden mit einem durchgängigen Bedien- und Anzeigenkonzept und mit einem nach oben offenen Rahmen als Matrix. An ihm richtet sich alles aus. Die Facettierung der Kanten ist ein wiederkehrendes Designelement. Einzigartig ist die geprägte Bedienblende mit Glaseinleger, in deren Zentrum der innovative „NeffNavigator" – Komfortbedienung mit dem perfekten Dreh – steht. Mit 14 Betriebsarten gelingt jedes Gericht perfekt. NeffLight® setzt die Speisen auf allen Ebenen perfekt ins Licht. Sehr ergonomisch: der mitdrehende Türgriff SLIDE®.

The Mega BW 1674 N oven causes a stir. Impressive with its new clear design, together with a consistent operating and display concept, with a frame open at the top as a matrix dictating the overall alignment. The faceting of the edges as a recurring design element. A unique feature is the embossed control panel with glass insert with the innovative "NeffNavigator" at its centre – convenient operation with the perfect twist. With 14 settings every dish turns out perfectly. NeffLight® sheds the right light on meals at all levels. Very ergonomic: the SLIDE® handle.

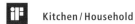

Product
Mega BE 1674 N
Elektro Einbaubackofen
Built-in electric oven

Design
Constructa-Neff Vertriebs GmbH
Gerhard Nüssler, Ralf Grobleben
München, Germany
Tesseraux+Partner
Potsdam, Germany

Manufacturer
Constructa-Neff Vertriebs GmbH
München, Germany

Der Backofen Mega BE 1674 N: Beeindruckend sein neues klares Design, verbunden mit einem durchgängigen Bedien- und Anzeigenkonzept. Ein nach oben offener Rahmen als Matrix, an dem sich alles ausrichtet. Die Facettierung der Kanten als markantes, die Ellipse als dezentes Designelement. Im Focus: die geprägte Bedienblende mit dem nach unten leicht geschwungenen Glaseinleger und den aus dem Zentrum heraus platzierten Bedienelementen. Mit zwölf Betriebsarten gelingt jedes Gericht perfekt. NeffLight® setzt die Speisen auf allen Ebenen perfekt ins Licht. Sehr komfortabel: der Etagenauszug VarioCLOU®. Sehr ergonomisch: der SLIDE® Türgriff.

The Mega BE 1674 N oven: Impressive in its new clear design, together with a consistent operating and display concept. A frame open at the top as a matrix with which everything is aligned. The faceting of the edges as a distinctive feature, the ellipse as an understated design element. In focus: The embossed control panel with the light downward curve of the glass insert and the central location of the control elements. With twelve settings, every dish is a success. The innovative NeffLight® casts the perfect light on the meals, at all levels. Very convenient: the VarioCLOU® shelves. Very ergonomic: the SLIDE® handle.

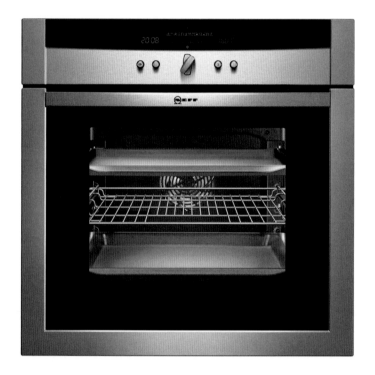

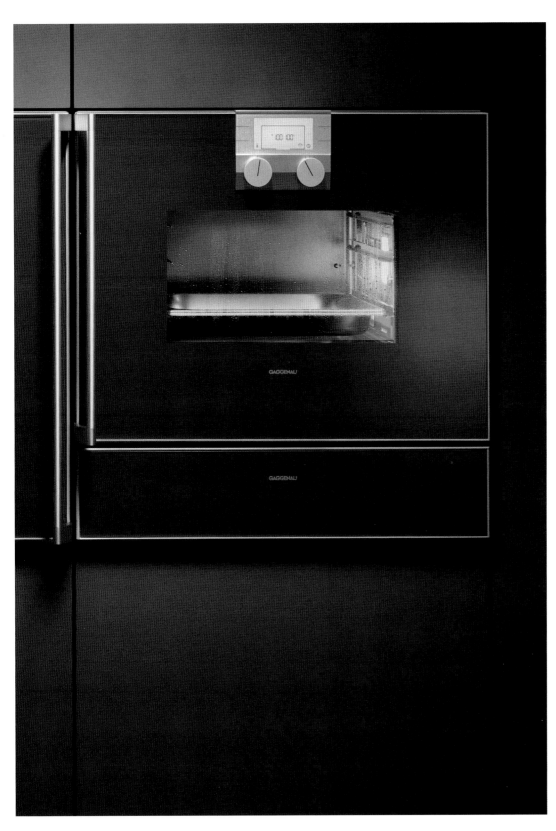

Product
BS 220
Dampfgarofen
Steam oven

Design
Gaggenau Hausgeräte GmbH
H. Reinhard Segers, Sven Baacke
München, Germany

Manufacturer
Gaggenau Hausgeräte GmbH
München, Germany

Der Dampfgarofen BS 220 von Gaggenau: Dampfgaren ist auch ohne Heißluft eine attraktive und schonende Garmethode. Ohne Druck dämpft das Gerät bei 100% Feuchtigkeit, mit elektronischer Temperaturregelung von 30 °C bis 100 °C und ist auch für Niedertemperatur-Dämpfen, Auftauen und Garen geeignet. Der Garraum ist aus Edelstahl. Der Einbau ist unkompliziert und mit Wassertank leicht zu handhaben. Die Glastür öffnet sich in voller Höhe und ist wahlweise anthrazit-, edelstahl- oder aluminiumfarben hinterdruckt. Das LCD-Funktionsdisplay, mit Knebeln und Sensortasten für die einfache Bedienung, ist in die Türe integriert.

Steam oven BS 220 from Gaggenau: Steaming is an attractive and gentle cooking method even without hot air. The oven uses 100% humidity to steam without pressure, has electronic temperature regulation (30 °C to 100 °C) and is also suitable for low-temperature steaming, defrosting and cooking. It features a stainless-steel cooking compartment. The built-in appliance is uncomplicated and the water tank easy to use. The glass door extends the full height of the oven and is available in anthracite, stainless-steel or aluminium-effect backing. The LCD function display is integrated in the door with control knobs and sensor buttons for easy operation.

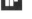 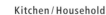

Product
BO 220
Backofen
Oven

Design
Gaggenau Hausgeräte GmbH
H. Reinhard Segers, Sven Baacke
München, Germany

Manufacturer
Gaggenau Hausgeräte GmbH
München, Germany

Der Backofen BO 220 von Gaggenau: Die große Glastür öffnet sich seitlich über die volle Höhe. Das gehärtete Glas ist wahlweise anthrazit-, edelstahl- oder aluminiumfarben hinterdruckt. Das LCD-Funktionsdisplay, mit Knebeln und Sensortasten für die einfache Bedienung, ist in die Tür integriert. 60 cm breiter Backofen, mit dem größten Nutzvolumen seiner Klasse und zwar 67 l. Halogen-Beleuchtung von oben. Ein Backofen mit neun Heizmethoden und zusätzlichem Heizkörper, der mit dem Sonderzubehör „Backstein" ausgerüstet werden kann. Exakte Temperaturen dank elektronischer Regelung von 50 °C bis 300 °C und pyrolytische Selbstreinigung.

Oven BO 220 from Gaggenau: The wide, side-opening glass door extends the full height of the oven. The toughened glass is available in anthracite, stainless-steel or aluminium-effect backing. The LCD function display is integrated into the door with control knobs and sensor buttons for easy operation. The oven is 60 cm wide and offers a usable volume of 67 l, the largest in its class. Halogen lighting from above. An oven with nine heating methods and additional heating elements, it can be equipped with a baking stone as a special accessory. Precise temperatures thanks to electronic regulation from 50 °C to 300 °C and pyrolytic self-cleaning.

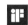

Product
HBC36D723 / HSC140P21
Kompakt-Dampfgarer mit Wärmeschublade
Compact steam oven with warming drawer

Design
Robert Bosch Hausgeräte GmbH
Robert Sachon, Bernd Kretschmer, Ulrich Goss
München, Germany

Manufacturer
Robert Bosch Hausgeräte GmbH
München, Germany

Trotz des professionellen Anspruchs, Wasserdampf und Heißluft in einem Gerät zu kombinieren und somit sowohl die Feuchtigkeit des Garguts zu erhalten als auch gleichzeitig eine knusprige Bräune zu erreichen, gibt sich das Äußere des Gerätes betont schlicht. Eine sinnvolle Ergänzung zu Einbaugeräten stellt die Wärmeschublade HSC140P21 dar. Nicht nur das Vorwärmen des Geschirrs, sondern u. a. auch das Warmhalten von Speisen und Sanftgaren beschreiben die Funktionsvielfalt des Gerätes. Die weiße Glasoberfläche vermittelt Leichtigkeit und Wohnlichkeit.

Although professionally combining steam and hot air in one appliance and thus preserving the moisture in the food as well as achieving a crisp roast, the appliance exterior is emphatically minimalist. A practical complement to built-in appliances is the warming drawer HSC140P21. Beside preheating dishes, the versatile talents of this appliance include keeping meals hot and slow cooking. The white glass surface conveys an impression of airiness and living ambience.

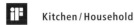
Product
HBC86P723/HSC140P21
Kompakt-Backofen mit Wärmeschublade
Compact oven with warming drawer

Design
Robert Bosch Hausgeräte GmbH
Robert Sachon, Bernd Kretschmer, Ulrich Goss
München, Germany

Manufacturer
Robert Bosch Hausgeräte GmbH
München, Germany

Trotz Integration unterschiedlichster Heiztechnolo-
gien (klassisch + Mikrowelle) und zahlreicher Auto-
matikprogramme, bis hin zur Selbstreinigungsfunk-
tion innerhalb der kompakten Geräteabmessungen,
gibt sich das Äußere des Gerätes betont schlicht.
Die weiße Glasoberfläche vermittelt Leichtigkeit und
Wohnlichkeit und hält sich im Küchenumfeld wohl-
tuend zurück. Eine ausgereifte Push/Pull-Mechanik
öffnet die Wärmeschublade. Die Anzeigeelemente
sind auf eine rote LED reduziert.

Although various heating techniques (conventional +
microwave) and several automatic programs through
to the self-cleaning function are integrated in its
compact format, the appliance exterior is emphatic-
ally minimalist. The white glass surface conveys an
impression of airiness and living ambience, merging
into the kitchen environment with pleasant discre-
tion. The warming drawer is opened by a perfected
push/pull mechanism that dispenses with any ad-
ditional handle elements. Even the display elements
have been reduced to solely indicating status by one
red LED light.

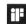

Product
HBA78B720
Einbau-Backofen, weiß
Built-in oven, white

Design
Robert Bosch Hausgeräte GmbH
Robert Sachon, Bernd Kretschmer, Ulrich Goss
München, Germany

Manufacturer
Robert Bosch Hausgeräte GmbH
München, Germany

Die Verwendung hochwertiger Materialien in Form von optischen Gläsern und deutlich akzentuiert wirkender Bedienelemente in glänzendem Aluminium steht bei diesem Gerät im Vordergrund. Die haptischen Qualitäten der Vollmetallausführung stehen den optischen in nichts nach. Das charaktervolle Weiß ist auf eine moderne, aber zugleich wohnliche Küchenästhetik abgestimmt. Mit Hilfe des ebenso eigenständigen wie intuitiven TouchControl-Interface, lassen sich die vielfältigen Gerätefunktionen (13 Heizarten/68 Automatikprogramme) spielerisch leicht bedienen. Der Backwagen mit Softeinzug kann mit modernsten Küchenauszugssystemen konkurrieren.

The use of select materials in the shape of optical glass and signature control elements in gleaming aluminium take centre stage on this appliance. This visual appearance is rivalled only by the haptic qualities of the all-metal design. The distinctive white is designed for a modern kitchen, yet at the same time living ambience. With the help of the TouchControl-interface that is both iconic and intuitive, the many functions (13 heating methods/68 automatic programms) can be operated effortlessly. The soft-action oven trolley can compete with the latest kitchen pull-out systems.

Product
HBC36D753
Kompakt-Dampfbackofen
Compact steam oven

Design
Robert Bosch Hausgeräte GmbH
Robert Sachon, Bernd Kretschmer, Florian Metz
München, Germany

Manufacturer
Robert Bosch Hausgeräte GmbH
München, Germany

Die innovative Kombination von Wasserdampf und Heißluft in einem Gerät ermöglicht es z.B., Braten innen saftig und außen dennoch knusprig zuzubereiten. Dieser professionelle Anspruch setzt sich auch in der Gestaltung des Gerätes fort. Qualität und technische Perfektion wird durch demonstrative Materialität und präzise gestaltete und hochwertig verarbeitete Details sinnlich erfahrbar gemacht. Das flächenbündig integrierte und durch klare Gliederung ebenso markante wie intuitive User-Interface prägt das Gesicht des Gerätes durch die sinnvolle Kombination von klassischem Drehwähler in Verbindung mit Touch- und hochauflösender Displaytechnologie.

The innovative combination of steam and hot air in one appliance produces e.g. roasts that are succulent on the inside yet crisp on the outside. This professional aspiration is also mirrored in the appliance design. In the demonstrative use of materials, precision-designed and superiorly crafted details, quality and technical perfection can be experienced with sensuous immediacy. The flush-integrated user interface with its clear design, which is at once iconic and intuitive, characterises the range look in its efficient combination of conventional rotary controls, touch and high-definition display technology.

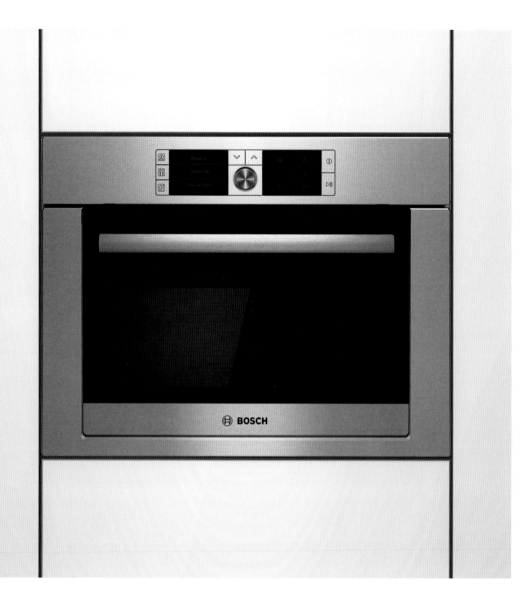

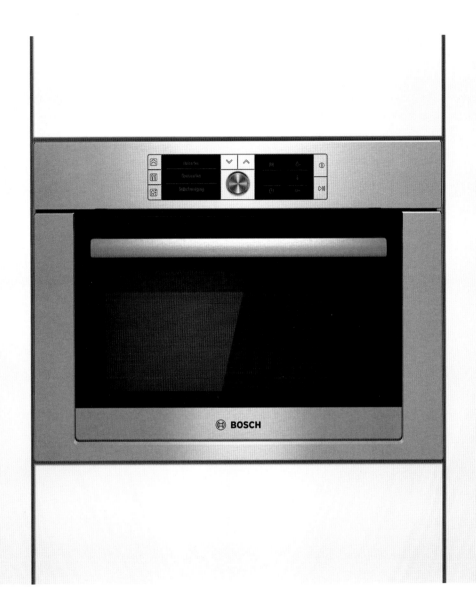

Product
HBC26D553
Kompakt Dampfgarer
Compact steam cooker

Design
Robert Bosch Hausgeräte GmbH
Robert Sachon, Bernd Kretschmer, Florian Metz
München, Germany

Manufacturer
Robert Bosch Hausgeräte GmbH
München, Germany

In Wasserdampf gegarte Speisen sind besonders zart und saftig. Die schonende Zubereitung erhält Farbe, Aromen, Vitamine und Mineralien der Nahrungsmittel. Dieser professionelle Anspruch setzt sich auch in der Gestaltung des Gerätes fort. Qualität und technische Perfektion werden durch demonstrative Materialität und präzise gestaltete und hochwertig verarbeitete Details sinnlich erfahrbar gemacht. Das flächenbündig integrierte und durch klare Gliederung ebenso markante wie intuitive User-Interface prägt das Gesicht des Gerätes durch die sinnvolle Kombination von klassischem Drehwähler in Verbindung mit Touch- und hochauflösender Displaytechnologie.

Steam-cooked food is especially tender and succulent. Gentle cooking preserves the color, flavor, vitamins and minerals in food. This professional aspiration is also mirrored in the appliance design. In the demonstrative use of materials, precision-designed and superiorly crafted details, quality and technical perfection can be experienced with sensuous immediacy. The flush-integrated user interface with its clear design, which is at once iconic and intuitive, characterises the range look in its efficient combination of conventional rotary controls, touch and high-definition display technology.

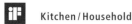

Product
HBM56B550B
Doppelbackofen
Double oven

Design
Robert Bosch Hausgeräte GmbH
Robert Sachon, Bernd Kretschmer, Ulrich Goss
München, Germany

Manufacturer
Robert Bosch Hausgeräte GmbH
München, Germany

Der professionellen Ansprüchen genügende Doppel-
backofen ist ideal zum zeitsparenden Zubereiten von
komplexen Menüs und unterschiedlichen Gerichten.
Präzise gestaltete Designdetails wie die facettierte
Türapplikation oder die metallischen Drehwähler ma-
chen den hohen Qualitäts- und Perfektionsanspruch
der Marke sinnlich erfahrbar. Das prägnante User-
Interface eignet sich hervorragend zur intuitiven Be-
dienung von getrennten Garräumen und der vielfäl-
tigen Gerätefunktionen. Eigens entwickelte haptisch
wie visuell ansprechende Touchsensoren mit Edel-
stahloberfläche integrieren sich ebenso perfekt in
das Gesamtbild wie die Anzeigeelemente.

The double oven, which meets professional require-
ments, is perfect for the time-saving preparation of
elaborate menus with various dishes. The brand's
select quality and aspirations to perfection can be
experienced with sensuous immediacy in precision-
crafted design features such as the facetted door ap-
plications or metallic selector. The iconic user inter-
face is excellently suited to the intuitive operation of
the separate ovens and diverse appliance functions.
Specially developed touch sensors with both haptic
and visual appeal, and a stainless steel surface, are
integrated just as perfectly in the overall picture as
the display elements.

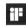

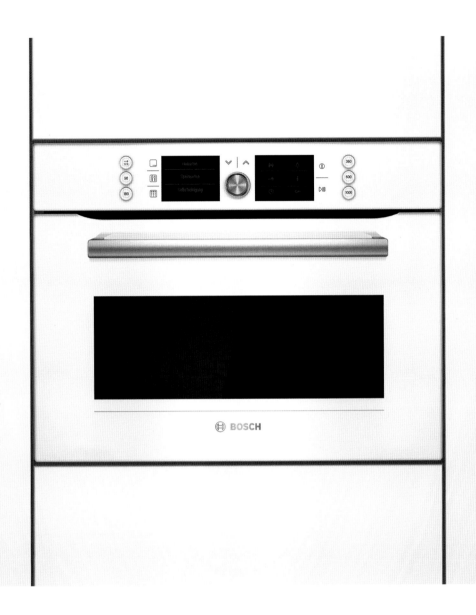

Product
HBC86P723
Kompakt-Backofen, weiß
Compact oven, white

Design
Robert Bosch Hausgeräte GmbH
Robert Sachon, Florian Metz, Bernd Kretschmer
München, Germany

Manufacturer
Robert Bosch Hausgeräte GmbH
München, Germany

Trotz Integration unterschiedlichster Heiztechnologien (klassisch + Mikrowelle) und zahlreicher Automatikprogramme, bis hin zur Selbstreinigungsfunktion innerhalb der kompakten Geräteabmessungen, gibt sich das Äußere des Gerätes betont schlicht. Die weißen Glasoberflächen vermitteln Leichtigkeit und Wohnlichkeit. Somit eignet sich das Gerät speziell zum Einbau in moderne, zum Wohnraum hin offene Küchensituationen. Das durch die klare Gliederung ebenso markante wie intuitive User-Interface prägt das Gesicht der Linie. Gezielt gesetzte Materialakzente von Drehwähler und Griff runden das Gesamterscheinungsbild ab.

Although various heating techniques (conventional + microwave) and several automatic programs through to the self-cleaning function are integrated in its compact format, the appliance exterior is emphatically minimalist. The white glass surfaces convey a sense of airiness and living ambience. The model is therefore ideal for integration in modern open-plan kitchen-cum-living areas. The range look is characterised by the user interface with its clear design which is at once iconic and intuitive. Deliberate material accents in the shape of rotary controls and handle round off the overall impression.

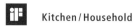
Product
HBC36D723
Kompakt-Backofen, weiß
Compact oven, white

Design
Robert Bosch Hausgeräte GmbH
Robert Sachon, Florian Metz, Bernd Kretschmer
München, Germany

Manufacturer
Robert Bosch Hausgeräte GmbH
München, Germany

Trotz des professionellen Anspruchs, Wasserdampf
und Heißluft in einem Gerät zu kombinieren und
somit sowohl die Feuchtigkeit des Garguts zu er-
halten als auch gleichzeitig eine knusprige Bräune
zu erreichen, gibt sich das Äußere des Gerätes be-
tont schlicht. Die weißen Glasoberflächen vermitteln
Leichtigkeit und Wohnlichkeit. Somit eignet sich das
Gerät speziell zum Einbau in moderne, zum Wohn-
raum hin offene Küchensituationen. Das durch die
klare Gliederung ebenso markante wie intuitive User-
Interface prägt das Gesicht der Linie. Gezielt gesetzte
Materialakzente von Drehwähler und Griff runden
das Gesamterscheinungsbild ab.

Although professionally combining steam and hot air
in one appliance and thus preserving the moisture in
the food as well as achieving a crisp roast, the appli-
ance exterior is emphatically minimalist. The white
glass surfaces convey a sense of airiness and living
ambience. The model is therefore ideal for integra-
tion in modern open-plan kitchen-cum-living areas.
The range look is characterised by the user interface
with its clear design which is at once iconic and in-
tuitive. Deliberate material accents in the shape of
rotary controls and handle round off the overall im-
pression.

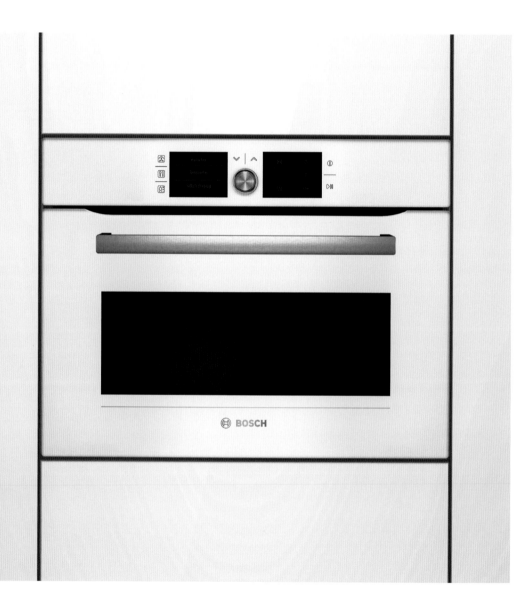

Product
BEKO OIM 25500 X
Einbaubackofen
Built-in oven

Design
Arcelik A. S. Industrial Design Team
Mathis Heller
Istanbul, Turkey

Manufacturer
Arcelik A. S.
Istanbul, Turkey

Der BEKO-Einbaubackofen zählt mit 43 dbA Geräuschentwicklung zu den leisesten Vertretern seiner Klasse. Sein Fassungsvermögen übertrifft vergleichbare Geräte um 7–14%. Der Ofen eignet sich auch zum 3D-Kochen, zur gleichzeitigen Zubereitung mehrerer Gerichte ohne Verfälschung des Eigengeschmacks. Zwei verschiedene pyrolythische Selbstreinigungsfunktionen erleichtern die Reinigung. Die „Kühl-Tür"-Technologie mit vier Glasschichten und versenkten Oberhitzeelementen sorgt für minimale Wärmeabstrahlung und für mehr Sicherheit. Besonders große, klar erkennbare Displaysymbole gewährleisten eine ergonomische Bedienung des Gerätes. Die einfach auszutauschenden Seitenhalterungen können mit einem Griff schnell befestigt oder entfernt werden.

The BEKO built-in oven is the quietest one in its category with 43 dbA noise level. It has 7–14% larger cavity than current ones. The oven also serves for 3D cooking, a new generation of technology to cook lots of dishes without blending food flavours or aromas. It has two different self-cleaning pyrolitic functions together with easy to clean cavity. The "Cool Door" with four layers of glass and hidden top heater are designed to minimize external heat to provide safety. Bigger and more visible symbols of the display ensure ergonomically usage. Easy-to-remove side racks can be fastened and removed with a single move.

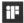
Product
Whirlpool Glamour Oven
Einbaubackofen
Built-in oven

Design
Whirlpool Corporation
European Design Team
Varese / Biandronno, Italy

Manufacturer
Whirlpool Corporation
Varese / Biandronno, Italy

WENIGER IST MEHR: Der minimalistische Ofen Whirlpool Glamour überzeugt mit hochwertigen Materialien, einwandfreier Verarbeitung und puristischem Design. Die seitlich öffnende Tür verbirgt einen großen Innenraum mit fünf Backebenen, einem neuen Luftzirkulationssystem, 6th Sense-Pyrotechnik und Dampfunterstützung. Das in die Glastür integrierte Bedienfeld mit Sensortasten hat ein 3,5 Zoll LCD-Farbdisplay, das bei ausgeschaltetem Ofen unsichtbar bleibt. Ansonsten erscheinen je nach Programm intuitive, durchdachte Grafiken. „Glamour" steht für ein strenges und dennoch emotionales Design – mit dem gewissen Etwas.

LESS IS MORE: Using only quality materials and impeccable constructive details, the Whirlpool Glamour oven is a "minimal" oven that offers clean, pure design. A full-size book-opening door reveals a big cavity with five cooking levels, a new airflow distribution, 6th Sense pyro-technology and steam-assisted technology. Its touch-sensitive control panel has a 3,5" screen and color graphic LCD display, integrated in a full-glass door. When the oven is off, the screen is invisible; turn it on, and intuitive and sophisticated graphics move across the display per selected program. "Glamour" personifies rigorous yet emotional design – with edge.

Product
HSC140P51
Wärmeschublade, Edelstahl
Warming drawer, stainless steel

Design
Robert Bosch Hausgeräte GmbH
Robert Sachon, Ulrich Goss
München, Germany

Manufacturer
Robert Bosch Hausgeräte GmbH
München, Germany

Eine sinnvolle Ergänzung zu Einbaugeräten stellt die Wärmeschublade HSC140P51 dar. Nicht nur Vorwärmen des Geschirrs, sondern u. a. auch das Warmhalten von Speisen und Sanftgaren beschreiben die Funktionsvielfalt des Gerätes. Die puristische, grifflose Edelstahlfront unterstreicht den professionellen Anspruch und wird durch eine ausgereifte Push / Pull-Mechanik geöffnet. Die Anzeigeelemente sind auf eine rote LED reduziert.

A practical complement to built-in appliances is the warming drawer HSC140P51. Beside preheating dishes, the versatile talents of this appliance include keeping meals hot and slow cooking. The purist stainless steel front, unmarred by handles, only reveals its inner qualities at second glance. Even the display elements have been reduced to solely indicating status. Besides professional preheating of dishes, meals can be kept hot or even slow cooked. The warming drawer is opened by a perfected push / pull mechanism that dispenses with any additional handle elements. The display elements have been reduced to solely indicating status by LED.

Product
HSC140P21
Wärmeschublade, weiß
Warming drawer, white

Design
Robert Bosch Hausgeräte GmbH
Robert Sachon, Ulrich Goss
München, Germany

Manufacturer
Robert Bosch Hausgeräte GmbH
München, Germany

Eine sinnvolle Ergänzung zu Einbaugeräten stellt die Wärmeschublade HSC140P21 dar. Nicht nur Vorwärmen des Geschirrs, sondern u.a. auch das Warmhalten von Speisen und Sanftgaren beschreiben die Funktionsvielfalt des Gerätes. Die weiße Glasoberfläche vermittelt Leichtigkeit und Wohnlichkeit und hält sich im Küchenumfeld wohltuend zurück. Eine ausgereifte Push/Pull-Mechanik öffnet die Wärmeschublade. Die Anzeigeelemente sind auf eine rote LED reduziert.

A practical complement to built-in appliances is the warming drawer, HSC140P21. Beside preheating dishes, the versatile talents of this appliance include keeping meals hot and slow cooking. The white glass surface conveys an impression of airiness and living ambience, merging into the kitchen environment with pleasant discretion. The warming drawer is opened by a perfected push/pull mechanism that dispenses with any additional handle elements. Even the display elements have been reduced to solely indicating status by one red LED light.

Product
WS 220
Wärmeschublade
Warming drawer

Design
Gaggenau Hausgeräte GmbH
H. Reinhard Segers Sven Baacke
München, Germany

Manufacturer
Gaggenau Hausgeräte GmbH
München, Germany

Die Wärmeschublade WS 220 von Gaggenau: Wärmeschubladen von Gaggenau haben einen hygienischen Innenraum aus Edelstahl und Glas und sind lebensmittelecht. Bei Temperaturen zwischen 40 °C und 80 °C können Braten nachreifen, Hefeteige aufgehen und Suppen warmgehalten werden. Auch zum schonenden Auftauen sind die Wärmeschubladen geeignet. Wärmeschubladen gibt es in drei verschiedenen Größen: 60 cm breit und 14 cm oder 29 cm hoch, oder 76 cm breit und 27 cm hoch. Sie sind je nach Bedarf mit Backofen, Dampfbackofen oder Kaffeevollautomaten kombinierbar. Die Geräte sind wie die Backöfen anthrazit-, edelstahl- oder aluminiumfarben hinterlegt.

Warming drawer WS 220 from Gaggenau: Gaggenau warming drawers have a hygienic interior of stainless steel and glass and are food safe. At temperatures of 40 °C to 80 °C, roasts can rest, yeast dough can rise and soups can be kept warm. Warming drawers are also suitable for gentle defrosting. Warming drawers are available in three sizes, 60 cm wide and 14 cm or 29 cm high, or 76 cm wide and 27 cm high. They can be combined as desired with an oven, steam oven or fully automatic coffee machine. Like the ovens, they are available in a choice of anthracite, stainless-steel or aluminium-effect backing.

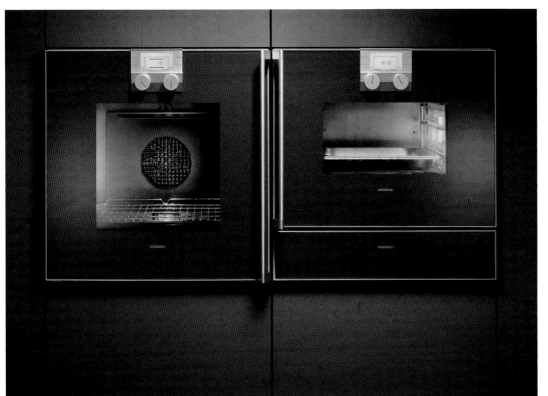

Product
TT 4490 N
Autarkes Induktionskochfeld
Induction hob

Design
Constructa-Neff Vertriebs GmbH
Gerhard Nüssler, Thomas Knöller
München, Germany
Tesseraux+Partner
Potsdam, Germany

Manufacturer
Constructa-Neff Vertriebs GmbH
München, Germany

Im wahrsten Sinne großartig: das 90 cm breite autarke Induktions-Kochfeld TT 4490 N mit der revolutionären TwistPad Bedienung. Aufsetzen, antippen, drehen – grenzenloser Bedienkomfort mit dem magnetischen, abnehmbaren TwistPad. Ebenso großartig: das elegante Design mit einem Zusammenspiel von extrem flachem Edelstahl-Zierrahmen, aufgesetzter, facettierter Glaskeramik und klarer Kochfeld-Grafik. Die Induktionsbeheizung gewährt zusammen mit innovativen Details wie der Wischschutz- oder Warmhaltefunktion puren Kochkomfort. Herausragend: die große Mehrkreis-Kochzone im Zentrum des Kochfelds.

Awesome in the truest sense: the 90 cm wide TT 4490 N induction hob with the revolutionary TwistPad operation. Put down, tip and turn – unlimited comfort of operation with the magnetic, detachable TwistPad. Just as awesome: the elegant design with an interplay of extremely shallow stainless steel decorative trim, raised faceted glass ceramic and clear graphics of the hob. Together with such innovative details as safety pilot and heat retention function, the induction heating guarantees pure cooking comfort. Outstanding: the large, multi-ring cooking zone at the centre of the hob.

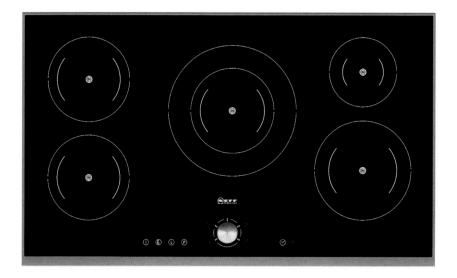

Product
TT 4440 N
Autarkes Induktionskochfeld
Separate induction hop

Design
Constructa-Neff Vertriebs GmbH
Gerhard Nüssler, Thomas Knöller
München, Germany
Tesseraux+Partner
Potsdam, Germany

Manufacturer
Constructa-Neff Vertriebs GmbH
München, Germany

Ein Superlativ in Bedienkomfort und elegantem Design: das autarke Induktionskochfeld TT 4440 N mit der evolutionären TwistPad Bedienung. Aufsetzen, antippen, drehen – mit dem magnetischen, abnehmbaren TwistPad wird die Bedienung zum genialen Dreh. Pure Ästhetik durch das Zusammenspiel von extrem flachem Edelstahl-Zierrahmen und aufgesetzter, fein facettierter Glaskeramik. Die klare Grafik der Kochzonen unterstreicht den professionellen Look dieses Kochfelds. Die Induktionsbeheizung gewährt zusammen mit innovativen Details wie Wischschutz- oder Warmhaltefunktion puren Kochkomfort.

A superlative in comfort of use and elegant design: the TT 4440 N separate induction hob with the evolutionary TwistPad operation. Put down, tip and turn – the magnetic, detachable TwistPad makes operation ingenious. Pure aesthetics thanks to the interplay of the extremely shallow stainless steel decorative trim and raised, finely faceted glass ceramic. The clear graphics of the cooking zones underline the professional look of this hob. Together with such innovative details as safety pilot and heat retention function, the induction heating guarantees pure cooking comfort.

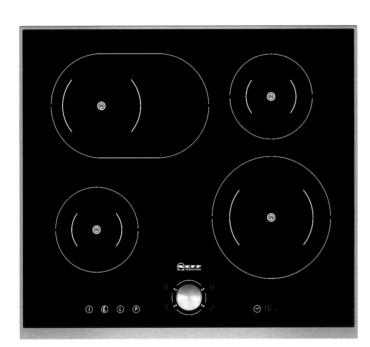

Product
TD 4420 N
Autarkes Induktionskochfeld
Separate induction hob

Design
Constructa-Neff Vertriebs GmbH
Gerhard Nüssler, Thomas Knöller
München, Germany
Tesseraux+Partner
Potsdam, Germany

Manufacturer
Constructa-Neff Vertriebs GmbH
München, Germany

Ein großer Genuss bereits beim Kochen: das elegante Design des autarken Induktionskochfelds TD 4420 N. Sein extrem flacher Zierrahmen aus hochwertigem Edelstahl und die aufgesetzte fein facettierte Glaskeramik bringen im edlen Zusammenspiel pure Ästhetik in die Küche. Die klare Grafik der Kochzonen und Übersichtlichkeit der „Digiselect-TouchControl" unterstreicht den professionellen Look dieses Kochfelds. Die Induktionsbeheizung gewährt puren Kochkomfort, der durch innovative Details wie die Wischschutz- oder Warmhaltefunktion und große Anzeigen für Timer und Kochstellen einzigartig gesteigert wird.

A huge pleasure when cooking: the elegant design of the TD 4420 N separate induction hob. Its extremely shallow decorative trim in high-quality stainless steel and the raised, finely-faceted glass ceramic in sophisticated interplay introduce pure aesthetics to the kitchen. The clear graphics of the cooking zones and lucid arrangement of the "Digiselect-TouchControl" underlines the professional look of this hob. The induction heating guarantees pure cooking comfort, uniquely heightened by innovative details, such as the safety pilot or heat retention function and large display for timer and burners.

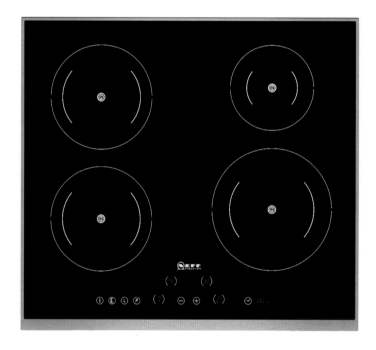

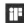

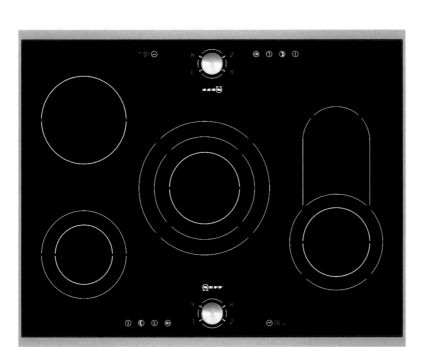

Product
TB 1482 N
Autarkes Elektro-Kochfeld
Separate induction hob

Design
Constructa-Neff Vertriebs GmbH
Gerhard Nüssler, Thomas Knöller
München, Germany
Tesseraux+Partner
Potsdam, Germany

Manufacturer
Constructa-Neff Vertriebs GmbH
München, Germany

Ein Highlight in Küchen mit einer freistehenden Koch-insel: das 80 cm breite, autarke Induktions-Kochfeld TB 1482 N mit zweifacher TwistPad Bedienung – höchs-ter Bedienkomfort von zwei Seiten mit dem magne-tischen, abnehmbaren TwistPad. Einfach begeisternd: das elegante Design mit einem Zusammenspiel von extrem flachem Edelstahl-Zierrahmen, aufgesetzter, facettierter Glaskeramik und klarer Kochfeld-Grafik. Kochen mit Induktion wird hier zum perfekten Koch-erlebnis. Sehr komfortabel: die innovative Warmhalte-funktion. Überaus praktisch: die Wischschutzfunktion und große Anzeigen für Timer und Kochstellen.

A highlight in the kitchen with a free-standing island: the 80 cm wide TB 1482 N separate induction hob with double TwistPad operation – highest comfort with operation from both sides via the magnetic, de-tachable TwistPad. Simply delightful: elegant design with an interplay of extremely shallow stainless steel decorative frame, raised, facetted glass ceramic and clear hob graphics. Cooking with induction heat be-comes the perfect cookery experience. A very com-fortable feature: the innovative heat retention func-tion. Particularly practical: the safety switch-off and a large display for timer and burners.

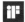

Product
CI 491 102
Induktionskochfeld
Induction cooktop

Design
Gaggenau Hausgeräte GmbH
H. Reinhard Segers, Soeren Strayle
München, Germany

Manufacturer
Gaggenau Hausgeräte GmbH
München, Germany

Aktiviert man das neue Induktionskochfeld CI 491 mit „Twist Pad", erscheinen um den zentral positionierten Bedienknebel herum alle Anzeige- und Bedienelemente im Blickfeld des Betrachters. Die hinterleuchtet dargestellten Kochzonensymboliken und Sensortasten (für die Zusatzfunktionen „Ankoch- und Kochzeitautomatik", „Bratsensorik" und „Booster"), bilden den Hintergrund für die elegante Bedienung des Gerätes durch das „Twist-Pad". Im ausgeschalteten Zustand überzeugt das Induktionskochfeld CI 491 den Betrachter durch das grafisch reduzierte Erscheinungsbild und mit seinem ruhigen und souveränen Charakter.

When the new induction cooktop CI 491 is activated using the "Twist-Pad", all the display and control elements around the central control knob do appear in a full view for the user. The back-lit cooking zone symbols and sensor buttons (for the additional functions "automatic quick boil" and "cooking timer", "sensor technology" and "booster function") set the background for elegant control of the appliance with the "Twist-Pad". When the induction cooktop CI 491 is not in use, it impresses with its slick appearance and even, superior character.

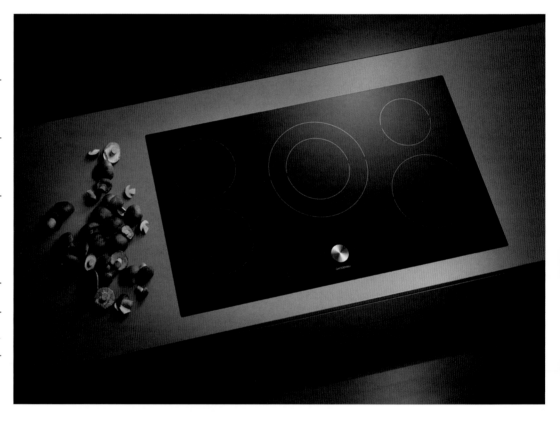

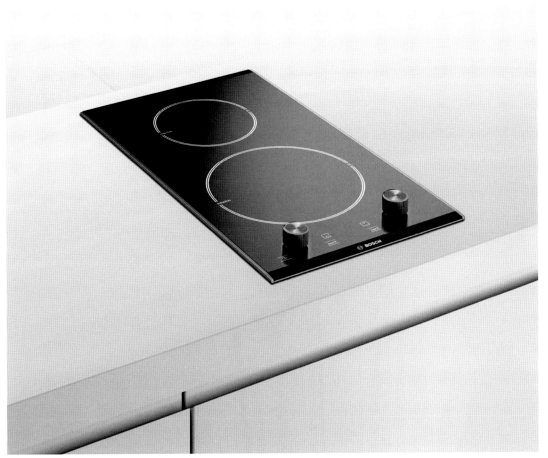

Product
PIE375C14E
Glaskeramik-Induktions-Domino-Kochstelle
Glass ceramic induction domino cooktop

Design
Robert Bosch Hausgeräte GmbH
Robert Sachon, Ulrich Goss
München, Germany

Manufacturer
Robert Bosch Hausgeräte GmbH
München, Germany

Diese Induktionskochstelle zeichnet sich durch hochwertige metallische Knebel aus, die durch ihr haptisches Feedback bei der Feineinstellung überzeugen und Verarbeitungsqualität auch visuell erlebbar machen. Wie bei allen Bosch-Kochstellen dieser Generation finden sich dieselben markenspezifischen Designmerkmale: Seitlich anschließende Edelstahlleisten, die erstmalig auch unterhalb der Vorderkante weiter geführt werden, bieten in Verbindung mit dem Facettenschliff der Glaskeramik optimalen Kantenschutz beim Handling mit Kochgeschirr. Die Flächenbündigkeit garantiert leichte Reinigungs- und perfekte Kombinationsmöglichkeiten.

This induction cooktop is characterised by exclusive metallic controls with an impressive haptic response when performing fine adjustments, and quality of workmanship that can also be visually appreciated. Like all Bosch cooktops of this generation, it displays the same brand-specific design features: Stainless steel side trims that for the first time ever are also featured under the front edge and, in conjunction with the bevelled ceramic glass, it affords an optimum edge of protection when handling cooking utensils. Flush integration assures ease of cleaning and ideal combination options.

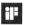

Product
PIE375N14E
Domino-Induktions-Kochstelle
Domino induction cooktop

Design
Robert Bosch Hausgeräte GmbH
Robert Sachon, Ulrich Goss
München, Germany

Manufacturer
Robert Bosch Hausgeräte GmbH
München, Germany

Energieeffiziente Induktions-Heizelemente erzeugen
die Hitze ohne Wärmeverlust direkt im Kochgeschirr.
Wie bei allen Bosch-Kochstellen dieser Generation
finden sich dieselben markenspezifischen Design-
merkmale: Seitlich anschließende Edelstahlleisten, die
erstmalig auch unterhalb der Vorderkante weiter ge-
führt werden, bieten in Verbindung mit dem Facet-
tenschliff der Glaskeramik optimalen Kantenschutz
beim Handling mit Kochgeschirr. Die Flächenbündig-
keit garantiert leichte Reinigungs- und perfekte Kom-
binationsmöglichkeiten. Das TouchControl-Interface
erlaubt die Direktwahl der Heizstufen, unterstützt
durch funktionelles Lichtdesign.

Energy-efficient induction heating elements gener-
ate heat directly in the cooking utensil without any
loss of heat. Like all Bosch hobs of this generation,
it displays the same brand-specific design features:
Stainless steel side trims that for the first time ever are
also featured under the front edge and, in conjunc-
tion with the bevelled ceramic glass, afford optimum
edge protection when handling cooking utensils.
Flush integration assures ease of cleaning and ideal
combination options. The TouchControl interface
permits direct selection of heat settings, visually sup-
ported by a functional light design.

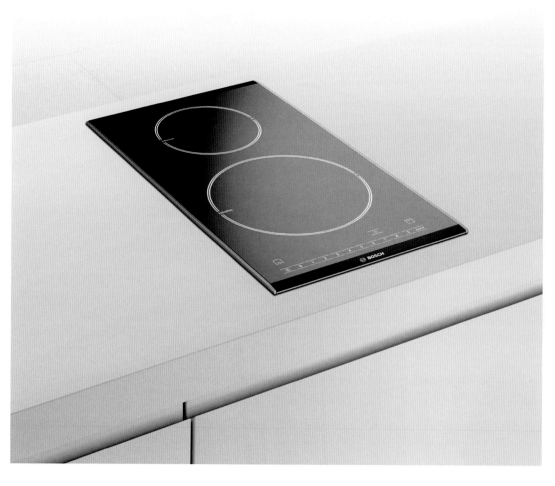

Product
PRB326B90E
Domino-Gaskochstelle
Domino gas cooktop

Design
Robert Bosch Hausgeräte GmbH
Robert Sachon, Alexander Marsch
München, Germany

Manufacturer
Robert Bosch Hausgeräte GmbH
München, Germany

Diese Gaskochstelle zeichnet sich durch Guss-Flächentopfträger und hochwertige metallische Knebel aus, die durch ihr haptisches Feedback bei der Feineinstellung überzeugen und Verarbeitungsqualität auch visuell erlebbar machen. Wie bei allen Kochfeldern dieser Gerätereihe finden sich dieselben markenspezifischen Designmerkmale: Seitlich anschließende Edelstahlleisten, die erstmalig auch unterhalb der Vorderkante weiter geführt werden, bieten in Verbindung mit dem Facettenschliff der Glaskeramik optimalen Kantenschutz beim Handling mit Kochgeschirr. Die Flächenbündigkeit garantiert leichte Reinigungs- und perfekte Kombinationsmöglichkeiten.

This gas cooktop is characterised by its cast iron pan supports and exclusive metallic controls with an impressive haptic response when performing fine adjustments, and quality of workmanship that can also be visually appreciated. Like all Bosch cooktops of this generation, it displays the same brand-specific design features: Stainless steel side trims that for the first time ever are also featured under the front edge and, in conjunction with the beveled ceramic glass, it affords an optimum edge of protection when handling cooking utensils. Flush integration assures ease of cleaning and ideal combination options.

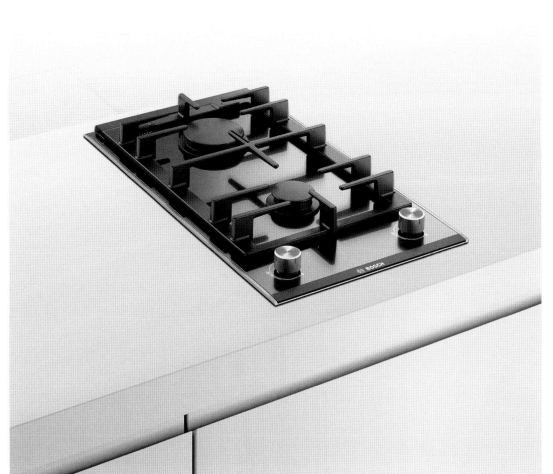

Product
NIB672T14E
Herdmulde Induktionskochfeld, weiß
Induction hob, white

Design
Robert Bosch Hausgeräte GmbH
Robert Sachon, Ulrich Goss
München, Germany

Manufacturer
Robert Bosch Hausgeräte GmbH
München, Germany

Induktionskochfelder erzeugen die Wärme direkt im Kochgeschirr. Durch die geringe Erhitzung der Glaskeramikfläche sind sie deshalb äußerst pflegeleicht, da überkochende Flüssigkeit nicht einbrennt. Die Technologie eignet sich daher auch für den Einsatz weißer statt der üblichen schwarzen Glaskeramik. Dadurch entsteht für den Kunden eine echte Alternative bei der Gestaltung seines Küchenumfelds, ohne auf Performance zu verzichten. Das auf Wohnlichkeit abzielende Weiß ist auf die anderen Bosch-Wärmegeräte der „White Range" abgestimmt. Flächenbündig befestigte, umlaufende Metallprofile bieten optimalen Kantenschutz und Reinigungsmöglichkeiten.

Induction hobs generate heat directly in the cooking utensil. As the ceramic glass surface is heated only slightly, they are extremely easy care as split liquids cannot burn onto the surface. The technology is therefore better suited for the use of white than the customary black ceramic glass. The customer is thus offered a genuine alternative when designing their kitchen ambience without having to compromise on performance. The white, designed to exude a living ambience, is matched to the other Bosch "White Range" cooking appliances. Flush-mounted surrounding metal trims afford an optimum edge of protection and ease of cleaning.

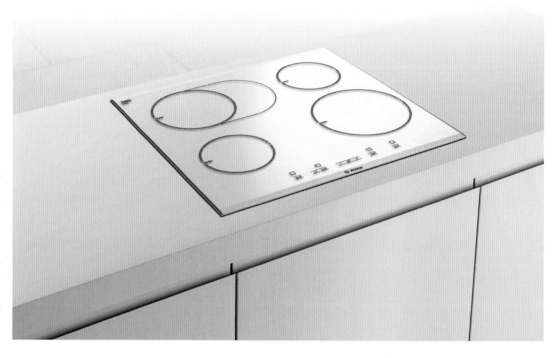

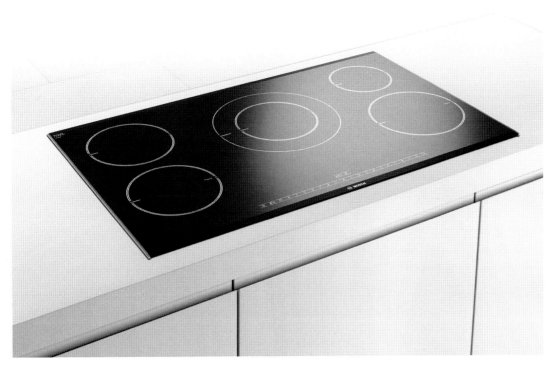

Product
PIK975N24E
Induktions-Kochstelle
Induction hob

Design
Robert Bosch Hausgeräte GmbH
Robert Sachon, Ulrich Goss
München, Germany

Manufacturer
Robert Bosch Hausgeräte GmbH
München, Germany

Die Großzügigkeit des energieeffizienten Induktions-kochfeldes wird durch das zurückhaltende Grafik-dekor und den Facettenschliff der Glaskeramik unter-strichen. Flächenbündige Metallleisten an den Seiten und erstmalig auch unterhalb der Vorderkante der Kochstellen sorgen für optimalen Kantenschutz bei leichter Reinigungsmöglichkeit. Das neu entwickelte, intuitive „DirectSelect"-TouchControl-Interface erlaubt die Direktwahl der jeweiligen Heizstufen incl. Zwi-schenstufen über eine Art linear angeordnete Zeh-nertastatur in nur einem Handgriff. Visuell werden die Vorgänge durch funktionelles Lichtdesign in Form eines beleuchteten Schwellbalkens unterstützt.

The generosity of the energy-efficient induction hob is emphasised by the discreet graphical decor and bevelled edges of the ceramic glass hob. Flush metal trims on the sides and, for the first time ever, under the front of the hob, guarantee optimum edge pro-tection and ease of cleaning. The newly developed intuitive "DirectSelect"-TouchControl interface per-mits direct selection of the individual heat and in-termediate settings at the turn of a hand using a linear-style numerical keypad. Processes are visually displayed by a functional light design in the shape of an illuminated display bar.

Product
TS 2236 N
Gaskochfeld Edelstahl
Gas hob stainless steel

Design
Constructa-Neff Vertriebs GmbH
Thomas Knöller, Gerhard Nüssler
München, Germany

Manufacturer
Constructa-Neff Vertriebs GmbH
München, Germany

Ein Highlight in der Küche: das 60 cm breite Gas-Kochfeld TS 2236 N in einem faszinierend klaren Design. Besonders augenfällig ist die hochwertige Edelstahl-Platine mit umlaufender Facette, das tiefgeprägte Bedienpult im neuen Design und die kraftvoll geradlinigen Gusstopfträger als harmonische Einheit. Sie kontrastieren fein mit den facettierten elipsoid gestalteten Drehwählern. Auf vier Gas-Kochstellen mit thermoelektrischer Zündsicherung lässt sich schnell, komfortabel und sicher kochen. Die neu gestalteten wertigen Topfträger bieten dem Kochgeschirr einen absolut kippsicheren Stand.

A highlight in the kitchen: the 60 cm wide TS 2236 N gas hob in a fascinatingly clear design. A particularly eye-catching feature is the high-quality stainless steel trim with facet throughout, the recessed control panel in a new design and the powerfully linear cast iron pan support as a harmonious unit, finely contrasted with the faceted, ellipsoid design of the knobs. On four gas burners with thermoelectric safety pilot, cooking is fast, comfortable and safe. The sophisticated, redesigned pan supports provide absolutely no-tilt stability for pots and pans.

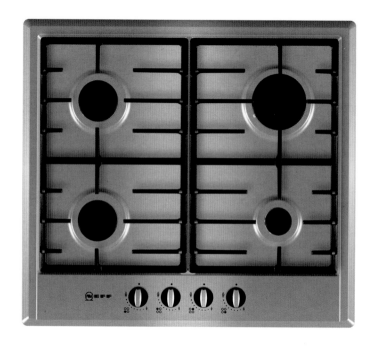

Product
CG 492
Gaskochfeld Edelstahl
Stainless steel gas hob

Design
Gaggenau Hausgeräte GmbH
H. Reinhard Segers, Soeren Strayle
München, Germany

Manufacturer
Gaggenau Hausgeräte GmbH
München, Germany

Das Edelstahl-Gaskochfeld CG 492 von Gaggenau: Verteilt auf fünf Gas-Brenner verfügt das Gerät über eine Gesamtleistung von 17 kW. Ein großer Stark- brenner mit drei Flammenkreisen für Paella- oder Wokpfannen, zwei Starkbrenner und zwei Normal- brenner. Die glattflächigen dreiteiligen Gussroste lie- gen auf gleicher Höhe wie die Arbeitsfläche und er- lauben ein bequemes Verschieben des Kochgeschirrs auf ebener Fläche. Die Flammen werden elektronisch überwacht und bei unbeabsichtigtem Erlöschen wie- der entzündet. Über massive Einhand-Bedienkne- bel kann die automatische Schnellzündung auch mit einer Hand bedient werden.

Stainless-steel gas hob CG 492 from Gaggenau: The appliance has a 17 kW total power, distributed across five gas burners. One large power burner with three flame rings is suitable for paella pans or woks, two power burners and two standard burners. The smooth, three part cast iron grids are at the same height as the work surface and allow pots and pans to be easily moved on a level surface, right to the work- top. Flames are electronically monitored and re-lit if unintentionally extinguished. Solid one-hand control knobs regulate the automatic fast ignition and can be used with only one hand.

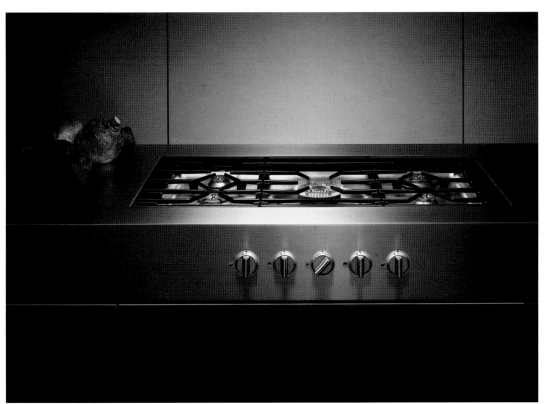

Product
Hot Top Gas
Rechaud
Heater

Design
A. & J. Stöckli AG
Jean-Franck Haspel Herbert Forrer
Netstal, Switzerland

Manufacturer
A. & J. Stöckli AG
Netstal, Switzerland

Ein Universalrechaud mit Kisag „LongFire" Brenner
für hohe Leistung und lange Brenndauer. Das Re-
chaud besitzt eine stufenlos regulierbare Flamme, ist
leicht nachfüllbar und verfügt über eine Brenndauer
von zwei Stunden (bei voller Leistung ca. 1¼ Std.).

A universal stove with a "LongFire" burner by Kisag
designed for high performance and long burning
time. The stove has an infinitely variable flame, is easy
to refill and burns for a period of up to two hours
(1¼ hrs. at full capacity).

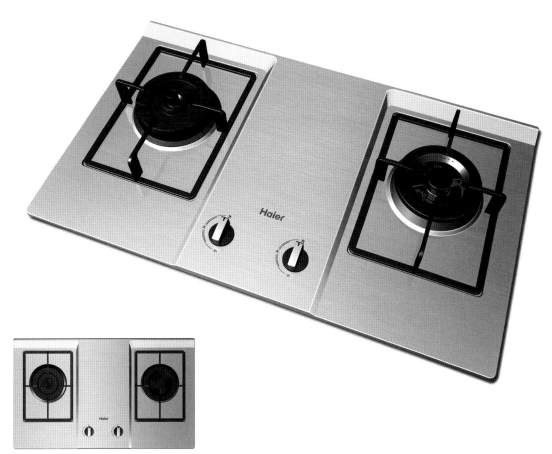

Product
QHA80
Gasherd
Gas cooktop

Design
Industrial Design Center of Haier Group
Ma Jian, Lan Cuiqin, Zhu Yuntao,
Chi Shasha, Wang Shuchun
Qingdao, China

Manufacturer
Haier Group
Qingdao, China

Das Modell ist sehr glatt, da es in klassischem Edelstahl gehalten ist. Die schiefe Ebene sieht elegant aus und ist einfach zu reinigen. Der Gasherd hat die Funktion der „Anti-Frei-Verbrennung", d.h. wenn sich kein Wasser im Topf befindet, erlischt das Feuer automatisch. Hintergrund ist ein Sensor, der die Überhitzung des Topfes feststellt und die Gaszufuhr unterbricht.

This model is classical metallic European style, whose bevel design style looks elegant and easy to clean surface. This stove has the feature of anti-dry-burning, which means that if there's no water in pot, the fire will run off automatically because it can cut off the gas resource when the sensor determine the pan is over high temperature. The new stainless steel, developed by ourselves, also presents a high glossy looking.

Product
PRH626B90E
Gas-Kochstelle, vierflammig
Gas cooker with four burners

Design
Robert Bosch Hausgeräte GmbH
Robert Sachon, Alexander Marsch
München, Germany

Manufacturer
Robert Bosch Hausgeräte GmbH
München, Germany

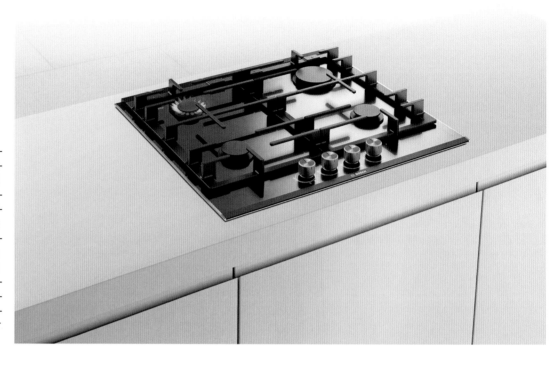

Kennzeichnend für die Gas-Kochstelle ist der Einsatz modernster Brennertechnologie in Kombination mit hochwertigen Materialien. Die seitlich und unterhalb der Kochstelle durch flächenbündig angebrachte Metallleisten eingefasste Glaskeramikoberfläche ist hochgradig kratzfest und erlaubt eine leichte Reinigung. Gegossene Flächenroste mit filigran gestalteten Fingern vereinen Sicherheitsaspekte mit ästhetischem Anspruch. Die Metallknebel runden das Gesamtbild ab. Durch konsequente Linienführung und abgestimmte Gerätemaße ist eine Erweiterung bzw. Kombination mit ergänzenden Kochfeldern aus dem reichhaltigen Domino-Programm der Marke möglich.

Characteristic for the gas cooker is the use of advanced burner technology combined with select materials. Flush metal trims at the sides and front encase the ceramic glass surface which is highly scratch-resistant and guarantees ease of cleaning. Cast iron continuous pan supports with filigree fingers combine safety aspects with an aesthetical approach. The overall picture is rounded off by metallic controls. Consistent style-matching and coordinated appliance dimensions permit an extension or combination with complementary hobs from the brand's extensive Domino range.

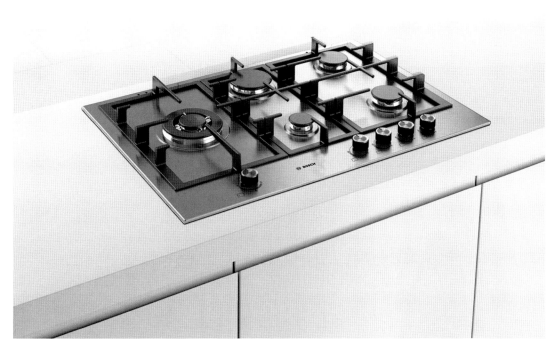

Product
PCQ755FDE
Edelstahl-Gaskochstelle
Stainless steel gas cooktop

Design
Robert Bosch Hausgeräte GmbH
Alexander Marsch
München, Germany

Manufacturer
Robert Bosch Hausgeräte GmbH
München, Germany

Prägendes Gestaltungsmerkmal der Edelstahl-Gas-kochstelle ist die geradlinige, fast grafische Gestaltung des flächigen Muldenblattes mit klarer Aufteilung der Kochzonen. Die fertigungstechnologisch anspruchsvolle Designvorgabe des extrem flachen Aufbaus des Muldenblattes, in das sich die Gusstopfträger flächenbündig integrieren, wurde detailgetreu umgesetzt. Der hohe qualitative Anspruch setzt sich bis hin zum präzise verarbeiteten Designdetail der metallischen Knebelkappen fort. Dadurch entsteht ein insgesamt sehr hochwertiger Geräteeindruck, der sich perfekt in ein modernes Küchenumfeld integriert.

An iconic design feature of the stainless steel gas cooktop is the linear, almost graphical design of the flush hob surface with its clearly defined cook zone structure. The technologically challenging design specification of an extremely shallow design for the hob surface, in which the cast pan rests are flush-integrated, has been implemented down to the tiniest detail. The high qualitative standards are also mirrored in the precision-crafted design feature of the metallic control caps. A select overall impression is thus created by the appliance which integrates perfectly with modern kitchen ambiences.

Product
PRR726F90E
Gaskochstelle, fünfflammig
Gas cooktop with five burners

Design
Robert Bosch Hausgeräte GmbH
Robert Sachon, Alexander Marsch
München, Germany

Manufacturer
Robert Bosch Hausgeräte GmbH
München, Germany

Die Gaskochstelle vereint Sicherheitsaspekte mit ästhischem Anspruch. Dies kommt im Einsatz modernster Gastechnologie wie vollelektronischer Zündung, automatischer Wiederzündung und Gas-Stop-Sicherungsschalter, aber auch in den gegossenen Flächenrosten mit den filigran gestalteten Fingern zum Ausdruck. Sie erlauben ein gefahrloses Handling des Kochgeschirrs. Die seitlich und unterhalb des Kochfelds durch flächenbündig angebrachte Metallleisten eingefasste Glaskeramikoberfläche ist hochgradig kratzfest und erlaubt eine leichte Reinigung. Ebenso hochwertige metallische Knebel runden das stimmige Gesamtbild ab.

The gas cooktop combines safety aspects with an aesthetical approach. This is manifest in the use of advanced gas technology, fully electronic ignition, automatic re-ignition and a gas-stop safety switch, and also in the cast iron continuous pan supports with their filigree fingers that guarantee safe handling of cooking utensils. Flush metal trims at the sides and front encase the ceramic glass surface which is highly scratch-resistant and guarantees ease of cleaning. The harmonious overall picture is rounded off by equally exclusive metallic controls.

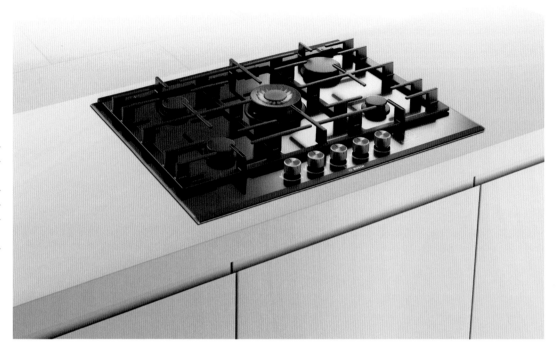

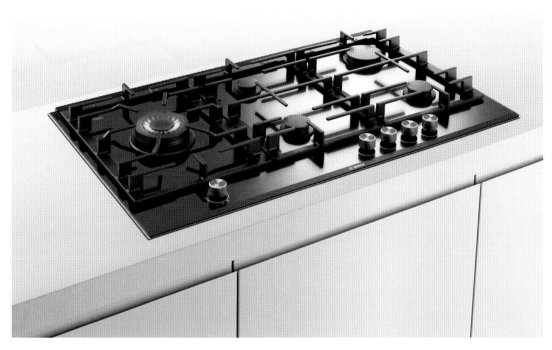

Product
PRS926B90E
Gaskochstelle mit Wok-Brenner
Gas cooktop with wok

Design
Robert Bosch Hausgeräte GmbH
Robert Sachon, Alexander Marsch
München, Germany

Manufacturer
Robert Bosch Hausgeräte GmbH
München, Germany

Die großzügige Anordnung der Brenner und klare Gliederung in verschiedene Kochzonen ermöglicht professionelles Kochen auch mit großem Kochgeschirr. Der Zweikreis-Wok-Brenner mit sechs kW entfaltet die entsprechende Leistung. Die zum Schutz seitlich und unterhalb der Kochstelle durch flächenbündig angebrachte Metallleisten eingefasste Glaskeramikoberfläche ist hochgradig kratzfest und erlaubt eine leichte Reinigung. Gegossene Flächenroste mit filigran gestalteten Fingern vereinen Sicherheitsaspekte mit ästhetischem Anspruch. Ebenso hochwertige metallische Knebel runden das Gesamtbild ab.

The spacious arrangement of burners and clear structuring in various cooking zones permits professional-style cooking even with large cooking utensils. The dual-ring six kW wok burner rolls out the appropriate performance. The flush metal trims encasing the ceramic glass surface at the sides and front is highly scratch-resistant and guarantees ease of cleaning. Cast iron continuous pan supports with filigree fingers combine safety aspects with an aesthetical approach. The overall picture is rounded off by exclusive metallic controls.

Product
TS 6666 N
Gas-Glaskeramik-Kochfeld
Ceramic gas hob

Design
Constructa-Neff Vertriebs GmbH
Thomas Knöller, Gerhard Nüssler
München, Germany
Tesseraux+Partner
Potsdam, Germany

Manufacturer
Constructa-Neff Vertriebs GmbH
München, Germany

Das 60 cm breite Gas-Kochfeld TS 6666 N besticht
mit seinem eleganten Design: Aufgesetzt auf einen
flachen Edelstahl-Designrahmen ist die fein facet-
tierte Glaskeramik, deren Facette in den vier ellipsoid
gestalteten Drehwählern ihre Wiederkehr findet. Mar-
kant die klare Gestaltung der wertigen Guss-Topf-
träger. Das Zusammenwirken von Kanten und Flächen
unterstreicht den professionellen Look. Auf vier Gas-
Kochstellen mit thermoelektrischer Zündsicherung
lässt sich schnell, komfortabel und sicher kochen. Die
neu gestalteten wertigen Topfträger bieten dem
Kochgeschirr einen absolut kippsicheren Stand.

The 60 cm wide TS 6666 N ceramic gas hob catches
the eye with its elegant design: raised on a shallow
stainless steel designer frame, the finely faceted glass
ceramic whose facet is reflected in the design of the
four ellipsoid knobs. A distinctive feature: the clear
design of the high-quality stainless steel pan holders.
The interplay of edges and surfaces underlines the
professional look. On four gas burners with thermo-
electric safety pilot cooking is fast, comfortable and
safe. The newly-design, high-quality pan supports
provide tilt-proof stability for pots and pans.

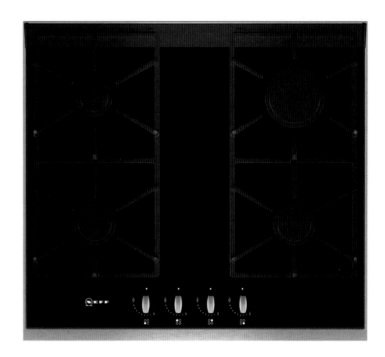

Product
PKN679C14D
Glaskeramik-Kochstelle, weiß
Glass ceramic cooktop, white

Design
Robert Bosch Hausgeräte GmbH
Robert Sachon, Ulrich Goss
München, Germany

Manufacturer
Robert Bosch Hausgeräte GmbH
München, Germany

Moderne Küchen sind hell und licht. Die weiße Glaskeramik-Kochstelle bietet dem Kunden eine echte Alternative bei der Gestaltung seines Küchenumfelds, ohne auf Performance zu verzichten. Das auf Wohnlichkeit abzielende Weiß ist auf die anderen Bosch-Wärmegeräte der „White Range" abgestimmt. Umlaufend an der facettierten Glaskeramik befestigte Metallprofile bieten optimalen Kantenschutz, ohne die Reinigungsmöglichkeiten zu beeinträchtigen. Farblich bewusst akzentuierte metallische Knebel unterstreichen den hohen Wertigkeitsanspruch des Gerätes.

Modern kitchens are bright and airy. The white ceramic cooktop offers customers a genuine alternative when designing their kitchen ambience without having to compromise on performance. The white, designed to exude a living ambience is matched to the other Bosch "White Range" cooking appliances. Metal trims around the bevelled edges of the ceramic glass do afford an optimum edge of protection without impairing ease of cleaning. Deliberate color accents created by the metallic controls emphasise the appliance's exclusiveness.

Product
PKT375N14E
Glaskeramik-Domino-Kochstelle
Glass ceramic domino cooktop

Design
Robert Bosch Hausgeräte GmbH
Robert Sachon, Ulrich Goss
München, Germany

Manufacturer
Robert Bosch Hausgeräte GmbH
München, Germany

Der Keramik-Grill bietet die Möglichkeit, direkt auf der Oberfläche zu grillen oder mit einem Bräter zu arbeiten. Wie bei allen Bosch-Kochstellen dieser Generation finden sich dieselben markenspezifischen Designmerkmale: Seitlich anschließende Edelstahlleisten, die erstmalig auch unterhalb der Vorderkante weiter geführt werden, bieten in Verbindung mit dem Facettenschliff der Glaskeramik optimalen Kantenschutz beim Handling mit Kochgeschirr. Die Flächenbündigkeit garantiert leichte Reinigungs- und perfekte Kombinationsmöglichkeiten. Das TouchControl-Interface erlaubt die Direktwahl der Heizstufen, unterstützt durch funktionelles Lichtdesign.

With the ceramic grill you can grill directly on the surface or use a roasting dish. Like all Bosch hobs of this generation, it displays the same brand-specific design features: Stainless steel side trims, that for the first time ever are also featured under the front edge, and in conjunction with the bevelled ceramic glass, afford optimum edge protection when handling cooking utensils. Flush integration assures ease of cleaning and ideal combination options. The TouchControl interface permits direct selection of heat settings, visually supported by a functional light design.

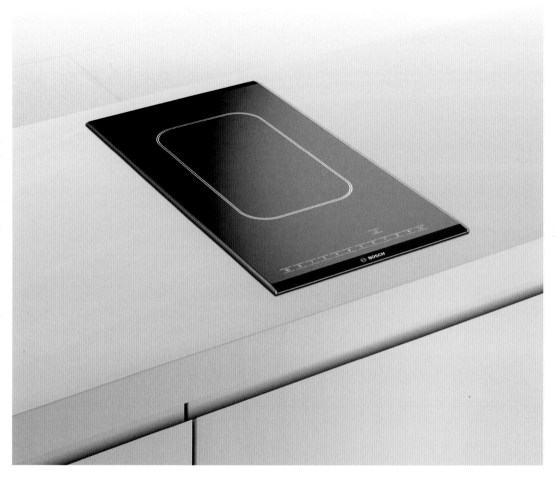

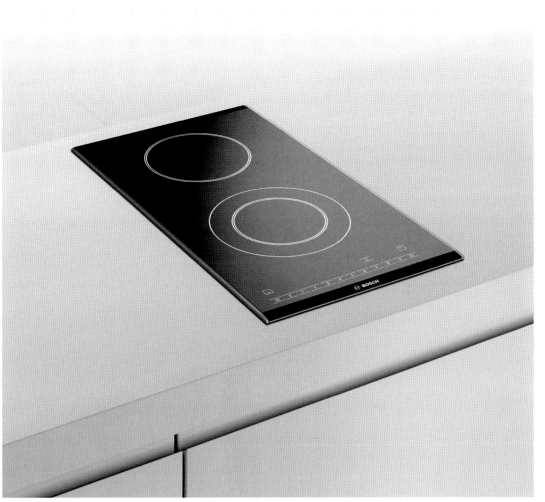

Product
PKF375N14E
Edelstahl-Glaskeramik-Domino-Kochstelle
Glass ceramic domino cooktop, stainless steel

Design
Robert Bosch Hausgeräte GmbH
Robert Sachon, Ulrich Goss
München, Germany

Manufacturer
Robert Bosch Hausgeräte GmbH
München, Germany

Domino-Einbaugeräte von Bosch sind frei kombinierbar und harmonieren miteinander durch ihre markante Design-Präsenz, bei gleichzeitig vornehmem Understatement. Die Edelstahl-Kochstelle PKF375N14E verfügt über zwei HighSpeed-Kochzonen, davon ist eine zweikreisig. Die dekorlose Glaskeramik mit Komfortprofil passt in jedes Einbaukonzept. Die neun Leistungsstufen sind durch sanftes Berühren des Bedienfeldes direkt auswählbar. Sicherheitsabschaltung und zweistufige Restwärmeanzeige reduzieren die Verbrennungsgefahr.

Domino built-in appliances from Bosch are free combinable and give together a perfect harmony by their remarkable design presence, whereas in the same time showing noble understatement. The stainless steel cooktop PKF375N14E has two high speed cooking zones, one of them in two parts. The decorless glass ceramic with comfort profile fits to each built in conception. The nine power levels may be selected directly by slightly touching the operation panel. Security power-off and a two step rest heat indication help to reduce danger of injury.

Product
Domino
Kombinationmuldenreihe
Combination cooktop range

Design
Robert Bosch Hausgeräte GmbH
Robert Sachon, Ulrich Goss, Alexander Marsch
München, Germany

Manufacturer
Robert Bosch Hausgeräte GmbH
München, Germany

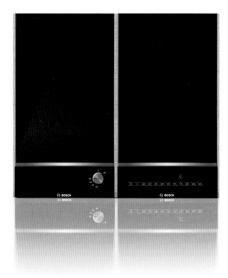

Die Gerätereihe erlaubt durch konsequente Linienführung vielfältige Kombinationsmöglichkeiten in der Küche. Die flächenbündigen Metallleisten seitlich und erstmalig auch unterhalb der Vorderkante der Dominos sichern speziell in der Verbindung mit dem Facettenschliff der Glaskeramik optimalen Kantenschutz beim Handling mit Kochgeschirr. Die Flächenbündigkeit garantiert leichte Reinigungsmöglichkeiten im Falle der Gerätekombination. Ein intuitives TouchControl-Interface erlaubt die Direktwahl der Heizstufen, visuell unterstützt durch funktionelles Lichtdesign. Die ebenso verfügbaren Knebelvarianten sprechen eher klassisch orientierte Kunden an.

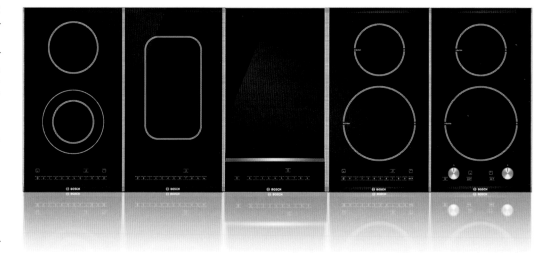

Underpinned by a consistent design language, these models offer versatile combination options in the kitchen. Especially when paired with the bevelled edges of the ceramic glass, the flush metal trims on the sides and now, for the first time also under the front edge of the Dominos, afford optimum edge protection when handling cooking utensils. The flush design guarantees ease of cleaning when combining appliances. An intuitive TouchControl-Interface permits direct selection of heat settings, visually supported by a functional light design. Customers who prefer a classic approach can select the also available knob control versions.

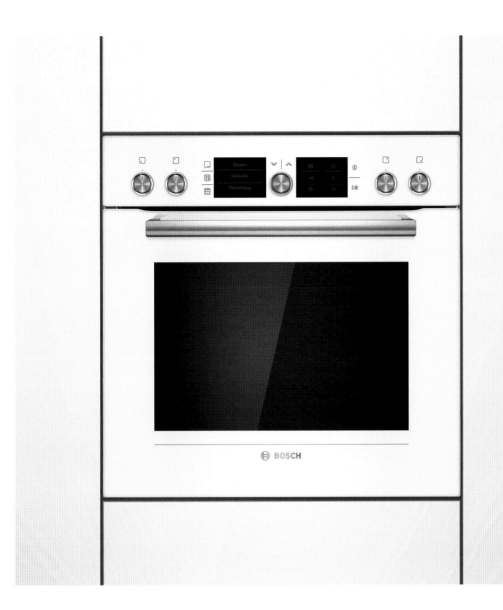

Product
HEB78D720
Einbauherd
Built-in cooker

Design
Robert Bosch Hausgeräte GmbH
Robert Sachon, Bernd Kretschmer, Ulrich Goss
München, Germany

Manufacturer
Robert Bosch Hausgeräte GmbH
München, Germany

Präzise gestaltete Designdetails wie die facettierte Türapplikation, die metallischen Knebel und Touchsensoren machen den hohen Qualitäts- und Perfektionsanspruch der Marke sinnlich erfahrbar. Das prägnante Autopilot-Interface erlaubt eine einfache Bedienung der vielfältigen Funktionen des Gerätes (13 Heizarten / 68 Programme) durch die sinnvolle Kombination von klassischem Drehwähler, in Verbindung mit TouchControl und hochwertiger Klartext-Anzeige. Das emotional wie funktional ansprechende SoftLight, ein Backwagen mit Soft-Eject-Auszug sowie die Pyrolyse-Selbstreinigungsfunktion runden das Angebot ab.

The brand's select quality and aspirations to perfection can be experienced with sensuous immediacy in precision-crafted design features such as the facetted door applications, metallic controls and touch sensors. The iconic auto pilot interface permits easy operation of the many appliance functions (13 heating methods / 68 programmes), in an efficient combination of conventional rotary selector, touch controls and an exclusive text display. SoftLight with an emotional and practical appeal, an oven trolley with Soft-Eject system and pyrolytic self-cleaning do complete this appliance's credentials.

Product
HEB78D750
Einbau-Multifunktionsherd
Built-in multifunctional cooker

Design
Robert Bosch Hausgeräte GmbH
Robert Sachon, Bernd Kretschmer, Ulrich Goss
München, Germany

Manufacturer
Robert Bosch Hausgeräte GmbH
München, Germany

Präzise gestaltete Designdetails wie die facettierte Türapplikation, die Metall-Knebel und Touchsensoren machen den hohen Qualitäts- und Perfektionsanspruch der Marke sinnlich erfahrbar. Das prägnante Autopilot-Interface erlaubt eine einfache Bedienung der vielfältigen Funktionen des Gerätes (13 Heizarten/68 Programme) durch die sinnvolle Kombination von klassischem Drehwähler in Verbindung mit TouchControl und hochwertiger Klartext-Anzeige. Das emotional wie funktional ansprechende SoftLight, ein Backwagen mit Soft-Eject-Auszug sowie die Pyrolyse-Selbstreinigungsfunktion runden das Angebot ab.

The brand's select quality and aspirations to perfection can be experienced with sensuous immediacy in precision-crafted design features such as the facetted door applications, metallic controls and touch sensors. The iconic auto pilot interface permits easy operation of the many appliance functions (13 heating methods/68 programms), in an efficient combination of conventional rotary selector, touch controls and an exclusive text display. SoftLight with an emotive and practical appeal, an oven trolley with Soft-Eject system and pyrolytic self-cleaning round off this appliance's credentials.

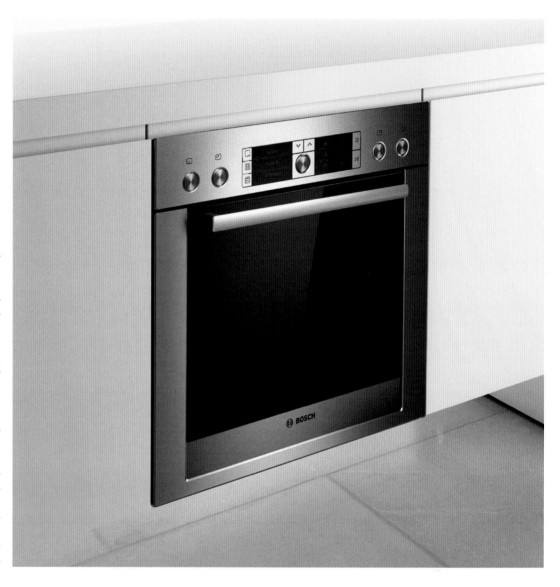

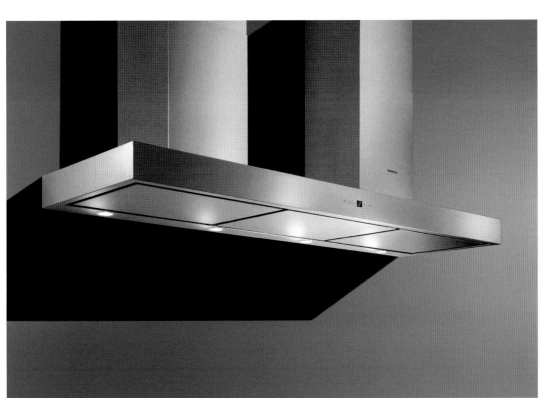

Product
LC359KA70, ET475ME11E, ET475MY11E,
EH475ME11E, EH375CE11E
Koch-Funktionseinheit
Cooking function unit

Design
Siemens Electrogeräte GmbH
Gerd E. Wilsdorf, Jörn Ludwig, Frank Rieser
München, Germany

Manufacturer
Siemens Electrogeräte GmbH
München, Germany

Eine Funktionseinheit aus Siemens Wandessen LC-359KA70 und Siemens Dominokochstellen EH475-ME11E, EH375CE11E sowie Domino Tepan Yaki ET-475MY11E und Domino Elektro-Grill ET475MU11E. Siemens Wandesse LC359KA70 aus Edelstahl, 180 cm breit, mit zwei Kaminen für die ambitionierte Hobby-Küche. Touch-Bedienung auf Metall. Arbeitslicht aus vier Halogen-Leuchten. Glattflächige Filterelemente. Luftleistung bis 1.800 m/Std. Siemens Domino Tepan Yaki Kochstelle 40 cm (ET475MY11E) und Siemens 40 cm Domino Elektrogrill-Kochstelle (ET475MU-11E). Domino-Induktions-Kochstelle 40 cm (EH475-ME11E) und Siemens Glaskeramik Induktions-Koch-stelle 30 cm (EH375CE11E).

Appliance set consisting of Siemens wall-mounted chimney hoods LC359KA70 and Siemens Domino cooking units EH475ME11E and EH375CE11E. Domino tepan yaki ET475MY11E, Domino electric grill ET475MU11E. The Siemens wall-mounted chimney hood LC359KA70, 180 cm wide and made of stainless steel, dominates the professional-style home kitchen. Touch operation with electronic display. Four halogen lights illuminate the work areas. Smooth-surface, easy-to-clean filter elements. Air volume up to 1,800 cubic meters per hour. Siemens 40 cm Domino tepan yaki cooking (Unit ET475MY11E) with easy-to-clean link mechanism and Siemens 40 cm Domino electric grill cooking unit (ET475MU11E). Siemens 40 cm Domino induction cooking unit (EH-475ME11E) with variable cooking zone and Siemens 30 cm ceramic induction cooking unit (EH375CE11E) with two cooking zones. All cooking units feature easy "touch slider" operation.

Product
Auto Slim light
Dunstabzugshaube
Chimney hood

Design
NTEC
Young Il-Jung, Jae Sung-Lee, Dong Ki-Lee
Seoul, South Korea
GS E&C
Ji Hyoung-Lee
Seoul, South Korea

Manufacturer
NTEC
Seoul, South Korea

Das sinnliche Design, das uns überwältigt, lässt Küchen eleganter erscheinen. Da der Ventilatormotor, der normalerweise den Lärm verursacht, von der Dunstabzugshaube getrennt wurde, fühlen Sie sich in Ihrer Küche immer wohl. Die Funktion des Lüfters wurde weiterentwickelt, sodass sich während des Betriebs der automatische Schalter im unteren Teil am Ausgang der Dunstabzugshaube öffnen lässt. Durch die verbesserte Funktion des automatischen Schalters und das elegante Design aus Aluminium erhöht sich Komfort und Sauberkeit. Dadurch, dass der Berührungsschalter für den Feuerlöscher in die Abzugshaube integriert ist, kann der Benutzer den Betriebsstatus der Abzugshaube oder des Feuerlöschers einfach erkennen. Nicht nur dies, sondern auch ein LED-Stimmungslicht ist in das Produkt eingebaut.

The sensual design establishes the elegance of the kitchen, while SF Fan (fan motor separation-type hood), a usual cause of noises, is separated from the hood. The auto-shutter has been adopted to open up the ventilation when operating. It upgrades the functions of ventilation while the auto-shutter part has been applied with the aluminium, enhancing luxuriousness and cleanness. The full-body hood touch switch for an extinguisher has been applied to a hood, letting a user easily know the operation status of a hood and an extinguisher. Not only that, but LED mood lighting is installed in the three-side of a product.

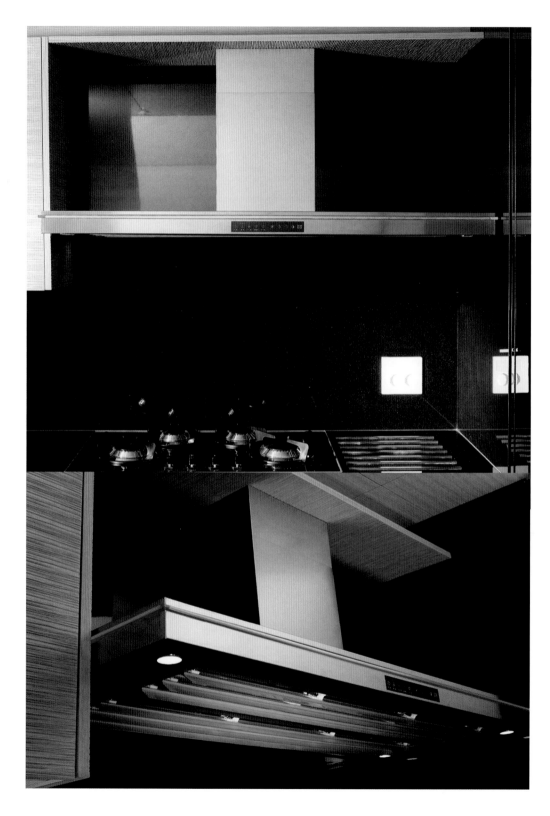

Product
DSW 9944 N
Edelstahl-Wandesse
Wall-mounted extractor hood, stainless steel

Design
Constructa-Neff Vertriebs GmbH
Ralf Grobleben
München, Germany

Manufacturer
Constructa-Neff Vertriebs GmbH
München, Germany

Elegant und außergewöhnlich in ihrer Optik: Die Neff-Wandesse DSW 9944 N. Klares Design mit großen Flächen aus hochwertigem Edelstahl mit fein proportionierten Luftdurchlässen. Der große schräg gestellte Korpus im spannungsvollen Kontrast zur Horizontalen und Vertikalen – die vorherrschende Formensprache in der Küche. Hervorragend die besondere Funktionalität: Die große schräg gestellte Filterfläche gewährt dem Nutzer bei der Zubereitung eine komfortable Kopffreiheit. Der Wrasen wird kraftvoll und leise abgesaugt. Halogenspots setzen die Kochstelle in perfektes Licht.

Elegant and with unusual optic appeal: The Neff DSW 9944 N wall-mounted extractor hood. Clear design with large surfaces in high-quality stainless steel with finely proportioned air inlets. The large angled body in exciting contrast to the horizontal and vertical lines, the dominant form language in the kitchen. Outstanding functionality: The large angled filter surface allows the user comfortable headroom when cooking, the expelled moisture is powerfully and quietly extracted. Halogen spotlights cast a perfect light on the hob.

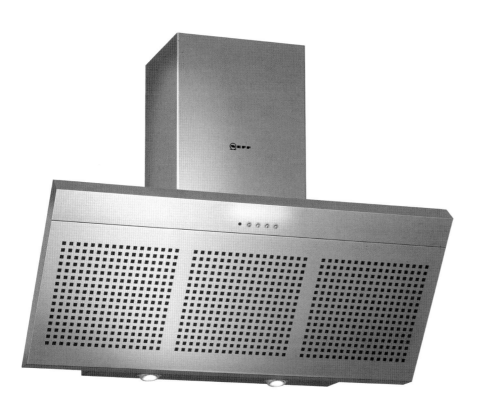

Product
DBF 7258 N
Wandesse
Wall-mounted extractor hood

Design
Constructa-Neff Vertriebs GmbH
Ralf Grobleben
München, Germany

Manufacturer
Constructa-Neff Vertriebs GmbH
München, Germany

Beeindruckende Dimensionen, gelungene Proportionen: Die 120 cm breite Wandesse DBF 7258 N begeistert mit faszinierend klarem Design. Die umlaufende Facettierung der Edelstahlkanten, die sich auch in anderen Neff-Einbaugeräten wiederfindet, setzt Akzente. Der schlanke Korpus in Box-Bauweise betont kräftig die Horizontale und kontrastiert in ausgewogenen Proportionen mit dem kraftvollen Kamin. Elegante Edelstahlflächen, an deren Rändern der Wrasen abgesaugt wird, verdecken großflächige Metallfettfilter. Das individuell dimmbare SoftLight® setzt die darunter liegende Kochinsel ins beste Licht.

Impressive dimensions, balanced proportions: the 120 cm wide DBF 7258 N wall-mounted extractor hood delights with fascinatingly clear design. The faceting of the stainless steel edges which recurs in other Neff built-in appliances sets accents. The slim body in box design powerfully emphasises the horizontal lines and contrasts in balanced proportions with the powerful chimney. Three large filter surfaces quickly and quietly dispel kitchen steam. Convenient operation with push buttons and seven-segment display. The individually dimmable SoftLight® casts the perfect light on the hob below.

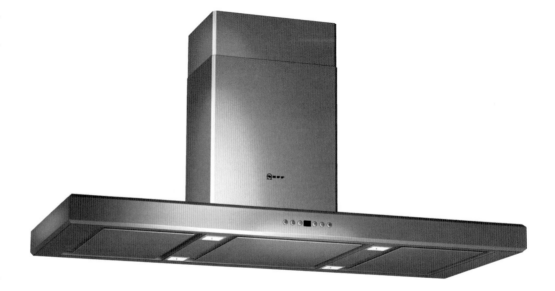

Product
DBF 7958 N
Wandesse
Wall-mounted extractor fan

Design
Constructa-Neff Vertriebs GmbH
Ralf Grobleben
München, Germany

Manufacturer
Constructa-Neff Vertriebs GmbH
München, Germany

Ein Highlight in der Küche: die 90 cm breite Wand-esse DBF 7958 N mit ihrem faszinierend klaren De-sign. Hoch ästhetisch die umlaufende Facettierung der Edelstahlkanten, die sich in anderen Neff-Ein-baugeräten wiederfindet. Da passt eins zum ande-ren. Der schlanke Korpus in Box-Bauweise betont die Horizontale und kontrastiert in perfekter Proportion mit dem kraftvollen Kamin. Elegante Edelstahlflächen, an deren Rändern der Wrasen abgesaugt wird, ver-decken großflächige Metallfettfilter. Das individuell dimmbare SoftLight® setzt die darunter liegende Koch-insel ins beste Licht.

A highlight in the kitchen: the 90 cm wide DBF 7958 N wall-mounted extraction fan with its fascinatingly clear design. Highly aesthetic the faceting around the stainless steel edges which recurs in other Neff built-in appliances. So they go hand in hand. The slim body in box design emphasises the horizontal lines and contrasts in perfect proportion with the powerful chimney. Large filter surfaces quickly and quietly dispel kitchen steam. Comfortable operation with push buttons and seven-segment display. The individually dimmable SoftLight® casts the perfect light on the hob below.

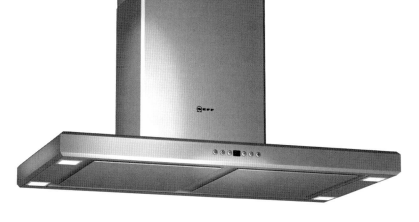

Product
DWB099751
Edelstahl-Wandesse
Chimney wall hood, stainless steel

Design
Robert Bosch Hausgeräte GmbH
Robert Sachon, Christoph Ortmann
München, Germany

Manufacturer
Robert Bosch Hausgeräte GmbH
München, Germany

Die Wandesse spricht durch ihre Materialität, Verarbeitungsqualität und Funktionalität Kunden mit hohen technischen wie gestalterischen Ansprüchen an. Die speziell entwickelten, haptisch wie visuell attraktiven, Touchsensoren mit Edelstahloberfläche und integriertem Lichtband zur visuellen Unterstützung der Bedienabläufe sind zwecks verbesserter Reinigungsfreundlichkeit flächenbündig integriert. Alle Leistungsdaten entsprechen höchstem Niveau. Die ergonomisch optimal angeordneten Halogenspots gewährleisten eine optimale Ausleuchtung der Arbeitsfläche und sorgen damit für perfekte Kochbedingungen.

In its materiality, quality of workmanship and function, this wall canopy hood appeals to customers with high standards in both technology and design. The specially developed touch sensors with stainless steel surfaces, which possess both haptic and visual appeal, and integrated light band for the visual support of operating processes, are flush-integrated for improved ease of cleaning. All performance data comply with first-rate standards. Perfectly positioned from an ergonomic point of view, the halogen spots assure optimum illumination of the working surface and thus an ideal cooking ambience.

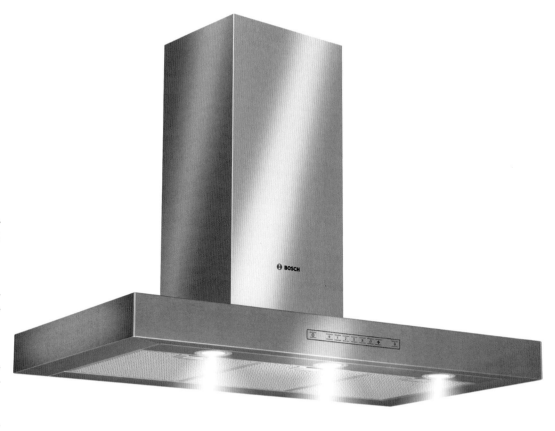

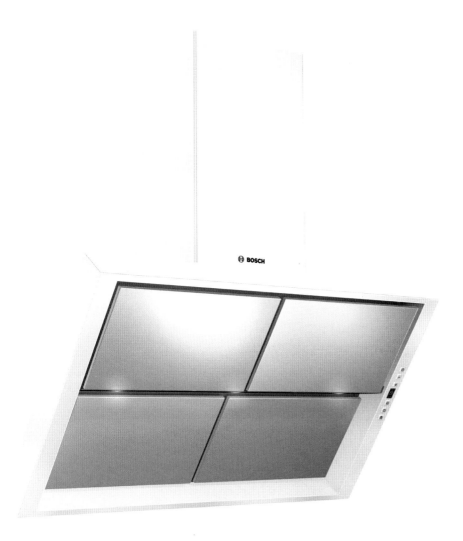

Product
DWK096720
Wandesse weiß
Wall chimney hood, white

Design
Robert Bosch Hausgeräte GmbH
Robert Sachon, Christoph Ortmann
München, Germany

Manufacturer
Robert Bosch Hausgeräte GmbH
München, Germany

In einer Kombination aus Edelstahl und Polarweiß präsentiert sich die BOSCH-Wandesse DKW096720 und kommuniziert so ihre Ausrichtung auf Farbtrends im Wohnbereich. Der aufgeräumte Clean-Look wird durch den Einsatz von Randabsaugungstechnologie unterstrichen. Die unsichtbaren Filterflächen wirken nicht nur eleganter, sondern erleichtern auch die Reinigung der Dunstabzugshaube. Obwohl man solche Geräteunterseiten nicht mehr zu verstecken braucht, dient die Neigung der Absaugfläche nicht alleine ästhetischen Zwecken, sondern in erster Linie dem ergonomischen Aspekt der Kopffreiheit.

The Bosch wall-mounted canopy hood makes its entrance in a stainless steel and polar white combo, thus communicating its compatibility with color trends in living areas. The sleek, clean look is emphasised by the implementation of peripheral venting. The invisible filter surfaces are not only stylish, they also facilitate canopy hood cleaning. Although hood undersides no longer require concealment, the inclination of the venting area not only serves an aesthetic purpose but primarily one of ergonomic, i. e. headroom.

Product
DHU965E
Wand-Unterbauesse, Edelstahl
Wall-hood, built under, stainless steel

Design
Robert Bosch Hausgeräte GmbH
Robert Sachon, Christoph Ortmann
München, Germany

Manufacturer
Robert Bosch Hausgeräte GmbH
München, Germany

Durch die gestalterische Anlehnung an die puristi-
sche Möbelästhetik eines „Cupboards" passt die frei-
hängende Dunstabzugshaube ebenso hervorragend
in ein offenes, wohnliches Küchenumfeld, wie auch
klassisch zwischen zwei Oberschränke integriert. Trotz
der gewollt zurückhaltenden Gestalt des Gerätes un-
terstreicht seine Materialität und Verarbeitung den
hohen qualitativen Anspruch des Gerätes, dem auch
Absaugleistung, Fettabscheidegrad sowie geringe Ge-
räuschentwicklung in nichts nachstehen.

Reminiscent in design of the purist furniture style of
a rack, the cooker hood is equally at ease in a free-
standing situation in an open-plan kitchen / living am-
bience as also conventionally nestling between two
wall units. Despite the deliberately discreet design of
the appliance, its materiality and crafting emphasise
its outstanding quality, rivalled only by its venting
capacity, grease separation efficiency and low noise
development.

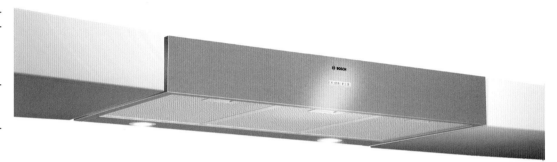

Product
IBF 7157 N
Inselesse
Island extractor hood

Design
Constructa-Neff Vertriebs GmbH
Ralf Grobleben
München, Germany

Manufacturer
Constructa-Neff Vertriebs GmbH
München, Germany

Ihr faszinierend klares Design macht sie zum Blick-fang in der Küche: die 100 cm breite Inselesse IBF 7157 N. Anregend die umlaufende Facettierung der Edelstahlkanten, die sich in anderen Neff-Einbauge-räten wiederfindet. Da passt eins zum anderen. Hohe Ästhetik und Betonung der Horizontalen durch den schlanken Korpus in Box-Bauweise – in perfekter Pro-portion zur sichtbaren Kraft in der Vertikalen durch den Kamin. Elegante Edelstahlflächen, an deren Rän-dern der Wrasen abgesaugt wird, verdecken groß-flächige Metallfettfilter. Das individuell dimmbare SoftLight® setzt die darunter liegende Kochinsel ins beste Licht.

Its fascinating clear design makes it an eye-catcher in the kitchen: the 100 cm wide IBF 7157 N island extractor hood. Striking: the faceting of the stainless steel edges which recurs in other Neff built-in appli-ances. So they all go hand in hand. High aesthetic standard and emphasis on the horizontal lines with the slim body in box design, in perfect proportion with the visible power in the vertical of the chimney. Elegant stainless steel surfaces with steam suction at the edges, concealed large-surface metal grease filter. The individually dimmed SoftLight® sheds the right light on the island unit below.

Product
CentopéiA
Obstkorb und Dekoration
Fruit holder and decoration

Design
DesfiacocO d. e. s. i. g. n.
Gustavo Engelhardt, Daniel Castelo, Diego Costi
Curitiba – PR, Brazil

Manufacturer
DesfiacocO d. e. s. i. g. n.
Cuririba – PR, Brazil

Der Obstkorb findet seine Inspiration in der Natur und ist als Designerstück ein außergewöhnliches Meisterwerk. Jede neue Anordnung zeigt unglaubliche Überraschung, die den Früchten eine künstlerische und dekorative Präsentation verleiht. Man kann den Obstkorb sowohl für große als auch kleine Früchte verwenden. Das Produkt wurde zu 100% aus wieder verwertbarem Material von Naturfasern wie Kokosnuss, Zuckerrohr und Holz entwickelt.

Designed based on natural shapes, the fruit bowl CentopéiA is an outstanding masterpiece. In each different composition an unbelievable surprise, the fruits get a decoration and artistic connotation. Both sides may be used for large or small fruits. The product was developed with 100% recyclable material, based on fibers of coconut, sugar cane and wood.

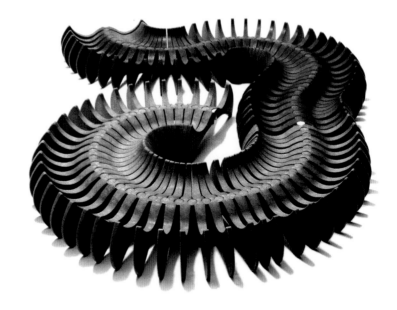

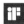

Product
Wanke 90
Waschmaschine
Washing machine

Design
Design Inverso
Marcos Sebben, Glademir Prestini, Eduardo Sanches,
Frederico Prates, Piero Piccinini
Joinville – SC, Brazil

Manufacturer
Wanke S. A.
Indaial – SC, Brazil

Die Waschmaschine Wanke 90 ist eine Evolution der traditionellen Rührwerk-Maschinen mit Holzbottich, wie sie deutsche Einwanderer in Südbrasilien eingeführt haben und wie sie noch immer gern benutzt werden. Das Ziel war es, diese alten Modelle den neuen Sicherheitsnormen und Leistungsmerkmalen anzupassen. Dabei sollten geeignete Materialien und Herstellungsprozesse zum Einsatz kommen. Das aus aufgeforstetem Holz gebaute Gerüst behält seine strukturelle Funktion bei. Der Bottich ist kunststoffbeschichtet und vereint den Zeitgeschmack mit den traditionellen ästhetischen Produktmerkmalen.

The Wanke 90 washing machine is an evolution from the traditional machines, based on wooden tank, introduced by German immigrants in the south of Brazil and still widely used there. The aim was to take the older models as the basis and adapt them to new safety and performance standards for the category, while using more appropriate materials and manufacturing processes for current conditions. The reforested wood body retains its structural function of holding an injected-plastic tank to combine contemporary concepts with traditional aesthetics characteristically associated with the product.

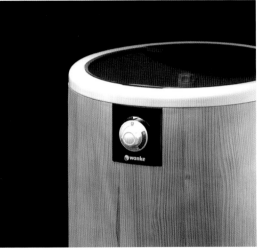

Product
Free Style
Schere
Scissors

Design
CACAU Design Industrial
Rafaelo Rodrigues da Silva, Ronnie Sodeyama Pinto
São Paulo – SP, Brazil

Manufacturer
Mundial S. A.
Gravataí – RS, Brazil

Nach langen anthropometrischen Studien und einer guten Beobachtungsrecherche haben wir festgestellt, dass es drei „Gebrauchsformen" der Scherenbenutzung gibt. Aufgrund dieser Informationsbasis haben wir eine Lösung für die Scherenbenutzung sowohl von Rechtshändern als auch Linkshändern vorgeschlagen. Diese Lösung verbessert die Berührungsfläche zwischen Benutzer und Produkt. Weil wir auf Innovation setzen, wählten wir eine Materialmischung, die eine bessere Berührung mit mehr Komfort und Sicherheit bei der Handhabung ermöglicht und somit den Gebrauch vereinfacht.

After lengthy anthropometric research and observation, we found there are basically three ways of using a pair of scissors. Based on these information we proposed a solution for a scissors suited to both right and left-handed users, improving the user-product interface. This solution also optimized the manufacturing process. Wagering on innovation, we decided to mix materials that provide better tactile features, providing comfort and safe use to facilitate the use of the scissors.

Product
Superpop
Waschmaschine
Washing machine

Design
Chelles & Hayashi Design
Gustavo Chelles
São Paulo – SP, Brazil

Manufacturer
Mueller Eletrodomésticos
Timbó – SC, Brazil

Die Waschmaschine mit einem innovativen Konzept ist an die Bevölkerung mit niedrigem Einkommen gerichtet. Ihr Design ist einfach, zweckmäßig, freundlich und kompakt mit Betonung auf dem breiten Transportrand, dessen Benutzung in bedürftigen Gemeinschaften üblich ist. Das Produkt gebraucht ein Wirbelwaschsystem, das energie- und wassersparend ist. Außerdem wurden alle unnötigen Teile entfernt, um die Kosten zu reduzieren und das Produkt dem Zielpublikum zugänglicher zu machen. Das Resultat ist das transportfähige und demontierbare Equipment, das bis auf 40% logistische Ersparnis ermöglicht.

This washing machine based on an innovative concept is directed at low-income population. Its design is simple, purposeful, friendly and compact, a highlight being the wide transportation edge, which is often used in needy communities. The design includes vortex type washing which reduces energy consumption and takes very little water. All unnecessary structures have been removed to cut costs and make the product most accessible for the target segment. The result was a machine that may be knocked down for transport to save up to 40% on logistics.

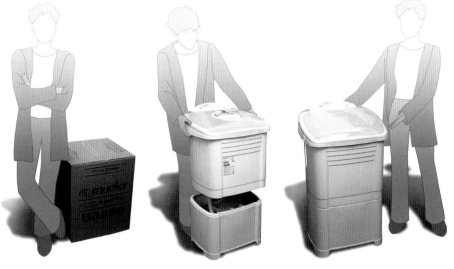

Product
PKU375N14E
Domino Elektro-Grill
Electric domino barbecue

Design
Robert Bosch Hausgeräte GmbH
Robert Sachon, Ulrich Goss
München, Germany

Manufacturer
Robert Bosch Hausgeräte GmbH
München, Germany

Der Lava-Grill ermöglicht ein professionelles Griller-lebnis. Die flächenbündige schwarze Glasabdeckung sorgt für eine perfekte Linienführung in Kombination mit anderen Geräten der Baureihe. Alle Kochfelder dieser Generation haben dieselben markenspezifischen Designmerkmale: Flächenbündig umlaufende Edelstahlleisten, die erstmalig auch unterhalb der Vorderkante weiter geführt werden, bieten in Verbindung mit dem Facettenschliff der Glaskeramik optimalen Kantenschutz, leichte Reinigungs- und perfekte Kombinationsmöglichkeiten. Das TouchControl-Interface erlaubt die Direktwahl der Heizstufen, unterstützt durch funktionelles Lichtdesign.

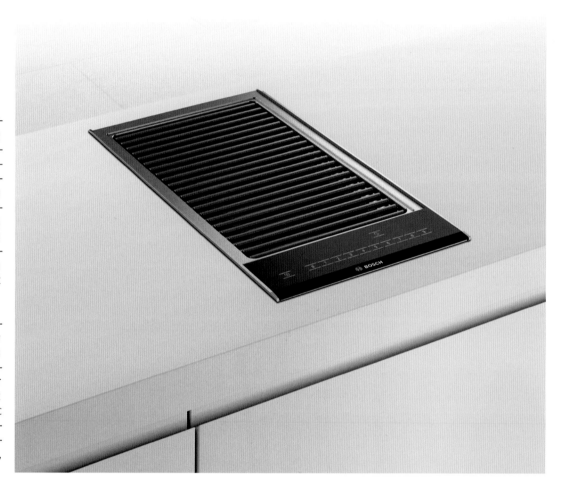

The Lava grill is the key to professional-style barbecuing. The flush-mounted black glass cover is perfectly matched to the other appliances in the range. All hobs of this generation possess the same brand-specific designer features: flush stainless steel side trims that for the first time ever are also featured under the front edge and, in conjunction with the bevelled ceramic glass, afford optimum edge protection, ease of cleaning and ideal combination options. The TouchControl interface permits direct selection of heat settings, visually supported by a functional light design.

Product
PRA326B90E
Domino-Gas-Dual-Wokbrenner
Domino gas dual wok burner

Design
Robert Bosch Hausgeräte GmbH
Robert Sachon, Alexander Marsch
München, Germany

Manufacturer
Robert Bosch Hausgeräte GmbH
München, Germany

Diese Gaskochstelle zeichnet sich durch einen hochwertigen Guss-Topfträger mit abnehmbarem Aufsatz aus, durch den die Performance des sechs kW starken Zweikreis-Wokbrenners optimal zum Tragen kommt. Wie bei allen Bosch-Kochstellen dieser Generation finden sich dieselben markenspezifischen Designmerkmale: Seitlich anschließende Edelstahlleisten, die erstmalig auch unterhalb der Vorderkante weiter geführt werden, bieten in Verbindung mit dem Facettenschliff der Glaskeramik optimalen Kantenschutz beim Handling mit Kochgeschirr. Die Flächenbündigkeit garantiert leichte Reinigungs- und perfekte Kombinationsmöglichkeiten.

This gas cooktop is characterised by an exclusive cast iron pan support with removable trivet, through which the performance of the six kW dual ring wok burner can be optimally deployed. Like all Bosch cooktops of this generation, it displays the same brand-specific design features: Stainless steel side trims that for the first time ever are also featured under the front edge and, in conjunction with the bevelled ceramic glass, it affords an optimum edge of protection when handling cooking utensils. Flush integration assures ease of cleaning and ideal combination options.

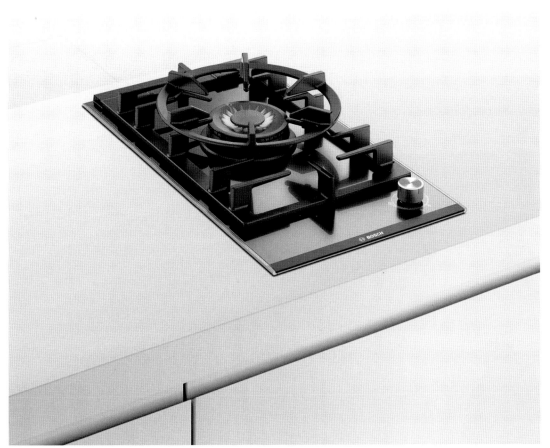

Product
HMT85GR53
Einbau-Mikrowelle mit Drehtür
Built-in microwave with revolving door

Design
Robert Bosch Hausgeräte GmbH
Robert Sachon, Florian Metz
München, Germany

Manufacturer
Robert Bosch Hausgeräte GmbH
München, Germany

Beste Mikrowellentechnologie in Form eines Ober-
schrankgerätes erhöht den Komfort auch im engen
Küchenumfeld. Zur leichten Reinigung ist der Boden
keramisch beschichtet und Spezialprogramme, wie
z. B. Auftaustufen, gewährleisten effizientes und ener-
giesparendes Zubereiten der Speisen. Durch Einsatz
von hochwertigen Materialien und durch seine klare
Gliederung drückt das Gerät Exklusivität aus und ist zu-
dem leicht verständlich. Das flächenbündig integrierte
Touch-User-Interface, in Kombination mit klassischen
Echtmetall-Bedienelementen, prägt das Gesicht des
Gerätes und gewährleistet intuitives Arbeiten.

Professional inverter microwave technology in the
shape of a wall cabinet model assures top results,
even in cramped kitchen surroundings. The base is
ceramic-coated for ease of cleaning and special pro-
gramms, e. g. defrost settings, guarantee efficient,
energy-saving food preparation. In its class, the ap-
pliance exudes a select appeal derived from the use of
precious materials, and additionally, it is pretty easy to
understand. The flushy integrated Touch-User-Inter-
face, which is combined with classic metal operating
elements, characterise the appearance of the appli-
ance and make it easy to use it intuitively.

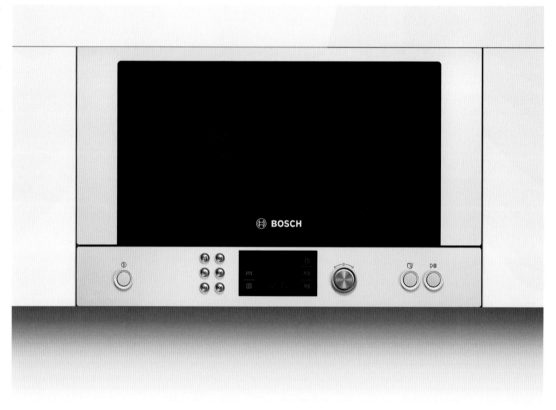

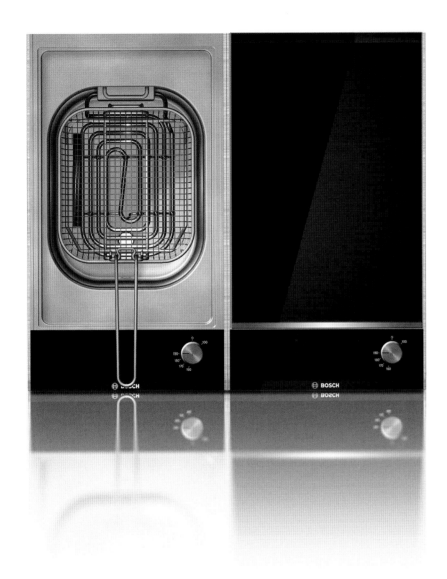

Product
PKA375V14E
Domino-Friteuse
Domino fryer

Design
Robert Bosch Hausgeräte GmbH
Robert Sachon, Ulrich Goss
München, Germany

Manufacturer
Robert Bosch Hausgeräte GmbH
München, Germany

Dieses mit einer schwarzen Glasabdeckung versehene Domino ermöglicht erstmals die nahtlose Integration einer hochwertigen Friteuse in die neue Domino-Designrange. Große Radien und übersichtliche Hauptflächen der Wanne garantieren zusammen mit konsequenter Flächenbündigkeit auch zu den nebenstehenden Geräten ein leichtes Reinigen. Die umlaufende Edelstahlleiste bietet in Verbindung mit dem Facettenschliff der Glaskeramik optimalen Kantenschutz beim aktiven Handling von Kochgeschirr. Der Edelstahlknebel unterstreicht die hohe Wertigkeitsanmutung des Geräts.

With its black glass cover this Domino achieves for the first time ever the seamless integration of an exclusive deep fat fryer in the new Domino-Design range. Large radii and a clear view of the generous container surfaces, paired with consistent flush integration, also to adjacent appliances, assure ease of cleaning. In conjunction with the bevelled edges of the ceramic glass, the surrounding stainless steel trim assures optimum edge protection when using cooking utensils. The stainless steel controls emphasise the select cachet exuded by the appliance.

Product
PKA375N14E
TouchControl Domino-Friteuse
TouchControl domino fryer

Design
Robert Bosch Hausgeräte GmbH
Robert Sachon, Ulrich Goss
München, Germany

Manufacturer
Robert Bosch Hausgeräte GmbH
München, Germany

Dieses mit einer schwarzen Glasabdeckung verse-
hene Domino ermöglicht erstmals die nahtlose In-
tegration einer hochwertigen Friteuse in die neue
Domino-Designrange. Große Radien und übersicht-
liche Hauptflächen der Wanne garantieren zusam-
men mit konsequenter Flächenbündigkeit auch zu
den nebenstehenden Geräten ein leichtes Reinigen.
Die umlaufende Edelstahlleiste bietet in Verbindung
mit dem Facettenschliff der Glaskeramik optimalen
Kantenschutz. Das TouchControl-Interface erlaubt die
Direktwahl der Heizstufen, unterstützt durch funktio-
nelles Lichtdesign.

With its black glass cover this Domino achieves for the
first time ever the seamless integration of an exclusive
deep fat fryer in the new Domino Design range. Large
radii and a clear view of the generous container sur-
faces, paired with consistent flush integration, also to
adjacent appliances, assure ease of cleaning. In con-
junction with the bevelled edges of the ceramic glass,
the surrounding stainless steel trim assures optimum
edge protection. The TouchControl-Interface permits
direct selection of heat settings, visually supported by
a functional light design.

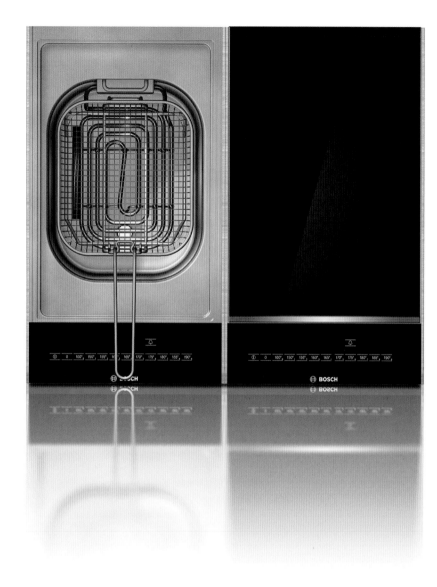

Product
Magic HPT-800
Elektrogrill
Electric grill

Design
Tong Yang Magic Co., Ltd.
Do-Hyung Ha
Chang-Sung Kum
Seoul, South Korea

Manufacturer
Tong Yang Magic Co., Ltd.
Seoul, South Korea

HPT-800 ist ein Kochgerät, mit dem man Fleisch braten und grillen kann. Das Gerät ist leicht zu reinigen, da es im Gegensatz zu den üblichen Grillgeräten dreidimensional geformt ist, sodass das Öl gut auslaufen kann. Außerdem besteht dieses Grillgerät aus drei trennbaren Teilen wie Bedienteil, Hauptteil und Erhitzungsteil. Sie können auseinandergenommen und getrennt gereinigt werden. Das Gerät hat eine schmale Form und kann so problemlos auf den Esstisch gelegt und benutzt werden. Die Teile des Geräts sind kompakt gebaut und man kann sie leicht aufbewahren.

HPT-800 is a cooking appliance to roast or grill meat. Usually, ordinary grill products are hard to clean because of too much oil, produced during cooking. This appliance is easy to clean. As compared with complicated pans with too many holes, this grill pan with three-dimensional shape, which drains oil well, offers easy cleaning function to users. It maximized the cleaning function by detaching the control part, main part and heating wire from the grill. Being a slim product, it can be easily used on the dining table, and can be kept easily because of its compact combination structure.

Product
KS 595
Freistehende Side-by-Side Kühl-Gefrier-Kombination
Freestanding side-by-side fridge-freezer combination

Design
Constructa-Neff Vertriebs GmbH
Tobias Schmidt, Gerhard Nüssler
München, Germany

Manufacturer
Constructa-Neff Vertriebs GmbH
München, Germany

Die Neff-Side-by-Side Kühl-Gefrier-Kombination KS 595 zieht alle Blicke auf sich. Zeitloses Design, ausgewogene Proportionen und feine Details, wie die markanten Stangengriffe und der flächenbündig integrierte Eis-/Wasserspender, verschmelzen zu einem imposanten Gerät im professionellen Edelstahl-Look. Ebenso hochwertig ist der großzügige aufgeräumte Innenraum. Hier findet das klare Design seine konsequente Fortsetzung. Das „AirFlow-System" mit permanenter Luftzirkulation oder die „NoFrost-Ausstattung" im Kühl- und Gefrierraum schaffen perfekte Bedingungen für die Bevorratung frischer Lebensmittel.

The Neff KS 595 side-by-side fridge-freezer draws all eyes. Timeless design, balanced proportions and fine details such as the distinctive bar handles and the flush-integrated ice/water dispenser blend to an imposing appliance in a professional stainless steel look. Of an equally high standard is the spacious, well-structured interior where the clear design is consistently continued. The "AirFlow-System" with permanent air circulation or the "NoFrost feature" in the fridge and freezer compartment creates perfect conditions for the storage of fresh food.

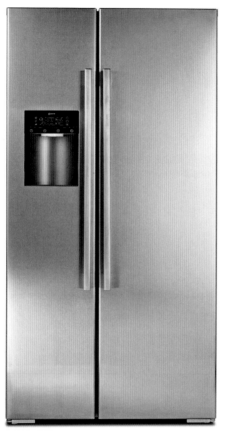
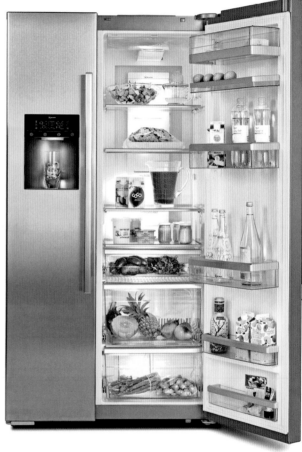

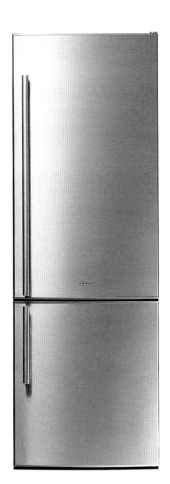

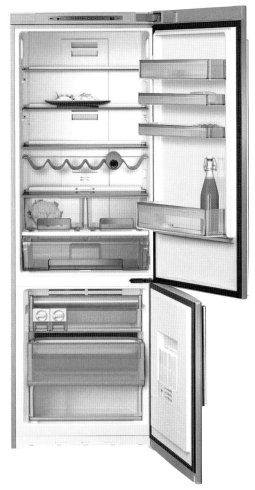

Product
KS 790
Kühl-Gefrier-Kombination
Fridge-freezer combination

Design
Constructa-Neff Vertriebs GmbH
Tobias Schmidt, Gerhard Nüssler, Sebastian Knöll
München, Germany

Manufacturer
Constructa-Neff Vertriebs GmbH
München, Germany

Die freistehende Neff-Kühl-Gefrier-Kombination KS 790 weckt Emotionen. Mit ihrer sanft überspannten Edelstahl-Gerätefront bricht sie die strenge Geradlinigkeit der Küchenarchitektur und vereint in einzigartiger Weise homogenes Design und ästhetische Funktionalität. Klar und zurückhaltend: Die Ausführung mit dreidimensional verformten Oberflächen aus hochwertigem Edelstahl und markanten Stangengriffen. Modernste Technik, großzügige Innenraumgestaltung und intelligente Ausstattungsdetails wie der Eiswürfelbereiter ermöglichen eine perfekte Vorratshaltung. Die innovative „NoFrost-Technologie" erspart lästiges Abtauen.

The Neff free-standing KS 790 bottom freezer arouses emotions. With it's gently rounded stainless front it breaks up the stern linearity of kitchen architecture and is a unique combination of homogenous design and aesthetic functionality. Clear and understated: The version with three-dimensional formed surfaces in high-quality stainless steel and distinctive bar handles. The most modern engineering, generous interior design and smart finishing details, such as the ice-cube maker, permit perfect storage. The innovative "NoFrost technology" cuts out inconvenient de-frosting.

Product
Side-by-Side, Piano Black
Kühl-Gefrier-Kombination
Fridge-freezer combination

Design
Constructa-Neff Vertriebs GmbH
Tobias Schmidt, Gerhard Nüssler, Sebastian Knöll
München, Germany

Manufacturer
Constructa-Neff Vertriebs GmbH
München, Germany

Die Neff-Side-by-Side Kühl-Gefrier-Kombination in Piano Black: Ausdruck vollkommener Perfektion mit einer imposanten schwarzen Lackoberfläche und markanten Edelstahl-Stangengriffen. Dazu faszinieren gestalterische Details wie der Eis- und Wasserspender. Elegant und klar auch das Design im Inneren mit einer spannenden Kombination von transparenten Flächen und stabilen Rahmenelementen. Modernste Technik garantiert beste Bedingungen für die Bevorratung frischer Lebensmittel. Das Geheimnis: permanente Luftzirkulation mittels „AirFlow-System" oder „NoFrost-Ausstattung" im Kühl- und Gefrierraum.

The Neff Piano Black side-by-side fridge-freezer: An expression of complete perfection with an imposing black lacquer surface and distinctive stainless steel bar handles. Complemented by fascinating design details such as the ice and water dispenser. The design in the interior too is elegant and clear with an exciting combination of transparent surfaces and stable frame elements. The most modern engineering guarantees the best conditions for storing fresh food: thanks to the permanent air circulation of the "AirFlow-Systems" and the "NoFrost feature" in the fridge and freezer compartments.

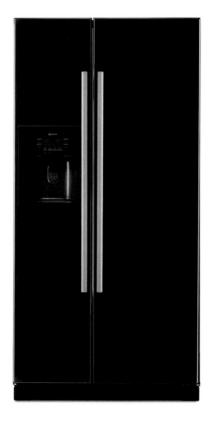
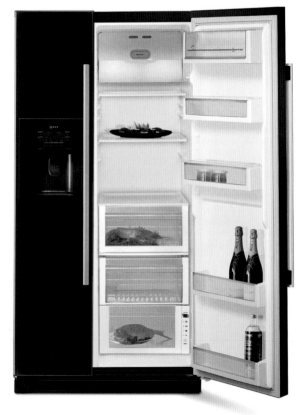

Product
AEG ARCTIS N 91250-4
Einbau-Gefriergerätereihe
Built-in freezer product range

Design
Electrolux Dienstleistungs GmbH
Industrial Design Center – Nürnberg
Nürnberg, Germany

Manufacturer
Electrolux Home Products Corporation N. V.
Zaventem, Belgium

Der ARCTIS N 91250-4 gehört zu einer Product-Range von Einbau-Gefrierschränken der Marke AEG-Electrolux. Die Energie-Effizienzklasse ist A+. Die gut lesbare Bedienblendenbedruckung ergänzt die übersichtlich angeordneten Bedientasten und Drehknebel. Die horizontale Anordnung der Tasten ist als Gestaltungsmerkmal in allen Produktgruppen zu finden und strukturiert sinnfällig verschiedene Funktions- und Bedieninhalte. Die verschiedenen Ausstattungsmerkmale in den Geräten entsprechen den höchsten Anforderungen an hygienische und frische Lagerung für die unterschiedlichsten Lebensmittel.

The ARCTIS N 91250-4 belongs to a product range of built-in freezer products from AEG-Electrolux with an energy efficiency class of A+. High-contrast and easy readable control panels complement the clearly arranged control buttons and rotating buttons. The horizontal alignment of the buttons, as a design characteristic, can be found in all product groups. It structures the different functional elements and user elements. The different features of the appliances are up to the highest standard of storing all kinds of food hygienic and keeping it fresh.

Product
AEG SANTO 75598 KG
Kühl-Gefrier-Gerätereihe
Cold product range

Design
Electrolux Dienstleistungs GmbH
Industrial Design Center – Nürnberg
Nürnberg, Germany

Manufacturer
Electrolux Home Products Corporation N. V.
Zaventem, Belgium

Der Santo 75598 KG ist eine elegante Kombination von Weinlagerzone, No-Frost-Gefrierfach und Kühlzone. Damit bietet er ausreichend Platz für Lebensmittel und Wein in einem Gerät. Die Product-Range der Side-by-Side-Kombination ist nicht nur solo aufgestellt ein Lichtblick an Design. Die Geräte lassen sich auch in der Tiefe perfekt zwischen den Küchenmöbeln platzieren. Die Türen und Seitenwände, mit Sockel und Abdeckung, sowie die eleganten Griffstangen sind aus hochwertigem Edelstahl gefertigt. Eine Glastür mit UV-Schutz und Doppelisolierung gibt den Blick frei auf die edlen Tropfen.

The Santo 75598 KG is an elegant combination out of wine-cooler, no-frost-freezer and fridge. There is enough space for food and wine within the same product. This product range of side-by-side combination are not only a design highlight as a standalone product, they can also be placed within the kitchen furniture environment. The doors and sidewalls, together with the plinth and top, and the elegant barhandles are all finished in stainless steel. The wine cooler door comes with UV-protective-glass and an insulation-glass-door.

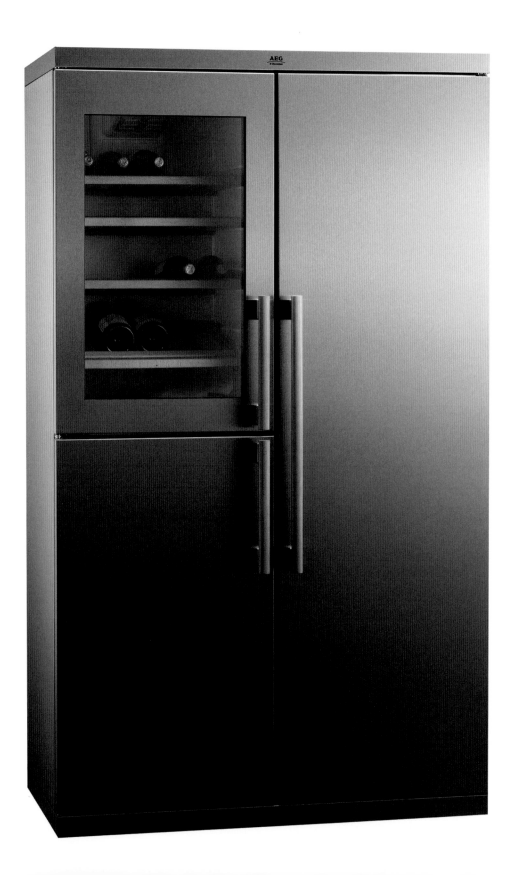

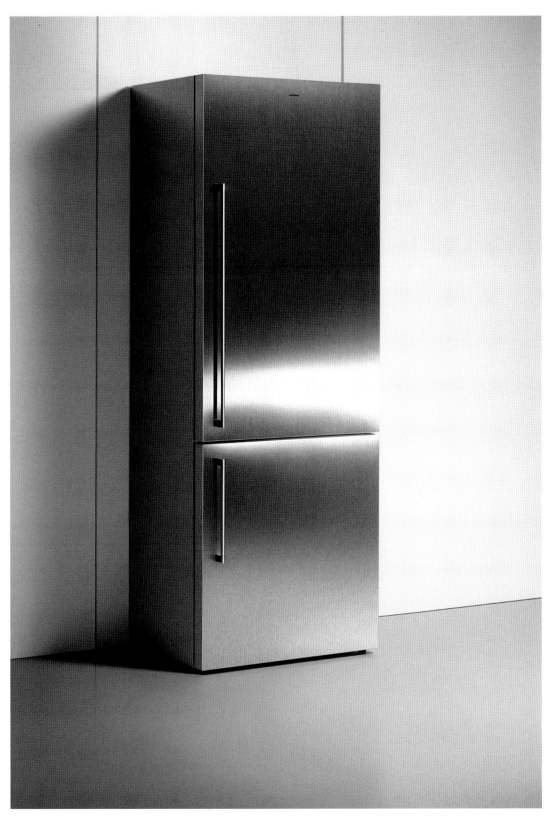

Product
RB 272 352
Kühl-Gefrier-Kombination
Fridge-freezer combination

Design
Gaggenau Hausgeräte GmbH
H. Reinhard Segers, Sebastian Knoell
München, Germany

Manufacturer
Gaggenau Hausgeräte GmbH
München, Germany

Die Kühl-Gefrier-Kombination RB 272 352 von Gaggenau: Großes freistehendes Gerät, 70 cm breit, 200 cm hoch, ist vollständig mit Edelstahl verkleidet und hat Aluminium-Profile. Hochwertige Innenausstattung mit herausnehmbaren Glas-Tablaren und Türabstellern aus massivem Aluminium. Neben der elektronischen Temperaturregelung mit exakt regelbaren Temperaturen von 2 °C–8 °C und einer Frischkühlzone, deren Temperatur 3 °C kälter als im Kühlraum ist, verfügt das Gerät über einen 4-Sterne-Gefrierraum. Die drei Klimazonen, „Kühlen", „Frischkühlen" und „Gefrieren" bieten 398 l. Nutzinhalt. Durch „No-Frost-Technik" entfällt das Abtauen von Hand.

Fridge-freezer combination RB 272 352 from Gaggenau: Large free-standing appliance, 70 cm wide and 200 cm high, has a complete stainless-steel housing and aluminium profiles. High-quality interior fittings: removable glass shelves and solid aluminium door racks. Alongside electronic temperature regulation with precisely adjustable temperatures from 2 °C to 8 °C and a fresh cooling zone that is 3 °C colder than the refrigerating zone, the appliance features a 4-star-freezer compartment. The three temperature zones – "refrigerator", "fresh cooling" and "freezer" – have a usable volume of 398 l. "No-frost technology" eliminates the need for manual defrosting.

Product
RB 272 370
Kühl-Gefrier-Kombination
Fridge-freezer combination

Design
Gaggenau Hausgeräte GmbH
H. Reinhard Segers, Sebastian Knoell
München, Germany

Manufacturer
Gaggenau Hausgeräte GmbH
München, Germany

Die Kühl-Gefrier-Kombination RB 272 370 von Gaggenau: Großes freistehendes Gerät, 70 cm breit, 200 cm hoch, ist vollständig mit Edelstahl oder Aluminium verkleidet. Die Türen sind wahlweise aus Edelstahl oder Aluminium, und zwar hinter Glas. Hochwertige Innenausstattung, mit herausnehmbaren Glas-Tablaren und Türabstellern aus massivem Aluminium. Neben der elektronischen Temperaturregelung mit regelbaren Temperaturen von 2 °C bis 8 °C und einer Frischkühlzone, deren Temperatur 3 °C kälter als im Kühlraum ist, verfügt das Gerät über einen 4-Sterne-Gefrierraum. Die drei Klimazonen „Kühlen", „Frischkühlen" und „Gefrieren" bieten 398 l.

Combination fridge-freezer RB 272 370 from Gaggenau: Large free-standing appliance, 70 cm wide and 200 cm high, has a complete stainless-steel or aluminium housing. Doors are either available in stainless steel or aluminium behind glass. High-quality interior fittings: removable glass shelves and solid aluminium door racks. Alongside electronic temperature regulation with adjustable temperatures from 2 °C to 8 °C and a fresh cooling zone, that is 3 °C colder than the refrigerating zone, the appliance features a 4-star-freezer compartment. The three temperature zones – "refrigerator", "fresh cooling" and "freezer" – have a usable volume of 398 l.

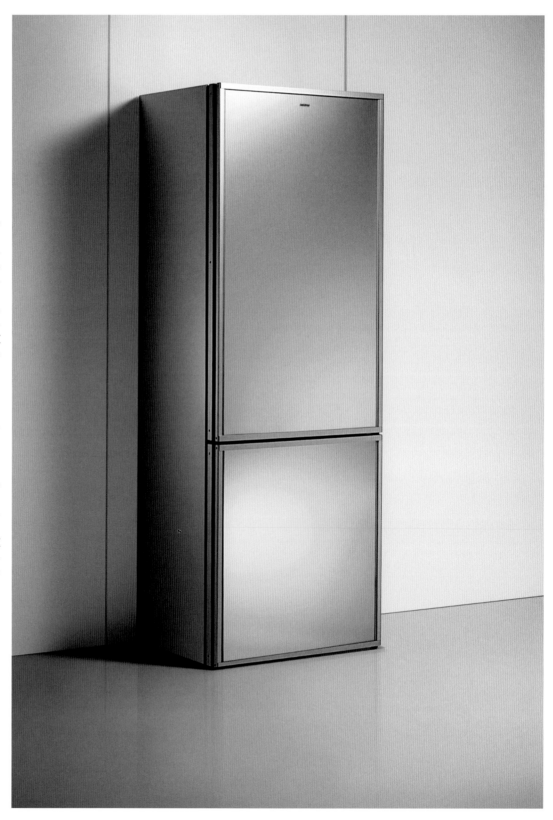

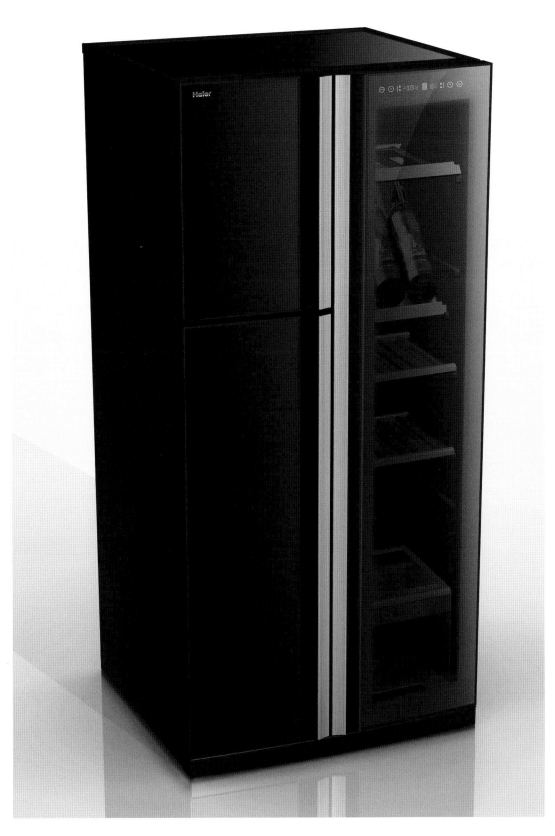

Product
Clear door Fridge
Kühlungszentrum
Cooling center

Design
Industrial Design Center of Haier Group
Li Biao, Lan Cuiqin, Song Jianlin, Yang Xiaoguang,
Mu Zhiguang, Jiang Chunhui, Zhou Shu
Qingdao, China

Manufacturer
Haier Group
Qingdao, China

Das ist ein völlig neues Produktkonzept im Wohn-
zimmer. Der traditionelle Kühlschrank steht in der
Küche, um Nahrungsmittel, Obst und Getränke zu
kühlen. In den letzten Jahren ist das Wohnzimmer
allmählich zum Zentrum des Lebens geworden. Im-
mer mehr Menschen möchten dort Obst oder kühle
Getränke haben. Ein üblicher Kühlschrank ist keine
ansprechende Erscheinung und auch zu groß für das
Wohnzimmer. Jetzt gibt es ein Kühlungszentrum, das
gleichzeitig Getränkezentrum und Gefrierschrank ist.
Durch die Tür kann man den Inhalt in der Innenseite
sehen und so die Vorräte rechtzeitig aufstocken. Durch
die am Boden angebrachten Rollen ist es für Frauen
oder Kinder einfach zu bewegen und somit für eine
Party überall im Haus einsetzbar.

It's a completely new product concept placed for liv-
ing rooms. Traditionally people use refrigerators in
the kitchen to cool items like beverage and fruits with
food. In the past years the people turn the living room
as a center of life more and more. Therefore most
people would like to have some cold drinks or fruits
there. A refrigerator has no sexy look and is also too
big to place it in a living room. Now we have Cooling
center, which is a combination of beverage center
and freezer. Through the clear right door you can see
the items inside and purchase more when it comes
empty. With rolls underneath it is easy for ladies or
kids to remove it and so it is versatile for a party any-
where in house.

Product
4Door B/F LMX25981ST
Kühlschrank
Refrigerator

Design
LG Electronics Inc.
Jee Hoon Shin, Min Sub Kim, Hong Sik Kwon,
In Sun Yeo, Han Young Doh
Seoul, South Korea

Manufacturer
LG Electronics Inc.
Seoul, South Korea

Die zwei Schubfächer der viertürigen, zweigeteilten Kühlabteilung bieten höchsten Komfort bei optimaler Raumnutzung. Dank des oberen Auszugs muss man sich endlich nicht mehr wie bei herkömmlichen drei-türigen Kühlschränken vornüber beugen, wenn man etwas herausnehmen will – die häufig verwendeten Artikel können bequem im oberen Fach verstaut wer-den, während die längerfristig gelagerten Artikel ge-trennt davon im unteren Auszug Platz finden. Der Wasserspender ist mit fast 28 Zentimetern der größte auf dem Markt. Über einen Berührungsknopf kann das Wasser dosiert in Behälter verschiedener Größe gefüllt werden.

The double drawers of the 4-door refrigeration com-partment divided into two parts provide users with optimum convenience and space efficiency. The unit features an upper drawer which can be used with-out having to bend one's back – a vast improvement over traditional 3-door products (no more bending all the way down to take out food). Users can store frequently accessed items in the upper drawer and items used less often separately in the lower drawer. The tall disperser – taller than 11 inches – is the biggest water dispenser on the market. A one-touch water button is used so that a user can get water using containers of various sizes.

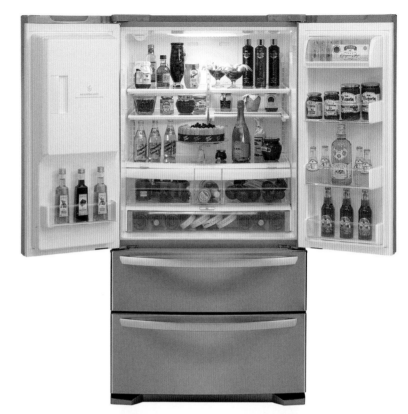

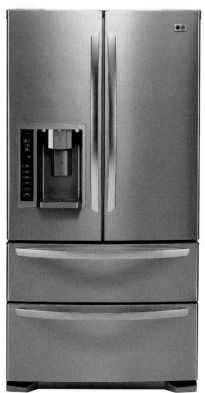

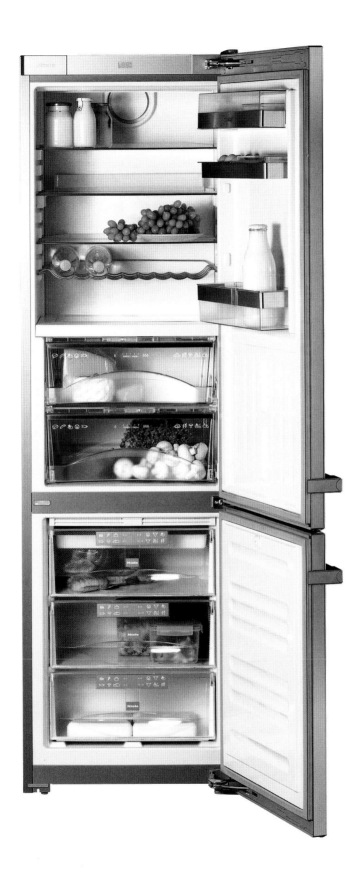

Product
KFN 14927 SD ed
Stand-Kühl-Gefrier-Kombination
Freestanding fridge-freezer combination

Design
Miele & Cie. KG
Werksdesign
Gütersloh, Germany

Manufacturer
Miele & Cie. KG
Gütersloh, Germany

Stand-Kühl-Gefrier-Kombination mit neuer, glatter Sensortasten-Bedienoberfläche „TouchControl" oberhalb des Kühlraums, DynaCool für gleichmäßigere Temperatur- und Luftfeuchtigkeitsverteilung sowie schnelleres Herunterkühlen der Lebensmittel, zweifache Deckenbeleuchtung, Türabstellersystem Vario-Bord, zum Servieren am Tisch geeignet, Active Air-Clean-Aktivkohlefilter, PerfectFresh-Schubfächer auf Teleskopschienen, voll ausziehbar, drei volltransparente Gefrierschubladen mit mengengesteuerter SuperFrost-Automatik, EasyOpen-Hebelgriff, Soft-Close-Türschließdämpfung, Nutzinhalt gesamt 325 l, Geräusch-Schallleistung 42 dB (A).

Freestanding fridge-freezer combination with new, flush sensor TouchControl user interface above cabinet, DynaCool for uniform temperature and humidity distribution and fast cooling of food, double roof lighting, Vario-Bord door rack system, suitable for serving food, Active AirClean filter, PerfectFresh drawers on fully telescopic runners, three fully transparent freezer drawers with quantity-controlled automatic SuperFrost, EasyOpen lever-type handle, SoftClose door damper, total useable capacity: 325 l, sound emissions: 42 dB (A).

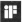

Product
K 14820 SD ed
Stand-Kühlautomat
Freestanding refrigerator

Design
Miele & Cie. KG
Werksdesign
Gütersloh, Germany

Manufacturer
Miele & Cie. KG
Gütersloh, Germany

– Stand-Kühlautomat mit neuer, glatter Sensortas-
ten-Bedienoberfläche „TouchControl" oberhalb des
Kühlraums
– DynaCool für gleichmäßigere Temperatur- und
Luftfeuchtigkeitsverteilung sowie schnelleres Her-
unterkühlen der Lebensmittel
– Zweifache Deckenbeleuchtung
– Türabstellersystem Vario-Bord, zum Servieren am
Tisch geeignet
– Active AirClean-Aktivkohlefilter
– EasyOpen-Hebelgriff
– SoftClose-Türschließdämpfung
– Nutzinhalt gesamt 391 l
– Geräusch-Schallleistung 37 dB (A)

– Freestanding refrigerator with new, flush sensor
"TouchControl" user interface above cabinet
– DynaCool for uniform temperature and humidity
distribution and fast cooling of food
– Double roof lighting
– Vario-Bord door rack system
– Active AirClean filter
– EasyOpen lever-type handle
– SoftClose door damper
– Total useable capacity: 391 l
– Sound emissions: 37 dB (A)

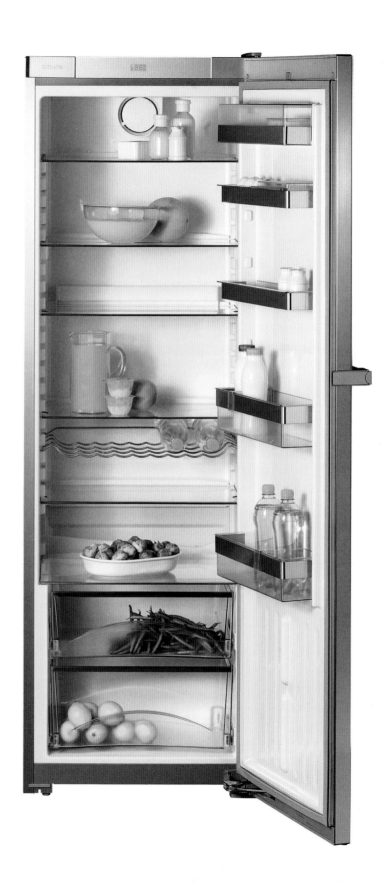

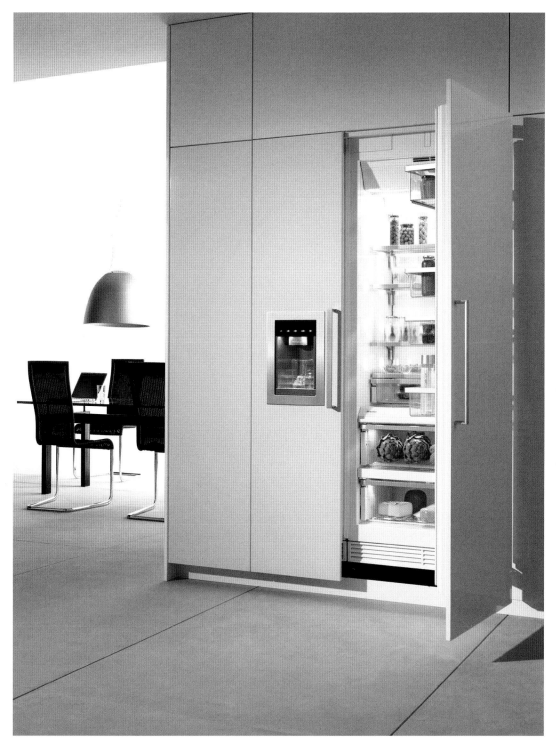

Product
F 1471 Vi / K 1801 Vi
Kühl-Gefrier-Kombination
Fridge-freezer combination

Design
Miele & Cie. KG
Werksdesign
Gütersloh, Germany

Manufacturer
Miele & Cie. KG
Gütersloh, Germany

Die „MasterCool" Linie setzt neue Maßstäbe für den Wettbewerb. Europäisches Design, kombiniert mit amerikanischen Dimensionen und Gebrauchsgewohnheiten machen aus „MasterCool" eine Einbaureihe der Superlative. Die Verwendung hochwertiger Materialien, ein lichtdurchfluteter Innenraum und die revolutionäre „MasterCool" Touch-Bedienung zeichnet diese Gerätelinie aus. Nicht zuletzt die in die Tür integrierte Ausgabeeinheit, die über eine Sensorbedienung gekühltes Wasser, Eiswürfel oder zerkleinertes Eis liefert, lässt keine Wünsche mehr offen.

The "MasterCool" range sets new standards. European design, combined with the American concept of size and user convenience makes "MasterCool" the ultimate designer range. The use of high-end materials, a well-lit cabinet and the revolutionary "MasterCool" touch-control characterise this range of appliances. And last but not least, the dispenser unit, integrated into the door, is offering chilled water, ice cubes or crushed ice, which leaves nothing to be desired.

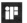

Product
KAD62P90
Side-by-Side NoFrost KG-Kombi
Side-by-side fridge-freezer

Design
Robert Bosch Hausgeräte GmbH
Ralph Staud, Thomas Tischer
München, Germany

Manufacturer
Robert Bosch Hausgeräte GmbH
München, Germany

Platzangebot und Ausstattung sind großzügig. Außen in Edelstahl bündig integrierter Ice-Water-Dispenser mit Touchelektronik. Innen getrennte Kaltluftkreisläufe, VitaFresh-Zone, klappbare Freezertürabsteller, leicht laufende Vollauszugsschalen, teilausziehbare Abstellplatten und Schnellzugriff auf Kühlakkus. Türabsteller und die neue „EasyLift"-Ablage sind samt Beladung verstellbar. Das geht besonders schnell und sogar mit nur einer Hand. Silberne Bügel, Griffe und Alu-Frontleisten sind ein durchgängiges Gestaltungselement dieser Kühlgeräteklasse. Viel Transparenz und helles LED-Licht von oben und in der Rückwand erhöhen die Übersichtlichkeit.

Space and features in abundance. Clad in stainless steel, with a flush-integrated iced water dispenser with touch electronics. Inside, separate cold air circuits, VitaFresh zone, folding freezer door racks, smooth-action fully extendable drawers, partially extendable shelves and easy access to freezer packs. Door racks and the new "EasyLift"-shelf can be effortlessly adjusted, even full. With exceptional swiftness and even single-handedly. Silver rails, handles and aluminium front trims are a universal design element of this refrigerator class. A high level of transparency and bright LED light from above and in the rear wall increase clear viewing.

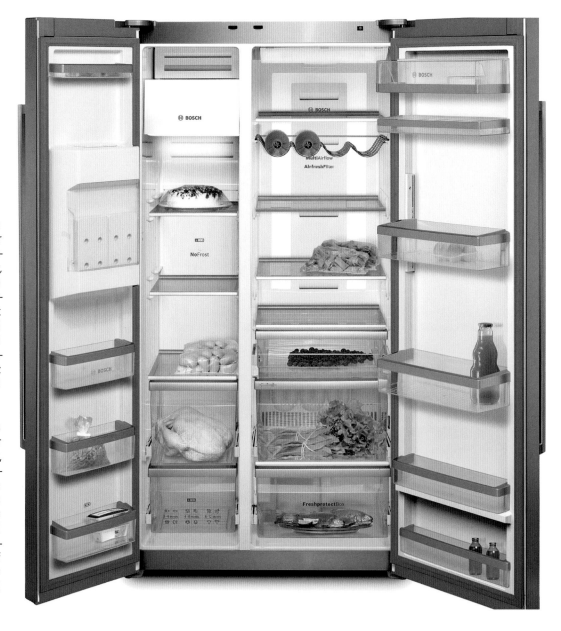

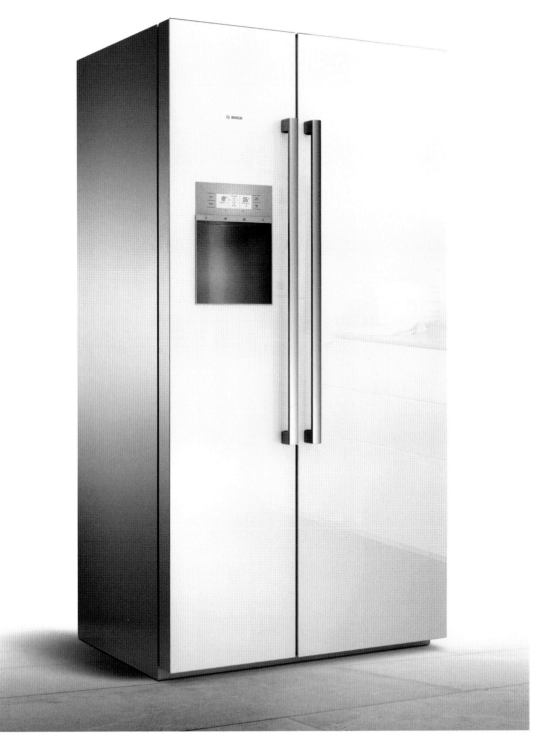

Product
KAD62S20
Side-by-Side-Kühl-Gefrier-Kombination
Side-by-side fridge-freezer

Design
Robert Bosch Hausgeräte GmbH
Ralph Staud, Thomas Tischer
München, Germany

Manufacturer
Robert Bosch Hausgeräte GmbH
München, Germany

Rahmenlose Glasfronten in weiß oder schwarz machen diesen großzügigen Kühlschrank zum wohnlich eleganten Kühlmöbel. Griffe samt Anbindung in Echtmetall sowie der bündig eingelassene „Ice-Water-Dispenser" mit Touchelektronik unterstreichen die Hochwertigkeit in Design, Materialität und Funktion. Im Innendesign wurde besonders auf einfache Bedienung Wert gelegt. Die neue „EasyLift"-Platte lässt sich sehr schnell in eine andere Höhe verstellen, sogar beladen und mit einer Hand. Viel Transparenz bietet gute Übersichtlichkeit. Silberne Bügel, Griffe und Alu-Frontleisten sind ein durchgängiges Gestaltungselement dieser Kühlgeräteklasse.

Frameless glass fronts in white or black transform this spacious fridge into a stylish piece of refrigeration furniture. Handles and connecting elements in genuine metal as well as the flush-recessed iced water dispenser with touch electronics emphasise the exclusive quality of the design, materials and function. Special emphasis was placed on ease of handling in the interior design. The new "EasyLift" shelf can be height-adjusted very quickly, even with contents and single-handedly. A high level of transparency assures clear viewing, silver rails, handles and aluminium front trims are a universal design element of this refrigerator class.

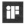
Product
KAD62S50
Side-by-Side Kühl-Gefrier-Kombination
Side-by-side fridge-freezer

Design
Robert Bosch Hausgeräte GmbH
Ralph Staud, Thomas Tischer
München, Germany

Manufacturer
Robert Bosch Hausgeräte GmbH
München, Germany

Rahmenlose Glasfronten in weiß oder schwarz machen diesen großzügigen Kühlschrank zum wohnlich eleganten Kühlmöbel. Griffe samt Anbindung in Echtmetall sowie der bündig eingelassene „Ice-Water-Dispenser" mit Touchelektronik unterstreichen die Hochwertigkeit in Design, Materialität und Funktion. Im Innendesign wurde besonders auf einfache Bedienung Wert gelegt. Die neue „EasyLift"-Platte lässt sich sehr schnell in eine andere Höhe verstellen, sogar beladen und mit einer Hand. Viel Transparenz bietet gute Übersichtlichkeit. Silberne Bügel, Griffe und Alu-Frontleisten sind ein durchgängiges Gestaltungselement dieser Kühlgeräteklasse.

Frameless glass fronts in white or black transform this spacious fridge into a stylish piece of refrigeration furniture. Handles and connecting elements in genuine metal as well as the flush-recessed iced water dispenser with touch electronics emphasise the exclusive quality of the design, materials and function. Special emphasis was placed on ease of handling in the interior design. The new "EasyLift" shelf can be height-adjusted very quickly, even with contents and single-handedly. A high level of transparency assures clear viewing, silver rails, handles and aluminium front trims are a universal design element of this refrigerator class.

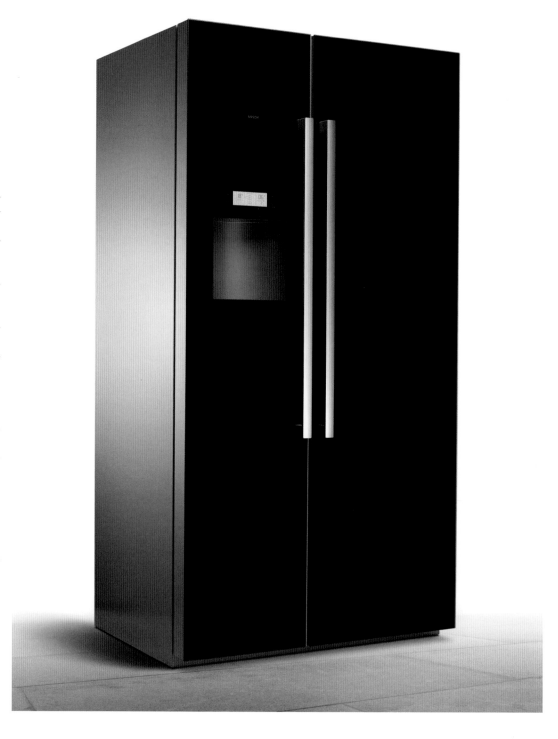

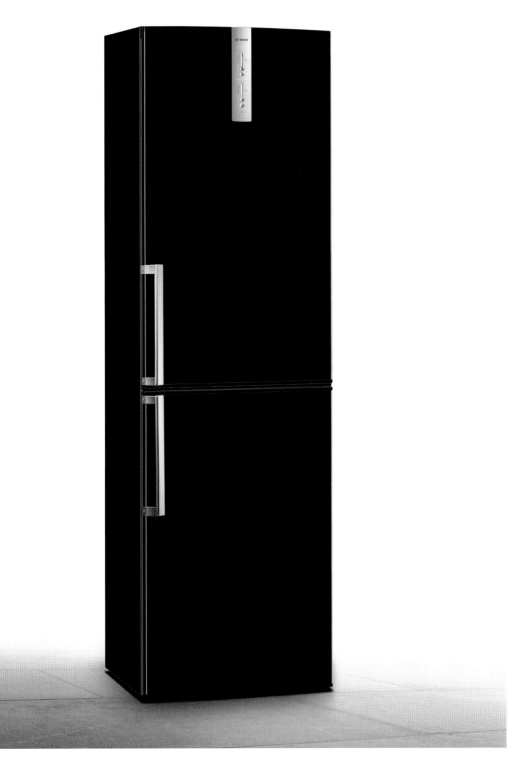

Product
KGN39A50
Solo-Kühl-Gefrier-Kombination
Freestanding fridge-freezer

Design
Robert Bosch Hausgeräte GmbH
Ralph Staud, Thomas Tischer
München, Germany

Manufacturer
Robert Bosch Hausgeräte GmbH
München, Germany

Auf der edlen schwarzen Hochglanzfläche wurden durch Aluminiumgriffe und durch die schlanke silberne Türelektronik mit ihren Chromelementen Akzente gesetzt. Die Tasten mit beleuchteten Schriftzügen und die Lichtlinien der Anzeige sind durch ihre Analogie zu einem Thermometer besonders einfach zu verstehen und zu bedienen. Sie sind Schmuckelement, Bedienung und Statusanzeige zugleich.

Sleek black high gloss surfaces are exclusively highlighted by aluminium handles and streamlined silver door electronics with chrome elements. The buttons with illuminated lettering and illuminated display lines, reminiscent of a thermometer, are particularly easy to understand and operate. They serve simultaneously as decorative elements, controls and status display.

Product
RSG5F
Kühlschrank
Refrigerator

Design
Samsung Electronics
Yang Yunho, Kim Jungmin
Seoul, South Korea

Manufacturer
Samsung Electronics
Seoul, South Korea

Der Side-by-Side-Kühlschrank RSG5F nutzt den In-
nenraum effizient und optimiert damit die Benutzer-
freundlichkeit – alles ist leicht zu finden. Zwar ist er
nicht größer als andere Kühlschränke auf dem Markt;
durch sein schlankeres Gehäuse und eine verbesserte
Inneneinrichtung bietet er jedoch einen um 140 Liter
vergrößerten Stauraum. Der unter Verwendung neuer
Technologien entwickelte Kühler erhöht die Feuchtig-
keit im Innenraum um 70 Prozent, was ideale Bedin-
gungen für die Lagerung von Speisen schafft.

The RSG5F is a side-by-side refrigerator that en-
hanced the effective use of each internal space and
maximized usability by allowing the user to easily find
what he/she is looking for. Even though the exterior
size is the same as that of other refrigerators available
on the market, the thickness of the body has been
reduced and improvements have been made to in-
ternal parts, enabling the user to store an additional
140 liters of food. This product employs a cooler that
has been developed using new technologies. The
cooler raises the level of moisture inside the refriger-
ator to 70 percent, allowing the user to store food in
the best conditions.

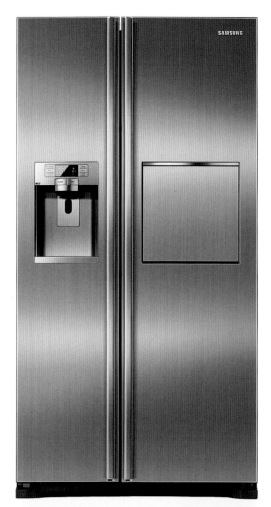

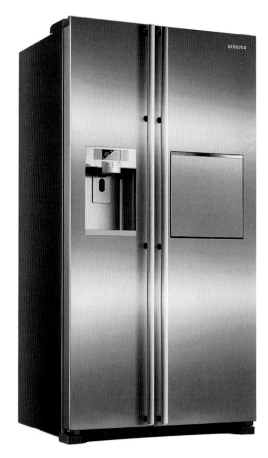

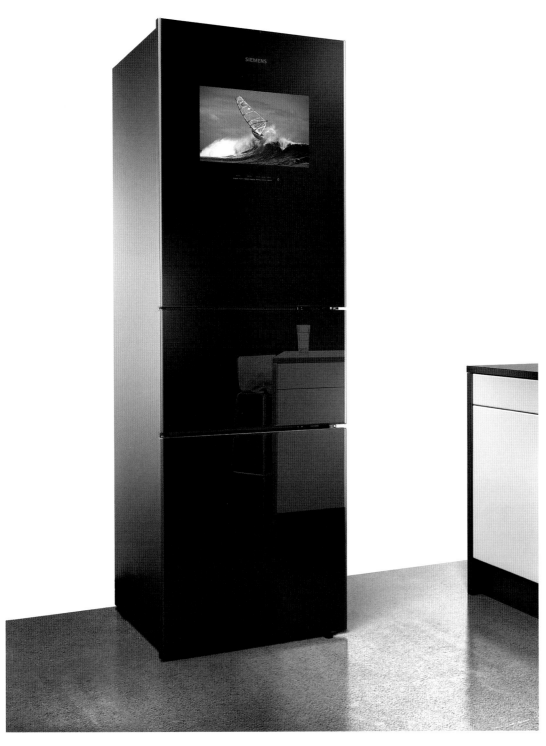

Product
KG28FM50
Multi-Media Kühl-Gefrier-Kombination
Multi-media fridge-freezer combination

Design
Siemens Electrogeräte GmbH
Christoph Becke
München, Germany

Manufacturer
Siemens Electrogeräte GmbH
München, Germany

Kühl-Gefrier-Kombination mit voll integriertem 17" LCD Wide-Screen-Display im 16:9 Format. Mit seiner reduzierten Formensprache, integrierten Griffleisten und neuartigen Glastüren orientiert sich dieser Kälte- solitär an aktuellen Küchenwelten. Der LCD-Bildschirm ist hinter der dunklen Glasfront perfekt in die Türe integriert. Der Bildschirm wird über Fernbedienung oder über Touchtasten an der Glasfront bedient. Das Gerät hat einen USB-Anschluss, ist HD-ready und sorgt mit einem DVB-T-Tuner für besten Empfang. Das Ge- rät besitzt eine große 0 °C-Zone mit zwei Schubladen zur optimalen Lagerung von Fleisch und Gemüse. Ex- trem energiesparend und KCKW/FKW-frei.

Fridge-freezer combination with fully integrated 17" LCD widescreen display in 16:9 format. With its mini- malist design, integrated handle strips and novel glass doors, the free-standing refrigerator is geared to today's kitchen world. The LCD display, integrated behind the glass, is only visible when on. Positioned at an optimal ergonomic height, the screen is controlled via remote or touch buttons behind glass. The appli- ance features a USB port, is HD ready and provides optimal reception with a DVB-T tuner. The appliance has a large 0 °C-zone, is extremely energy-saving and CFC/HFC free.

Product
wall Cube
Kältegerät
Refrigerator

Design
Siemens Electrogeräte GmbH
Christoph Becke, Christian Hoisl, Boris Angele
München, Germany

Manufacturer
Siemens Electrogeräte GmbH
München, Germany

Neuartiges Kältegerät für Hotels, Office- und Wohn-
bereich. Durch reduzierte Formensprache, Dimensio-
nierung und neuartige Wandmontage passt wall
Cube perfekt in Hotels als Mini-Bar und in Office-
und Wohn-Bereiche. Wechselbare Fronten können
aktuelle architektonische Farb- und Materialtrends
aufnehmen. Dank flexibler Innenausstattung finden
neben Getränken und Snacks auch Gläser und Fla-
schenöffner im gekühlten, elektronisch regelbaren
Innenraum Platz. Über den Schiebedeckel ist der In-
nenraum bequem zugänglich. Das Gerät ist extrem
leise, energiesparend und 100 % FCKW/FKW-frei.

Innovative refrigerator for hotels, office and living
areas. With its minimalist design, new dimensions
and novel wall-mounted assembly, the wall Cube
is a perfect fit as a minibar in hotels and for office
and living areas. Changeable fronts can incorporate
current architectural trends in color and materials.
With flexible interior features, the cold, electronically
controllable interior even offers a place for a bottle
opener and glasses in addition to drinks and snacks.
The interior is conveniently accessible through the
sliding lid. The appliance is extremely quiet, energy-
saving and 100 % CFC/HFC free.

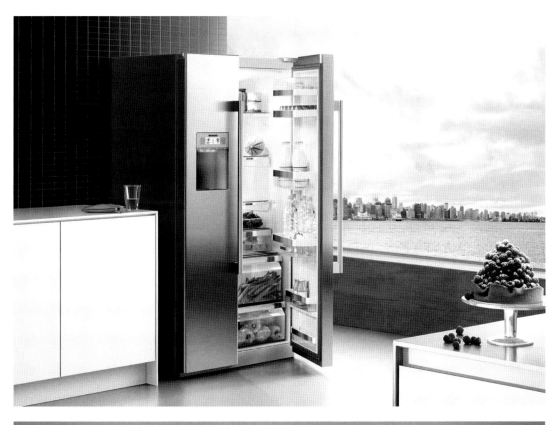

Product
KA62DP90
Side-by-Side Kühlschrank
Side-by-side refrigerator

Design
Siemens Electrogeräte GmbH
Christoph Becke, Max Eicher
München, Germany

Manufacturer
Siemens Electrogeräte GmbH
München, Germany

„coolDuo" ist ein Statement. Klar, hochwertig und funktionell bis ins Detail. Glasplatten sind einfach mit einer Hand höhenverstellbar, selbst dann, wenn sie voll beladen sind. Die Temperatur kann gradgenau und individuell für verschiedene Bereiche eingestellt werden. Jedes Lebensmittel hat den richtigen Platz und kann optimal gelagert werden. Besonders angenehm für den Benutzer ist die ausgezeichnete LED-Beleuchtung, die den Innenraum hell und übersichtlich macht. Dennoch ist „coolDuo" durchaus sparsam im Energieverbrauch: A+.

"coolDuo" makes a statement. With clean, stylish lines and a functional approach right down to the smallest detail. The height of the glass shelves is simple to adjust with one hand, even when fully loaded. The temperature can be individually regulated for the various zones, with "to-the-degree" accuracy, providing the appropriate location and optimum storage conditions for every type of food. The outstanding LED lighting is particularly user-friendly, ensuring that the interior space is brightly lit for maximum visibility. Nevertheless, the "coolDuo" boasts an exceptionally frugal "A+" energy consumption rating.

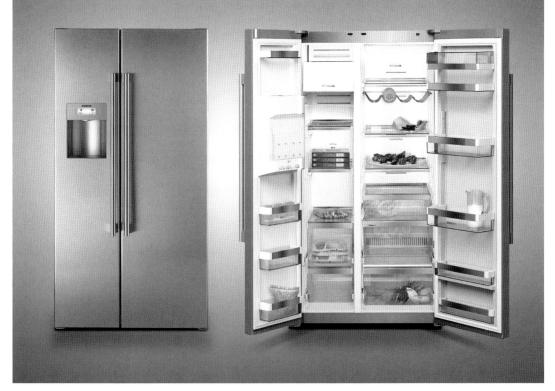

Product
cool Cube
Kältegerät
Refrigerator

Design
Siemens Electrogeräte GmbH
Christoph Becke, Christian Hoisl, Boris Angele
München, Germany

Manufacturer
Siemens Electrogeräte GmbH
München, Germany

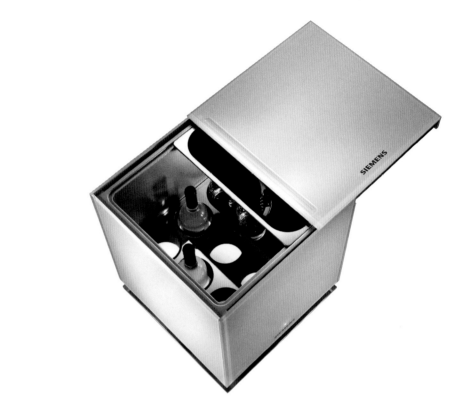

Neuartiges Kältegerät für Wohn- und Office-Bereich.
Durch reduzierte Formensprache und neuartige Dimensionen passt cool Cube perfekt in Wohn- und Office-Bereiche. Wechselbare Fronten können aktuelle architektonische Farb- und Materialtrends aufnehmen. Dank flexibler Innenausstattung finden neben Getränken und Snacks auch Gläser und Flaschenöffner im gekühlten, elektronisch regelbaren Innenraum Platz. Der Schiebedeckel dient als temporäre Stellfläche für Gläser, der Innenraum bleibt trotzdem bequem zugänglich. Das Gerät ist extrem leise, energiesparend und 100% FCKW/FKW-frei.

Innovative refrigerator for living and office areas. With a minimalist design and new dimensions, the cool Cube fits perfect for living and office areas. Changeable fronts can incorporate current architectural trends in color and materials. With flexible interior features, the cold, electronically controllable interior even offers a place for a bottle opener and glasses in addition to drinks and snacks. The sliding lid serves as a temporary resting spot for glasses while the interior remains conveniently accessible. The appliance is extremely quiet, energy-saving and 100% CFC/HFC free.

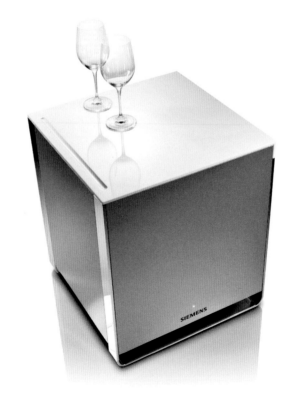

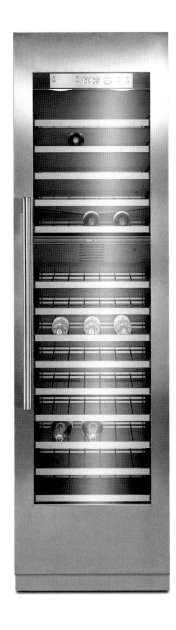

Product
KWC 61
COOLINARO® Weintemperierschrank
COOLINARO® wine cooler

Design
Constructa-Neff Vertriebs GmbH
Tobias Schmidt, Gerhard Nüssler
München, Germany

Manufacturer
Constructa-Neff Vertriebs GmbH
München, Germany

Der Weintemperierschrank KWC 61 aus der einzig-artigen COOLINARO®-Reihe von Neff ist Ausdruck eines erlesenen Lebensstils. Elegantes Design steckt in einem außergewöhnlichen Format. Die große Glastür gibt den Blick frei in den ästhetisch gestalteten In-nenraum mit 14 ausziehbaren Tablaren. Markant: die Edelstahlfront mit Stangengriff – der perfekte Rah-men für die Präsentation feinster Weine. Moderne Technik garantiert eine professionelle Weinlagerung: UV-geschützt, erschütterungsfrei, gleichmäßige und konstante Temperatur in zwei getrennten Tempera-turzonen von +5 °C bis +18 °C durch dynamische Kühlung.

The KWC 61 wine cooler from Neff's unique COOLINARO® series is an expression of a select life-style. Elegant design in an extraordinary format. The large glass door offers a clear view of the aesthetically-designed interior with 14 pull-out trays. A distinctive feature: the stainless steel front with bar handle – the perfect setting for presenting fine wines. Modern engineering guarantees professional wine storage: UV-protected, vibration-free, uniform and constant temperature in two separate temperature zones from +5 °C to +18 °C thanks to dynamic cooling.

Product
RW 496 250
Weinklimaschrank
Wine storage cabinet

Design
Gaggenau Hausgeräte GmbH
H. Reinhard Segers, Sebastian Knoell
München, Germany

Manufacturer
Gaggenau Hausgeräte GmbH
München, Germany

Der Weinklima- und Temperierschrank RW 496 von Gaggenau: Ob freistehend oder voll integrierbar, bietet dieses Gerät mit drei getrennt steuerbaren Klimazonen eine konstante Temperatur mit gradgenauer Regelung von 4 °C bis 21 °C. Der Modus zur schonenden Weintemperierung und die vibrationsarme Lagerung garantieren für bis zu 118 Flaschen optimalen Weingenuss. Die Innenausstattung in unbehandeltem Buchenholz und Aluminium ist individuell zusammenstellbar und voll ausziehbar. Die separat zuschaltbaren Präsentationslichter im Edelstahlinnenraum rücken die edlen Tropfen in das richtige Licht.

The wine storage and temperature control cabinet RW 464from Gaggenau: Whether freestanding or fully integrated, this appliance with three independently adjustable, precision-controlled temperature zones (from 4 °C to 21 °C) ensures that temperatures remain constant. The gentle wine cooling mode and vibration-free storage guarantee optimal wine enjoyment for up to 118 bottles. The untreated beech and aluminium interior can be individually arranged and is fully extendable. The stainless-steel interior features presentation lights for a stylish display of the finest wines.

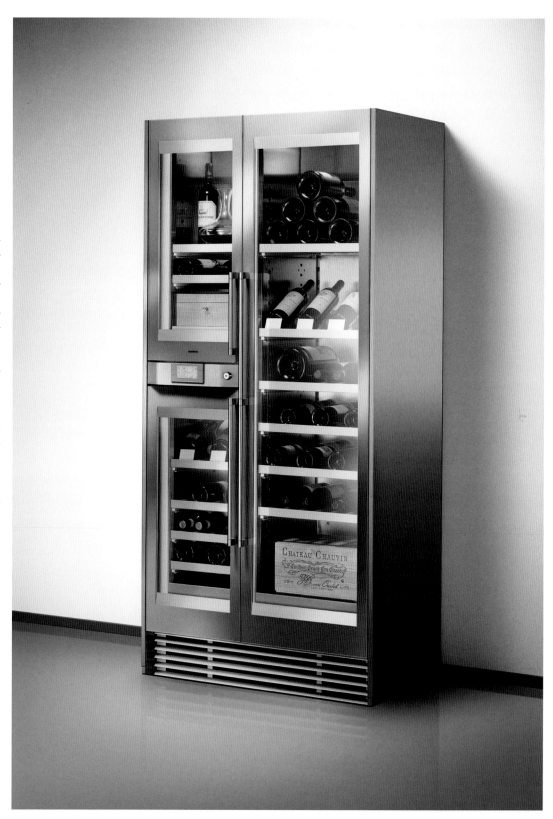

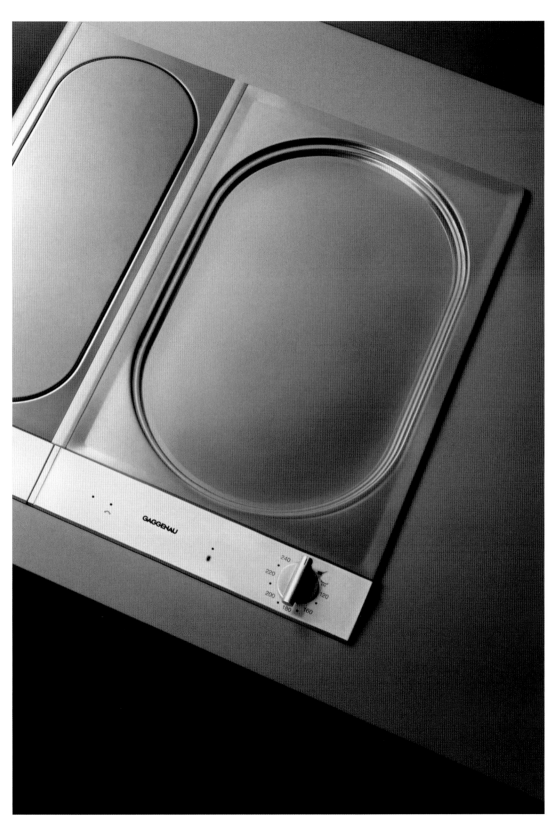

Product
VP 230
Vario Teppan Yaki

Design
Gaggenau Hausgeräte GmbH
H. Reinhard Segers, Soeren Strayle
München, Germany

Manufacturer
Gaggenau Hausgeräte GmbH
München, Germany

Das Teppan Yaki VP 230 von Gaggenau: Mit dem Teppan Yaki VP 230 wird direkt auf der geschliffenen Edelstahl-Sandwichplatte gegart – nach japanischer Tradition. Die maximale Leistung beträgt 1.800 Watt. Mit Hilfe von zwei mitgelieferten Spateln wird kurz angebratener Fisch oder Gemüse gewendet und die Sauce dirigiert. Dabei bleibt die Oberfläche immer leicht zu reinigen. Das Teppan Yaki VP 230 ist 28 cm breit. Die Bedienleiste besteht aus Aluminium. Kombinierbar ist das Teppan Yaki mit den anderen Vario-Kochgeräten der Serie 200.

Teppan Yaki VP 230 from Gaggenau: With the Teppan Yaki VP 230, cooking is done directly on the smooth stainless-steel griddle plate in the traditional Japanese way. It has 1,800 watts maximum power. Included in delivery are two spatulas, used to turn the fried fish or vegetables and spread the sauce. The surface is always easy to clean. The Teppan Yaki VP 230 is 28 cm wide. The control panel is aluminium. The Teppan Yaki can be combined with other series 200 Vario cooking appliances.

Product
KWT 1601 Vi
Weintemperierschrank
Wine Cooling Conditioner

Design
Miele & Cie. KG
Werksdesign
Gütersloh, Germany

Manufacturer
Miele & Cie. KG
Gütersloh, Germany

Gute Tropfen sind doch eigentlich viel zu schade für den dunklen Keller. In dem voll integrierbaren Weintemperierschrank der „MasterCool" Linie ruhen die edlen Preziosen auf ausziehbaren Tablaren aus bestem Akazienholz. Drei Temperaturzonen sind unabhängig voneinander elektronisch regelbar und liefern ideale Bedingungen für die unterschiedlichen Weine. Die Glastür wird entweder mit Edelstahl umfasst oder in die Möbelfront integriert. Durch seine transparente Front und die akzentuierte Beleuchtung wirkt er elegant und fügt sich unaufdringlich in die Küche ein.

Fine wines are really far too good to be hidden away in a dark cellar. In the "MasterCool" range, bottles with their precious contents can mature in peace in fully integrated wine conditioning units on top-quality acacia wood pull-out shelves. All three temperature zones have separate electronic controls and permit the storage of different types of wine requiring different temperatures. The glass doors have either a stainless steel frame or are integrated in the furniture front. The translucent fronts and atmospheric lighting express an elegance and blend in harmoniously into the kitchen.

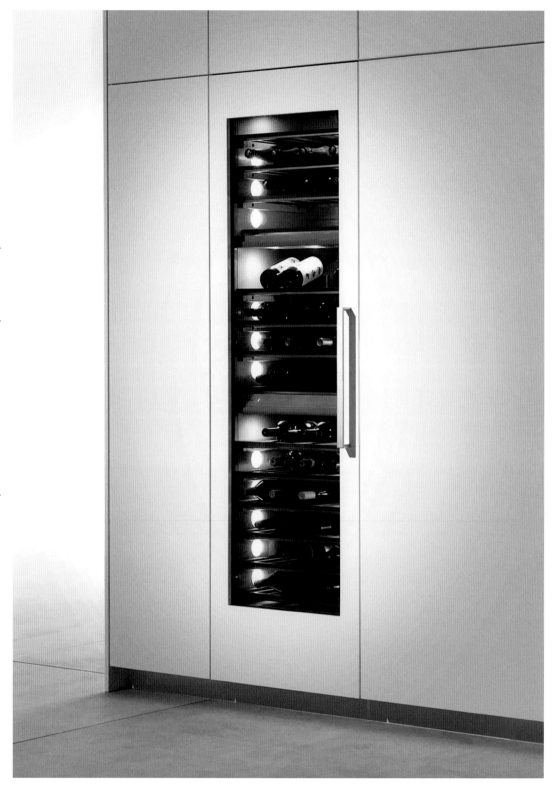

Product
Sublim'O
Trinkwasserspender und 10-Liter-Flasche
Water cooler and 10-litre bottle

Design
Enthoven Associates Design Consultants
Antwerpen, Belgium

Manufacturer
Sip-Well
Londerzeel, Belgium

Sip-Well bringt einen hochwertigen Wasserspender mit Flasche heraus, der gut in moderne Wohnsituationen wie auch in kleine Büros passt. Das Farbschema der Verkleidung kann beliebig verändert werden, so dass sich das Gerät in jegliche Umgebung einfügt. Trotz der geringen Standfläche, die das Design so vielseitig wie möglich machen soll, sind alle wichtigen Komponenten vorhanden. Besonders beachtet wurden Ergonomie, Hygiene und Zusammensetzung. Die 10-Liter-Flasche mit innovativem Griffsystem und kratzfester Oberfläche steht im Einklang mit dem coolen Design. Der Kunde kann zwischen vier verschiedenen Flaschenfarben wählen.

The ambition of Sip-Well was to launch a high-end cooler with bottle that fits modern home interiors as well as small offices. The cladding of the cooler can be altered to any color scheme matching every interior. The design has a minimal "footprint" to maximize versatility but still includes all key features. Special attention was paid to ergonomics, hygiene and assembly techniques. The 10-litre bottle falls "flush" with the cooler design. It features a surface that conceals scratches and an innovative handle system. To personalize the bottle to the customer, it is available in four different colors.

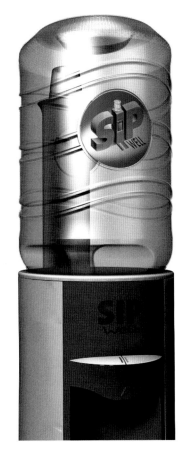

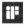

Product
KeruKeru
Soßenspender
Liquid sauce dispenser

Design
U. I. Design Co., Ltd.
Chuan-Ron Lee
Taipei, Taiwan

Manufacturer
GazinCreate Co., Ltd.
Taipei, Taiwan

Immer wieder kommt es vor, dass zu viel Soße auf den Teller gerät. Doch übermäßige Mengen stellen eine unnötige Belastung für die Gesundheit dar. Und wenn die Soße zu salzig oder zu sauer ist, ruiniert sie jede perfekte Mahlzeit. KeruKeru sorgt dafür, dass Sie die Soßenmenge auf Ihrem Teller stets unter Kontrolle haben. Mit dem großen, an der Öffnung angebrachten Messlöffel können Sie die Soße für Ihre Mahlzeit genau dosieren.

Sometimes we forget how much sauce we put on our plate. Serving excessive amounts creates an unnecessary burden on your health. If the sauce is too salty or too sour, it will ruin a perfect dish. The idea behind KeruKeru is knowing how much goes onto your dish. A large measuring spoon at the opening lets you see how much sauce to use for your meal.

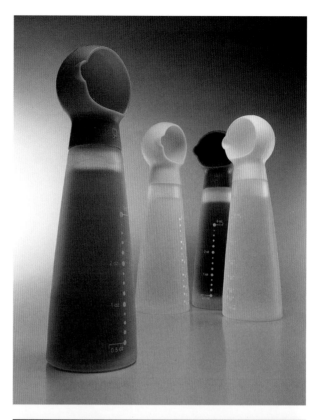

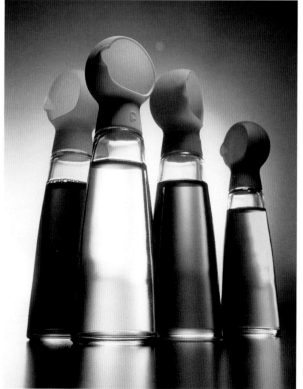

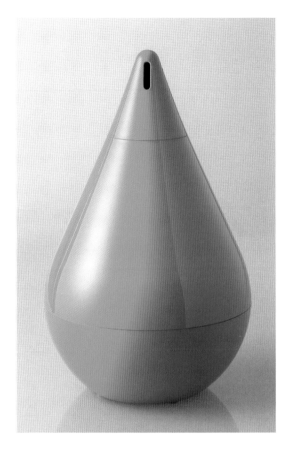

Product
Water Drop
Luftbefeuchter
Humidifier

Design
Loofenlee Co., Ltd.
Kyung Mi Lee, Chul Ju Park, Chang Hwan Oh
Seoul, South Korea

Manufacturer
Loofenlee Co., Ltd.
Seoul, South Korea

In Ihrem Haus fließt Regenbogenwasser! Verschiedenfarbige Wassertropfen schaffen eine angenehme Atmosphäre. Dabei kommt ein ultrafeiner Filter aus Kupferfasern zum Einsatz, der in Japan als sterilisierend anerkannt ist. Metalle wie Silber oder Kupfer haben eine leicht sterilisierende Wirkung, doch der ultrafeine Filter aus Kupferfaser maximiert die Sterilisierung aufgrund seiner erheblich größeren Oberfläche. Ein Knopfdruck genügt für alle Funktionen (Ein / Aus, Niedrig, Normal, Hoch). Die in ihrem Inneren geomantischen Tropfen können die in künstlichen Raummaterialien enthaltene Energie des Feuers ausgleichen.

Elegant rainbow water drops in your house! Various colors and beautiful water drop designs improve the atmosphere in your home. An ultra-fine copper fiber filter approved in Japan for its sterilizing performance was employed. While metals such as silver or copper have a slight sterilizing effect, the ultra-fine copper fiber filter maximizes sterilization with a surface area significantly larger than other metals. Simple one-touch button – a single button for all functions (ON / OFF, Low, Normal, High). Geomantic interior. The water drops may compensate for the energy of fire in artificial interior materials.

Product
PIU
Geschirr, Thermoskanne, Glas
Table ware, thermos jug, glass

Design
PATRICK FREY Industrial Design
Patrick Frey
Hannover, Germany

Manufacturer
AUTHENTICS GmbH
Gütersloh, Germany

Die Serie PIU bringt Geschirr, Glas und Thermoskanne in einheitlichem Design auf den Tisch. Trotz unterschiedlicher Materialien wirken die elegante, leicht taillierte PIU-Thermoskanne aus hochglänzendem Kunststoff und das ebenfalls taillierte PIU-Porzellangeschirr mit passender Glasserie wie aus einem Guss. Die Thermoskanne lässt sich dank des intelligenten Verschlusses mit Silikonmembran mit einer Hand öffnen und wieder verschließen. Die Teller können als Deckel für die Schalen und Schälchen benutzt werden. Die passende Glasserie besteht aus Trinkgläsern, einer Karaffe und zwei Vasen.

The PIU series brings a consistent design of tableware, glass and thermos jug to your table. Despite their different materials, the elegant, slightly waisted PIU thermos jug of high-gloss plastic and the equally waisted PIU porcelain tableware with matching glassware exhibit a homogeneous quality. Thanks to its intelligent top closure with silicone membrane, the thermos jug can be opened and closed using just one hand. Plates can be used as lids for bowls and small bowls. The matching glassware comprises drinking glasses, a carafe and two vases.

Product
Beeck Feinkost
Schalen und Besteck
Display dishes and cutlery

Design
feldmann+schultchen design studios
Ursula Eisen, Stephan Kremerskothen,
André Feldmann, Arne Schultchen
Hamburg, Germany

Manufacturer
Polyconcept Hong Kong Ltd.
CP Centrum für Prototypenbau GmbH
Erkelenz, Germany

Feinköstliches in seiner schönsten Form – so präsentieren sich die hochwertigen, frischen Salat-Kreationen der Feinkost-Marke Beeck in einer exklusiv entwickelten Schalenfamilie. Wir haben Schalen und Besteck entwickelt, die optimale Handlingeigenschaften aufweisen und die Produkte differenziert und emotional präsentieren. Die sechs verschiedenen Schalengeometrien sind in Form und Fassungsvermögen an unterschiedliche Produktwelten des Feinkostsalat-Sortiments angepasst. Die organische Linienführung der Schalen schafft eine emotionale, hochwertige Verkaufsumgebung und zugleich eine untrennbare Verbindung zwischen Marke und Produkt.

Delicatessen presented beautifully – fresh, superior quality salad creations exhibited in a range of new bowls, developed exclusively for the fine food brand Beeck. We have created bowls and cutlery for a differentiated and emotional product presentation and optimized handling features. A range of six bowl shapes have been adapted in form and capacity to accommodate a variety of product worlds within the fine food salad assortment. The organic alignment of the bowls creates an emotional, premium quality sales environment and harmonizes brand and product at the same time.

Product
Gourmet
Porzellan
Porcelain

Design
Arzberg-Porzellan GmbH
Heike Philipp
Schirnding, Germany

Manufacturer
Arzberg-Porzellan GmbH
Schirnding, Germany

Mit Gourmet präsentiert Arzberg das zeitgemäße Porzellan für die perfekte Tischkultur. Der Entwurf von Heike Philipp zeigt weiche fließende Formen und folgt gleichzeitig einer klaren Linie. Einfallsreich kombiniert die Designerin perfekte vertraute Proportionen mit neuartig arrangierten Formen. Gourmet ist Design für den modernen Genuss. Dieses Porzellan macht jede Menüfolge begeistert mit.

Arzberg now presents Gourmet, the contemporary porcelain for perfect tableware. The design by Heike Philipp features flowing forms and clear-cut lines. The designer has creatively combined perfect, familiar proportions with refreshingly tweaked forms. Gourmet is a design for modern tastes. This fine china will work with any menu.

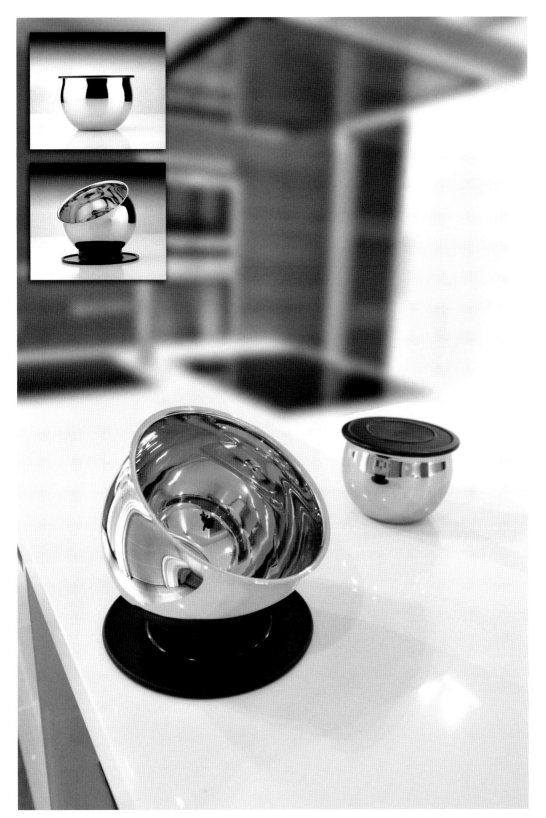

Product
Zeno
Rührschüssel
Mixing bowl

Design
Berghoff Worldwide
Frederik Aerts
Heusden-Zolder, Belgium

Manufacturer
Berghoff Worldwide
Heusden-Zolder, Belgium

Die Zeno Rührschüssel ist aus hochwertigem, hochglanzpoliertem und rostfreiem Edelstahl gefertigt. Die natürliche Kugelform ist typisch für dieses Produkt und birgt einen wichtigen Bestandteil seiner Funktionalität. Auf der Unterseite des flachen Deckels ist ein Ring eingearbeitet, der von der Außenseite nicht sichtbar ist. Legt man den Deckel umgekehrt auf die Arbeitsfläche, dient er als Fuß für die Rührschüssel. Durch die Kugelform kann die Rührschüssel in sämtliche Richtungen gedreht werden, ohne umzufallen. So können Zutaten beigegeben oder Salat sowie Snacks angerichtet werden – alle Positionen sind möglich. Die Rührschüssel kann auch perfekt für die Lebensmittelaufbewahrung geschlossen werden.

The Zeno mixing bowls are made out of mirror polished stainless steel. The natural round shape is not only typical but at the same time also functional for this product. On the inside of the flat lid there is a hollow ring which is not visible on the outside. This makes it possible to use the lid as a holder for the bowls: simply place the lid upside down on the kitchen unit, and the bowl can be placed in this holder. The round shape allows for the bowl to be turned in all positions without falling over. Mixing ingredients, presenting salads or snacks: each position is possible. The mixing bowls can perfectly be closed to store food.

Product
Zipfer Design Glas
Bierglas
Beer glass

Design
KISKA GmbH
Andrea Friedl, Jens Roeper,
Cornelius Nissen, Nils Radau
Niederalm bei Salzburg, Austria

Manufacturer
Brau Union Österreich AG
Linz, Austria

Das Zipfer-Glas ist der Beweis für die perfekte Verbindung von langer Brautradition mit dem innovativen Charakter einer Premium-Biermarke. Bei der Neugestaltung wurde auf die praktischen Anforderungen in der Gastronomie Rücksicht genommen. Außergewöhnlich ist die Querschnittsänderung im Glas, ein eckiger Sockel und runde Öffnung. Die Standfläche des Glases und das Gewicht verhindern ein zu leichtes Kippen. Die Form, mit einer Erweiterung nach oben, erleichtert das Zapfen und gibt andererseits, durch die Verjüngung nach unten, dem Schaum länger Halt. Ein entscheidender Faktor ist auch die grifffreudige Taillierung.

The Zipfer glass is an excellent illustration of the perfect bond between a long tradition of brewing and the innovative character of a premium beer brand. The new design has factored in the practical requirements of the catering industry. The change in cross section in the glass is exceptional with its angular base and round opening. The base of the glass and its weight prevent it from toppling over too easy. The form, with its opening upwards, makes pouring easier and, as it tapers downwards, also holds the head longer. A decisive factor is also its slim shape that makes it a pleasure to hold.

Product
Terraillon Maya
Backwaage
Baking scales

Design
Design Partners
Cathal Loughnane, James Lynch
Bray, Co Wicklow, Ireland

Manufacturer
Terraillon
Chatou, Cedex, France

Eine wahrhaft praktische Waage für alle, die gern zu-hause kochen, backen und Marmeladen einmachen: Maya vereint einige der wichtigsten Küchengeräte in einem. Sie ist zunächst eine Waage, enthält jedoch auch einen durchsichtigen Einsatz, der zum Abmes-sen von Zutaten verwendet werden kann, sowie eine große Schale zum Mixen mit Gummiboden für beste Stabilität. Das Design ist funktional, lässt jedoch an traditionelle Backgeräte, Puddingschalen, Kuchenfor-men usw. denken. Wir wollten einen zweckmäßigen Look erzielen, der jedoch auch an einige der grund-legenden Freuden des Lebens erinnert: Essen, Wohl-befinden und Familie.

We wanted to create a truly practical scale for people who love to cook, bake and make preserves in their home. Maya provides some of the essential tools re-quired in the kitchen. It is primarily a weighing scale, but it also includes a transparent tray which can be inverted for measuring out ingredients and a large bowl for mixing. The bowl has an integrated rubber base for stability when mixing becomes more phys-ical. The design is functional but reminiscent of trad-itional baking equipment, pudding bowls, cake tins etc. We wanted the design to look purposeful and to remind us of some basic pleasures, food, comfort and family.

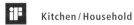
Product
Eva Trio Kite
Schneidbretter
Chopping boards

Design
Storm Design
Julie Storm
Hillerød, Denmark

Manufacturer
EVA DENMARK A/S
Maaloev, Denmark

Eine Schneidbrettserie mit einzigartigem Design. Die Bretter sind aus geölter Eiche hergestellt. Durch die Kanten an den Brettern können z. B. klein geschnittenes Gemüse oder gehackte Kräuter leicht vom Brett z. B. in einen Topf oder auf einen Teller gegeben werden. Drei Varianten sind verfügbar: quadratisch, dreieckig klein, dreieckig groß.

A series of chopping boards in a unique design. The boards are made from oiled oak. The rims of the boards make it easy to move e. g. chopped vegetables or herbs from the board e. g. to a pot or plate. Available in three sizes: square, triangle small, triangle large.

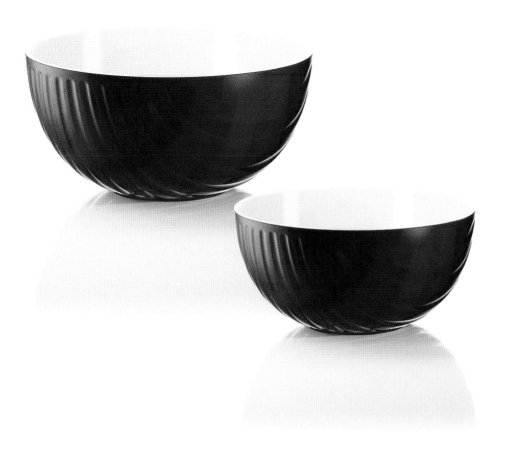

Product
Mirage
Schüssel
Salad bowl

Design
Nichetto & Partners s. a. s.
Luca Nichetto
Porto Marghera, Venezia, Italy

Manufacturer
FRATELLI GUZZINI S. p. A.
Recanati, Italy

Mirage, von dem venezianischen Designer Luca Nichetto entworfen, ist eine zum Servieren bestimmte Kollektion. Aus wertvollem Acryl realisiert, ist sie durch die Transparenz des Glases gekennzeichnet, aber auch durch das Spiel von Nuancen, die eine optische Bewegung schaffen. Leicht erhobene Wellen auf der Oberfläche rufen ein interessantes taktiles Erlebnis hervor. Dank ihrer runden Form und ihrer Tiefe sind die beiden Schüsseln – mit einem Durchmesser von 20 cm bzw. 25 cm – sehr geräumig. Sie sind zweifarbig (innen weiß, außen farbig). Die neue Kollektion umfasst auch ein Salatset, ein Salatbesteck und einen Brotkorb.

The Mirage range by Venetian designer Luca Nichetto, is a collection made of acrylic material dedicated to serving food. It resembles the transparency of glass due to an ensemble of shades that create a visual movement, while the tactile sensations enhance the product surface. The two bowls of 20 and 25 cm in diameter are perfect for serving due to their rounded forms and depth. The Mirage range is characterised by intense shades that gradually become lighter creating a selection of multiple tones. The collection also includes a salad set, salad servers and a bread basket.

Product
1893
Damaszener Messerserie
Damascus knife series

Design
Friedr. Dick GmbH & Co. KG
Deizisau, Germany

Manufacturer
Friedr. Dick GmbH & Co. KG
Deizisau, Germany

Damaszener-Messerserie 1893: Atelier-Messerserie aus feinstem Damaszenerstahl. Individualität zum Genießen. Gefertigt aus rostfreiem Stahl (FD VG 10–33) in 33 Lagen. Nicht nur die Klinge, sondern auch die Zwinge und die Endkappe sind aus feinstem Damaszener-Stahl, der mit seinem changierenden Glanz an ein Tuch aus edlem Seidendamast erinnert. Aufgrund des unterschiedlichen Metall-Verlaufs der rostfreien Stahlschichten ergibt jedes Werkstück ein Unikat. Das spezielle Material und das einzigartige Herstellungsverfahren des Griffes geben dem Messer ein besonderes haptisches Gefühl.

Damascus knife series 1893: studio knife series from the finest Damascus steel. Made from stainless steel (FD VG 10–33) in 33 layers. Not just the blade, but also the bolster clamp and the cap are made of the finest Damascus steel. The iridescent shine of the finest Damascus steel is reminiscent of a damask silk towel. In view of the varying arrangement of the stainless steel layers, every article is a unique work piece. The special materials and the inimitable manufacturing technique of the handle give the knife an exceptional haptic quality.

Product
Function 4
Kochgeschirrserie
Cooking range

Design
NOA GbR
Aachen, Germany

Manufacturer
WMF AG
Geislingen, Germany

Function 4 – das innovative und funktionale Kochge-schirr von WMF. Der rote Silikonring, der wesentlicher Bestandteil des Deckels ist, verleiht Function 4 vier unterschiedliche Ausgießöffnungen. Voll ausgießen, große oder kleine Sieböffnung sowie geschlossen. Diese Positionen sind außen auf dem Metallring des Deckels genau gekennzeichnet. Zusätzlich ermöglicht der Silikonring ein geräuschloses Aufsetzen des Deckels. Darüber hinaus sind die Function 4-Töpfe mit allen WMF-Qualitätsmerkmalen ausgestattet wie Kaltgriffe, Innenskalierung und TransTherm®-All-herdboden.

Function 4 – the innovative and functional cooking range by WMF. The red silicone ring, which is the most substantial part of the lid, gives Function 4 its four individual pour characteristics. The lid can be set to allow free pouring, to reveal small or large open-ings or to close the spout completely. The functions are displayed clearly on top of the metal ring. Ad-ditionally the lid can be placed on the pot silently. Further the Function 4-pots entail all WMF quality features such as, cool touch handles, an index scale and the TransTherm®-bottom.

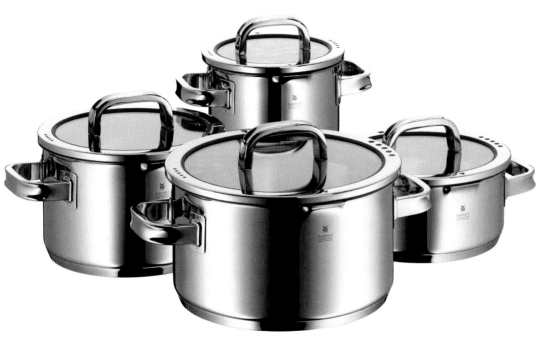

Product
miniMAX®
Kochgeschirrserien
Cookware series

Design
TEAMS Design GmbH
Esslingen, Germany

Manufacturer
Silit-Werke GmbH & Co. KG
Riedlingen, Germany

– Die kleinen Großen in den Farben: „Energy Red",
 „Crazy Yellow", „Wild Orange", „Lemon Green"
 und „Silargan® Black"
– Stapelbar
– Farbe und intelligente Technik für den kleinsten
 Raum
– Nickelfrei, antibakteriell, geschmacksneutral – zum
 schonenden Kochen, Servieren und Aufbewahren
– Luftdichte Aufbewahrung mit dem Silit-Aroma-
 deckel
– Hitzebeständiger Glasdeckel mit hochwertiger Edel-
 stahleinfassung
– Ideal zum wasser- und energiesparenden Sicht-
 kochen
– Glanzbeständige hygienische Oberfläche – pflege-
 leicht und spülmaschinenfest
– Garantiert geeignet für alle Herdarten, einschließ-
 lich Induktion
– Made in Germany.

– The compact giants in "Energy Red", "Crazy Yel-
 low", "Wild Orange", "Lemon Green" and "Silargan®
 Black"
– Stackable
– Color and intelligent design for exceptionally small
 spaces
– Nickel-free and anti-bacterial – for gentle cooking,
 serving and storing
– Silit aroma lid permits air-tight storage of foods
– Full-view lid with high-quality stainless steel rim
– Ideal for water-reduced, energy-saving full-view
 cooking
– Smooth and hygienic surface – easy to clean and
 dishwasher-proof
– Guaranteed to be suitable for all types of stoves,
 including induction
– Made in Germany.

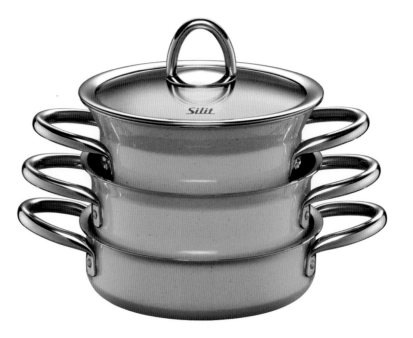

Product
MakeEdge®
Schleifgerät zur Wartung von Messern
Honer for maintenance of knives

Design
Ideas-Denmark
Henrik Casper
Brondby, Denmark

Manufacturer
Ideas-Denmark
Brondby, Denmark

MakeEdge® ist ein einzigartiges Messer-Wartungsgerät – innovativ, gründlich getestet und revolutionär genug für eine Patentanmeldung. Die Einstellung zum Schleifen wird von Grund auf verändert. MakeEdge® dient dem täglichen Feinschliff, NICHT dem Wetzen. Es soll den Wetzstahl ersetzen: Keramische, auf einen Klickaufsatz montierte Steine – dieses kleine, flexible Gerät ist in jedes vom Kunden gewünschte Design und Material integrierbar. Es kann als Hand-, Tisch- und Wandschleifgerät oder als Teil eines anderen Produkts (Schneidebrett, Messerblock) eingesetzt werden. Lassen Sie sich von den Bildern inspirieren.

MakeEdge® is a unique knife maintenance gizmo – innovative, thoroughly tested and unique enough to be a patent pending invention. A whole new way of thinking when it comes to honing in combination with design. MakeEdge® is for everyday honing NOT sharpening. It is a kitchen tool meant to replace the sharpening steel. MakeEdge® is a mechanism built of a set of ceramic stones that are mounted on a click-in unit. Small, flexible and easy to incorporate in any design and material customers may desire. Examples include a handheld honer, a tabletop or a wall-mounted honer or as a part of another product (cutting board/knife block). See picture for inspiration.

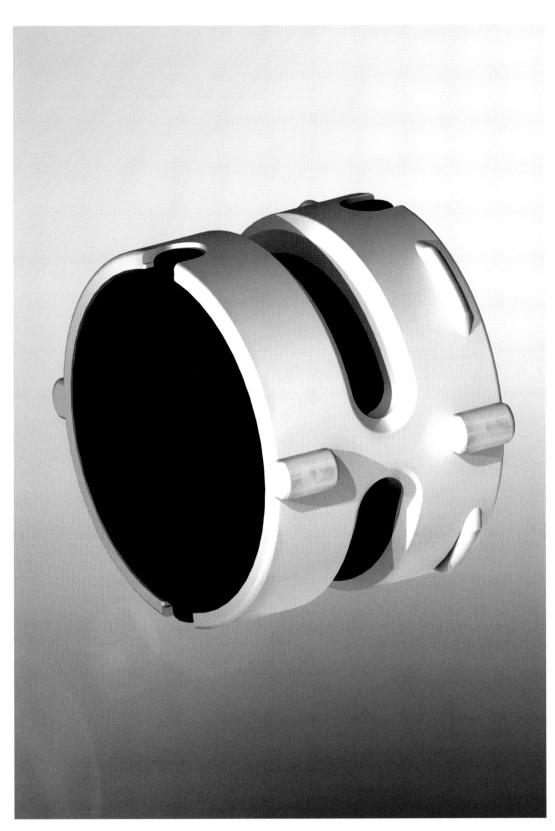

Product
LATTE MACCHIATO
Spezialglas
Special glass

Design
RASTAL GmbH & Co. KG
Carsten Kehrein, Dr. Steffen Schwarz
Höhr-Grenzhausen, Germany

Manufacturer
RASTAL GmbH & Co. KG
Höhr-Grenzhausen, Germany

Form folgt Funktion – bei dem Spezialglas für Latte Macchiato ist dies ein Muss, denn was wäre der italienische Kaffeeklassiker ohne die dekorative Trennung von Milch, Espresso und Milchschaum. Kennzeichnend für das innovative Spezialglas ist die verstärkte Glaswandung der Griffzone. Sie verlangsamt nachweislich die Abkühlung des Getränks und das Vermischen der Schichten. Dieser Effekt wird zusätzlich durch einen innenliegenden Absatz optimiert, der gleichzeitig ein sicheres Stapeln von besonders vielen Gläsern ermöglicht. Das Design wurde in Zusammenarbeit mit dem Kaffeespezialisten Dr. Steffen Schwarz entwickelt.

Form follows function – for this special latte macchiato glass, a must. Because the Italian coffee classic is unimaginable without the decorative separation of milk, espresso and frothed milk. The characteristic feature of the innovative design is the thickened wall in the holding area of the glass. This demonstrably retards the cooling of the beverage and the intermingling of the layered contents. This effect is further optimized by an inner ledge which additionally allows secure stacking of an exceptionally large number of glasses. The design was developed in cooperation with the coffee specialist Dr. Steffen Schwarz.

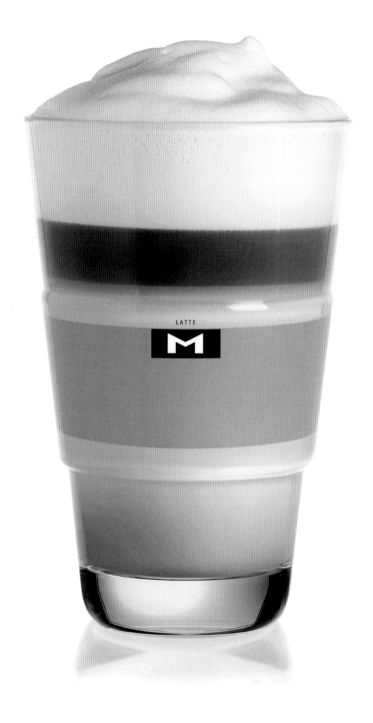

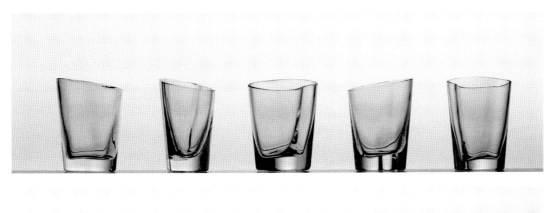

Product
happycell
Gläser
Glass tumblers

Design
Demirden Design
Nil Deniz
Istanbul, Turkey

Manufacturer
ILIO
Istanbul, Turkey

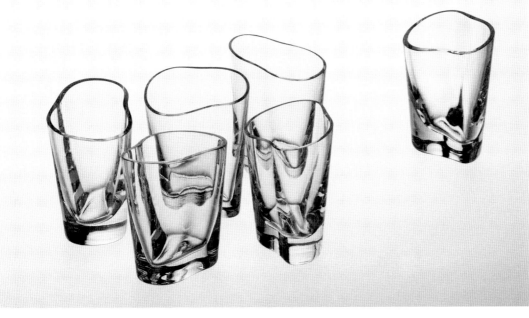

Zunehmender Individualismus verdrängt die Bedeutung wertvoller mit anderen Menschen zu teilender Momente. Geselliges Beisammensein steht hinter der Konzeption von happycell. Die vier unterschiedlichen Größen ergänzen sich gegenseitig und haben eigene Merkmale. Das Schnapsglas wirkt lustvoll, das Whiskeyglas hingegen gediegen. Die formlos handgefertigte Kristallform und die winkligen Schliffe wecken Illusionen: Bei geändertem Blickwinkel bekommt jedes Glas ein verändertes Aussehen. Jede Berührung führt zu neuem Erlebnis – eine Entdeckung der persönlichen Verbindung mit dem Produkt.

With our ever more individualistic lives we tend to forget the beauty of sharing precious moments. Just the way people get together, happycells congregate thus becoming more meaningful and adding joy to our lives. The four sizes complement each other with their own traits. The shot glass is a joyful character while the whiskey glass has a more dignified look. Their amorphous handmade crystalline shapes and angular cuts seem to be an illusion: each glass takes on a different look when viewed from different angles. With every touch, they bring a new experience – a discovery of one's own ergonomic bonds with the product.

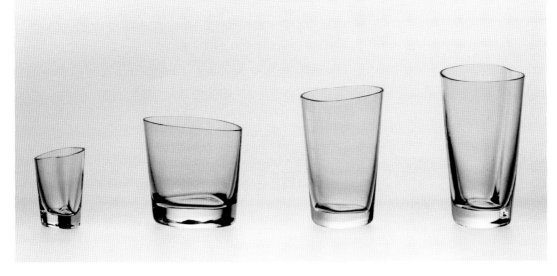

Product
Pan guard
Pfannenuntersetzer aus Silikon
Silicone pan guard

Design
Kuhn Rikon AG
Philipp Beyeler
Rikon, Switzerland

Manufacturer
Kuhn Rikon AG
Rikon, Switzerland

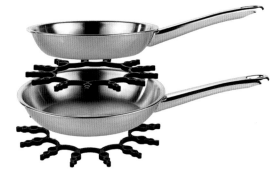

Dieser flexible und hitzebeständige Untersetzer für heiße Töpfe, Pfannen, Gratinformen und Schüsseln kann auf zwei Größen gefaltet werden: auf einen Durchmesser von 150 oder 260 mm. Damit passt er sich praktisch allen gängigen Pfannengrößen an. Zudem kann er als kratzsicherer Aufbewahrungsschutz für Bratpfannen eingesetzt werden. Und er schützt den Tisch nicht nur, er setzt auch fröhliche Akzente.

This flexible and heat resistant table mat for hot pots, pans, gratin moulds and bowls can be folded into two sizes: to a diameter of 150 or 260 mm. It therefore covers practically all standard pan sizes. In addition, it can also be used as a scratch-proof storage protection for frying pans. And it not only protects the table, but also sets cheerful accents. The table mat is dishwasher safe.

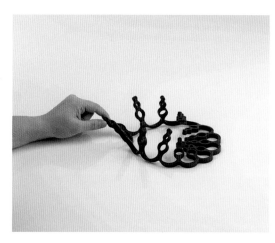

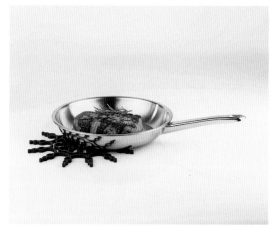

Product
Shaker-Ball
Cocktailshaker
Cocktail shaker

Design
Roberto Giacomucci
Ancona, Italy

Manufacturer
Magppie Retail Ltd.
Delhi, India

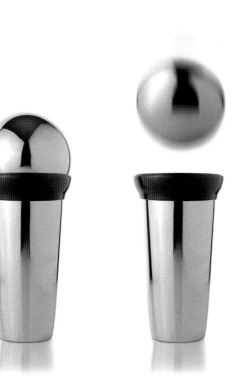

Der Shaker-Ball erfindet den Cocktailshaker neu. Das technisch und typologisch innovative Gefäß hat die Form einer ergonomischen, einfach zu bedienenden Kugel aus Stahl. Hauptmerkmal des Shaker-Ball ist das präzise ausgewogenes Design – ein Ausgleich zwischen der rigorosen Geometrie des Behälters und dem weichen Erscheinungsbild, das den Ball dominiert und durch das er sich gleichzeitig angenehm anfassen lässt. Entwickelt für alle Liebhaber der Cocktailzubereitung, vor allem für Barkeeper, die gerne einmal ein bisschen angeben.

The Shaker Ball is a new concept of the cocktail shaker. The closure is innovative, technological and typological, created by a sphere of steel, which is ergonomic and easy to use. The essential feature of Shaker Ball is achieved through a precise balance of design, which is modulated between the rigorous geometry of the container and the soft image of the ball that dominates it while also making it pleasant to grip. Designed for all those who love to prepare cocktails, particularly for bartenders who wish to show off.

Product
Soyamilk Brewer
Haushaltsgerät
Home appliance

Design
U10 Inc.
G Liu, Jo Chen
U10 Team
Taipei, Taiwan

Manufacturer
Hang Zhou Onondo Appliances Inc. by Joyoung
Hang Zhou, China

Dieser Sojamilchbereiter der chinesischen Marke Onondo überzeugt durch sein innovatives Design. Als Inspirationsquelle dienten Architekturelemente gotischer und romanischer Schlösser.

An innovative soy milk maker designed for a Chinese based brand called Onondo. Inspired by the architecture of Romanesque and Gothic castles.

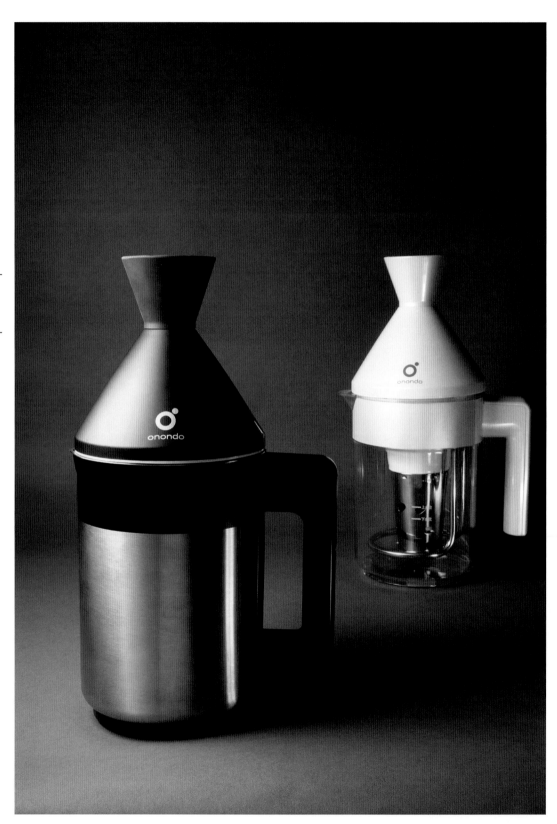

Product
White Edition
Einbaugeräteserie
Built-in range

Design
Robert Bosch Hausgeräte GmbH
Robert Sachon, Alexander Marsch,
Christoph Ortmann, Ulrich Goss, Bernd Kretschmer,
Florian Metz, Christiane Bausback
München, Germany

Manufacturer
Robert Bosch Hausgeräte GmbH
München, Germany

Wo Edelstahl als Material eher Professionalität zum Ausdruck bringt, will die weiße Produktfamilie mit Glasoberflächen bewusst Leichtigkeit und Wohnlichkeit vermitteln. Die umfangreiche Produktpalette genügt jedoch nicht nur ästhetischen, sondern auch professionellen Ansprüchen. Der Einsatz hochwertiger optischer Gläser und mehrlagiger Drucke führt zu einem stimmigen, charaktervollen Weiß-Eindruck. Die reduzierte Bediengrafik der Touchsensoren steht im spannungsvollen Kontrast zu den gezielt gesetzten Materialakzenten der Drehwähler und Griffe. Das durch klare Gliederung ebenso markante wie intuitive User-Interface prägt das Gesicht der Linie.

Whereas the material stainless steel expresses professionalism, the white series with its glass surfaces intentionally conveys a sense of airiness and living ambience. The extensive model spectrum nonetheless fulfils both aesthetical and professional requirements. The use of high quality optical glass and multilayer prints evokes a harmonious white impression, full of character. The minimalist control graphics on the touch sensors creates an exciting contrast to the deliberate material accents of the rotary controls and handles. The range look is characterised by the user interface with its clear design which is at once iconic and intuitive.

Product
26701 / 26703 / 26704
Opus Thermoskanne
Opus thermos jug

Design
Rosendahl A/S
Ole Palsby
Hørsholm, Denmark

Manufacturer
Rosendahl A/S
Hørsholm, Denmark

Dänemarks international bekannte Designer-Ikone Ole Palsby kreierte eine völlig neue, kompromisslose Thermoskanne. Der funktionale Stil der Kanne verstärkt die Aussage: „Ich bin für den Kaffee gemacht – für nichts anderes." Ein runder Verschluss, der in der perfekten Höhe liegt und den Augen schmeichelt. Der Ausguss ist klassisch und steht für den Charakter dieses Produkts, das kaum tropft. Der relativ kleine Henkel ist perfekt proportioniert – und doch ist er so groß, dass er für einen sicheren Griff sorgt. Die „soft" Oberfläche in blau, grau oder schwarz kann nur als schmeichelnder Mantel beschrieben werden. Ole Palsby's einfache, funktionelle Innovation für die „Opus Linie".

Denmark's internationally acclaimed iconic designer Ole Palsby has created a completely no-fuss jug. Its clean, confident styling almost radiates the message: "I am for coffee and that's it". It has a round stopper that protrudes at just the right height above the large opening and the spout is classic and characteristic of the kind of spout that drips the least. The relatively small handle is well proportioned in relation to the jug and yet sufficiently large to provide a good grip. The soft coated surface in blue, grey or black could almost be described as a velvet coating suit. Ole Palsby's simple, functionalist innovation for the "Opus range".

Product
Cutlery Series
Besteck
Cutlery

Design
JASPER MORRISON Ltd.
London, United Kingdom

Manufacturer
Ryohin Keikaku Co., Ltd.
Tokyo, Japan

Obwohl das Design des neuen Muji-Bestecks auf archetypische, über hundert Jahre alte Besteckformen zurückgreift, wirkt es durch raffiniertes Umarbeiten einzelner Partien und Profile dennoch modern. Es ist für den Alltagsgebrauch geeignet, aber auch fein genug für förmliche Anlässe und Restaurants. Mit seiner unauffälligen Form passt es in jede Umgebung.

The design of the new Muji cutlery can be described as a revisiting of an archetypal form of cutlery which has been in existence for more than a hundred years, and at the same time a subtle reworking of sections and profiles to give it a modern edge. At the same time, it is suitable for everyday use and refined enough for more formal occasions or restaurant use. Its discrete form allows it to be "at home" in any atmosphere.

Product
Eva Solo Dishcloth
Spültuch
Dishcloth

Design
Tools Design
Henrik Holbæk, Claus Jensen
Copenhagen, Denmark

Manufacturer
EVA DENMARK A/S
Maaloev, Denmark

Trennen Sie sich von Ihrem alten Spültuch, das feucht und zusammengeknüllt auf dem Küchentisch liegt. Ein Spültuch muss nach Gebrauch trocknen können, sonst ist es schnell voller Bakterien und riecht unangenehm. Das Eva Solo Spültuch entfaltet sich nach Gebrauch und bleibt sogar stehen, während es trocknet. Mit seiner Oberfläche aus Mikrofaser und einem Kern aus absorbierendem Schaumstoff ist das Eva Solo Spültuch ein wirkungsvolles, hygienisches Hilfsmittel, das einen Platz neben der Spüle verdient. Der beiliegende Halter ist aus matt poliertem Edelstahl.

Say goodbye to your old dishcloth that is lying in a soggy lump next to the sink. A dishcloth must be able to dry after use, otherwise bacteria and odours quickly begin to develop. The Eva Solo dishcloth is designed to unfold after use and even remains standing as it dries. With its microfiber outer shell and core of absorbent foam, the Eva Solo dishcloth is an effective and hygienic tool that deserves a place of honor at any kitchen sink. The accompanying stand is manufactured in matt polished stainless steel.

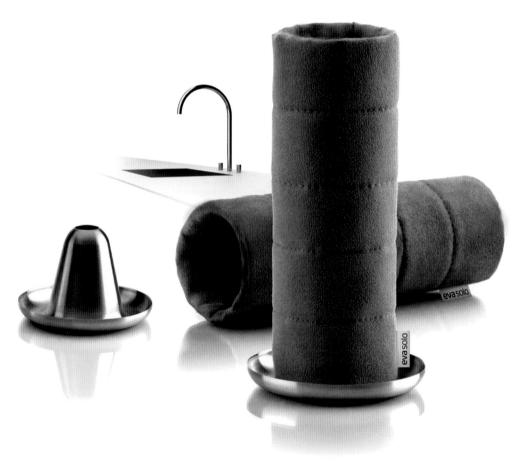

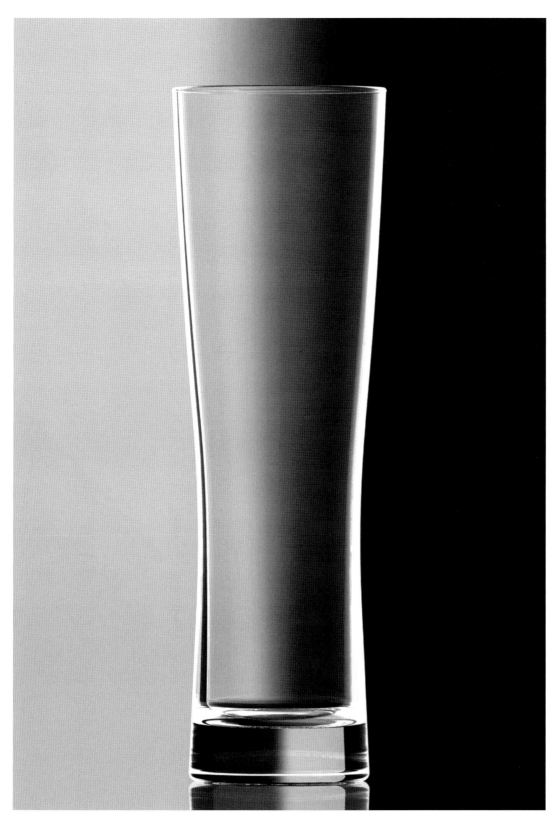

Product
Monterey
Becher
Tumbler

Design
Prof. Michael Boehm
Berlin, Germany

Manufacturer
Sahm GmbH & Co. KG
Höhr-Grenzhausen, Germany

Seit 1900 entwirft und entwickelt Sahm Gläser für die Getränkeindustrie. Mit dem Monterey Becher entstand ein weiteres modernes und zugleich anmutiges Trinkgefäß, das mit seiner ansprechenden Gestaltung vielfältig verwendet werden kann und sich nicht unbedingt auf eine Getränkeart festlegen lässt.

Sahm has been developing and designing glasses for the beverage industry since 1900. With the Monterey tumbler, the company has created another modern, but nonetheless graceful drinking glass, whose attractive design lends itself to a broad range of purposes, resisting any attempts at tying it to a particular type of beverage.

Product
HB26D552, HB36D572, HB86P572, TK76K572
Einbau-Gerätesystem
Built-in system

Design
Siemens Electrogeräte GmbH
Gerd E. Wilsdorf, Frank Rieser, Martin Müller
München, Germany

Manufacturer
Siemens Electrogeräte GmbH
München, Germany

Einbau-Dampfgarer HB26D552, Einbau-Dampfback-
ofen HB36D572, Einbau-Mikrokombibackofen HB-
86P572 und Einbau-Kaffeevollautomat TK76K572 –
ein neues Einbaugeräteprogramm in Edelstahl. Das
Kompaktgeräteprogramm ermöglicht eine optimale
Kundenindividualisierung und bietet ein klares, prä-
gendes und innovatives Designkonzept, wegweisend
im Bereich der Hausgeräte. Neu entwickeltes Bedien-
konzept mit neuem Grafikdisplay und Klartext-Benut-
zerführung.

Built-in steamer HB26D552, built-in steam-oven HB-
36D572, built-in microwave-combination-oven HB-
86P572 and built-in fully automatic coffee machine
TK76K572. A new range of built-in appliances in
stainless-steel. These compact units leave room for
customization and feature a clear and innovative
design concept that sets new trends in kitchen ap-
pliances. New developed operating concept with
new white-on-black graphic display, a menu-driven
interface.

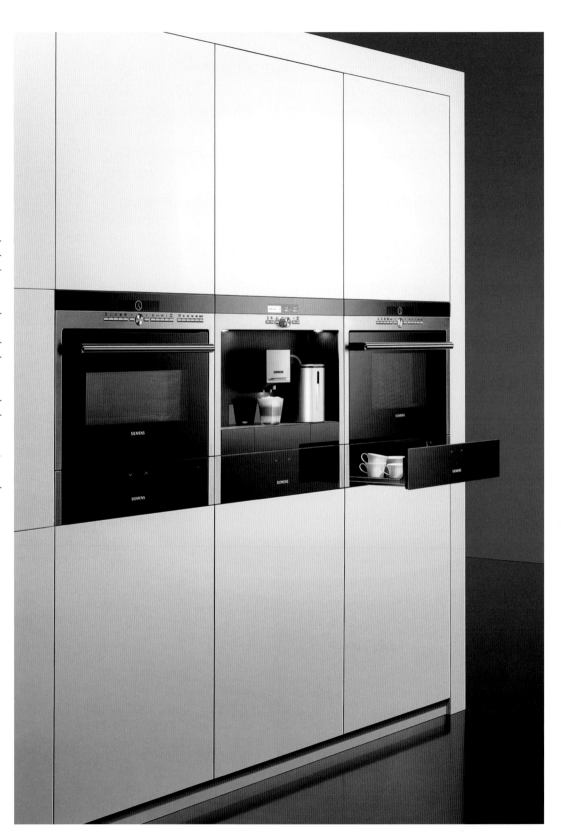

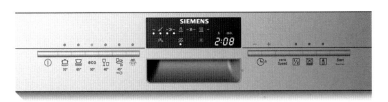

Product
"light control"
Bedienkonzept für Einbaugeräte
Concept for controlling built-in appliances

Design
Siemens Electrogeräte GmbH
Design Team
München, Germany

Manufacturer
Siemens Electrogeräte GmbH
München, Germany

Siemens „lightControl" ist ein durchgängiges Konzept zur Bedienung der Einbaugeräte.
Die Geräte besitzen eine einheitliche Bedienlogik. Die markante Gestaltung der Anzeige- und Bedienelemente hat einen hohen Wiedererkennungswert. Der Hauptschalter befindet sich immer links außen und die Start-Taste immer rechts außen. Der Bedienablauf erfolgt in Leserichtung. „lightControl" zeichnet sich darüber hinaus durch eine eindeutige Trennung von Bedienung (unten), Quittierung in Lichtfarbe Blau und Anzeige (oben) in der Lichtfarbe Weiß aus.

Siemens "lightControl" is a comprehensive concept for controlling built-in appliances.
The devices feature a uniform operating logic. Thanks to the distinctive design of the display and control elements, they have a high recognition value. The main switch is always located on the outside left and the start button always on the outside right. The operating sequence is in reading order. "lightControl" also features a clear separation between the controls (bottom), confirmations in the light color blue and the display (top) in the light color white.

Product
GrateCut®
Raspelreibe und Hobelreibe
Grater and shredder

Design
TEAMS Design GmbH
Esslingen, Germany

Manufacturer
Silit-Werke GmbH & Co. KG
Riedlingen, Germany

- Edelstahl / Kunststoff
- Durch spezielles Verfahren hergestellte Reibfläche
 – extrem scharf
- Das Schneidgut wird hauchdünn geschnitten und
 nicht gerissen
- Vitamine bleiben erhalten
- Ohne Anstrengung wird weiches und hartes
 Schneidgut geschnitten
- Nichts verstopft und verklebt
- Verschleißfrei
- Ergonomisch gestalteter Sicherheitsgriff mit Dau-
 menmulde
- Raspelreibe: ideal für Ingwer, Knoblauch, Schoko-
 lade, Äpfel
- Hobelreibe: ideal für Schokolade, Hartkäse, Ge-
 müse
- Mit integriertem Reibeguthalter
- Sichere Aufbewahrung durch Kunststoffschutz
- Spülmaschinengeeignet.

- Stainless steel / plastic
- Specially manufactured grating and shredding sur-
 face – extremely sharp
- Wafer-thin cutting rather than tearing to preserve
 vitamins
- Cuts soft and hard foodstuffs – no sticking, no
 clogging
- Wear-resistant
- Ergonomically designed safety handle with thumb
 groove
- Grater: ideal for ginger, garlic, chocolate, apples
- Shredder: ideal for chocolate, hard cheese, vege-
 tables
- With integrated grip to fixate foodstuff
- Plastic protective cover ensures safe storage
- Suitable for dishwasher.

Product
Tempera®
Haftfrei-Pfanne
Non-stick pan

Design
Silit-Werke GmbH & Co. KG
Riedlingen, Germany

Manufacturer
Silit-Werke GmbH & Co. KG
Riedlingen, Germany

Erleben Sie mit Tempera® ein völlig neues und gesundes Bratvergnügen. Mit der CeraProtect®-Hartversiegelung eröffnet Silit ein neues spektakuläres Kapitel in der Pfannentechnologie. Das Ergebnis ist ein Feuerwerk ungeahnter Fähigkeiten: kein Anhaften, minimaler Fettbedarf, ein faszinierender Abperleffekt und eine fast unglaubliche Temperaturbeständigkeit bis 400 °C. Die Silit CeraProtect®-Hartversiegelung wurde auf der Basis feinster ultraharter mineralischer Bestandteile entwickelt. Sie ist damit so hart und abriebfest, dass sie auch stärkste Beanspruchungen verkraftet.

Enter Tempera® – the completely new, healthful frying experience. With CeraProtect® hard coating, Silit has started a spectacular new chapter in the history of cookware technology. The result is a firework with remarkable features: no sticking, requires nearly no fat, a fascinating beading effect and almost unbelievable temperature resistance up to 400 °C. Silit's CeraProtect® hard coating was developed on the basis of finest, ultra-hard mineral components which make it so hard and abrasion-resistant that it can take enormous wear and tear.

Product
Competence®
Kochgeschirrserie
Cookware series

Design
TEAMS Design GmbH
Esslingen, Germany

Manufacturer
Silit-Werke GmbH & Co. KG
Riedlingen, Germany

- Edelstahl Rostfrei 18/10
- Robuste Profi-Qualität mit edler Oberfläche
- Erstklassige Verarbeitung und perfekte Funktion
- Stabile und ergonomische Edelstahl-Griffe mit wärmeisolierenden Eigenschaften
- Aufliegedeckel in schwerer Ausführung – sitzt sicher und fest
- Ideal für wasserarmes Garen
- Breit ausgestellter Schüttrand
- Praktisch bis ins Detail: mit Innenskalierung
- Rundum verkapselter „Silitherm-Allherdboden" für alle Herdarten, inklusive Induktion, verteilt die Wärme gleichmäßig und speichert sie lange
- Pflegeleicht und spülmaschinenfest
- Made in Germany.

- 18/10 stainless steel
- Robust professional quality with elegant surface – first-class craftsmanship and perfect functionality
- Stable, ergonomic stainless-steel handles with heat-insulated features
- Extra-sturdy lay-on-lid – fits firmly and snugly
- Ideal for water-reduced cooking
- Wide rounded pouring rim
- Practical down to the last detail – with interior measuring scale
- Encapsulated "Silitherm universal base" – suitable for all types of stoves, including induction, distributes heat evenly and stores it for a long time
- Easy to clean and dishwasher-proof
- Made in Germany.

Product
OXO Good Grips 360 Travel Mug
Reisebecher
Travel mug

Design
Smart Design
Peter Michaelian, Erica Eden, Eric Freitag
New York, NY, United States of America

Manufacturer
OXO International
New York, NY, United States of America

Das Design-Team konzentrierte sich auf eine Reihe von Verbesserungen in der Erweiterung des OXO-Reisebechers einschließlich Ein-Hand-Funktionalität, Benutzerfreundlichkeit und eine verbesserte Reinigung. Die 360°-Öffnung rund um die Lippe der Tasse ermöglicht das Trinken aus jeder Richtung, was vor allem während der Fahrt vorteilhaft ist. Der Becher hat drei Silikon-Dichtungen, um sicherzustellen, dass nichts ausläuft. Außerdem verfügt er über eine Doppelwand zur Verbesserung der thermischen Speicherung, was vor allem für heiße Getränke wichtig ist. Ein einfacher „Klick" zum Öffnen reicht, um einen Schluck zu trinken oder ein Überschwappen zu verhindern. Ein weicher anti-rutsch Griff gibt einen sicheren Halt während des Gehens und der konisch geformte Becher passt in die verschiedensten Auto-Becherhalter.

The design team focused on a series of improvements in the extension of the OXO Travel mug line including one-handed functionality, ease-of-use, and improved cleaning. The 360° opening around the lip of the mug allows drinking from any direction, especially convenient while driving. The mug features three silicone seals to insure no spills and double wall construction to improve thermal retention, keeping beverages hotter longer. Click to open and click to seal from a simple button for easy sipping and no spilling. A soft, non-slip handle provides a secure hold when on the go and the tapered mug accommodates a variety of car cup holders.

Product
Modell F
Falafel-Portionierer
Falafel portioner

Design
Tim Oelker Industrial Design
Tim Oelker
Hamburg, Germany

Manufacturer
Stöckel Söhne GmbH
Eutin, Germany

Der Falafel-Portionierer Modell F, der in drei Größen erhältlich ist, nimmt Kichererbsenmus auf und gewährleistet sicheres Portionieren in heißes Frittierfett. Die T-förmige Konstruktion wurde gewählt, um beim Portionieren einen möglichst großen Abstand zwischen Hand und Frittierfett sicherzustellen. Für eine optimale Reinigung ist das Gerät durch Herausschrauben des Schiebegriffs zu demontieren. Außerdem ist die Stufenbohrung des Kunststoffgriffs, der die Feder und den Auswerfer aufnimmt, durchgängig und somit spülbar. Alle Metallteile bestehen aus lebensmittelneutralem Edelstahl.

Available with three different sizes, the falafel portioner Modell F is to be filled with mush of chick peas and enables safe portioning for deep-frying. The T-shaped construction was chosen in order to ensure a large distance between hand and deep-frying oil. For optimal cleaning the falafel portioner can be disassembled by unscrewing the slider. The bore hole in the plastic handle, which contains the spring and the ejector, is end-to-end drilled, so that it can be rinsed thoroughly. All metal parts are made of food-safe stainless steel.

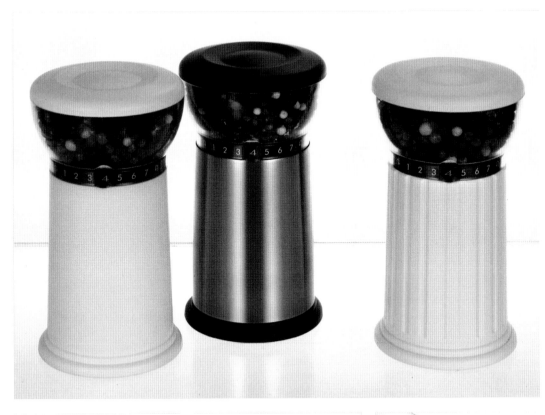

Product
PEPPERTOWERmini
Manuelle Gewürzmühle
Manual spice mill

Design
BEE DESIGN INC.
Ping-Hung Su
Taipei City, Taiwan

Manufacturer
Combat Electric Co., Ltd.
Banciao City, Taipei Country, Taiwan

Eine gewöhnliche Gewürzmühle, vereint mit außergewöhnlichem Design, wie z.B. dem automatischen Boden. Wenn die Gewürzmühle zum Mahlen gedreht wird, öffnet sich der Boden automatisch, um die gemahlenen Gewürze aus der Mühle auszugeben. Hört man auf zu drehen, schließt sich der Boden automatisch und unverzüglich, damit der Tisch sauber bleibt. Ebenso ist die Zahlenmanschette eine präzise und praktische Hilfe für die Einstellung des Mahlgrades. Das praktische Design des Gewürzbehälters ermöglicht dem Benutzer die einfache Zufüllung von Gewürzen.

An ordinary spice mill, attached with an extraordinary design concept, such as the automatic base. While twisting to grind, the base opens automatically to dispense ground spice. While stop twisting, the base shuts automatically and immediately, to keep the tabletop free of spills. Also the numeric collar is a precise and convenient control for the grinding adjustment. The practical top filling design offers an easy access for spice loading.

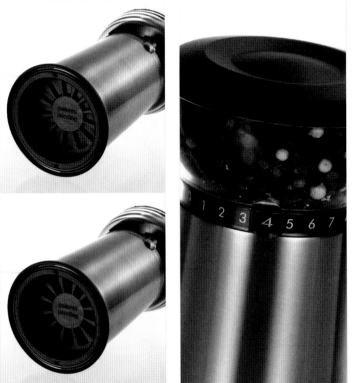

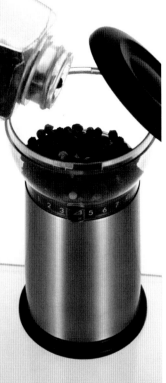

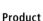

Product
Griffbereit-Serie
Küchenutensilien
Kitchen preparation tools

Design
Tupperware General Services N. V.
Vincent Jalet, Jan-Hendrik de Groote –
Tupperware Europe
Africa & Middle East Design Group
Aalst, Belgium

Manufacturer
Tupperware France S. A.
Joué-Les-Tours, France

Die Griffbereit-Serie besteht aus modernen Küchen-
helfern. Die Serie hat ergonomisch geformte, rutsch-
sichere Griffe, die höchsten Komfort sowie Sicherheit
beim Kochen bieten. Jeder Küchenhelfer kann an
einer Leiste aufgehängt werden. Die Teile dieser Serie
hinterlassen keine Kratzer in beschichteten Pfannen
und widerstehen Temperaturen von bis zu 200 °C.
Die Serie besteht aus: Servierlöffel zum Servieren von
heißen bzw. kalten Gerichten, Pfannenwender zum
Drehen und Wenden, Spachtel zum Unterheben von
geschlagener Sahne und zum Ausschaben von Teig,
Tellerbesen um Mehl unterzuziehen und zum Schla-
gen von Eiweiß und schließlich einem Greifer zum
Greifen, Halten, Drehen und Wenden.

The Kitchen preparation tools are a modern set of
kitchen utensils. They are designed with an ergo-
nomic, non-slip handle, to guarantee great comfort
and ease while preparing meals. The handles have
holes to hang the tools on a rack. The tools don't
leave any scratches on no-stick coated pans, resist
temperatures up to 200 °C and are dishwasher safe.
The range consists of a serving spoon for versatile
serving of hot or cold dishes, a spatula to flip and
turn food, a silicone spatula to mix dough, batter and
scrape out bowls, a whisk to add maximum air and
blend ingredients, and also a tong to toss and turn
almost any type of food.

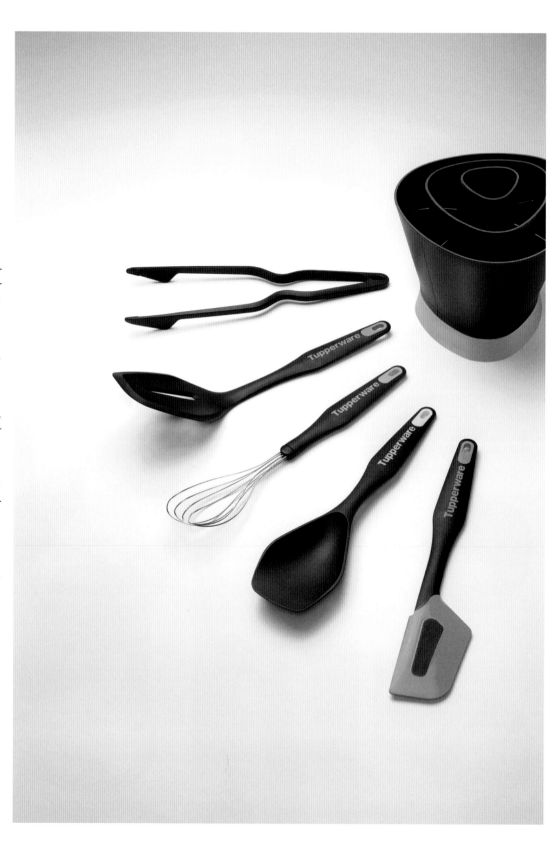

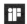

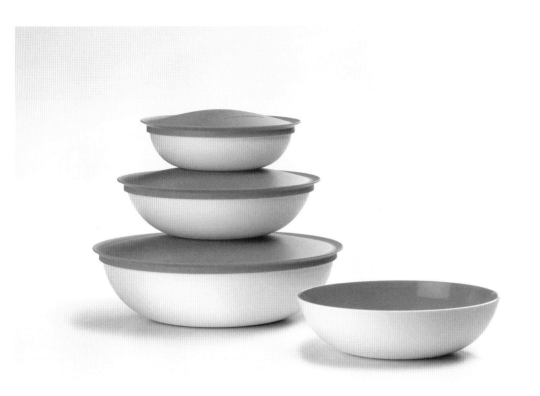

Product
Allegra Line
Servierschalen und Servierteller
Serving bowls and plates

Design
Tupperware Corporation
Doug Laib
Orlando, FL, United States of America

Manufacturer
Tupperware Belgium N. V.
Aalst, Belgium

Das klare Design der Allegra Serie besticht durch zeitgemäße Ästhetik und passt perfekt in die moderne Küche. Diese Produkt-Serie ist gekennzeichnet durch funktionale Schönheit und eignet sich ideal für das Servieren und Aufbewahren einer großen Vielfalt von Lebensmitteln. Die Allegra Serie besteht aus einer großen 3,5 l Schale, einer mittelgroßen 1,5 l Schale und vier Serviertellern. Jede Schale wird durch einen passenden wasserdichten Deckel vervollständigt. Die Schalen werden aus zwei Komponenten hergestellt: eine für den Innenraum und eine für die Außenseite. Die flüssigkeitsdichten Deckel verhindern ein Auslaufen während des Transports.

The cleanly designed Allegra Line has a modern aesthetic and meets the needs of a modern kitchen. It is a highly practical range and is perfect for everyday serving and storing of a wide range of foods. The Allegra Line consists of a large 3.5 l bowl, a medium 1.5 l bowl and four extended serving plates. Each bowl is complemented by a matching liquid tight seal. The bowls are made in two components, one for the interior and the other for the exterior. These components compliment each other in color and surface finishes. The liquid tight seals prevent any risk of spilling in transport.

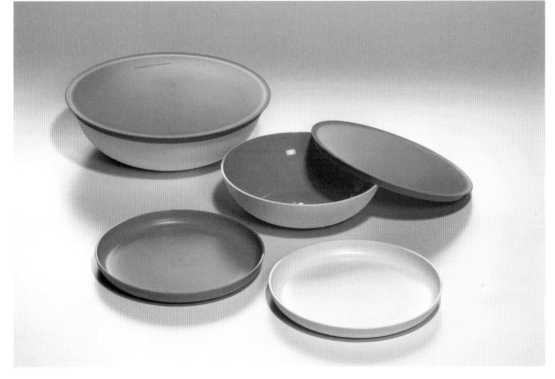

Product
4340440_443
Vasen
Vases

Design
Holmegaard A/S
Maria Kariis
Hørsholm, Denmark

Manufacturer
Holmegaard A/S
Hørsholm, Denmark

Die luxuriöse und skulpturale „2Lips" Vase, kreiert von der skandinavischen Designerin Maria Kariis, ist die neueste Blüte des einzigartigen Holmegaard Glassortiments für das Zuhause. Mit ihrem zeitgemäßen Design und ihrer originellen, inspirierenden Ausdrucksweise steht diese Vase für das bekannte Designkonzept der Skandinavier: minimalistisch, aufblühendes Leben oder in all ihrer unberührten Einfachheit als eine stilistische, pure Bodenvase. Sie wurde in zwei Größen mit transparentem blauem und grünem Glas und in Form einer nostalgischen Tulpenblüte designt. Mit oder ohne Blumenschmuck – die voluminöse und organische Proportion begeistert.

The luxurious and sculptural "2Lips" vase, designed by the scandianvian Designer Maria Kariis, is the latest bud from Holmegaard's unique assortment of glassware for the home. With its contemporary design and organically inspired idiom the vase fully expresses the very concept of Scandinavian minimalism, blossoming with life or as a stylistically pure floor sculpture in all its untouched simplicity. It has been created in two sizes and transparent glass in blue and green in a shape reminiscent of a tulip bud. With or without contents, the vase's voluminous organic proportions add to its blossoming aesthetic beauty.

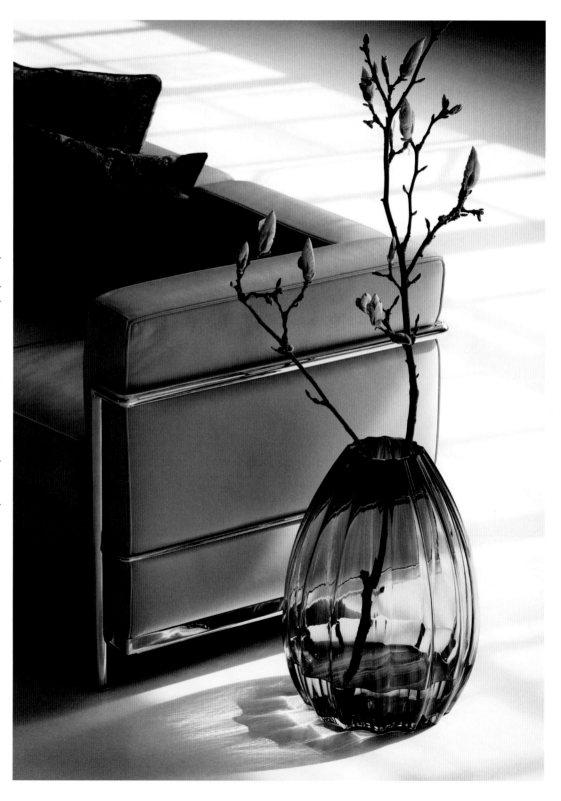

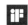

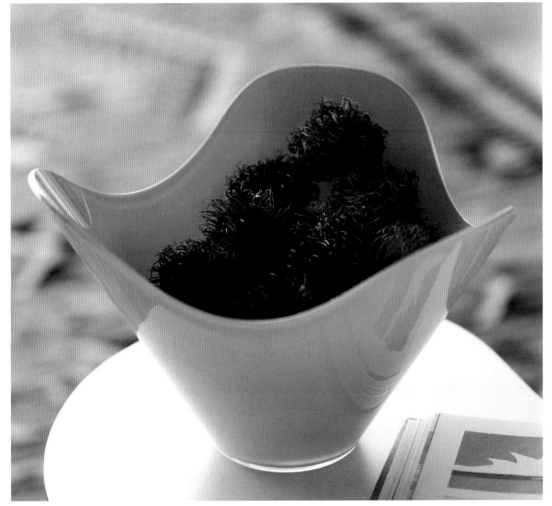

Product
4340445_447
Schale
Bowl

Design
Holmegaard A/S
Peter Svarrer
Hørsholm, Denmark

Manufacturer
Holmegaard A/S
Hørsholm, Denmark

Glaskünstler Peter Svarrer kreierte eine originelle wundervolle Schale: Devine. Mit ihrem weißen Äußeren, weichen nach aufwärts strebenden Kurven und der kraftvollen Farbtönung im Inneren, verströmt Glaskünstler Peter Svarrer's neue Divine-Schale eine raffinierte Mischung aus Purismus, Sanftheit und Strenge. Verbunden mit ihrer offenen Formgebung ist sie warm und einladend in ihrem Ausdruck, während sie Schönheit ausstrahlt – das alles in wohlproportionierter Form. Die Schale kann als feudale Obstschale benutzt werden oder man lässt sie in ihrer eleganten graphischen Schlichtheit alleine wirken – mit orangem, grünem oder schwarzem Inneren.

Glass artist Peter Svarrer has created the organically beautiful bowl: Divine. With its white exterior, soft upwardly aspiring curves and powerfully colored interior, glass artist Peter Svarrer's new Divine bowl exudes a subtle blend of purity, softness and strength. Combined with its open shape it is warm and inviting in expression, while emanating a beautiful, well proportioned sense of harmony and balance. The soft idiom is also a sophisticated supplement to the strict Scandinavian interior décor style. Use the bowl as an exclusive fruit bowl or let it stand alone in all its elegant graphic simplicity, with orange, green or black inside.

Product
Winkeltürenschrank
Easy access end unit

Design
LEICHT Küchen AG
Waldstetten, Germany

Manufacturer
LEICHT Küchen AG
Waldstetten, Germany

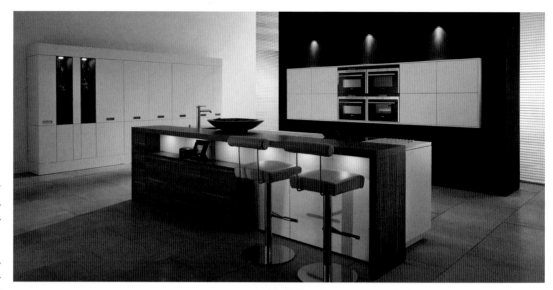

Der nur 30 cm breite Winkeltürenschrank von LEICHT
ermöglicht einen eleganten Abschluss für Schrank-
zeilen. So kann nun auch bei freistehenden, puris-
tischen Küchenplanungen die Frontoptik seitlich
fortgeführt werden. Der Sockel wird entsprechend
zurückgesetzt oder mit einer Deckenblende front-
bündig zu Gunsten einer geschlossenen Optik mon-
tiert. Die auf Gehrung verleimte Winkeltür ist an der
Rückwand angeschlagen und gibt beim Öffnen das
Schrankinnere über die gesamte Tiefe frei, so erhält
man großzügigen Eingriff trotz der schmalen Bau-
weise. Die Innenfarbe wird nach Wunsch gefertigt.
Glasfachböden erzeugen eine lichte Anmutung.

The special angled door cupboard from LEICHT, only
30 cm wide, do provide an elegant finish for the
end of cupboard runs. Now, even with freestanding,
puristic kitchen layouts, the front appearance can be
continued along the side. The plinth is either recessed
or fixed with a flush-front ceiling blender, to give a
closed appearance. The mitre glued right angled door
is hinged at the rear and on opening provides an
entrance to the total cupboard interior thus allow-
ing generous access despite the narrow construction.
The interior color is at the customer's request, with
glass shelves, creating a light and airy feel.

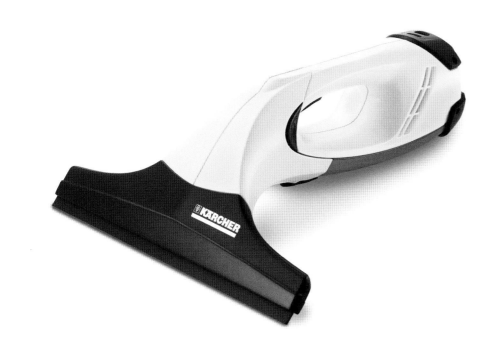

Product
WV 50
Akku-Fenstersauger
Window vac

Design
Alfred Kärcher GmbH & Co. KG
Michael Meyer
Winnenden, Germany
Pearl Creative Industrial Design
Tim Storti Christian Rummel
Ludwigsburg, Germany

Manufacturer
Alfred Kärcher GmbH & Co. KG
Winnenden, Germany

Der Akku-Fenstersauger WV 50 hilft, Glasflächen, Spiegel und andere glatte Oberflächen schneller, einfacher und gründlicher zu reinigen. Das einzigartige Gerät kombiniert eine Wasserabsaugung mit einer doppelten Abziehlippe und kommt nach dem Wischen der Fläche zum Einsatz. Heruntertropfendes Schmutzwasser wird dabei sofort von der Oberfläche abgesaugt, ohne Streifen oder Flecken zu hinterlassen. Das 700 g leichte Gerät wird mit einem Lithium-Ionen-Akku betrieben. Die Laufzeit mit einer Ladung beträgt etwa 20 Minuten – lang genug für 25 bis 30 m² oder zehn bis 15 Fenster.

The WV 50 cordless window vac helps to clean glass surfaces, mirrors and other smooth surfaces faster, more easily and more thoroughly. This unique appliance combines a water vacuum with a double squeegee and is used after the surface has been sprayed and wiped down. Dripping water is removed from the surface immediately, no streaks or spots are left. Weighing only 700 g, it is powered by a rechargeable lithium-ion battery. The running time per charge is about 20 minutes, which is sufficient to clean a surface of 25 to 30 m² or ten to 15 windows.

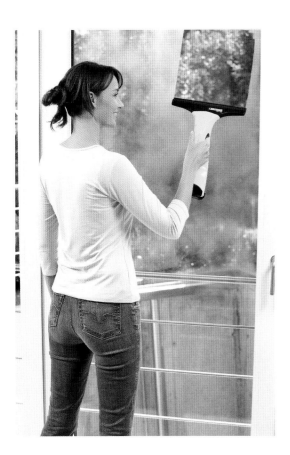

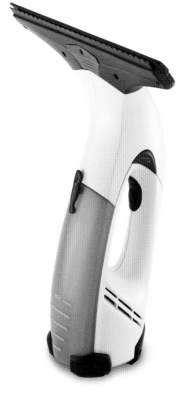

Product
VC-CX200D
Staubsauger
Vacuum cleaner

Design
Toshiba Corporation
Toshiyuki Yamanouchi
Tokyo, Japan

Manufacturer
Toshiba Home Appliances Corporation
Tokyo, Japan

Dieser umweltfreundliche Zyklonstaubsauger zeichnet sich durch leichte Bedienbarkeit und hohe Saugleistung aus. Das in der Mitte angeordnete große Rad verbessert Wendigkeit, reduziert Laufgeräusche und verhindert Beschädigung des Bodens. Ein langer Schlauch erleichtert die Reinigung an hoch gelegenen Orten. Durch einen vertikalen Luftstrom wird der Staub auf einem Netzfilter abgelagert und sammelt sich dann in den beidseitig angeordneten Staubbehältern, sodass der Luftstrom nicht beeinträchtigt wird. Im automatischen „eco-Betrieb" wird unnötiger Stromverbrauch und CO_2-Abgabe reduziert. Stilistisch bringt das große Rad den vertikalen Luftstrom zum Ausdruck. Die Form repräsentiert die Funktion. Einfache Formgestaltung bei unkonventionellem Design.

This powerful, easy-to-use, environmentally sound cyclone vacuum cleaner offers various features, including a large central spindle and improved circulation, quiet operation, design to keep floors scratch-free, and an upper hose to help clean high spots. To maintain power and aid maintenance, a downward vortex blows dust from the filter into the sides of a dust cup, where it collects; and a separate filter self-cleaning function activates when the handle is grasped. An automatic "eco mode" minimizes power consumption and thereby CO_2 emissions. A design based on the spindle and vortex airflow marks a clean break from conventional designs.

Product
Flexibin
Mülleimer
Trash can

Design
Jianye Li
Shatin, Hong Kong

Manufacturer
Jianye Li
Shatin, Hong Kong

Flexibin ist ein minimalistischer Mülleimer. Er besteht aus einem einzigen Edelstahldraht, der so gebogen ist, dass Plastik- oder Papiertüten verschiedener Größen eingehängt werden können. Die Idee ist ebenso einfach wie brillant. Der Draht ist so fest geformt, dass man die Tüten bedenkenlos daran befestigen kann; dabei ist er flexibel genug für verschiedene, auch für sehr große Tüten.

Flexibin is a minimalist trash can. Its design features a one-piece polished stainless steel wire, bent in a way to adapt to plastic/paper bags of various sizes. The idea is simple and brilliant. The wire provides enough shape to hold the bag as well as enough flexibility to accommodate different sizes of bags and even larger loads.

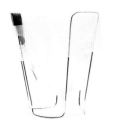

Bad und Wellness werden eins. Das Bad als traditioneller Nutzungsbaustein eines Gebäudes mit den Impulsen des gesundheitsbewussten Lebens für das Produktdesign erzeugt ein neues Ganzes, einen faszinierenden neuen Mikrokosmos, nicht nur, aber natürlich im Besonderen im Wohnbereich.

Diesmal beeindruckte die Jury nicht das eine Produkt, das alle anderen in den Schatten stellt, sondern die Breite der Anwendungen und die Qualität der Produkte, die in gutes Design umgesetzt wurden. Dies zeigt, welche Bedeutung dieser ritualisierte Lebensbereich auch bei den Herstellern und ihren Designern gewonnen hat. Dabei nähern sich die Anwendungsbereiche Wohnen und Arbeiten an. Was früher ein Produkt für den Wohnbereich war, ist heute auch im Arbeitsbereich gewünscht.

Im Blick ist dabei nicht mehr nur das Einzelprodukt, sondern das durchgängige Design ganzer Produktfamilien mit umfassender Funktionalität. Die Auseinandersetzung mit Ritualen, die sich von Kulturkreis zu Kulturkreis in ihrer Bedeutung und Ausprägung unterscheiden, haben Designer inspiriert und erzeugen im Produktangebot trotz aller bekannten globalen Vereinheitlichungen spezifische Vielfalt und erfrischende Lebendigkeit. Technologische Innovationen und die Implementation neuer Funktionalitäten allerdings waren diesmal genauso wie Lösungen für generationenübergreifendes Produktdesign nicht zu erkennen.

Bath and wellness become one. The bath as a traditional, essential component of a building with the product design impulses of a health-conscious lifestyle creates a new entity, a fascinating new microcosm – not only, but of course especially in the home.

This time around, the jury was not impressed by that one product that overshadows all others but by the range of applications and the quality of products that embodied good design. This illustrates the importance that this ritualized part of life has gained for manufacturers and their designers. Residential and commercial areas of application are starting to merge. What used to be a product for residential use is now also desirable in a commercial environment.

The focus is no longer on individual products, but on the consistent design of entire product families with comprehensive functionality. The examination of rituals, which have varying significance and characteristics from one cultural group to another, has inspired designers and resulted in specific variety and a refreshing liveliness in the product range regardless of any global standardization. However, neither innovative technologies and the implementation of new functionality nor cross-generational product design solutions were discernible this time around.

Product
Water Lounge
Duschsystem
Shower system

Design
SAMSUNG C & T
Eunhwa Lee, Hyukwoo Kwon
Seoul, South Korea
Tangerine & Partners
Dontae Lee, David Sutton
London, United Kingdom

Manufacturer
SAMSUNG C & T
Seoul, South Korea

Water Lounge ist eine Dusche, in der man sich see-lisch und körperlich wohl fühlt. Im Gegensatz zu der vorhandenen stehend genutzten Dusche ist Water Lounge für jeden geeignet. Water Lounge verfügt über eine Fußwaschwanne, in der man auch sitzend bequem duschen kann. In dieser Dusche spiegelt sich die koreanische Tradition des Fußbads mit der Kombination eines Duschbads wider, was speziell für Frauen und ältere Menschen sehr angenehm ist. Beim Duschen kann man, je nach Geschmack, mit dem eingebauten MP3-Spieler Musik genießen. Durch ver-schiedene Wassertemperaturen wird die ausstrah-lende Lichtfarbe verändert, was individuell reguliert werden kann.

Water Lounge is a renovating multi shower system that suggests a new kind of cultural identity. Water lounge has three types of shower systems; using the shower systems while standing and sitting are both possible and users can enjoy body cares and washing feet. Korean people's traditional habit of washing feet is properly adopted within the function of the shower system. And especially, it is very much convenient for women and old people. Moreover, MP3 players and speakers are installed within the shower system, so that the users can listen to the music they want. They also can feel the various change of the lighting with the different temperature of the water.

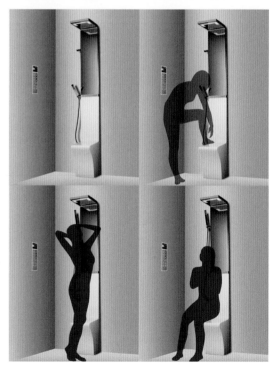

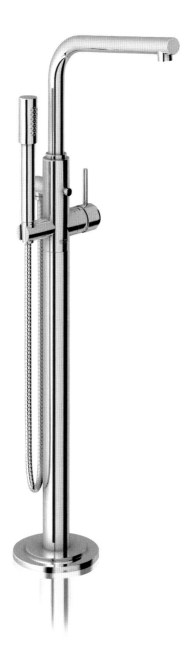

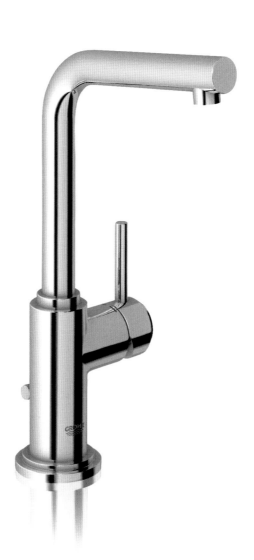

Product
Atrio 7°
Einhandmischer Kollektion
One hand mixer collection

Design
Grohe AG
In-House Design Team
Düsseldorf, Germany

Manufacturer
Grohe AG
Düsseldorf, Germany

Atrio 7° verkörpert die klare Philosophie der Bauhaus-Bewegung – die Quelle der Inspiration für die gesamte Kollektion. Die durchgängige Ästhetik wird durch die Wiederholung der Geometrie erreicht. Ein schlichter Zylinder, mit großer Sorgfalt in verschiedenen Tiefen und Durchmessern gefertigt, lässt perfekte Proportionen und eine exzellente Funktionalität entstehen. Die 7°-Neigung des Auslaufs, kennzeichnend für die gesamte Produktpalette, schafft eine kohärente Formensprache und definiert die optimale Position für den Wasserauslauf.

Atrio 7° clearly resonate the understated semantic philosophy of the Bauhaus movement, which was a source of inspiration for the collection. The consistency of the aesthetic is achieved through its repetitive geometry. A simple cylinder is extruded in varying depths and diameters with great sensitivity to ensure perfect proportions and superior functionality. The 7° inclination of the spout throughout the entire range creates a coherent semantic and defines the optimum position for the floating water.

Product
PUZZLE
Dusche
Bathroom shower

Design
Corallo Co., Ltd.
Seungjae Lee, Seungbum Kim
Seoul, South Korea

Manufacturer
Cebien Co., Ltd.
Gyeonggi-do, South Korea

PUZZLE ist als Regal gestaltet, auf dem man Shampoo, Seife und anderen Duschbedarf ablegen kann. Spiegel und Duschkopf sind bequem einstellbar; jeder kann PUZZLE in Heimarbeit leicht selbst installieren. Da Duschbäder normalerweise nicht sehr abwechslungsreich gestaltet sind, suchten wir nach neuen Ideen. So entstand PUZZLE, einzigartig und unkonventionell. Fünf Farben sind möglich: Rot, Grün, Weiß, Braun und Silber. Das unvergleichliche Farbarrangement ist eine Augenweide und schafft einen Duschplatz für alle Sinne.

PUZZLE was designed like a shelf, so users can put shampoo, soap, or anything for the shower on it. The mirror and showerhead are conveniently adjustable. Also, the Puzzle can be a D.I.Y. (Do It Yourself) item since it is easy to install. While the features of shower items are monotonous, we looked for something creative and the answer was PUZZLE which has unique and unbalanced design. Five colors are available: Red, Green, White, Brown, Silver. The unique color arrangement can be an obzee as "Happy eyes fashion item" to the bathroom. It can create a sensible shower space with specific bathroom items.

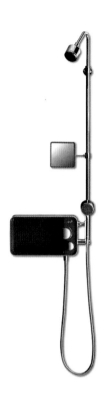

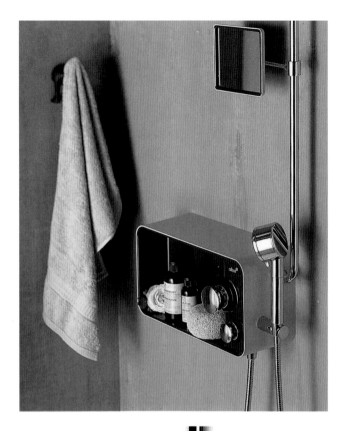

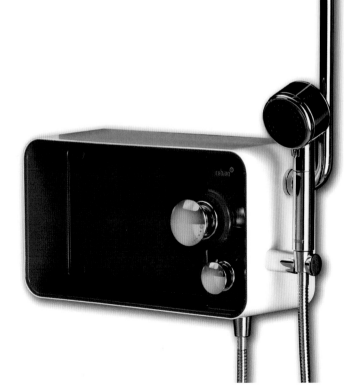

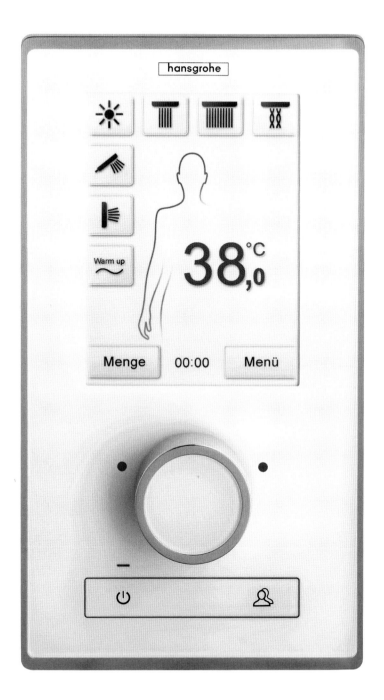

Product
Hansgrohe RainBrain
Digitale Duschsteuerung
Digital shower electronics

Design
Phoenix Design GmbH & Co. KG
Stuttgart, Germany

Manufacturer
Hansgrohe AG
Schiltach, Germany

Die Duschsteuerung Hansgrohe RainBrain bietet digitalen Bedienkomfort für vielfältige Duschfunktionen – Brausenarten, Temperatur, Licht bis hin zur musikalischen Unterhaltung, direkt übertragen vom MP3-Spieler per Bluetooth. Dank der Mineralglas-Touch-Oberfläche und großer ansprechender Symbole sind Funktionen und Multimedia-Anwendungen intuitiv bedienbar. Die weiße Oberfläche ist chromfarben gerahmt. Eine elegante Kombination, die am Drehsteller für Temperatur und Start/Stopp wieder aufgegriffen wird. Damit spiegelt das „cleane" Design das Konzept von RainBrain wider: Aus Hightech und Komplexität wird komfortabler digitaler Lifestyle.

The Hansgrohe RainBrain shower electronics offer digital operating comfort for a wide variety of shower functions – spray types, temperature and light through musical entertainment, provided directly by a MP3-player featuring Bluetooth. Due to the mineral glass touch-surface and large symbols, the functions and multimedia applications can be operated intuitively. The white surface is framed in chrome – presenting an elegant combination which is reflected by the rotary adjuster for temperature and start/stop. The clean design characterizes the concept of the RainBrain: high tech and complexity are transformed for a simple, digital lifestyle.

Product
Easy In
Duschbadewanne
Shower- and bathtub

Design
SPANNAGEL. DESIGN
Köln, Germany

Manufacturer
repaBAD GmbH
Wendlingen, Germany

Die Neukonzeption Easy In vereint Baden und Du-
schen in einem Produkt und ist somit ideal bei wenig
Platz im Bad. Sobald die Glastür der Easy In-Wanne
aufgeschoben wird, ist ein Eintritt wie in eine normale
Dusche möglich. Der dreieckige Grundriss der Wanne
bietet viel Platz im Duschbereich. Die Glasabtren-
nung bietet perfekten Spritzwasserschutz. Wird die
Tür, die elektronisch gesichert ist, geschlossen, wird
daraus eine bequeme und geräumige Badewanne.
Diese Produktinnovation ermöglichte ein äußerst in-
novatives Design: geradlinig, langlebig, ruhig und
schnörkellos. Ein zukünftiger Klassiker eben.

The newly designed Easy In combines a bath and
shower in a single product and so it is ideal for bath-
rooms with limited space. As soon as the glass door
of the Easy In bath is pushed open, you can step in
just like in a normal shower. The triangular shape of
the bath offers more space in the shower area, while
the glass partition gives you ideal splash protection.
If the electronically secured door is closed, you can
enjoy a comfortable and spacious bath. This innova-
tive product allowed us to create an extremely in-
novative design: linear, timeless, calm and unembel-
lished. Simply a classic of the future.

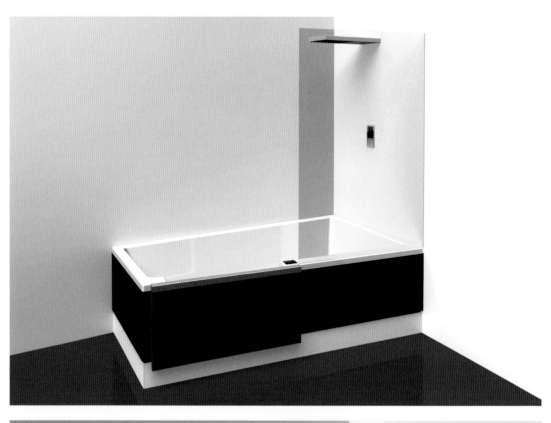

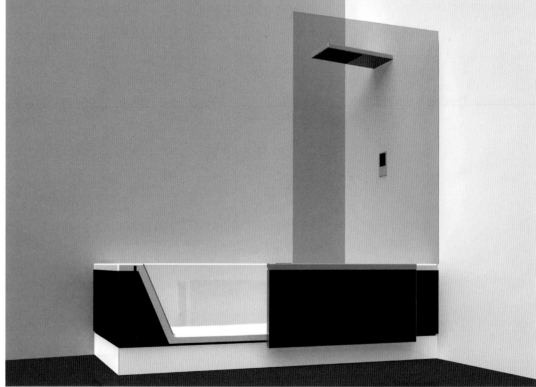

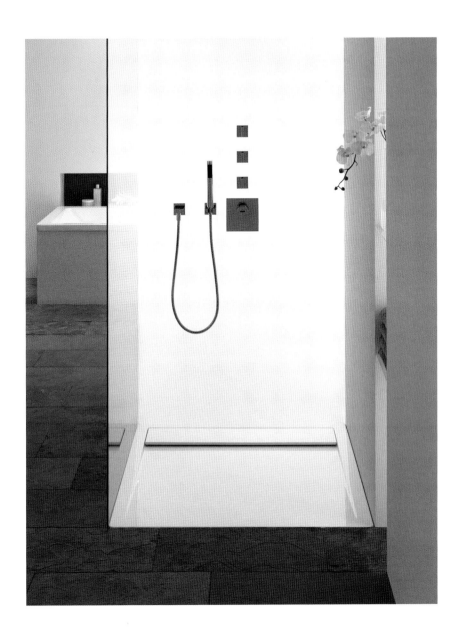

Product
LADOPLAN
Duschwanne
Shower tray

Design
Kaldewei
Werksdesign
Ahlen, Germany

Manufacturer
Kaldewei
Ahlen, Germany

Geradlinig, edel und schlicht. Mit diesen drei Begriffen lässt sich die klare Formensprache der neuen LADOPLAN präzise beschreiben. Die elegante, seitlich positionierte Ablaufabdeckung integriert sich dabei harmonisch in die Gesamtgestaltung. Der von „el lado", spanisch für „die Seite", kommende Name sagt schon alles: Diese großzügige, bodengleiche Dusche läuft ähnlich wie ein flacher Sandstrand sanft zu einer Seite hin aus und überzeugt durch ihr einfaches, durchdachtes Design.

Straight-lined, refined and sleek. These words sum up the clear formal vocabulary of the new LADOPLAN shower tray. The elegant waste cover positioned to one side is integrated harmoniously into the overall design. The name, from "el lado", Spanish for "the side", says it all: This spacious floor-level shower is like a flat beach with the water gently ebbing away at one side – a design whose appeal unites simplicity with sophistication.

Product
Overflow Collection
Badewanne mit Überlauf
Overflow bathtub

Design
KÄSCH GmbH
Werksdesign
Ismaning, Germany

Manufacturer
KÄSCH GmbH
Ismaning, Germany

Die Overflow Collection ist eine Badewannen-Serie mit einer angefügten Überlaufrinne, bei der das überlaufende Wasser durch eine spezielle Whirlpooltechnik in die Wanne zurückgeführt wird. Die Badewanne ist dadurch immer bis zur Oberkante mit Wasser gefüllt, egal ob Personen die Wanne besteigen oder verlassen. Dieser Wasserkreislauf kann auch auf Wunsch mit einem Heizsystem ausgestattet werden. Es ist dann nicht nötig, wie bei herkömmlichen Modellen, während des Bades laufend warmes Wasser nachlaufen zu lassen, das dann wieder über den Überlauf unwiederbringlich verschwindet.

Overflow Collection is a bathtub series with connected overflow channel and special whirlpool system, which returns the overflowed water from the overflow channel into the tub. This means, the bathtub is filled up to the rim regardless, no matter if people enter or leave the tub. As an option heating system can be added. Unlike conventional models, it is not necessary to refill the bath with hot water, which then disappears through the overflow drain.

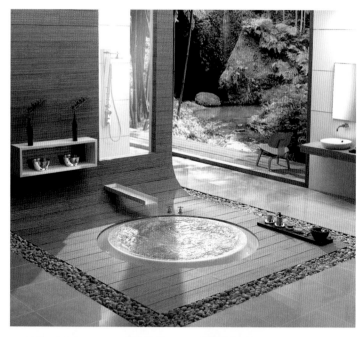

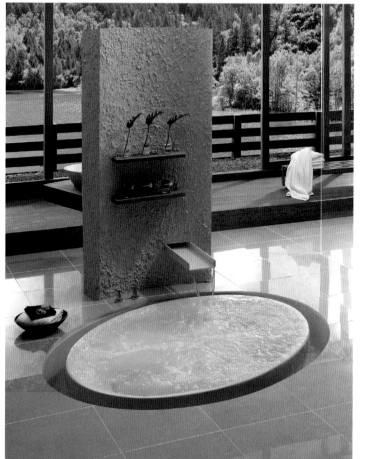

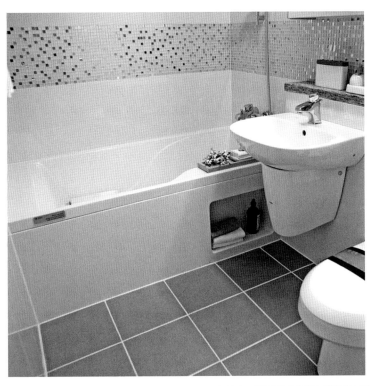

Product
Void & Projection
Badewanne
Bathtub

Design
SK Engineering & Construction
Hae-Yong Kim, Eun-Young Kim
Seoul, South Korea

Manufacturer
Samsung Fiber Ceramic
Busan, South Korea

Diese bequeme und praktische, innovative Badewanne bricht mit stereotypen Designvorstellungen. Mit ihrer Funktionsauswahl und zusätzlichem Platz für Badutensilien macht sie jedes Bad zu einem Genuss. Platz für Badeartikel findet sich vor allem an den seitlichen Wänden, die bei herkömmlichen Badewannen ungenutzt bleiben. Ein abnehmbarer Multifunktionssitz rundet gemeinsam mit einem Vorsprung für Halb- und Vollbäder das Bild ab. Diese Badewanne im neuartigen Design ist für Alt und Jung genau das Richtige.

This innovative bathtub is designed to be more convenient and practical, shedding conventional design stereotypes. The bathtub features a selection of functions and extra space to keep bathroom supplies, making it more convenient and comfortable to take a bath. In particular, the bathtub offers space for bathroom supplies on the sides, which was unused on conventional bathtubs, as well as a detachable multi-function seat and a projection for both a half-body and whole-body bath. With an enhanced design, the bathtub is ideal for anyone from children to elderly people.

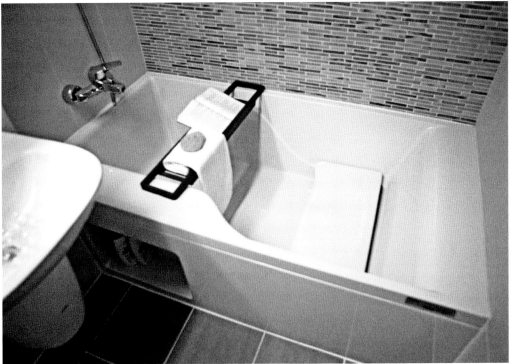

Product
Tandem project
Waschbecken und Korb
Washbasin and wastepaper basket

Design
Paolo Ulian
Marina di Massa, Italy

Manufacturer
AZZURRA SANITARI IN CERAMICA S. P. A.
Castel Santelia, Italy

Waschbecken und Abfallkorb sind zwei Notwendigkeiten, die im Badezimmer häufig aufeinander treffen. So findet der Abfallkorb z.B. oft im ansonsten leer bleibenden Raum unter dem Waschbecken Platz. Aus dieser kuriosen Synergie heraus entstand das Tandem-Projekt: Das Waschbecken enthält einen abnehmbaren Korb, der aufgrund seiner großzügigen Maße und der zwei Griffe auch als Wäschekorb genutzt werden kann.

In the bathroom, the washbasin and the wastepaper basket are two typologies which always meet. The wastepaper basket is often placed into the space which remains empty under the washbasin. Project Tandem is based on this synergistic relationship which is sometimes established between objects. In this project, the washbasin includes a removable wastepaper basket which, thanks to its generous size, can also be used as a laundry basket with two handles.

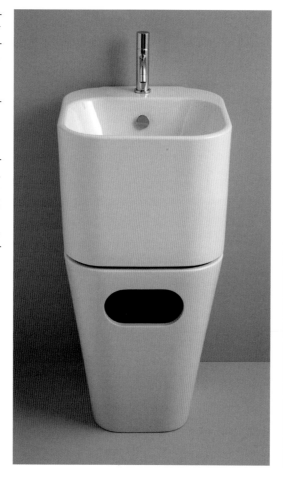
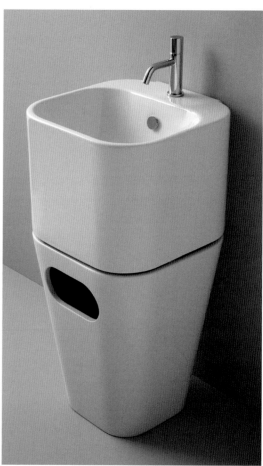

Product
Dimensions
Abdeckungen für Duschabläufe
Grates for shower drains

Design
Dallmer GmbH & Co. KG
Johannes Dallmer
Arnsberg, Germany

Manufacturer
Dallmer GmbH & Co. KG
Arnsberg, Germany

Handwerkliche Präzision und eine eigenständige, architekturorientierte Gestaltung charakterisieren die Produktserie Dimensions. Die Abdeckungen für Ablaufstellen in bodengleichen Duschen entfalten durch ihre geometrische Formgebung ein hohes Maß an optischer Präsenz und setzen Akzente in der Badgestaltung. Die Ablaufabdeckungen sind aus 5 mm starkem Edelstahl gefertigt. Kundenspezifische Wünsche, wie z. B. Monogramme oder besondere Oberflächenveredelungen, können berücksichtigt werden. Die Serie Dimensions bietet so hochwertige Lösungen für viele Einbausituationen.

Precision craftsmanship and independent design oriented to architectural aspects are characteristic of the Dimensions product series. The covering grates for floor drains in level-access showers create a high degree of optical presence with their geometric forms and set striking accents in bathroom designs. They are made of stainless steel with a thickness of 5 mm. Customer-specific surface finishes and monograms are available, thus offering high-grade solutions for many installations and fitting situations.

Product
ACO Showerdrain curve
Runde Duschrinne und Glas
Curved showerdrain and glass

Design
ACO Haustechnik
Stadtlengsfeld, Germany
Glamü GmbH
Heitersheim, Germany

Manufacturer
ACO Haustechnik
Stadtlengsfeld, Germany

Transparentes Design mit intelligenter Technik vereint die neue Walk-in-Dusche „Intro S Rund Plus". Für einen sicheren Stand des gebogenen Glaselementes sorgt die designstarke Duschrinne ACO Showerdrain durch eine spezielle Führung. Der Edelstahl-Rinnenkörper hält das 9 mm dicke Verbundsicherheitsglas in der Nut so sicher, dass ein einziges wandseitiges Profil genügt. So fügt sich die bodenebene Duschlösung mit einem Maß von 1.100 × 1.100 mm und einer Glashöhe von 2.000 mm dezent in die Badgestaltung ein. Für zusätzlichen Komfort sorgt eine separat vor dem Zugang einsetzbare Glaswand.

The new walk-in shower "Intro S Round Plus" combines aesthetic appeal and intelligent design techniques. Due to a unique guidance system, the ACO Showerdrain system provides a safe and positive location to accommodate the curved glass area. A single wall stainless steel channel reliably maintains the 9 mm laminated safety glass in the required location. This floor-level access shower solution conveniently integrates into the bathroom design with its overall dimensions of 1,100 × 1,100 mm and a height of 2,000 mm. Visual appearance and comfort is enhanced with an additional glass panel positioned across the entrance to the shower.

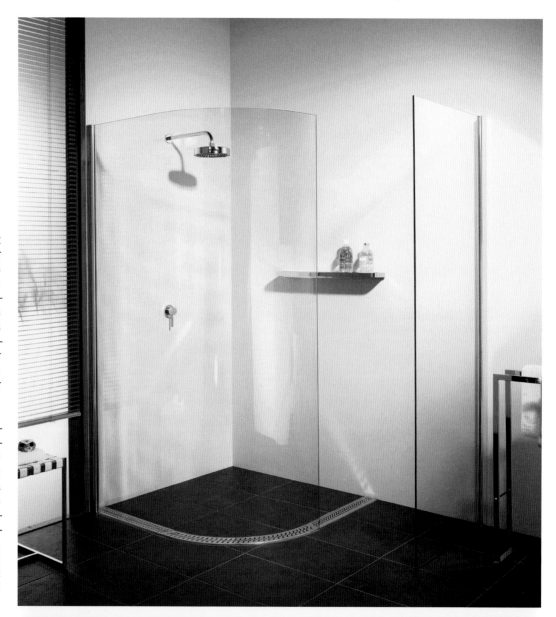

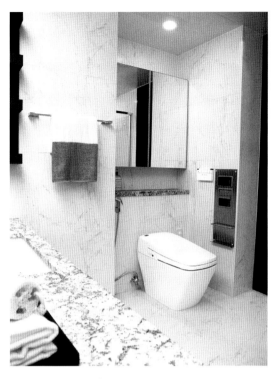

Product
TANKLESS®
Tanklose Toilette mit integriertem elektronischem Bidet
Tankless toilet with built-in electronic bidet

Design
VOVO CORPORATION
Ji-Young Jang, Eu-Hyang Sun
Seoul, South Korea

Manufacturer
VOVO CORPORATION
Seoul, South Korea

Tanklose Toilette mit integriertem elektronischem Bidet
1. Toilette ohne Wassertank
2. Waschen: komfortable Gesäßreinigung
3. Bidet: sichere komfortable Reinigung des Vaginalbereichs
4. Erhebliche Wassereinsparung durch das Spülsystem TANKLESS® mit Wasserstrahl-Siphonspülung (Mikrocontroller-gesteuert: 5,4 l bei Sparspülung, 6 l bei Vollspülung)
5. Fortschrittliche Technik
6. Moderne Hi-Tech-Materialien – STM bietet makellose Qualität bei geringem Gewicht
7. Spülung wird nach Benutzung durch einen Sensor automatisch ausgelöst.
8. Sitzheizung mit einstellbarer Temperatur
9. Der Deckel senkt sich langsam auf den Sitz.

Tankless toilet with built-in electronic bidet
1. Toilet without water tank attached
2. Washing: cleans posterior comfortably
3. Bidet: offers safe and comfortable vaginal cleaning
4. TANKLESS® flushing system saves a considerable amount of water with its siphon water jet flushing (Micro controlled 5.4 liters for economical flushing, 6 liters for full flushing)
5. Advanced technology
6. Hi-tech cutting edge material, STM is light weight and provides flawless quality
7. Sensor triggers automatic flushing after use
8. Heated seat with adjustable thermostat
9. Gently closing lid

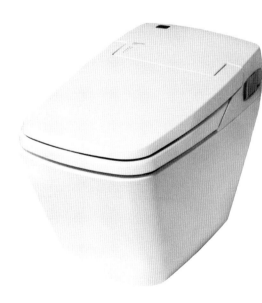

Product
IlBagnoAlessi dOt
Duschkabine
Shower cabin

Design
Wiel Arets
Maastricht, Netherlands Antilles

Manufacturer
Laufen Bathrooms AG
Laufen, Switzerland

Mit ihrer reduzierten rahmenlosen Form lenkt die Duschkabine aus der Serie IlBagnoAlessi dOt nicht von ihrem ursprünglichen Zweck ab – der Reinigung von Körper und Seele. Denn für den niederländischen Architekten und Designer Wiel Arets steht trotz auffälliger Details die Konzentration auf das Wesentliche im Vordergrund. Die Serie bietet sechs verschiedene Modelle der Duschkabine, die die charakteristischen Designmerkmale der Serie zeigen – Kubus, Kreis und der Dot. Die gebogenen Glasmodule sind innerhalb der Duschwanne angebracht – das Wasser bleibt drin und es wird kein Silikon benötigt.

With its reduced frameless design the shower cabin of IlBagnoAlessi dOt is not detracting from its original purpose – the cleansing of body and soul. Because for the Dutch architect and designer Wiel Arets the primary concern is the clear focus on the essential in spite of peculiar details of the shower cabin. The range of IlBagnoAlessi dOt offers six different models of the shower cabin, all showing the characteristic design elements of the series – cubes, circles and the dot. The bended glass screens are fitted inside the shower tray – so water stays inside and no silicon profile is needed.

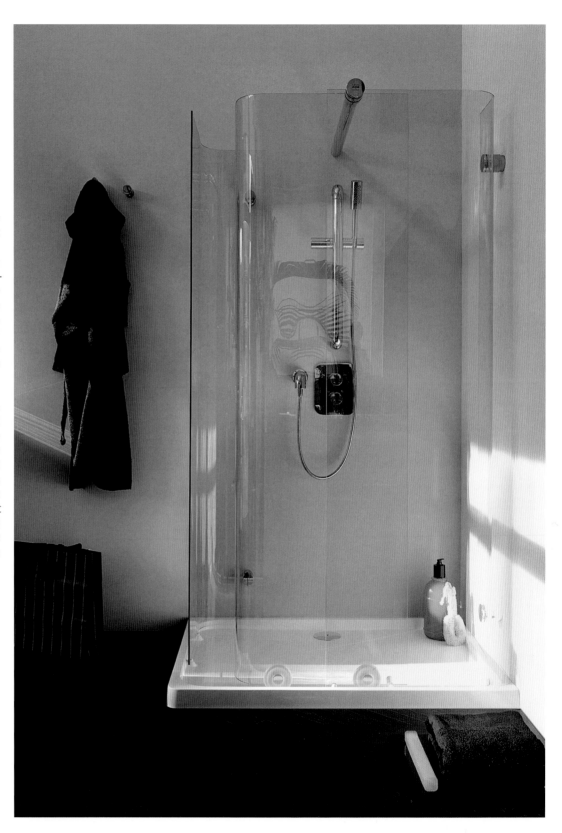

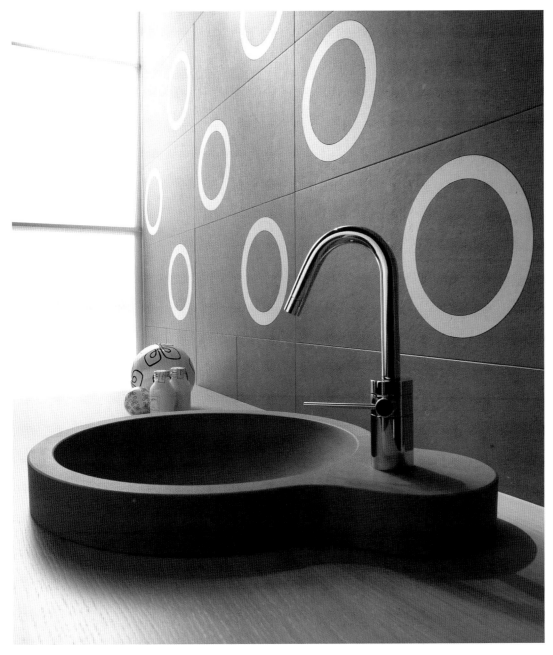

Product
OTTO
Waschbecken
Washbasin

Design
Carlo Martino
Studiomartino.5
Roma, Italy

Manufacturer
I CONCI s. r. l. Unipersonale
Bellocchi di Fano (PU), Italy

Der Kreis ist die geometrische Form, die am meisten den Ansprüchen derer gerecht wird, die klare, regelmäßige, aber nicht ausschließlich eckige Formen mögen. Der Kreis ist außerdem die Form, die am ehesten mit Wasser assoziiert wird. Ringe und Kreise bilden diesen schlichten Halb-Einbauwaschtisch. Ein weiterer kleinerer Kreis bildet die Installationsfläche für den Wasserhahn. Das Thema des Kreises wurde auch auf die Wandverkleidung übertragen, auf der die Eleganz der Zweifarbigkeit dominiert.

The circle is today the geometric matrix that answers more than others to the need of who loves pure and regular shapes not exclusively quadrangular shapes. The circle is also the shape that is most likely associated with water. Rings and circles created the project of a simple semi built-in basin wherein another circle joins together which functions as comfortable top for faucets. The theme of the circle is transferred on the cover for the wall texture where the elegance of the dichroism dominates.

Product
LUMINIST
Kristallbecken
Crystal bowl

Design
TOTO Ltd.
Masanobu Wano, Shigeru Aso
Kitakyushu, Japan

Manufacturer
TOTO Ltd.
Kitakyushu, Japan

Die Funktionalität und Flexibilität der Epoxidharze, die in dem Kristallbecken LUMINIST verwendet werden, sind ideal für Spülbecken und Arbeitsplatten. Die Erfindung von LUMINIST ist eine bemerkenswerte Leistung zweier Jahrzehnte. Dieses von TOTO patentierte Material ist lichtdurchlässig wie Glas, kennt aber nicht die Grenzen von Epoxidharzen. LUMINIST kann große Hitze aushalten und ist schlagfest. Flecken und Kratzer können daher einfach weggewischt werden. Dank seiner Lichtdurchlässigkeit kann das Material in neuen Produkten mit Beleuchtung eingesetzt werden und gibt jedem Raum einen modernen Touch.

The functionality and flexibility of LUMINIST's hybrid epoxy resin material used in this Crystal bowl, is also ideal for sinks and countertops. The invention of LUMINIST is a remarkable achievement spanning nearly two decades. This TOTO patented material offers glass-like translucence while overcoming the traditional epoxy-resin limitations. LUMINIST has been engineered to withstand high levels of heat and is impact-resistant, meaning that stains and scratches can simply be wiped away. Its translucent nature lends this material to novel applications with lighting, while its crisp form can accentuate any space by giving it a modern flavor.

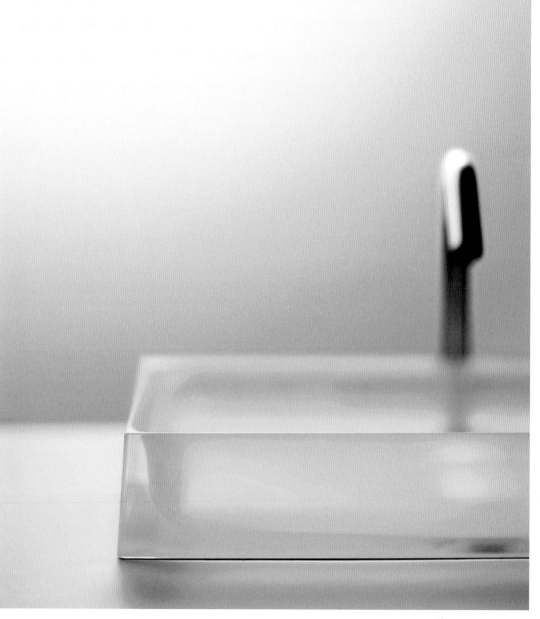

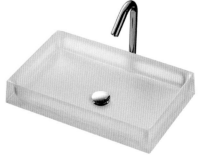

Product
RENESSE
Wasserhahn
Lavatory faucet

Design
TOTO Ltd.
Junichi Tani, Elium Studio, Fusako Jouffroy
Kitakyushu, Japan

Manufacturer
TOTO Ltd.
Kitakyushu, Japan

Die RENESSE Linie bietet zeitloses Design mit Sinn für Handwerkskunst. Diese Aufsätze sind nicht nur eine Augenweide, sie sind auch extrem funktional. RENESSE Designs sind Ergebnis eines hingebungsvollen Herstellungsprozesses mit Liebe zum Detail. Heraus kommen ein erfrischender Look, eine solide Griffigkeit und eine unübertroffene Qualität. Das geometrische Design, Erkennungsmerkmal dieser Kollektion, besticht durch seinen spiegelartigen Glanz. Allein dieser Glanz macht aus jedem Bad eine Oase heiterer Gemütsruhe und Schönheit. Säuberung und Wartung sind einfach.

The RENESSE line offers timeless design that puts an emphasis on craftsmanship to create an exquisite work of art. Not only are these fixtures aesthetically eye-pleasing, but their level of functionality is a joy to use. RENESSE designs are the fruits of a highly involved manufacturing process with meticulous attention to detail. The results are a refreshing look, solid feel and unsurpassed quality. This collection's signature geometric design dazzles with its polished mirror-shine finish. This brilliance alone can transform any bathroom space into an oasis of serenity and beauty while allowing for easy cleaning and maintenance.

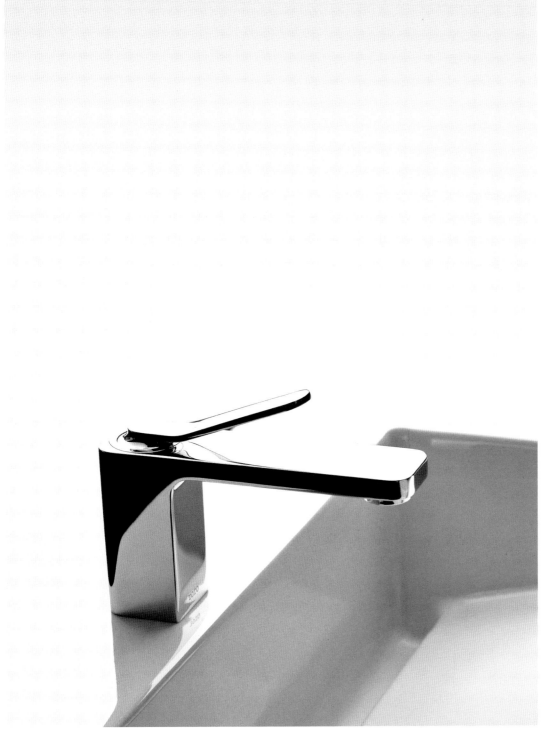

Product
EcoPower
Ökologischer Wasserhahn
Ecological faucet

Design
TOTO Ltd.
Kitakyushu, Japan

Manufacturer
TOTO Ltd.
Kitakyushu, Japan

TOTO's einzigartige EcoPower Technologie hat eine ökologische Armatur und ist sowohl für den Hausgebrauch als auch für die kommerzielle Nutzung geeignet. Die Armatur ist elegant und spart Wasser, Strom und Platz. Sie ist die erste selbst ladende Armatur der Welt. Dank einer wiederaufladbaren Batterie und einem Wasser-Generator, der nur vom Spülwasser angetrieben wird, kann die Armatur jahrelang ohne Wartung auskommen. Ein Infrarot- Mikrosensor sorgt für noch mehr Genauigkeit und für 84 % weniger Abwasser. Gleichzeitig ist die Armatur dank ihrer „no touch" Funktion sehr hygienisch.

TOTO's unique EcoPower technology offers an ecological faucet that is suitable for both residential and commercial applications. Behind the faucet's elegant appearance lies astounding innovation that saves water, electricity and space. This is the world's first self-charging faucet. Thanks to a rechargeable battery and self-generating hydropower generator – powered by the very water consumed – the faucet can go without maintenance for years. An infrared micro sensor at the tip increases detection accuracy and can help to cut waste water by up to 84 %. At the same time, the no-touch function makes the faucet hygienically appealing.

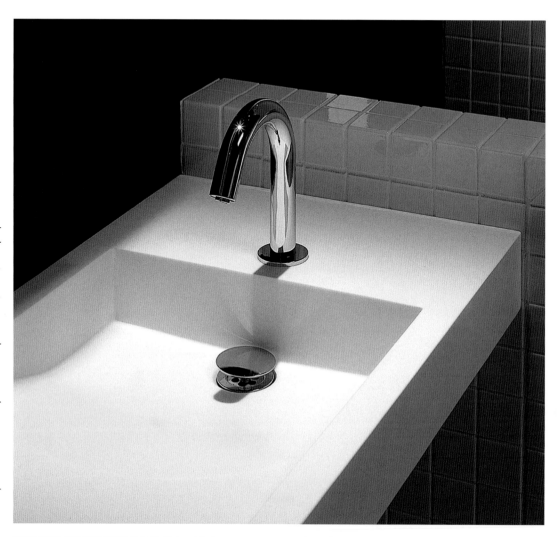

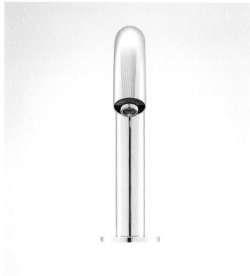

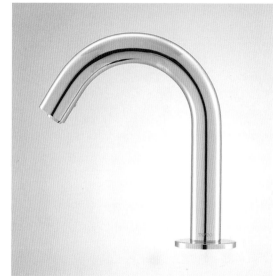

Product
NEOREST AH
Toilette
Toilet

Design
TOTO Ltd.
Yasushi Takahashi , Minoru Tani,
Hajime Kakihana, Yuji Yoshioka
Kitakyushu, Japan

Manufacturer
TOTO Ltd.
Kitakyushu, Japan

Die NEOREST AH ist eine revolutionäre Toilette, bei der sich Funktionalität und Schönheit ergänzen. NEOREST AH hat ein randloses Wasserbecken, eine Einzel-Toilettenspülung und eine fleckenresistente, mit CeFiONtect beschichtete, Oberfläche, die die Reinigung einfach macht. Die patentierte Tornado-Spülung vernichtet Bakterien. Die Design-Innovationen sind umweltfreundlich und kostensparend. Die Spülung verbraucht nur 5,5 l Wasser. Dank ihres hybriden Öko-Systems ist diese Toilette auch in Hochhäusern und anderen Orten mit niedrigem Wasserdruck ideal. Die NEOREST AH definiert Badezimmereleganz neu und setzt neue Standards.

The NEOREST AH is a revolutionary toilet that perfectly merges functionality and beauty. The sleek NEOREST AH features a rimless basin, single flush path and stain-resistant CeFiONtect coated surface for exceptionally easy cleaning, while its patented Tornado-flush keeps bacteria at bay. Groundbreaking design innovations offer environmental and cost merits: energy is conserved, and a long flush uses only 5.5 liters of water. Moreover, this toilet's hybrid ecology system makes it suitable for environments with low water pressure, such as high-rise condominiums. The NEOREST AH redefines bathroom elegance and sets a new standard for the industry.

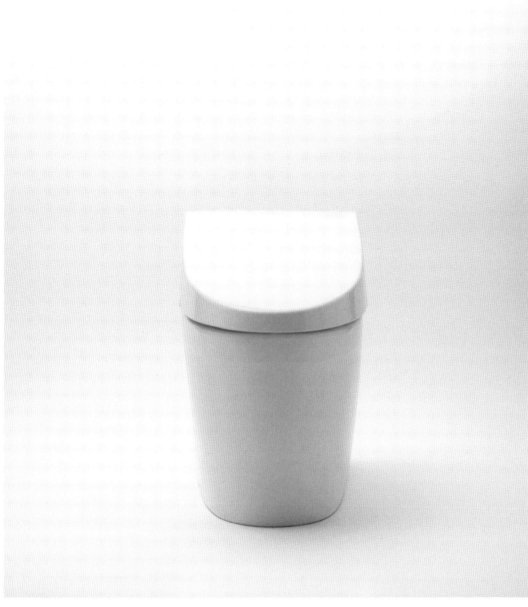

Product
RENESSE
Duschvorrichtung
Shower tower

Design
TOTO Ltd.
Junichi Tani, Elium Studio, Fusako Jouffroy
TANI / TOTO Ltd.
Kitakyushu, Japan

Manufacturer
TOTO Ltd.
Kitakyushu, Japan

Die RENESSE Linie bietet zeitloses Design mit Sinn für Handwerkskunst. Die Aufsätze sind nicht nur eine Augenweide, sie sind auch extrem funktional. RENESSE Designs sind Ergebnis eines hingebungsvollen Herstellungsprozesses mit Liebe zum Detail. Heraus kommen ein erfrischender Look, eine solide Griffigkeit und eine unübertroffene Qualität. Das geometrische Design, Erkennungsmerkmal dieser Kollektion, besticht durch seinen spiegelartigen Glanz. Allein dieser Glanz macht aus jedem Bad eine Oase heiterer Gemütsruhe und Schönheit. Säuberung und Wartung sind einfach.

The RENESSE line offers timeless design that puts an emphasis on craftsmanship to create an exquisite work of art. Not only are these fixtures aesthetically eye-pleasing, but their level of functionality is a joy to use. RENESSE designs are the fruits of a highly involved manufacturing process with meticulous attention to detail. The results are a refreshing look, solid feel and unsurpassed quality. This collection's signature geometric design dazzles with its polished mirror-shine finish. This brilliance alone can transform any bathroom space into an oasis of serenity and beauty while allowing for easy cleaning and maintenance.

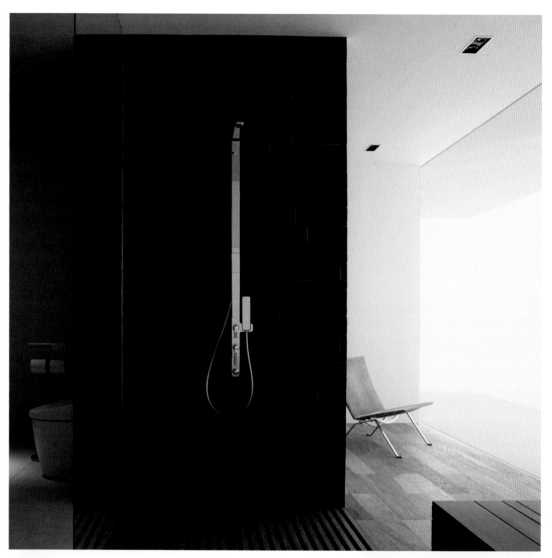

Product
Scoop
Badewanne
Bathtub

Design
SAMSUNG C & T
Hyukwoo Kwon, Eunhwa Lee
Union SB International Co., Ltd.
Chunhee Seo
Seoul, South Korea
Tangerine & Partners
Dontae Lee, Roland Boal
London, United Kingdom

Manufacturer
SAMSUNG C & T
Seoul, South Korea

Scoop, die multifunktionale Badewanne, inklusive beweglichem Waschbecken, ist eine neue Badewanne, in der sich koreanische Waschkultur und Sensibilität widerspiegeln. Die Badewanne wird durch Treppen und Aufbewahrungsmöglichkeiten ergänzt und kann noch bequemer benutzt werden. Das bewegliche Waschbecken kann für die Kleintierpflege, Fuß- und Handwäschen sowie für die weiteren Bedürfnisse des Benutzers eingesetzt werden. Außerdem ist auch ein Stuhl in die Badewanne integriert, sodass auch Halbkörperbäder, die gut für die Gesundheit sind, genommen werden können. Der Stuhl selbst kann aus der Badewanne entfernt werden. Die neue und multifunktionale Badewanne unterscheidet sich von den vorhandenen Badewannen, weil sie noch effektiver und sensibler ist.

Versatile washbowl, a consolidated type of bathtub Scoop, in which Korean unique emotional atmosphere has been reflected. Stairs that are attached to the bathtub have versatile washbowl and racks, which can be used for washing pet, feet spa and other various purposes according to user's tastes. Moreover, a chair is also installed inside the bathtub, which enables the half-body bath. Half-body bath is good for health, and the chair itself can be separated from the bathtub. Scoop is a clearly differentiated versatile washbowl that has been upgraded in terms of the effective usage of bathtubs and their functions.

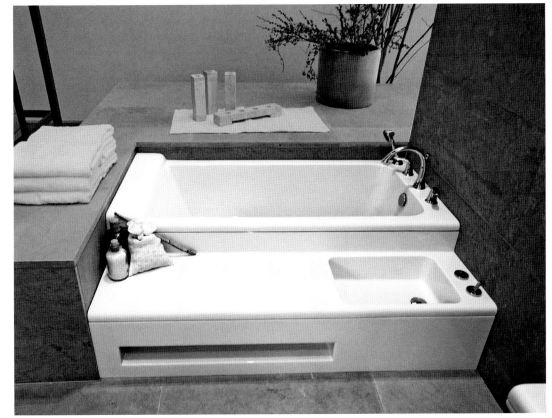

Product
Symetrics
Modulsystem
Module system

Design
sieger design GmbH & Co. KG
Sassenberg, Germany

Manufacturer
Aloys F. Dornbracht GmbH & Co. KG
Armaturenfabrik
Iserlohn, Germany

Symetrics ist ein architektonisches Gesamtkonzept für das Bad. Es ermöglicht durch die sehr präzisen Strukturen eine Gestaltung, die dem Raum selbst mehr Raum gibt: mehr Raum für die Verwirklichung des persönlichen Charakters, mehr Raum auch für Mobiliar. Der Grundgedanke: ein Raster. Auf dieses Raster mit dem Basismaß 60 × 60 mm wurden alle Symetrics-Module abgestimmt, so dass sie sich vollkommen frei miteinander kombinieren lassen. Alles passt dabei zu allem – von Waschtisch über Wanne und Dusche bis zum Bidet. Dadurch stehen nicht die einzelnen Armaturen im Mittelpunkt, sondern der Raum als Ganzes.

Symetrics is a total architectural concept for the bathroom. Through its very precise structures, Symetrics allows a design which creates more space in the space: more space for giving expression to your personality; more space also for furniture. The basic idea: a grid. All Symetrics modules have been coordinated with this grid and its basic measurement of 60 × 60 mm so that they can be combined just as you wish. Everything fits with everything else – from the wash stand through the bath tub and shower to the bidet. This means that the focus has moved from individual fittings to the space as a whole.

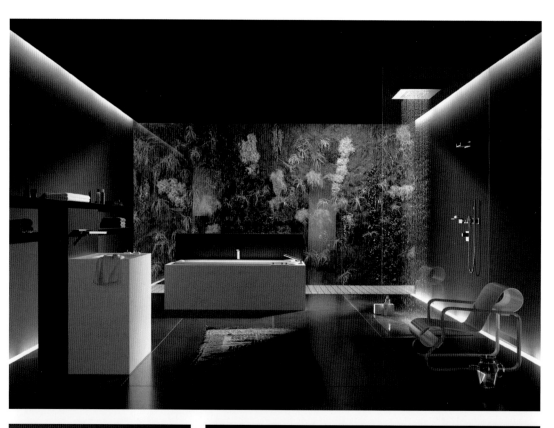

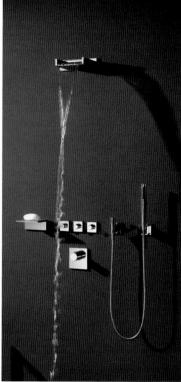

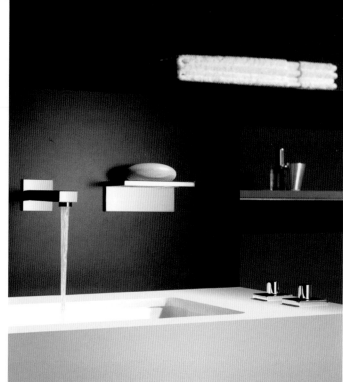

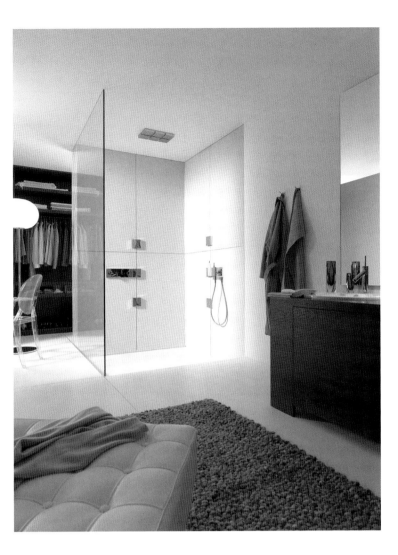

Product
Axor Starck ShowerCollection
Modulares Duschsystem
Modular shower system

Design
Philippe Starck
Paris, France

Manufacturer
Hansgrohe AG
Schiltach, Germany

Die Axor Starck ShowerCollection ist ein modulares System für die Dusche, das aus beliebig kombinierbaren Elementen besteht. Basismodul des umfassenden Baukastens sind quadratische Elemente, die es in unterschiedlichen Funktionalitäten gibt: Brausen-, Thermostat-, Licht- oder Lautsprechermodul, Ablagen sowie die Bedieneinheiten. Alles lässt sich zu stimmigen Systemkombinationen oder auch völlig frei zusammenstellen – dank ihrer perfekten Technologie und ihres durchgängigen Designs. Daraus ergeben sich unendlich viele ganz individuelle Lösungsmöglichkeiten, sodass die Axor Starck ShowerCollection ein Höchstmaß an Gestaltungsfreiheit bietet.

The Axor Starck ShowerCollection is a modular shower system consisting of elements that can be combined as desired. Quadratic elements with a wide variety of functions form the basis of this comprehensive set: shower, thermostat, light and speaker modules and shelves as well as control units. Thanks to perfected technology and a consistent design, all components can be assembled into a harmonious system or freely combined. This results in a virtually unlimited number of individual layout options so that the Axor Starck ShowerCollection offers the ultimate in design freedom.

Product
Euphoria
Handbrause
Hand shower

Design
Grohe AG
In-House Design Team
Düsseldorf, Germany

Manufacturer
Grohe AG
Düsseldorf, Germany

Die neue Handbrause Euphoria hat sich ganz natürlich entwickelt. Sie ist auf das Wesentliche reduziert und überzeugt durch ihre schlichte Schönheit. Der Griff und der Sprühkopf gehen nahtlos ineinander über. Der Chromring um den Sprühkopf akzentuiert die beiden Strahlarten „Rain" und „Champagne". Der Sprühkopf hat einen großzügigen Durchmesser von 110 mm für ein herrliches Duscherlebnis, mit gutem Gewissen der Umwelt gegenüber. Der Wasserverbrauch wird intelligent reduziert, indem die inneren Teile das Wasser gleichmäßig auf alle Düsen verteilen – für ein unvergleichliches Duscherlebnis bei geringerem Wasserverbrauch.

The new Euphoria hand held shower has evolved like nature, reducing the unnecessary to ensure beauty with reason. The handle and the spray face flow seamlessly in a sensual transition forming a ring of chrome around the spray face, celebrating the dual spray combination of "rain" and "champagne". The spray face has a generous diameter of 110 mm delivering a great showering experience, but with consideration for the fragile environment in which we live. Intelligently engineered to reduce water consumption, the inner parts distribute water evenly to every nozzle for an unparalleled showering experience using less water.

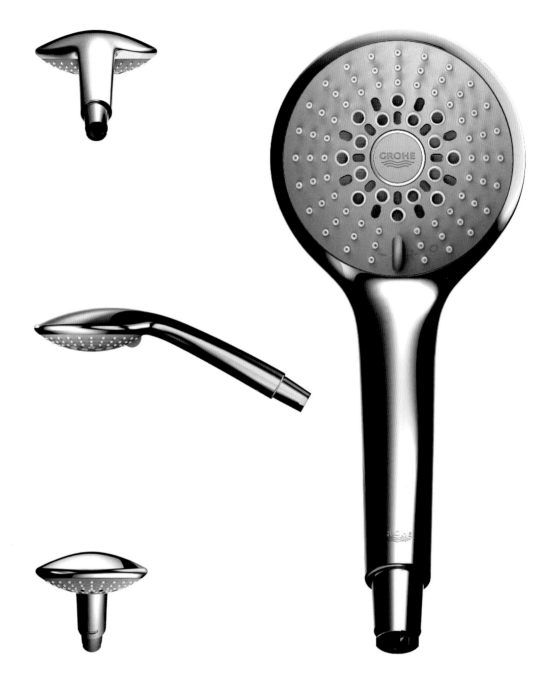

Product
Hansgrohe Pura Vida
Handbrause
Hand shower

Design
Phoenix Design GmbH & Co. KG
Stuttgart, Germany

Manufacturer
Hansgrohe AG
Schiltach, Germany

Sinnlich abgerundete Formen, wertige Flächigkeit und die Kombination aus lichtem Weiß und glänzendem Chrom sorgen bei der Pura Vida-Handbrause für spannende Kontraste und sinnliche Leichtigkeit. Der flache 150 mm große Brausenkopf ist als Quadrat mit weichen Ecken gestaltet und löst sich damit von der klassisch runden Form. Das Prinzip des integrativen Designs setzt sich fort bei der harmonischen Verschmelzung des Brausenkopfs mit dem flächigen sanft abgerundeten Griff. Mit ihren perfekt geformten Proportionen wirkt die Pura Vida-Handbrause wie aus einem Guss – emotionales, „begreifbares" Design im wahrsten Sinne des Wortes.

With sensuously rounded shapes, a premium finish and the combination of bright white and gleaming chrome, the Pura Vida hand shower creates exciting contrasts and sensual lightness. Deviating from the classic round shape, the flat 150 mm shower head is designed as a square with soft corners. The principle of integrative design continues in the harmonious fusion of the shower head with the flat, gently rounded handle. With its perfectly formed proportions, the Pura Vida hand shower appears as though it were all of a piece – an emotional, palpable design in the truest sense of the word.

Product
Hansgrohe Pura Vida
Kopfbrause
Overhead shower

Design
Phoenix Design GmbH & Co. KG
Stuttgart, Germany

Manufacturer
Hansgrohe AG
Schiltach, Germany

Sinnliches Duschvergnügen vermittelt bereits die Formensprache der Kopfbrause Pura Vida. Der aus der Verschmelzung zweier hochwertiger Zinkdruckguss-Schalen hervorgegangene, rechteckige Brausenkopf besticht durch seine ungewöhnliche flache Form, die mit einer Breite von 420 mm die Silhouette des Duschenden perfekt aufgreift. Der breite flächige Brausenarm visualisiert Stabilität und wirkt doch dank präziser dünner Kanten angenehm leicht und zurückhaltend. Eine dezente Chromkante rahmt die weiße Strahlscheibe ein. So lassen weich fließende Formen und das pure Weiß die großvolumige Pura Vida-Kopfbrause förmlich schweben.

The design language of the Pura Vida overhead shower conveys sensual showering pleasure. The angular shower head evolving from a combination of two high-quality zinc die-cast bowls is distinguished by its unusual flat design, which perfectly outlines the silhouette of the shower user thanks to a width of 420 mm. The wide flat shower arm visualizes stability and comes across as pleasantly light and restrained thanks to precisely slim edges. The spray disc is framed by a subtle chrome edge. Flowing shapes and the pure white color thus enable the voluminous Pura Vida overhead shower to literally float.

Product
Nova
Spülsystem
Flushing system

Design
Grohe AG
In-House Design Team
Düsseldorf, Germany

Manufacturer
Grohe AG
Düsseldorf, Germany

Für maximale Flexibilität lässt sich die neue Nova Betätigungsplatte hoch- oder querformatig montieren. Die einfache Kombination aus rechteckiger Platte und innen liegendem Kreis ist zur leichteren intuitiven Benutzung mit einer dezenten Kante versehen. Der Kreis selbst teilt sich in ein kleines und ein größeres Segment, welches zur Benutzung der Sparfunktion animiert. Die Ästhetik der Platte wurde sorgfältig auf die „Cosmopolitan Kollektionen" von Grohe abgestimmt. Auf diese Weise harmonieren alle Elemente im Bad, von den Armaturen und Spülsystemen bis hin zu den Accessoires, perfekt miteinander.

The new Nova flushing plate can be mounted in both portrait and landscape positions, affording maximum flexibility. The simple combination of the rectangular plate and the inner circle are united with a subtle chamfer, in order to guide the user to the point of interaction. The circle is divided into two segments, small and large, emphasizing the eco flush function. The aesthetic of the plate has been carefully created to ensure it aligns with the Grohe "Cosmopolitan Collections", delivering the added benefit of complete coordination in the bathroom environment, from faucets and accessories to flushing systems.

Product
PROIEZIONI
Sanitärkeramik
Sanitary ware

Design
CDC Corporate Design Catalano
Mario Rossi, Carlo Martino
Fabrica di Roma, Italy

Manufacturer
Ceramica Catalano srl.
Fabrica Di Roma, Italy

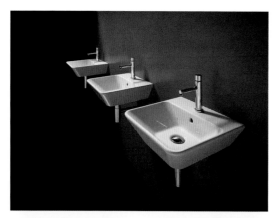

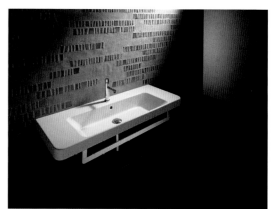

Eine neue Sanitärfamilie inspiriert mit der Idee der Leichtigkeit. Eine raffinierte Synthese aus Eleganz, Funktionalität und Innovation. Ein Gleichgewicht zwischen Formen, Materialien und Dimensionen, das Produkte mit einer perfekten Vielfunktionalität entstehen ließ. PROIEZIONI ist eine Sanitärfamilie, die aus sechs Waschtischen, alle mit einer Tiefe von nur 42 cm, und einem Wand-WC und einem Wand-Bidet besteht. Diese Produkte, die sich alle in ihrer Form sehr ähnlich sind, lassen sich mit einigen WCs und Bidets des Systems Zero kombinieren.

A new range of sanitary-ware items, inspired by lightness; a distinguished synthesis of elegance, functionality and innovation. A refined balance of shapes, materials and dimensions, that leads to design perfectly multi-functional products. PROIEZIONI is a sanitary-ware range – made up in its initial configuration – of six washbasins, all 42 cm distant from the wall, and dedicated wall-hung WC and bidet. Due to their morphology and typological affinity, these items can be matched with some Zero WCs and bidets.

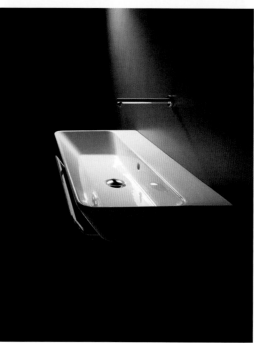

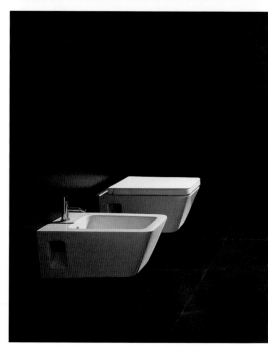

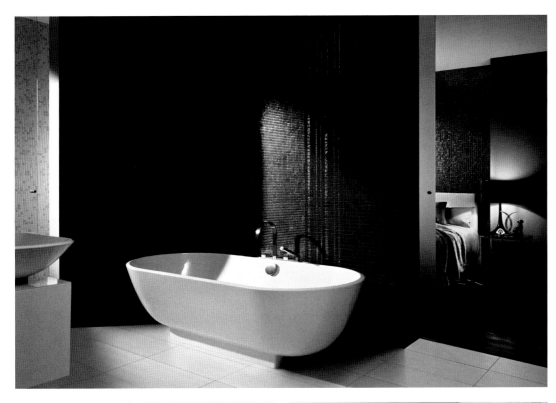

Product
Jasba – NATURAL GLAMOUR
Fliese
Tile

Design
Köhler & Wilms Products GbR
Irmy Wilms
Herford, Germany
Dt. Steinzeug Cremer & Breuer AG
Christiane Lion
Alfter-Witterschlick, Germany

Manufacturer
Dt. Steinzeug Cremer & Breuer AG
Alfter-Witterschlick, Germany

Die Marke Jasba steht für Mosaik. Das bestechendste Designmerkmal der keramischen Fliesenserie NATURAL GLAMOUR ist die innovative Glasurtechnik. Kontraste wie „Matt", „Metallic", „Lüster" und „Farbe" variieren das Relief. Das Architekturornament entsteht durch Rhythmisierung von Oberflächen, Format- und Farbkombinationen. Verwendet werden natürliche Rohstoffe. Die Materialinnovation „Hydrotect" ist reinigungsfreundlich, antibakteriell und baut Gerüche sowie Luftschadstoffe ab. Sicherheit bei Nässe bietet die rutschhemmende Oberfläche „Secura". Komplex anmutende, vorkonfektionierte Mosaike können vom Handwerker schnell gestaltet werden.

The brand Jasba stands for mosaic. The most impressive design feature of the ceramic tile series NATURAL GLAMOUR is the innovative glazing technique. Contrasts like "matt", "metallic", "lustre" and "color" vary the relief. Architectural ornaments are created by making surfaces rhythmic, by combinations of sizes and colors. Natural raw materials are used. The material innovation "Hydrotect" is easy to clean, has an antibacterial effect and eliminates odours as well as air pollutants. Safety in case of wetness is ensured by the slip-resistant "Secura" surface. Complex, prefabricated mosaic surfaces can be quickly designed by the craftsman.

Product
SimplyU / Natural
Waschplatz-System
Washstand system

Design
Artefakt
Achim Pohl, Tomas Fiegl
Darmstadt, Germany

Manufacturer
Artefakt
Darmstadt, Germany

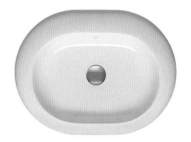

Als Teil der Systemwelt SimplyU bietet Natural in Kombination mit dem Sekundärprogramm – Box, Ablage, Spiegel und Accessoire – optimale Lösungen rund um den Waschplatz. Die extrem flexible Struktur erlaubt damit eine individuelle Anpassung an den ganz persönlichen Lebensstil. Wie ein vom Wasser geformter Kiesel ist Natural einzigartig und doch Teil des Ganzen. Als Teil eines modernen Bewusstseins, spielt Natural großzügig mit weich fließenden Oberflächen und fokussiert auf die emotionalen Aspekte. Natural trennt sich bewusst von der Welt des Minimalismus und ergänzt selbstbewusst den modernen Lebensstil amorpher Architektur- und Wohnwelten.

For a part of the system SimplyU Natural offers optimal solutions around the bath with its secondary program: box, board, mirror and accessories. The extreme flexible configuration allows individual adjustment to the very personal lifestyle. Like a pebble, which is shaped by the water, Natural it is unique and still part of it all. As a part of a modern awareness, that enjoys also the sensual and the calm moments of the life, Natural is playing generously with soft flowing surfaces, focussing to the emotional aspects. Natural parts with the minimalism and complements the modern lifestyle of amorphous architecture and living environment.

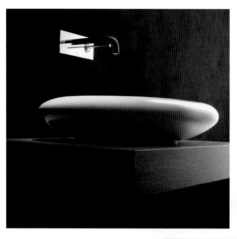
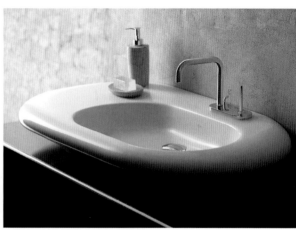
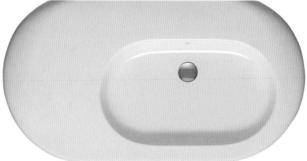

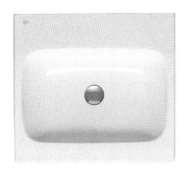

Product
SimplyU/Dynamic
Waschplatz-System
Washstand system

Design
Artefakt
Achim Pohl, Tomas Fiegl
Darmstadt, Germany

Manufacturer
Artefakt
Darmstadt, Germany

Als Teil der Systemwelt SimplyU bietet Dynamic in Kombination mit dem Sekundärprogramm – Box, Ablage, Spiegel und Accessoire – optimale Lösungen rund um den Waschplatz. Die extrem flexible Struktur erlaubt damit eine individuelle Anpassung an den ganz persönlichen Lebensstil. Klare Linienführung und geometrische Grundform führen zu der eigenständigen Ästhetik von Dynamic. Nur der Waschbereich reflektiert die Schnittstelle Mensch/Wasser und spiegelt in reduzierter Weichheit den Aspekt der Entspannung und Ruhe. Dynamic ist gestalterisch auf das Wesentliche reduziert und Teil einer minimalistischen Architektur und Wohnwelt.

For a part of the system SimplyU Dynamic offers optimal solutions around the bath with its secondary program: box, board, mirror and accessories. The extreme flexible configuration allows individual adjustment to the very personal lifestyle. Clear lines and geometrical basic design lead to the self-contained aesthetics of Dynamic as natural part of the functional quality. Only the wash area reflects the interface human/water and mirrors with reduced softness the aspect of relaxing. Dynamic is reduced to the essential and part of a minimalist architecture and lifestyle.

Product
mirrorwall
Spiegelwandsystem
Mirrorwall system

Design
Herbert Schultes Design
Fürstenfeldbruck, Germany

Manufacturer
Duravit AG
Hornberg, Germany

mirrorwall ist die Verbindung von Funktionalität und Komfort, Minimalismus und Sinnlichkeit. mirrorwall kombiniert elegant Waschplatz, Spiegel und ein intelligentes Beleuchtungssystem zu einem stimmigen Ganzen. Eine echte Neuheit sind die glatten keramischen Fronten der großräumigen Auszüge. Wahlweise: Die 500-Lux-Aufsatzleuchte garantiert eine perfekte Ausleuchtung des Gesichts, alternativ dazu leuchten zwei drehbare Lichtsäulen das Spiegelbild gleichmäßig aus und strahlen in den Raum ab. Gesteuert wird das System kinderleicht per Touch-LED.

mirrorwall is the ideal combination of practicality and convenience, minimalism and design. It features an elegant washbasin, mirror and intelligent lighting system. The smooth ceramic fronts of the spacious drawers are a genuine innovation. The optional 500 luxury clip-on lamp provides powerful illumination. Alternatively the two swivel light columns reflect in the mirror surface to light up the room. The system is simply controlled by means of touch LED.

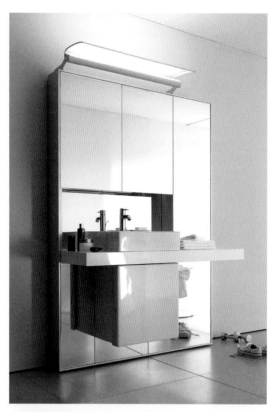
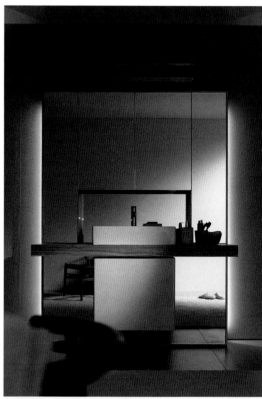
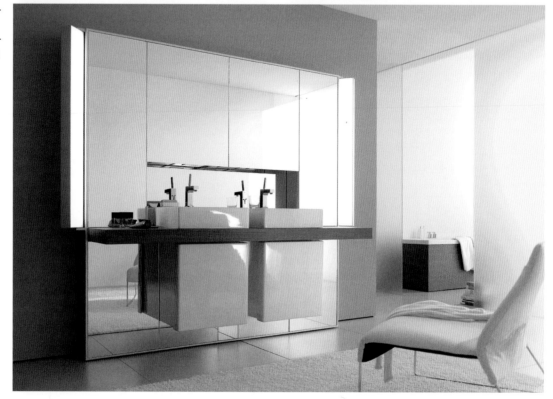

Product
NERO
Wäschebox
Laundry bag

Design
BODUM AG
Bodum Design Group
Triengen, Switzerland

Manufacturer
BODUM AG
Triengen, Switzerland

Es macht Spaß, seine Kleider schön gestapelt im Kleiderschrank zu sehen. Es macht weniger Spaß, einen Stapel schmutzige Wäsche anschauen zu müssen. Sogar das heiß geliebte T-Shirt und die teure Hose sehen nach nichts aus, wenn sie im Wäschekorb verknittern. Weil wir alle ein paar schmutzige Geheimnisse haben, gibt es nun den BODUM NERO – einen Wäschesack, der oben ganz einfach mit Magneten geschlossen werden kann. Er hat außerdem zwei Griffe und kann bestens herumgetragen werden. NERO ist aus einem neoprenähnlichen Material gefertigt. Die innere Hülle ist ein Baumwoll-Polyester Mix. NERO ist in verschiedenen tollen Farben erhältlich.

We're looking at our clothes with a sense of accomplishment once we have them neatly piled in the closet. Nothing can be as unsightly, though, as a pile of dirty clothes. Even the most treasured and expensive shirts and pants don't look like much when they're all wrinkly in a laundry bag. Because everybody has their dirty secrets, we've created the BODUM NERO – a laundry bag that closes on top with the ease of magnets and has two handles for easy transportation. It's made of a neoprene-like material and the inner lining is a cotton-polyester mix. NERO is available in a variety of fun colors.

Product
Quadra
Einhandmischer-Kollektion
One-hand mixer collection

Design
Grohe AG
In-House Design Team
Düsseldorf, Germany

Manufacturer
Grohe AG
Düsseldorf, Germany

Quadra zeichnet sich aus durch eine einfache Geometrie, die – sanft abgerundet – zur Interaktion einlädt. Vollständig integriert fügt sich der „Mousseur" unsichtbar in das puristische Design, bietet Komfort für den Nutzer und bringt Ruhe in das Badambiente. Als ein ikonisches Statement präsentiert sich der schlaufenförmige Griff und ermöglicht es dem Nutzer, die Vorteile der modernen, dezent im Armaturenkörper verborgenen, Keramikkartusche zu erleben.

Quadra celebrates the use of simple geometry, which has been softened and humanized to entice interaction. A fully integrated "Mousseuser" maintains the purity of the design, delivering comfort to the user and calm to the bathing space. The loop-shaped handle is a bold iconic statement, which enables the user to experience the benefits of the advanced ceramic cartridge; discreetly placed within its body.

Product
Grohtherm 3000 C
Thermostate
Thermostats

Design
Grohe AG
In-House Design Team
Düsseldorf, Germany

Manufacturer
Grohe AG
Düsseldorf, Germany

Die neuen Grohtherm 3000 Cosmopolitan Thermostate verbinden zeitloses Design mit einer Vielzahl von verbraucherorientierten Merkmalen. Die ikonischen Thermostate basieren auf der einfachen ästhetischen Philosophie extrudierter Zylinder in perfekten Proportionen. Damit wird Gleichgewicht, Schlichtheit und Harmonie geschaffen. Die grafischen Elemente erleichtern die intuitive und sichere Bedienung und leiten den Nutzer im Sinne einer hervorragenden Ergonomie. Mit einer beeindruckenden Kombination, der von Grohe patentierten Technologien wie „TurboStat", „CoolTouch" und „StarLight-Chrome", bietet sie dem Verbraucher ein einzigartiges Erlebnis.

The new Grotherm 3000 Cosmopolitan thermostats combine timeless design with an array of consumer focused features. The iconic thermostats are based on the simple aesthetic philosophy of extruding cylinders in perfect proportions to create balance, simplicity and harmony. The graphics facilitate intuitive and safe use and the buttons guide the user to ensure superior ergonomics. Hosting an impressive combination of Grohe patented technologies, including "TurboStat", "CoolTouch" and "StarLight-Chrome", it is delivering an unparalleled consumer experience.

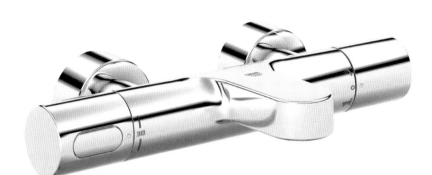

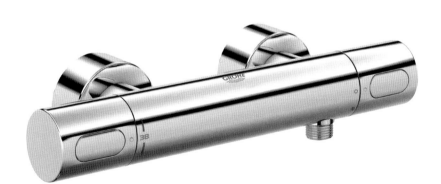

Product
Heater
Warmwasserbereiter
Water heater

Design
Industrial Design Center of Haier Group
Sun Jingyan, Lan Cuiqin, Lu Xinmin,
Song Lei, Yan Rui
Qingdao, China

Manufacturer
Haier Group
Qingdao, China

Dieser Warmwasserbereiter mit einer dreidimensionalen Wärmtechnologie enthält einen Vorwärmmodus und einen Echtzeitwärmmodus, welche dem Benutzer die Wartezeit verkürzen. Die revolutionäre Technologie des Antistromverlusts gibt dem Benutzer zusätzliche Sicherheit. Er ist nicht nur das Ergebnis eines einfachen Produktdesigns, sondern auch eine Verschönerung im Badezimmer. Der blaue LED-Anzeiger zeigt die Temperatur an, während das weiße LED-Hintergrundlicht den ganzen Raum beleuchtet.

This water heater adopts three dimensions heating technology, which integrates pre-warm and real time warm modes to let users spend less time in waiting. The revolutionary anti electric leak technology brings more safety to consumers. It's a convergence of simple product design and bathroom decoration. The blue LED indicator shows the temperature while white LED backlight will illuminate the whole room.

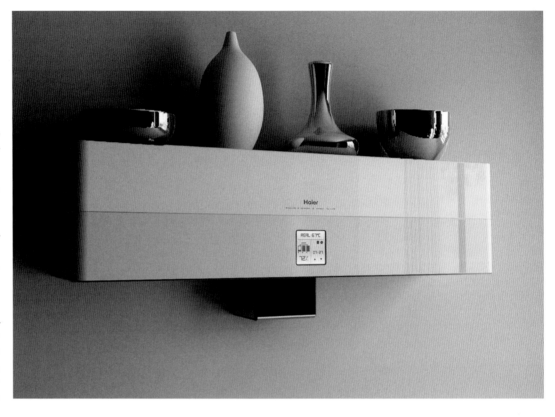

Product
Rainshower F Series
Seitenbrause
Body spray

Design
Grohe AG
In-House Design Team
Düsseldorf, Germany

Manufacturer
Grohe AG
Düsseldorf, Germany

Die UP-Seitenbrausen geben dem Nutzer die maximale Freiheit in der Gestaltung ihrer bevorzugten Brausenkonfiguration. Die flachen Paneele fügen sich nahtlos in die Umgebung ein. Dadurch reduziert sich der technische Charakter des Produkts und die Dusche wird geräumiger. Bei allen Seitenbrausen sorgt die patentierte Grohe „Dreamspray-Technologie" für eine gleichmäßige Verteilung des Wassers an alle Düsen und reduziert so den Wasserverbrauch ohne Beeinträchtigung des Duschvergnügens. Mit Grohe „SpeedClean" lassen sich die Düsen durch einfaches Drüberstreichen leicht von Kalk befreien.

The concealed range of body sprays provides total freedom, affording consumers the flexibility to create their preferred interface to water. The flat panels blend seamlessly into an environment, reducing the technical nature of the product and maximizing the showering space. Each unit contains patented Grohe "Dreamspray" technology, which guarantees water dissipation evenly to every single nozzle, using less water to create the perfect shower. The silicone spray with "SpeedClean" ensures all nozzles remain free from blockages with a simple wipe of the hand.

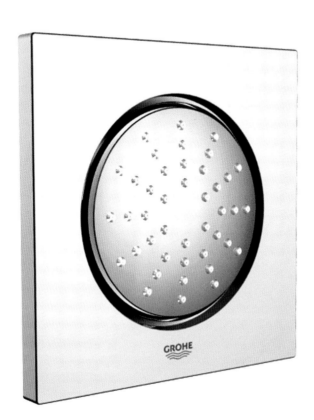

Product
Hansgrohe Pura Vida
Waschtischmischer
Basin mixer

Design
Phoenix Design
Stuttgart, Germany

Manufacturer
Hansgrohe AG
Schiltach, Germany

Die Armatur Pura Vida steht für einen neuen, lebendigen und freien Umgang mit Formen. Er zeigt sich
im Spiel mit den Kontrasten zwischen Flächen und
fließendem Volumen, zwischen Weiß und Chrom.
Die weiche organische Unterseite in klarem Weiß
wird abgelöst von einer chromglänzenden großzügigen Fläche. Ihre Eleganz spiegelt den Luxus unbeschwerter Klarheit wider. Mit seinem weiß lackierten, schlanken und perfekt proportionierten Korpus
scheint der Pura Vida-Waschtischmischer in weichen
klaren Linien bis hin zum schlanken langen Pin-Griff
aus der Keramik herauszuwachsen und erweckt so
den Eindruck von schwebender Leichtigkeit.

The Pura Vida faucet stands for a new, lively, free
exploration of shapes. This is revealed by the playful contrast between faces and flowing volume, between white and chrome. The soft, organic underside in clear white transitions into a generous expanse
of gleaming chrome. Its elegance reflects the luxury
of untroubled clarity. With its white, slim, perfectly
proportioned body, the Pura Vida basin mixer appears to emerge from the ceramics in soft, clear lines
up to the long, slim pin handle to create an impression
of floating lightness.

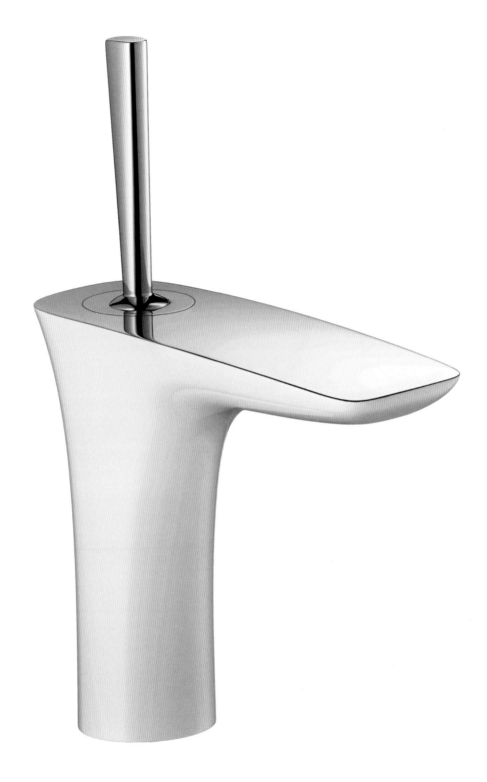

Product
Tork Elevation
Seifenspender für öffentliche Waschräume
Dispensers for public washrooms

Design
Meyerhoffer Inc.
Thomas Meyerhoffer
Montara, CA, United States of America

Manufacturer
Tork
SCA Tissues Europe
Göteborg, Sweden

Millionen von Menschen auf der ganzen Welt werden diese funktionellen Papier- und Seifenspender in öffentlichen Waschräumen jeden Tag nutzen. Ziel war die Gestaltung eines Objekts, das in jede Umgebung passt, was Meyerhoffer zu einem zurückhaltenden, neutralen Design inspirierte. Da der Ort der Papierausgabe intuitiv erfasst werden soll, ist der untere Teil des Spenders durchsichtig. So lässt sich auch leicht erkennen, wann wiederaufgefüllt werden muss. Die plastische, kapselartige Konstruktion schützt das Papier und erweckt den Eindruck, als schwebe der schmale Spender an der Wand.

A silent and functional design for millions of users. This line of paper and soap dispensers for public washrooms will be used by millions of people all over the world every day. The goal of fitting into any environment inspired Meyerhoffer to design an object that appears silent and neutral. The studio wanted the user to intuitively understand where paper is delivered and used a translucent material in the lower part of the dispensers. This also makes it easy for service to know when a refill is required. The sculptural capsule-like design protects the paper and makes the slim dispensers appear as though they are floating on the wall.

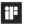
Product
BA10
Digitales Bidet
Digital bidet

Design
Woongjin Coway Co., Ltd.
Sang-Hwa Lee, Young-Soo Lee
Seoul, South Korea

Manufacturer
Woongjin Coway Co., Ltd.
Seoul, South Korea

Dieses Produkt ist das Ergebnis einer Umfrage zum Thema „Badezimmerkultur" und „Bequemlichkeit". Leicht bedienbar und ergonomisch geformt sollte das Bidet sein. Die Form erinnert an ein Automobil, sodass Schwellenängste beim Gebrauch elektrischer Badezimmereinrichtungen abgebaut werden. Die Bidet-Düse dient der gleichzeitigen Reinigung und Desinfektion. Auf Umweltfreundlichkeit wurde beim Entwurf des Produkts großen Wert gelegt.

This product is designed with basic concept of harmony with interior through design researches related bathroom culture and convenient utility of consumers. The image of high dignity is emphasized in this product by designing soft curve, simple design, and dynamic line like automobile body so that users can use with no refusal to electronic products of bathroom. Also, applied anti-germs and sterilizing materials inhibit germs proliferation and gave environment-friendly image to the nozzle where water sprouts when using washing function and bidet, and saving power and water heating functions make users to use it safely and comfortably.

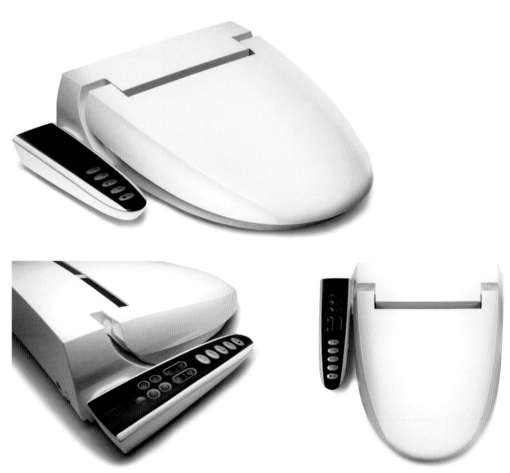

Product
Planus
Handtuchwärmer
Towel warmer

Design
King & Miranda Design S. r. l.
Perry King, Santiago Miranda, Christopher Knox
Milano, Italy

Manufacturer
Zehnder Group Produktion Gränichen
Gränichen, Switzerland

Planus ist ein reiner Handtuchwärmer, der dank seiner innovativen Heiztechnik innerhalb weniger Minuten das Badetuch kuschelig erwärmt. Planus wird elektrisch betrieben. Der eingebaute Timer sorgt dafür, dass er nur dann wärmt, wenn dies gewünscht ist. Seine Heizleistung beträgt 250 Watt (niedrige Betriebskosten). Planus ist schwenkbar bis 180° und kann dadurch sehr Platz sparend eingebaut werden. Zudem ist er sehr einfach zu montieren – mittels mitgelieferter Montageschiene – und noch einfacher zu bedienen: Durch einmaliges Drücken des Schalters nimmt er zuverlässig seine Arbeit auf, wann immer trockene und kuschelig warme Handtücher benötigt werden.

The Planus is a towel drying radiator which operates electrically. Due to the innovative heating technique Planus is able to heat up bath towels within just a few minutes. The inbuilt timer is to provide warmth only when required and the moderate heating output of 250 watt results in very low operating costs. Thanks to his swivelling feature to 180°, Planus can be installed also in very limited spaces. In addition to that he can be mounted extremely easy by fixing the installation bar – of course included in the packaging – to the wall. Plug in and enjoy beautiful warm towels by pushing the operation button: just as easy as that.

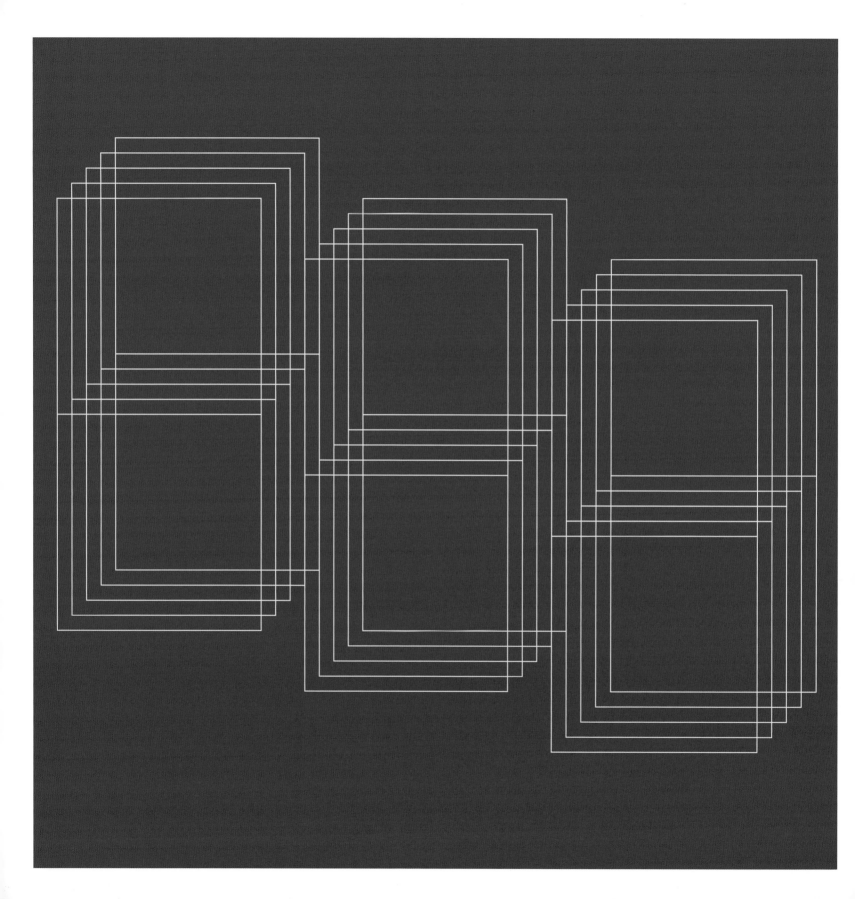

Gemeinsam mit Jim Kraimer und Gottfried Beer hatte ich das Vergnügen, eine Auswahl der designstärksten Einreichungen in der Kategorie 11. Buildings vornehmen zu dürfen. Diese spannende Kategorie erstreckte sich von einzelnen Kleinstprodukten bis hin zu kompletten Gebäudeausstattungen.

Dabei haben uns die hohe Qualität der einzelnen Einreichungen und die große Bandbreite an Produkten in der Kategorie wirklich beeindruckt.

Wie viel Design, Entwicklungsleistung und echte Innovation steckt in einer auf den ersten Blick einfachen und gewöhnlichen Wärmepumpe? Wie viel Ergonomie und Gestaltungskonsistenz steckt in moderner Gebäudekommunikationsausstattung? Wie viel Liebe zum Design und zum Detail stecken in pneumatischen Maschinenelementen? Und wie viel Prozessgestaltungs- und Designleistung wird in modernste Fertigungsanlagen investiert? Bei zahlreichen Produkten war die ergänzende Erklärung des iF Begleiterteams eine wertvolle Hilfe, die besondere Designleistung umfänglich zu verstehen und bewerten zu können – vielen Dank dafür! Faszinierend war bei einigen Einreichungen, wie sich Markenphilosophie und -positionierung von Unternehmen konsequent in der Produktgestaltung fortsetzen. Neue Technologien sowie Fertigungsmöglichkeiten in Verbindung mit neuen Materialien schaffen die Grundlage für echte Innovation. Die zwei Tage waren sehr interessant und haben viel Spaß gemacht. Vielen Dank dafür an das iF Team und meine Mitjuroren Jim Kraimer und Gottfried Beer. Und herzlichen Glückwunsch an alle Gewinner!

In conjunction with Jim Kraimer and Gottfried Beer, I had the pleasure to participate in the selection of the best designs from category 11. Buildings. This exciting category ranges from the smallest individual products to comprehensive building equipment.

We were truly impressed by the high quality of the individual entries and the wide range of products in this category.

How much design, development effort and true innovation is concealed in a heat pump that appears simple and ordinary at first glance? How much ergonomics and design consistency are hidden in modern building communication equipment? How much love of design and details are involved in pneumatic machine elements? And how much process styling and design effort is invested in the latest production facilities? For many of the products, supplementary explanations by the iF attendant team were extremely helpful in obtaining a comprehensive understanding and assessing specific design efforts – thank you very much for that! The way some entries consistently implemented their company's brand philosophy and positioning was fascinating. New technologies and production capabilities combined with novel materials form the basis of true innovation. The two days were very interesting and a lot of fun. My sincere thanks to the iF team and my co-jurors Jim Kraimer and Gottfried Beer. And congratulations to all the winners!

Product
AQW12AWA
Klimaanlage
Air condition

Design
Samsung Electronics
Hyungsub Choi, Joohee Ryu
Seoul, South Korea

Manufacturer
Samsung Electronics
Seoul, South Korea

AQW12AWA ist eine Wandklimaanlage, die in ihrer von der Windströmung inspirierten Form zu einem Schmuckstück für jede Inneneinrichtung wird – der Entwurf versucht, den Fluss des Windes in all seiner Schönheit nachzubilden. Ist das Gerät in Betrieb, schiebt sich die vordere Abdeckung in sinnlichen Bewegungen nach vorne.

The AQW12AWA is a wall-hanging air conditioner that is based on an image of flowing wind. The product features a design that embodies the beautiful curves of natural wind, transforming the product into a beautiful part of the interior decor. The front cover moves to the front when the product is in use to create sensible movements.

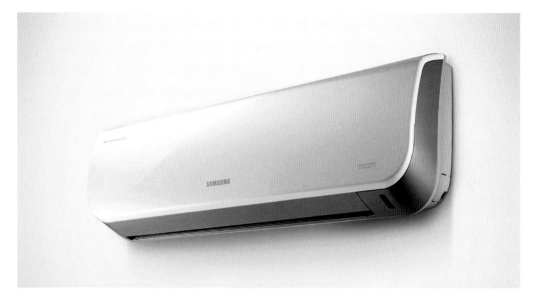

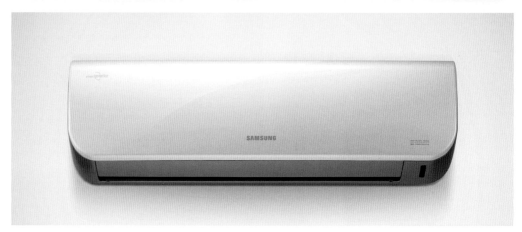

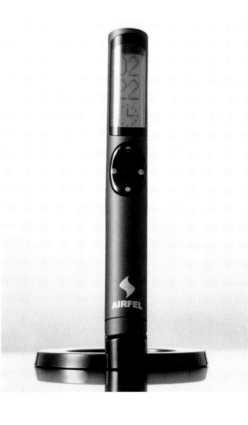

Product
Airfel PenRemote
Fernbedienung für Klimaanlagen
Remote control for aircondition

Design
Hulusi Neci
Istanbul, Turkey

Manufacturer
Airfel Heating and Cooling System
Istanbul, Turkey

PenRemote ist eine universelle Klimaanlagen-Fernbedienung sowie ein Luftfeuchtigkeitsmesser, ein Raumthermometer und eine Tischuhr. In diesem Projekt wurde die Fernbedienung, die zuvor als Schachtel mit ein paar Knöpfen darauf vernachlässigt wurde, in eine Identität gehüllt, die von ihrer historischen Benutzung abgeleitet wurde. Eigenschaften:
– Alle Funktionen liegen auf einer Taste.
– Die weltweit ergonomischste Klimaanlagen-Fernbedienung für Handflächen und Finger-Anatomie.
– Weltweit einfachste Klimaanlagen-Fernbedienung.
– Weltweit dünnste Klimaanlagen-Fernbedienung (21 mm Durchmesser).
– Arbeitet mit nur einer AA-Batterie.

PenRemote is a universal air condition remote control, a humidity meter, a room thermometer and a table clock. With this project, remote control, which has always been neglected so far and which could not pass beyond as a box with some buttons on it, was wrapped into an identity, originated from its usage first-ever in history. Features:
– All functions are in one button directly under your thumb.
– The world's most ergonomic air-condition remote control for palm and finger anatomy.
– World's simplest air-condition remote control.
– The world's slimmest air-condition remote control (21 mm diameter).
– The world's first air-condition remote control working with only one AA battery.

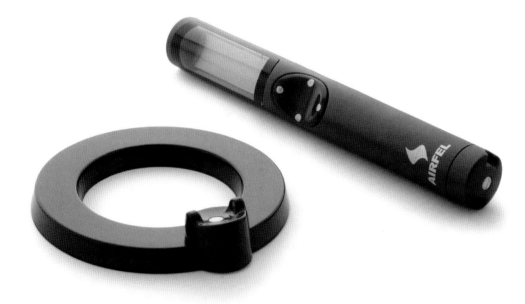

Product
Silent-PP
Hausentwässerungssystem
Drainage piping system

Design
Eidenbenz Industrial Design Est.
Ruedi Eidenbenz
Triesen, Liechtenstein

Manufacturer
Geberit International AG
Jona, Switzerland

Das steckbare Entwässerungssystem bietet die einfachste Art der Montage: Systemteile zusammenstecken und ausrichten. Das neuartige Konzept besticht neben einem strömungsoptimierten und geräuscharmen Durchfluss vom Abwasser insbesondere durch vier wesentliche Designelemente. Die Winkelnoppen und der Anschlagring ermöglichen das Ausrichten der Formstücke zueinander und das Erkennen der Einstecktiefe. Die vier seitlich ausfließenden Rippen bezwecken eine gute Haptik beim Ineinanderstecken. Der in Fließrichtung sich abflachende Podestkörper integriert die Produktbezeichnung und das Firmenlogo und verbindet alle Designelemente zu einer Einheit.

The pluggable drainage system offers the simplest installation method: Just plug the components together and align them. In addition to its low-noise, optimized wastewater volume flow, the new concept is characterized by four main design elements. The reference nubs and stop ring make it possible to align the fittings properly and determine the insertion depth. The four laterally extending ribs serve to create a good surface feel when inserting one fitting into another. The flattened ridge along the direction of flow integrates the product designation and company logo and unifies all the design elements into a single unit.

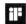

Product
WPL 14 HT
Luft-Wasser Wärmepumpe
Air-water heat pump

Design
EDF Recherche & Dévelopment
Guillaume Foissac
Moret sur Loing, France
burmeister industrial design
Kay Burmeister
Hannover, Germany

Manufacturer
Stiebel Eltron
Holzminden, Germany

Die von Stiebel Eltron und EDF für den Renovierungsmarkt im Wohnungsbestand entwickelte Luft/ Wasser Wärmepumpe WPL 14 HT ermöglicht mit hohen Vorlauftemperaturen die Nutzung des vorhandenen Heizverteilsystems und stellt darüber hinaus die Trinkwassererwärmung sicher. Die WPL HT fügt sich mit ihrer eigenständigen Formensprache und akzentuierter Farbgebung selbstbewusst in verschiedenste Umfelder ein. Die gerundeten Konturen verleihen dem Produkt Leichtigkeit und Dynamik. Das Erscheinungsbild unterstreicht den Leitgedanken von Stiebel Eltron, innovative Heizenergiekonzepte für alle Arten von Gebäuden anzubieten.

The WPL 14 HT air/water heat pump developed by Stiebel Eltron and EDF for the refurbishment market in housing supply, allows with its high flow temperatures the use of the existing heat distribution systems and ensures heating drinking water in addition. The WPL HT fits confidently into the most diverse environments thanks to its unique formal language and the accentuated color schemes. The rounded contours lend the product a sense of lightness and dynamism. The visual appearance emphasizes the guiding principle at Stiebel Eltron of providing innovative concepts for heating energy in all types of buildings.

Product
System controller
Wärmepumpenregler
Heat pump controller

Design
Taurus Design
Rudi Biller
Iserlohn, Germany

Manufacturer
Stiebel Eltron
Holzminden, Germany

Die neue Regler-Generation für Wärmepumpen setzt mit ihrer sensorischen Steuerfläche Maßstäbe bei der Heizungssteuerung in Bezug auf Bedienkomfort und Design. Der Regler zeichnet sich durch reduzierte Designsprache und eine berührungssensitive Steuerung aus. Das ringförmig angeordnete, ergonomische Bedienelement sorgt mittels Rotationsbewegung mit dem Finger für eine intuitive Navigation durch die Menüpunkte. Für eine visuelle Menü-Unterstützung ist eine leicht verständliche, klar strukturierte grafische Benutzeroberfläche realisiert worden. Verwendung findet der Regler in Wärmepumpen sowie als wandmontierte Fernbedienung im Wohnraum.

With its sensorial control surface the new generation of controllers for heat pumps sets standards for heating controls when it comes to user convenience and design. Their minimalist formal language and their controls, which are sensitive to touch, characterize the controllers. The circular, ergonomically control element affords intuitive navigation through the different menu items as a result of rotary movements by the finger. Visual help for menu controls is provided by an easily understandable graphical user interface with a clear structure. The control unit is used in heat pumps as well as wall-mounted remote controls in the home.

Product
XT PLUG & DIM
Schalterprogramm
Switch range

Design
Tobias Grau GmbH
Tobias Grau
Rellingen, Germany

Manufacturer
Tobias Grau GmbH
Rellingen, Germany

XT PLUG & DIM verbindet eine neuartige Ästhetik mit einem hohen Bedienkomfort durch neue Mikrotasten. Es können an Stelle von festgelegten Einzel- und Mehrfachrahmen alle Elemente einzeln oder in beliebiger Reihenfolge und Länge miteinander kombiniert und einfarbig oder zweifarbig zusammengestellt werden. Farben: weiß, schwarz, grau und rot. Zubehör: Tastschalter, Tastdimmer, Drehdimmer + Kippschalter für 230 V; Funktaster; Sensorschalter für 230 V; Taster zur Relaisansteuerung für Kleinschutzspannunginstallationen und einsetzbar in der Gebäudesystemtechnik (BUS); Steckdosen sowie Anschlussdosen für Antennen, TAE und UAE.

Thanks to its new micro switches, the XT PLUG & DIM combines a new aesthetic language with a high level of convenience. Instead of using preordained single or multiple frames, the various elements can be used individually or combined in any sequence or length desired. Available in white, black, grey and red. If desired, two colors can be combined within a single element. Elements: push-button switches, push-button dimmers, rotary dimmers and rocker switches for 230 V; sensor switches for standard 230 V; radio switches; relay switches for safety extra-low voltage installations and for BUS; power sockets; sockets for antennae, TAE + UAE.

Product
Mini-Touch
Elektronisches Aufzug-Bedienfeld
Elevator operation panel

Design
Otis Elevator Korea
Lee Danny, Kim HakCheol, Lee HanWoo
Seoul, South Korea

Manufacturer
Otis Elevator Korea
Seoul, South Korea

Das elektronische Aufzug-Bedienfeld „Mini Touch"
wird im Inneren einer Aufzugkabine installiert. Sein
schlankes, glattes Design ist revolutionär und viel
emotionaler als herkömmliche Edelstahlplatten mit
Druckknöpfen. Es vermittelt eine ganz neue Erfah-
rung beim Liftfahren – dank zehnstelliger Kombi-
nation und RFID-Kartenschlüssel statt unübersicht-
licher Druckknöpfe findet man sich auch in hohen
Gebäuden leicht zurecht. Auf den zwei Bildschirmen
der interaktiven Benutzeroberfläche lassen sich die
Informationen einfach und schnell ablesen. Darüber
hinaus können über die direkte LAN-Kommunikation
verschiedene weitere Informationen angezeigt wer-
den.

"Mini Touch – E/L operating panel" is a design for an
installation inside an elevator cage. The slim and slick
design is a real evolution in comparison to the old
type of STS plate with "push" buttons and is more
emotional. It gives elevator users a new experience by
providing an easy path to find their way with a 10-key
combination operation and RFID card keys substitut-
ing chaotic buttons also in high-rise buildings. "Mini
touch" adopts a 2 screen interactive User-Interface
with which customers can easily and quickly recog-
nize information. It also can display a variety of infor-
mation directly through LAN communication.

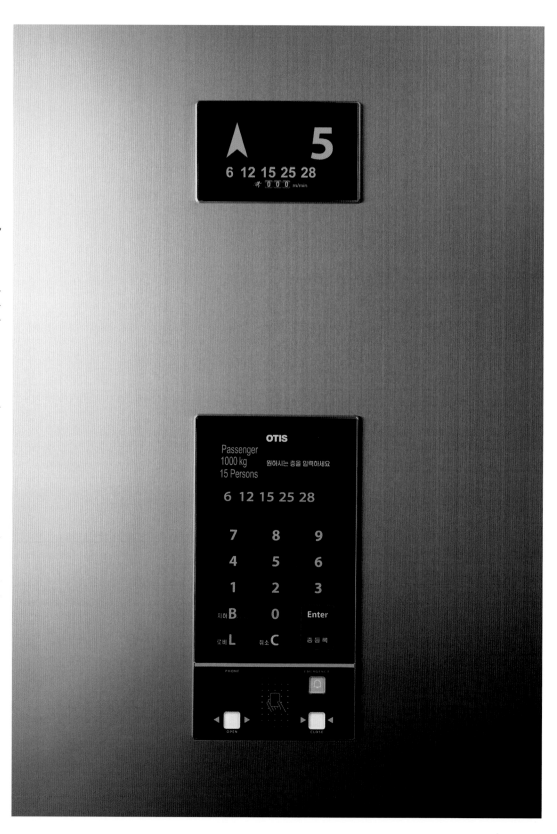

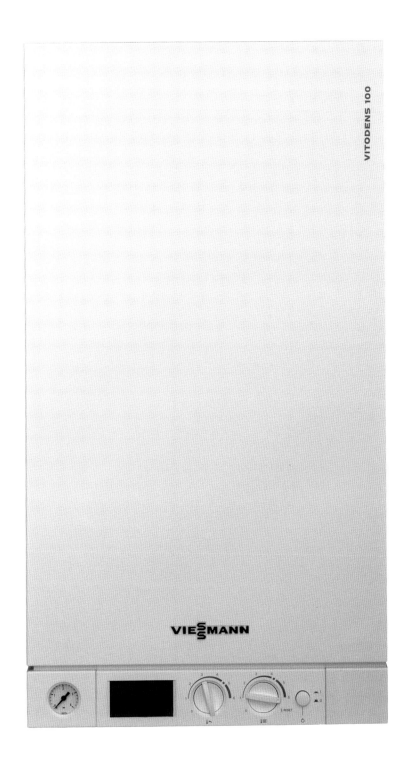

Product
Vitodens 100-W
Gas-Brennwert-Wandgerät
Gas condensing boiler

Design
Phoenix Design GmbH & Co. KG
Stuttgart, Germany

Manufacturer
Viessmann Werke GmbH & Co. KG
Allendorf/Eder, Germany

„Weniger ist mehr" – nach dieser Maxime sind alle neuen Heizsysteme von Viessmann gestaltet. Die damit erreichte hohe Integrationsfähigkeit in das Wohnumfeld ist das erklärte Ziel. Die Großzügigkeit und Klarheit des einteiligen Blechgehäuses in Verbindung mit der als Gerätebasis ausgebildeten Regelungseinheit ergeben ein architektonisch anmutendes formales Gesamtkonzept und bürgen optisch für Sicherheit und Qualität. Im Montage- und Servicefall wird mit zwei Handgriffen durch Abnehmen des einteiligen Gehäuses und Herausklappen der Regelungseinheit der komplette Anschlussraum von vorne frei zugänglich.

"Less is more" – all new heating systems from Viessmann are designed according to this maxim. The high integration capability achieved in the living area is the aim here. The generosity and clarity of the single sheet steel casing in conjunction with the control unit forms part of the appliance design create an architecturally pleasant formal appearance that suggests reliability and quality. Access for servicing and maintenance requires only two steps: the removal of the single part housing and of the front of the control unit from the wiring chamber.

Product
Slimlock
Edelstahl Design Schloss für Glastüren
Design lock for revolving glass doors

Design
astec gmbh
Axel Schlueter, Tobias Jung
Albstadt, Germany

Manufacturer
astec gmbh
Albstadt, Germany

astec Slimlock. Das Design-Schloss für Drehtüren in Ganzglasanlagen wirkt betont schlank und setzt nach oben strebende Formakzente. Das schmale Schloss ist in einer Aussparung des Glastürblattes angeordnet. Mit einer integrierten, patentierten Klemmeinrichtung werden die beiden Halbschalen des Schlosskastens und des Schlossgegenkastens aus massivem Edelstahl symmetrisch auf das Glastürblatt gespannt. Schraubverbindungen sind nicht sichtbar. astec Slimlock ist in den Längen 600 mm, 450 mm und 300 mm lieferbar. Drückergarnituren und Schließzylinder aller gängigen Fabrikate und Systeme sind einsetzbar.

The design lock for revolving glass doors is deliberately slim in appearance and is designed to draw attention upwards. The Slimlock is positioned in a recess in the door leaf. Both half-shells in the lock case and the counter case which are made of solid stainless steel are fitted symmetrically on the glass door leaf using an integrated, patented clamping device. Screws are invisible. astec Slimlock is available in the following lengths: 600 mm, 450 mm and 300 mm. All commonly available makes and systems of door handle sets and lock cylinders can be used.

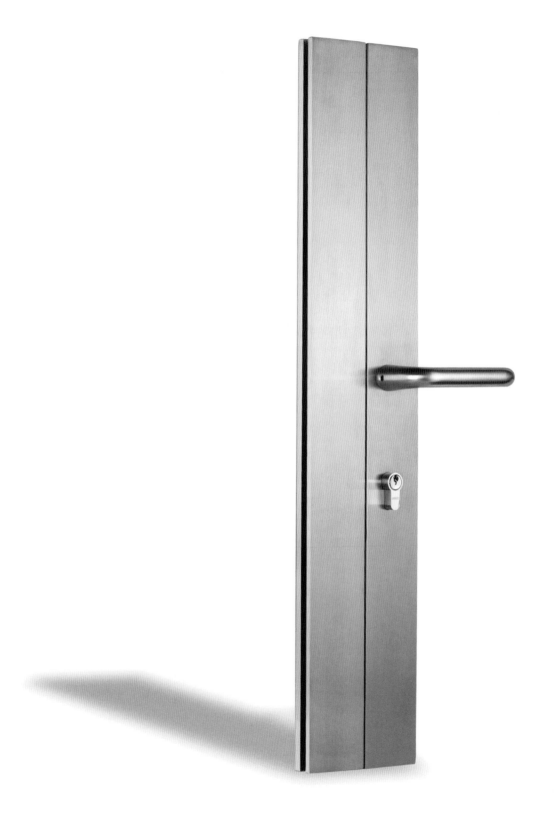

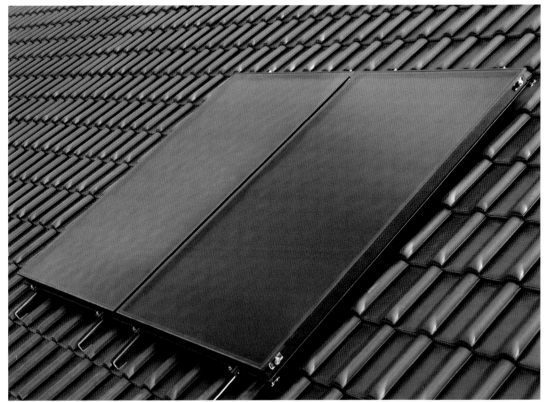

Product
auroTHERM
Solar-Flachkollektor
Solar flat plate collector

Design
Vistapark GmbH
Wuppertal, Germany
Vaillant GmbH
Remscheid, Germany

Manufacturer
Vaillant GmbH
Remscheid, Germany

Der Vaillant Solar-Flachkollektor auroTHERM kombi-
niert höchste Leistung, elegantes Design und ein-
fache Montage. Die kompakte Bauweise mit dem
besonders flachen Rahmen erlaubt die harmonische
Integration in unterschiedlichste Dachformen. Damit
wird der Kollektor integraler Bestandteil der Archi-
tektur. Durch die fast randlose Fassung des Oberflä-
chenglases entsteht eine zurückhaltend strukturierte
Fläche, die in Kombination mit weiteren Solar-Flach-
kollektoren ein visuell unaufdringliches Element in
der Dachfläche bildet. Das Montagesystem, das für
alle Vaillant Solar-Kollektoren identisch ist, ermög-
licht eine einfache, schnelle und sichere Installation.

The Vaillant auroTHERM solar flat plate collector com-
bines optimum performance, a smart design and
simple installation. The compact construction with
a particularly flat frame means that it can be harmo-
niously integrated into the most wide-ranging roof
shapes and therefore becomes an integral part of the
architecture. The homogenous surface glass of the
almost frameless mounting allows to combine several
collectors in a continuous visual field The auroTHERM
collector covers all areas of solar thermal applications.
Thanks to the proven assembly system used for all
Vaillant solar panels, it can be installed onto the roof
quickly and safely.

Product
Compact-Select-Sets
Türsprech-Sets
Door intercom sets

Design
S. Siedle & Söhne
Eberhard Meurer
Furtwangen, Germany

Manufacturer
S. Siedle & Söhne
Furtwangen, Germany

Compact-Select-Sets sind vorkonfigurierte Sprech-
oder Videoanlagen. Tür- und Innenstation entspre-
chen sich in der Formensprache, in den Proportionen,
im sandwichartigen Aufbau und in den Materialien:
eloxiertes, massives Aluminium vor einem Kunststoff-
korpus. Die neutrale Farbgebung des Kunststoffs und
großzügig bemessene Flächen betonen Materialität
und Ästhetik des Metalls. Das Design berücksichtigt
ergonomische Erfordernisse, unter anderem durch Ver-
zicht auf übertriebene Miniaturisierung.

Compact select door intercom sets are always pre-
configured audio and video systems. Door and in-
door stations match in terms of their styling, their
proportions, their sandwich style construction and
their materials: solid anodized aluminium in front of
a plastic body. The neutral coloring of the plastic and
generously proportioned surfaces emphasizes the
material character and aesthetics of the metal. The
design takes into account ergonomic requirements,
including measures such as avoiding excessive mini-
aturization.

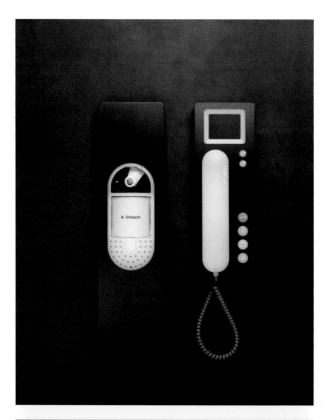

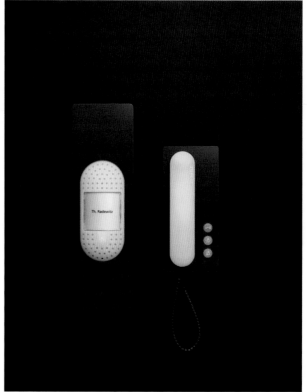

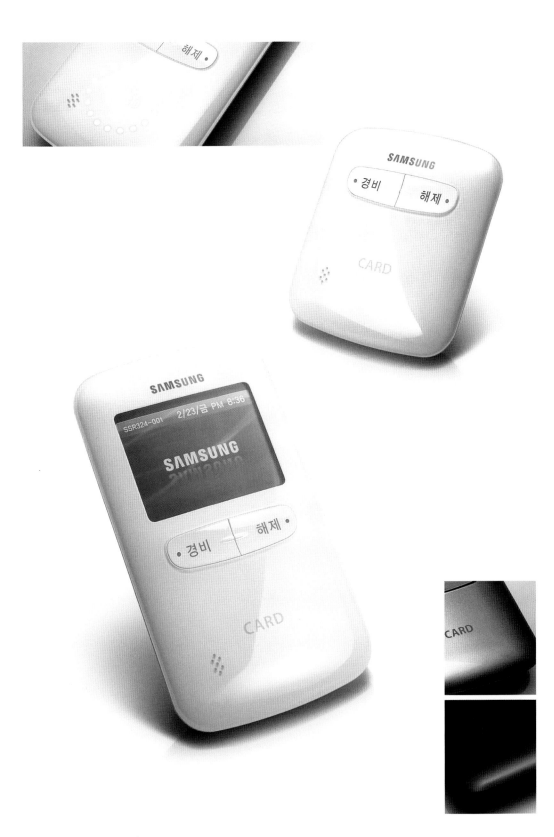

Product
Premium Card Reader
Zugangskontrollterminal
Access control terminal

Design
SAMSUNG S1
Ki Choul Lee, Jong Man Park
Seoul, South Korea

Manufacturer
SAMSUNG S1
Seoul, South Korea

Der Premium-Kartenleser (Pebble) ist ein Zugangs-kontrollgerät. Seine kieselsteinförmige Gestalt ist von natürlicher Schönheit und verkörpert den Kontrast zwischen hart und weich. Dank der großen Farbauswahl ist dafür gesorgt, dass für jeden Geschmack das Richtige dabei ist. Die neue, nachbearbeitungsfreie Drei-Wege-Folienhinterspritzung ist wasserdicht und schützt vor Ausbleichung und Abnützung. Nachbearbeitungs- und Teilekosten entfallen. Der Montageprozess wurde vereinfacht, was zu erheblichen Produktivitätsverbesserungen und beträchtlichen Kostensenkungen führte.

The Premium Card Reader (Pebble) is an access control product. Its pebbles-like style embodies the contradictory characteristics of softness and hardness, based on natural figurative beauty. A wide variety of colors have been adopted to satisfy user's tastes. The new film insert three-way injection molding approach, without any post spray processing, addresses such issues as discoloration, abrasion, and being waterproof. In addition, post processing costs and parts costs are reduced. The assembly process has been streamlined, resulting in substantial improvements in productivity and considerable cost reductions.

Product
Linha Yacht
Schloss und Griff
Lock and handle

Design
BMW DesignworksUSA
Holger Hampf
California, CA, United States of America

Manufacturer
PADO S / A
Cambé – PR, Brazil

Die Yacht-Linie besteht aus vier Schlössern und Griffen und wurde in Zusammenarbeit mit BMW DesignworksUSA in einem weltweiten Exklusivvertrag mit PADO entwickelt. Die Schlösser sind aus hochwertigem INOX-Stahl gefertigt und werden nach weltweiten Standards hergestellt. Das Design bezieht sich auf die Form von Yachten und Booten, ist seewasserfest und auch für die Nautik entworfen. Das Produkt vereint Ergonomie und Design, Herstellungsverfahren, Wohlgefallen und Technologie in sich. Die Entwicklung des neuen Designs basiert auf folgenden Kriterien: Marke, Design, Funktionalität, einfacher Gebrauch und Einbau sowie Qualität.

Constituted by 4 locks and door pullers the Yacht Line was developed in a partnership with the company BMW DesignworksUSA in a worldwide exclusive contract with PADO. The locks are of a high quality standard in stainless steel, following worldwide standards. Avoidance of corrosion was also projected for the nautical segment. The design has references to curves of boats and yachts. The product reunites ergonomics and designs, assembling concepts, satisfaction and technologies. The prospect of this new design for this product was based on following criteria: brand, design, workability, simplicity and quality.

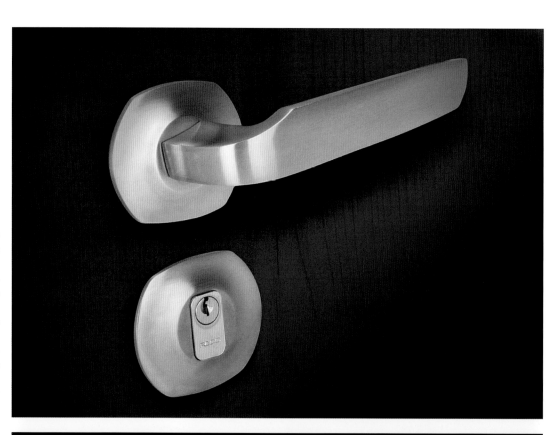

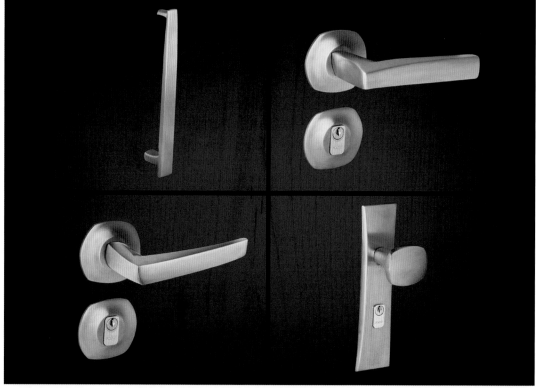

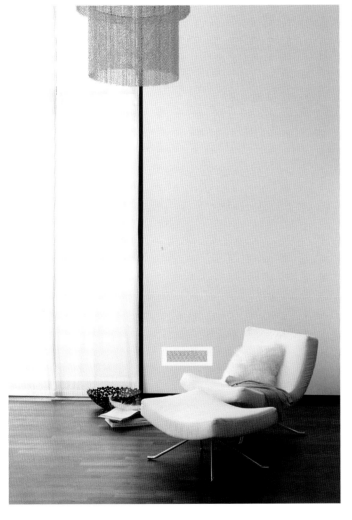

Product
Zehnder Engelberg
Design-Abdeckgitter
Designer cover grid

Design
Die Hausmacher
Tine Wagenmann, Dietmar Brandt,
Anthony Wagemann, Robert Alex,
Nene Nooij, Tim Prell
Düsseldorf, Germany

Manufacturer
Zehnder GmbH
Lahr, Germany

Mit der Designlinie Zehnder Engelberg wird aus einem Lüftungsgitter ein gestalterisches Element. Mit seiner klaren geometrischen Struktur passt es in ein modernes Design-Ambiente genauso wie in ein Alpen-Cottage. Es ist für den Wand- und Bodenbereich geeignet. Zehnder und Designerin Tine Wagenmann wählten neben Edelstahl natur und weiß als Material Corian, das hochwertig, ausgesprochen robust und einfach zu reinigen ist. Maße: 350 × 150 mm, 260 × 160 mm.

With the design Zehnder Engelberg a ventilation grid becomes a creative element. It fits with its clear geometric structure as well into a modern design ambience as in an alpine cottage. It is suitable for use as wall and floor outlet. Zehnder and the designer Tine Wagenmann have chosen natural stainless and white steal besides Corian, which stands for its high quality; it is extremely stable and easy to clean. Dimensions: 350 × 150 mm. 260 × 160 mm.

Product
Zehnder Abacus
Design-Abdeckgitter
Designer cover grid

Design
Die Hausmacher
Tine Wagenmann, Dietmar Brandt,
Anthony Wagemann, Robert Alex,
Nene Nooij, Tim Prell
Düsseldorf, Germany

Manufacturer
Zehnder GmbH
Lahr, Germany

Mit der Designlinie Zehnder Abacus sind Lüftungsgitter nicht mehr nur Lüftungsgitter sondern als dekoratives Element im Raum einsetzbar. Zehnder Abacus passt besonders ins moderne Design-Ambiente und ist für den Wand-, und Deckenbereich geeignet. Die Designerin Tine Wagenmann ließ sich von der gleichnamigen Rechenhilfe inspirieren. Neben Edelstahl natur und weiß, wählten Zehnder und die Designerin als Material Corian, das hochwertig, ausgesprochen robust und einfach zu reinigen ist. Maße: 260 × 160 mm, 350 × 150 mm.

With the design Zehnder Abacus ventilation grids are no longer just ventilation grids they are also applicable as decorative elements in a room. Zehnder Abacus matches very well in modern design ambience and is suitable for use as a wall and ceiling outlet. The designer Tine Wagenmann was inspired by the slide rule with the same name. Zehnder and Tine Wagenmann have chosen natural stainless and white steal besides Corian, which stands for high quality; it is extremely stable and easy to clean. Dimensions: 260 × 160 mm, 350 × 150 mm.

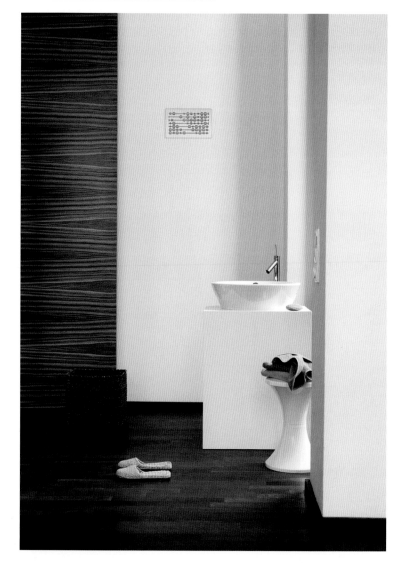

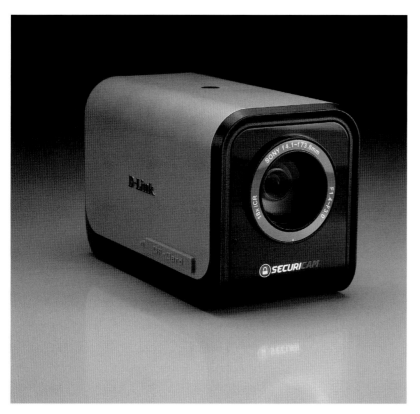

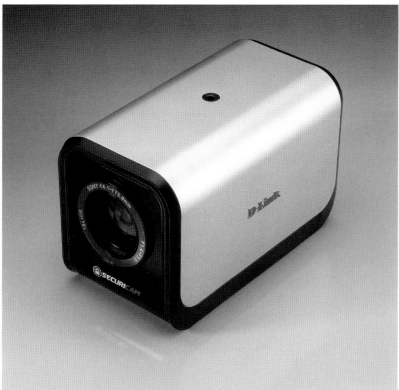

Product
DCS-3415
Netzwerk-Kamera
Network camera

Design
D-Link Corporation
Lin Chia-Hao
Taipei, Taiwan

Manufacturer
D-Link Corporation
Taipei, Taiwan

Die Netzwerkkamera DCS-3415 ist ideal für hochwertige Überwachungs- und Sicherheitsanlagen. Mit Progressiv-Scan-Sensor und optischem 18-fach-Zoom schießt sie lebensechte MPEG-4-Bilder. Die Auto-Iris-Funktion und der abnehmbare IR-Sperrfilter machen sie zu einer Kamera für 24-Stunden-Überwachung. Über RS-485-Schnittstelle und DC12V-Stecker kooperiert sie mit externen Geräten (IR-Illuminator oder Scanner). Dank PoE-Fähigkeit kann sie über nur ein Kabel mit Daten und Strom versorgt werden. Der äußere Metallring steht für echte Sicherheit. Weiteres Kennzeichen ist das zweifarbige, zurückhaltende Erscheinungsbild.

The DCS-3415 network camera is ideal for high-end surveillance and security applications. The progressive scan sensor and 18 × optical zoom lens captures vivid images in MPEG-4 format. The built-in auto-iris feature and a removable IR-cut filter make this camera suitable for 24-hour surveillance. An RS-485 port and a DC12V jack allow the DCS-3415 to cooperate with external devices such as an IR illuminator or scanner. Its PoE ability allows a single cable to connect and power it. The unique outer metal ring represents a safe environment and not just a "secured space". Discreet looks and the two-tone design further brand the camera.

Product
Faltwerktreppe
Treppe
Folded plate stair

Design
Zeitform-Design GmbH
Günter Weber
Mainleus, Germany

Manufacturer
Zeitform-Design GmbH
Mainleus, Germany

Variable Systemtreppe. Durch die enorme Haltbarkeit der reinen Holzverbindung sowie des speziellen Vollholz-Sandwichmaterials entsteht eine in sich so tragfähige Einheit, dass nur drei Befestigungspunkte an der Außenseite ausreichen. Andere Systeme müssen an jeder Stufe befestigt werden. Die Konstruktion kann in jeder Form (gerade, gewendelt, asymmetrisch, oval, Freiform …) gebaut werden und braucht keine stützende Wand (Abhängung genügt). Dadurch kann man „Skulpturen" bauen, ohne, dass der Preis explodiert. Damit ist diese Konstruktion die erste Faltwerktreppe, die eine solche Stabilität erreicht. EU-Zulassung erteilt am 16. April 2008.

Variable stairs system. The enormous durability of the timber joints and the special wooden sandwich material form the basis of a unit which is so stable that only three fixing points are needed on the outer side. Other stairs systems need joints to be fixed on each step. Any form of construction is possible (straight, coiled, asymmetrical, oval, free form), without requiring a supporting wall (suspension suffices). This allows for staircase "sculptures" without the price reaching explosive limits. This construction is the first folded plate stair achieving such high levels of stability. The EU qualification approval was granted 2008.

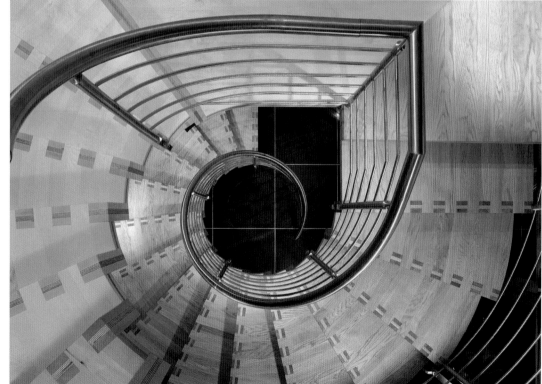

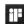

Product
Schalterprogramm Gira Event Klar
Switch range

Design
Phoenix Design GmbH & Co. KG
Stuttgart, Germany
Gira Giersiepen GmbH & Co. KG
Gira Designteam
Radevormwald, Germany

Manufacturer
Gira Giersiepen GmbH & Co. KG
Radevormwald, Germany

Das Schalterprogramm Event wird von Gira neu definiert: Gira Event Klar. Das Design überzeugt durch eine klare Tiefenoptik mit hochglänzender Oberfläche. Der besondere optische Effekt beruht auf einer speziellen Technologie, bei der transparenter Kunststoff farbig hinterlegt wird. Dadurch verändert sich der Lichteinfall auf die neuen Farben, die Gira anbietet: Weiß, Schwarz, Grün, Aubergine, Braun und Sand. Einsätze dazu gibt es in Reinweiß glänzend und Cremeweiß glänzend sowie in Anthrazit und der Farbe Alu. Gira Event Klar ist lieferbar mit über 230 Funktionen für die moderne Elektroinstallation.

Gira has newly defined the Event switch range: Gira Event Clear. The design convinces with a clear, deep appearance and high-gloss surface. The optical effect is based upon a special technology that enables transparent plastic to be color highlighted. This modifies the incidence of light upon the new colors offered by Gira: white, black, green, aubergine, brown and sand. Suitable inserts are available in pure white glossy, cream white glossy, anthracite and aluminium. The functions are as new as the colors – Gear Event Clear is available in full assortment, meaning over 230 functions for modern electrical installation.

Product
Gira Rufsystem 834 Dienstzimmerterminal
Gira nurse call system

Design
Tesseraux + Partner
Potsdam, Germany
Gira Giersiepen GmbH & Co. KG
Gira Designteam
Radevormwald, Germany

Manufacturer
Gira Giersiepen GmbH & Co. KG
Radevormwald, Germany

Das Gira Rufsystem 834 ist für den Betrieb in Kran-
kenhäusern, Pflegeheimen und Pflegeorganisatio-
nen ausgelegt, es kann aber auch in Arztpraxen oder
öffentlichen Sanitäranlagen eingesetzt werden. Das
Besondere dabei: Die verschiedenen Funktionen des
Gira Rufsystems 834 lassen sich in die Rahmen der
Gira Schalterprogramme Standard 55, E2, Event,
Esprit, E22 und das Flächenschalter Programm in-
tegrieren. Damit passt das Rufsystem nicht nur zum
jeweiligen Schalterprogramm, sondern in Kranken-
und Pflegebereichen lässt sich nun die gesamte Elek-
troinstallation durchgängig in ein und demselben De-
sign realisieren.

The Gira nurse call system is designed for operation
in hospitals, care homes and other care organiza-
tions, but can also be used for doctor's offices and
public sanitary installations. The special feature: The
various functions of the Gira nurse call system can
be integrated in the frames of the Standard 55, E2,
Event, Esprit, E22 and F100 switch ranges. The nurse
call system is therefore not only matched to the cor-
responding switch range, but in hospital and care
applications the complete electrical installation can
now be implemented in one and the same design.

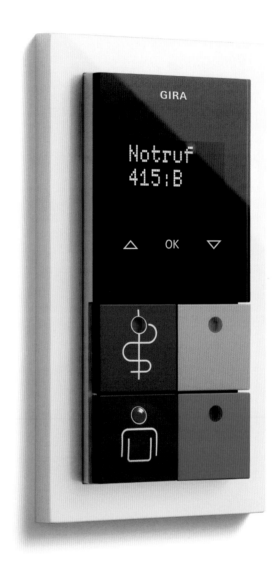

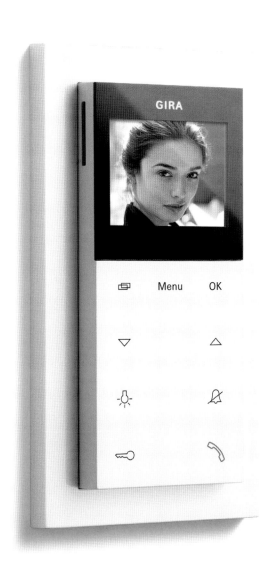

Product
Gira Wohnungsstation Video AP
Surface-mounted home station video

Design
Phoenix Design GmbH & Co. KG
Stuttgart, Germany
Gira Giersiepen GmbH & Co. KG
Gira Designteam
Radevormwald, Germany

Manufacturer
Gira Giersiepen GmbH & Co. KG
Radevormwald, Germany

Kompakt, elegant und technologisch auf dem neuesten Stand ist die Gira Wohnungsstation Video AP. Ein besonderes Merkmal der Wohnungsstation ist die homogene Front. Lautsprecher und Mikrofon sind von vorne nicht direkt sichtbar. Die hochauflösenden 2 TFT-Farbdisplays der neuesten Generation bieten eine hohe Tiefenschärfe und eine hervorragende Bildqualität, selbst bei unterschiedlichen Blickwinkeln. Kapazitive Sensortechnik erlaubt eine komfortable Bedienung durch leichtes Berühren der Tasten. Die Gira Wohnungsstation Video AP kann mit den Rahmen der Gira Schalterprogramme Standard 55, Event, Esprit, E22 und Flächenschalter kombiniert werden.

Compact, elegant and technologically up-to-date perfectly describe the Gira surface-mounted home station video. A special feature of the new home station is the homogeneous front. Loudspeaker and microphone are concealed from frontal view. The latest generation high-resolution 2" TFT color display offers a high level of depth definition and outstanding picture quality, even from various angles. Capacitive sensor technology allows convenient operation via a light touching of the buttons. The Gira surface-mounted home station video can be combined in various colors with the frames of the Gira Standard 55, Event, E2, Esprit, E22 an F100 switch rang.

Product
il vetro COMFORT
Video-Glasfreisprechstelle
Video glass intercom

Design
Tesseraux + Partner
Potsdam, Germany

Manufacturer
SKS-Kinkel Elektronik GmbH
Hof, Germany

Die Video-Freisprechstelle il vetro COMFORT wird unter Putz montiert und trägt lediglich 8 mm auf der Wand auf. Das 5,7"-Farbdisplay ermöglicht eine komfortable Videofunktion. Die Primärfunktionen sind deutlich dargestellt und werden direkt bedient. Alle weiteren Features, detailliertere Einstellungen zu den verschiedenen Funktionen, werden über eine Touchdisplay-Bedienung gesteuert, sind aber im Normalbetrieb nicht sichtbar. Die Akustik wird mit seitlichen Schallaustrittsöffnungen realisiert. il vetro COMFORT ist im Design zurückhaltend, um sich im größtmöglichen Maße in das architektonische Umfeld integrieren zu können.

The il vetro COMFORT video door station is flush-mounted and protrudes only 8 mm from the wall. The 5.7"-color display allows for ease of video operation. The primary functions are clearly displayed and can be directly accessed. All additional features and detailed settings for the various functions are controlled via a touch display, but this is not visible under normal operating conditions. The acoustics are handled via lateral loudspeaker openings. il vetro COMFORT has an understated look allowing it to blend easily with the overall interior and architectural design.

Product
INTUS 600
RFID-Zutrittsleser
RFID access reader

Design
ergon3
Thomas Detemple
München, Germany

Manufacturer
ergon3
München, Germany

Zeitgemäßer Zutrittsleser für RFID-Identifikationskarten. Das dezente Design des INTUS 600 passt sich der Umgebung an, bleibt dabei aber eigenständig und interpretiert die Designlinie der INTUS-Familie im kleinen Gehäuse neu. Das MagicEye, als bestimmendes Designelement aller INTUS-Geräte, wird in einzelne Lichtelemente aufgelöst. Sie signalisieren auf einen Blick: Gerät bereit, Karte akzeptiert oder abgewiesen. Für höhere Sicherheitsanwendungen ist es vorbereitet für die Eingabe von PIN-Nummern. Konsequent umweltfreundlich gebaut und leicht recycelbar nach RoHS, mit langlebiger Tastatur und schlagfestem Gehäuse.

A state-of-the-art access reader for RFID cards. While discreetly blending in with its environment, the INTUS 600 distinctively re-interprets the design line of the INTUS family with compact housings. The MagicEye as the dominating INTUS design element is resolved into individual light elements clearly signaling "device ready", "card accepted", or "card rejected". PIN code entry is possible for higher security applications. The INTUS 600 features a durable keyboard and shock-resistant housing. With its consistently environmentally friendly design, it is easily recyclable in line with the RoHS guidelines.

Product
HNT-3100
Home Network Wall-Pad

Design
Dadam Design Associates Inc.
Rock Hyun, Kim
Seoul, South Korea

Manufacturer
HYUNDAI TELECOMMUNICATION CO. Ltd.
Seoul, South Korea

Dieses Design-Konzept offenbart mit seiner einfachen Form kultivierte Schärfe. Die angemessenen und schlanken Proportionen werden durch eine einfache, schön gestaltete und eine mit den Bedienelementen ausgestattete Seite, betont. Die mit einem Laser ausgeschnittenen Symbole lassen das Gerät leuchten und besser aussehen. Die Proportionen der Vorderseite und des Gehäuses sind in verschiedenen Materialien und Farben gehalten, um einen schönen Kontrast zu den Symbolen zu erhalten. Das sanfte Blumenmuster lässt das Gerät luxuriös und prächtig aussehen.

The design concept shows refined sharpness while preserving a simple shape. Appropriate proportions and slimness are presented by having one simple side that is finely treated and another with a slope and touch buttons. The icons on the right side give a lighting effect to the simple shape through laser cutting, making the product generally look better. The proportions of the front cover and the main body are of different materials and colors in appropriate division to keep the edge with the size of the icons. The soft flower patterns are applied to give a posh and splendid atmosphere.

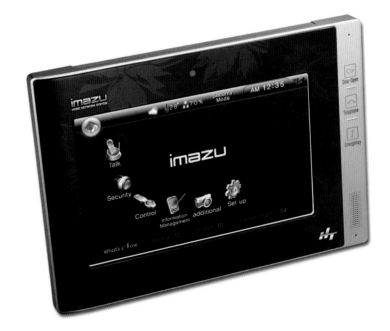

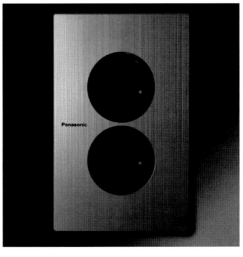

Product
FLATIMA series
Beschaltungsgeräte
Wiring devices

Design
Panasonic Electric Works Co., Ltd.
Corporate Design Department
Katsumi Kikuchi, Ichiro Shibamura
Osaka, Japan

Manufacturer
Panasonic Electric Works Co., Ltd.
Osaka, Japan

Eine Serie, die mit ihrer überlegenen Qualität überzeugt und die Vorstellung von Beschaltungsgeräten revolutioniert. Sie wurde speziell für den koreanischen Markt konzipiert. Die Schaltstruktur mit Ein/Aus-Druckmechanismus ist der weltweit erste mit dieser einzigartigen Technologie von Panasonic. Maximiert wurde dieses Merkmal durch die Flachheit des Produkts und die Plattenstruktur, die in herkömmlichen Beschaltungsgeräten ihresgleichen suchen. Aluminiumtafeln, ausgewähltes Metall für den modernen Wohnraum und ein mattschwarzes Finish ergeben eine Kombination, die beeindruckt. Der scharfkantige Look passt sich jeder Inneneinrichtung an.

Wiring device series aimed at the Korean market. A series that reflects pursuit of superior quality and a revolution in the image of wiring devices. Targets the modernizing Korean luxury apartment market. The switch structure with push-on/off handling mechanism is a world first with technology unique to Panasonic. This feature is maximized by the flatness of the product and the plate structure, unprecedented in conventional wiring devices. Aluminium boards, selected metal for modern living space and matt black finish create a combination with impact. The resulting cutting edge image harmonizes with any interior.

Product
AURORA C1
Deckenberieselungsanlage mit Beleuchtung
Ceiling sprinkler with fluid-driven lighting

Design
DUCK IMAGE CO., Ltd.
Ta-Wei Chien, Yien-Bo Chen
Hsinchu, Taiwan
Industrial Technology Research Institute
Jung-Huang Liao
Chutung, Hsinchu, Taiwan

Manufacturer
Industrial Technology Research Institute
Chutung, Hsinchu, Taiwan

Die Deckenberieselungsanlage wird auf der Vorderseite des Sprinklers oder direkt am Wasseranschluss installiert. Wasser fließt durch die Turbine, treibt ihre Rotoren an und erzeugt Elektrizität. Die Energie versorgt das Beleuchtungssystem. Das Beleuchtungssystem benötigt deshalb weder Batterien, elektrische Leitungen noch Solarenergie. Diese Erfindung fördert den Klimaschutz, Bequemlichkeit und die Lebensqualität.

Fluid-driven lighting system is installed on the front-end of sprinkler or at the back-end of outlet. The centrifugal or axial-flow turbine will be driven to generate electricity by the generator connected with the turbine as the fluid passes through the inner tube. The power will provide the lighting system and it does not need any battery, electric wire and solar energy absolutely. This invention can have the advantages of environment-protection, convenience and life-quality promoting.

Product
Randi-Line® Komé
Türgriff
Door lever

Design
C. F. Møller Architects
Jon Bröcker, Michael S. Colfeldt
Aarhus C, Denmark

Manufacturer
Ingersoll Rand Security Technologies A/S
Randers NØ, Denmark

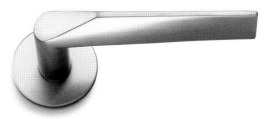

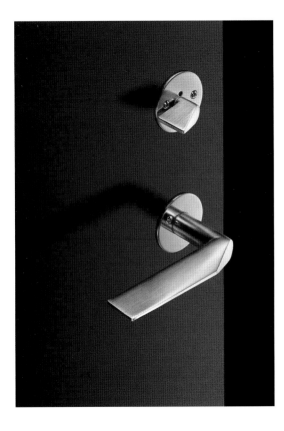

Architektur, Funktion und Ergonomie sind die Grundlagen, auf denen die neue Griffserie, Randi-Line® Komé, der C. F. Møller Architekten entstand. Ein Vorschlag für einen weiteren modernen Klassiker in der bewährten Randi Qualität. Der tägliche Gebrauch offenbart die funktionelle und ergonomische Dimension – kleine Dinge, die zusammen den großen Unterschied ausmachen. Randi-Line® Komé ist eine komplette Serie von Türdrückern, Rosetten und Schildern aus Edelstahl, die mit den anderen Produkten von Randi kombiniert werden können. Eine gute Wahl für das professionelle Planen und Bauen.

Architecture, function and ergonomics are the foundations of a new and exciting series of door handles, Randi-Line® Komé, designed by Danish C. F. Møller Architects represent a serious contender for a modern classic, with the familiar Randi quality. Even small things make a big difference – the brushed, silky-soft stainless surface and the angle for the thumb make this quite simply a good handle to use. Randi-Line® Komé is a complete series of lever handle, thumb turn, roses and back plates in stainless steel, and can be combined with the existing Randi product range. For professional building the right choice.

Product
Sentido
Schalter
Switch

Design
manzana
Klaas Arnout, Sandra Maes
Gent, Belgium

Manufacturer
basalte
Gent, Belgium

Sentido-Schalter zeichnen sich durch Schlichtheit, Komfort und hohen Anspruch an die Qualität aus. Aufgrund einer innovativen Berührungstechnologie, hochwertiger Materialien und einer reduzierten Formgebung entfalten sie eine zeitlose Anmutung. Die Oberfläche besteht aus gebürstetem Aluminium und ist berührungsempfindlich. Eine leichte Berührung genügt, um Leuchten zu bedienen. Sentido-Lichtschalter sind in zwei Ausführungen erhältlich: einmal mit zwei und einmal mit vier verschiedenen Funktionen. Wenn mehr als eine Fläche gleichzeitig berührt wird, entsteht eine zusätzliche Komfortfunktion.

The Sentido switch series is marked by simplicity, comfort and high demands in terms of quality. Thanks to an innovative touch technology, the high-quality materials used and a reduced styling, the switches are imbued with an appearance of timelessness. The surface is brushed aluminium and is touch-sensitive. A slight touch suffices to operate lighting. Sentido light switches are available in two types: one with two functions and one with four functions. Touching more than one switch area simultaneously activates an additional comfort function that can be used to switch all the lights in the room on or off in a single movement.

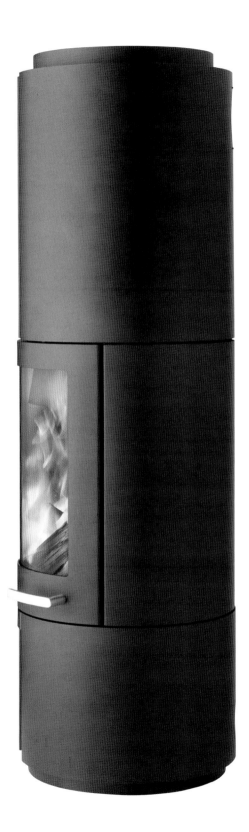

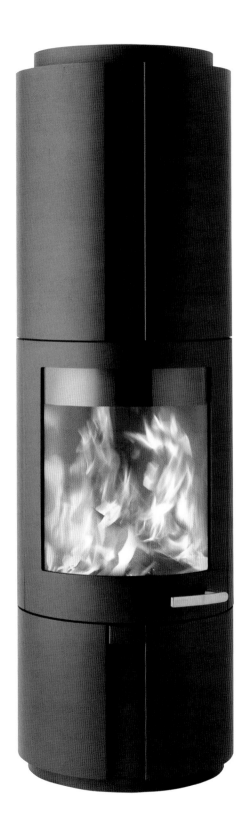

Product
SOLO
Kaminofen
Wood burning stove

Design
Helix Akantus Formgestaltung
Cornelius van den Hövel,
Gerhard Scherbinski-von Volkmann, Rolf Bürger
Münster, Germany

Manufacturer
Skantherm Wagner GmbH & Co. KG
Rheda-Wiedenbrück, Germany

Kaminofen aus Stahl, Durchmesser ca. 46,8 cm, Gesamthöhe 150 cm. Die Brennkammer (Mittelteil) ist in beiden Richtungen drehbar. Sowohl das Oberteil über der Brennkammer als auch das Unterteil bleiben bei der Drehbewegung feststehend. In der Endposition ergibt sich eine durchgängige Linie der Stahl-Türbreite (Lisene) mit der Fuge, die frontal von oben nach unten verläuft.

Wood burning stove, material steel, diameter ca. 46.8 cm, total height 150 cm. The burning chamber (middle part) is pivoting in both directions. Either the upper part as well as the bottom part remains in a fix position when the middle part is rotating. In the final position there is a general line of the steel-door width (pilaster strip) with the joint, which is going from the top to the bottom.

Product
T 15/1
Trockensauger
Dry vacuum cleaner

Design
Alfred Kärcher GmbH & Co. KG
Denis Dammköhler
Winnenden, Germany

Manufacturer
Alfred Kärcher GmbH & Co. KG
Winnenden, Germany

Der extrem leise arbeitende Trockensauger T 15/1 ist mit großem, 15 Liter fassenden Behältervolumen für lange Arbeitsintervalle beim Einsatz in der gewerblichen Gebäudereinigung entwickelt worden. Auch die Zubehöraufbewahrung mit integrierter Schlauchfixierung sowie zwei Parkpositionen für die Bodendüse entsprechen den Anforderungen der professionellen Zielgruppe. Das robust konstruierte Chassis schützt die Technik vor Schlägen und Stößen. Ein Drehregler mit innovativer Öffnungsgeometrie ermöglicht die stufenlose Regulierung der Saugleistung, ohne dass dabei die Lautstärke spürbar zunimmt.

The extremely quiet T 15/1 dry vacuum cleaner has a big 15 litre container for long periods of uninterrupted operation in contract cleaning. The accessory stowage facilities on the unit also comply with the professional criteria required for the target group: the suction hose can be locked in position and the floor tool can be parked in two different positions. The rugged housing protects machine components from knocks. Suction power is adjustable directly on the rotary controller with its sophisticated aperture geometry without any noticeable increase in noise level.

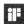

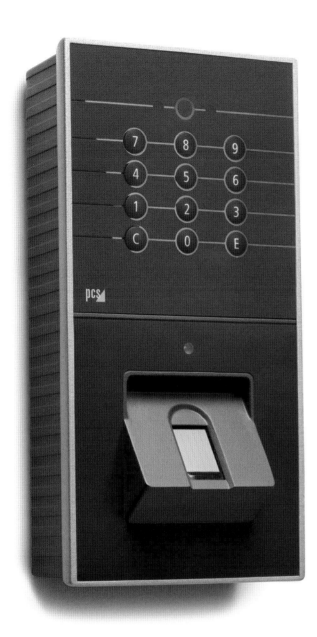

Product
INTUS 600FP
Fingerprint-Leser
Fingerprint reader

Design
ergon3
Thomas Detemple
München, Germany

Manufacturer
ergon3
München, Germany

Biometrische Zutrittskontrolle mit kontaktlosem Leser und PIN kombiniert: So kompakt kann ein leistungsfähiger Zutrittsleser aufgebaut sein. Konsequent in der Designlinie der INTUS-Familie ist der INTUS 600FP durch den modularen Aufbau wahlweise für Komfort-, Sicherheits- oder Hochsicherheitsanwendungen konfigurierbar. Neben dem MagicEye als zentrale Anzeige, prägt die ergonomische Integration des großen Flächen-Fingerprint-Sensors das Erscheinungsbild. Das robuste Gehäuse mit Schloss und Sabotagekontakt unterstreicht den professionellen Charakter des Gerätes für den Einsatz in Sicherheitsanwendungen.

Biometric access control combined with an RFID reader and PIN code entry: that's how compact a powerful access reader can be. Consistently in line with the INTUS family design, the modular INTUS 600FP can be configured for user-friendly, secure, and highly secure applications. Its predominant feature next to the central MagicEye indicator is an ergonomically integrated large-area fingerprint sensor. The robust housing secured by a lock and a tamper contact underlines the professional character of the device for use in high-security applications.

Der Endnutzer hat bei der Auswahl der Objekte, mit denen er außerhalb seiner eigenen vier Wände im Alltag konfrontiert wird, wenig mitzureden. Die Designer trifft daher ebenso wie die Entscheidungsträger im Hinblick auf die Qualität der Objekte, die Formen sowie die von ihnen ausgestrahlte Atmosphäre eine große Verantwortung, denn hierdurch wird die Lebensqualität aller Menschen beeinflusst.

Ich bin oft unterwegs, besuche zahlreiche Städte und verbringe viel Zeit außerhalb meiner kleinen Welt, die ich zu Hause und am Arbeitsplatz geschaffen habe. Der öffentliche Raum hat für mich eine große Bedeutung – ständig bin ich von Dingen umgeben, die ich nicht selbst ausgesucht habe, für die andere Menschen Geld ausgegeben haben ... oder auch nicht: Sehen Sie sich nur die Bahnhöfe in Brüssel an, und Sie werden verstehen, warum diese Orte Tausende von Reisenden keinen Deut glücklicher machen. Jedes Mal, wenn ich dort bin, werde ich völlig deprimiert – und jetzt stellen Sie sich vor, wie wohltuend das Gegenteil wäre!

Leider merkt man in der Kategorie Public Design sofort, dass guter Gestaltung hier eine ganz andere Bedeutung zugemessen wird als in der zweiten Kategorie, die ich als Jurymitglied zu beurteilen hatte – Freizeit. Das ist eine Kategorie, in der die Menschen zum Kaufen verführt werden müssen. Die Kunden sind heutzutage gut informiert, kritisch und ganz bestimmt nicht dumm. Der Bedarf an gutem Design ist extrem hoch, und die Hersteller unternehmen in diesem Bereich ersichtlich enorme Anstrengungen. Natürlich tragen die Designer auch hier Verantwortung, doch letzten Endes entscheidet der Kunde selbst darüber, mit welchen Objekten er in seinem Alltag konfrontiert werden will.

Bei der Entscheidung über die Gestaltung öffentlicher Räume sollte man sich stets folgende Frage stellen: Würde ich das in meinem eigenen Haus haben wollen? Auf diese Weise kann der Designer die Dinge mit mehr Emotionalität gestalten.

End users have little say in choosing the objects they will be confronted with in daily life outside the private spaces they live in. Designers and decision-makers have huge responsibilities concerning the quality of objects, forms and atmospheres that will influence the quality of life of other people.

I travel a lot, I visit many cities and spend a lot of time outside the little environment I have created for myself at home and also at work. Public spaces are important to me, and I'm constantly surrounded by things I didn't choose myself, things that other people decided to spend money on ... or not: Come with me to the modern railway stations of Brussels, and you will understand why these places do not make thousands of travelers any happier. I get totally depressed every time I go there; imagine the benefits of the opposite!

Unfortunately, you can immediately tell that good design is assessed differently in the public design category than in the other category for which I had the pleasure of being a jury member: Leisure, a category where people have to be seduced to buy. Customers nowadays are well informed, critical and definitely not stupid. The need for good design is extremely high and you can see that producers invest an enormous amount of effort. Of course designers have a responsibility here as well, but in the end it will be the consumer himself who will decide whether he wants to be confronted with an object in his daily life or not.

A good question to add to the public design decision-making process: Would I want this in my own house? This will give designers the opportunity to create designs with more emotional qualities.

Product
FSB – Fingerscan 2.0
Fingerscan-Türgriff
Fingerscan handle

Design
FSB
Brakel, Germany

Manufacturer
FSB
Brakel, Germany

Mit dem Türgriff Fingerscan 2.0 lassen sich Haus-
oder Wohnungseingangstüren schlüssellos öffnen.
Klassische FSB-Rohrgriffmodelle werden mit einer
dezent angebrachten biometrischen Identifikations-
einheit ausgestattet. Fingerscan-Türgriffe können für
private Hausbesitzer bis zu 10 Personen bzw. 99 Fin-
ger verwalten und als Netzwerklösung bis zu drei
Türen bzw. sonstige Applikationen betreiben. Eine
netzwerktechnisch komplexere Ausführung ist für
Unternehmen realisierbar. Abgerundet wird das Sys-
tem um ein Motorschloss oder eine motorisch betrie-
bene Mehrfachverriegelung, die die Tür immer wie-
der, nachdem sie ins Schloss gefallen ist, verriegelt.

The Fingerscan 2.0 pull handle allows doors of flats or
houses to be opened without a key. Classic FSB tubu-
lar handle models are stylishly fitted with a biometric
identification unit for this purpose. Fingerscan door
pulls can administer up to 10 persons or 99 fingers
for homeowners and operate up to three doors or
other applications in networked arrangements. More
complexly networked variants can be configured for
companies. A motorized lock or a motor-operated
multipoint locking facility that always locks the door
when it closes rounds off the system.

Product
Prizis Kiosk
Selbstbedienungsterminal
Self-service terminal

Design
Itautec
Edson Danta Dias, Fabio Sant'Ana
Jundiaí – SP, Brazil

Manufacturer
Itautec
São Paulo – SP, Brazil

Das Prizis Kiosk ist das neueste Produkt im Bereich Itautec-Selbstbedienung mit perfekter Ergonomie durch kühnes, kompaktes und modernes Design. Das Prizis Kiosk bietet Institutionen und Betrieben verschiedener Segmente viele Nutzungsmöglichkeiten sowie den Angestellten, Kunden, Mitgliedern und Schülern die Einfachheit und Zweckmäßigkeit einer interaktiven und persönlichen Selbstbedienung. Neben den üblichen Terminal-Leistungen stehen verschiedene weitere Angebote zur Verfügung: Dienstleistungsanfragen, Produktverkauf, Finanzierungen und Aktualisierung des Personalregisters. Es unterstützt den Zugang zum Internet.

The Prizis Kiosk is the newest product line of self-service Itautec. Presents perfect ergonomics through a bold design, compact and modern. The Prizis Kiosk allows institutions and companies from different segments to benefit from its resources, offering its employees, customers, members or students, the ease and convenience of self-service, fully interactive and personalized. There is even more than the regular services available: various consultations, prompt service, offer to sell the product; financing; update of registration, in addition it provides public Internet access.

Product
Validador Iconn
Ticket-Entwerter
Ticketing validator

Design
Questto Design
Levi Girardi, Luiz Alves
São Paulo – SP, Brazil

Manufacturer
iConn Tecnologia
São Paulo – SP, Brazil

Dieser Fahrkartenentwerter ist ein Equipment für städtische Verkehrssysteme, wie Busse, Kleinbusse usw., dessen besonderer Unterschied darin liegt, dass er auch als selbständiges System verwendet werden kann. Aus diesem Grund hat das Equipment niedrige Kosten und kann einfach eingebaut werden. Es ist ein Equipment mit hoher Technologie, das mit Karten – mit oder ohne Kontakt – arbeitet und so eine geeignete Kontrolle des Tickets ermöglicht.

The Iconn ticketing validator can be used on board of public transportation systems such as buses, minivans etc. The main differential is that utility operators can use it likewise in a conventional system or it may be used in autonomous charging models, like in markets where the vehicle's proprietor is the one operating the system. This equipment has low costs and can be easily installed, so that the driver himself can handle the job. This high technology equipment operates using cards with or without contact and enables full control of the tariff system.

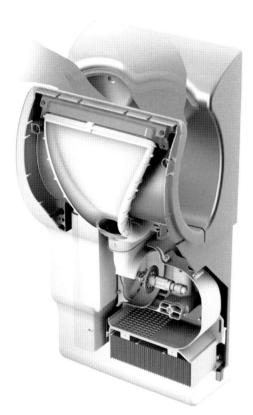

Product
Dyson Airblade
Händetrockner
Hand dryer

Design
Dyson Ltd.
James Dyson
Malmesbury, Wiltshire, United Kingdom

Manufacturer
Dyson GmbH
Köln, Germany

Der Dyson Airblade Händetrockner trocknet Hände vollständig in nur zehn Sekunden und verbraucht im Vergleich zu gewöhnlichen Warmluft-Händetrocknern bis zu 80 Prozent weniger Energie. Der digitale Motor des Airblade erzeugt einen Luftstrom, der mit rund 644 Kilometern pro Stunde fließt. Die ungeheizte Luft wird durch einen 0,3 Millimeter breiten Spalt geführt. Der Luftstrom arbeitet wie ein unsichtbarer Scheibenwischer, der die Nässe von den Händen wischt und diese vollständig trocken hinterlässt. Die HEPA-Filtrierung entfernt über 99,9% der Bakterien aus der Luft, bevor diese auf die Hände geblasen wird.

The Dyson Airblade hand dryer is a breakthrough in hand-dryer technology. Filtering incoming air to remove 99.9% of bacteria, the Dyson Airblade hand dryer creates a high-speed sheet of unheated air by forcing it through an aperture with the width of an eyelash. This sheet of air wipes the water from hands in just 10 seconds. Powered by Dyson's digital motor the Dyson Airblade hand dryer uses up to 80% less energy than warm air hand dryers.

 Public Design / Interior Design

Product
ECR-2000
Aufladegerät
Automated load machine

Design
KODAS Design
You-sup Yi, Hyun Jung, Jung-mi Song
Seoul, South Korea

Manufacturer
eb Co., Ltd.
Seoul, South Korea

Ein automatisiertes Aufladegerät, das es den Fahrgästen ermöglicht, die Bilanz ihrer Chipkarte zu überprüfen und das Guthaben aufzuladen. Das Gerät wird im Bus installiert. Der Bildschirm, auf dem die Karteninformationen der Fahrgäste angezeigt werden, befindet sich auf der Oberseite, damit andere persönliche Informationen nicht einsehen können. Das Auflade-Gehäuse ist rund geformt, um unterschiedliche Kartengröße zu akzeptieren, und wird durch eine LED beleuchtet. Die Beleuchtung vereinfacht es den Fahrgästen, die Karte in den rechten Kartenschlitz zu stecken.

An automated load machine enables passengers to check the balance of their smart card and charge it. It is installed inside the bus. There are several buttons from top to bottom according to the steps that are required to complete the charging process. Passengers can simply start with the button on top and follow the buttons down to complete the process. The display screen, where passenger card information is shown, is placed on top, so that no one else can see your private information. The charging part is of a round shape to accept various sizes of cards and supported by LED lighting to guide passengers to insert the card into the right slot.

Product
KRYPTON
Display-Wandsystem
Wall system

Design
NOSE Applied Intelligence AG
Ruedi Müller, Urs Herger
Zürich, Switzerland

Manufacturer
EXPOTECHNIK Heinz Soschinski GmbH
Taunusstein, Germany

Das modulare Display-Wandsystem Krypton besteht aus extrudierten Aluminium-Stranggussprofilen und wurde für den Einsatz auf Messen, Events und permanenten Installationen konzipiert. Nahezu grenzenlose Gestaltungsmöglichkeiten hinsichtlich der Fassadengestaltung von der Textilmembran bis zu 50 mm starken Paneelen aus Glas, Aluminium, Acryl, Stein oder Holz eröffnen eine Vielzahl an architektonischen Möglichkeiten. Zu den Ausstattungselementen gehören elektrische Schiebetüren, integriertes Kabelmanagement, Showcases und Multimedia-Equipment sowie eine Biege- und Neigesteifigkeit, mit der Bauhöhen von bis zu 14 Metern realisierbar sind.

The Krypton modular wall system is based on extruded aluminium profiles designed for exhibitions, events and environments. Virtually endless design possibilities in regards to surface material such as, textile sheeting, 50 mm thick panels made off glass, aluminium, acrylic, stone and wood allow a wide range of architectural freedom. Additionally electrical sliding doors, showcases and multimedia equipment can be integrated. The typical technical specifications of the Krypton wall system enables wall heights of up to 14 meters.

Product
GAMMA
Counter und Präsentationsserie
Counter and presentation serie

Design
NOSE Applied Intelligence AG
Ruedi Müller, Urs Herger
Zürich, Switzerland

Manufacturer
EXPOTECHNIK Heinz Soschinski GmbH
Taunusstein, Germany

Die Counter- und Präsentationsserie Gamma ermöglicht anspruchsvolle Markenkommunikation auf Messen und Ausstellungen. Die Serie besteht aus den Varianten Info- und Präsentationscounter, Bartheke, Workstation sowie Showcase. Gamma basiert auf zwei gleichproportionierten übereinander geschichteten Korpuselementen, die gegeneinander verschoben werden können. Die Oberflächen sind austauschbar und können so leicht den individuellen Anforderungen des Kunden angepasst werden. Wandlungsfähigkeit und lange Produktlebensdauer erfüllen sowohl ökologische wie auch ökonomische Aspekte.

The Gamma counter and presentation series is a sophisticated way to communicate brands at any event or exhibition. This series contains info- and product presentations counters, a bar and workstation and showcase modules. The Gamma concept is based on a two double-deck, same-sized main frames, which can be slid into opposite ways. The surfaces are interchangeable and can be easily adapted to customers individual requirements. The interchangeability and sustainability of the products are environmentally friendly and economical at the same time.

Product
ON-OFF Markers
Klappschilder
Collapsible markers

Design
Fontana-Hunziker Design Office
Daniel Hunziker, Georg Fontana
Rapperswil, Switzerland

Manufacturer
Faltmann
Stäfa, Switzerland

ON-OFF Markers TISCHNUMMERN MIT DOPPEL-
FUNKTION. Nachhaltige Edelstahl-Tischnummern mit
einer Doppelfunktion. Der Fuß der Tischnummern ist
das Réservé-Schild. Ein einfaches Umkippen genügt
und aus der Tischnummer wird ein Réservé-Schild.
Dies funktioniert natürlich auch umgekehrt. Material:
1,5 mm Stainless Steel.

ON-OFF Markers TABLE-NUMBRES WITH TWO FUNC-
TIONS. Sustainable stainless steel table numbers with
two functions. The foot of the table number is the
reservation sign. Simply tip the table number over
and it turns into a reservation sign. This works also
reversed. Material: 1.5 mm stainless steel.

Product
Serviceinsel
Service island

Design
LengyelDesign
Designteam
Essen, Germany

Manufacturer
Deutsche Post AG
Bonn, Germany

Die in einem modularen System aufgebaute Service-
insel für Post-, Paket- und Finanzdienste vereint be-
stehende Automaten verschiedener Hersteller unter
einem Dach und einer Marke zu einer ikonenhaften
Einheit. Die Geräte werden durch eine Fassade aus
verspiegeltem, satiniertem Glas abgedeckt, während
die Interfaces in einem vorgegebenen Raster bündig
in die Glasfront eingepasst sind. Dadurch wird eine
einheitliche Benutzerführung ermöglicht, während
die unterschiedlichen Gehäuse der Geräte verborgen
bleiben. Das durchgängige Raster der Verkleidung
gewährleistet eine optimale Wiedererkennung der
Serviceinsel in allen Konfigurationen und Größen.

The modular system of the service island for post, par-
cel and financial services unites existing automats by
various manufacturers under one roof and one brand
to become an iconic unit. A reflective satin glass fa-
cade covers the automats, while the interfaces are
flush fit into the glass front according to a preset
pattern. This enables consistent user guidance, while
the different cases remain hidden. The continuous
pattern of the casing guarantees optimum recogni-
tion of the service island at any size or set-up.

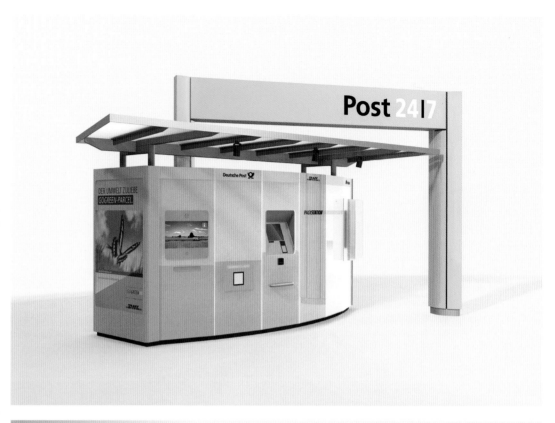

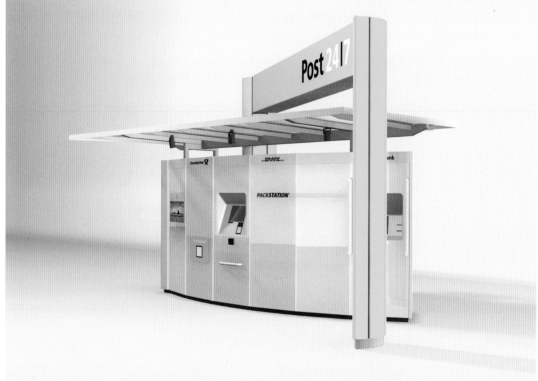

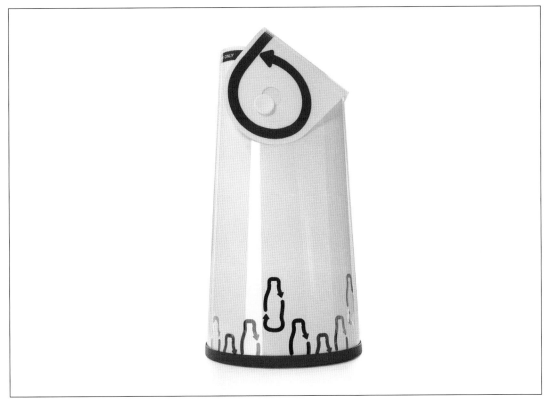

Product
Coca-Cola Refresh
Behältnis zur Wiederverwertung
Recycling bin

Design
fuseproject
Yves Behar, Josh Morenstein, Nick Cronan
San Francisco, CA, United States of America

Manufacturer
Profit Master Displays Inc.
Atlanta, GA, United States of America

Mit dem Coca-Cola Refresh Recycling Bin will Coca Cola seinen Anspruch als Weltmarktführer im PET-Recycling erweitern. Dies ist ein innovativer Schritt, um die Aufgabe Müllvermeidung durch Recycling zu lösen. Refresh kombiniert grüne Philosophie mit grüner Produktion und grünem Transport. Es ist bemerkenswert einfach aus einem Stück in RPET gefertigt, eine einfach gegossene Form mit einem Druckknopf. Die Komponenten kann man für den Transport flach packen und verbrauchen daher kaum Energie bei der Produktion, Transport und Herstellung. Das Behältnis hat das Potenzial, zu einer Ikone zu werden, und soll vorrangig an Orten mit hohem Verkehrsaufkommen aufgestellt werden, um dort Bewusstsein für Nachhaltigkeit zu schaffen.

The Coca-Cola Refresh Recycling Bin, part of Coke's effort to become a global leader in PET recycling, is an innovative step towards solving the problem of trash vs. recycling. The bin is unique because it not only encourages people to recycle, it also showcases the exeptional design potential of recycled plastic. The Refresh Bin combines green philosophy, green manufacturing, shipping and assembly. The construction is remarkably simple, it's made from one piece of sheet material die-cut into an inner and outer shell of the most available form of RPET, a simple molded base and plastic snaps. Its' components pack flat for shipping and require very little energy to create, transport and assemble. The bin is iconic and welcoming, by being placed in high-traffic areas, it raises awareness about sustainability.

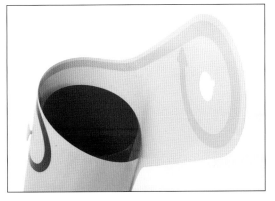

Product
NYC Condom
Kondomautomat
Condom dispenser

Design
fuseproject
Yves Behar, David Riofrio, Josh Morenstein,
Guiseppe Della Salle
San Francisco, CA, United States of America

Manufacturer
Ultimate Hydroforming
Sterling Heights, Mi, United States of America

Der Kondomautomat NYC Condom geht auf eine Initiative des New Yorker Gesundheitsdepartments zurück: Die kostenlose Verteilung von Kondomen ist eine effektive Maßnahme gegen HIV-Infektionen und unerwünschte Schwangerschaften. Der Automat ist der Hauptvertriebsweg des Gratis-Kondom-Programms. Durch die Gestaltung soll dem negativen Beigeschmack entgegengewirkt werden; dabei ging es um die Errichtung eines integrierten, in verschiedene Orte und Umgebungen passenden Netzes. Die Form erinnert an ein in der Brieftasche aufbewahrtes Kondom – ein typisch New Yorker Entwurf für alle Hautfarben.

The NYC Condom is an initiative of the NYC department of Health: the free distribution of condoms is an effective measure against HIV infections and unwanted pregnancies. The dispenser is the primary distribution system for the free condom program. Visually and graphically, the purpose of the NYC Condom initiative is to help the city of New York achieve its two main goals: raising citizen's awareness of the condoms and driving dispenser adoption by businesses. The challenge was creating an integrated system of dispensers and condoms that could live in multiple venues and environments. Reminiscent of a condom shape warped into the surface of one's leather wallet, the design is distinctly New York and approachable to multiple demographics from high end lounge to bar to clinic and shelters.

Product
68 Q-MC ACCIAIO INOX
Energieverteiler
Energydistributor

Design
GEWISS SPA
Cenate Sotto-Bergamo, Italy

Manufacturer
GEWISS SPA
Cenate Sotto-Bergamo, Italy

Dieser Energieverteiler mit Außenverkleidungen aus poliertem Edelstahl AISI 316L vervollständigt die Baureihe 68 Q-MC. Er ist ideal für Anwendungen im Marinebereich. Das Gehäuse, aus Technopolymer, erfüllt alle Anforderungen der Schutzklasse II. Der Kopf besteht ebenfalls aus Technopolymer, was zur Verhütung der Brandgefahr beiträgt. Das Kopfende ist mit einem Griff und 2 Ablagen für Schläuche ausgestattet. Der Griff vereinfacht den Transport, die Ablage erleichtert die Bedienung. Der Energieverteiler kann mit Steckdosen für elektrischen Strom (NORM IEC 60-309-1/2), Anschlüssen für TV/SAT/RJ45 für Telefon, mit Wasser- u. Leuchtbausatz ausgestattet werden.

The terminal in electro polished stainless steel AISI 316L completes the 68 Q-MC range. The stainless steel is ideal for applications in the marine area and provides a high level of mechanical resistance to shocks and double shell electrical insulation, class II. The head is also in Techno polymer: This avoids any risk of fire hazard. A head handle facilitates transportation and side sections allow the winding of water tubes. The terminal has an electrical enclosure for protection devices. It can be also equipped with interlocked socket-outlets (standard IEC 60309-1/2), TV/STA and RJ45 Telephone socket-outlets, and with a water or lighting kit.

Product
Mediamesh®
System zur architekturintegrierten Medialisierung
System for architecturally integrated facade media-
lisation

Design
ag4 media facade GmbH
Köln, Germany

Manufacturer
GKD – Gebr. Kufferath AG
Düren, Germany

Mediamesh®, Edelstahlgewebe mit LED-Profilen, me-
dialisiert Fassaden vollflächig bei Tag und Nacht. Das
transparente System verbindet die architekturinte-
grierte Ästhetik der gewebten Haut mit innovativer
Bespielung in höchster Bildauflösung – bei uneinge-
schränkter Nutzung der dahinter liegenden Räume.
Ob Bilder, Videos oder Live-Übertragung: Media-
mesh® wird individuell auf jede Anwendung und
Gegebenheit entwickelt. Geringer Stromverbrauch,
lange Lebensdauer, Wetter- und Temperaturbestän-
digkeit von –20 °C bis +70 °C sprechen für das Ge-
samtkonzept. Mediamesh® ist ein Gemeinschafts-
produkt der ag4 media facade GmbH und GKD –
Gebr. Kufferath AG.

Mediamesh®, stainless steel mesh with LED profiles
turn the full surface of façades into a multimedia
spectacle, by day and night. The transparent sys-
tem combines aesthetic integration into architecture
and innovative high-resolution projection capability
– without limiting the use of the rooms behind the
façade. Whether for images, videos or live transmis-
sions, Mediamesh® is custom configured for each
individual application and occasion. Low power con-
sumption, long service life, weather and temperature
resistance from –20 °C to +70 °C all speak for this
integrated concept. Mediamesh® is a joint produc-
tion of ag4 media facade GmbH and GKD – Gebr.
Kufferath AG.

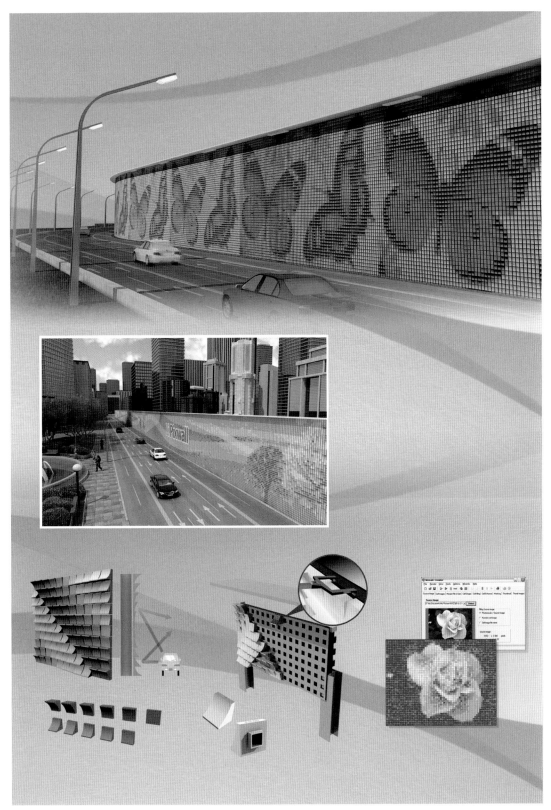

Product
Xi-Pixwall
Modul-Kompoundierung Lärmschutz
Modular sound proof wall system

Design
GS E&C
Myoung hoe Seo
Seoul, South Korea

Manufacturer
GS E&C
Seoul, South Korea

„Xi-Pixwall" ist ein neues modulares Lärmschutzwand-System für Straßen. Es ist flexibel, passt sich den jeweiligen Bedürfnissen der Umwelt an und hebt sich dadurch von den bereits existierenden funktionalen Formen ab. Mit den sechs verschiedenen Blockmodulen kann man elf verschiedene Helligkeitsstufen einstellen. Diese elf Stufen werden von den Pixeln erkannt und verwandeln die Lärmschutzwand in ein einziges, großes Display. Jede mit Pixeln versehene Einheit ist abnehmbar und lässt sich ohne irgendwelche Hilfen einfach in verschiedene Bilder umwandeln. Sein Äußeres passt sich ganz leicht der jeweiligen Umwelt an und wird dazu beitragen, ein Meilenstein der Region und der Kultur sowie ein kommunikatives Medium zu werden.

"Xi-Pixwall" is a modular sound proof wall system for roadsides. It is flexible and forms a surface for environments and situations while escaping from existing methods providing function-based form. 6 types of block module create 11 levels of shades with light. 11 levels of shades are recognized as pixels and turn the soundproof wall into one large display. Each unit block becoming a pixel is detachable, and easily turns into various images without additional resources. It can change its looks by changes of environment, and it will hopefully become a landmark contributing region and culture as for a communication medium.

Product
CUBEnch
Öffentliche Bank
Public bench

Design
designmu
Wan sup Kim
GS E&C
Hye ri Jeong, Joon won Suh
Seoul, South Korea

Manufacturer
GS E&C
Seoul, South Korea

Der CUBE wird an öffentlichen Orten installiert. Als Designkonzept wurde „Cool und Soft" gewählt. Dem simplen geradlinigen Stück wurden warme und fein-fühlige Materialien hinzugefügt und damit ein „Emo-tional High Tech" angestrebt. Das Sitzmöbel kann flexibel als Ein-, Zwei- oder Mehrfachsitzer arrangiert werden. Um die Basismodule herum kann man bei CUBE die Länge und Winkel der einzelnen Sitzeinhei-ten je nach Situation beliebig variieren.

The CUBE is multi-functional street furniture for public spaces. The "cool & soft" design concept combines plain and elegant forms with warm sensuous mater-ials. The L-shaped seat consists of a wooden surface and steel, a stone cube connects it to the ground. The seating furniture can be flexibly used as single, double or multiple bench arrangement; lengths and angles can be adjusted to suit individual demands. In this way, the CUBE adapts harmoniously and com-municatively to the environment.

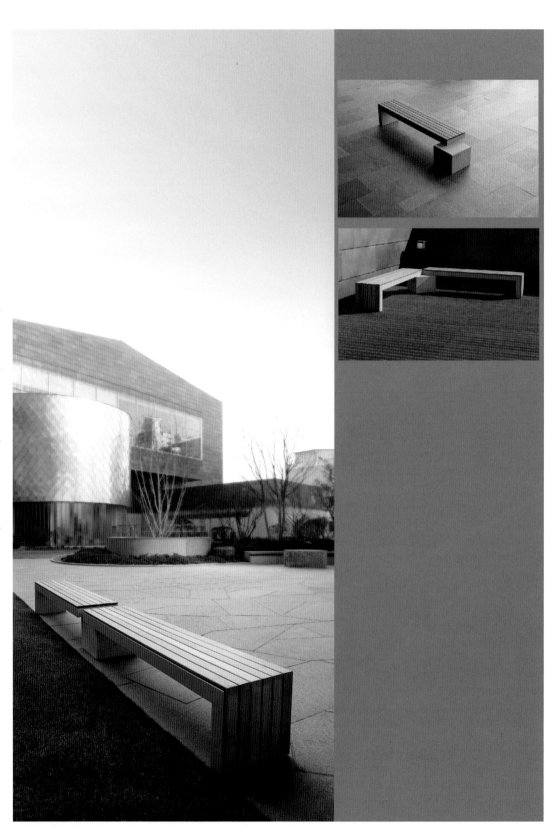

Product
FSB – Schutzbeschlag
Security hardware

Design
FSB
Hartmut Weise
Brakel, Germany

Manufacturer
FSB
Brakel, Germany

Der Schutzbeschlag FSB 7361/7360 ist als klassische Wechselgarnitur ausgelegt und wird innenseitig mit einem formal abgestimmten Türdrücker samt eckigem Schild geliefert. Das Elektronik-Paket besticht durch seine kabellose Konzeption und fügt dem Schutzbeschlag innovative funktionale Aspekte hinzu. Der kapazitive Klingelsensor mit LED-Sendekontrolle auf der Außenseite sowie das türschildintegrierte Funk-Klingelmodul auf der Innenseite fungieren als batteriebetriebene Einheit. Eine Sender-Reichweite von 200 Metern ermöglicht die flexible Anbringung und Nutzung des zugehörigen Klingelmoduls. Selbstverständlich ist die höchste Schutzklasse S4.

FSB 7361/7360 security hardware is designed as a standard entrance door furniture and supplied with a matching lever handle plus straight-cornered back plate for the inside. The electronics require no cabling whilst adding innovative functions to the hardware. The capacitive bell sensor combines with a LED transmission control device on the outside and a radio-operated bell module built into the inside back plate to act as a battery-operated unit. A transmission radius of 200 meters makes for flexible positioning and use of the attendant bell module. Top S4 security rating is of course delivered.

Product
Teaterstolen
Theaterstuhl
Theatre chair

Design
Lundgaard & Tranberg Arkitekter
Signe Baadsgaard, Kenneth Warnke
København K, Denmark

Manufacturer
Getama Danmark A/S
Gedsted, Denmark

Ansatz für die Gestaltung des Stuhls bildet jene Bewegungsfreiheit, die die moderne, sich nicht nur auf die Bühne beschränkende Theaterkunst ihrem Publikum heute abverlangt; der Zuschauer muss sich an seinem Platz stets frei bewegen können. Die runde Sitzfläche und geschwungene Lehne des Stuhls erlauben eine Vielzahl verschiedener Sichtpositionen und bieten selbst bei einer bis zu 45° gedrehten Stellung ein bequemes Sitzen. Der Stuhlrücken wird nun zur Armlehne und unterstützt ein entspanntes, doch aufrechtes Sitzen. Zudem tragen die in besetztem und unbesetztem Zustand gleichen schallabsorbierenden Eigenschaften positiv zur Raumakustik bei.

The chair design is inspired by the freedom of movement needed by a spectator of the modern theatre. The action of a theatre piece is no longer limited to the stage, requiring a spectator to move freely while seated in order to follow the action. The round seat and curved shell of the chair allow for a range of viewing positions, providing comfortable back support even when turning up to 45°. When sitting in this angled position, the seatback serves as an armrest, supporting a relaxed but upright position. The chair also helps to ensure proper acoustics in the space, with an empty chair absorbing the same amount of sound as a person.

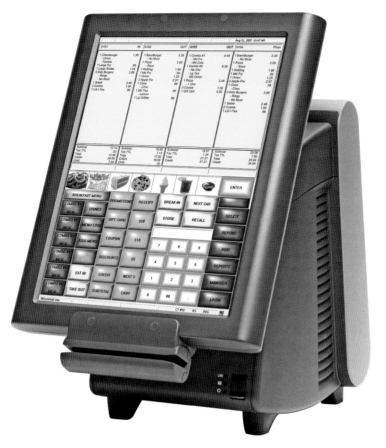

Product
JS-950WS, „Stingray"
PC-Gestützte Kassensysteme
EPoS work station

Design
Panasonic Corporation
Yokohama, Japan

Manufacturer
Panasonic System Solutions Company
Yokohama, Japan

Panasonic System Solutions Europe stellt die neue Referenz für PC-gestützte Kassensysteme vor: die JS-950WS „Stingray". Mit ihrer flexiblen, offenen Architektur und ihrer vielseitigen, modularen Bauweise wird Stingray den Markt für PC-Kassen grundlegend verändern. Das innovative Konzept der Stingray ist auf den Grundsatz zurückzuführen, dem Kunden genau das maßgeschneidert anzubieten, was er benötigt. Dank der offenen Plattform passt sich Stingray an verschiedene Unternehmensanforderungen an. Außerdem ermöglicht sie jederzeit eine Nachrüstung oder Aufrüstung der Kassenhardware durch den einfachen Austausch von einzelnen Komponenten.

Stingray's innovative approach derives from providing users exactly what they need. Its open platform and modular construction means it will evolve as business needs change allowing both software and hardware upgrades at any stage in its lifetime. Its unique design means working parts can be replaced individually, so maintenance is faster and more cost-effective than ever before. To ensure continuous operation and for the safety of the users, Stingray is made of ABS, for flame resistance, and it is built to withstand spills, dirt, grease and delivers all the durability and reliability users have come to expect from Panasonic.

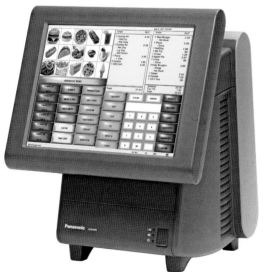

Product
Call a Bike Terminal
Service Terminal

Design
Ströer Out-Of-Home Media AG
Roger Marschaleck
Köln, Germany

Manufacturer
Ströer Out-Of-Home Media AG
Köln, Germany

Das Call a Bike System von Ströer und der Deutschen Bahn bietet Touristen und Bürgern die Möglichkeit der unkomplizierten Fahrradausleihe. Um die Akzeptanz zu steigern und den Komfort zu erhöhen, sind Terminals entwickelt worden, die die einmalige Registrierung und das Entleihen von Rädern ermöglichen sowie einen Überblick geben, an welchen Standorten wie viele Räder vorhanden sind. Mittels eines interaktiven Touchscreens sind über große Eingabefelder die notwendigen Eingaben leicht und einfach durchzuführen. Das qualitativ hochwertige Äußere der Stele wird durch individuell hinterdruckte Echtglaseinsätze sowie Aluminium-Seitenprofile geprägt.

The Call a Bike system from Ströer and Deutsche Bahn means hiring a bike couldn't be simpler for tourists and residents alike. In order to increase coverage and convenience, terminals have been developed which enable one-off registration and the hiring of bikes and which also provide an overview of the number of bikes available at the various locations. The interactive touch screen and large entry fields make using the system child's play. The elegant column creates a high-quality look with a customized, back-printed glass insert and aluminium side sections.

Product
Säule interactive
Kultursäule interactive
Culture column interactive

Design
Ströer Out-Of-Home Media AG
Roger Marschaleck, Frank Fangmann
Köln, Germany

Manufacturer
Ströer Out-of-Home Media AG
Köln, Germany

Die elektronische Kulturinformationssäule ist eine Säule der neuesten Generation. Ein riesiges digitales Display in der oberen Säulenhälfte präsentiert die städtischen Kulturangebote. Der „City Guide" im unteren Bereich des Stadtmöbels bietet aktuelle Informationen rund um die Stadt: Veranstaltungshinweise, Kinoprogramm, Restaurantführer und vieles mehr. Details dazu und auch die Vorbestellung von Karten zu den gezeigten Veranstaltungen können angesehen, heruntergeladen oder ausgedruckt werden. Die Handhabung und Darstellung der Inhalte ist barrierefrei und überzeugt durch seine Benutzerfreundlichkeit.

The electronic culture information column is truly a state-of-the-art column. With the integration of the latest advertising media and an interactive terminal, this item of street furniture combines advertising with interaction for the urban landscape. Alongside dynamic advertising, the column also features a city guide. It provides information about the city, which encourages users to take an interactive approach. The design of the touch screen interface offers simple and reliable navigation to a wide range of users. The combination with the digital display means that advertising and information complement each other perfectly.

Product
DB Service Point
Info+Service Counter

Design
Dietz Joppien Architekten AG
Albert Dietz, Christian Mäthlau
Frankfurt a. M., Germany
unit-design GmbH
Bernd Hilpert, Peter Eckart, Robert Cristinetti
Frankfurt a. M., Germany

Manufacturer
Signature
Birkenfeld, Germany

Die neu gestalteten Service Points präsentieren die Deutsche Bahn als kundenorientiertes und freundliches Unternehmen. Die modular aufgebaute Produktfamilie verbessert in einer integrierten Lösung alle gestalterischen und funktionalen Aspekte: Raumklima, Arbeitsplatzergonomie, Beleuchtung und Sichtbarkeit, Corporate Design, Statik, Konstruktion und kostengünstige Herstellung. Die Gestaltung ist geprägt durch prismenartig gefaltete Rahmenelemente und die Geste der sich öffnenden Form. Der Service Point erscheint in unterschiedlichen Breiten, als freistehendes oder eingebautes Element sowie als mobile Lösung für den einzelnen Bahnsteig.

The newly designed Service Points present the Deutsche Bahn as a client-orientated and friendly concern. The modular built product family improves, within an integrated solution, all design and functional aspects: atmospheric environment, workplace ergonomics, lighting and visibility, corporate design, static, construction and cost-effective manufacture. The design is distinguished through prism-like, folded frame elements and the gesture of the open form. The Service Point appears in different widths, as freestanding or fitted element, or as a mobile version for single platforms.

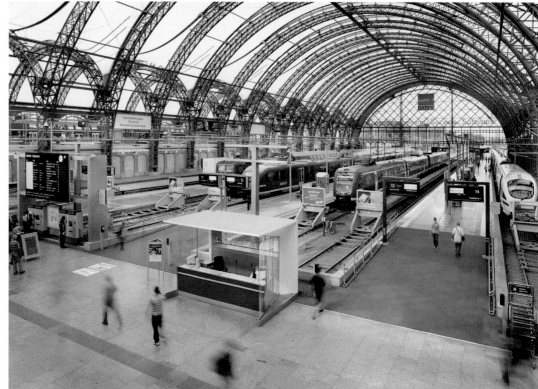

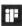

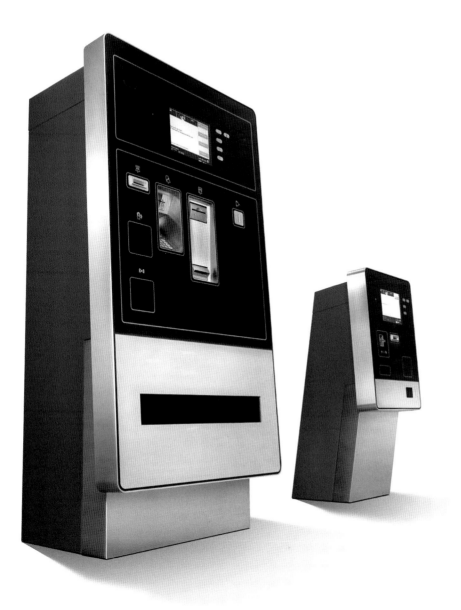

Product
WPS parking system
Parksystem
Parking system

Design
VanBerlo strategy+design
Design Team VanBerlo
Eindhoven, The Netherlands

Manufacturer
WPS Parking Systems B. V.
Eindhoven, The Netherlands

WPS hat kürzlich eine völlig neue Parkraumlösung auf den Markt gebracht. Mit einem Kassenautomat, Einfahrts- und Ausfahrtterminals sowie mit einem webbasierten Parkraummanagement wurde das Gesamtsystem von Grund auf neu ausgestaltet. Die neue Serie von Parkautomaten bietet:
– ein ikonisches, modernes Design, das der Produktfamilie ein richtiges Identifikationsmerkmal verleiht
– aufgrund neuer Standards höchsten Benutzerkomfort, dank der Verwendung von Ikonen statt Textangaben und eines LCD-basierten Graphikdisplays
– eine große Flexibilität bezüglich der möglichen Konfigurationen, damit auf spezifische Kundenwünsche eingegangen werden kann.

WPS, one of the largest suppliers of parking systems, recently introduced its all-new high-end parking solution. Consisting of a pay terminal, entry and exit terminals and a web-based parking management system, the entire system was designed from scratch. The new line features:
– An iconic, modern design that creates a clear product family
– New standards of ease of use, thanks to a logical arrangement of interface elements, use of icons instead of text and an LCD-based graphical UI
– A great flexibility in possible configurations to cater for individual demands.

Product
WERMA 494.0 × 0 / 894.0 × 0
Ampelserie
Traffic light series

Design
Design Tech
Jürgen R. Schmid
Ammerbuch, Germany
WERMA Signaltechnik GmbH + Co. KG
Timo Schöttle
Rietheim-Weilheim, Germany

Manufacturer
WERMA Signaltechnik GmbH + Co. KG
Rietheim-Weilheim, Germany

Als Weltneuheit bietet die elegante Leuchtenserie 494/894 erstmals Ampelfunktion mit akustischer Signalisierung in einem Gerät. Geschwungene Formen wachsen aus der Wand und finden ihr Echo in runden Lichtelementen. Diese signalisieren in Rot, Gelb, Grün eindeutig ihre Funktion. Dank konstruktiver Finesse kann der Kunde das Licht in die gewünschte Richtung drehen. Robuste Kunststoffe, energiesparende LEDs und umweltfreundliche Herstellung machen die Leuchten zu umweltverträglichen Signalgebern. Die Ampel-/Leuchtenserie von WERMA eignet sich aufgrund ihrer Designqualität vorzüglich für den Einsatz im öffentlichen Raum.

A worldwide first, this stylish light series offers a combination of audible signalization with a traffic light design – all in one device. The sleek, curved appliance blends into the wall and corresponds with round light elements in red, yellow and green. Thanks to precise design engineering, the customer can easily twist the lights to the desired direction. Due to efficient production and the use of robust synthetic material and energy-saving LEDs, the series is a great ecological choice. The WERMA traffic light series is excellent for applications in public areas where design and aesthetics play an important role.

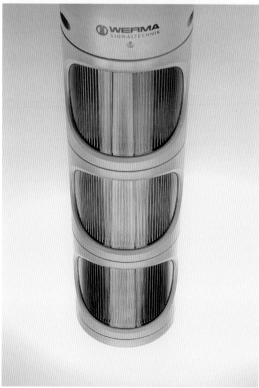

Product
Von 1128 bis 2008
Staatlicher Hofkeller Würzburg
State-run wine cellar Würzburg

Design
archicult gmbh
Christoph Pullmann, Sven Unger
Zwingenberg, Germany
archicult rhein-main
Das Atelier für Kommunikation im Raum
Christoph Pullmann
Zwingenberg, Germany

Manufacturer
Staatlicher Hofkeller Würzburg
Würzburg, Germany

Altes mit Neuem verbinden und ein eingestaubtes Image aufpolieren waren die Aufgabe. 900 Jahre Verbundenheit mit dem Bistum Würzburg, ein Weinanbaugebiet, das sich über 100 km und vier Gesteinsarten ausdehnt und die Menschen tragen zur unverwechselbaren Identität des Staatlichen Hofkellers Würzburg bei. Unser Ziel war es, diese, wie auch das Image des Staatlichen Hofkellers Würzburg ins 21. Jahrhunderts zu transportieren und im dreidimensionalen Raum zu kommunizieren. Zwischen Tradition und Moderne, durch Identität und Image, mit Mensch und Natur. Außerdem wurden die internen Abläufe im eigenen, als auch im Kundeninteresse neu sortiert.

To connect the old with the new and to brush up a fusty image were our tasks. 900 years of strong ties to the diocese Würzburg, a wine-growing area spreading over 100 km and four different kinds of rock and the work of the staff contribute to the distinctive identity of the state-run wine cellar, "Staatlicher Hofkeller Würzburg". It was our aim to express its modern identity and its image in the 21st century and communicate it in a three dimensional space. Inbetween tradition and modernity, through identity and image, with people and nature. Furthermore the internal workflow has been optimized.

Produkte dieser Kategorie sind im Entstehungsprozess geprägt durch eine intensive Auseinandersetzung der Ingenieure, Designer und Mediziner im Hinblick auf den Patienten. Neueste Erkenntnisse der Medizin, der Technologie und Wissenschaft und neue Materialien werden bei der Entwicklung der Produkte für die gesundheitliche Vorsorge, für die Laborarbeit, für die Intensivmedizin und für die Rehaphasen der Menschen, in den Entstehungsprozessen berücksichtigt.

Dabei entwickeln Ingenieure und Designer oft im direkten klinischen Alltag in enger Kooperation mit Ärzten und medizinischem Personal die neuen Produkte.

Die psychische Situation und Empfinden der Patienten spielt dabei eine große Rolle.

High-tech wird nicht nur bei komplexen Geräten wie Computertomographen eingesetzt, sondern neue textile Materialien und Webtechnologien werden zur Herstellung von orthopädischen Bandagen hergestellt, die für die Patienten eine völlig neue Mobilität im Heilungsprozess oder im fortlaufenden Gebrauch von großer Hilfe sind. Ein leichtes und flexibel einsetzbares System zur Stützung von Torax oder Gliedmaßen bringt dem Patienten Tragekomfort und kann so seine Psyche im Rehaprozess unterstützen.

Feinmechanische OP-Geräte, die am und im Patienten zum Einsatz kommen, die vom Arzt und medizinischem Personal geführt werden, müssen der feinmotorischen Handhabung wegen von bester ergonomischer Gestaltung und Auswahl der Materialien sein.

Ganz einfache Produkte, die bei der Pflege und Hygiene am Patienten zur Anwendung kommen, verlangen von den Entwicklern ebenfalls die intensive Auseinandersetzung mit dem Gebrauch und sei es nur ein Essteller oder eine Bettpfanne die eine überzeugende Lösung zeigen und zudem für das Pflegepersonal eine Erleichterung deren täglichen Aufgaben bedeutet.

Manche der Produkte zeigten gute technische Lösungen, die ästhetische und ergonomische Umsetzung jedoch erlaubte keine Auszeichnung. Die Herausforderung für die Entwickler ist ein „humanes" Produkt zu gestalten, das wie in kaum einem anderem Bereich ganz unmittelbar und sehr intim mit den „kranken" Patienten in Interaktion steht.

In the development process, the products in this category are defined by the intensive involvement of engineers, designers and medical professionals as well as the perspective of the patient. Product developments for prevention, laboratory use, intensive care and rehabilitation took into account the latest insights from the world of medicine, technology and science as well as new materials.

In many cases, engineers and designers developed new products directly in everyday clinical situations and in close cooperation with doctors and medical personnel.

The mental situation and sensation of patients plays a major role in this process.

High-tech not only applies to complex equipment such as computer tomographs; new textile materials and weaving technologies are used to produce orthopedic supports that are of great assistance to patients with entirely new levels of mobility during the healing process or ongoing use. A lightweight, flexible support system for the thorax or limbs offers wearer comfort for the patient, thereby also providing psychological support during the rehabilitation process.

Since precision operating theatre equipment used on and in the patient and operated by physicians and medical personnel requires fine motor manipulation, the best ergonomic design and choice of materials is essential.

Very simple products used for patient care and hygiene also require developers to examine their application in detail, even if it is merely a dinner plate or bed pan that offers a convincing solution and also makes the day-to-day tasks of nursing staff easier.

While some of the products feature good technical solutions, their aesthetic and ergonomic implementation are not worthy of an award. The challenge for the developers is to design a "humane" product that interacts very directly and intimately with the "ill" patient in a way not seen in any other field.

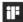
Product
Bauerfeind JT20
Polyzentrisches Prothesenkniegelenk
Polycentric knee joint

Design
Rokitta, Produkt & Markenästhetik
Team Rokitta
Mülheim a. d. Ruhr, Germany

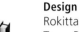

Manufacturer
Bauerfeind AG
Zeulenroda-Triebes, Germany

Das polyzentrische Prothesenkniegelenk JT20 von Bauerfeind ermöglicht das Umstellen von einer sicheren auf eine dynamische Geometrie. Grundlage dafür sind zwei Polkurven, die durch einfaches Drehen des Excenters einstellbar sind. Im JT20 sind ein mechanischer Federvorbringer und ein pneumatischer Dämpfer – die so genannte Voranschlagsdämpfung – integriert. Beide Bestandteile sorgen im Zusammenspiel für ein harmonisches Gangbild. Mit diesem komplexen System können Oberschenkel- und Knieexamputierte optimal versorgt werden. Es ist speziell für die Mobilitätsgrade 2 und 3 konzipiert und trägt bis zu 150 Kilogramm Körpergewicht.

The JT20 polycentric knee joint from Bauerfeind enables adjustment between safe and dynamic geometries. The basis for the system is provided by two centrodes, which can be simply adjusted by turning the excenter. A mechanical spring forwarder and a pneumatic shock absorber – the so-called pre-shock damping – are integrated in the JT20. The interaction of both components allows a harmonic walking pattern. This complex system allows optimal provision for thigh and knee amputees. It has been specially designed for mobility classes 2 and 3, and can carry up to 150 kilograms of body weight.

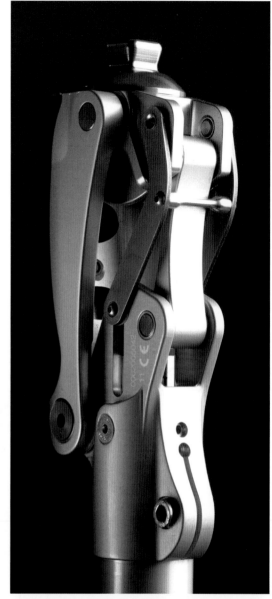

Product
Tricodur® GenuMotion
Kniebandage
Knee bandage

Design

Lothar Böhm GmbH
Nicolas Eilken, Sebastian Ronefeld
Hamburg, Germany

Manufacturer
BSN medical GmbH
Hamburg, Germany

Ein revolutionäres Konzept. Die Tricodur® GenuMotion ist neuer Benchmark im Bereich der Kniebandagen. Das von Designern und Therapeuten entwickelte Konzept wurde speziell für die Bedürfnisse der Babyboomer-Generation entworfen. Das 360 Grad Helix Design setzt neue Maßstäbe in Gestaltung und Therapie. Folgende Innovationen wurden u. a. entwickelt:
– „easy put on" und „anti-slip" ohne Framilon
– Bewegungsfreiheit und Atmungsaktivität in Motion-Comfort-Zone im Bereich der Kniekehle
– 3D-Stricktechnologie mit therapieunterstützendem Kompressionsverlauf
– selbsterklärende Positionierung der Bandage
– neues zielgruppenspezifisches Farbkonzept.

A revolutionary concept. The Tricodur® GenuMotion is a new benchmark in the field of knee bandages. The concept developed by designers and therapists was especially designed for the needs of the baby boom generation. The 360-degree Helix design sets new standards in creation and therapy. Following innovations were amongst others developed:
– "easy put on" and "anti-slip" without framilon mobility and breathability in Motion-Comfort-Zone in the area of the hollow of the knee.
– 3D knitting technology with therapeutically assisting compression progress.
– Self-explanatory positioning of the bandage.
– New target group specific color concept.

Product
Omo Immobil
Schultergelenkorthese
Shoulder joint orthosis

Design
Otto Bock HealthCare GmbH
Matthias Vollbrecht, Boris Ljubimir
Duderstadt, Germany

Manufacturer
Otto Bock HealthCare GmbH
Duderstadt, Germany

Die innovative Schultergelenkorthese Omo Immobil von Otto Bock vereint einzigartige Funktionalität mit attraktivem Design. Nach Operationen und Verletzungen der Schulter ermöglicht sie neben der funktionellen Lagerung in Abduktion auch die Positionierung in Außenrotation. Dabei lässt sie sich mithilfe klettbarer Funktionselemente individuell an die Bedürfnisse der Patienten anpassen und bietet durch die frei wählbare Kombination aller Einstellmöglichkeiten einen außerordentlichen Funktionsumfang. Das schlanke Design der Omo Immobil sorgt in Verbindung mit dem geringen Gewicht und dem weichen, atmungsaktiven Polster für höchsten Tragekomfort.

The innovative Omo Immobil shoulder joint orthosis from Otto Bock combines unique functionality and an attractive design. After surgery and injuries of the shoulder it allows a positioning of this body part with external rotation in addition to functional positioning in abduction. Thanks to hook and loop functional elements the orthosis can be individually adapted to the requirements of the patients, and the freely selectable combination of all adjustment options offers an extraordinary functional range. The slim design of the Omo Immobil orthosis combined with its low weight and soft, breathable padding ensures superior wearer comfort.

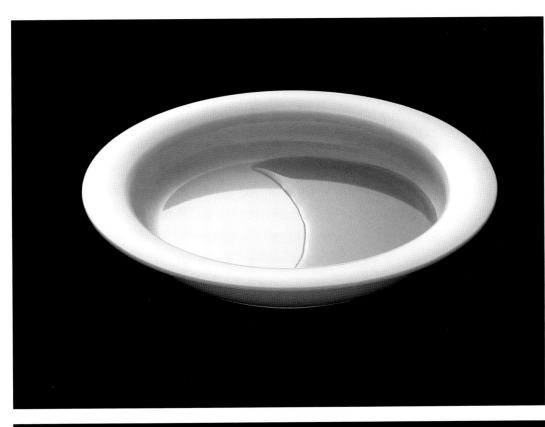

Product
Teller Vital
Esshilfe
Eating aid

Design
ORNAMIN Kunststoffwerke
Thorsten Erdelt
Minden, Germany

Manufacturer
ORNAMIN Kunststoffwerke
Minden, Germany

Der Teller Vital aus hochwertigem Melamin-Kunststoff ist eine Esshilfe, die man als solche nicht erkennt. Die innovative Lösung für Teller mit Randerhöhung verbindet zeitloses Design dezent mit hoher Funktionalität und intuitiver Handhabung. Durch den schrägen Innenboden sammelt sich Flüssigkeit auf einer Seite des Tellers. Dort sorgt ein versteckter Überhang dafür, dass das Essen leichter auf die Gabel oder den Löffel gelangt. Ein Antirutsch-Ring am Boden verhindert das Kippen oder Verrutschen des Tellers und bietet damit zusätzlichen Halt. Das erhöht die Selbstständigkeit und trägt gleichzeitig zu einer gepflegten Tischkultur bei.

The high-quality melamine plate "Vital" is an eating aid, which is not recognizable as such. The innovative solution for raised-edge plates discreetly combines timeless design with a high level of functionality and intuitive handling. The inclined bottom causes liquid to collect on one side of the plate where a concealed overhang ensures that food is easier to pick up using a fork or a spoon. An anti-slip ring on the base prevents the plate from tipping or slipping, thus providing additional grip. All of these factors increase independence and contributes to a beautiful table at the same time.

Product
TENEO
Dentale Behandlungseinheit
Dental treatment center

Design
PULS Design und Konstruktion
Andreas Ries, Dieter Fornoff,
Torsten Richter, Hendrik Breitbach,
Fritz Hensel, Steffen Reitz,
Marco Nunes
Darmstadt, Germany

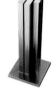

Manufacturer
Sirona Dental Systems GmbH
Bensheim, Germany

TENEO ist die neue Behandlungseinheit von Sirona im Premiumsegment. Sie vereint neueste Technologie mit der Integration von Therapieformen wie Endodontie und Implantologie. Das Konzept folgt der Philosophie einer einfachen, individuellen Bedienbarkeit, die den Behandler entlastet. Beispiel hierfür ist die neue Bedienoberfläche „Easy Touch", die den Workflow konsequent unterstützt. Innovative Lösungen setzen neue Maßstäbe in der Ergonomie und beim Patientenkomfort. Das Design verbindet markenspezifische Merkmale mit neuen gestalterischen und funktionalen Elementen und prägt zukunftsweisend das Erscheinungsbild der Marke.

TENEO is Sirona's new dental treatment centre targeted at the premium market segment. It incorporates sophisticated modern technologies and caters for specialized treatment procedures such as endodontics and implantology. The TENEO product philosophy emphasizes simplicity, intuitiveness and user-friendliness. One example is the new "EasyTouch" user interface, which streamlines the dentist's workflow. Numerous innovative product features set new standards in ergonomics and patient comfort. The product design retains familiar Sirona-specific features and at the same time establishes a new design idiom for the Sirona brand.

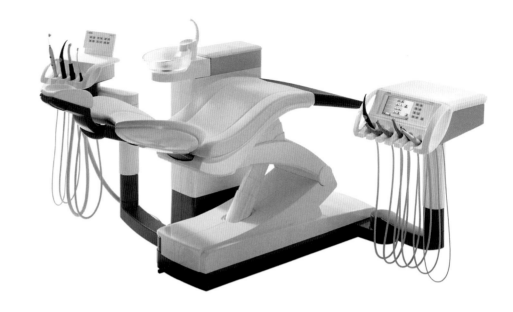

Product
HeartStart FR3
Defibrillation- und Herz-Lungen-
Reanimation System
AED / CPR system

Design
Philips Design
Philips Design Team
Eindhoven, The Netherlands
Philips Healthcare Cardiac Care
Seattle, WA, United States of America
Laerdal Medical AS
Stavanger, Norway

Manufacturer
Royal Philips Electronics
Eindhoven, The Netherlands

HeartStart FR3 ist ein automatisches externes System zur Defibrillation und Herz-Lungen-Reanimation der nächsten Generation. Es erlaubt geschulten Erste-Hilfe-Kräften die schnelle und effektive Behandlung eines plötzlichen Herzstillstands. Da sich das System beim Öffnen automatisch einschaltet, brauchen die Benutzer nur den audiovisuellen Anleitungen zu folgen und müssen keine Schalter bedienen. Sobald die Polster und die Maske angelegt sind, analysiert das System den Herzrhythmus des Patienten und entscheidet, ob zunächst eine Herz-Lungen-Wiederbelebung oder ein Defibrillationsschock erforderlich ist.

The HeartStart FR3 is a next generation automatic external defibrillator and cardiopulmonary resuscitation system. Intended for use by trained responders, e.g. firefighters, police, medical emergency response teams, hospital personnel, etc. in providing rapid, effective treatment of sudden cardiac arrest victims. The system turns on automatically when it is opened; users simply need to follow visual and audio instructions, without looking for further controls. Once the pads and CPR meter are applied, the system analyzes patient heart rhythm and makes a decision whether the patient would benefit from receiving CPR first or a defibrillation shock.

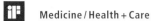

Product
Cardiohelp
Lebenserhaltungssystem
Life support system

Design
Design Tech
Ammerbuch, Germany

Manufacturer
Maquet Cardiopulmonary AG
Hechingen, Germany

CARDIOHELP ist ein tragbares Lebenserhaltungssystem für Patienten, die dringend eine Kreislauf- und/oder Lungenunterstützung benötigen. Mit seinem geringen Gewicht und kleinen Maßen ist es das kleinste und leichteste Life Support System weltweit. Mit den spezifischen Betriebsmodi und Einmalprodukten ist CARDIOHELP optimal für den Einsatz auf Intensivstationen, in der Notaufnahme, im Herzkatheterlabor und im Operationssaal sowie den inter- und intrahospitalen Transport geeignet. CARDIOHELP zeichnet eine einfache Bedienung aus. Mit einem einzigen Dreh-Drück-Knopf und einem Touchscreen kann das Gerät bedient werden.

CARDIOHELP is a portable life support system designed to treat and transport patients needing longer term respiratory and/or circulatory support. With its low weight and small dimensions CARDIOHELP is the smallest and lightest life support system worldwide. With its specific user modes and the special disposables, CARDIOHELP is ideal for multidisciplinary indications. It can be used on the Intensive care unit, cathlabs, operating theatres, emergency rooms and of course during transport. CARDIOHELP stands for easy to use and patient safety. The device can be used only with one push- and rotary-knob and a touch screen.

Product
ESPRIMO MA
Medizinisches Kommunikationsgerät
Personal healthcare device

Design
LUNAR Europe GmbH
Roman Gebhard, Matthis Hamann,
Christian Rogge, Daniel v. Waldthausen
München, Germany
Fujitsu Siemens Computers GmbH
Toni Koberling
München, Germany

Manufacturer
Fujitsu Siemens Computers GmbH
München, Germany

Der ESPRIMO MA ist ein mobiles Informations- und Kommunikationsgerät, das speziell für den Healthcare-Markt konzipiert wurde. Das Touchscreen-Display und die vordefinierten Applikationstasten ermöglichen eine schnelle Dateneingabe, die Untersuchungsdaten sind dank drahtloser Konnektivität überall einsehbar. Informationen lassen sich mittels Barcode- und RFID-Lesegerät einlesen und Befunde mit der integrierten Kamera dokumentieren. Das robuste und leichte Gehäuse ist ergonomisch optimiert, aufgrund seines lüfterlosen Designs leicht zu desinfizieren und schützt die sensiblen Daten vor äußeren Einflüssen.

The ESPRIMO MA is a mobile information and communication device that was specially designed for the healthcare market. The touch screen display and the defined application buttons enable fast data entry, and thanks to wireless connectivity examination data can be viewed anywhere. Barcode and RFID readers are used to enter information and diagnostic findings can be documented via integrated camera. The robust and lightweight housing is ergonomically optimized, easy to disinfect due to its fanless design and protects sensitive data against outside influences.

Product
Vivid S6
Echokardiografie-System
Echocardiography system

Design
GE Healthcare
Aurelie Boudier, Betty Hohmann
Buc Cedex, France

Manufacturer
GE Healthcare
Buc Cedex, France

Das Echokardiografie-System Vivid-S6 stellt Bilder für die Ultraschalldiagnose her. Miniaturkomponenten sorgen für eine einzigartige Bauweise und optimale Bedienbarkeit. Die kompakte Größe ermöglicht Nähe zum Patienten und der artikulierte Arm funktioniert in stehender und sitzender Position, um Schädigungen der Skelettmuskeln vorzubeugen. Jedes Detail wurde zum Wohle des Benutzers geschaffen und um dieses Produkt zum kleinsten seiner Art zu machen. Das als äußerst innovativ geltende Vivid-S6-Design mit seinem gabelförmigen Griff, klaren Linien, modernen Materialien und cleveren Ideen ist attraktiv, anders und frisch.

Vivid-S6 is an echocardiography system generating images for a diagnostic by ultrasounds. The equipment has adopted miniaturized components to create a unique architecture that optimizes usability. Its compactness eases proximity to patient, and its articulated arm works in both standing and seating position for reducing MSD disorders. Every detail was thought to add value to users and make this product the smallest of its category. Perceived as very innovative, Vivid-S6 design with its front wishbone handle appeals, creates positive differentiation, and revitalizes medical products with pure lines, modern materials and bright renderings.

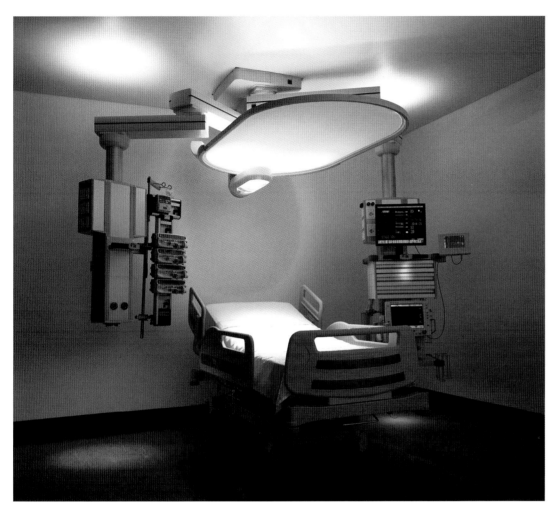

Product
AmbientLine
Lichtsystem für die Intensivstation
Lightsystem for intensive care

Design
Held+Team
Fred Held, Thomas Märzke
Hamburg, Germany

Manufacturer
Trumpf Medizin Systeme GmbH
Puchheim, Germany

Die Belastung von Patienten in Intensivstationen durch künstliches Licht ist nachgewiesen sehr hoch. Mit der weltweit erstmalig vorgestellten Lösung lassen sich für jeden Patienten individuelle Lichtszenarien einstellen. Melatoninregulierung durch Lichtfarben (Tag-/Nacht-Rhythmus stabil halten), Leselicht, Raumlicht (farbig, warm oder kalt), Untersuchungslichter, Bodenlicht etc. Auf das Segel kann ein TV-Bild projiziert werden, um im Liegen einfach TV zu sehen. Für die Reinigung kann es abgenommen und gewaschen werden. Die extrem technische Anmutung von Deckenstativen wird verdeckt und ein angenehmer „Lichthof" geschaffen.

The impact in intensive care stations to patients by artificial light is proved and tremendous. With the worldwide new system each patient could get his individual light scenario. Individual light for day/night rhythm by colored light, reading light, general room light, examination light, floodlight, etc. On the sail a TV picture could be projected to watch TV easily. For cleaning the sail could be simply removed and washed. The extreme technical appearance of ceiling systems could be covered and a comfortable "areaway" implemented instead.

Product
HiQ+ Bipolar
Laparoskopische Zange
Laparoscopic forceps

Design
Held+Team
Fred Held, Burkhard Peters
Hamburg, Germany

Manufacturer
Olympus Winter + Ibe GmbH
Hamburg, Germany

Laparoskopische Handinstrumente dienen der Durchführung endoskopischer Eingriffe in der Chirurgie. Mit einem Endoskop wird das Bild auf einen Monitor übertragen. Üblich sind Einweginstrumente. Die HiQ+ ist ein Mehrweginstrument. Durch die bipolare Technik wird die Belastung des Patienten durch HF-Strom drastisch reduziert. Es ist ein scherenartiger als auch erstmalig(!) ein Hintergriff möglich. Die Gestalt des Produktes richtet sich nach dem Merkmalkatalog für alle Olympus Instrumente.

Laparoscopic Instruments are used for endoscopic surgery. The picture is transferred by an endoscope to the monitor. Usually instruments are disposable. HiQ+ is a reusable instrument! The bipolar technology reduces the impact due to HF power to the patient fundamentally. The handle can be used conventional (finger in ring) or also first time by "backside grip". The design follows the rules of Olympus Corporate Design.

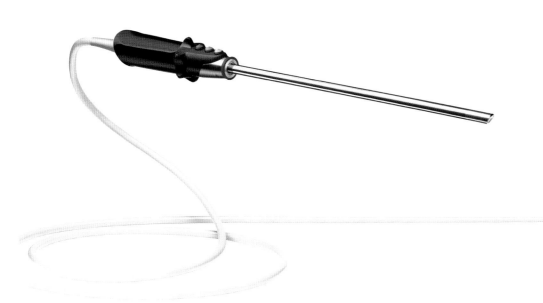

Product
HD Endoeye 30°
HD Videolaparoskop
HD videolaparascopy

Design
Held+Team
Fred Held, Thomas Märzke
Hamburg, Germany

Manufacturer
Olympus Winter + Ibe GmbH
Hamburg, Germany

Videolaparoskope sind das Basisinstrument im mini-malinvasiven OP. Sie übertragen das Bild auf den Monitor. Erstmals ist es gelungen, den Chip so zu verkleinern, dass er in der Spitze Platz findet und trotzdem volle HD-Auflösung besitzt. Weiterhin einmalig ist der Blickwinkel von 30° und dessen Nachführbarkeit. Darüber hinaus ist es das einzige Instrument, welches voll autoclavierbar ist (134° Dampf). Das Instrument wird vom Assistenten geführt und muss in jedem Winkel in den Bauchraum geführt werden. Daher ist die Ergonomie „universell" angelegt mit einer klaren „Oben"-Orientierung. 3 Knöpfe sind frei programmierbar.

Videolaparoscopes are the basic tools in minimal invasive OR. They transfer the image from the OR field to the monitor. For the first time the image chip is reduced in size and is located at the tip and still providing images in full HD resolution. The 30° view and its full movability is new. Also it is worldwide the only instrument which is fully autoclavable (134° steam). The instrument is used by the assistant in OR and must be hold in any angle towards the abdomen. Thus the universal ergonomic approach is that it can always be held top up. 3 buttons can be programmed individually.

Product
Mini3000
HNO Instrumente
ENT instruments

Design
Held+Team
Fred Held, Thomas Märzke
Hamburg, Germany

Manufacturer
HEINE Optotechnik GmbH
Herrsching, Germany

Die Produktserie gehört zu den Basisinstrumenten eines HNO-Arztes, die sich bei ihm ständig in Gebrauch befinden. Damit werden Auge, Nase, Ohr, Mund und Haut betrachtet. Im Griffteil befinden sich Batterien und eine Lichtquelle. Der Clip enthält den Schalter, der das Instrument automatisch ausschaltet, wenn man es ins Jackett steckt. Die Köpfe sind je nach Anwendung wechselbar. Das Design folgt dem für Heine definiert Merkmalkatalog.

This series of products is one of the basic tools of an ENT doctor. They are used to look in/on eye, ear, nose, mouth, and skin. The handle contents a battery and a light source. A clip includes the on/off switch (also 50% power level). The lamp will be turned off, if you put it into your front pocket by the clip in which the switch is included. The additional functional parts on top are based on their category shape to make it easier to differentiate which part has which function. Consistent characteristics are linked to an overall "Heine" design.

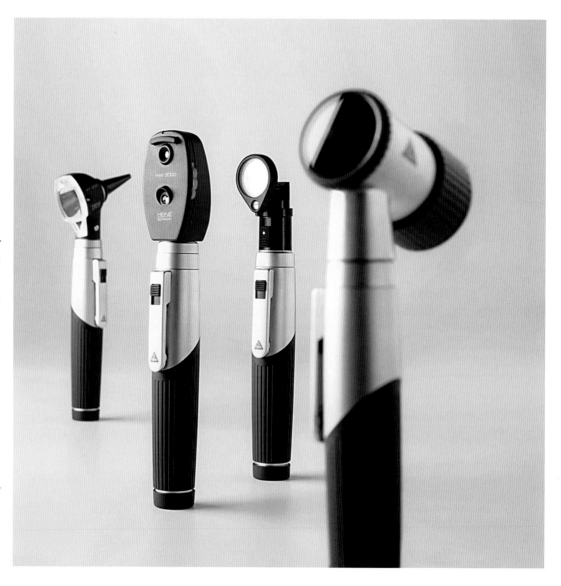

Product
Forano
Gasentnahmestelle
Hospital tapings

Design
Held+Team
Fred Held, Burkhard Peters
Hamburg, Germany

Manufacturer
Greggersen Gasetechnik GmbH
Hamburg, Germany

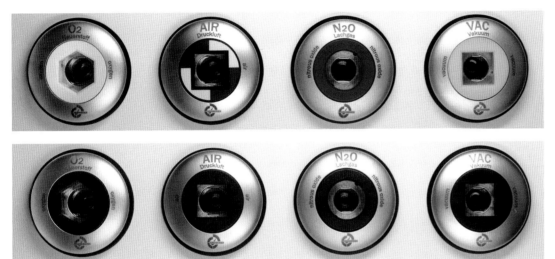

Über Entnahmestellen werden für die Patientenversorgung Gase aus zentralen Gasversorgungsanlagen zugeführt. Standard sind heute Vollkunststoffblenden. Große Fugen zur Wand ermöglichen Keimaustritte aus der Wand. Neue und optimierte Aspekte: intuitive Bedienung durch automatisches Rasten beim Hineinstecken. Entrasten erfolgt durch Drücken der Scheibe, dabei wird gleichzeitig (!) das eingesteckte Gerät leicht nach vorne gedrückt. Langlebigkeit durch Edelstahlgehäuse. Perfekte Reinigung durch glattflächige Ausführung. Codierung nach allen internationalen Normen möglich. Gummiabdichtung zur Wand gegen Keimaustritt. Einfachste Wartung möglich. 3 Sprachen.

Tapings provide medical equipment with gas from a central supply unit for patient treatment. Today's standards are plastic bezels. They create large gaps in the wall and allow germ emission. New and optimized aspects: intuitively handling by automatic catch while plugging equipment. Un-lock by pushing the disc. At the same time (!) the plugged equipment jumps out for easy removal. Long lasting due to stainless steel housing. Smooth surfaces ease cleaning. Rubber seal between tap and wall gaps can be prevented and dust-free connection is provided for the first time. All international code standards are possible. Easy maintenance. 3 languages.

Product
Tissue Seal
Chirurgisches Instrument
Surgical instrument

Design
Held+Team
Fred Held, Burkhard Peters
Hamburg, Germany

Manufacturer
BOWA-electronic GmbH
Gomaringen, Germany

„Sealmode" Instrumente werden in der offenen Chirurgie eingesetzt. Sie bilden in der Funktion eine neue Gerätegattung. Mit dem Zangenmaul werden Gefäße gefasst und mittels eines definiert ablaufenden Programms durch HF-Spannung versiegelt. Die Schließkraft wird mit einer Raste sichergestellt. Erstmals ist hier nur das Maul ein Einwegteil – ansonsten das ganze Instrument. Der Handgriff ist so geformt, dass er wie eine chirurgische Schere gefasst werden kann. Die Kunststoffummantelung stellt die elektrische Isolierung sicher. Das rote Silikonband hilft bei Umfassung ein differenziertes taktiles Feedback zu erhalten.

"Sealmode" instruments are used in open surgery. With the tip of the forceps you grasp blood vessels and seal them by a defined HF tension. A ratchet guarantees the clamp force. The disposable part is very small – only the top. Usually the whole instrument is disposable! The shape is orientated towards typical surgical forceps. The full plastic isolation is a safety precaution against electrical hazard. The red silicon prevents from slipping they also give a detailed tactile feedback from fingertip to the hand.

Product
Laryngoskop HD2
Laryngoscopy

Design
Held+Team
Fred Held, Thomas Märzke, Thilo Hogrebe
Hamburg, Germany

Manufacturer
Olympus Winter + Ibe GmbH
Hamburg, Germany

Laryngoskope werden für die Untersuchung der Stimmbänder und des Rachens verwendet. Dazu wird der Schaft in den Mund eingeführt. Die Diagnose erfolgt direkt durch die Optik oder eine angeschlossene Kamera. Licht wird über ein anschließbares Lichtleitkabel eingebracht. Mit Stroposkoplicht kann die Bewegung der Stimmbänder untersucht werden. Das Instrument ist sehr viel leichter als Konkurrenzprodukte. Es ist das einzige Instrument, das einen Griff aufweist. Dieser kann mit einem Klick zur einfacheren Reinigung abgenommen werden. Aufgrund des Aufbaus aus Edelstahl erfüllt es alle heutigen Anforderungen an die Sterilisation.

Laryngoscopes are used for the visual examination of the throat and vocal cords. The shaft is inserted into the mouth. Light is brought to the tip by a fiberglass cable. The lightcable is fixed to the instrument at the handle area. By using light from a stroposcope it is possible to indicate any illness of the moving vocal cords. The whole instrument is lightweight in comparison to competitors and is made out of stainless steel to fulfill sterilization needs. It is the only instrument, which offers the user a specific ergonomic handle for easy use without increasing the size of the instrument. The handle can be easily removed.

Product
DenTek – Dental Repair Products
Zahnreparaturprodukte
Dental repair products

Design
Philips Design
Philips Design Team
Eindhoven, The Netherlands

Manufacturer
DenTek Oral Care, Inc.
Maryville, TN, United States of America

Die Temparin-Zahnreparaturprodukte von DenTek wurden von Philips Design anhand von Kundenumfragen komplett neu gestaltet, um sie noch benutzerfreundlicher zu machen und ihnen in der Auslage eine professionelle Ausstrahlung zu verleihen. Erzeugnisse und Marketingstrategie wurden gleichzeitig entwickelt. Die Zahnreparaturprodukte bieten eine vorläufige Alternative zu verloren gegangenen Füllungen, Plomben und Kronen, bis der Zahnarzt einen permanenten Zahnersatz einsetzen kann. Ein Satz besteht aus dem Reparaturmaterial und den Applikatoren. Das neu gestaltete Produkt ist viel leichter zu benutzen, da die Applikatoren und die einzelnen Dosierungen in einer Packung zusammengefasst sind.

Philips Design, using consumer insights to develop a user-friendlier product and a unique shelf presence with professional flair, redesigned DenTek's Temparin line of tooth repair products. Product and communications were developed concurrently. The dental repair products provide a temporary remedy for lost fillings, inlays and crowns, until a dentist can provide a permanent solution. The kits consist of both repair material and applicators. The redesigned product is far easier to use because of a more intuitive product system, incorporating custom applicators and individual doses packaged together.

Product
Delmedica Investments – Xhalo
Inhalator

Design
Philips Design
Philips Design Team
Eindhoven, The Netherlands

Manufacturer
Delmedica Investments
Singapore, Singapore

Xhalo ist ein wieder verwendbares Handgerät, das sich vom Patienten sehr einfach bedienen lässt. LED-Anzeigen und Tonausgaben verdeutlichen, wann er mit dem Blasen beginnen bzw. aufhören soll. Dank der täglichen Nutzung des Xhalo kann ein Asthmatiker rechtzeitig erkennen, ob ein Asthmaanfall unmittelbar bevorsteht, und die erforderlichen Vorkehrungen oder Abhilfemaßnahmen treffen. Das Funktionsprinzip beruht auf der Tatsache, dass sich eine entwickelnde Virusinfektion in der Temperatur der ausgeatmeten Luft bemerkbar macht. Der Patient atmet durch die Nase ein und bläst die Luft durch den Mund direkt in das Xhalo.

Xhalo is a handheld device that is reusable. Usage is intuitive for patients with LED lighting used together with audible sounds to indicate when to start and finish blowing. The asthmatic inhales into the Xhalo on a daily basis to get a prediction if an asthma attack is imminent. This will allow asthmatics to take necessary preventive or pre-emptive measures. Xhalo is based on the link between exhaled breath temperature and early signs of viral infection before they develop. The patient inhales through the nose and exhales through the mouth directly into Xhalo. It has a heat sink and temperature sensor inside a thermally sealed flask.

Product
Xper Patient Table
Patiententisch
Patient table

Design
Philips Design
Philips Design Team
Eindhoven, The Netherlands

Manufacturer
Royal Philips Electronics
Eindhoven, The Netherlands

Der Xper-Patiententisch für kardiovaskuläre Röntgen-systeme erlaubt die optimale Positionierung des Pa-tienten bei der Bilderfassung. Das Krankenhausteam erhält dadurch einen bestmöglichen Zugang zum Patienten, gleichzeitig aber auch zur Benutzerober-fläche des Systems. Dank der korrekten Lage und der integrierten Kabel lassen sich sowohl der Komfort als auch die Sicherheit/Überwachung des Patienten sowie die Nutzbarkeit/Effizienz des Systems optimal gestalten.

The Xper Patient Table for cardio vascular X-ray sys-tems, positions the patient for optimal image acquisi-tion. It provides optimal patient accessibility for the clinical team as well as accessibility to the system user interface. Patient comfort, patient safety/monitor-ing and usability/efficiency are optimized through minimal repositioning and integrated cable manage-ment.

Product
Kitten Scanner
Interaktiver Spielscanner
Interactive toy scanner

Design
Philips Design
Philips Design Team
Eindhoven, The Netherlands

Manufacturer
Royal Philips Electronics
Eindhoven, Netherlands

Der Kitten Scanner erläutert Kindern die Vorgänge während der Computertomografie. Mit interaktiven Rollenspielen und Geschichten werden die verschiedenen Untersuchungsschritte beschrieben, um den Kindern die Furcht vor den klinischen Abläufen und der unbekannten Technologie zu nehmen. Der Kitten Scanner wird im Wartezimmer aufgestellt, so dass die Kleinen damit spielen können. Dabei erfahren sie, was eine computertomografische Untersuchung ist, wie sie funktioniert, was damit erreicht wird und warum sie erforderlich ist. Die Kinder lernen den Ablauf kennen und wissen, was sie bei der tatsächlichen Untersuchung zu erwarten haben.

Kitten Scanner is a product that helps to teach children about what happens during a CAT (or CT) examination. Interactive role-play and storytelling are used to shed light on the different steps of a CT exam and to take the fear away from clinical procedure and technology. The Kitten Scanner is placed in the waiting room of the hospital and invites children to interact and play with it. Through the act of playing the child learns about what a CT exam is. How it works, what it does, why they would need the exam. The child becomes familiarized with the procedure and knows what to expect in a real exam. This takes the fear and anxiety away.

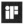
Product
CX50
Ultraschallsystem
Ultrasound system

Design
Philips Design
Philips Design Team
Eindhoven, The Netherlands

Manufacturer
Royal Philips Electronics
Eindhoven, The Netherlands

Das CX50 ist ein kompaktes, tragbares Echokardio-
graphie-Ultraschallsystem für einfache und effiziente
Ultraschalluntersuchungen. Es bietet Ultraschalltech-
nikern und Ärzten auch außerhalb der Praxis kom-
fortable Diagnose- und hervorragende Bildverarbei-
tungsfunktionen. Das System kann problemlos direkt
am Krankenbett, in der Intensivstation, im OP-Saal, in
der Notaufnahme oder einer kleineren Klinik einge-
setzt werden, so dass die Kranken zur Untersuchung
nicht erst an einen anderen Ort verlegt werden müs-
sen. Es lässt sich in einer speziellen Tragetasche un-
terbringen und einfach transportieren.

The CX50 is a compact handheld echocardiography
ultrasound system designed to make portable ultra-
sound exams easy, efficient and simple. It was created
with the idea to enable mobile sonographers or doc-
tors who need to be "on the go" with a convenient
diagnostic system and premium imaging capabilities
that can be taken to various locations such as a pa-
tients bedside, CCU, ICU, OR and ER departments or
a satellite clinic with ease, rather then move patients
in poor health to locations where the systems are
stationed. It can be packed in its special travel case
for easy transport to remote destinations.

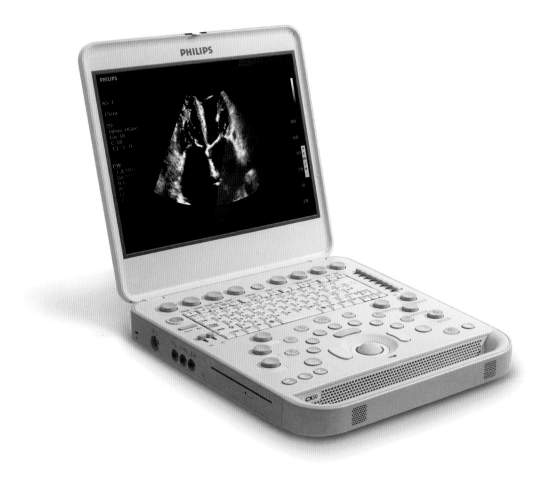

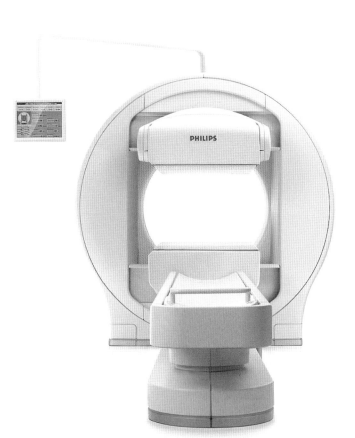

Product
BrightView SPECT
Gammakamera für die Nuklearmedizin
Nuclear medicine gamma camera

Design
Philips Design
Philips Design Team
Eindhoven, The Netherlands

Manufacturer
Royal Philips Electronics
Eindhoven, The Netherlands

BrightView SPECT ist eine Gammakamera mit einstellbarem Blickwinkel für die Nuklearmedizin. In diesem medizinischen Spezialgebiet werden Krankheiten mit Hilfe einer geringen Menge radioaktiver Spurenelemente erkannt und behandelt. Die verabreichten Spurenelemente können von einer Gammakamera erfasst werden und erzeugen durch ihre jeweilige Verteilung im Körper des Patienten informative Bilder über den Zustand des betroffenen Organs. Aus diesen Bildern kann ein Arzt eine Diagnose der Krankheit ableiten. Dank dieser überaus empfindlichen Testmethode lassen sich zahlreiche Krankheiten bereits zu einem sehr frühen Zeitpunkt erkennen.

BrightView SPECT is a nuclear medicine variable angle gamma camera. Nuclear Medicine is a medical specialty in which the diagnosis and treatment of human diseases are made by using a small amount of radioactive tracers. After administration of the tracer, images of the organ of interest in the patient's body are obtained with a gamma camera that shows the localization of the tracer. Physicians interpret them for the diagnosis of the disease. These tests are very sensitive and can detect many diseases at early stages. Nuclear medicine tests provide information about the functional status and viability of different organs and tissues.

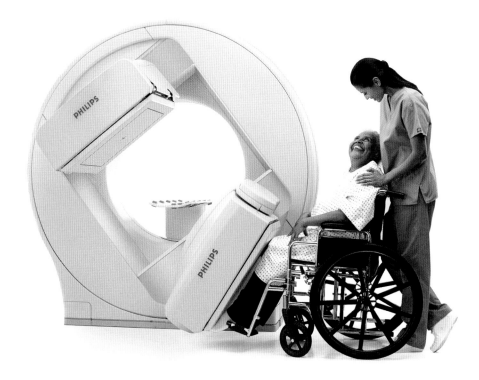

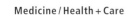

Product
HCG-801
Mobiler EKG-Monitor
Portable ECG monitor

Design
YS design Inc.
So Noguchi
Osaka, Japan

Manufacturer
OMRON HEALTHCARE Co., Ltd.
Kyoto, Japan

Das Omron HCG-801 ist ein mobiles EKG-Gerät, welches jederzeit und überall die Aufzeichnung kardialer Ereignisse ermöglicht, wenn Brustschmerzen oder Herzklopfen auftreten. Es gewährleistet 30 Sekunden lange Aufzeichnungen und gibt somit Ihrem Arzt eine Hilfestellung für eine korrekte Diagnose der Herzerkrankung. Die ergonomische Form trägt dazu bei, die richtige Körperhaltung einzunehmen. Alles was Sie tun müssen, ist den Startknopf zu drücken. Das ergonomische Design des Pick-Up-Sensorsystems gewährleistet klare Signale für weitere Auswertungen. Die aufgezeichneten Ergebnisse werden auf dem Bildschirm mit Hintergrundbeleuchtung angezeigt.

HCG-801 is a portable electrocardiograph that enables you to record a precordial electrocardiogram (ECG) anywhere and anytime chest pain or palpitation occurs. It provides a 30 second recording and helps your doctor to make a correct diagnosis of your heart disease. Its well-considered shape leads you to take the most appropriate posture. All you have to do is to push the accessible start button. The guidance screens also helps to obtain a better recording. Its ergonomic design of the pick-up sensor system provides sufficiently clear signals for further evaluation. The recorded results are displayed on the high-resolution screen with backlight.

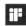

Product
HEM-7301-IT / 7300
Digitales Blutdruckmessgerät
Digital automatic blood pressure monitor

Design
C Creative Inc.
Takashi Shigeno, Kazuya Andachi
Tokyo, Japan

Manufacturer
OMRON HEALTHCARE Co., Ltd.
Kyoto, Japan

Durch die verbesserte Platine und Druckpumpe wurde dieses Oberarm-Blutdruckmessgerät als kompaktes Gerät mit einem großen LCD-Display realisiert. Dank seiner guten Transportfähigkeit sind Messungen selbst im Büro oder auf Reisen möglich. Mit beispiellosem Design, einem Minimum an Elementen, feiner Oberflächenstruktur und detailliertem Design der Rückseite sowie dem industrieweit ersten Invers-Display, sollen auch Benutzer angesprochen werden, die das Image herkömmlicher Modelle nicht mögen. Die mitgelieferte Software Bi-Link ermöglicht es Ihnen, Schwankungen auf dem PC grafisch zu verfolgen und die Mittelwerte vom Morgen und vom Abend miteinander zu vergleichen.

An upper-arm blood pressure monitor with compact main unit and large LCD realized by improved pressure pump and substrate. Its portability makes it easy to take continuous measurements even at office or while traveling. With unprecedented design; minimized elements and detailed texture and backside design, and industry's first reverse display, aimed to attract users who don't like the image of conventional models. Bi-Link, the attached software enables you to monitor the variation trends graphically on PC and compare averaged values in the morning with the ones of the evening.

Product
C-Leg® compact
Elektronisches Kniegelenk
Electronic knee joint

Design
Otto Bock HealthCare GmbH
Hans-Willem van Vliet
Duderstadt, Germany

Manufacturer
Otto Bock HealthCare GmbH
Duderstadt, Germany

Das C-Leg®compact ist ein Mikroprozessor-gesteuertes Beinprothesensystem für Amputierte mit geringerem Aktivitätsgrad.
Auf einen Blick:
– Mikroprozessor-gesteuertes Beinprothesensystem mit Echtzeit-Einstellung, welches den Amputierten Sicherheit in hohem Maße, Mobilität und Komfort bietet
– zusätzliche Steh- und Sperrfunktion für Menschen mit hohem Sicherheitsbedürfnis – leichte Aktivierung durch drahtlose Fernsteuerung
– elektronische Steuerung auf 50 Hz Frequenz (Sensor-Feedback und hydraulische Anpassung alle 0,02 Sekunden)
– extrem robust, dennoch leicht: 1.236 g
– Mobilitätsgarantie von 3 Jahren.

The C-Leg®compact is a microprocessor controlled leg prosthesis system for less active amputees.
At a glance:
– real time microprocessor-controlled leg prosthesis system offering more stability, mobility and comfort to amputees.
– Extra standing and locking feature for less active amputees – easily activated via wireless remote control.
– Electronic control at a frequency of 50 Hz (sensor feedback and hydraulic adaptations every 0.02 seconds).
– Extremely rugged but lightweight: 1,236 g.
– Mobility warranty of 3 years.
– The gait pattern is nearly physiological. The system is constantly adapting to its user's gait situation.

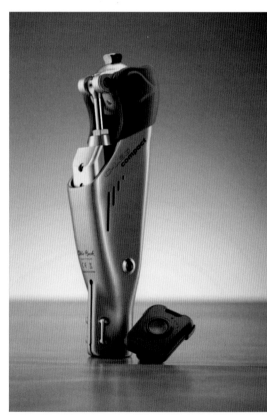

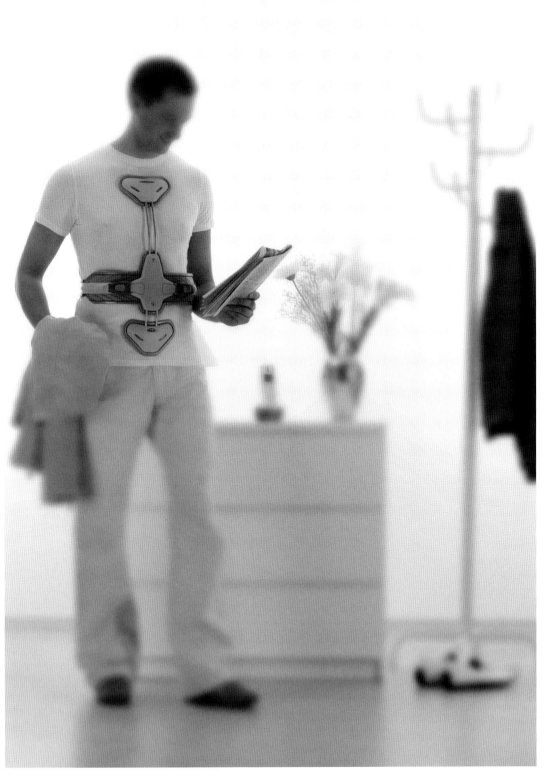

Product
Dorso Arexa
Hyperextensionsorthese
Hyperextension orthosis

Design
Otto Bock HealthCare GmbH
Boris Ljubimir, Klaus Lidolt, Helmut Wagner
Duderstadt, Germany
Adam Wehsely-Swiczinsky
Wien, Austria

Manufacturer
Otto Bock HealthCare GmbH
Duderstadt, Germany

Die Hyperextensionsorthese Dorso Arexa von Otto Bock verbindet hohe Funktionalität und Tragekomfort mit einem innovativen Design. Druckpolster an den Lenden sowie am Brust- und Schambein richten die Wirbelsäule auf und wirken entlastend und stabilisierend. Dank variabler Verlängerungselemente, die mit einem einfachen Klick-System angebracht werden, lässt sich die Dorso Arexa individuell anpassen und deckt so mit nur einer Größe ein breites Versorgungsspektrum ab. Zudem kann der Taillengurt exakt auf das erforderliche Maß gekürzt werden. Das sportliche Erscheinungsbild erhöht die Patienten-Compliance und fördert eine optimale Rehabilitation.

The Dorso Arexa hyperextension orthosis from Otto Bock combines outstanding functionality and a high level of wearer comfort with an innovative design. Pressure pads on the lumbar region, sternum and pubic bone straighten the spine for a load-relieving and stabilizing effect. Thanks to the variable extension elements attached using a simple click system, the Dorso Arexa can be customized and covers a large fitting spectrum with a single size. The waistband can also be shortened to the precise length required. With its sporty appearance, it improves patient compliance and promotes optimum rehabilitation.

Product
Aurinio L 160
LED-OP-Leuchte
LED OT luminaire

Design
Deck 5
Dietmar Dix, Marcus Frankowski,
Harald Steber, Meike Noster
Essen, Germany

Manufacturer
TRILUX GmbH & Co. KG
Arnsberg, Germany

Schon das futuristische Design der Aurinio L 160
zeigt, dass es sich hier um eine außergewöhnliche
Lichtlösung handelt. Ihr wichtigstes Merkmal: Die
Ausstattung mit LEDs. Zum einen bewahrt deren kal-
tes infrarotfreies Licht das Gewebe des Patienten
vor Austrocknung und sorgt für optimale Arbeitsbe-
dingungen für den Chirurgen. Zum anderen sind die
LEDs extrem wartungsarm und zuverlässig. Die Sym-
biose aus Design, Technik und Funktionalität zeigt
sich auch in der strömungsoptimierten Bauform der
OP-Leuchte. Somit ist sie speziell für den Einsatz unter
Reinluftdecken prädestiniert.

The futuristic design of the Aurinio L 160 demon-
strates that this is an unusually interesting lighting so-
lution. It's most important feature: the implementa-
tion of LEDs. On the one hand their cool, infrared-free
light protects the tissue of patients from dehydration
and creates optimal working conditions for the sur-
geon. And on the other hand the LEDs are extremely
maintenance-friendly and reliable. The symbiosis of
design, technology and functionality can also be seen
in the current-optimized construction of the OR light.
It is thus especially suitable for implementation below
clean room ceilings.

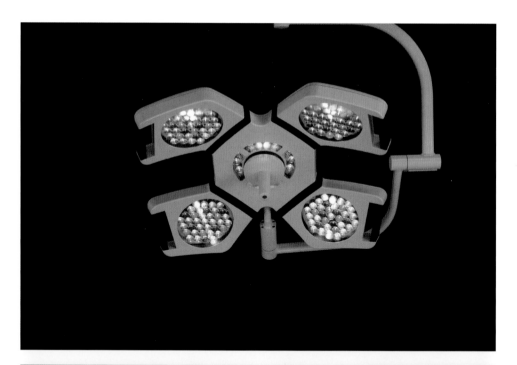

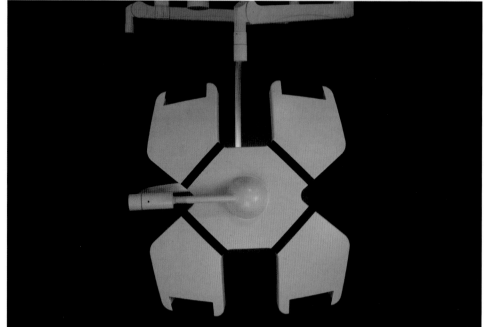

Product
Aurinio L 120
LED OP-Leuchte
LED OT luminaire

Design
Deck 5
Dietmar Dix, Marcus Frankowski
Essen, Germany

Manufacturer
TRILUX GmbH & Co. KG
Arnsberg, Germany

Der kleine Bruder der Aurinio L 160 präsentiert sich mit den gleichen Highlights wie das Original: außen futuristisches Design mit strömungsoptimierter Bauform, innen Hightech Leuchtmittel Power-LED. Kaltes infrarotfreies Licht zugunsten von Patient und Chirurg zeichnen sie genauso aus wie extreme Wartungsfreundlichkeit, nur alles etwas kleiner: die klassische Satelliten-Leuchte, prädestiniert für den Einsatz unter Reinluftdecken mit Laminar-Airflow. Typisch für einen Satelliten ist die Option einer Video-Kamera im Handgriff zur OP-Dokumentation.

The small brother of the Aurinio L 160 offers the same highlights as the original: external futuristic design with flow-optimized form, inner high-tech Power-LED light source. It is also distinguished by cold infrared-free light for the benefit of patients and surgeons and extreme ease of maintenance, everything is just a little bit smaller: the classic satellite luminaire that is predestined for use under clean-air ceilings with laminar air flow. The option of a video camera is typical for a satellite as an easy step for OT documentation.

Product
iLED
Operationsleuchte
Surgical light

Design
Held + Team
Thomas Märzke, Friedemann Schreiber, Fred Held
Hamburg, Germany

Manufacturer
TRUMPF Medizin Systeme GmbH & Co. KG
Puchheim, Germany

Als weltweit erste LED-Operationsleuchte definierte iLED neue Standards im Markt und überzeugt nach wie vor durch unübertroffene Funktionalität und Lichtleistung: Ein einzigartiges optisches Lichtsystem, die Multi-Linsen-Matrix, sorgt für exzellente Ausleuchtung im OP-Feld. Anpassungsfähige Farbtemperatur des Lichts für beste Kontraste in verschiedenen Gewebearten. Adaptive Lichtverteilung garantiert schattenfreies Licht auch in schwierigsten Situationen. Sterile Bedienung der Leuchtenfunktionen erlaubt dem OP-Team schnelle und direkte Bedienung aller Funktionen. Strömungsgünstiges Design sorgt für ausgezeichnete Klimadeckenverträglichkeit.

Being the world's 1st LED based surgical light; iLED has set new standards in the market. Today, it still impresses with unmatched functionality and lighting power. A unique optical lighting system, the Multi-Lens-Matrix, guarantees excellent illumination in the surgical field. Variable color temperature of the light ensures best contrasts in different tissues. Adaptive light distribution allows for shadow free light even in most difficult situations. Sterile control of all light functions enables the OR team to quickly and directly adjust all functions. Flow-enhancing design caters for superior compatibility with laminar airflow systems.

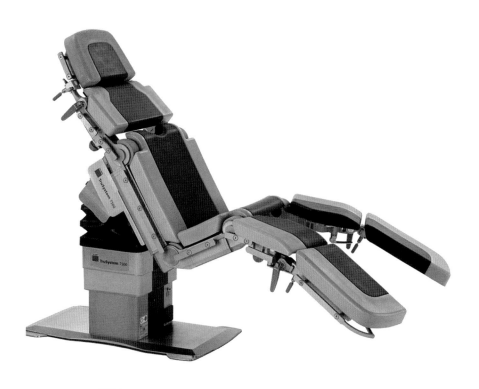

Product
TruSystem 7500
OP-Tisch-System
Operating table system

Design
Art-Kon-Tor
Ilka Schlesiger, Marwin Kock
Jena, Germany

Manufacturer
TRUMPF Medizin Systeme GmbH & Co. KG
München, Germany

TruSystem 7500 verfügt über zahlreiche motorisierte, präzise und schnelle Bewegungsfunktionen und extreme Verstellbereiche. Wie z. B. eine Trendelenburg-Lage (Kopf tief) von 65° oder eine seitliche Kantung von 30°. Manuelle Bedienhebel sind für einen gezielten Zugriff farblich abgesetzt. Die Tischplatte, deren Design der menschlichen Anatomie folgt, ermöglicht eine physiologisch korrekte Patientenlagerung. Für die intuitive motorische Verstellung der einzelnen Elemente reflektiert die Funkfernbedienung den tatsächlichen Aufbau des OP-Tischs. Die schlanke Säule und die flache Bodenplatte gewährleisten außerdem guten Zugang zum Patienten.

TruSystem 7500 allows numerous motorized, precise and fast moving functions as well as extreme adjustment angles. For example, a 65° Trendelenburg (head down) or a 30° lateral tilt. The manual operation handles are color-coded for easy recognition and fast access. The tabletop design follows the anatomy of the human body and this way enables a physiologically correct positioning of the patient. The revolutionized radio remote control reflects the actual set-up of the table for an intuitive control of the single motorized elements. In addition, the slim column and the flat base plate allow the nursing staff easy access to the patient.

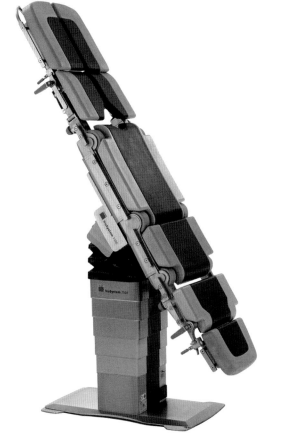

Product
Infinity® C700
Medical Cockpit™

Design
Corpus-C Design Agentur
Alexander Müller, Sebastian Maier
Fürth, Germany

Manufacturer
Dräger Medical AG & Co. KG
Lübeck, Germany

Das Infinity Medical Cockpit™ ist das intelligente Zentrum des Infinity Acute Care System. Diese Systemkomponente gewährleistet ein besseres Patientenmonitoring, kontrolliert und steuert Therapien und managt Patienten-Informationen. Die Daten sind alle auf einem harmonisch gestalteten Monitor verfügbar. Sein elegantes Design und seine glänzende Oberfläche runden seine qualitativ hochwertige Erscheinung ab. In Kombination mit der CPU überzeugt das Infinity® C700 mit einem 20" Widescreen, der mit einem farbigen, hochauflösenden Touchscreen mit einer guten Übersicht ausgestattet ist. Je nach Präferenz des Pflegepersonals kann der Drehknopf entweder an der unteren oder rechten Seite befestigt werden.

The Infinity Medical Cockpit™ is the intelligence centre of the Infinity Acute Care System. It is the common system component, designed to monitor the patient, control therapy and manage patient information on a single screen using a harmonized user interface and operating concept. Its elegant design and glossy surface gives it a high quality look. The Infinity® C700 combines a CPU with a 20" widescreen, touch screen color display, offering a large viewing angle and high image clarity. Its rotary knob can be mounted on the bottom or right side of the display just as caregivers prefer, allowing for full control over the workplace and the patient.

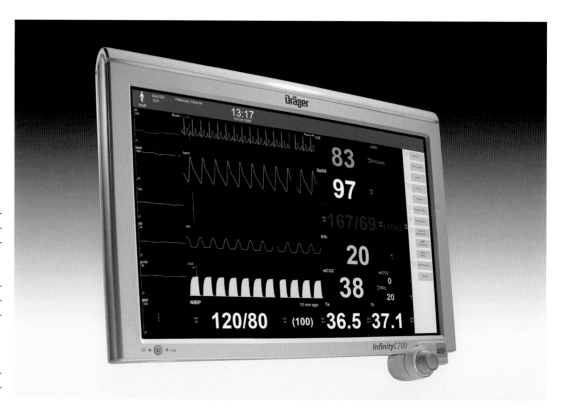

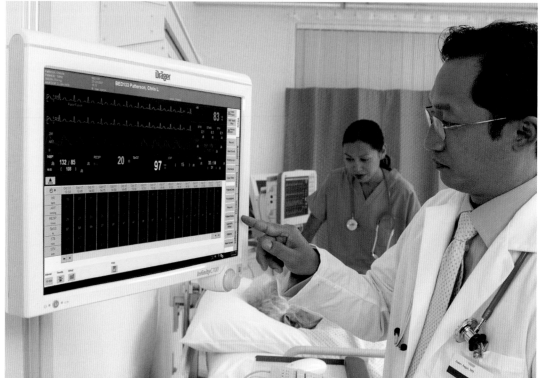

Product
Ponta
Balken Versorgungseinheit
Beam system supply unit

Design
Corpus-C Design Agentur
Alexander Müller, Sebastian Maier
Fürth, Germany

Manufacturer
Dräger Medical AG & Co. KG
Lübeck, Germany

Ponta ist ein an der Decke installierter Supportbalken, der den komplexen Arbeitsplatz in der Intensivmedizin organisiert. Er sichert ein freundliches, sauberes Umfeld für Patienten und medizinisches Personal bei maximaler Ausnutzung des Platzes. Das Schienensystem erlaubt ein sicheres und einfaches Bewegen der Geräte entlang des Balkens. Die Bremsen können mit einer Hand betätigt werden, was vor unbeabsichtigten Bewegungen schützt. Gas-, Elektrizitäts- und IT-Anschlüsse sind integriert, genauso wie dimmbare Lichtquellen, die für ein indirektes Licht sorgen sowie eine Lese- und Untersuchungslampe. Das kompakte Design, die glatten Oberflächen und die abgerundeten Ecken schützen vor Staub und erleichtern die Reinigung.

Ponta is a ceiling mounted supply beam for organizing the increasingly complex critical care workplace, creating a friendly and clean environment for patients and caregiver with a maximum utilization of space. The rail system allows a defined, secure and easy movement of equipment along the beam. The brakes can be operated with one hand preventing unintentional movement. Gas, electricity and IT supply connections are completely integrated, just like dimmable sources for indirect light, reading and examination light and night lighting. Its closed design, smooth surface and rounded corners prevent dust accumulation and facilitate cleaning.

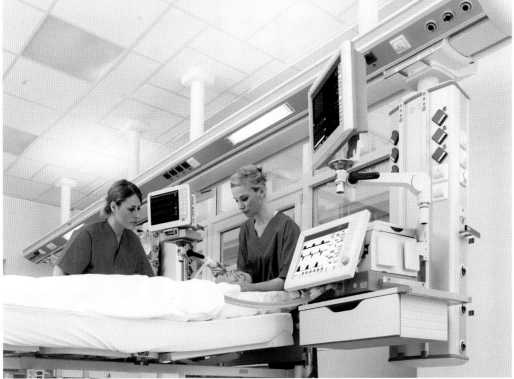

Product
Infrared thermometer
Stirn- und Ohrthermometer
Ear / forehead infrared thermometer

Design
Acute Ideas Co., Ltd.
Albert Chen, William Shu
Taipei, Taiwan

Manufacturer
Acute Ideas Co., Ltd.
Taipei, Taiwan

Ein perfektes Infrarot Thermometer für die ganze Familie, das man entweder für die Ohren oder für die Stirn benutzen kann. Eltern können es benutzen, um die Stirntemperatur ihres Babys oder ihre eigene Temperatur im Ohr zu messen. Das einzigartige Design gestattet den Versuch, das Gerät auch simultan zu benutzen. Indem man den Hauptteil des Geräts dreht, kann man das Ober- und Unterteil des Thermometers in verschiedene Winkel bewegen, um unterschiedliche Messpositionen zu erreichen. Dies wird für den Benutzer eine ganz neue Erfahrung bringen.

A perfect infrared thermometer for all family members, which is designed for ear and forehead measurements. Parents can use it to measure forehead temperature of babies or ear temperature of themselves. A unique design allows the probe to be moved simultaneously by turning the main body, in the meantime the upper seat and lower seat of the housing can be pivotally rotated to different angles to meet demands that may arise during self-measurement or measurement of other people; this creates a brand new using experience.

Product
Renewing IPLeffecter
Hautpflegeprodukt
Skin care cosmetic

Design
AmorePacific
Yee-Hwa Kim
Seoul, South Korea

Manufacturer
AmorePacific
Seoul, South Korea

Das Produkt korrigiert Hautirritationen und Pigmentierungen wie eine Schönheits-OP. Die Behandlung wird in zwei Schritte aufgeteilt und verstärkt damit die Effekte der Absorption und einer IPL-Bestrahlung. Die Verpackung mit dem neu entworfenen Pumpmechanismus, besticht durch ihre schlanke Silhouette und ähnelt dem metallischen Material für eine medizinische Laseroperation. Das Programm ist pro Set für 2 Schritte und das Derma-ray (Schönheitsgerät) komponiert. Jedes Set läuft 2 Wochen, deshalb haben wir das Produkt in 4 Fächer verpackt, sodass es für eine 8-Wochen-Kur reicht. Die flache Form ist vergleichbar einem medizinisches Behältnis und erleichtert damit das Entnehmen des Inhalts.

It helps to improve blemishes and pigmentations just like a surgery. It segments absorption by 2 steps, and increases the effects of the absorption and ion-emissions. The container has a slim proportion and is of metal materials to resemble a medical laser surgical operation. For a better usage the pump button was redesigned. This product is also composed for step 1, step 2, and derma-ray (beauty tool). Each set runs 2 weeks, so we've packed this program in 4 clear cases as a total 8-week program. The flat form is shaped like a medical container and it makes it easier to pull out the contents.

Product
ERÊ
Module für Psychomotorik
Modules for psychomotricity

Design
Paulo Dias Design
Paulo Dias Batista Junior
Curitiba – PR, Brazil

Manufacturer
Instituto Terressência
Curitiba – PR, Brazil

Die ERÊs wurden ursprünglich als Kletter- oder Bau-
blöcke entworfen, um von Physiotherapeuten bei
Stimulanzübungen mit Kindern mit Hirnlähmung ein-
gesetzt zu werden. Später bemerkte man, dass sie als
Spielgerät auch für Kinder und Jugendliche ohne Be-
hinderungen Lerneffekte haben. Mit den ERÊs kann
das Kind oder der Jugendliche im kognitiven-raum-
geometrischen Prozess neue Produkte entwickeln.
Auf diese Weise werden sie bei dem systematischen
Bau ihres eigenen Objekts zum Designer, um der Not-
wendigkeit des Spielens oder der Interaktion nach-
zukommen. Die Modulform des ERÊs wird durch den
mathematischen Schnitt eines Schaumblocks ohne
Restbestand gewonnen.

ERÊs were originally designed as climbing/building
blocks to be used by physiotherapists in stimulation
sessions for children with cerebral paralysis. Later, it
was realized that they might be educationally effect-
ive as well as a toy for children and teenagers without
special needs. A child or a young person may use
ERÊs to make different products through the geo-
metric/spatial cognitive process, designing them by
building their own objects to meet the need to play/
interact systematically. ERÊ modules are obtained by
a mathematically sectioning a foam block without
leftovers.

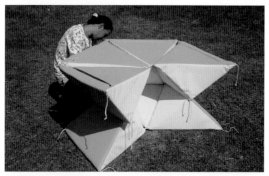

Product
MAMMOMAT Inspiration
Mammographiegerät
Mammography unit

Design
designaffairs GmbH
designaffairs Design-Team
Erlangen, Germany
Siemens AG Healthcare Sector
Eva Eliasson, Ulf Zimmermann, Martin Ramsauer
Erlangen, Germany

Manufacturer
Siemens AG Healthcare Sector
Erlangen, Germany

MAMMOMAT Inspiration ist eine intelligente Mammographieeinheit, die den Arbeitsablauf vereinfacht und zudem Patientinnen mehr Komfort bietet. Das einzigartige Design bringt, durch runde, weiche Formen und klare Linien, Eleganz in die Räume. Unterstrichen wird dies durch sanfte Farben der Abdeckung, erhältlich in Pastell-Pink, Limone und Silber. Dazu setzen die Bedienknöpfe einen lebhaften Akzent. Ein besonders auffallendes Designelement ist die farbige LED-Leuchtscheibe. Diese ist individuell einstellbar und hält Mitarbeiterinnen und Patientinnen bei guter Laune. Eine Aufrüstung für weiterführende Diagnostik – und 3D-Tomosynthese ist möglich.

MAMMOMAT Inspiration is an intelligent mammography unit that streamlines the workflow and focuses on patient comfort. The open and functional design is one-of-a-kind. Its smooth round shapes and clear lines add elegance to the rooms, emphasized by the soothing colors of the cover that is available in a pastel pink, lime, and silver. These colors are retaken in the design of the operating buttons. The most significant design element is the colorful, unique moodlight panel, based on LED technology. It can easily be set up and will keep the staff and the patients in a good mood. An upgrade for stereo tactic biopsy and 3D-tomosynthesis is possible.

Product
ENDOPATH® DEXTRUS™
Zugangs-Port für minimal-invasive Chirurgie
Surgical hand access port

Design
Ethicon Endo-Surgery
Mike Cronin, Greg Johnson
Cincinnati, OH, United States of America

Manufacturer
Ethicon Endo-Surgery
Cincinnati, OH, United States of America

Die Vorteile der minimalinvasiven Chirurgie (MIC) sind weithin bekannt. ENDOPATH® DEXTRUS™ überbrückt die Kluft zwischen offener Chirurgie und MIC und ermöglicht dem Chirurgen somit mehr Flexibilität, Freiheit und Leistungsvermögen. Das System mit Zugangs-Port und Fingerwerkzeugen zeichnet sich durch drei exklusive Design-Merkmale aus. Erstens ist es eine innovative Alternative zur offenen Chirurgie. Zweitens erlaubt es dem Chirurgen in laparoskopischen Prozeduren, seinen Tastsinn wirksam einzusetzen. Und schließlich vermitteln die Fingerwerkzeuge von Dextrus dem Chirurgen das vertraute Gefühl traditioneller chirurgischer Instrumente.

The benefits of minimally invasive surgery (MIS) to patients and to the healthcare system are widely documented. ENDOPATH® DEXTRUS™ bridges the gap between open surgeries and MIS, maximizing surgeon flexibility, freedom and performance. The system, which includes an access port and finger tools, offers three exclusive design features. One, it provides an innovative alternative to open surgery for large organ removal. Two, it allows the surgeon to leverage his/her sense of touch in laparoscopic-based procedures. Finally, it brings the familiarity of traditional surgical instruments to the surgeons' fingertips with Dextrus finger-mounted tools.

Product
opus
Digitale Motorbürette
Digital electronic burette

Design
Phoenix Design GmbH & Co. KG
Andreas Haug, Tom Schönherr
Stuttgart, Germany

Manufacturer
Hirschmann Laborgeräte GmbH & Co. KG
Eberstadt, Germany

Hirschmann Laborgeräte hat eine neue, moderne, digitale Motorbürette opus mit einem klaren integrativen Produktdesign entwickelt als eine vielseitige Lösung für viele Probleme der täglichen Laborroutine. Die funktionellen Elemente sind logisch miteinander verknüpft. Das kompakte Design mit Touchscreen reduziert so die hohe technische Komplexität auf ein sympathisch einfaches, ergonomisches und bedienungssicheres Produkt. Durch das vom Grundgerät entkoppelte Bedienteil ist eine freie Positionierung möglich. Die Touchscreen-Oberfläche ermöglicht eine intuitive Bedienung.

Hirschmann Laborgeräte has developed the modern digital electronic burette opus with a clear and integrative product design as a versatile solution for many problems in the daily laboratory routine. Controls and operation elements are logically connected. The compact design with soft touch controls minimizes the technical complexity to a simple-to-operate product with excellent ergonomics. The touch screen controller is separated from the base unit and thus enables free positioning of the components. The touch screen surface facilitates the intuitive operation of the instrument.

Product
RV10
Rotationsverdampfer
Rotary evaporator

Design
IKA-WERKE GMBH & CO. KG
IKA designcenter
Staufen, Germany

Manufacturer
IKA-WERKE GMBH & CO. KG
Staufen, Germany

IKA – Rotationsverdampfer RV10 basic, digital, control Prinzip: Extraktion von Inhaltsstoffen aus Lösungen durch Erhitzung, Rotation, Vakuum und Kühlung. Gliederung in drei Bereiche: Komponentenebene mit Mechanik, Elektronik, Vakuumpumpe; Prozessebene mit Heizung, Rotationsantrieb und Glaskörper; Bedienebene mit Steuerungs- und Kontrollelementen im Frontbereich. Ergonomie: Leichtes Installieren der Glasteile, einfacher Probenwechsel und einfachste Reinigung; Bedienung im kühlen Frontbereich. Intuitive und logische Bedienerführung. Design: Offen und kompakt. Integration und Gliederung. Transparenz und Volumen.

IKA – rotary evaporator RV10 basic, digital, control principle: Extraction of ingredients from solutions by way of distillation (heating, rotation, vacuum and cooling). Divided into three sections: component level with mechanics, electronics, vacuum pump; process level with heating, rotational drive and vitreous body; operation level with regulation and control elements in front area. Ergonomics: easy installation of vitreous parts, easy sample change and simplest possible cleaning. Cool front area operation. Operator guidance is intuitive and logical. Design: open and compact. Volume and transparency.

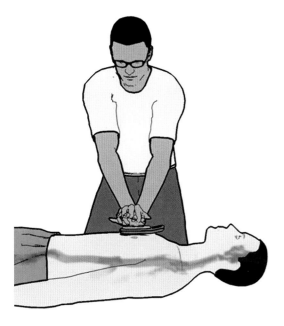

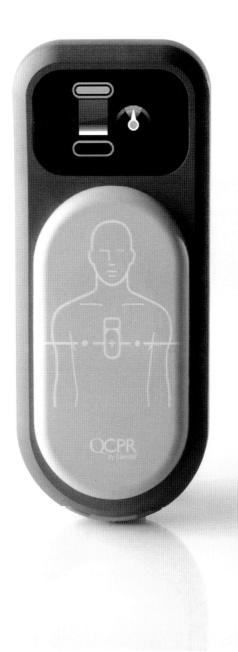

Product
CPRmeter
HLW Messgerät mit Feedback
CPR measurement device with feedback

Design
Laerdal Medical AS
Laerdal Design Department / Laerdal R&D
Stavanger, Norway
Philips Design Seattle
Philips Healthcare
Cardiac Care
Seattle, WA, United States of America

Manufacturer
Laerdal Medical AS
Stavanger, Norway

Das CPRmeter ist ein kompaktes Messgerät mit Feedbackeigenschaften für den professionellen Einsatz beim plötzlichen Herztod. Klinische Studien betonen die Notwendigkeit der Optimierung der HLW-Qualität, um noch mehr Leben zu retten. Das CPRmeter führt den Anwender mittels einer dynamischen Anzeige von korrekter Kompressionstiefe und -frequenz, durch Berechnung von Druck und Kompressionstiefendaten. Das CPRmeter wurde in vielfachen Anwenderstudien so entwickelt, dass es professionellen wie auch ungeübten Anwendern relevante und abgewogene Rückmeldung gibt. Dies verbessert in Stress-Situationen die HLW-Qualität – für mehr Überlebende.

CPRmeter is a measurement and feedback device for professional use during chest compressions on cardiac arrest victims. Clinical research has shown the need to improve CPR quality to save more lives. The CPRmeter is placed on the chest of the patient and guides the user to correct compression depth and rate through a dynamic visual interface, based on advanced calculations of depth and force data. Through extensive user testing, the CPRmeter is designed to provide relevant and balanced feedback for both experienced and infrequent users in a challenging, stressful use context, all to assure high quality CPR and more survivors.

Product
HANSATON VELVET X-Mini
Digitales Hörsystem
Digital hearing system

Design
Pilotfish GmbH
Pilotfish Team
München, Germany
Pilotfish Inc.
Pilotfish Team
Taipei, Taiwan

Manufacturer
Hansaton Akustik GmbH
Hamburg, Germany

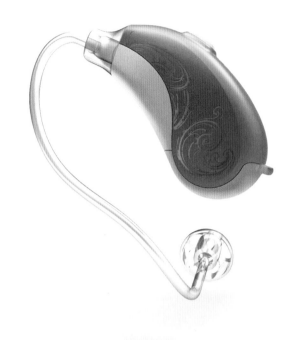

Das VELVET X-Mini ist mit 20 × 15 × 7,5 mm das kleinste Hochleistungs-Hörsystem mit Außenhörer von HANSATON. Die Profillinie trennt das Gehäuse in Ober- und Unterschale mit ausklappbarem Batteriefach und verleiht dem Gerät einen klaren, eleganten Charakter und eine sanfte ergonomische Form. Die austauschbare Oberschale ist in unterschiedlichen Farben, Designs und innovativen Finishes erhältlich, wodurch das VELVET X-Mini wie ein Schmuckstück anmutet. Beim Tragen verschwindet der kleine Korpus unsichtbar hinter dem Ohr und kann auf Wunsch auch drahtlos mit externen Geräten wie Mobiltelefonen oder dem Fernseher verbunden werden.

The VELVET X-Mini is a high-performance receiver-in-canal hearing system measuring only 20 × 15 × 7.5 mm. Its profile line splits the housing into a top and bottom part and continues smoothly towards the back to form the battery door. This gives the device a distinct character while at the same time a softer and more ergonomic shape. The exchangeable top shell is available in different colors, graphics and innovative finishes, transforming the product into a customizable, jewel-like accessory. When worn, the ultra small body disappears discreetly behind the ear; it can connect wirelessly to external devices such as mobile phones or TV.

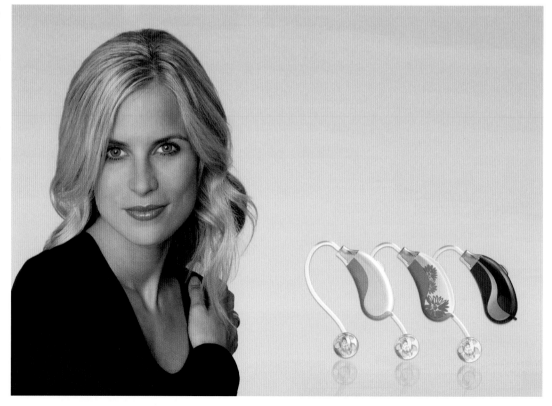

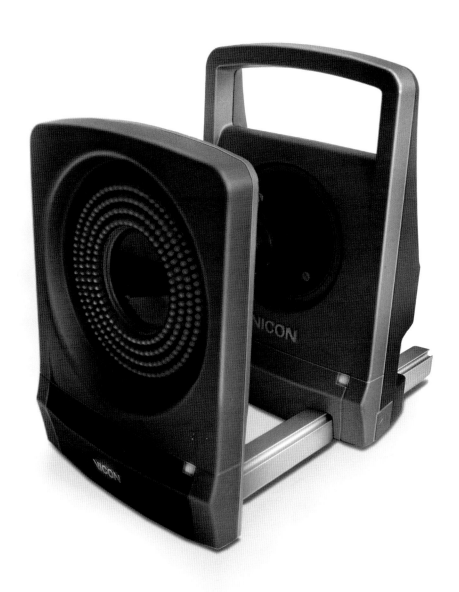

Product
VICON T-Series Camera
Motion Capture Camera

Design
PDD Group Ltd.
Oliver Stokes
London, United Kingdom

Manufacturer
VICON Motion Systems Ltd
Oxford, United Kingdom

VICON-Kameras werden seit mehr als 20 Jahren in Krankenhäusern verwendet. Die T-Serie demonstriert einen gigantischen Technikvorsprung. Erstmals kann eine komplette Ganganalyse vorgenommen werden, die auf einer maximalen Fokussierung auf die Bewegung und Rehabilitation des Patienten basiert. Im Gegensatz zu den vorherigen 4 Mega Pixel fängt die Kamera die Bewegung des Patienten jetzt mit einer Auflösung von 16 Mega Pixel ein. Damit verfolgt die Kamera nicht nur die schnellste sondern auch jede subtilste Bewegung. Eine On-Board-Verarbeitung der Daten ermöglicht eine verbesserte Information und Diagnose. Mit den starken Stroboskopen kann die Kamera überall eingesetzt und an jedem Ort aufgestellt werden.

VICON cameras have been used in hospitals for over 20 years. T-Series demonstrates a giant leap in technology enabling a complete gait analysis to be performed with maximum attention focused on the patient's movement and rehabilitation. Capturing a patient at 16 mega pixels resolution compared to the previous 4 means the camera can now accurately track the patient's fastest and subtlest movements. On-board processing means better quality data enabling an increased focus on patient diagnosis. Powerful strobes of the camera mean they're easy to move and set up in different locations.

Product
Bauerfeind SofTec® Coxa
Hüftgelenkorthese
Hip orthosis

Design
Rokitta, Produkt & Markenästhetik
Designteam Rokitta
Mühlheim, Germany

Manufacturer
Bauerfeind AG
Zeulenroda-Triebes, Germany

Dass eine Hüftorthese gleichzeitig sicher und komfortabel sein kann, beweist die SofTec® Coxa von Bauerfeind. Sie sorgt für eine sichere Führung des Hüftgelenks und unterstützt so effektiv die Therapie bei Hüftluxationen. Entscheidend für die Wirkung der SofTec® Coxa ist das Zusammenspiel des innovativen Gelenks mit der in die weichen und atmungsaktiven Gestrickteile eingebundenen Beckenfassung und Oberschenkelschale. Die einzelnen Bestandteile lassen sich individuell exakt an den Patienten und das Therapiestadium anpassen. Der Tragekomfort sowie das einfache An- und Ablegen der Orthese tragen zu einer hohen Patientencompliance bei.

The fact that a hip orthosis can also be safe and comfortable is proven by the SofTec® Coxa from Bauerfeind. The orthosis ensures safe management of the hip joint and effectively supports therapy for hip dislocation patients. An essential aspect for the effectiveness of SofTec® Coxa is the interaction of the innovative joint with the pelvic harness and thigh shell integrated in the soft and breathable fabric sections. The various components can be individually precisely adapted to the patient and the stage of therapy. The wearing comfort, along with simple fitting and removal of the orthosis, contributes to a high level of patient compliance.

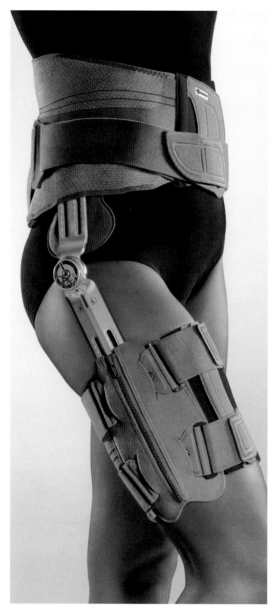

Product
Cleanius
Steckbecken Bettpfanne
Bedpan

Design
ServoClean
Emerkingen, Germany

Manufacturer
HOLZAMMER Kunststofftechnik GmbH
Sengenthal, Germany

Steckbecken Cleanius ersetzt den 100 Jahre alten Blechnachttopf. Die Bettpfanne verfügt über folgende Eigenschaften: warmer Kunststoff, geschlechterunabhängig, Urin und Stuhl gleichzeitig, Wirbelsäulenaussparung, Dekubitusprophylaxe, große Auflageflächen mit hoher Druckentlastung, hoher Liegekomfort durch flachen Rand, Genitalabdeckung mit Spritzschutz, Sichtschutz, Geruchsschutz, keine Bettenverschmutzung, auslaufsicher, Kanalisierung der Ausscheidungen, Kreisdichtung mit Doppelkammer ist auslaufsicher, keine Vakuumadhäsion, geringere Gesäßverschmutzung; der Patient liegt über, nicht in seinen Ausscheidungen; keine Sekundärinfektionen, Pflegesicherheit, Kostenersparnis. Ein Attraktivitätsgewinn für Institutionen.

Bedpan Cleanius replaces uncomfortable 100-year-old steel bedpan. Features: warm plastic, unisex, urine and stool simultaneously, vertebral column relieving immersion, Decubitus prophylaxis, big surface allows reduction of point load, high lying comfort, flat edges, genital cover protection, reduction of odors, no soiled beds, leak proof genital cover with splash protection, funnel of excrements into Cleanius; all around sealing-double chamber system, no vacuum suction, reduced soiling of buttocks because patient is lying above, not in his excrements; no super infections, safety in care. Institutions gain reputation and reduce cost.

Product
Fußschalter VIO
Foot switch

Design
Tricon Design AG
Kirchentellinsfurt, Germany

Manufacturer
ERBE Elektromedizin GmbH
Tübingen, Germany

Mit dem Fußschalter VIO werden Funktionen von ERBE Chirurgiesystemen aktiviert, so z. B. elektrochirurgisches Schneiden (gelb) und Koagulieren (blau). In der Gestaltung zeigt sich das Spannungsfeld zwischen medizinischer Präzision und robustem Werkzeugcharakter einer Bedienung, die im wahrsten Sinne des Wortes mit Füßen getreten wird. Unter dem OP-Tisch positioniert, bekommt der Chirurg den Schalter kaum zu Gesicht, vielmehr bekommt er ihn zu spüren: Er muss ihn blind und sicher bedienen können. Dafür steht ein Edelstahlbügel zur Verfügung, der sich raumgreifend ertasten und orientieren lässt und so die Lage der Pedale zweifelsfrei vermittelt.

The foot switch VIO has been developed for use of different ERBE surgical units. The design reflects the tension between medical precision and the robust tool-character of a foot-operated device, which will be trampled by foot in the truest sense of the word. Situated underneath the table the switch is not visible during surgery, but sensible: The surgeon must activate it blindly and – very important – safely. For this operation a stainless steel bracket is provided with which the user can feel around and that he can orient towards the appropriate direction. So the position of the reduced designed pedals becomes doubtless clear.

Product
Vibringe
Endodontisches Gerät
Endodontic device

Design
VanBerlo strategy+design
Design Team VanBerlo
Eindhoven, The Netherlands

Manufacturer
Vibringe B. V.
Utrecht, The Netherlands

Vibringe ist ein innovatorisches endodontisches Gerät für Wurzelkanalspülungen, das zu einer wesentlichen Vereinfachung zahnärztlicher Behandlungen beiträgt. Unter Verwendung einer patentierten schallbasierten Flusstechnologie wird eine akustische Strömung im Wurzelkanal angeregt, welche die Spülergebnisse bedeutend verbessert. Vibringe präsentiert sich in einem modernen und hygienischen Design, das bestens zum innovatorischen Charakter des Produkts passt. Besonders von Vorteil im Gebrauch sind das einzigartige induktive Ladesystem für einen schnurlosen Einsatz, die Einknopfsteuerung und integrierte LED-Leuchte zum Ausleuchten der Behandlungszone.

Vibringe is an innovative endodontic device for root canal irrigation that makes the dental practioners life easier. The product uses a patented sonic flow technology, which causes acoustic streaming in the root canal, which dramatically improves irrigation results. Vibringe has a friendly, modern and hygienic design that befits the innovative character of the product, and is very easy to use. It also features a unique inductive charging system and is therefore suitable for wireless operation. Easy to operate with one button control, an ergonomic shape and integrated LED light to illuminate the treatment area.

In dieser Kategorie sind die Kriterien für die Beurteilung der Designqualität äußerst facettenreich und nutzerorientiert. Da geht es einmal darum, wie sich das Produkt anfühlt. Wichtig ist auch, ob die Technik Leistung, verbesserte Ergonomie und erhöhte Sicherheit bietet. Es geht um die Verarbeitungsqualität. Und nicht zuletzt um ein schönes, angemessenes Erscheinungsbild. Anders ausgedrückt: Gutes Design bedeutet nicht nur, besser auszusehen, sondern etwas besser zu machen. Anderenfalls ist das Äußere nichts weiter als ein leeres Versprechen.

Glücklicherweise hat unser Jury-Team zahlreiche hervorragende Produkte gesehen, die dieser weiten Definition von gutem Design gerecht werden und ihr Versprechen an den Nutzer halten – also das Leben und die Arbeit der Menschen verbessern.

Wir zeichneten über 80 Produkte aus, von denen die allermeisten in Deutschland oder einigen seiner Nachbarländer entwickelt worden waren. Offensichtlich sind viele Unternehmen in dieser Region einer starken Tradition für das Design industrieller Werkzeuge und Ausrüstungsgegenstände verhaftet, wobei die Erfahrung des Nutzers eindeutig im Vordergrund steht.

Als Jury waren wir auch offen für niedrigpreisige Produkte aus Asien und anderen Regionen. Einige dieser Produkte wurden ausgezeichnet; viele schafften es jedoch nicht, da irgendetwas Wichtiges fehlte. So hatten wir etwa eine Handbohrmaschine zu beurteilen, die ebenso gut aussah wie sie sich anfühlte, doch aus ihrem Inneren kam ein billiges Klappergeräusch. Eine Motorsäge fanden wir sehr „cool", doch ein Herstellungsfehler hatte auf dem Griff eine scharfe Kante hinterlassen. Wir sahen eine innovative Holzschleifmaschine mit enttäuschender Graphik. In all diesen Fällen war trotz des niedrigen Preises die Designqualität kein Problem. Ich empfehle den Designern dieser Produkte, ihre Bemühungen vollständig der Nutzererfahrung unterzuordnen und die Produkte im nächsten Jahr erneut einzureichen.

The criteria for judging design quality in this category are very multifaceted and user-driven. It's the "feel" of the product in your hand. It's the right technology that delivers performance and enhances ergonomics and safety. It's the manufacturing quality. And, of course, it's also good, appropriate appearance. In other words, good design is not just about looking better, but rather it's about doing something better. Otherwise, appearance is just an empty promise.

Fortunately, our jury team found many excellent products that meet the broad definition of good design, and fulfill their promise to the user, that is, they enhance people's lives and the work they do.

We gave awards to over 80 products, and the vast majority were designed or manufactured in Germany or a few of its close neighbors. It's obvious that many companies in this region have a strong tradition in the design of industrial tools and equipment, and have a clear focus on the user experience.

As a jury, we were also sensitive to lower-priced products from Asia and elsewhere. While a few of these products received an award, many did not make the cut because one important element was missing. For example, we saw a hand drill that looked and felt great, but it had a cheap rattling sound inside. We also saw a very cool power saw, but a manufacturing flaw left a sharp edge on the molded grip. We saw an innovative wood sander, but the graphics were disappointing. In all these cases, design quality was easily achievable despite a low price point. For these products, I encourage the designers to simply refocus their efforts on the total user experience, and resubmit their products next year.

Product
3M Speedglas 9100
Schweißmaske
Welding shield

Design
Ergonomidesign
Oskar Juhlin, Martin Birath,
Henrik Olsson
Bromma, Sweden

Manufacturer
3M Svenska AB
Gagnef, Sweden

9100 – eine neue Plattform für die 3M-Schweiß-masken-Serie. Ergonomidesign hat aus einer zwanzig-jährigen, von Erkenntissen aus der Industrie geprägten Erfahrung die ideale Schutzmaske entwickelt. Schutz, Komfort und Leistung sind überragend, Passform, Festigkeit und Gewichtsverteilung einstellbar, die Justiermöglichkeiten um 200% gestiegen. Die Drehpunktanordnung minimiert Hebelkräfte. Das patentierte Kopfband setzt zur Vermeidung von Druck auf Nerven, Arterien und Akupressurpunkte ergonomische Erkenntnisse aus verschiedenen Kulturkreisen um. Das automatisch abdunkelnde Glas verbessert den Augenschutz erheblich.

9100 – a new platform for the entire line of 3M's protective welding equipment. Ergonomidesign has transformed 20 years of experience and user insights from the welding industry into the ideal shield. 9100 offers outstanding protection, comfort and performance. It changes how the welder wears the shield and experiences its fit, stability and balance. Adjustment possibilities have increased by 200%. A new pivot location minimizes leverage forces. Eastern and Western ergonomics are included in the patented headband to avoid pressure on nerves, arteries and acupressure points. The new auto darkening glass radically improves eye protection.

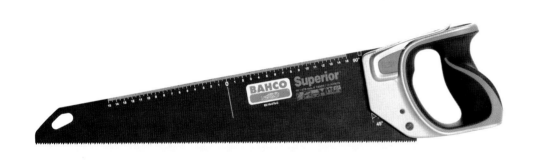

Product
Bahco Handsaw System
Handsäge
Handsaw

Design
Ergonomidesign
Hans Himbert, Mårten Andrén,
Olle Bobjer, Oskar Juhlin
Bromma, Sweden

Manufacturer
SNA Europe
Enköping, Sweden

Das innovative Handsägesystem von Bahco wird die Welt des Sägens verändern. In einen Griff mit Patentverschluss lassen sich bequem verschiedene Sägeblätter einsetzen. Bei der Entwicklung wurde auf kleinste Details Wert gelegt – so entstand ein äußerst ergonomischer Präzisionsgriff aus stabilem, mit weichen Materialen (TPE) belegtem Aluminium. Die asymmetrische Gestaltung eliminiert Druckpunkte und sorgt für maximale Unterstützung beim Sägen. Den Griff gibt es in verschiedenen Größen für Rechts- und Linkshänder. Da abgenutzte Sägeblätter ersetzt werden können, ist der Griff nachhaltig wiederverwendbar.

The innovative Bahco Handsaw System will change the way you use and purchase a saw. It consists of a separate handle with a patented locking mechanism to easily exchange blades, as well as different blades for different tasks. The designers focused extensively on even the smallest details and used soft materials (TPE) on a solid aluminium body to create a handle with superior ergonomics and increased precision. The asymmetrical design eliminates pressure points and provides maximum support. It is available in different sizes for both right- and left-handed use. The option to replace worn blades means that the handle can be reused over and over again.

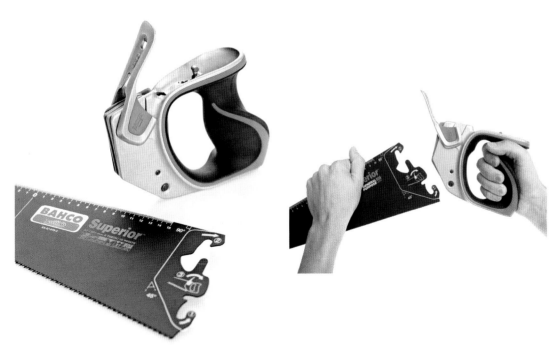

Product
Hilti S-MS
Schnellschraube
High-speed screw

Design
Hilti Corporation
Schaan, Liechtenstein

Manufacturer
Hilti Corporation
Schaan, Liechtenstein

Der unscheinbare Meilenstein: Schrauben ohne Bohren mit Hilti S-MS. Sie wurde entwickelt für die Verbindung von Trapezblechstößen, zur Verschraubung von Lüftungskanälen oder zum Befestigen von zwei dünnwandigen Blechen. Ohne Vorbohren wird die Schraube direkt durch das Blech geschraubt. Der spanlose Prozess verhindert effektiv die Korrosion am Schraubloch, Nacharbeiten sind unnötig. Die Schrauben garantieren hohe Sicherheit bei den gleichzeitig höchsten Lastwerten am Markt. In Kombination mit dem eigens hierfür entwickelten Standgerät kann der Anwender sehr ergonomisch und mit extrem hoher Setzfrequenz arbeiten.

Inconspicuous, but a milestone nevertheless, the Hilti S-MS is a screw that does away with drilling. It's designed for use at joints in trapezoidal metal sheets, screw fastenings on air ducts and other applications using thin sheet metal. The screw is simply driven through the sheet metal. As no drilling is required and no metal cuttings are formed during the driving operation, corrosion around the screw hole is effectively prevented. The screw achieves the highest loading capacity of all comparable screws. In conjunction with its own specially-developed stand-up screwdriving tool, this high-speed screw offers great ergonomic advantages.

Product
Hilti D 8-FV
Helix Schraubdübel System
Helix screw anchor system

Design
Hilti Corporation
Schaan, Liechtenstein

Manufacturer
Hilti Corporation
Schaan, Liechtenstein

Der D 8-FV ist ein einzigartiges Befestigungselement für alle Dämmstoffdicken, kombiniert mit beeindruckenden thermodynamischen Eigenschaften. Das innovative Dübel-Design mit der Doppel-Helix-Spirale schneidet sich mühelos in EPS-Dämmplatten und Mineralwolle. Zugleich sorgt er für eine optimale thermische Entkopplung, wodurch Wärmebrücken auf das physikalische Minimum reduziert werden. Die Dübel und das Spezial-Setzwerkzeug wirken in einzigartiger Weise zusammen und ergeben das einfachste Schraubdübel-System am Markt. Die Handhabung ist unkompliziert. Aufgrund des Bau-Prinzips ist nur eine einzige Dübellänge nötig.

Featuring impressive thermodynamic properties, the D 8-FV is a unique fastener for use with insulation materials of all thicknesses. Thanks to its innovative double-helix spiral design, this anchor cuts its way effortlessly into expanded polystyrene and mineral wool insulation sheets. It also ensures optimum thermal isolation by reducing thermal bridging to the lowest physically possible level. The D 8-FV anchor and the special setting tool function together in a unique way, resulting in the simplest screw anchor system on the market. Installation of the anchor is very straightforward and, due to its design, only one length is required.

Product
Hilti TE DRS-B
Staubabsaugung
Dust removal system

Design
Hilti Corporation
Schaan, Liechtenstein
Proform Design
Winnenden, Germany

Manufacturer
Hilti Corporation
Schaan, Liechtenstein

Die TE DRS-B ist die erste professionelle, extrem effektiv arbeitende Staubabsaugung für alle Meißel- und Sanierungsarbeiten im Innenbereich. Das System saugt bis zu 95% des kritischen Feinstaubs am Werkzeug und an der Werkzeugaufnahme ab. Dies bewirkt höchstmögliche Staubfreiheit und schützt Anwender und Gerät zugleich. Dank Schnellverschluss ist die Staubabsaugung einfach und ohne Werkzeug am Gerät montierbar. Das TE DRS-B-System ist aus speziellen Soft-Materialien gefertigt und deshalb extrem robust und langlebig. Zusammen mit den Hilti-Staubsaugern bietet Hilti ein leistungsfähiges Gesamtsystem, das dem Feinstaub wirkungsvoll begegnet.

The TE DRS-B is the first effective dust removal system for professional use in all indoor chiseling and renovation work. Up to 95% of critical fine dust at the tool's chisel and chuck is collected by the system. The operator and the tool are thus protected from the effects of dust exposure. Thanks to its quick-release design, the dust removal system can be attached and removed easily without tools. The TE DRS-B system is made from a special flexible material and is thus extremely robust and durable. In conjunction with its range of vacuum cleaners, Hilti offers a complete high-performance system capable of effectively combating fine dust.

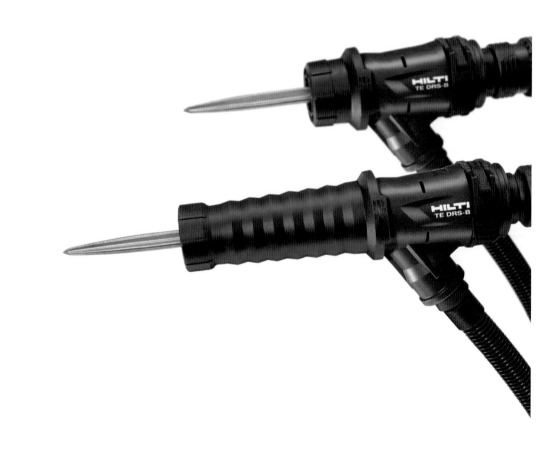

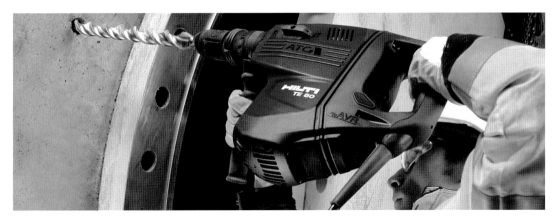

Product
Hilti TE 80
Kombihammer
Combination hammer

Design
Hilti Corporation
Schaan, Liechtenstein
Proform Design
Winnenden, Germany

Manufacturer
Hilti Corporation
Schaan, Liechtenstein

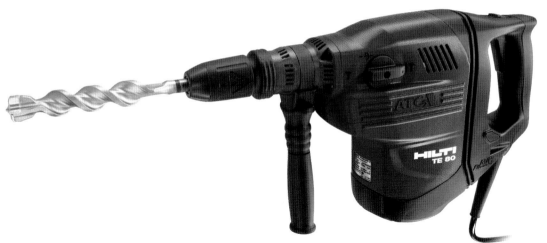

Mit Vibrationswerten von unter neun m/s² ist der TE 80 Spitzenreiter der zehn kg-Klasse. Die erforderliche Anpresskraft ist niedrig. Das Arbeiten dadurch weniger ermüdend als mit vergleichbaren Geräten. Mit 1.700 Watt Motorleistung und 380 U/min. setzt der Kombihammer neue Standards in punkto Leistung, Ergonomie und Arbeitsschutz. Ein weiterer Sicherheitsvorteil ist Hilti's einzigartige elektronische Schnellabschaltung ATC, die bei einem gefährlichen Verhaken des Bohrers die Verletzungsgefahr deutlich verringert. Das konsequent umgesetzte Design klassifiziert durch diverse Merkmale den TE 80 klar als Kombihammer im Hilti-Produktsortiment.

With a vibration value of less than nine m/s², the TE 80 is the front runner in the ten kg class. Requiring only minimal contact pressure, this tool is less tiring to work with than comparable types. With its 1,700-watt motor and speed of 380 rpm, it sets new standards in terms of performance, ergonomics and working safety. Also on board is ATC, Hilti's unique electronic safety cut-out that greatly reduces the risk of injury in the event of the drill bit sticking. Thanks to uncompromising implementation of its design, incorporating various characteristic features, the TE 80 is immediately recognized as a member of the Hilti combination hammer range.

Product
Hilti VC 20-UM
Trocken-/Nass-Sauger
Wet/dry vacuum cleaner

Design
Hilti Corporation
Schaan, Liechtenstein
Proform Design
Winnenden, Germany

Manufacturer
Hilti Corporation
Schaan, Liechtenstein

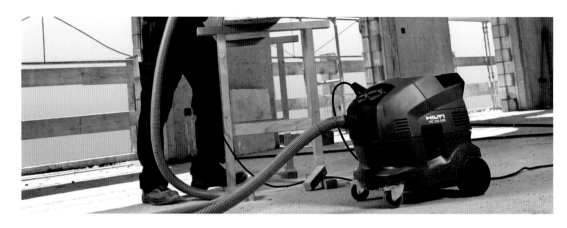

Kraftvoll, robust und gründlich: Hilti setzt mit dem
VC 20-UM den Grundstein für eine staubarme und
saubere Baustelle. Der universell einsetzbare Sauger
beeindruckt durch hohe Absaugleistung und ein
praktisches, handhabungsorientiertes Design. Auf-
grund der hohen Flexibilität kann der Trocken-/Nass-
Sauger mit einer Vielzahl an Hilti-Geräten kombiniert
werden. Die „Hilti AirBoost Filtertechnologie" garan-
tiert konstant hohe Saugleistung: Das neue, innova-
tive System sorgt für eine Luftumkehr im Gerät und
reinigt den Filter automatisch alle 15 Sekunden. Das
Design positioniert den Sauger klar als unterstützen-
des Sekundär-Gerät im Hilti-Portfolio.

Powerful, ruggedly built and highly efficient, the Hilti
VC 20-UM vacuum cleaner is the key to a clean, vir-
tually dustless workplace. Offering impressively high
suction performance and a practical, user-friendly de-
sign, its great versatility makes this wet/dry universal
vacuum cleaner the perfect partner for a wide range
of Hilti tools. Constantly high suction performance is
guaranteed by the "Hilti AirBoost filter technique",
an innovative system that cleans the filter by briefly
reversing the air flow within the appliance every
15 seconds. The vacuum cleaner's design positions it
clearly in its supporting role within the Hilti product
range.

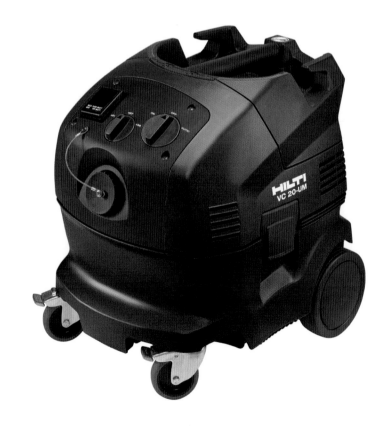

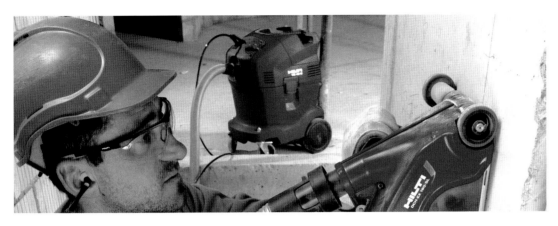

Product
Hilti VC 40-U
Trocken-/Nass-Sauger
Wet/dry vacuum cleaner

Design
Hilti Corporation
Schaan, Liechtenstein
Proform Design
Winnenden, Germany

Manufacturer
Hilti Corporation
Schaan, Liechtenstein

Der VC 40-U ist der Allrounder unter den neuen Hilti Trocken-/Nass-Saugern. Mit dem großzügigen Staubnutzvolumen von 40 kg lässt sich jeglicher Schmutz bei Bohr-, Schlitz-, Schleif- oder Kernbohranwendungen optimal entfernen. Große baustellentaugliche Transporträder, der optionale Schubbügel und eine einfache Handhabung sorgen für bestmöglichen Komfort. Die „Hilti AirBoost Filtertechnologie" garantiert konstant hohe Saugleistung: Das neue, innovative System sorgt für eine Luftumkehr im Gerät und reinigt den Filter automatisch alle 15 Sekunden. Das Design positioniert den Sauger klar als unterstützendes Sekundär-Gerät im Hilti-Portfolio.

The VC 40-U is the all-rounder among new Hilti wet/ dry vacuum cleaners. Thanks to a generous container capacity of 40 kg, dirt and waste materials from drilling, slitting, grinding or core drilling work can efficiently be collected. Exceptional convenience is ensured by the large wheels and optional handle bar for easy on-site transport. Constantly high suction performance is guaranteed by the "Hilti AirBoost filter technique", an innovative system that cleans the filter by briefly reversing the air flow within the appliance every 15 seconds. The vacuum cleaner's design positions it clearly in its supporting role within the Hilti product range.

Product
Hilti PV 45
Linienlaser
Line laser

Design
Hilti Corporation
Schaan, Liechtenstein
Kiska
Anif / Salzburg, Austria

Manufacturer
Hilti Corporation
Schaan, Liechtenstein

Exaktes Ausrichten im Innenbereich wird mit dem PV 45 zur einfachen und schnellen Ein-Mann-Routine. Dafür sorgen der präzise Laserstrahl, die perfekt durchdachte Bedienung mit einem einzigen großen Drehknopf und das optimal auf den harten Baustellenalltag ausgelegte Design. Somit lässt sich das Gerät auch mit Handschuhen problemlos bedienen. Die gedämpften Füße und der großzügige Elastomer-Bereich schützen den Linienlaser vor möglichen Beschädigungen. Überlegene Messleistungen werden dank „Hilti Pulse Power" erreicht: Eine Million Impulse / Sekunde garantieren, dass der Laserstrahl beim ersten Passieren sicher vom Empfänger detektiert wird.

With the PV 45, accurate alignment in interior finishing becomes a quick, easy one-man job. Ruggedly designed to withstand hard, everyday jobsite use, this tool features a precise laser beam and a single, large control knob for straightforward operation. It's therefore easy to use even when wearing gloves. Vibration-absorbing feet and a generously-sized synthetic rubber covering help protect this line laser from damage. "Hilti Pulse Power", a system that generates a million laser impulses per second and thus ensures detection of the laser beam at the first pass, guarantees superior laser alignment performance.

Product
Robust Line
Verpackung für Bohrer etc.
Packaging for drill bits etc.

Design
Studio Hannes Wettstein AG
Zürich, Switzerland

Manufacturer
Bosch Power Tools, Accessory Business Unit
Scintilla AG
Solothurn, Switzerland

Die handlichen Robust Line Sets von Bosch bieten Zubehör für die meisten Anwendungen im Innenausbau und auf der Baustelle. Das Sortiment umfasst dabei praxisorientierte Sets mit Bohrern, Stichsägeblättern und Schrauberbits. Die kompakten Robust Line Sets von Bosch zeichnen sich durch besonders hohe Robustheit und Bedienerfreundlichkeit aus. Der Inhalt ist gut sichtbar, die praktischen Sets sind einfach zu öffnen und die Zubehöre gut zu entnehmen. Der innovative stoßdämpfende Außenrahmen der Boxen hält dabei gröbsten Belastungen stand. Die Robust Line Sets sind ideal für Maschinen- oder Werkzeugkoffer, passen aber auch in die Tasche.

The handy Robust Line sets from Bosch offers accessories for most applications for interior fitting work in and on the construction site. The range is comprised of user-oriented sets with drill bits, jigsaw blades and screwdriver bits. The compact Robust Line sets from Bosch are set apart by their particularly robust and user-friendly design. The contents are clearly visible, the sets are easy to open and the accessories are easy to remove. The innovative shock absorbing outer frame of the box can withstand the biggest impact. The Robust Line sets are ideal for machine or tool cases, but they also fit in your pocket.

Product
Ferm 18V
Akkustichsäge
Cordless jig saw

Design
Brandes en Meurs industrial design
Bastiaan Kok, Michiel Meurs,
Jeroen Sluijter, Joyce Smits
Utrecht, The Netherlands

Manufacturer
Ferm b. v.
Zwolle, The Netherlands

Diese 18-Volt-Stichsäge gehört zu einer Reihe von
Werkzeugen mit identischer Li-Ion-Batterie. Zu den
vielen innovativen Funktionen zählen ein LED-Spot-
light, ein Staubblassystem und eine Geschwindig-
keitssteuerung. Die Sägeblattaufbewahrung und die
Anzeige für die Winkeleinstellung sind in der Alu-
minium-Fußplatte untergebracht. Eine LCD-Anzeige
gibt Auskunft über restliche Arbeitszeit. Der 2 K-Soft-
grip ist ergonomisch gestaltet; das robuste Gehäuse
wird durch Magnesiumelemente geschützt. Diese
18-Volt-Stichsäge ist ein Beispiel für das von Brandes
en Meurs industrial design entwickelte Ferm Premium
Power-Design.

This 18V jig saw is one of a line of tools sharing the
same lithium-ion battery. The jig saw includes many
innovative functions. Saw storage and the angle ad-
justment indicator have been combined at the back
of the aluminium foot. The saw has an LED spotlight,
dust exhaust channel and speed control. An LCD in-
dicates the battery life on the job. The ergonomically
shaped handle has a 2K softgrip. The rugged hous-
ing is protected by magnesium panels. The design of
the 18V jig saw is an example of the Ferm Premium
Power design developed by Brandes en Meurs in-
dustrial design.

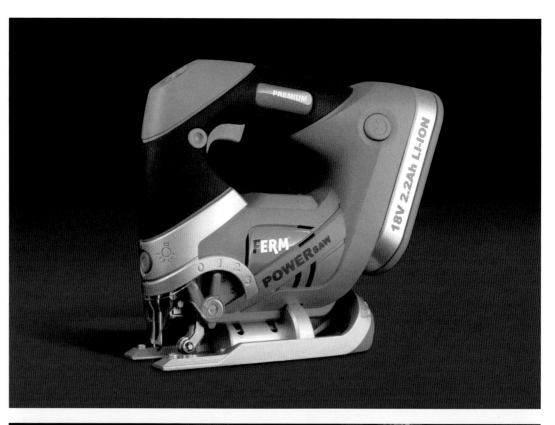

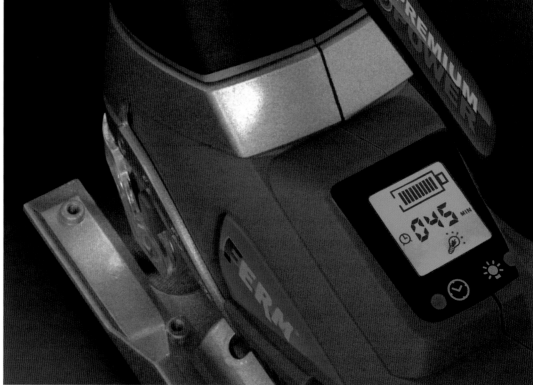

Product
Ferm 18V drill
Akkubohrmaschine
Cordless drill

Design
Brandes en Meurs industrial design
Bastiaan Kok, Michiel Meurs, Jeroen Sluijter
Utrecht, The Netherlands

Manufacturer
Ferm b. v.
Zwolle, The Netherlands

Ein 18-Volt-Akkuschrauber, das erste aus einer Reihe von Werkzeugen mit identischer Li-Ion-Batterie. Die Kraft dieser Batterie macht den Heimwerker zum Profi. Bei Entwicklung und Produktion standen Qualität und die Liebe zum Detail im Vordergrund. Der 2 K-Softgrip-Handgriff ist ergonomisch gestaltet; das robuste Gehäuse wird durch Magnesiumelemente geschützt. Eine LCD-Anzeige gibt Auskunft über die restliche Arbeitszeit. Zwei LEDs beleuchten den Arbeitsbereich. Dieser 18-Volt-Akkuschrauber ist ein Beispiel für das von Brandes en Meurs industrial design entwickelte Ferm Premium Power-Design.

This 18V drill is the first of a line of tools sharing the same lithium-ion battery. The power of this battery brings professional power within reach of D. I. Y. ers. The drill itself was designed and produced with an eye for quality and detail. The ergonomically shaped handle has a 2K softgrip. The rugged housing is protected by magnesium panels. An LCD indicates the battery life on the job. Two LEDs illuminate the working area. The design of the 18V drill is an example of the Ferm Premium Power design that has been developed by Brandes en Meurs industrial design.

Product
Ferm 7,2V driver
Akkuschrauber
Cordless driver

Design
Brandes en Meurs industrial design
Bastiaan Kok, Michiel Meurs, Joyce Smits
Utrecht, The Netherlands

Manufacturer
Ferm b.v.
Zwolle, The Netherlands

Der 7,2-V-Akkuschrauber von Ferm ist ein kompaktes, ergonomisches Werkzeug, dessen doppelte Lithium-Ionen-Batterie genügend Energie zum Bohren und Schrauben liefert. Das Gehäuse besteht komplett aus 2K-Softgrip mit Bedienfläche aus Aluminium und Kupplungsring. Im Fuß befinden sich eine Batterie-anzeige und ein Punktstrahler. Eine Magnetfläche auf der Oberseite hält kleine Metallteile oder Schrauben. Das Ladegerät ist mit zwei Zubehörfächern ausge-stattet. Der 7,2-V-Akkuschrauber von Ferm ist ein ausgezeichnetes Beispiel für das Design der Ferm-Power-Tools, das von den Industriedesignern Brandes en Meurs entwickelt wurde.

The Ferm 7.2 V driver is a compact and ergonomic tool. With its dual lithium-ion cells, it provides ample power for drilling and driving. The tool has a 2K soft grip that covers the entire housing and a magnesium panel and clutch ring. A battery indicator and spot-light have been positioned in the foot; a magnetic surface at the top holds bits or screws. The charger is equipped with two drawers for drill bits and screw bits. The design of the 7.2 V driver is an example of the Ferm Power design that has been developed by Brandes en Meurs industrial design.

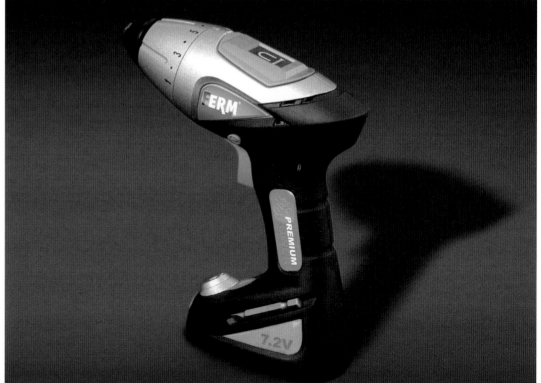

Product
Triplet Hawk®
Diamantenlupe
Diamond loupe

Design
Enthoven Associates Design Consultants
Antwerpen, Belgium

Manufacturer
Swiss Axe
Antwerpen, Belgium

Triplet Hawk® ist ein innovatives Vergrößerungsglas für Diamantenhändler und Juweliere. Eine Lupe ist für diese Berufe nicht nur ein wichtiges Werkzeug – sie hat geradezu Symbolcharakter. Dieses Produkt ist ein Beispiel dafür, wie Marktkenntnisse in Verbindung mit Kompetenz im Industriedesign etwas wahrhaft Neues hervorbringen können. Qualität und Ergonomie wurden stark verbessert, was sich bei intensiver Nutzung auszahlt. Triplet Hawk® erweist sich damit als High-End-Produkt, das hervorragende Leistungen (eine der besten Linsen auf dem Markt) mit einem funktionellen, alle Sinne ansprechenden Design vereint.

The Triplet Hawk® is an innovative magnifying glass for professional diamond traders and jewelers. A loupe is the necessary tool to execute their profession but on top of that it's an icon. This product is an example of how market knowledge combined with industrial design expertise, can lead to real innovations. The product is improvement on quality and on the intensive usage as the design seriously improved the ergonomics of the product. TripletHawk® is a high-end product that combines excellent performance (one of the best lenses on the market) with functional body design all translated within an emotional look & feel.

Product
DNCE-LAS
Elektrozylinder mit Linearmotor
Electric cylinder with linear motor

Design
Festo AG & Co. KG
Esslingen, Germany

Manufacturer
Festo AG & Co. KG
Karoline Schmidt
Esslingen, Germany

Der Elektrozylinder mit Linearmotor DNCE-LAS wird in Verpackungsmaschinen und bei der Zuführtechnik eingesetzt, um Produkte zu sortieren, zu transportieren und zu vereinzeln. Dort wird viel Wert auf Beschleunigungen und Geschwindigkeiten gelegt, damit ein hoher Maschinendurchsatz erreicht wird. Schnelle, hochdynamische Positionieraufgaben im Genauigkeitsbereich von ±0,02 mm führt der Antrieb zuverlässig durch. Die erforderlichen Komponenten sind in einer kompakten Einheit untergebracht. Das klare Design unterstreicht den linearen Charakter des Antriebs, der durch die typischen Designmerkmale von Festo gut zum Produktprogramm passt.

The DNCE-LAS electric cylinder with linear motor is used in packing machines and conveying technology to sort, transport and separate products. Great store is placed on acceleration and speed so that a high machine throughput can be achieved. The drive can reliably complete rapid, highly dynamic positioning tasks in an accuracy range of ±0.02 mm. The required components are housed in a compact unit. The clear design underlines the linear character of the drive, which, together with its typical Festo design features, fits in well with the product range.

Product
MPA-F
Ventilinsel
Valve terminal

Design
Festo AG & Co. KG
Karoline Schmidt
Esslingen, Germany

Manufacturer
Festo AG & Co. KG
Esslingen, Germany

Ventilinseln werden in automatisierten pneumatischen Anlagen eingesetzt, um elektrische Signale zu identifizieren und weiterzuleiten. Die MPA-F ist die Erweiterung einer bestehenden Ventilinselreihe, die im Maschinenbau eingesetzt wird. Durch den besonders hohen Durchfluss ist sie deutlich schneller bei der Signalverarbeitung. Zusätzlich ist sie mit einem robusten, dauerhaften Kennzeichnungssystem ausgestattet, das sowohl für Papier- als auch für Kunststoffschilder geeignet ist und ohne Werkzeug montiert werden kann. Dies bietet Klarheit im Servicefall. Alle Elemente der MPA-F sind aufeinander abgestimmt und stimmen mit dem Corporate Design von Festo überein.

Valve terminals are used in automated pneumatic systems to identify and pass on electrical signals. The MPA-F is an extension to an existing series of valve terminals, used in machine construction. It is significantly quicker in signal processing because of its particularly high flow rate. It is also equipped with a robust, permanent marking system, suitable for both paper and plastic plates that can be fitted without the use of tools. This ensures clarity during servicing. All the elements of MPA-F are coordinated and comply with Festo's corporate design.

Product
SRBP
Sensorbox binär und analog
Binary and analogue sensor box

Design
Festo AG & Co. KG
Karoline Schmidt
Esslingen, Germany

Manufacturer
Festo AG & Co. KG
Esslingen, Germany

Die binäre und analoge Sensorbox SRBP wird zur Statusanzeige und zur elektrischen Rückmeldung der Endlagenstellungen von Schwenkantrieben eingesetzt. Das Einsatzgebiet der Sensorbox erstreckt sich von der hygienischen Lebensmittelindustrie bis hin zu Außenanwendungen in der Petrochemie. SRBP vermeidet störungsbedingte Stillstände und reduziert durch frühzeitige Diagnose und Warnung den Ausfall von Produktionskapazitäten. Dabei wird eine Drehbewegung in ein schaltendes Ausgangssignal umgewandelt und über eine mechanische Anzeige dargestellt. Ein robustes Gehäuse und der modulare Aufbau ermöglichen eine Kombination mit Antrieben von Festo.

The SRBP binary and analogue sensor box is used for status display and for electrical feedback of the end positions of semi-rotary drives. The field of application for the sensor box extends from the hygiene-oriented food industry to exterior applications in the petrochemical industry. SRBP avoids shutdowns caused by faults and reduces the loss of production capacity through timely diagnostics and warnings. A rotary movement is converted into a switching output signal and displayed via a mechanical indicator. Its robust casing and modular design enable it to be combined with Festo drives.

Product
OVEM
Vakuumsaugdüse
Vacuum generator

Design
Festo AG & Co. KG
Yvonne Krehl, Karoline Schmidt
Esslingen, Germany

Manufacturer
Festo AG & Co. KG
Esslingen, Germany

Die modulare Vakuumsaugdüsenreihe OVEM vereint Funktionalität, Sicherheit und ein großes Anzeigeelement zu einer kompakten Einheit, die individuell für Kunden angepasst werden kann. Integrierte Ventile sorgen für kurze Schaltzeiten, um schnelles Ansaugen und präzises Ablegen des Werkstücks zu ermöglichen. Die Reihe ist mit einer integrierten Fehleranalyse- und Diagnosefunktion ausgestattet und damit bedienungsfreundlich sowie wartungsarm. Übersichtliche Betätigungselemente sorgen für einfache Installation und Anwendung und hochwertige Materialien für eine lange Lebensdauer des Produkts. Das klassische Design strukturiert die einzelnen Funktionsbereiche.

The modular OVEM series of vacuum generators combines functionality, reliability and a large display into a compact unit that can be adapted to the customer's needs. Integrated valves ensure fast switching times, permitting fast aspiration and precise placement of a workpiece. The series is equipped with an integrated fault analysis and diagnostic function, is user friendly and requires little maintenance. Clearly laid out actuating elements ensure a simple installation and use, while high-quality materials ensure the product's long service life. The classic design structures the separate functional areas.

Product
SME / SMT-10M
Zylinderschalter
Cylinder switch

Design
Festo AG & Co. KG
Karoline Schmidt
Esslingen, Germany

Manufacturer
Festo AG & Co. KG
Esslingen, Germany

Die neue Zylinderschalterbaureihe SME/SMT-10M eignet sich für alle Profilzylinder, Greifer und Schlitten mit C-Nut. Er wird in der Fabrikautomation besonders zur Abfrage von Magnetpositionen an pneumatischen Antrieben eingesetzt. Der Schalter bietet dem Kunden die freie Wahl über Kabellänge, Kabelsorte und Anschlusstechnik und kann von oben schnell und direkt in die Nut eingesetzt werden. Die erhabene Schaltpunktmarkierung und das robuste, sichere Klemmprinzip erleichtern den präzisen Einbau. Nahezu unsichtbar integrierte LED's zeigen den Schaltzustand und damit die Stellung des Antriebs an.

The new SME/SMT-10M series of cylinder switch is suitable for all profile cylinders, grippers and slides with a c-slot. It is used in factory automation systems particularly for querying magnet positions on pneumatic drives. The switch gives the customer free choice of cable length, cable type and connection technology and can be inserted quickly and directly in the slot from above. The excellent switching point marking and the robust, secure clamping design make a precise installation simple. Practically invisibly integrated LED's indicate the switching status and do show the position of the drive.

Product
MS9
Wartungsgerätereihe
Service unit series

Design
Festo AG & Co. KG
Karoline Schmidt
Esslingen, Germany

Manufacturer
Festo AG & Co. KG
Esslingen, Germany

Die Druckluftaufbereitungseinheit MS9 ist eine Ergänzung der bestehenden Wartungsgerätereihen. Die einzelnen Module können sowohl untereinander, als auch mit Modulen kleinerer Baugrößen zu kundenspezifischen Lösungen kombiniert werden. Durch die robuste Konstruktion ist die MS9 besonders für raue Umgebungen geeignet und bietet vielfältige Einsatzmöglichkeiten in der Automobil- und Nahrungsmittelindustrie. Die Gestaltung betont die einzelnen Module, die durch die dazwischenliegenden Verbindungselemente farblich gegliedert werden. Das Handeinschaltventil kann mit einem Vorhängeschloss gegen unbeabsichtigtes Betätigen gesichert werden.

The MS9 compressed air preparation unit complements Festo's existing series of service units. The individual modules can be combined with one another and also with smaller sized modules, to create customised solutions. Thanks to its sturdy design, the MS9 is particularly suited to harsh environments and finds many applications in the automotive and food industries. The design stresses the individual modules that are divided by colored connectors. The manual on-off valve can be secured against unintentional operation by means of a padlock.

Product
HEXAnamic
Schraubendreher
Screwdriver

Design
HAZET-WERK GmbH & Co. KG
Thomas Piel, Holger Scheer, Peter Welp,
Uni Siegen: Prof. Dr.-Ing. Helmut Strasser,
Prof. Dr.-Ing. Karsten Kluth, Dr.-Ing. Erwin Keller
Remscheid, Germany

Manufacturer
HAZET-WERK GmbH & Co. KG
Remscheid, Germany

Neuer HEXAnamic-Schraubendreher-Satz:
– fünfteilig
– Anatomisch geformte Griffe für die perfekte Ver-
 bindung zwischen Hand und Schraubendreher
– Drei-Komponenten-Griff, gestaltet nach neuesten
 ergonomischen Erkenntnissen in Zusammenarbeit
 mit führenden Arbeitswissenschaftlern in Deutsch-
 land; Komponente 1 (hart): optimale Klingenfixie-
 rung, Komponente 2 (hart): Stabilität gegenüber äu-
 ßeren Schlageinwirkungen, Komponente 3 (weich):
 für ausgeprägten Abgleitschutz bei axialem An-
 pressdruck
– Versetzter Sechskant im vorderen Griffbereich be-
 wirkt optimierten Abgleitschutz und verhindert un-
 kontrolliertes Wegrollen des Schraubendrehers.

The new HEXAnamic screwdriver Set:
– five parts
– Anatomically shaped for perfect coupling between
 hand and screwdriver
– Three-component handle cover, designed accord-
 ing to latest know-how in cooperation with lead-
 ing German work scientists; component 1 (hard):
 optimal blade fixation, component 2 (hard): stabil-
 ity against impacts, component 3 (soft): protection
 against slipping-off at axial contact pressure
– Recessed hexagon at the front of the handle: opti-
 mized protection against slipping-off, prevents the
 screwdriver from unintended sliding-off
– Slip-proved even with oily hands
– Well-sized quick-rotation area.

Product
Eurobind 4000
Klebebinder
Adhesive binder

Design
Heidelberg Industrial Design
Bernd Reibl
Heidelberg, Germany

Manufacturer
Heidelberg Postpress Deutschland
Leipzig, Germany

Der neue Klebebinder Eurobind 4000 nimmt die Corporate Designelemente auf. Die geometrische Architektur und große Flächen mit markanten Elementen sind Basismerkmale der Gestaltung. Sie demonstrieren Klarheit und (Lauf-)Ruhe und steigern die Wiedererkennung. Die Maschine gliedert sich in die Zusammentragmaschine und den Klebebinder. Die Darstellung des Workflows ist ein grundlegendes Element, welches sich an allen Heidelberg-Produkten als durchgehendes Wiedererkennungsmerkmal zeigt. Deutlich wird dies auch durch die Farbgestaltung und die großzügigen Fenster am Klebebinder, welche eine optimale Einsicht auf den Produktionsprozess bieten.

The new adhesive binder Eurobind 4000 includes corporate design elements. Geometric architecture and large surfaces with striking elements are the key design features. They demonstrate clarity and peace (quiet operation) and increase recognition. The machine is divided into the collator and the adhesive binder. The workflow display is a key recognition element that allows all Heidelberg products to stand out. This is also emphasized by the color scheme and the generously dimensioned windows on the adhesive binder, which allow optimum viewing of the production process.

Product
CS 33ET
Motor-Kettensäge
Engine chain saw

Design
Hitachi Koki Co. Ltd.
Masato Sakai, Masanori Okada
Hitachinaka-City, Ibaraki-Pref., Japan

Manufacturer
Hitachi Koki Co. Ltd.
Hitachinaka-City, Ibaraki-Pref., Japan

Jedes der Modelle CS 33ET, TCS-3301PFS und PMS-3301PFS ist eine umweltfreundliche Kettensäge, die den Gasausstoß durch einen Katalysator reduziert. Der Soft-Touch-Handgriff ist optimal geformt für höchstzuverlässige Anwendung. Darüber hinaus befindet sich eine konkav geformte Daumenauflage zwischen dem hinteren und vorderen Handgriff, damit kontrolliertes Handling in jede Richtung gewährleistet ist. Das Gehäuse ist stabil genug, um starke Erschütterungen während der Anwendung auszugleichen. Dies wird durch eine glatte Gehäuseform und durch die Konstruktion mit der Ventilatoröffnung ermöglicht.

Each model of CS 33ET, TCS-3301PFS and PMS-3301PFS is an environmentally-friendly engine chain saw that reduces gas emissions with a catalytic muffler. The handle is covered with soft material and optimally shaped for high level of reliable operability and stable balance. Moreover, a thumb rest (concave part) is provided at the joint between the rear and front handle to ensure stable operation in any direction. The case is strong enough to withstand heavy shocks during operation thanks to a smooth surface and the honeycomb construction ventilator window.

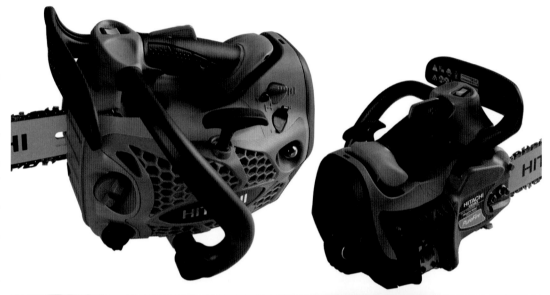

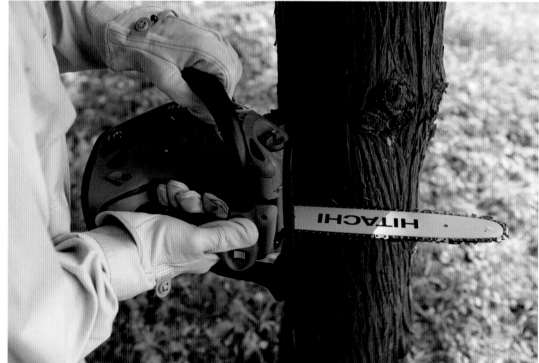

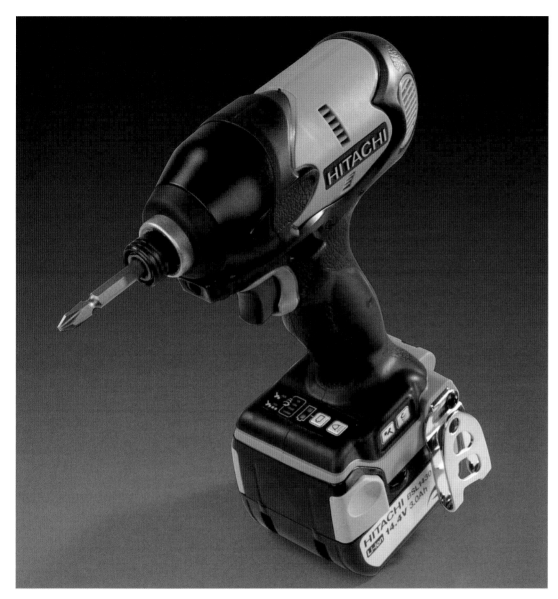

Product
WH 14DBL
Akku-Schlagschrauber
Cordless impact driver

Design
Hitachi Koki Co. Ltd.
Takeshi Taniguchu, Masanori Okada
Hitachinaka-City, Ibaraki-Pref., Japan

Manufacturer
Hitachi Koki Co. Ltd.
Hitachinaka-City, Ibaraki-Pref., Japan

Akku-Schlagschrauber werden zum Befestigen und Lösen von Schrauben in vielen Anwendungsbereichen benutzt. Das Modell WH 14DBL hat die folgenden Merkmale:
– Es ist vielseitig einsetzbar, dank einer vierstufigen variablen und festeinstellbaren Drehzahl- und Schlagkontrolle.
– Das Motorgehäuse ist vollständig mit einer elastischen, weichen Soft-Touch-Schicht ummantelt. Damit wird verhindert, dass die Maschine bei Schräglage abrutscht oder das Gehäuse beschädigt wird.
– Es ist noch einfacher, den Handgriff festzuhalten und ihn mit dem optimalen Form- und Gewichtsausgleich zu führen.
– Ein Riemenhaken kann, wenn benötigt, schnell ausgezogen und, wenn nicht mehr benötigt, eingeschoben werden.

Cordless impact drivers are used to tighten and loosen screws in building work. The Model WH 14DBL has the following features:
– It is versatile thanks to the four-step variable speed control mechanism for accurate speed and impact control.
– The body is entirely covered with soft material, to prevent the tool from sliding when placed on a slope and damaging building materials.
– The handle is easier to grip and press with optimum shape and weight balance and comfortable switch for easier operation.
– A belt hook can be quickly drawn out when needed and retracted when not needed.

Product
miniTwin4
Sicherheits-Lichtgitter
Safety light grid

Design
synapsis design GmbH
Frank Detering
Stuttgart, Germany

Manufacturer
SICK AG
Waldkirch, Germany

Das miniTwin4 ist das weltweit kleinste Lichtgitter mit höchster Sicherheitsstufe (Typ vier). Zur Bereichsabsicherung an Maschinen/Anlagen dienen zwei gegenüberliegende Lichtgitter (Länge 120 bis 1200 mm). Dank einer neuen Technologie sind sie erstmals baugleich (Twins). Ein Prisma in der Strahlführung erlaubt die schlanke asymmetrische Grundform, die sich sehr gut in beliebige Umgebungen integriert. Die leichte Wölbung der Aluminiumprofile verbindet visuell beide Geräte miteinander. Die Zuleitung kann wahlweise nach oben oder unten weisen. Dadurch sind sowohl die Geräte als auch die Anschlüsse verwechslungssicher (Poka-Yoke-Prinzip).

The miniTwin4 is the world's smallest light grid with the maximum safety rating (type four). Two light grids (length 120 to 1200 mm), mounted opposite each other, create a protective field in front of machinery. For the first time, an identical pair can be used, thanks to new technology. An internal prism guides the beam, allowing a slender, asymmetrical device shape that integrates well into surroundings. The curve of the aluminium sections creates visual continuity between the pair of devices. Cables can be directed upwards or downwards, ensuring that neither the devices nor the connections can be accidentally transposed (Poka-Yoke principle).

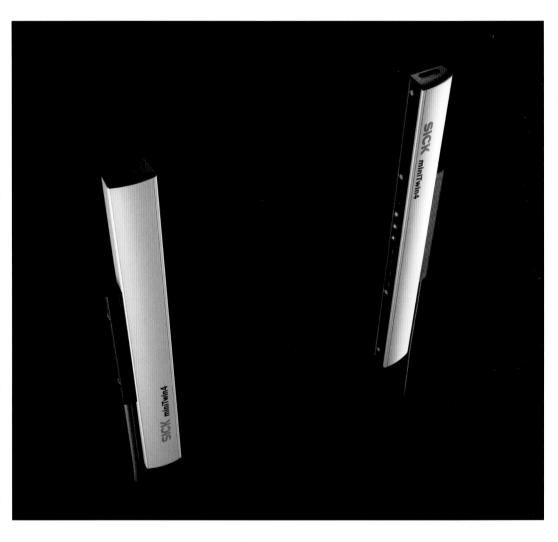

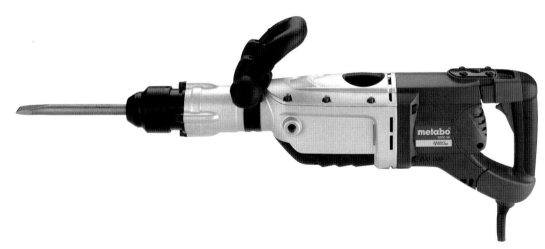

Product
MHE 96
Meißelhammer
Chisel hammer

Design
Scala Design
Peter Boulton
Böblingen, Germany

Manufacturer
Metabowerke GmbH
Nürtingen, Germany

Der Große, der nicht lange fackelt: Der MHE 96 ist der Richtige für das Korrekturmeißeln im großen Stil, das Meißeln von Schalungen und alle Abbrucharbeiten in Beton, Stein, Ziegel oder Asphalt. In Kombination mit einer Rüttelplatte ist er das optimale Gerät, um Betonfüllmaterial und Erde zu verdichten. Eine unverzichtbare Maschine für alle, die auf großen Baustellen harte Brocken zu bewältigen haben. Die Merkmale:
– Metabo VibraTech (MVT), d. h. vibrationsreduziertes und dadurch gelenkschonendes Arbeiten durch integriertes Dämpfungssystem an den Handgriffen.
– Lange, schlanke Bauweise für aufrechte Arbeitsposition bei Bodenarbeiten.

The giant that never sleeps: The MHE 96 is the right choice for large-scale restoration work, ideal for chiselling out frames, paving, walled sections or fence posts in concrete, stone, brick or asphalt. When combined with a tamping plate, it is the optimum device for compacting concrete fill material and soil. An essential machine for anyone requiring a heavy duty mobile breaker. Special attributes:
– Metabo VibraTech (MVT) means reduced vibration levels and therefore less impact on joints due to the integrated damping system on the handles.
– Long, slim design for an upright working position when performing tasks at ground level.

Product
KHE 56
Kombihammer
Combination hammer

Design
Scala Design
Peter Boulton
Böblingen, Germany

Manufacturer
Metabowerke GmbH
Nürtingen, Germany

Der 1.600 Watt Kombihammer KHE 56 eignet sich zum Bohren in Beton, zur Oberflächensanierung oder aber zum Bohren und Schlitzen in Mauerwerk. Ein robustes Getriebegehäuse aus Magnesiumdruckguss, Abschaltkohlebürsten sowie eine geschützte Power- und Serviceanzeige sorgen dabei für hohe Lebensdauer und Bedienfreundlichkeit. Lösungen zum Anwenderschutz: eine zusätzliche Vibrationsdämpfung am Haupthandgriff sowie der Metabo VibraTech (MVT)-Zusatzhandgriff zum Anschrauben.

The 1,600 watt KHE 56 combination hammer is suitable for drilling in concrete, surface for repair work or drilling and cutting masonry. The robust die-cast magnesium gear housing, auto-stop carbon brushes and protected power and service displays offers a long service life and user-friendly operation. User-safety solutions are also in the foreground. These include additional vibration damping on the main handle and the screw-on Metabo VibraTech (MVT) additional handle.

Product
UHE 28 Plus
Mulithammer
Multi hammer

Design
Scala Design
Peter Boulton
Böblingen, Germany

Manufacturer
Metabowerke GmbH
Nürtingen, Germany

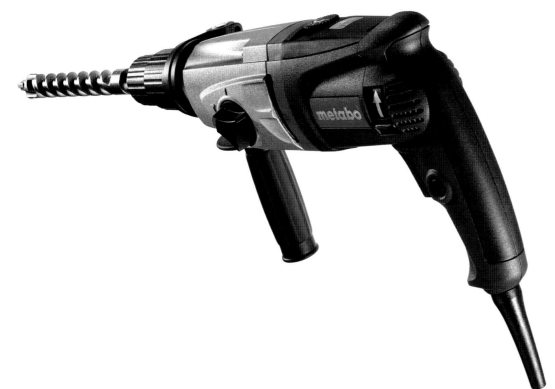

Kombi oder Multi: Unsere Hämmer haben ordentlich Kraft. Mit drei Joule Einzelschlagenergie und 4.400 Schlägen pro Minute bringen sie noch mehr Bohrleistung als zuvor. Mit dem Kombihammer UHE 28 Plus können Sie Hammerbohren, Bohren ohne Schlag, Schrauben oder Meißeln. Der Multihammer UHE 28 Plus hat zusätzlich einen zweiten Gang für noch effektiveres Bohren in Holz oder Metall. Der einzige Hammer mit vier Funktionen. Unser bewährtes Schlagwerk wurde an den Marathonmotor angepasst und verbessert. Das sorgt für einen maximalen Bohrfortschritt. Die bewährte ergonomische Gehäuseform sorgt für ermüdungsarmes Arbeiten und die lange Lebensdauer.

Combination or multi: Our hammers have proper power. With three Joules single-blow energy and 4,400 blows per minute, it is giving you more drilling capacity than ever before. The combination hammer UHE 28 Plus lets you hammer drill, drill without impacts, screw and chisel. The multi-hammer UHE 28 Plus features an additional second gear for even more effective drilling in wood or metal. The only hammer with four functions. Our proven Metabo impact mechanism has been adapted to the high performance. Marathon motor and improved even more. This ensures maximum drilling progress. The proven ergonomic housing takes care for low-fatigue working.

Product
1600.00
Abstoßmesser
Trimming knife

Design
bluequest Product Engineering GmbH
Marc Namur
Weiterstadt, Germany

Manufacturer
MOZART AG
Solingen, Germany

Ein Spezialmesser für die Entfernung von Schweiß-
nähten bei der Verlegung von Bodenbelägen aus
Gummi oder PVC. Durch seinen neuartigen Aufbau
mit durchgehendem Metallkern und Soft-Touch-Griff
liegt es sehr ausgewogen in der Hand und bietet Ro-
bustheit für den Handwerker. Die ergonomisch opti-
mierten Griffmöglichkeiten, in Verbindung mit der
Strukturierung der rutscharmen Oberfläche, ermög-
lichen ein ermüdungsarmes Arbeiten. Einzigartig ist
die integrierte Vorschneide- und Feinschneideeinrich-
tung mit Knickschutz für die Schneidklinge. Dadurch
kann der Handwerker sehr effizient und präzise mit
nur einem Werkzeug die Schweißnähte bündig ab-
trennen.

A special knife for removing welding seams while lay-
ing rubber or PVC flooring. Thanks to its innovative
construction with continuous metal core and well-
balanced soft-touch handle, it's both durable and sits
comfortably in the hand. The ergonomic handle and
the textured non-slip surface provide perfect grip,
preventing fatigue while working. The integrated
features for scoring and fine-cutting and a protec-
tive cover to keep the blade from breaking are unique
touches that allow the user to efficiently and precisely
separate welding seams flush to the surface with just
one tool.

Product
Skilsaw 4270 / 4370
Stichsägen
Jigsaws

Design
npk design
Janwillem Bouwknegt, Herman van der Vegt
Leiden, The Netherlands

Manufacturer
Skil Europe BV
Breda, The Netherlands

Beide Stichsägen passen sich dem Firmenimage anderer Skil-Produkte an, ohne die eigene Identität zu verlieren. Bei der luxuriöseren Ausführung, der Skilsaw 4370, kann eingestellt werden, mit welchem Material gearbeitet wird. Der Schalter befindet sich ganz bequem am Handgriff. Eine transparente Kappe schützt den Nutzer, erhält aber gleichzeitig eine gute Sicht auf das Werkzeug und fungiert als Lichtbegleiter für die kleine Lampe, die auf den Arbeitsbereich gerichtet wird. Außerdem verfügen beide Produkte über eine einstellbare Staubabsaugung. Die Piktogramme, Markenzeichen und Typenbezeichnungen wurden von der grafischen Abteilung entwickelt.

The design of both jigsaws fit the look & feel of other Skil products, while maintaining an identity of their own. The Skilsaw 4370, the more luxurious of the two tools, can be adjusted to the material that you work with. The handle is provided with a comfortable long switch. The transparent cap at the front of the device serves as protection and offers optimal visibility of the work-piece. It also serves as an extra light guide for the spotlight directed towards the work area. Furthermore, both products are equipped with an adjustable dust remover. The graphic design department created the icons, type designation and labels.

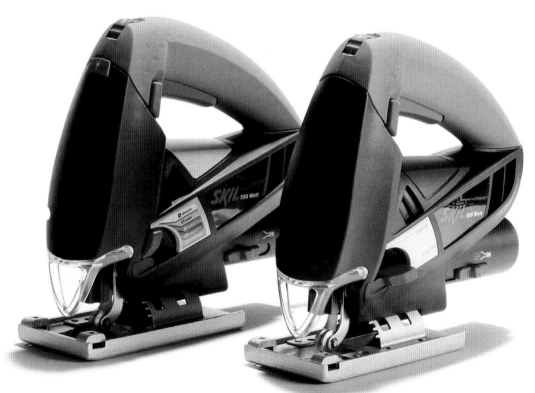

Product
FORMAT 4 kappa 550
Formatkreissäge
Panel saw

Design
plato. designgroup
Volker Stumpf
München, Germany

Manufacturer
Felder KG
Hall in Tirol, Austria

Solides Erscheinungsbild, Größe, Leistung, Präzision, Arbeitssicherheit, deutlich verbesserte Bedienfreundlichkeit und technische Innovationen sind Merkmale, mit denen sich die neue Formatkreissäge FORMAT 4 kappa 550 der Firma Felder KG von den Mitbewerbern differenziert. Semantische Gestaltmerkmale prägen die Maschine und vereinen formal die Arbeitssicherheit mit dem wertigen Erscheinungsbild der Maschine. Zudem wird die Präzision und Leistung der Maschine betont. Stoßkanten aus Kunststoff heben sich formal und farblich ab und verringern ebenso die Verletzungsgefahr wie der umschäumte Griff des Touchpanels, der angenehm zu greifen ist.

Solid build, size, performance, precision, operator safety and technical innovations are just some of the noticeable highlights that differentiate the new FORMAT 4 kappa 550 by the Felder KG from its competition. The semantic design defines the machine and unites the integrated safety features and high quality finish with the power and precision of this machine. Synthetic body panels highlight its welts whilst also offering additional protection to the user, such as the foam grip on the control panel.

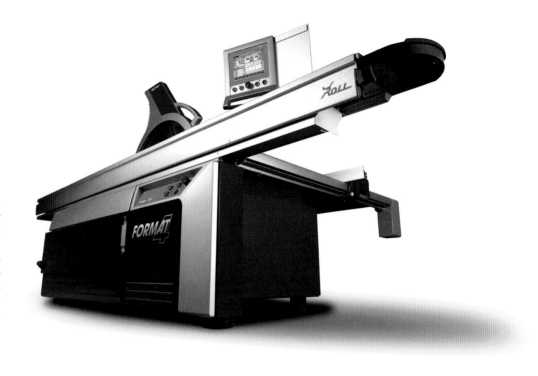

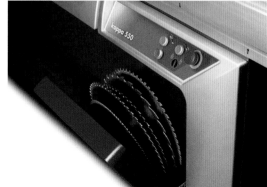

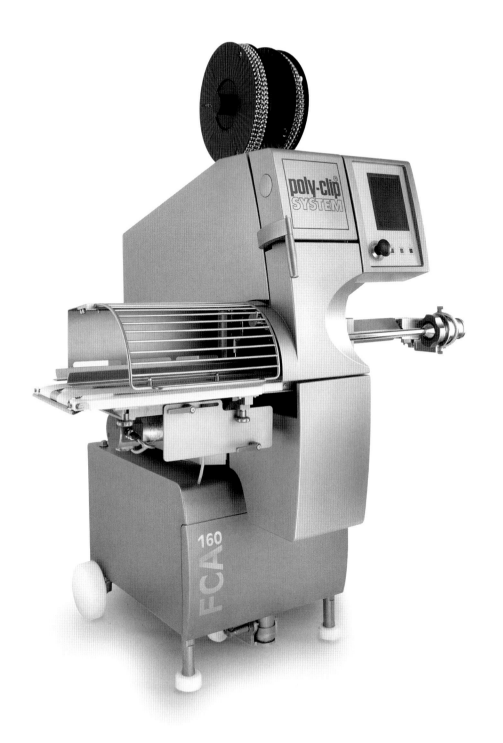

Product
FCA
Doppel-Clip Automat
Automatic double clipper

Design
PULS Design und Konstruktion
Andreas Ries, Marco Nunes
Darmstadt, Germany

Manufacturer
Poly-clip System GmbH & Co. KG
Frankfurt a. M., Germany

Poly-clip System ist der weltweit führende Hersteller von Clipverschluss-Systemen, der mit der FCA-Generation eine neue Baureihe von Clip-Automaten für die fleischverarbeitende Industrie auf den Markt bringt. Die Baureihe zeichnet sich durch einen hohen Automationsgrad und selbstregelnde Prozesse aus, die für höchste Produktivität sorgen. Je nach Produktgröße können bis zu 250 Takte pro Minute erzielt werden – wobei ein sicherer Produktverschluss gewährleistet ist. Strenge Hygienevorschriften in der Lebensmittelindustrie erfordern gut zu reinigende, glattflächige Strukturen und Oberflächen. Das Design erzeugt ein identitätsprägendes Erscheinungsbild.

Poly-clip System is the leading producer of clip-closure systems globally, and with the FCA generation it is bringing to market a new range of automatic double-clippers for the meat processing industry. The range is characterised by a high degree of automation and self-regulating processes, ensuring maximum productivity. Up to 250 cycles a minute are possible, depending on product size, and a secure product closure is always guaranteed. Strict hygiene regulations in the food industry require smooth-surfaced structures easy to clean. The design supports optimised operating processes and creates a unique characteristic appearance.

Product
FG8
Funktionsgriff
Functional handle

Design
Rohde AG
Günter Rohde
Nörten-Hardenberg, Germany

Manufacturer
Rohde AG
Nörten-Hardenberg, Germany

Funktionsgriff mit zwei farbig beleuchteten Edelstahl-Drucktastern, geschliffenen Rohren und Endkappen aus Edelstahl sowie naturfarben eloxiertem Griffschenkel und Aluminium-Gehäuse, wahlweise mit Laserbeschriftung. Das Anschlusskabel wird aus dem unteren Rohrende mittels Kupplungsverbindung herausgeführt. Alternativ mit Not-Aus-Taster am oberen Rohrende erhältlich.

Functional handle with two illuminated push buttons, fine ground tube and end caps made of stainless steel and aluminium housing, optional laser printed on request. The connection cable is lead out of the lower tube end. Alternatively, it is available with an emergency push button on the upper tube end.

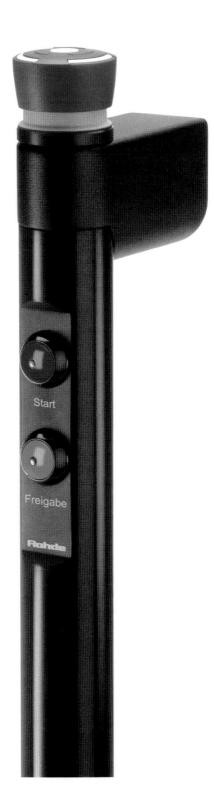

Product
FG7
Funktionsgriff
Functional handle

Design
Rohde AG
Günter Rohde
Nörten-Hardenberg, Germany

Manufacturer
Rohde AG
Nörten-Hardenberg, Germany

Funktionsgriff mit zwei beleuchteten, farbigen Druck-tastern aus Kunststoff, schwarz eloxiertem Alumi-nium-Rohr mit Laserbeschriftung und Griffschenkeln aus Polyamid PA6 mit Feinstruktur. Das Anschluss-kabel wird aus einem der beiden Griffschenkel, je nach Kundenwunsch mit oder ohne Kupplungsan-schluss, herausgeführt. Alternativ mit Not-Aus-Taster am oberen Rohrende erhältlich.

Functional handle with two illuminated, coloured plastic push buttons, laser printed aluminium tube and handle shanks made of polyamide PA6 with fine structure. The connection cable is lead out of one handle shank, on request with or without coupling. Alternatively, it is available with an emergency push button on the upper tube end.

Product
TE1
Not-Aus-Schalter
Emergency stop switch

Design
Industrie Design
Marco Meier
Odenthal, Germany

Manufacturer
Johnson Electric
Saia-Burgess Halver GmbH
Halver, Germany

Wenn Sicherheit zur Millimeterarbeit wird: kein Problem für den „E-Stop". Aufwändige Funktionalitäten lassen sich heute auf immer kleinerem Raum unterbringen. Große Schalter stehen einem kompakteren flacheren Gerätedesign aber oft im Wege. Mit dem neuen superkompakten „E-Stop" benötigt Sicherheit ab sofort nur noch eine Einbautiefe unter 20 mm und damit deutlich weniger als die Länge eines halben Streichholzes. Neue Freiräume für ein schlankeres und ergonomischeres Design – ohne Kompromisse bei der Sicherheit. Die optionale Beleuchtung mittels LED macht den „E-Stop" zu einer Schalterlösung, ideal für sämtliche Applikationen.

When safety becomes a matter of millimetres: no problem for the "E-Stop". These days, the space required to accommodate extensive functionality is ever decreasing. However, large switches often stand in the way of a more compact, lower-profile equipment design. With the new, super-compact "E-Stop" safety from now on only requires an installation depth of less than 20 mm and therefore considerably less than the length of half a matchstick. New vacuity for slimmer and more ergonomic design – without compromising safety. The optional LED illumination makes the "E-Stop" an ideal switch solution with a wide variety of applications.

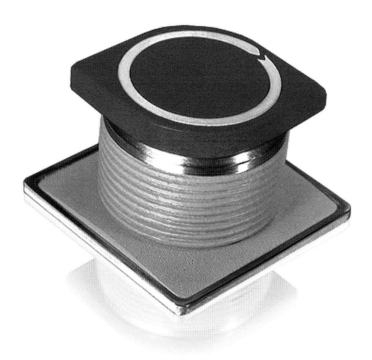

Product
TE1
Not-Aus-Schalter
Emergency stop switch

Design
Industrie Design
Marco Meier
Odenthal, Germany

Manufacturer
Johnson Electric
Saia-Burgess Halver GmbH
Halver, Germany

Wenn Sicherheit zur Millimeterarbeit wird: kein Problem für den „E-Stop". Aufwändige Funktionalitäten lassen sich heute auf immer kleinerem Raum unterbringen. Große Schalter stehen einem kompakteren flacheren Gerätedesign aber oft im Wege. Mit dem neuen superkompakten „E-Stop" benötigt Sicherheit ab sofort nur noch eine Einbautiefe unter 20 mm und damit deutlich weniger als die Länge eines halben Streichholzes. Neue Freiräume für ein schlankeres und ergonomischeres Design – ohne Kompromisse bei der Sicherheit. Die optionale Beleuchtung mittels LED macht den „E-Stop" zu einer Schalterlösung, ideal für sämtliche Applikationen.

When safety becomes a matter of millimetres: no problem for the "E-Stop". These days, the space required to accommodate extensive functionality is ever decreasing. However, large switches often stand in the way of a more compact, lower-profile equipment design. With the new, super-compact "E-Stop" safety from now on only requires an installation depth of less than 20 mm and therefore considerably less than the length of half a matchstick. New vacuity for slimmer and more ergonomic design – without compromising safety. The optional LED illumination makes the "E-Stop" an ideal switch solution with a wide variety of applications.

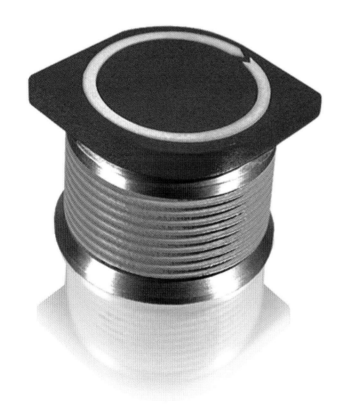

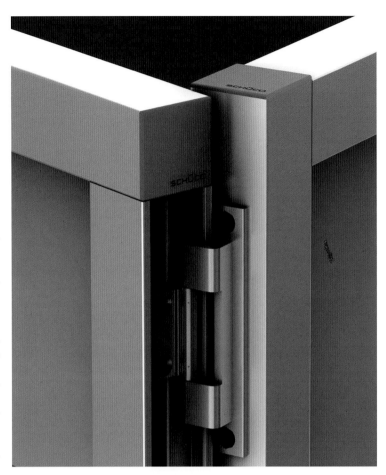

Product
Aluminium System für den Maschinenbau MS 40⁺
Verdeckt liegendes Drehband für rahmenlose Scheiben
Unvisible fitting for frameless panes

Design
Schüco International KG
Geschäftsbereich Schüco Design
Borgholzhausen, Germany

Manufacturer
Schüco International KG
Geschäftsbereich Schüco Design
Borgholzhausen, Germany

Das Systemsortiment von MS 40⁺ bietet perfekt auf-
einander abgestimmte Komponenten, mit denen
solche Lösungen für den Maschinenbau realisierbar
sind, die auch im Detail höchste Ansprüche an Funk-
tionalität und Design stellen. Gestern wurden die
Scheiben noch umlaufend in Profilen gehalten.
Heute werden Scheiben häufig rahmenlos gewünscht,
jedoch zusätzlich bearbeitet und mit sichtbaren Be-
schlägen befestigt. Morgen bieten wir mit dem ver-
deckt liegenden MS 40⁺-Beschlag in Verbindung
mit rahmenlosen Scheiben eine Lösung, die gleichzei-
tig höchste ästhetische Ansprüche, Leichtigkeit und
Transparenz sowie einen erhöhten Schutz vor Verlet-
zungen bietet.

The MS 40⁺ range of systems provides perfectly co-
ordinated components which can be used to create
solutions for machinery that meet the highest stand-
ards of functionality and design even in the details.
Yesterday panes were held by surrounding profiles.
Today panes are favoured frameless but processed
and fastened with visible fittings. Tomorrow with the
MS 40⁺ fitting we will offer a solution with frameless
panes which meets aesthetic demands, offers light-
ness and transparency as well as a higher protection
against injuries.

Product
Windkraftanlage
Wind power station

Design
Schumann Büro für industrielle Formentwicklung
Dirk Schumann
Münster, Germany

Manufacturer
Nordwind Energieanlagen GmbH
Neubrandenburg, Germany

Die Innovation der Windkraftanlagen besteht in einer neuartigen Technologie der Energieübertragung. Statt über mechanische Getriebe erfolgt die Kraftübertragung über ein verschleißarmes, hydrostatisches Pumpensystem. Die Technologie bewirkt: Steigerung des Wirkungsgrades, Senkung der Servicekosten, Senkung der Investitionskosten, Senkung der Geräuschentwicklung, Steigerung der Akzeptanz regenerativer Energiegewinnung. Die Gestaltung der Anlage hat eine skulpturale und emotionale Wirkung und fügt sich so harmonischer in das Landschaftsbild ein.

The innovation in the wind generators lies in the innovative energy transmission technology. Instead of using mechanical systems, the power is transmitted by a low-wear hydrostatic pump system. The benefits of this technology are: Increase in efficiency, Reduction in service costs, Reduction in investment costs, Reduction in noise emissions, Increases in acceptance of regenerative energy production. The design of the system has a sculptural and emotional effect and thus fits in more harmoniously with the landscape.

Product
ZENTRICO THL plus
Lünette
Steady rest

Design
Busse Design + Engineering GmbH
Elchingen, Germany
Markus Damang, Schunk Projektleitung,
Produktentwicklung
Mengen, Germany

Manufacturer
H.-D. SCHUNK GmbH & Co. Spanntechnik KG
Mengen, Germany

Das markante, schlanke Design verbindet ein Höchst-
maß an Funktionalität mit einer attraktiven Optik. Die
klare Formensprache signalisiert Langlebigkeit, Ge-
nauigkeit, Funktionssicherheit und ein hohes Maß
an Performance. Bei der Gestaltung verschmilzt eine
Vielzahl technischer Formelemente zu einem stimmi-
gen Gesamtbild, das den hohen Qualitätsanspruch
unterstreicht. Markentypisch: das olivgoldene Eloxal
im hinteren Teil der Lünette mit den drei Rillen. Die
drei Rillen der Umlaufnuten entsprechen dem einge-
tragenen Markenzeichen von SCHUNK „The Original
with the three Rings".

The striking, slim look combines highest functional-
ity with an attractive appearance. The simple design
stands for long tool life, high precision, operational
reliability and high performance. In order to empha-
size the high quality requirement, the focus of the
design was to combine a large number of technical
elements to an harmonic general appearance. Brand-
typical: The olive-golden anodized coating in the rear
part of the steady rest with the three rings. The three
rings of the circular grooves comply to the trademark
protection of SCHUNK "The Original with the three
Rings".

Product
Trolley SIPLACE
Mobiler SMD-Spleißtrolly
Mobile SMD splicecart

Design
Siemens AG, Industry Sector
Design Management
Andreas Preussner
München, Germany
die haptiker GmbH
Taufkirchen b. München, Germany

Manufacturer
Siemens AG, Industry Sector
München, Germany

Der Spleißtrolly ermöglicht das mobile Bereitstellen, Verarbeiten und Transportieren von Spleiß- und Klebematerialien in der Bauelemente-Bestückindustrie zwischen den Produktionslinien. Sein Einsatz führt zu qualitativ besseren Arbeitsergebnissen mit weniger Ausfall. Der Trolley ist eine fertigungsgünstige innovative Arbeitserleichterung für Bestück- und Linienpersonal durch das Zusammenfassen von fünf Arbeitsfunktionen, welche sonst an der Arbeitskleidung getragen oder stationär ausgeführt wurden. Das außergewöhnliche Griff-Design erleichtert mit seinen zwei Funktionen das Transportieren entlang der Fertigungslinien sowie das präzise Bewegen zwischen den Bestückautomaten. Es wurden umweltfreundliche Materialien und Lacke eingesetzt.

The innovative design of the splicecart simplifies the SMD line operating (SMD = Service-Mounted-Device) and improves splicing quality. The trolley is a new assistance for SMT-production workers, that combines five manual separated functions, to be done with one easy mobile workstation. The unusual round handle design with its two functions allows material transportation between the SMT-production lines (SMT= Service-Mounted-Technology) and storage as well as precise and easy splice procedure. Through its design, the splicecart is easy to handle and saves operation time. To manufacture the splicecart ecological materials and paint are used.

Product
SIRIUS COMPACT
Industrielle Schalttechnik
Industrial controls

Design
ergon3
Thomas Detemple, Peter Trautwein
München, Germany
Siemens AG, Industry Sector
Design Management
Gunter Ott
Nürnberg, Germany

Manufacturer
Siemens AG, Industry Sector
Amberg, Germany

Diese Produkte gehören zur bewährten SIRIUS-Gerätereihe der industriellen Schalttechnik. Sie werden benutzt, um als Motorstarter den zuverlässigen und energieeffizienten Betrieb von Elektromotoren zu gewährleisten. Das Design-Konzept soll technische Eleganz, Präzision und Hochwertigkeit zum Ausdruck bringen. Die angewendete Formensprache verbindet gespannte Formen und ruhige plane Flächen mit klaren Details. Gewölbte Flächen betonen die Bedienoberflächen, horizontal orientierte Gestaltungselemente wie Lüftungsbereiche und Lichtkanten verbinden funktionale Elemente und fassen die Module visuell zusammen. Die Produktgrafik ist auf die minimalen Platzverhältnisse auf der Bedienoberfläche der Startermodule abgestimmt.

These products belong to the well known SIRIUS industrial controls product line. They are used as motor starters, to enable the reliable and energy efficient usage of electric motors. The industrials design concept is set to express technical elegance, precision and high value. The formal language applied combines high quality curved and plane surfaces with clear detailing. Curved surfaces are being used to emphasize the user interface areas. Horizontally oriented design elements, like cooling vents and light lines visually, connect the functional elements and bring the modules together, to look as a complete array. The product graphics is especially designed to meet the requirements of the minimal place granted for lettering.

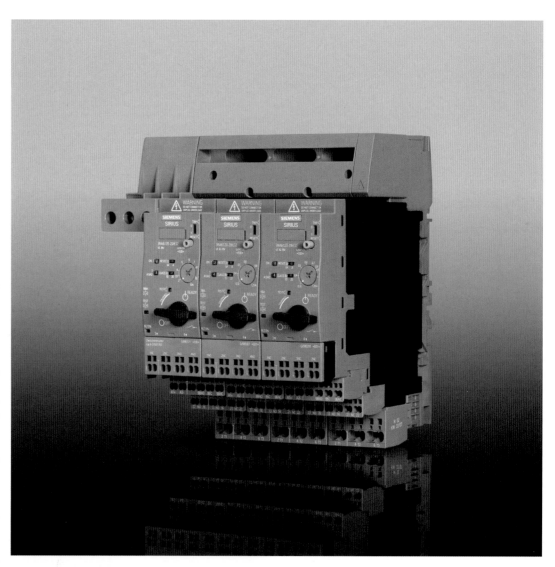

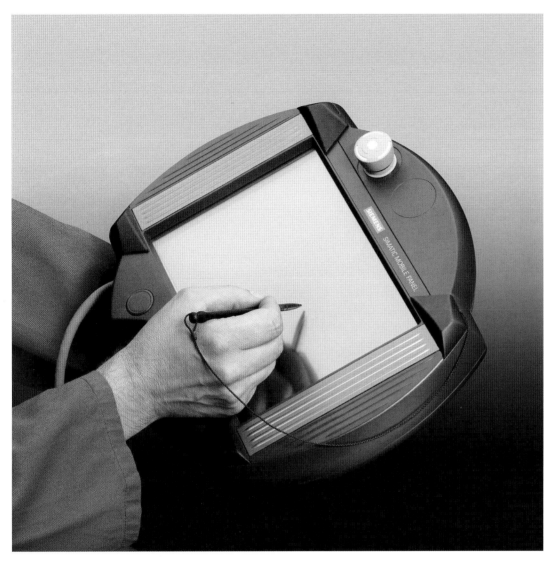

Product
SIMATIC MOBILE PANEL
Mobile Maschinensteuerung
Mobile plant control

Design
at-design
Jan Andersson, Tobias Reese
Fürth, Germany
Siemens AG, Industry Sector
Design Management
Gunter Ott
Nürnberg, Germany

Manufacturer
Siemens AG, Industry Sector
Nürnberg, Germany

Dies ist ein weiteres Siemens-Gerät für die mobile Anlagensteuerung und ist sowohl als Kabel- als auch als Wireless-Variante erhältlich. Das Design-Konzept soll technische Eleganz, Präzision, Tragekomfort und Robustheit zum Ausdruck bringen. Die angewendete Formensprache verbindet hochwertige gespannte Formen und ruhige Flächen mit klaren Details. Dadurch wird dem Bediener vermittelt, ein hochwertiges Spitzenprodukt dieses Marktsegmentes in Händen zu halten. Das Gehäuse widersteht Stürzen aus einer Höhe von 1,30 m. Zusätzliche Puffer schützen als integrierte Details das besonders tiefliegende 10" Touch-Display. Das Gerät entspricht der Schutzart IP65 und kann zudem kundenspezifisch ausgestattet werden.

This is another Siemens device for Mobile Plant Control, available as well as wire-connected and wireless version. The Industrial Design concept is set to express elegance, precision, easy-to-carry and robustness. The formal language applied combines high quality curved and plane surfaces with clear detailing. This combination makes the user feel that he is working with one of the most advanced products of this product segment. The enclosure will resist falling down from heights like 1.30 m. Additional bumpers protect the 10" touch display that is positioned very deep inside the body. This device meets the requirements of IP65 and may be customized.

Product
HY
Hygienischer Zylinder
Hygienic cylinder

Design
SMC Corporation
Tokyo, Japan

Manufacturer
SMC Corporation
Tokyo, Japan

Anwendungen in der Lebensmittelindustrie stellen durch den Kontakt mit Wasser und Reinigungschemikalien besonders hohe Ansprüche an die verwendeten Zylinder. Diesen Anforderungen begegnet SMC mit der neuen Serie HY. Vier verschiedenen Bauformen ermöglichen, für jede Anwendung den passenden Zylinder zu finden und auch ISO / VDMA konform zu konstruieren. Durch spezielle Abstreifdichtungen konnte die Wasserbeständigkeit und damit die Lebensdauer um ein Vielfaches gesteigert werden. Die besonders glatten Oberflächen, die Vermeidung von toten Räumen und abgesetzte Signalgeberschienen sorgen dafür, dass am Produkt keine Rückstände haften bleiben.

Applications in the food industry demand due to the contact with water and cleaning chemicals notably high requirements on the used cylinders. The company SMC meets these requests with the new serial HY. Four different models enable to find for any applications the appropriate cylinders and to be ISO / VDMA conform constructed. Due to a special wiper ring the constancy of water and thereby the lifetime could be increased tremendously. The particular plain surfaces, the avoiding of dead spots and discharged Auto-switch rail make sure that no residues cling to the product.

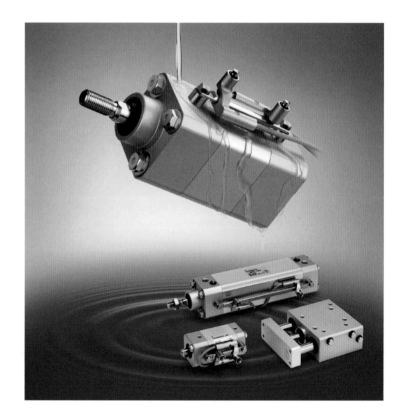

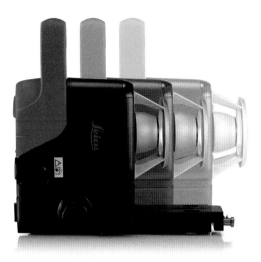

Product
Roteo 35
Geosystems Rotationslaser
Geosystems rotating laser

Design
SIGNCE
Design Team
München, Germany

Manufacturer
Leica Geosystems
Heerbrugg, Switzerland

Das Design des Leica Roteo 35 Rotationslasers unterstützt den Anwender durch sein kompaktes robustes Spritzwasser und Staub geschütztes Gehäuse bei vielen Anwendungen im Innenausbau. Die Kombination aus robustem Kunststoff, gummierten Griffbereichen und metallischen Schutzelementen garantiert höchsten Schutz und dauerhaft zuverlässige Messungen. Ein großzügiger, intuitiver Bedienbereich gewährleistet eine unproblematische Handhabung und macht das Gerät zu einem verlässlichen Partner im alltäglichen Einsatz auf Baustellen. Das Gerät stellt sich vollautomatisch ein und die integrierte Wandhalterung ist per Infrarotfernbedienung höhenverstellbar.

The design of the Leica Roteo 35 all-in-one rotating laser supports its user through a compact, durable, splash water and dust protected housing during multiple applications of interior fittings. The combination of robust plastic, rubberized gripping areas and metal protection parts guarantees a maximum protection and everlasting, reliable measurements. Its broad and intuitive operation area assures an unmistakable handling and makes the Roteo 35a reliable partner for daily construction site applications. The device fully levels automatically and the integrated wall mounting allows a remote controlled height adjustment.

Product
SPERIAN Milan™
Arbeitsschutzbrille
Safety spectacle

Design
SPERIAN Eye Face Protection
Smithfield, RI, United States of America

Manufacturer
SPERIAN Eye Face Protection
Smithfield, RI, United States of America

Ein Augenschutz in nie da gewesener Form. Ein schlankes, sportlich leichtes Design, hochwertige Materialien und viele auf verschiedene Tätigkeiten abgestimmte Scheibenvarianten machen die SPERIAN Milan™ zu einer wirklich gern getragenen Schutzbrille. Flexible Bügel reduzieren den Druck auf die Schläfen und mit dem einstellbaren Nasenteil passt man sie leicht an jede Gesichtsform an. Zudem gibt es die SPERIAN Milan™ auch mit einer Vielzahl von Laser-Schutzfiltern. Eine Schutzbrille, mit der sich jeder leicht anfreundet. Das ist zeitgemäßer Arbeitsschutz.

A safety eyewear unlike any seen before. The sleek, sporty, and lightweight design, premium materials, and a big variety of lenses fitting any application, make SPERIAN Milan™ a unique eyewear experience. Flexible temples reduce temporal pressure, while an adjustable nose piece delivers function that personalizes fit for almost any face. Exclusive highlight of SPERIAN Milan™ are the optional Laser protection lenses. A safety spectacle everybody loves to wear. That's contemporary occupational safety.

Product
SPERIAN Protégé™
Arbeitsschutzbrille
Safety spectacle

Design
SPERIAN Eye Face Protection
Smithfield, RI, United States of America

Manufacturer
SPERIAN Eye Face Protection
Smithfield, RI, United States of America

Perfekter Schutz erfordert eine perfekte Passform. Die SPERIAN Protégé™ vereint sportliches Aussehen mit dem Komfort von Leichtigkeit und Flexibilität. Das „Floating Lens Design", mit einer Linsenkrümmung sieben Dioptrien für einen gesichtsnahen Sitz und mehr Sicherheit, ohne auf breiteren Gesichtern an den Schläfen zu drücken oder auf schmalen Gesichtern zu rutschen. Weiches TPE-Material an den Bügelenden garantiert ein sicheres und angenehmes Tragegefühl, während die weichen klaren Nasenreiter das Herunterrutschen vermeiden. Verschiedene Scheibenvarianten lassen die SPERIAN Prótégé™ für viele Anwendungen passen.

Perfect protection requires a perfect fit. SPERIAN Protégé™ spectacles combine sports-styling with lightweight comfort and flexible design. Floating lens design features a seven-base lens for a closer fit and extra protection, and offers increased flexibility in fit and the secure wrap-around brow expands to fit a wide range of users without exerting any pressure on the temples or modifying the lens geometry. Soft temple tip pads provide a comfortable and secure fit, while the soft, clear nose pads prevent slipping. Several lens options make SPERIAN Protégé™ suitable for any application.

Product
IDC 15-2 TEC Li
Akku-Schlagschrauber
Cordless impact screwdriver

Design
STUDIOWERK DESIGN
Roland Schirrmacher, Fred Kern
Inning, Germany

Manufacturer
PROTOOL GmbH
Wendlingen, Germany

Der IDC Akku-Schlagschrauber ist für die ganz harten Fälle zum Bohren und mit zuschaltbaren Tangentialschlag für besonders schwere Schraubaufgaben. Trotz robuster und langlebiger Bauweise ist der IDC leicht und das Optimum aus Ergonomie, Kraft, Geschwindigkeit sowie innovativer Motoren- und Lithium-Ionen-Akku-Technologie. Das Design mit seinen Stoßwülsten aus Weichpolymer ermöglicht und betont den harten Einsatz dieses Schraubers. Der bürstenlose EC-TEC-Motor produziert zu jedem Anwendungsfall das passende Drehmoment.

The IDC cordless impact screwdriver is suitable for challenging drilling tasks and, with the additional tangential impact feature, for tough screw driving jobs. The IDC is lightweight in spite of its robust, sturdy construction. It optimizes ergonomics, power and speed as well as innovative motor and lithium-ion battery technology. The design with soft polymer bumpers supports and emphasizes the toughness of this screwdriver. The brushless EC-TEC motor produces the right amount of torque for every application.

Product
PDC 18-4 TEC Li
Akku-Schlagbohrschrauber
Cordless drill and screwdriver impact

Design
STUDIOWERK DESIGN
Roland Schirrmacher Fred Kern
Inning, Germany

Manufacturer
PROTOOL GmbH
Wendlingen, Germany

Der PDC Akku-Schlagbohrschrauber ist das Multitalent mit Schlag zum Bohren und Schrauben. Trotz robuster und langlebiger Bauweise ist der PDC leicht und das Optimum aus Ergonomie, Kraft, Geschwindigkeit sowie innovativer Motoren- und Lithium-Ionen-Akku-Technologie. Das Design mit seinen Stoßwülsten aus Weichpolymer ermöglicht und betont den harten Einsatz dieses Schraubers. Der bürstenlose EC-TEC-Motor und das Vier-Gang-Getriebe produzieren zu jedem Anwendungsfall das passende Drehmoment. Der zuschaltbare Axialschlag erweitert sein Einsatzgebiet.

The PDC cordless impact screwdriver is the multi-talent with impact for drilling and screw driving. The PDC is lightweight in spite of its robust, sturdy construction. It optimizes ergonomics, power and speed as well as innovative motor and lithium-ion battery technology. The design with soft polymer bumpers supports and emphasizes the toughness of this screwdriver. The brushless EC-TEC motor and four-speed transmission produce the right amount of torque for every application. An additional axial impact feature expands the range of applications.

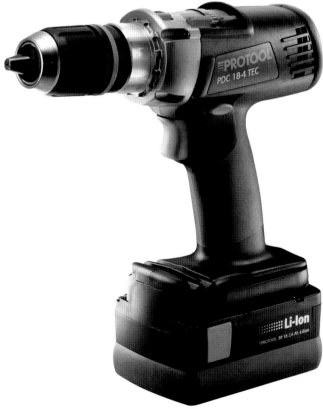

Product
DRC 12-4 TEC Li
Akku-Bohrschrauber
Cordless drill and screwdriver

Design
STUDIOWERK DESIGN
Roland Schirrmacher, Fred Kern
Inning, Germany

Manufacturer
PROTOOL GmbH
Wendlingen, Germany

Der DRC Akku-Bohrschrauber ist der Kompakte
mit dem kräftigen Dreh zum Bohren und Schrau-
ben. Trotz robuster und langlebiger Bauweise ist der
DRC leicht und das Optimum aus Ergonomie, Kraft,
Geschwindigkeit sowie innovativer Motoren- und
Lithium-Ionen-Akku-Technologie. Das Design mit
seinen Stoßwülsten aus Weichpolymer ermöglicht
und betont den harten Einsatz dieses Schraubers.
Der bürstenlose EC-TEC-Motor und das Vier-Gang-
Getriebe produzieren zu jedem Anwendungsfall das
passende Drehmoment.

The DRC cordless screwdriver is a compact power-
house with plenty of torque for drilling and driving.
The DRC is lightweight in spite of its robust, sturdy
construction. It optimizes ergonomics, power and
speed as well as innovative motor and lithium-ion
battery technology. The design with soft polymer
bumpers supports and emphasizes the toughness
of this screwdriver. The brushless EC-TEC motor and
four-speed transmission produce the right amount of
torque for every application.

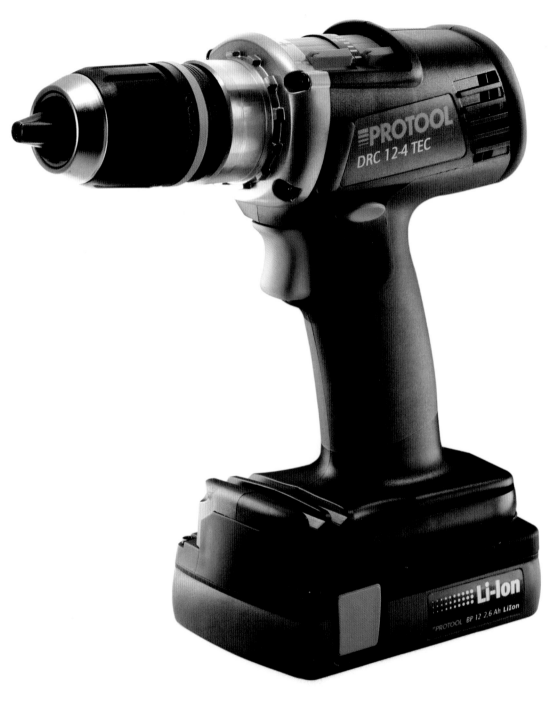

Product
SHINEX RAP 150
Rotationspolierer
Rotary polisher

Design
STUDIOWERK DESIGN
Roland Schirrmacher, Fred Kern
Inning, Germany

Manufacturer
FESTOOL GmbH
Wendlingen, Germany

Der SHINEX ist ein ideales Gerät, um Hochglanzflächen zu erzeugen. Er zeichnet sich durch seine gute Ergonomie, Robustheit sowie Leistung aus. Dabei ist das griffoptimierte Gehäuse mit seinen Softgrip-Bereichen für alle Griffpositionen optimal gestaltet. Durch den niedrigen Schwerpunkt wird ein Verkippen verhindert. Die stabile rutschfeste Geräteablage erleichtert die Arbeit und den Polierzubehör-Wechsel. Der leicht zu reinigende Flusenfilter schützt den Motor.

The SHINEX is an ideal device for creating high-gloss finishes. It features excellent ergonomics, robustness and performance. The grip-optimized housing with its soft grip zones is perfectly designed for all gripping positions. Tilting is prevented by the low centre of gravity. The sturdy slip-resistant equipment tray makes working and exchanging polishing accessories easier. An easy-to-clean lint filter protects the motor.

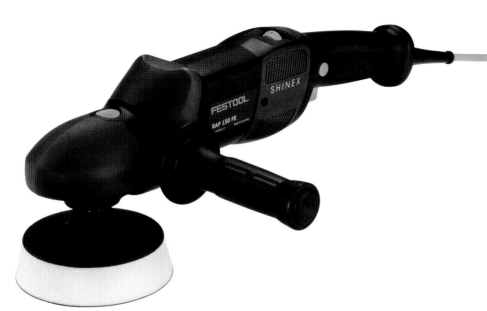

Product
T 12+3 und T 15+3
Akku-Bohrschrauber
Cordless drill and screwdriver

Design
STUDIOWERK DESIGN
Roland Schirrmacher, Fred Kern
Inning, Germany

Manufacturer
FESTOOL GmbH
Wendlingen, Germany

Die neue T+3-Serie bewegt sich nicht mehr in einer Volt-Klasse, sondern in einer Klasse, die sich durch das Zusammenspiel von Kraft und Intelligenz neu definiert. Mit einem bürstenlosen Motorenkonzept, das ein Plus an Leistung garantiert, ausdauernden Akku-Packs, mit moderner Lithium-Ionen-Technologie und einer kompakten Bauweise sowie einem Handling, mit dem die vorhandene Kraft auch über einen langen Zeitraum bequem und effizient genutzt werden kann, beeindruckt es.

The new T+3 series is no longer assigned to a voltage class, but to a class defined by the interplay of power and intelligence. It impresses with a brushless motor concept that guarantees ultimate performance, long-lasting battery packs with modern lithium-ion technology and a compact design as well as handling that allows its power to be used comfortably and efficiently – even over extended periods of time.

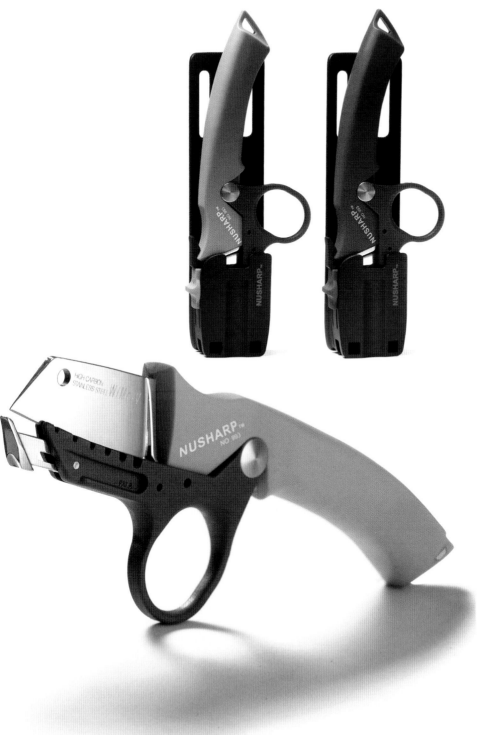

Product
Cruiser
Kabelmesser-Set
Cable stripping knife set

Design
Tiger Lin
Chin-Sui Town, Taichung County, Taiwan

Manufacturer
Nusharp Inc.
Taichung, Taiwan

Das einzigartige „P-Ring-Glied" an der Unterseite des Messers dient zum Schutz von Hand und Klinge. Für einen präzisen Schnitt geht die Führungsplanke an der Spitze des „P-Ring-Gliedes", je nach Tiefe des Schnittes, von selbst zurück. Somit ist während der Ablöse- und Ziehbewegung ein präzises Ergebnis möglich. Die Führungsplanke kann auch für gerade Schnitte verwendet werden. Das Messer ist leicht mit einer Hand zu bedienen. Dazu muss der Mittelfinger nur in den „P-Ring" gesteckt werden. Die praktische Hülle mit einem Schlosssystem gibt es für Rechts- und Linkshänder.

Universal „P-ring jaw" design offers great hand protection and protects the knife edge. As a pad while cutting, ensure a precise and sharp cut. Depending on the cutting depth, the universal design of the draw-back guide pad at the tip of the „P-ring jaw" can be drawn back automatically during the dragging-stripping movement to achieve a precise and efficient result. It also can work as a guide for a straight cut. Ergonomics and streamlined design ensure the knife can be handled with one hand without slipping away by inserting the middle finger into the „P-ring". Outstanding cover with a lock design is suitable for either right-or left-hand user.

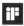

Product
Submarine
Kabelmesser-Set
Cable stripping knife set

Design
Tiger Lin
Chin-Sui Town, Taichung County, Taiwan

Manufacturer
Nusharp Inc.
Taichung, Taiwan

Das einzigartige „P-Ring-Glied" an der Unterseite des Messers dient zum Schutz von Hand und Klinge. Als Unterstützung beim Schneiden gewährleistet es einen präzisen Schnitt. Der Stift an der Spitze des „P-Ring-Gliedes" bietet während der schnellen Ab-isolierungs- und Schiebebewegung eine hohe Sicherheit vor der Beschädigung anderer Kabel. Das ergonomische Design des Griffes stellt sicher, dass das Messer leicht mit einer Hand bedient werden kann, ohne abzurutschen. Dazu muss der Mittelfinger nur in den „P-Ring" gesteckt werden. Die praktische Hülle mit einem Schlosssystem gibt es für Rechts- und Linkshänder.

The universal "P-ring jaw" design offers high hand protection at work as well as it protects the edge. As a pad while cutting, the cable can ensure a precise and sharp cut. Universal design of the plank at the tip of the "P-ring jaw" offers a high protection for the insulation of cable during the fast pushing-stripping movement. Ergonomics and streamlined design ensure that the knife can be handled with one hand without slipping away by inserting the middle finger into the "P-ring". Outstanding cover with a lock design is suitable for either right-or left-hand user.

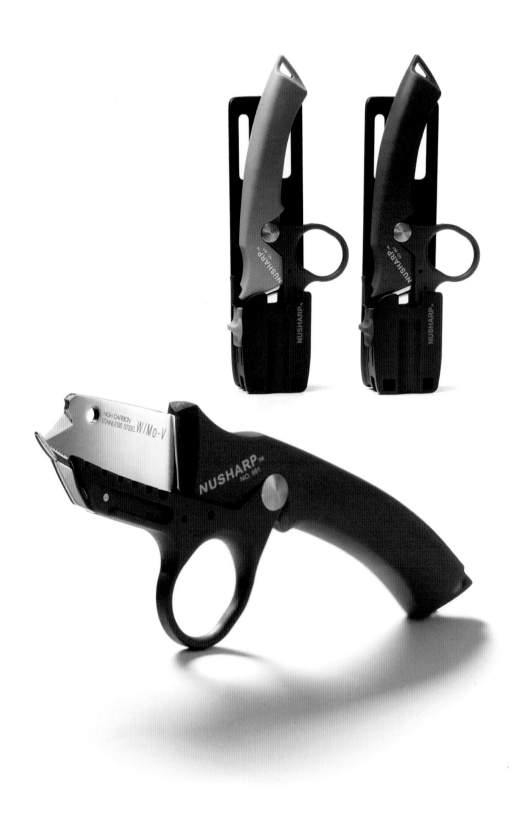

Product
TruLaser 3030
Laserschneidanlage
Laser cutting system

Design
TEDES. Designteam GmbH
Robert Müller, Werner Hawran
Roth, Germany

Manufacturer
TRUMPF Werkzeugmaschinen GmbH & Co. KG
Ditzingen, Germany

Die Laserschneidanlage TruLaser 3030 schneidet Bleche bis 25 mm Dicke. Sie zeichnet sich durch ihr glattflächiges klares „One-Box"-Design aus. Die neue Farbgebung mit reinem Weiß, dunklem Blau und silbernen Farbakzenten unterstreicht ihre schlichte Eleganz. Die Laserschutzkabine besteht komplett aus Makrolon. Dies erlaubt ein rahmenloses Fensterband, das die ganze Schutzkabine umschließt und in transparente rahmenlose Falttüren übergeht. Das Bedienkonzept der TruLaser 3030 wurde grundlegend überarbeitet. Ergebnis ist ein ergonomisches frei schwenkbares Panel mit einer selbsterklärenden Touch-Bedienung und einer herausziehbaren Tastatur.

The TruLaser 3030 laser cutting system cuts sheet metal up to 25 mm thick. It is distinguished by its smooth, sleek one-box design. The new color scheme with pure white, dark blue and silver highlights underscores its simple elegance. The laser safety enclosure consists entirely of Makrolon. This allows a frameless ribbon window, which envelops the complete enclosure and merges into transparent, frameless folding doors. The entire operating concept of the TruLaser 3030 has been thoroughly revised. The result is an ergonomic swivel panel that can be positioned as required, with self-explanatory touch operation and a pull-out keyboard.

Product
ZYKLOP
Knarre (Schraubwerkzeug)
Ratchet

Design
Wera Werk Hermann Werner GmbH
Michael Abel, Dirk Schardt, Ralf Richter
Wuppertal, Germany

Manufacturer
Wera Werk Hermann Werner GmbH
Wuppertal, Germany

Der ZYKLOP vereint mit den Funktionen verschiedener Knarren und Schraubendreher sechs verschiedene Werkzeuge in einem einzigen Werkzeug. Er besticht durch seine Robustheit, auch im Dauereinsatz, und erzielt dabei bis zu dreifach höhere Arbeitsgeschwindigkeiten gegenüber herkömmlichen Knarren. Die hohe Arbeitsgeschwindigkeit resultiert aus der Schwungmassenkonstruktion und dem rotationssymmetrischen Design. Zusätzlich beschleunigend wirkt die Freilaufhülse in Kombination mit dem frei schwenkbaren Knarrenkopf. Der Kopf dieser Knarre erinnert an einen Zyklopen. Die Linie des Produktdesigns ist auch bei den passenden Knarrenboxen erkennbar.

The ZYKLOP ratchet combines the advantages of six different ratchet types and screwdrivers in just one tool. It presents an appealing robustness in constant use and its design accelerates the screwdriving process up to three times compared to a normal ratchet. The ZYKLOP's speed is a result of the special rotating mass design and the rotationally symmetrical structure of the handle. The incredible speed is also caused through the combination of a freewheel sleeve and a swivelling ratchet head. The ZYKLOP presents a distinctive ratchet head reminiscent of a cyclops. The typical product design can also be recognized at the ratchet box.

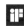

Product
Mx series
SMD-Bestückungsautomat
SMT Mounter

Design
View Design
Dong-Seok Kang, Seung-Gi Lee,
Han-Moon Kim, Mi-Young Kim
Seoul, South Korea

Manufacturer
Mirae Company
Cheonan-Si, South Korea

Dieses hochwertige Halbleiter-Gerät überzeugt durch erstklassiges Design. Es verkörpert die Philosophie der Mirae Company, die Einfachheit und Schönheit durch die Vermählung von modernster Technik mit einem sinnvollen Design anstrebt. Die Mirae-Produkte stehen für Integrität; sie zeichnen sich aus durch schlichte Formen, gerade Linien und starke Farbkontraste. Die einfachen Linien und die perlweiße Farbe vermitteln ein Gefühl von Perfektion. Für ein digitales Erscheinungsbild wurde als Lüftung eine perforierte Platte verwendet. Wenn das Gerät nach dem Einschalten zum Leben erwacht, flimmert ein blaues LED.

A high-class design was adopted in line with the image of this high-priced semiconductor device. It embodies the design philosophies of Mirae Company, pursuing convenience and beauty by converging cutting-edge technology and a sensible design. The identity of Mirae Company products is detailed by enhancing its integrity through a simple form, straight lines, and material color contrasts. A sense of sophistication is conveyed by using simple lines and the white pearl color. To add a digital image, a standardized perforated board is employed for the air vent. When the device is turned on, a blue LED flickers as if it has come to life.

Product
Eclipse
Ergonomische Kittpistole
Ergonomic sealant applicator

Design
WeLL Design
Mathis Heller
Utrecht, The Netherlands
PC Cox Limited
Design Department
Newbury, United Kingdom

Manufacturer
PC Cox Limited
Newbury, United Kingdom

Eclipse ist die neue Reihe ergonomischer Ein- und Zweikomponenten-Kittpistolen, gefertigt aus glasfaserverstärktem Polymer und Aluminium. Die leichtgewichtige und robuste Pistole setzt neue Maßstäbe in Bezug auf Ergonomie, weil der Griff unter dem Schwerpunkt positioniert ist, und durch die Verwendung von Soft-Touch. Durch die Gestaltung fungiert die obere Griffzone als „Kissen" und lässt das Gerät auf der Hand des Nutzers ruhen, was die Finger sehr entlastet. Auswechselbare Kunststoff-Einsätze an der Front des Gerätes machen den Gebrauch unterschiedlichster Kartuschen möglich.

Eclipse is the new range of ergonomically designed single and dual-component sealant and adhesive applicators, manufactured from reinforced engineering polymers. The lightweight and durable applicator means a major step in ergonomics by moving the handle under the point of gravity and using a soft-touch grip. Using the upper part of the handle as a "cushion" makes it possible for the applicator to rest on top of the user's hand, holding it without gripping his fingers. Unique push-in plastic plates enable a variety of cartridge sizes, clip-together cartridges and fixed cartridges.

Product
UV-Setter Series
UV-Setter

Design
Achilles Associates bvba
Lukas Van Campenhout, Philip Olieux,
Lieven Luyssen, Bart Hullak, Huetzin De Raet
Mechelen, Belgium

Manufacturer
basysPrint by Punch Graphix
Lier, Belgium

Punch Graphix entwickelt, produziert und vertreibt unter dem Namen basysPrint Mid- und High-End-CTP(Computer to Plate)-Maschinen. Zur Serie gehören sechs verschiedene, modulare Maschinen verschiedener Kapazitäten und Größen. Laut Entwicklungsvorgabe sollte das Design auf dem der Xeikon-Maschinen beruhen. Im Ergebnis bewahrte Achilles bei allen Plattenbelichtern das modulare Konzept sowohl im Erscheinungsbild als auch in der Funktion der äußeren Verkleidung. Die Oberseiten der Maschinen sind gemäß den verschiedenen Einheiten geteilt – damit fällt der modulare Gesichtspunkt sofort ins Auge.

Punch Graphix develops, manufactures and distributes mid and high-end prepress CtP (Computer-to-Plate) machines under the name basysPrint. The series includes six different modular machines of varying capacity and size. The emphasis during the design briefing was put on the request to base the design on that of Xeikon machines. As a result, Achilles maintained the modular concept both in appearance and function in the outer paneling of each plate setter. The top of each machine is divided according to the different units, so the modular aspect is immediately clear.

Product
Dino-Lite
Digitales Mikroskop
Digital microscope

Design
AnMo Electronics Corp.
Paul NW Wu
Hsinchu, Taiwan

Manufacturer
AnMo Electronics Corp.
Hsinchu, Taiwan

Dino-Lite, die innovative, von AnMo Electronics ent-
wickelte Serie digitaler Handmikroskope, revolutio-
niert mit patentierter Technik und einem eleganten,
ergonomischen Design die Welt der Mikroskopie und
der digitalen Bilderfassung. Die vielseitigen und hand-
lichen Geräte ermöglichen zahlreiche praktische An-
wendungen u. a. in den Bereichen Bildung, Industrie
und Medizin. Ein Drehen des Einstellknopfs fokussiert
das Beobachtungsobjekt mit einer je nach Abstand
zehn- bis 200-fachen Vergrößerung. Die mitgelie-
ferte Software „DinoCapture" enthält viele nützliche
Features einschließlich einer Bemaßungsfunktion.

The innovative Dino-Lite series of handheld digital mi-
croscopes, developed by AnMo Electronics, is revolu-
tionizing the world of microscopy and digital image
capturing with its patented technologies and stylish
ergonomic design. Dino-Lite's versatility and portab-
ility lend themselves to a wide range of practical appli-
cations in educational, industrial, medical and many
other fields. Simply rotating the adjustment knob will
bring an observed object into focus with a magnifi-
cation range of 10X–200X, depending on the work-
ing distance. The included "DinoCapture" software
provides the user with a variety of useful features in-
cluding measurement.

Product
Vanquish
Visuelle Qualitätskontrolle
Auto optical inspector

Design
DESIGN DEUTSCHE
Chih-Hang Cheng
Kaohsiung, Taiwan

Manufacturer
YAYA Tech
Hsing-Chu, Taiwan

Hier handelt es sich um eine Inspektionsmaschine, die mit hoher Geschwindigkeit arbeitet. Ihren Einsatz hat sie in der Leiterplattenindustrie. Die Hauptfunktionen sind:
1. Die Position jedes Loches zu lokalisieren.
2. Die Effizienz der Bohrmaschine und Bits zu sichern.
3. Qualitätskontrolle während des Bohrprozesses.
Die AOI-Maschine zeichnet sich durch eine benutzerfreundliche Handhabung, einen klaren Arbeitsablauf und durch eine niedrige Komplexitätsrate für die Produktion aus.

This is a high speed inspection machine, applied for PCB industry. The main functions of this machine are:
1. Measurement hole location.
2. Assure the efficiency of drilling machines and bits.
3. Quality control of drilling process.
It is a high precise functional AOI, which has user-friendly ergonomic handling, a clear workflow and a lower complexity of production.

Product
Vantage
Visuelle Qualitätskontrolle
Auto optical inspector

Design
DESIGN DEUTSCHE
Chih-Hang Cheng
Kaohsiung, Taiwan

Manufacturer
YAYA Tech
Hsing-Chu, Taiwan

Hier handelt es sich um eine Inspektionsmaschine, die mit hoher Geschwindigkeit arbeitet. Ihren Einsatz hat sie in der Leiterplattenindustrie. In der Maschine vereinen sich ein hoch leistungsfähiges Optiksystem, ein präziser Mechanismus und ein exzellenter Algorithmus, was den Kunden bei der Qualitätskontrolle der Produktion hilft. Innerhalb von drei Minuten kann es die Tiefe der IC-Substrate bei über zwei Millionen Löchern vermessen und ein dreidimensionales Profil für jedes Loch generieren.

This is a high speed inspection machine for PCB industry. Combining with powerful optical system, precise mechanism, and superior algorithm, it helps customers to secure their production quality. It can measure more than two million holes' depth of IC substrate within three minutes and create a three dimensional profile for each hole.

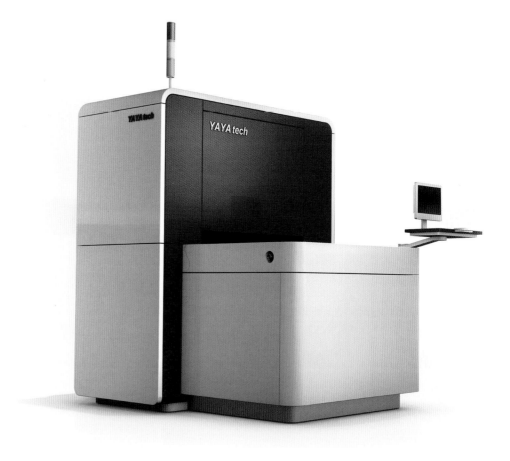

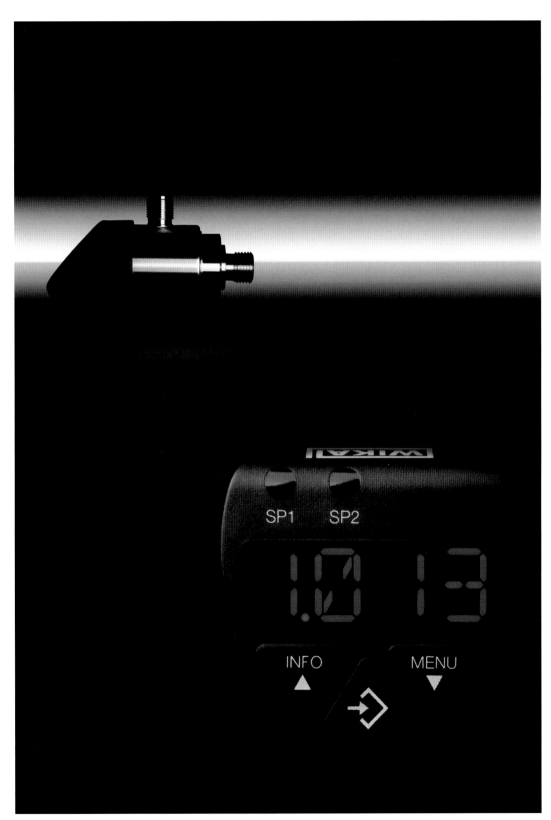

Product
WIKA 01
Elektronisches Druckmessgerät
Electronic pressure device

Design
Design 3
Sabine Schober, Wolfgang Wagner
Hamburg, Germany

Manufacturer
WIKA Alexander Wiegand GmbH & Co. KG
Klingenberg, Germany

Elektronische Druckmessgeräte werden besonders im Maschinen- und Anlagenbau für die Überwachung und Steuerung von Betriebsdrücken eingesetzt. Aufgrund der oft rauen und bauraumbegrenzten Umgebung müssen die Geräte sehr robust, kompakt und anpassbar an die verschiedensten Einbausituationen sein. Anzeige- und Bedieneinheiten sollen daher drehbar und in unterschiedlichsten Positionen gut ables- und bedienbar sein. Das vorgestellte Konzept unterstützt diese hohen Anforderungen durch eine besonders klare und funktionale Gestaltung.

Electronic pressure devices are mainly used to monitor and control operating pressure in machine and plant construction. Due to the frequently severe environments with limited installation space, these devices have to be very robust, compact and adaptable to a wide variety of installation situations. This means display and operating elements should be rotatable and designed so they are easy to read and operate in a variety of positions. The concept introduced here meets these high standards with an especially clear and functional design.

Product
AnimallTAG ID
Vieh-Identifikationssystem
Animal identification system

Design
Megabox Design e Soluções
Aguilar Selhorst, Felipe Locatelli,
Vinicius Iubel, Wagner Nono
Curitiba – PR, Brazil

Manufacturer
Animalltag
São Carlos – SP, Brazil

Das Viehidentifikations- und Erforschungssystem AnimallTag besteht aus einem visuell-elektronischen Ring. Das Unterteil ist in flexibles Polyurethan mit spitzer Metallansatzstelle mit der Funktion injiziert, das Tierohr zu löchern und das Oberteil am gesamten Satz zu fixieren. Das visuell-elektronische Oberteil ist in Faser-NY mit flexiblem Polyurethan überinjiziert. Der elektronische TAG besitzt einen inneren Chip für das Speichern von Tierdaten. Eine andere Systeminnovation ist eine mit einer Schicht bedeckte antiseptische Mischung im Oberteil, die bei der Ringanwendung platzt und die Stelle aseptisch macht.

The AnimallTAG livestock identification and tracking system uses visual rings and electronic tags. The lower part is flexible injected polyurethane with a pointed metallic insert to pierce the animal's ear and attach the upper part to the whole. The upper part – visual and electronic – is reinforced by fiber and over-injected with flexible polyurethane. The electronic TAG has an internal chip to store the animal's data. Another of the system's innovative aspects is the antiseptic compound in the upper part, sealed by a film that is broken when attaching the ring in order to ensure local asepsis.

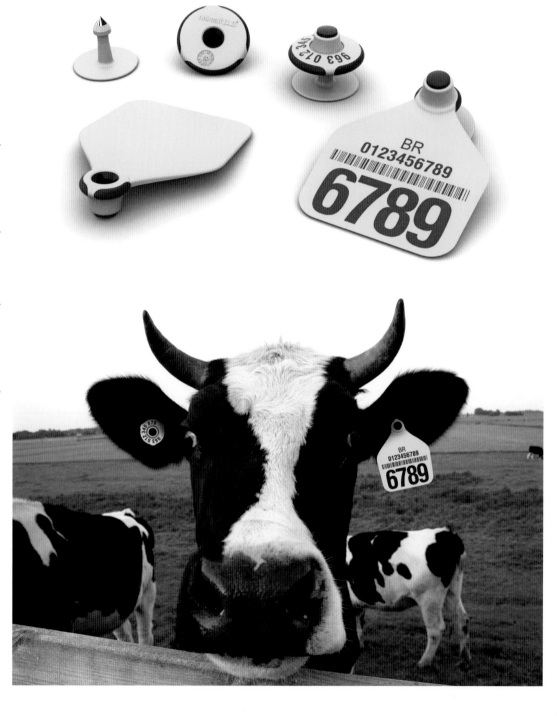

Product
5-Finger-Roboterhand
Multisensorielle Roboterhand
Multisensor robothand

Design
Genesis-design GmbH
Dirk Jürgens
München, Germany

Manufacturer
DLR
Wessling, Germany

Die von den Ingenieuren des DLR und des HIT (Harbin Institute of Technology) neu entwickelte, humanoide Roboterhand besteht aus fünf modular aufgebauten Fingern mit jeweils vier Gelenken und drei Freiheitsgraden. Trotz höherer Komplexität ist sie kleiner und leichter als ihre Vorgängerversionen. Insgesamt 15 Motoren sind in den Fingern und in die Handwurzel integriert. Jedes Gelenk ist mit einem absoluten Winkelsensor und einem DMS-basierten Drehmomentsensor ausgestattet. Die Hand kommuniziert über einen echtzeitfähigen Hochgeschwindigkeitsbus mit der übergeordneten Steuerung.

This humanoid robot hand was jointly developed by engineers of DLR and HIT (Harbin Institute of Technology). It consists of five modular fingers incorporating four joints each with three degrees of freedom. Despite its higher complexity this dextrous hand is smaller and of less weight than its forerunners. Altogether 15 motors are integrated into the finger bodies and the palm. Each joint is equipped with an absolute angle sensor and a strain-gauge based joint torque sensor. The communication to its supervising controller is performed via a high speed real time bus.

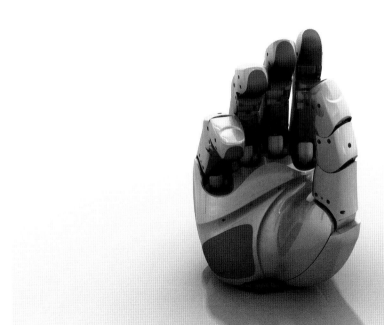

Product
TP-510
Hand-Terminal zur Bedienung von Robotern
Robot handheld terminal

Design
Hyundai Heavy Industries
Techno Design Institute
Choong Dong Lee, Woo Chan Kwon, Mi Suk Seong
Yongin-si, Gyeonggi-do, South Korea

Manufacturer
Hyundai Heavy Industries
Yongin-si, Gyeonggi-do, South Korea

Das Bedien-Terminal TP-510 wurde nach einer Unter-
suchung der realen Arbeitsumgebung durch zusätz-
liche Tasten und bessere Griffigkeit benutzerfreund-
licher gestaltet. Der obere Teil dient als Griff zur
Dämpfung von Stößen. Die Tasten der Kontrollbox
wurden neu arrangiert, um den Bewegungsfluss des
Anwenders zu erleichtern. Durch die Verwendung
eines einzigen, von ABS autorisierten Materials ist
das TP-510 einfach zusammenzusetzen und zu re-
cyceln. Der 7-Zoll-LCD-Touchscreen ermöglicht eine
intuitive Bedienung. Vor allem das betriebsfreund-
lichere Layout des interaktiven Tastenfeldes und der
Schaltflächen trägt zur besseren Bedienbarkeit des
TP-150 bei.

The usability of the industrial robot manipulator
TP-510 has been improved with additional buttons
and a better grip through the analysis of user work
environments. Its upper part functions as a handle
designed to lessen internal impacts. By rearranging
buttons on the control box, the TP-510 attempts to
optimize user movement flows. The use of a single
material authorized by ABS makes the TP-510 easy
to assemble and recycle. A 7-inch LCD touch screen
enables intuitive operation. By grouping the layout
of its interactive keypad and buttons for easier oper-
ation, the TP-510 enhances usability.

Product
PROFITEST MASTER
Schutzmaßnahmen Prüfgerät
Professional test instrument

Design
Eckstein Design
München, Germany

Manufacturer
GMC-I Messtechnik GmbH
Nürnberg, Germany

Der PROFITEST MASTER ist ein Präzisions-Prüfgerät, mit dem sich die Auslegung von Schutz- und Sicherheitsmaßnahmen in elektrischen Anlagen messen lässt. Das Design verwirklicht ein ganzheitliches Ergonomiekonzept und macht gleichzeitig den hohen Qualitätsanspruch des Herstellers deutlich. Der Kopf des PROFITEST MASTER ist innerhalb von 270° per Stufenraster-Gelenk verstellbar. Diese Flexibilität erlaubt in allen Gebrauchslagen, ob auf dem Tisch oder umgehängt, einen direkten Blick auf das Anzeigefeld. Eine hochwertige Gummiummantelung schützt das Gerät effektiv gegen alltägliche Beanspruchungen und verbessert die Griffeigenschaften.

PROFITEST MASTER is a high-precision test instrument designed for measuring the effectiveness of protective measures in electrical systems. The design incorporates an overall ergonomic concept by emphasizing the manufacturer's demand for high quality. The top panel of the PROFITEST MASTER can be adjusted within a range of 270° by snap-detenting hinge. This flexibility assures a direct view of the display panel regardless of the instrument's position – on a table or suspended around the neck. A high-quality rubber cover protects the instrument effectively against the stresses of daily use and improves the instrument's grip.

Product
FS
Parallelanschlag
Parallel guide system

Design
STUDIOWERK DESIGN
Roland Schirrmacher, Fred Kern
Inning, Germany

Manufacturer
FESTOOL GmbH
Wendlingen, Germany

Der Parallelanschlag FS ermöglicht präzise parallele Schnitte und Fräsungen. Der große Zeitvorteil entsteht besonders beim Zusägen von gleich breiten Werkstücken, wie z. B. bei Regalbrettern oder dünnen Leisten. Auch Eintauchschnitte wie parallele Lüftungsöffnungen lassen sich schnell realisieren. Der Anschlag ist sehr flexibel und kann Platz sparend transportiert werden.

The FS parallel guide system facilitates precise parallel cutting and milling. It results in significant time savings, especially when preparing work pieces of the same size such as shelves or thin moldings. Plunge cuts such as parallel ventilation openings can also be realized quickly. The stop is extremely flexible and space-saving for transportation.

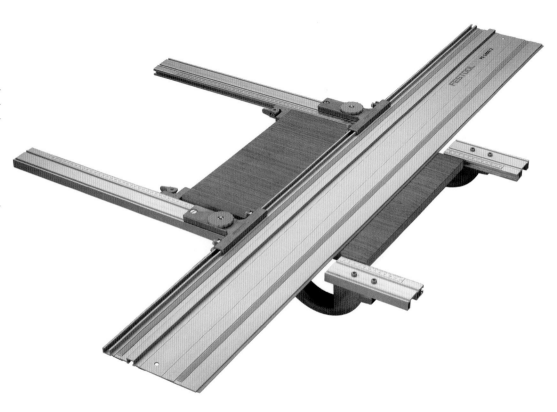

Product
Origo
Reinigungswagen-Serie
Trolley range

Design
piu products
Torsten Gratzki, Jens Deerberg
Essen, Germany

Manufacturer
Freudenberg Haushaltsprodukte KG
Mannheim, Germany

Die Origo Reinigungswagen-Serien bieten mehr als 1,2 Millionen Konfigurationsmöglichkeiten und stehen somit für höchste Flexibilität und Modularität. Höhenverstellbare Schiebebügel, Schalen und Einschübe sowie einfache Manövrierbarkeit zeugen von einer anwenderfreundlichen Ergonomie und belegen die durchdachte Konstruktion. Jedes Element vermittelt hohe Qualität und Funktionalität, wie beispielsweise das modulare Metallrahmensystem, das einfach kombinier- und erweiterbar ist, oder die Aufbereitungsboxen, die aufgrund ihrer ergonomischen Größe leicht in die Schienen des Reinigungswagens eingeschoben und fixiert werden können.

The Origo trolley range stands for highest flexibility and modularity by offering more than 1.2 million ways to configure it. Origo offers user friendly ergonomics just as adjustable handlebars, trays and drawers, easy maneuverability and well thought through architecture. Every part stands for high quality and functionality, like the metal frames, which can be easily combined to form different frames of the trolley. Pre-boxes with their ergonomic size can be put into drawer rails easily. When pulling them out, a stop fixes them to offer an easy access to the content.

Product
Baureihe PG 8535/36
Reinigungs- und Desinfektionsgerät
Washer disinfector

Design
Miele & Cie. KG
Werksdesign
Gütersloh, Germany

Manufacturer
Miele & Cie. KG
Gütersloh, Germany

Die neuen Reinigungs- und Desinfektionsgeräte PG 8535/36 setzen Maßstäbe in der Aufbereitung von chirurgischem Instrumentarium in Kliniken/OP-Praxen sowie Laborglas in Industrie, Umwelt- und Forschungslaboratorien. Die Baureihe verfügt über viele Innovationen wie der neuen freiprogrammierbaren Steuerung Profitronic+, der Sprüharmsensierung „Perfect Speed", der Ultraschall-Dosiervolumenkontrolle „Perfect Flow" bis hin zu dem Leitfähigkeitsmessmodul „Perfect Pure". Die Gestaltung lässt Bakterien durch glatte Flächen und Hinterglassteuerung keine Ablagerungsmöglichkeiten und vereinfacht eine schnelle Wischdesinfektion nach jeder Anwendung.

Miele's new PG 8535/36 washer disinfector set standards in terms of reprocessing surgical instruments in hospitals and outpatient surgeries and glassware for industrial, environmental and research laboratories. This series offers many innovations such as the new freely programmable Profitronic+ controls, "Perfect Speed" spray arm sensing, "Perfect Flow" ultrasonic volume control technology and a "Perfect Pure" conductivity meter. The design of the smooth surfaces and controls behind glass prohibits soil and bacteria from collecting and simplifies wet-wipe disinfection after every use.

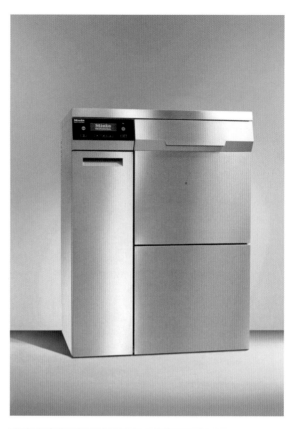

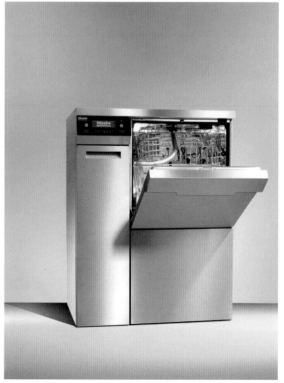

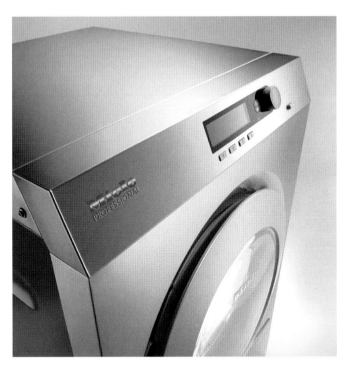

Product
PT 7186
Trockner für die professionelle Nutzung
Professional tumble dryer

Design
Miele & Cie. KG
Werksdesign
Gütersloh, Germany

Manufacturer
Miele & Cie. KG
Gütersloh, Germany

Wäschetrockner der Baureihe PT 7186 werden in Waschsalons bis hin zu Krankenhäusern eingesetzt. Die großen Türen haben zwei Gläser, ein wäscheabweisendes und ein türbündiges, das vor den hohen Temperaturen schützt und gut zu reinigen ist. Durch Greifen in die umlaufende Fase ist es dem Benutzer möglich, an der ergonomisch günstigsten Stelle die Tür zu öffnen – bei bauseitigen oder optionalen Gerätesockeln eine Erleichterung. Die großvolumige Trommel ist gut einzusehen, zu befüllen und zu entladen. Die Steuerung ermöglicht dem Erstbenutzer im Waschsalon ebenso eine einfache Bedienung wie dem Wäschereiprofi, der tief in die Parameter eingreift.

PT 7186 tumble dryers are used in laundrettes and hospitals. The large doors consist of two glass panels, the inside panel thrusts laundry back into the drum, the outside panel protects against high temperatures and is easy to clean and flush with the machine front. Easy door opening by first pressing the door-button and then gripping the door by the concealed recess, which runs around the entire door, at the most convenient point. This is particularly convenient for the user when machines are installed on an on-site or optional plinth. The interior of the large-volume drum is fully visible and the machine is easy to load / unload.

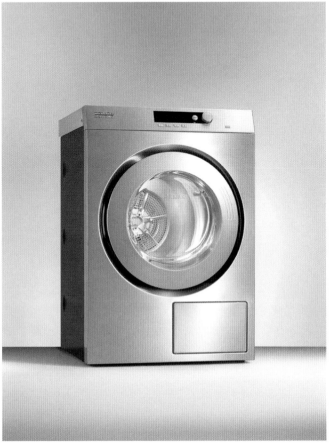

Product
PW 6163
Waschmaschine für professionelle Nutzung
Professional laundry care

Design
Miele & Cie. KG
Werksdesign
Gütersloh, Germany

Manufacturer
Miele & Cie. KG
Gütersloh, Germany

Die PW 6163 bereitet infektiöse Wäsche in Alten- und Pflegeheimen sowie Krankenhäusern auf. Sie ermöglicht eine optimale räumliche Trennung nach reiner und unreiner Seite, da sie zwischen zwei Räumen eingebaut wird. Im unreinen Raum wird die Schmutzwäsche beladen und kann nach Programmende nur im Reinraum entnommen werden. Das Design entspricht durch glatte Flächen den hohen technischen und hygienischen Anforderungen und bringt die Leistungsmerkmale dieses Gerätes zum Ausdruck. Die stabile Trommeltür hält den hohen Fliehkräften stand und lässt sich gut öffnen. Es gilt die Formel: keimfreie Wäschereinigung bei geringen Verbrauchsdaten.

PW 6163 machine process infectious laundry in nursing homes and hospitals. These barrier washer-extractors are built into a diaphragm wall and ensure optimal separation of contaminated and clean sides of the reprocessing operation. Contaminated laundry is loaded into the machine on the unclean side and at the end of the programme it can be removed only on the clean side as bacteria-free laundry. With its smooth surfaces it meets the most demanding of technical specifications and hygienic standards and underlines the machine's performance features. The rugged door withstands the high centrifugal forces at play and can still be opened with ease.

Product
CLEANTEX CT 26 und CT 36
Absaugmobil
Dust extractor

Design
STUDIOWERK DESIGN
Roland Schirrmacher, Fred Kern
Inning, Germany

Manufacturer
FESTOOL GmbH
Wendlingen, Germany

Die neuen CLEANTEX Absaugmobile CT 26 und CT 36 sind kleiner und kompakter als ihre Vorgänger und das bei einem größeren Behältervolumen. Die „AUTOClean" Hauptfilterabreinigung sorgt auch dann für eine konstante hohe Saugkraft, wenn große Mengen an Feinstaub produziert werden, die sonst schnell einen Filtersack zusetzen. Durch einen modularen Steckplatz lässt sich das Absaugmobil den individuellen Bedürfnissen anpassen.

The new CLEANTEX CT 26 and CT 36 dust extractors are smaller and more compact than their predecessors even though they have a larger reservoir volume. The AUTOClean main filter unit ensures consistently powerful suction, even when a large quantity of fine dust that would otherwise quickly clog a filter bag is being generated. The dust extractor can be adapted to individual requirements thanks to a modular slot.

Product
Stopfen IV
Wasserfüllsystem
Water filling system

Design
bsf batterie füllungs systeme GmbH
Elke Oschmann
Bergkirchen, Germany

Manufacturer
bsf batterie füllungs systeme GmbH
Bergkirchen, Germany

Der Batteriefüllstopfen ist Mittelpunkt eines Wasser-
nachfüllsystems für Industriebatterien, u.a.: Elektro-
fahrzeuge, Energiespeicher (Notstromversorgung, er-
neuerbare Energien). Aufgabe: schnelles und siche-
res Befüllen der Batteriezellen auf ökologischer und
ökonomischer Basis. Ein patentiertes Einspritzsystem,
bei dem in Rotation versetztes Wasser einen Sog er-
zeugt, war die Lösung. Technische Präzision auf kleins-
tem Raum. Gestalterisches Ziel war, das Design des
einzelnen Füllstopfens minimalistisch, jedoch klar in
seiner Funktionalität und Symbolik zu definieren, so
dass die Unterordnung in das Gesamtsystem auf der
Batterieoberfläche deutlich wird.

The battery filling plug is the centre of a single point
watering system for industrial batteries e.g. in electric
vehicles, for energy storage (battery back-up, renew-
able energy). Task: quick and secure filling of battery
cells, considering both ecology and economy. The
solution has been a patented injection system where
rotating water is creating suction. Technical precision
within smallest space. The aim of the design has been
to define the single filling plug in a minimalist way,
however clear in its function and exemplary in the
integration of the filling system on the battery top.

Product
PUK Vario
Säge
Saw

Design
Büro für Konstruktion & Gestaltung
Prof. Hagen Kluge, Brigitte Sommerrock
Tiefenbach, Germany

Manufacturer
Josef Haunstetter Sägenfabrik KG
Augsburg, Germany

PUK-Sägen sind für stabilste Ausführung und höchste Lebensdauer bekannt. Eine zeitlose Formgebung unterstützt diesen Anspruch im harmonischen Zusammenspiel der einzelnen Funktionen. Die PUK Vario erreicht eine optimale Ergonomie mit ungewöhnlich großem, verletzungssicher gestaltetem Greifraum und fluchtender anatomischer und funktioneller Achse sowie einfachem Einsetzen der Sägeblätter mit stufenloser Spannvorrichtung. Eine Novität sind die variabel lieferbaren Bügel- und Sägeblattlängen von 75–200 mm. Die Säge lässt sich problemlos in alle Einzelteile demontieren.

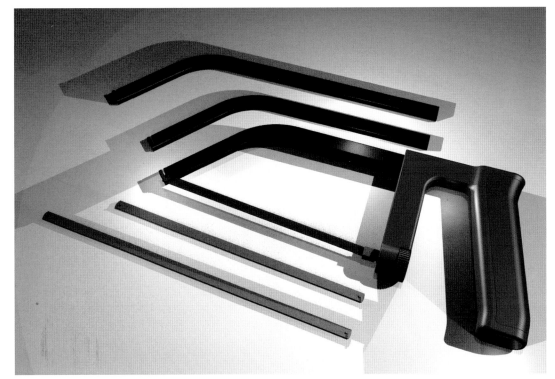

PUK saws have always been known for their solid construction and extremely long lifetime. Timeless design supports the high standards combining the single functions harmoniously. The PUK Vario reaches excellent ergonomics with its extraordinarily large, specially protected grip and its ergonomic and functional axis lying in the same line. Sawblades can easily be changed, and tension can be adjusted progressively. Yet another innovation is that sawblades and frames are available in variable lengths from 75 to 200 mm. The saw frame can be easily disassembled into its single parts.

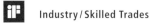

Product
VEGA
Barcode Scanner

Design
EYE-D Designed Innovation
Ron Verweij
Druten, The Netherlands
Champtek Inc.
Wei-Chuan Lu, Feng-Hsu Lin
Taipei, Taiwan
Brinno Inc.
Chen-I Hsu
Taipei, Taiwan

Manufacturer
Champtek Inc.
Taipei, Taiwan

VEGA CCD ist ein Barcode-Handscanner mit Bluetooth-Funktion für den Einzelhandel – für Tankstellen, Bekleidungsgeschäfte, Baumärkte etc. Er vereint Praktikabilität mit Eleganz, ohne Abstriche bei der überlegenen Technik zu machen. Es handelt sich um ein „High Tech, High Touch"-Gerät: Das ergonomische Design verhindert auch nach längerem Gebrauch Ermüdungserscheinungen und Handgelenksbeschwerden. Zu den nützlichen Funktionen zählt ferner ein rutschfester Handgriff mit einer Fläche für Werbebotschaften. Alles in allem setzt der VEGA im Bereich der Autoerkennung neue Maßstäbe.

VEGA CCD scanner is a handheld barcode scanner with Bluetooth function. It targets users in retail environments, such as gas stations, clothing stores, hardware stores, etc. Without sacrificing technical superiority, VEGA's design couples practicality with sleek looks. It's a "High Tech, High Touch" experience, offering ergonomic design (which prevents fatigue during long time usage and wrist injuries), and useful features (e.g., slip-proof handle and marketing material area) for users. Overall, VEGA is an innovative benchmark in the auto-identification industry.

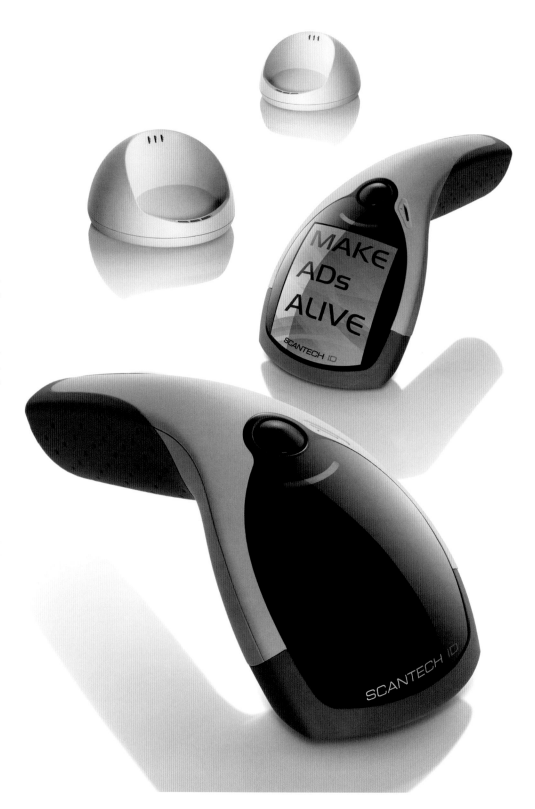

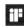

Product
ZEBEX Z-3051HS
Barcode Scanner

Design
ZEBEX Industries Inc.
Taipei County, Taiwan

Manufacturer
ZEBEX Industries Inc.
Taipei County, Taiwan

Der Z-3051HS ist ein portabler Einzeilen-Laserscanner mit einer von ZEBEX entwickelten Funktionseinheit. Der eingebaute Decoder Z-SCAN+ ermöglicht Scannen in Echtzeit; fast jeder Code wird auf Anhieb eingelesen. Dieser schlanke und leichte, ergonomisch gestaltete Scanner steckt in einem stabilen Gehäuse. Die kleine, im Lieferumfang enthaltene Standardhalterung nimmt kaum Platz in Anspruch. Das mit Dreifarben-LED, programmierbarem Piepser und Multi-Interface ausgestattete Gerät bietet eine eindrucksvolle Scanleistung von bis zu 500 Scans in der Sekunde – das bedeutet Effizienz für Einzelhandel, Büro und Lager.

The Z-3051HS is a handheld single-line laser scanner with a ZEBEX scan engine. It is enhanced by built-in Z-SCAN+ hardware decoding technology, which provides real-time scanning and ensures an unparalleled first read success rate. This slender, lightweight scanner strikes a balance between ergonomics and durability; it comes with a standard holder with narrow base to save counter space. Equipped with a 3-color LED, programmable beeper and multi-interface connectivity, the device has a remarkably powerful scanning performance of up to 500 scans/sec allowing users to streamline processes in any retail, office or warehouse environment.

Product
OPASI008
Scannermodul
Powerscan kit

Design
Squareone GmbH
Gert Trauernicht, Sven Schulz,
Sascha Dittrich, Stephanie Wirth
Düsseldorf, Germany

Manufacturer
t+t Netcom
München, Germany

Für die TT 8000er Serie des t+t Netcom Industrie PDAs haben wir ein Powerscan-Modul für den „Warehousebetrieb" entwickelt. Das Scannermodul kann an die Modulschnittstelle des PDA angekoppelt werden und zeichnet sich durch eine eigene und „hotswapfähige" Leistungsversorgung mit Industrieakkus aus. Das Powerscan-Modul wird von der Elektroniksteuerung des PDA automatisch erkannt und versorgt sich je nach Ladezustand des Haupt- oder Scannerakkus vollkommen selbständig mit der nötigen Energie. Das Gerät ist ein Teil der t+t Netcom Modulfamilie und wird durch eine spezielle Ladestation und zahlreiche Gürteltragesysteme ergänzt.

We developed an additional power scan module to be mounted on TT Netcom's TT 8000 industrial PDA series, which has been especially designed for warehouse operations. Being charged by a hot-swappable power source, the module is connected and automatically recognized by the PDA's peripheral interface. Depending on its charge condition, the scanner can be supplied by either the PDA's or its own batteries. The scan module is part of the t+t Netcom PDA Family and includes a lot of accessories such as a wall-mountable charging station or a belt holster.

Product
Ypsator
Mehr-Etagen-Laminator
Multi opening lamination line

Design
Design Tech
Ammerbuch, Germany

Manufacturer
Robert Bürkle GmbH
Freudenstadt, Germany

Photovoltaikmodule sind empfindliche Bauteile und müssen durch eine Laminierung vor Oberflächenbeschädigungen geschützt werden. Diese Aufgabe übernimmt der Ypsator, mit dem synchron mehrere Module laminiert werden können. Die vier Module Beladung, Laminierpresse, Kühlpresse und Entladung befinden sich hinter einer selbsttragenden, kulissenähnlichen Verkleidung. Ihre Kassettierung nimmt das Motiv der Solarmodule auf. Be- und Entlademodule sind als eigene Volumen ausgebildet, was ihre besondere Funktion im Prozessablauf unterstreicht. Zwischen Verkleidung und Anlage befinden sich Wartungsgänge, die schnell zugänglich sind.

Photovoltaic modules are delicate devices. They have to be protected from surface damage by lamination. That is the task of the Ypsator, which can laminate several modules simultaneously. Its four units: charging, laminating press, cooling press and discharging are placed behind a self-supporting casing, which is alike a backdrop. Its coffering reflects the theme of the solar cell. Charging and discharging units have their own prominent volume, which emphasises their special role in the process sequence. For maintenance purposes, there are easily accessible walks between chasing and machine.

Product
Profibox
Verpackung
Packing

Design
design AG
Frank Greiser
Rheda Wiedenbrück, Germany

Manufacturer
Conacord
Lippstadt, Germany

Die Profibox ist ein Verkaufs- und Verpackungssystem für Bänder, Ketten und Kabel. Die Box soll die Formsprache einer Spule besitzen und den Schutz einer Verpackung vermitteln, da diese sowohl im SB-Markt als auch im Handwerker-Fahrzeug als Spender eingesetzt wird. Anforderungen aus dem Verkauf von Meterware waren zu einer Lösung mit Wiedererkennungswert zusammenzuführen. Die Box besitzt eine Etikettierfläche zur Abrechnung des gesamten Gebindes. Unter dem Siegel befindet sich der Block mit den scanbaren Zetteln für die Abrechnung der Meterware. Der Griff trägt bis zu 20 kg. Materialien und Farbcodes können angepasst werden.

The professional box is a sales and packing system for tapes, chains and cables. The box is to possess the form language of a coil and offers the protection of a packing while it will be used as a dispensing unit both in the self-service store and in the craftsman's vehicle. Requirements from the sales of material sold by the metre were to be combined in a solution with recall value. The box possesses a label field for calculating the complete bundle. Under the seal there is the block with the scannable slips for calculating the material sold by the metre. The handle can carry up to 20 kg. Different materials and color codes are available.

Product
FlexiSEAL
Verpackungsmaschine
Wrapping machine

Design
designship
Thomas Starczewski, Ralph Schneider
Ulm, Germany

Manufacturer
Köra-Packmat Maschinenbau GmbH
Villingendorf, Germany

FlexiSEAL – Folienverpackungsmaschine zur Verarbeitung von flachen und 3-D-Produkten. Im Zentrum der Anlage sitzt das optisch hervorgehobene Hauptmodul mit Touchscreen und Schweißeinheit. Ihm kann eine Vielzahl unterschiedlicher Module zugeordnet werden. Das modulare Konzept realisiert kurze Planungszeiten, individuelle Anlagen und nachträglich einfach zu modifizierende Konfigurationen. Die ergonomisch optimierte Arbeitshöhe von 100 cm und die Übersichtlichkeit gewährleisten sichere und optimale Bedienung bei Produktion und Service. Die Geräuschkapselung der Module erfolgt durch besonders gestaltete Hauben.

FlexiSEAL – foil wrapping plant for the processing of flat and three-dimensional products alike. In the centre of the unit there is an optically highlighted main module with touch screen and welding unit, where different kinds of auxiliary modules can be added. This modular concept allows short planning times, individual arrangements and easy to modify configurations at a future date. An ergonomically optimized working height of 100 cm and a clear arrangement assure safe and ideal handling during operation and service. Noise reduction is achieved through specially designed covers.

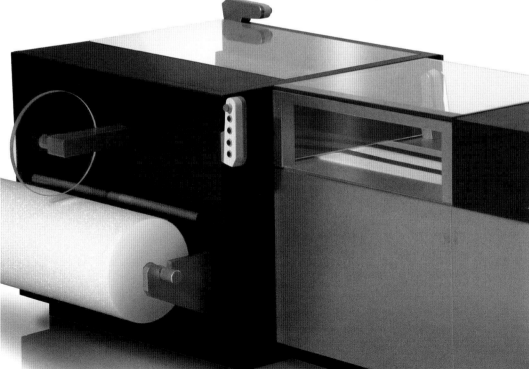

Product
metron
Werkzeug für Produktdesigner
Product designer tool

Design
egg design
Gyong Hun Kim, Young Seok Ryu, Hong Chol Kim
Seoul, South Korea

Manufacturer
egg design
Seoul, South Korea

Beim computergestützten Design ist es für gewöhnlich schwierig, die richtigen Designelemente zu finden, denn die Computermodelle unterscheiden sich von den realen Produkten. metron hat für Designer eine nach Größe geordnete Zusammenstellung häufig verwendeter Designelemente wie Rundungen, Einfassungen, Löcher, Prägungen, Stärke, Bedrucken etc. entwickelt. Mit metron kann der Designer das Element seiner Wahl leicht erkennen und berühren und damit präzise beurteilen.

In computer-assisted design, it is common for designers to experience difficulty in finding the proper design elements due to differences between computer-designed models and real products. metron for designers has developed a graph of commonly used design elements such as rounding, trimming, holes, embossing, thickness, imprinting and others by size. Designers can easily identify their chosen design elements and touch them with their hands, finally allowing them to precisely evaluate their choice through metron.

Product
CFT
Scharniere
Hinges

Design
Elesa S. p. A.
Monza, Italy

Manufacturer
Elesa S. p. A.
Monza, Italy

Scharnier aus glasfaserverstärktem polyamidbasiertem (PA) Technopolymer mit Drehstift aus Acetalharztechnopolymer und polyesterbasierten (PBT) Technopolymerabdeckungen. Erhältlich in schwarz. Montage mit Bohrungen für Zylinder- und Senkkopfschrauben. Die Schraubenabdeckungen verdecken Montageschrauben oder -muttern und verhindern Staub- bzw. Schmutzablagerungen in den Hohlräumen. Sie können auch mit gedruckten Logos, Markenzeichen bzw. Symbolen maßgeschneidert und in verschiedenen Farben geliefert werden.

Hinge in glass-fibre reinforced polyamide based (PA) technopolymer with acetal-resin based technopolymer rotation pin and polyester based (PBT) technopolymer screw-covers. Black colour. Assembly by means of through holes for cylindrical and countersunk head screws. The screw covers conceal the assembly screws or nuts and prevent the deposit of dust or dirt in the cavities. They can also be customised with printed logos, marks or symbols or provided in different colours.

Product
MC17 Mobile Computer
Drahtloser Produktscanner
Wireless product device

Design
Motorola Enterprise Mobility
Mark Palmer, Curt Croley,
Jaeho Choi, Markus Heberlein
Holtsville, NY, United States of America

Manufacturer
Motorola Enterprise Mobility
Holtsville, NY, United States of America

MC17 ist ein drahtloses Gerät, das es Kunden ermöglicht, Produkte, die sie kaufen möchten, zu scannen. Der Kunde kann alle angeforderten Produktinformation sehr schnell bekommen, da das Gerät einen direkten und personifizierten Anschluss zwischen Kunden und Einzelhändler bereitstellt. Während das MC17 hauptsächlich für die Kunden entwickelt wurde, kann die Vorrichtung auch von Unternehmen genutzt werden, etwa zum Erfassen des Warenbestandes.

MC17 is a self-service wireless device that enables customers to scan products as they shop, speed through checkout lines, view product information, and receive personalized promotions. It enables an enriched shopping experience by providing a direct, personalized connection between customers and retailers. While the MC17 is primarily intended for use by customers visiting a retail establishment, the device may also serve as a productivity tool for store associates for tasks such as inventory and queue busting.

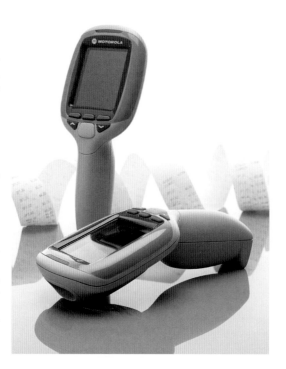

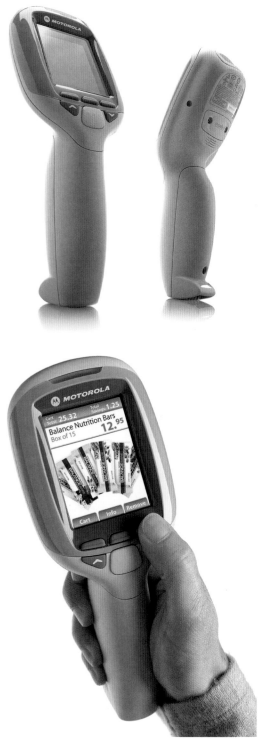

Product
Océ ColorStream® 10000
Hochgeschwindigkeitsdrucker
High speed color printer

Design
Oce Technologies Bv
Océ Design in collaboration with Océ Printing Systems
Venlo, The Netherlands

Manufacturer
Oce Technologies Bv
Venlo, The Netherlands

Der Océ ColorStream® 10000 ist ein Vollfarbdrucker, in dem das Papier für perfekte Registerhaltigkeit gleichzeitig auf beiden Seiten bedruckt wird. Der Drucker ermöglicht das bedarfsgerechte Drucken von Büchern, personalisierten Broschüren oder Zeitungen mit Offset-Anmutung. Er kombiniert Vollfarbe, „CustomTone" (ein nach Maß angefertigter Toner) und S/W in einem Ablauf und optimiert die Geschwindigkeit selbständig, je nach Farbgebrauch, von S/W (800 ppm) bis auf Vollfarbe (168 ppm). Trotz geringer Stückzahl und Industriegebrauch steht diese Ausführung für ICT (Innovative Communication Technologies) und Produktivität. Dieses wird durch die Verwendung gleicher Teile ermöglicht.

The Océ ColorStream® 10000 is a full color printer, in which paper is printed on both sides simultaneously for perfect front-back register. Supporting a wide range of stock, it enables on-demand book printing, personalized brochures or newspapers with an authentic offset look and feel. It combines full color, "CustomTone" (custom made toner to match corporate identity) and B/W prints in one workflow, optimizing its speed automatically, detecting B/W (800 ppm) and full color (168 ppm). Despite the low series and industrial character, the design communicates both ICT and productivity, what was made possible by means of repeating the same parts.

Product
MINITEC
Mobilgehäuse
Mobile enclosures

Design
polyform Industrie Design
Martin Nußberger
München, Germany

Manufacturer
Odenwälder Kunststoffwerke Gehäusesysteme GmbH
Buchen, Germany

Die perfekten Begleiter. Die Standardgehäuse-Reihe MINITEC überzeugt durch Mini-Maße und maximalen Nutzen. Am Lanyard, Armband oder mit Handschlaufe wird das MINITEC zum treuen Begleiter und ist stets in greifbarer Nähe des Bedieners. So klein und leicht passen sie, z.B. am Schlüsselbund, auch in jede Hosentasche und sind das perfekte Accessoire für den täglichen Einsatz.

The perfect companions. The MINITEC range of cases will convince you thanks to their mini-dimensions and maximum practicality. Whether on a lanyard, as a bracelet or with a wrist strap, the MINITEC will be your faithful companion and is always within easy reach of the user. They are so small that they fit into any trouser pocket and are the perfect accessory for everyday use.

Product
Reca Koffer
Sortiment-Kassettensystem
Assortment cassette system

Design
rose plastic AG
Werksdesign
Hergensweiler, Germany

Manufacturer
rose plastic AG
Hergensweiler, Germany

Neues ergonomisch optimiertes Kassettensystem aus leichtem und widerstandsfähigem ABS, dessen hochtransparenter Deckel sofort über den gesamten Inhalt Auskunft gibt. Seitliche Griffmulden ermöglichen auch bei schwerem Kassetteninhalt einfachen und sicheren Transport. Die Innenaufteilung kann über Tiefzieheinsätze variabel gestaltet werden. Der einteilige klappbare und zusätzlich weich beschichtete Tragegriff wird ohne Werkzeug montiert und bietet genügend Fläche für eine zusätzliche Markenkennzeichnung. Mittels einer Sicherungsvorrichtung wird auch bei offenen Schiebeverschlüssen der Inhalt beim Anheben am Griff gegen Herausfallen gesichert.

New ergonomically optimized cassette system made from light and robust material ABS. Thanks to the highly transparent covers the content can be seen at a glance. The easy grasp features on both cassette sides enable secure and easy transport even with heavy contents. It has a big choice of compartment versions by use of thermo-formed inserts. The cassette handle consisting of one part is foldable, offers "soft-touch" and can be assembled without any tools. At the same time it offers additional space for brand labels/imprints, etc. Thanks to a safety device the content will not drop out when taking the open cassette at its handle (open sliding clasps).

Product
C Touch
Touchsreen-Einheit
Touchscreen unit

Design
Thomas Hofmann . Entwicklung interaktiver Medien
Thomas Hofmann, Colja Nowakowski,
Michael Bresser
Essen, Germany

Manufacturer
SIG Combibloc Systems GmbH
Linnich, Germany

Touchscreen-Einheit zur Steuerung von Verpackungs-
maschinen für Getränke und Lebensmittel. Das Gerät
ist wasserdicht (IP65) und verfügt über ein RFID-Trans-
pondersystem. Die Einheit ist Bestandteil der C Touch-
Produktfamilie.

Touchscreen unit to control filling processes of drinks
and food packages. The complete unit is waterproof
(IP65) and cleanable by high pressure cleaner. The
product is equipped with a RFID detector. The touch-
screen is part of the C Touch product family.

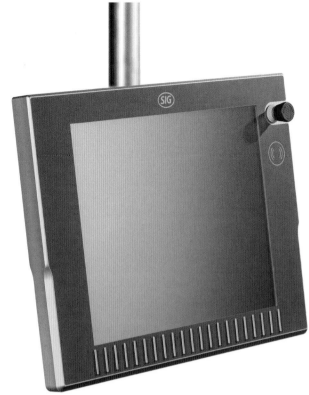

Product
Dräger Drugtest 5000
Drogentestgerät
Drug tester

Design
Bachorski Design
Bachorski Kirchhoff GbR
Rüdiger Bachorski, Niels Kirchhoff
Lübeck, Germany

Manufacturer
Dräger Safety AG & Co. KGaA
Lübeck, Germany

Der Dräger Drugtest 5000 Analysator ist die Auswerteeinheit des Dräger Drugtest 5000 Testsystems. Mit dem „Test-Kit" wird eine Speichelprobe entnommen, die vom Analysator verarbeitet, ausgewertet und angezeigt wird. So können verschiedene Drogensubstanzklassen innerhalb weniger Minuten nachgewiesen werden. Der auf dem Farbdisplay dargestellte Testablauf sowie das sinnfällige Design erleichtern die Bedienung. Gummielemente schützen das Gerät im mobilen Einsatz. Durch eine Vielzahl von Schnittstellen kommuniziert der Drugtest Analysator mit anderen Geräten (Drucker, Dräger Alcotest, …) und wird so zu einer Plattform für die Vor-Ort-Messung.

The Dräger Drugtest 5000 analyzer is the processing unit of the Dräger Drugtest 5000 test system. It processes and analyzes oral fluid samples collected with the Drugtest "Test-Kit" and displays the measurement results. Thus, various drugs of abuse, can be detected in a few minutes. Operation of the device is facilitated by visual instructions on the color display and the device's evident design. Rubber boots protect the device during outdoor operation. A variety of interfaces allows the Drugtest analyzer to communicate with a number of other devices (printer, Dräger Alcotest, …) turning it into a platform for point of care applications.

Erfreulich ist es festzustellen, dass sich auch Hersteller großvolumiger Investitionsgüter vorwagen und am iF product design award teilnehmen. Was im Bereich der Konsumgüter gang und gebe ist, hat sich in der Investitionsgüterindustrie noch nicht als Standardpraxis durchgesetzt. Denn wenn Industrial Designer in den Entwurfsprozess einbezogen werden, ist dieser Schritt sicherlich zu honorieren – zumal, wenn es um mehr als eine nachträglich applizierte visuelle Aufmöbelung geht.

So wie man in den Wissenschaften, zumal der experimentellen Physik, zwischen small science und big science unterscheidet, so kann man auch im Bereich des Design zwischen small design und big design eine Grenze ziehen. Damit ist keine Wertung impliziert. Es geht schlicht um unterschiedliche Arbeitsstile: auf der einen Seite eine individualistische Arbeitsweise, die keine großen Ressourcen erfordert; auf der anderen Seite eine teamartige Kooperation mit Vertretern verschiedener Disziplinen und mit entsprechender Infrastruktur. Für beide Arbeitsstile fanden sich Beispiele in den hier kommentierten Produktbereichen.

Ob nun im Maschinenbau oder Industrial Design, in beiden Fällen macht sich die Entwurfsqualität unter anderem am Entwurfskonzept und an der Lösung von Details fest. Vor einigen Jahren war das Wort sustainability noch ein Fremdwort im Designdiskurs und in der Entwurfspraxis. Insgleichen spielte die Sorge um Energieaufwand und Nutzung energetischer Ressourcen kaum eine Rolle. Das hat sich heute geändert. In vielen Produktbeschreibungen wird die Frage der Nachhaltigkeit explizit erwähnt, wobei allerdings bislang selten zwischen ökologischer und sozialer Nachhaltigkeit unterschieden wird.

It is pleasing to see that the manufacturers of large-scale capital equipment are coming out of the woodwork and participating in the iF product design award. What is common in the consumer goods segment has yet to become standard practice in the capital equipment industry. When industrial designers are included in the conceptual design process, this step is surely worthy of a reward – especially when more than a subsequent visual face-lift is involved.

Just like science and especially experimental physics differentiates between small science and big science, it is possible to draw a line between small design and big design in the design field. This does not imply a ranking. It simply refers to different modes of operation: On the one hand, an individualistic approach that does not require any great resources; on the other hand, team-like cooperation between representatives of various disciplines with a corresponding infrastructure. Examples of both approaches were found in the product groups discussed here.

Be it in machine construction or industrial design, in both cases the design quality is, among other things, based on the conceptual design and detailed solutions. Just a few years ago, the word sustainability was unknown in design courses and in practice. Energy costs and the consumption of energy resources also did not play a major role. This has changed in the meantime. While the issue of sustainability is explicitly mentioned in many product descriptions, most of them do not differentiate between ecological and social sustainability.

Product
Kverneland balers
Stroh- und Heuballenpressen
Balers

Design
VanBerlo strategy+design
Design Team VanBerlo
Eindhoven, The Netherlands

Manufacturer
Kverneland Group
Geldrop, The Netherlands

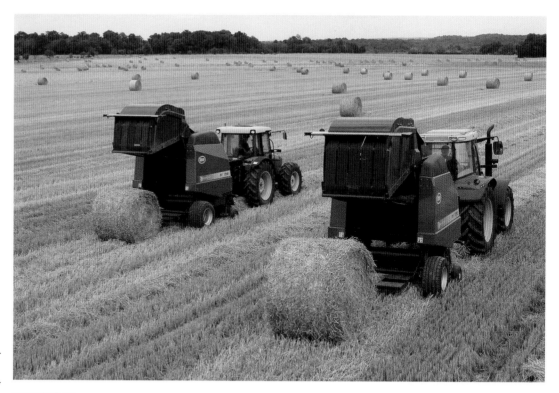

Kverneland Group (Marken Kverneland und Vicon) ist eine der führenden internationalen Firmen, die sich auf die Entwicklung, Fertigung und den Vertrieb von Landmaschinen spezialisiert hat. Eine neue Serie von Stroh- und Heuballenpressen (3 Typen) wurde kürzlich vorgestellt, die in Sachen Außendesign und Außenbeschriftung völlig neu ausgestaltet worden sind, so dass die moderne Vicon-Identität deutlich hervorgehoben wird. Der Entwurf der Außenflächen konzentrierte sich auf die Herstellung einer erkennbaren Produktfamilie, wobei die Inanspruchnahme firmeneigener Fertigungstechniken den Selbstkostenpreis möglichst niedrig gehalten hat.

Kverneland Group is one of the leading international companies developing, producing and distributing agricultural machinery. Recently the group launched a new and more focused branding strategy, which concentrates on the Vicon and Kverneland brands. A new range of balers was recently introduced that features a new exterior design and graphic that clearly communicates a modern Vicon identity. Applied to a range of fixed chamber, variable chamber and big square balers, the design of the exterior panels focused on creating a recognizable product family, while the use of in-house production techniques enabled the cost price to remain low.

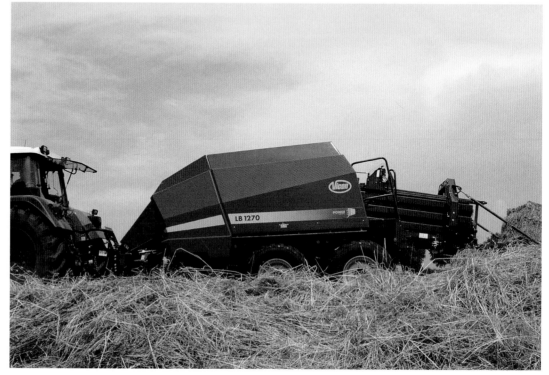

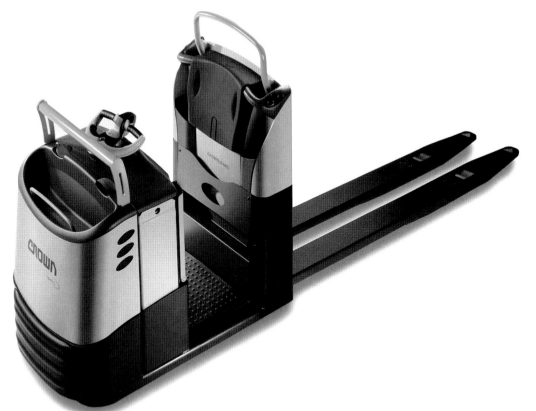

Product
Crown GPC 3000
Niederhub-Kommissionierer
Low-level order picker

Design
Crown Gabelstapler GmbH & Co. KG
Markus Graf, Jim Kraimer,
Michael P. Gallagher
München, Deutschland
Formation Design Group
Robert Henshaw, Russell Kroll,
Mark Londborg, Philip Palermo
Atlanta, GA, United States of America

Manufacturer
Crown Equipment Corp.
New Bremen, OH,
United States of America

Die Niederhub-Kommissionier-Serie GPC 3000 von Crown setzt neue Standards im Lager- und Logistik-Bereich. Der GPC 3000 bietet Kunden während des Kommissionier-Prozesses herausragenden Mehrwert durch reaktionsschnelle Fahrleistung, Komfort für er-müdungsfreies Arbeiten und innovative Funktionen zur Vereinfachung der Bewegungen des Bedieners rund um das Gerät. Mit der herunterklappbaren Tritt-stufe zur Vergrößerung der Reichweite des Bedieners, dem einfach zu bedienenden Pick Position Control™ System und der bedienfreundlichen X10® Deichsel ist der GPC 3000 der fortschrittlichste und effizien-teste Niederhub-Kommissionierer auf dem Markt.

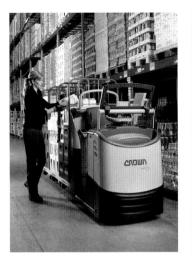

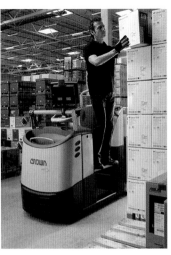

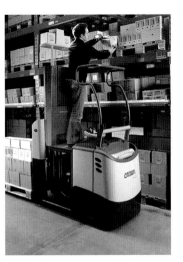

The Crown GPC 3000 Series is a full range of low-level order pickers that sets a new standard in the warehousing and logistics industry. The GPC 3000 creates customer value throughout the whole pick-ing process with responsive driving performance, fa-tigue-reducing comfort, and innovative features that simplify the operator's movements both on and off the truck. Designed with patent-pending fold-down steps which extend the operator's reach to the se-cond level rack, easy-to-use Pick Position Controls™ and the user-friendly X10® Control Handle, the GPC 3000 is the most advanced and efficient order picker on the market.

Product
Toyota Traigo 48
Gabelstapler
Electric forklift truck

Design
Toyota Industries Corporation
Tadayuki Yakushi
Kariya, Aichi, Japan

Manufacturer
Toyota Industries Corporation
Kariya, Aichi, Japan

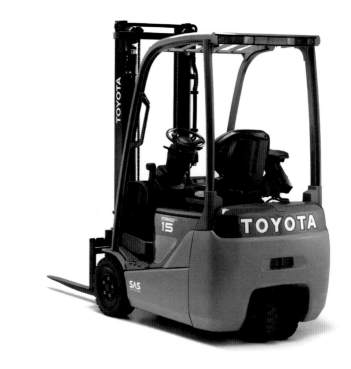

Der Toyota Traigo 48 ist unser bisher kompaktester 48V Gabelstapler. Diese brandneuen Modelle arbeiten dank der Toyota AC2 Drehstromtechnik höchst effektiv über längere Zeiträume hinweg. Die erhöhte Leistungsfähigkeit der Batterie maximiert die Betriebszeit. Die niedrige Trittstufe und der große Handgriff am Einstieg machen den Zugang leicht. Der neue 48V bietet den kleinsten Wenderadius seiner Klasse. Das variable, keilförmige Design macht nicht nur einen dynamischen Eindruck, sondern ermöglicht auch die nutzerspezifische Längen- und Höhenanpassung der verschiedenen Variationen. Er ist zudem als Dreirad- und Vierradstapler erhältlich.

The Toyota Traigo 48 is our most compact 48V forklift ever made. These all-new models will operate at peak effectiveness for longer periods of time due to Toyota AC2 power system, while increased battery efficiency maximizes uptime. The low entry step and large entry assist grip provide easy access. The new 48V offers the smallest turning radius in its class. The adjustable wedge line design gives not only dynamic impression but also accept user specific length and height adaptation of the different variations. Also available in 3wheel and 4wheel versions. For more information, visit www. toyota-forklifts. eu

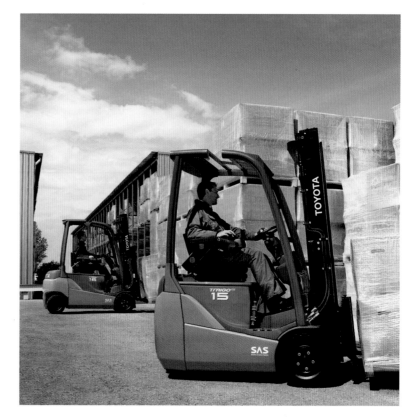

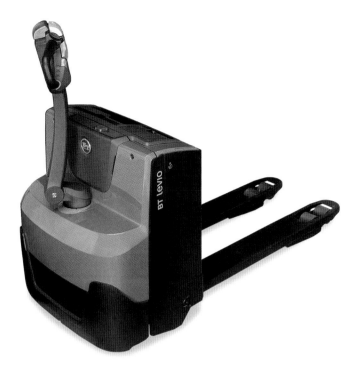

Product
BT Levio
Elektrischer Niederhubwagen
Electric powered pallet truck

Design
Toyota Material Handling Europe
Magnus Oliveira Andersson
Mjölby, Sweden

Manufacturer
BT Products
Mjölby, Sweden

BT Levio ist eine Baureihe von vielseitigen Elektro-hubwagen, die für den leichten und sicheren Transport von Lasten entworfen wurde. Sie zeichnen sich durch Langlebigkeit aus und sind sehr zuverlässig. Der Niederhubwagen bietet eine große Bandbreite an Modellen für verschiedene Be- und Entladungsvorgänge. Der BT Levio wurde nach den Schlüsselwörtern Einfachheit, Sicherheit und Zuverlässigkeit konzipiert. Er ist einfach zu bedienen und durch das kompakte Fahrgestell, mit ergonomischer Anordnung der Bedienelemente, ermöglicht er eine freie Sicht auf die Gabeln. Mehr Details finden Sie unter www.bt-levio.eu

BT Levio is a range of versatile powered pallet trucks designed to move loads easily and safely. They're built to be durable and therefore very reliable with models suited for a range of loading and unloading operations. BT Levio is designed with the keywords simplicity, safety and durability. It's easy to use with a compact chassis, ergonomic positioning of the control arm and visibility all over the forks. For full details visit www.bt-levio.eu

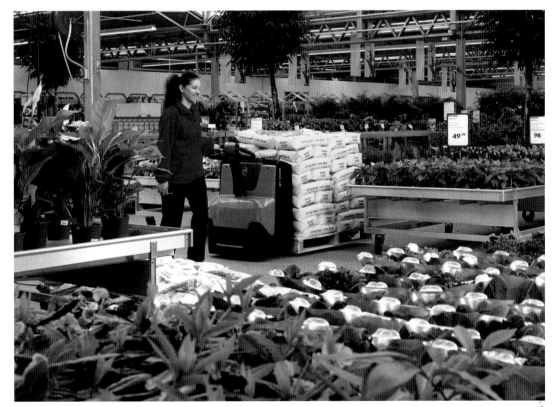

Product
Vision 5100-2 / Vision 5103-2
8ft Asphaltfertigerlinie
8ft class road paver

Design
Dialogform GmbH
Ulrich Ewringmann, Boris Eickhoff
Taufkirchen, Germany

Manufacturer
Joseph Vögele AG
Mannheim, Germany

Die 8ft Rad- und Raupenfertiger der Mittelklasse
sind komplette Neuentwickelungen speziell für den
US-Markt. Sie verfügen über das intuitive Bedienkon-
zept ErgoPlus. Durch ihre kompakte Bauweise, ihre
Wendigkeit und die effektive Abgasreduzierung der
Motoren nach Tier III sind sie vor allem für mittlere
Baumaßnahmen auch im innerstädtischen Bereich
geeignet, wo ebenso ein Höchstmaß an Übersicht-
lichkeit gefragt ist. Die extrem leisen Maschinen sind
dabei für einen Einsatz besonders in lärmkritischen
Zonen prädestiniert. USA-spezifisch ist die Ausrüstung
mit Gummiraupen.

The 8ft wheeled and tracked mid-range finishers
are completely new developments especially for the
US market. They have the intuitive operating con-
cept ErgoPlus. Thanks to their compact construction,
maneuverability and the effective exhaust fume re-
duction of the motors in accordance with Tier III, they
are above all suitable for average building activity, in-
cluding in the inner-city area, where a high amount of
clarity is also required. The extremely quiet machines
are at the same time predestined for use in noise-
critical zones in particular. The equipment is tailored
with rubber tracks.

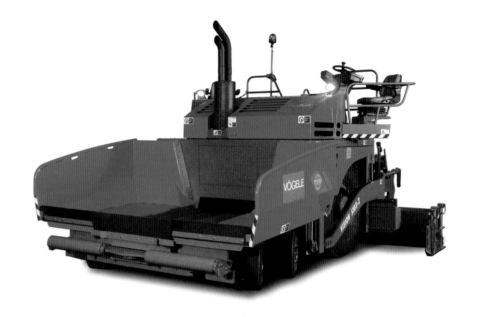

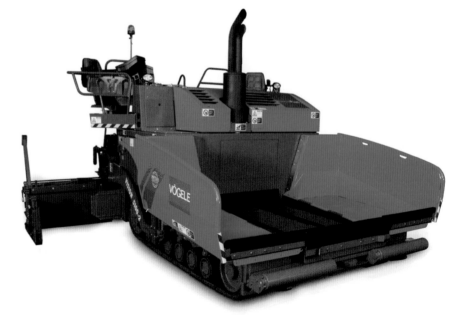

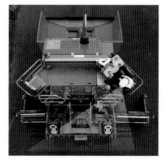
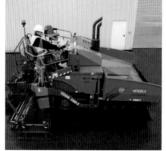
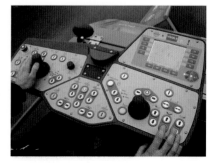

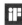

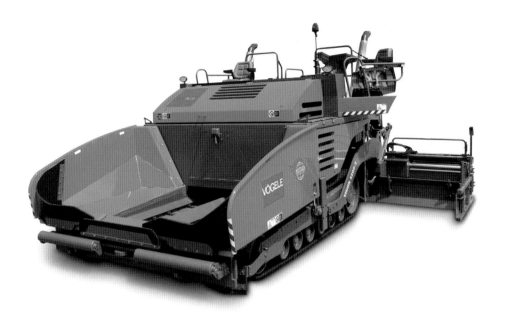

Product
Vision 5200-2 / Vision 5203-2
10ft Asphaltfertigerlinie
10ft class road paver

Design
Dialogform GmbH
Ulrich Ewringmann, Boris Eickhoff
Taufkirchen, Germany

Manufacturer
Joseph Vögele AG
Mannheim, Germany

Die 10ft Asphaltfertiger Vision 5200-2 und Vision 5203-2 sind speziell für den US-Markt mit seinen hohen Einbaugeschwindigkeiten von bis zu 76 m/min neu entwickelt. Sie verfügen über das intuitive Bedienkonzept ErgoPlus. US-Fertiger dieser Klasse sind flacher, aber wesentlich breiter als europäische Fertiger. Dennoch bestechen beide Maschinen durch ihre leichte Manövrierbarkeit. Die erstmals am Heck platzierte, kombinierte Abluftführung verbessert die Übersichtlichkeit der Maschinen so, dass der Fahrer sie trotz ihrer Größe jederzeit bequem sitzend bedienen kann. Die Geräusch- und Abgasemissionen sind drastisch reduziert.

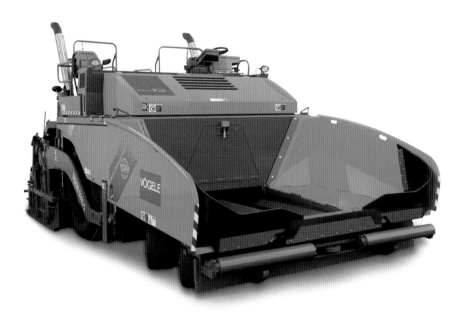

The 10ft Paver Vision 5200-2 and Vision 5203-2 have been especially redeveloped for the US market with their high covering speeds. They have the intuitive operating concept ErgoPlus. US finishers of this range are flatter yet considerably wider than European finishers. Nonetheless both machines are enticing thanks to their easy maneuverability. The combined extracted air shroud, situated on the rear for the first time, improves clarity when using the machines in such a way that, in spite of their size, the driver can operate them at any time while sitting comfortably. Noise and exhaust fume emissions are drastically reduced.

Träumen, wünschen, forschen, machen: Advanced Studies sind eine besonders interessante Kategorie des Wettbewerbs. Sie dienen nicht nur zur Weiterbildung von Designern, die ihren Einfallsreichtum an zukunftsträchtigen Projekten schulen. Interessant für die Öffentlichkeit wird ein solches Projekt, sobald es über den Charakter einer reinen Fingerübung hinausgeht. Beim Entwurf solcher Zukunftsstudien drängen sich bestimmte Fragen auf. Zum Beispiel: Wie könnten in einer absehbaren Zukunft neue Dienstleistungen oder Produkte beschaffen sein, die wegweisend sind? Leider verlieren manche Designer bei Projekten ohne konkreten Auftrag den Boden unter den Füßen. Wenn man sich beispielsweise über vorgeblich unabänderliche Gesetzte des Marktes hinwegsetzt, um Neues zu schaffen, so gelten deshalb trotzdem Regeln der Dimensionierung, der Proportion, des effektiven Materialeinsatzes weiter, ganz zu schweigen von den Gesetzen der Physik. Auch Advanced Studies sollten sich mit diesen Regeln auseinandersetzen. Wenigstens eine Andeutung über bestehende oder künftig verfügbare Techniken sollten sie enthalten. Dann aber, das zeigt auch der diesjährige Wettbewerb, könnte es Designern gelingen, tatsächlich Einfluss auf die gestaltete Umwelt von morgen zu nehmen.

Dreaming, wishing, researching, doing: Advanced Studies is an especially interesting category in this competition. Not only does it promote the continuing education of designers who practice their ingenuity on future-oriented projects. Such projects are of interest to the general public as soon as they go beyond the nature of a mere finger exercise. Certain questions arise in the design of such future studies. For example: How can new, groundbreaking services or products for the foreseeable future be designed? Unfortunately, some designers lose their footing when it comes to projects with no concrete goal. For example, when one transcends the ostensibly unalterable laws of the market in order to create something new, the rules of dimensioning, proportion and the effective use of materials continue to apply – not to mention the rules of physics. Advanced Studies should also keep these rules in mind. They should at least contain a hint of technologies that exist or will be available in the near future. But then – and this is supported by this year's competition – designers may be able to actually influence the design environment of tomorrow.

Product
tubeBot
Rohrleitungsroboter
Pipe robot

Design
Ralf Kittmann
Jonathan Herrle
Berlin, Germany
Josef Niedermeier
München, Germany

Manufacturer
Kunsthochschule Weißensee
Berlin, Germany

tubeBot ist ein autonomer Wartungsroboter für Rohrleitungen städtischer Trinkwassersysteme. Durch das schnelle und unkomplizierte Aufspüren von Leckagen bei laufendem Betrieb wird der unzeitgemäße Wasserverlust in großen Städten deutlich reduziert. Dank seines intelligenten Funktionskonzepts, durch welches der vorhandene Druck in den Leitungen genutzt wird, kommt der tubeBot ohne zusätzliche Energie aus. Dieses neuartige saubere Prinzip sorgt für einen effizienteren Umgang mit der kostbaren Ressource Trinkwasser und spiegelt sich in der klaren Gestaltung des tubeBot wider.

tubeBot is an autonomous maintenance robot for urban drinking water piping systems. Due to the quick and easy detection of leakages during normal operation, the out-of-time water loss in large cities can be significantly reduced. Thanks to its intelligent functionality of using the existing pressure in the pipes, the tubeBot works without an additional energy supply. This completely new, clean concept ensures a more efficient management of water as a precious resource, which is also reflected by the clear design of the tubeBot.

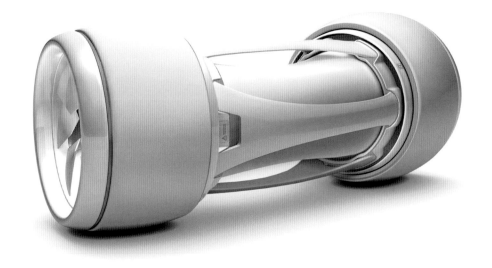

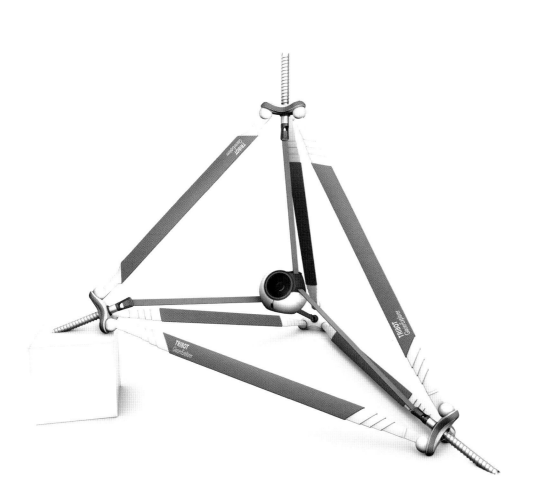

Product
triBot
Forschungsroboter
Research robot

Design
Ralf Kittmann
Jonathan Herrle
Berlin, Germany
Josef Niedermeier
München, Germany

Manufacturer
Kunsthochschule Weißensee
Berlin, Germany

triBot ist ein Forschungsroboter, der in extremen Umgebungen von Gletschern und Polarregionen Daten für Wissenschaft und Forschung sammelt. In Zeiten des Klimawandels rücken diese Regionen in den Fokus globaler Forschungsaktivitäten. Um in diesen Gegenden verlässlich zu agieren, ist ein hoch flexibles Bewegungsmuster notwendig. Dank der Tetraedergeometrie kennt der triBot kein Oben, Unten, Rechts und Links. Zur Fortbewegung werden die Seitenlängen des Tetraeders variiert, der Schwerpunkt verschiebt sich und der triBot kippt auf die Seite. Mit seiner hochspezialisierten Sensoreinheit sammelt der triBot wichtige Daten für künftige Klimamodelle.

triBot is a research robot which collects data for science and research in extreme environments such as glaciers and polar regions. In times of climate change these regions move into the focus of global research activities. In order to operate reliably in these areas, highly flexible movement patterns are necessary. Thanks to its tetrahedral geometry there is no up, down, left and right for the triBot. To move forward, the sides of the tetrahedron are varied, the balance point shifts and the triBot tilts to the side. With its highly specialized sensor unit the triBot collects important data for future climate models.

Product
MIRO
Medizinroboter
Medical robot

Design
Tilo Wüsthoff Industrial Design
München, Germany

Manufacturer
Deutsches Zentrum für Luft- und Raumfahrt
Wessling, Germany

MIRO ist ein Leichtbauroboter für den Einsatz in unterschiedlichen chirurgischen Aufgabenstellungen. Geringes Gewicht und kompakte Abmessungen erleichtern die Integration eines oder mehrerer Arme in die Platzverhältnisse im OP. Funktionsumfang und Leistungsdaten ermöglichen den Einsatz bei offener Chirurgie und bei minimalinvasiven Operationstechniken wie der endoskopischen Herzchirurgie. Das Erscheinungsbild erlaubt die eindeutige Positionierung von MIRO als Medizingerät. Umlaufende Linien zeigen Präzision und Dynamik. Gelenke und ihre Bewegungsrichtungen werden hervorgehoben und erlauben eine intuitive Bedienung des Roboters.

MIRO is a light-weight robot for the application in various surgical procedures. Low weight and compact dimensions simplify the integration of one or more robot arms into the operating room where space is sparse. MIRO's features and performance allow applications in open surgery as well as minimally invasive surgical procedures like endoscope heart surgery. MIRO's design language explicitly displays qualities of a medical instrument. Circulating edges express precision and dynamics. They emphasize the joints and their direction of motion, allowing intuitive handling of the robot.

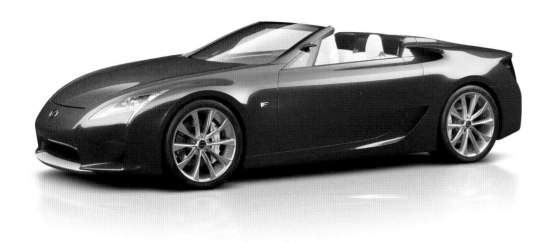

Product
LF-A
Premium-Auto
Super car

Design
TOYOTA MOTOR CORPORATION
Toyota City, Aichi, Japan

Manufacturer
TOYOTA MOTOR CORPORATION
Toyota City, Aichi, Japan

Lexus strebt mit „L-Finesse" nach neuen Werten im Premium-Design – inspiriert von japanischer Ästhetik mit ihrem Kontrast zwischen der Reinheit prägnanter Einfachheit und der Tiefe faszinierender Eleganz. Der LF-A steht für ein grundlegend neues Design von Premium-Fahrzeugen. Die dynamische Formsprache gemeißelter Kurven und fließender Linien vereint sich mit faszinierender, aus Formkontrasten entstehender Tiefe. Die innovative Anordnung großer Bauteile sorgt für optimale Gewichtsbalance und Stabilität, was bei schneller Fahrt entscheidend ist. Gleichzeitig entstand eine Silhouette mit einzigartigen Proportionen.

Lexus seeks to create an entirely new value in premium design through "L-finesse", which draws from Japanese aesthetic values based on the visual contrast between the purity of "incisive simplicity" and the depth of "intriguing elegance". The LF-A marks a fundamental shift in super car design. Sculpted curves and fluid lines make a dynamic statement together with fascinating depth arising from the contrasting forms. By taking an entirely new approach to the positioning of major components, the LF-A has achieved the optimum weight balance so vital to high-speed handling and stability as well as defining a unique proportion and silhouette.

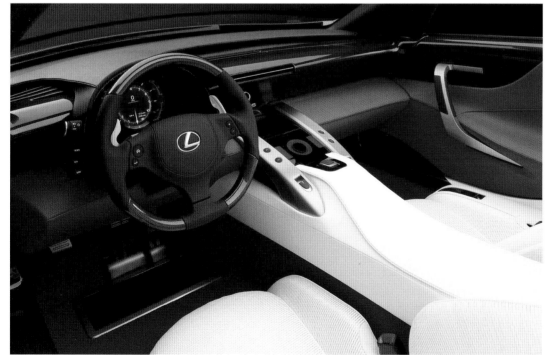

Product
Premium Attitude
Konzeptfahrzeug
Concept car

Design
Faurecia Design Studio France
Andreas Wlasak, Sebastien Jesus, Julien Beauregard,
Cedric Habert, Nicolas Pegorier, Jean Paul Herlem,
Frederic Poisson, Samira Raschke
Nanterre cedex, France
Faurecia Design Studio Germany
Thorsten Süß, Axel Werner, Markus Uhlig,
Julien Seiller, Martin Schulz,
Karl Wingert, Frederick Bois
Hagenbach, Germany
Faurecia Design Studio USA
Rob Fitzpatrick
Auburn Hills, Mi, United States of America

Manufacturer
Faurecia Group
Nanterre cedex, France

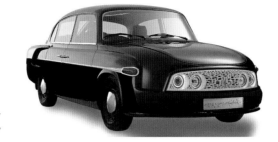
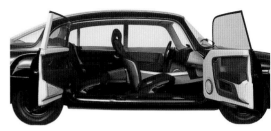

Das Konzeptfahrzeug Premium Attitude bietet aus-
gewählte Innovationen für den Fahrzeuginnenraum.
Automobilhersteller können diese Innovationen be-
reits in der nächsten Fahrzeuggeneration einsetzen.
Premium Attitude ist mehr als ein Konzept, es ist Re-
alität. Faurecia demonstriert hier seine Fähigkeit, De-
signinnovationen zu entwickeln und – kombiniert mit
realisierbaren technischen Lösungen – in ein Fahrzeug
zu integrieren. Faurecia präsentiert die Design- und
Technologiekompetenz in seinen sechs Produktlinien
ganz bewusst in einem kompletten Konzeptfahrzeug,
sodass für den Kunden ein schlüssiger Gesamtein-
druck entsteht.

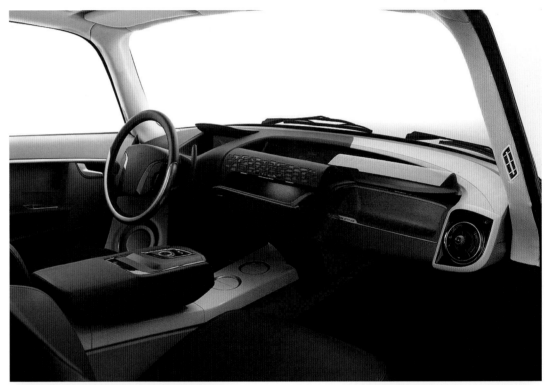

Faurecia's Premium Attitude concept car reveals the
next generation of interior innovations available to
automakers. Premium Attitude displays Faurecia's abil-
ity to create new design innovations and to integrate
them into highly feasible engineering solutions within
one car. The Premium Attitude concept is aimed at
starting new dialogue with automakers' design, prod-
uct planning and senior management departments
before new vehicle projects are started. By present-
ing a full vehicle concept, Faurecia demonstrates its
design and engineering expertise across six product
lines in a vehicle environment, as the end-user would
experience it.

Product
MILA Alpin
Konzeptfahrzeug
Concept car

Design
MAGNA STEYR Fahrzeugtechnik AG & Co. KG
Tim Doherty, Andreas Wolfsgruber
Graz, Austria

Manufacturer
MAGNA STEYR Fahrzeugtechnik AG & Co. KG
Graz, Austria

Erstmalig präsentiert anlässlich des Genfer Automobilsalons 2008. Beim MILA Alpin handelt es sich um einen kompakten Offroader mit alternativen Antriebsmöglichkeiten. Die Formensprache des MILA Alpin sorgt für eine ansprechende Optik – mit Anleihen aus der Natur, klar wie Fels und Eis. Seine einzigartige Konfiguration macht ihn zu einem Fahrzeug, das sich durch absolute Geländetauglichkeit und hervorragende Schlechtwegeigenschaften auszeichnet. Damit eignet er sich als Freizeitfahrzeug genauso wie als Nutzfahrzeug für spezielle Einsatzzwecke.

Premiered at Geneva Motorshow 2008. An extremely capable and compact off-roader, MILA Alpin takes its design language and color scheme from the mountain rock and ice of the Alps; the scenario for which the car was created. The detailing takes its inspiration from technical equipment used in the mountain environment. Its unique configuration makes the MILA Alpin a vehicle which stands out because of its excellent all-terrain capability and outstanding rough road characteristics. The exceptional handling makes the MILA Alpin great fun to drive on the road too.

Product
The Cube
Fernbedienung
Remote controller

Design
Hyundai Engineering & Construction
Seuli-Ki Park, Su-Jung Kim
Seoul, South Korea

Manufacturer
Hyundai Engineering & Construction
Seoul, South Korea

In einem modernen Haushalt befinden sich zahlreiche Fernbedienungen. Hier haben wir es mit einer intelligenten Fernbedienung zu tun, die viele andere in sich vereinigt – einfach, intuitiv und reaktionsschnell. Sie steuert Lampen und andere Geräte über Bluetooth und erkennt neue Geräte in Echtzeit. Einsetzbar ist sie für Stereoanlagen, Heizungen und vieles mehr. Wenn Sie von Zimmer zu Zimmer gehen, überträgt jeder neue Raum seine spezifischen Funktionen via Bluetooth auf das Gerät. Die jeweils verfügbaren Funktionen werden auf dem Display anzeigt.

There are many remote controllers in the modern house. This design is for a smart remote controller which integrates various other remote controllers. It is simplified, intuitive and responsive. It can control lighting fixtures and other devices by Bluetooth, recognizing new devices in real time when they are added to a room. This feature applies to stereo systems, heaters etc. When you go from one room to another, each room transfers its available functions to the remote controller through Bluetooth and the remote controller shows the changed functions on the display.

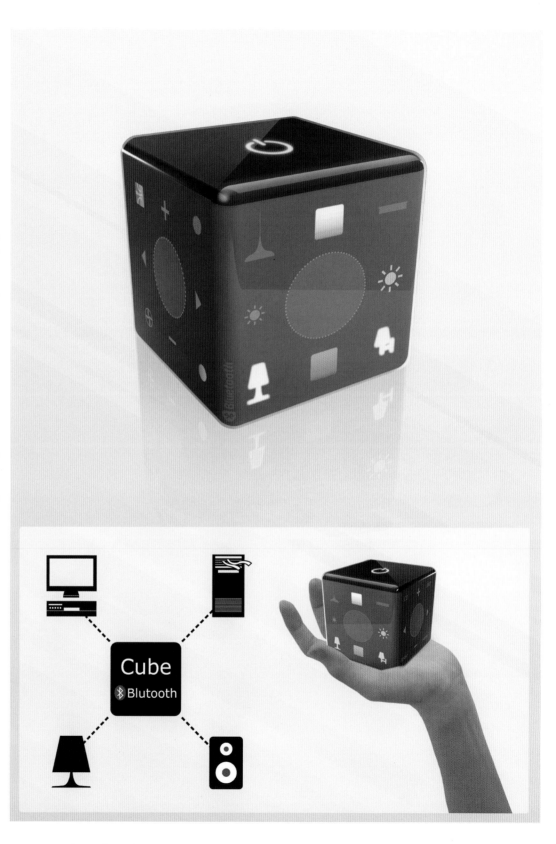

Product
Lighting Controller
Lichtschalter
Switch

Design
Hyundai Engineering & Construction
Kim Su-Jung, Park Seul-Ki
Seoul, South Korea

Manufacturer
Hyundai Engineering & Construction
Seoul, South Korea

Haben Sie vor lauter Lichtschaltern Probleme, den richtigen zu finden? Bei Präsentationen, Konferenzen oder Vorlesungen wird auf der Suche nach dem richtigen Schalter zwangsläufig immer wieder das Licht an- und ausgeschaltet. Gibt es denn keine Möglichkeit, Zeit und Strom zu sparen – und sich nicht zu blamieren? Dieses neue Schaltersystem zeigt separate Beleuchtungsgruppen mit jeweils unterschiedlichen Farben an. Sie müssen nur Ihre Position auf dem Bildschirm orten und die ein- oder auszuschaltende Gruppe auswählen. Sollen mehrere Beleuchtungsgruppen bedient werden, ist dieses System allen anderen überlegen.

Overwhelmed by the number of light switches when trying to find the right one? In presentation, conference or lecture facilities, we make a lot of mistakes as we inevitably keep turning on and off the lights to see which switch is the right one. Isn't there any way to save time and electricity, and probably save face too? This new switch system shows divided lighting groups with different colors for each group. Just check your location on the screen, and choose the group you want to turn on or off. If you want to turn on several lighting groups, this system is more useful than others.

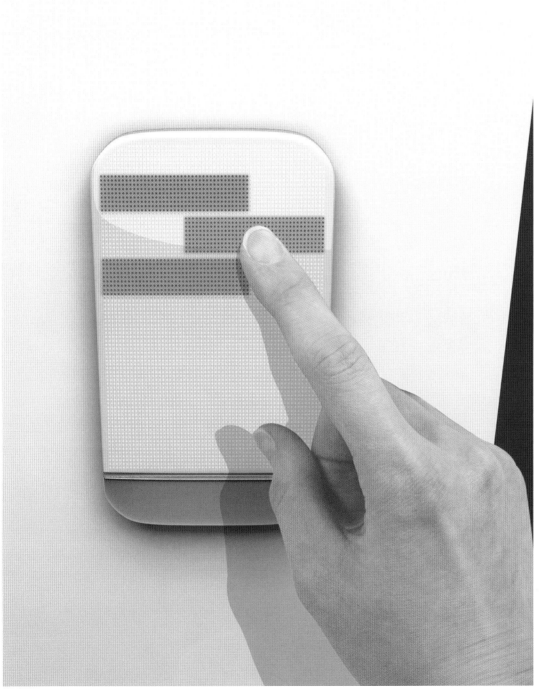

Product
Sognare
Solarbetriebene Musiklaube
Solar music pergola

Design
Hyundai Engineering & Construction
Song-Young You
Seoul, South Korea

Manufacturer
Hyundai Engineering & Construction
Seoul, South Korea

Die solarbetriebene Musiklaube ist eine Kombination aus einer Bank und einer mit Sonnenenergie betriebenen Musikanlage – ein Platz zum Ausruhen und Musikhören in Einem. Bei der Entwicklung standen Umweltschutz und Energieeinsparung im Vordergrund. Die sparsamen LED-Lichter werden durch eine Solarzelle gespeist, die tagsüber Sonnenenergie speichert und nachts über einen Sensor automatisch Licht erzeugt. Die schlichten Linien des floralen Designs harmonieren mit der Umwelt. Mit diesem sinnvollen Produkt kann man sich seine Lieblingsmusik je nach Zeit, Wetter und Jahreszeit bequem online aussuchen.

The solar music pergola is a combination of a bench and music center using solar power. It offers a space to take a rest and listen to music at the same time. An environmental design and reduced energy consumption were both considered. With LED lights, we can save energy by using a solar cell which collects solar energy during the daytime and automatically generates light at night using a sensor. It is composed of simple lines and design elements motivated by flowers and nature, harmonizing with the environment. It´s a sensibly designed product, allowing people to select their favorite music online according to the time, weather and seasons.

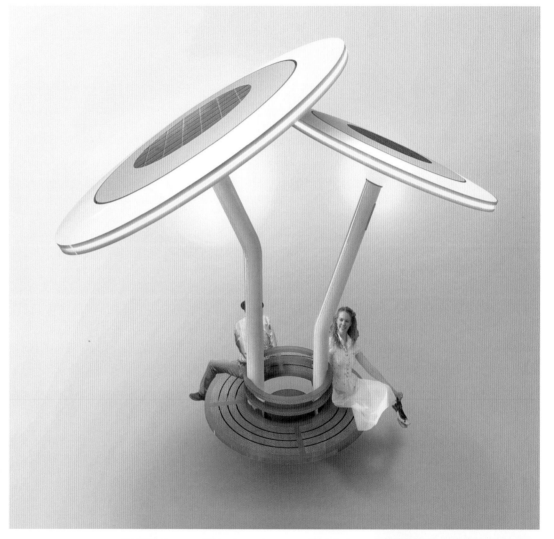

Product
OLPC XOXO
Laptop und Computer
Laptop and computer

Design
One Laptop per Child
Concept- Nicholas Negroponte
Cambridge, MA, United States of America
fuseproject
Yves Behar, Bret Recor
San Francisco, CA, United States of America

Das Hauptanliegen des OLPC XOXO ist es, das Lernen zu fördern und den Preis für Laptops zu reduzieren, so dass sich auch Entwicklungsländer Massenankäufe leisten können. Der XOXO-Laptop im Buchformat ist ca. halb so groß wie das erste Gerät. Das neue Design ist leichter, so dass auch Kinder es überallhin mitnehmen können. Das Dual-Mode-Display mit zwei Touchscreens optimiert das E-Book-Erlebnis. Das Design sieht im vertikalen Format eine rechte und eine linke Seite vor. Horizontal ergibt sich ein aufklappbarer Laptop und eine flache, über zwei Bildschirme durchgehende Oberfläche, die wie eine Tafel verwendet werden kann.

The primary goal of the OLPC XOXO is to advance learning as well as driving down the cost of laptops so that it is affordable for volume purchases by developing nations. The XOXO laptop will be about half the size of the first device and will approximate the size of a book. The new design is lighter and easier for children to carry with them wherever they go. Dual touch-sensitive displays will be used to enhance the e-book experience with a dual-mode display. The design provides a right and left page in vertical format, a hinged laptop in horizontal format, and a flat two-screen wide continuous surface that can be used in tablet mode.

Product
AURORA H1000
Wasserkanone mit wasserbetriebener Beleuchtung
Fire hydrant with fluid-driving lighting

Design
DUCK IMAGE CO., Ltd.
Ta-Wei Chien, Yien-Bo Chen, Shih-Cheng Lin,
Hung Cheng, Mei-Yi Chiang
Hsinchu, Taiwan
Industrial Technology Research Institute
Jung-Huang Liao
Chutung, Hsinchu, Taiwan

Manufacturer
Industrial Technology Research Institute
Chutung, Hsinchu, Taiwan

Feuerwehrmänner haben häufig das Problem, dass sich in einem brennenden Gebäude keine Lichter anschalten lassen, da das Feuer den Stromkreis unterbrochen hat. Die AURORA H1000-Wasserkanone ist mit einer Lichtquelle ausgestattet, die durch das aus der Kanone austretende Wasser angetrieben wird. Das herausströmende Wasser treibt eine Miniturbine an, die Elektrizität erzeugt. Dies aktiviert ein äußerst helles LED-Licht, mit dem Feuerwehrmänner den Ort des Einsatzes mit zusätzlichem Licht erhellen können. Dadurch wird die Sicherheit der Feuerwehrmänner erhöht und das Feuer lässt sich noch effizienter bekämpfen. Außerdem zeigt der Lichtstrahl den Menschen, die aus dem Feuer flüchten, den Weg zu den Rettungskräften.

When fighting fires, firemen often come across buildings whose lights cannot be switched on because the fire has disrupted the power supply. The AURORA H1000 fire hydrant combines a lighting technology driven by liquid with the nozzle. When the water flow is turned on, it powers turbine blades to create electricity. This lights up a high brightness LED, providing the scene of the fire with additional light, increasing the safety of the firemen and boosting their fire fighting efficiency. Furthermore, the light beam points the way towards the rescue workers for people escaping the fire.

Product
DH-01
Digitale Richtungshupe
Digital directional horn

Design
DUCK IMAGE CO., Ltd.
Ta-Wei Chien, Yien-Bo Chen,
Chung-Hsuan Wang, Mei-Yi Chiang
Hsinchu, Taiwan
Industrial Technology Research Institute
Jung-Huang Liao
Chutung, Hsinchu, Taiwan

Manufacturer
Industrial Technology Research Institute
Chutung, Hsinchu, Taiwan

In Zukunft werden Steuerräder im Auto mit digitalen Technologien, z. B. dieser berührsensiblen Oberfläche mit personalisiertem visuellem Design, ausgestattet werden. Fahrer erhalten damit eine noch bessere Übersicht über Fahrtinformationen und die Umgebung. Mit einer digitalen Richtungshupe kann das Hupsignal in eine bestimmte Richtung und über eine bestimmte Entfernung ausgegeben werden, um Insassen und nicht betroffene Verkehrsteilnehmer nicht unnötig zu stören. Das System stellt nicht nur einen Beitrag zur Verringerung der Lärmbelästigung dar, sondern erhöht auch die Sicherheit beim Fahren. Integriert wurden drei weiterentwickelte Technologien: Hecksicherung mit interaktivem Anschluss, Widerstandsdruck-Bedienfeld und digital ausgerichtete Hupe.

The future steering wheel is integrated by new technologies, which is operated with interactive touch interface by projective and personalized visual design. It makes driver easier to control the driving information and environment. Evolutional digital directional horn system could shoot alarm sound to a specific direction and distance without disturbing other passengers or vehicles. The system doesn't only prevent noisy pollution, but also improve the driving safety substantially. It is integrated by three advanced technologies as following: rear-projection interactive interface, resistance-pressured touch panel and digital directional horn.

Product
N1
MP3 Spieler
MP3 player

Design
Reigncom Limited
Yeongkyu Yoo, Minjung Kim, Semin Jun
Seoul, South Korea

Manufacturer
Reigncom Limited
Seoul, South Korea

Das N1 bietet auf eine lustige und interessante Weise
an, Musik zu hören. Die neue Anwenderkopplung ba-
siert auf bevorzugte Bedienungsanwendungen wie
pusten, klopfen, schütteln und beugen. Durch G-Sen-
sor erkennt das N1 jede Bewegung wieder zum „Ein-
schalten", „Ausschalten", „Wiedergabe", „Auswählen
der Musik" oder „Sprachaufnahme" und führt die
entsprechende Funktion aus. Das N1 besteht aus zwei
Teilen: Spieler und Lautsprecher. Wenn sie miteinander
verbunden sind, ahmen sie einen alten Plattenspieler
nach.

The N1 introduces a fun and interesting way to listen
to your music. Its user interface is based on the user's
previous actions such as blowing, knocking, shaking,
and bending. Liberally utilizing the G-sensor, N1 rec-
ognizes your motions to power itself on and off, or
to play a song, or to start the voice recorder. The N1
comes in two units – he player unit and the speaker
unit. When the two units are combined they mimic
an old gramophone.

Product
Design Probe
Biosphärische Landwirtschaft
Biosphere home farming

Design
Philips Design
Design Team
Eindhoven, The Netherlands

Manufacturer
Philips Design
Eindhoven, The Netherlands

Das Konzept „Biosphere home farming" erzeugt Nahrungsmittel und Haushaltsgas durch Wasserfilterung. Es bereichert das familiäre Nahrungsangebot um täglich mehrere hundert erzeugte Kalorien an Fisch, Wurzelgemüse, Gräser, Pflanzen und Algen. Im Gegensatz zu konventionellen hydroponischen Gärten umfasst das System einen Methangasofen zur Erzeugung von Wärme und Gas zur Stromerzeugung. Die Algen produzieren Wasserstoff und das Wurzelgemüse Sauerstoff, der für die Versorgung der Fische genutzt wird. In die Pflanzen wird CO_2 gepumpt. Das System ist in sich abgeschlossen und verwandelt Abwasser sowie nicht verwertbare Haushaltsabfälle in essbare Nahrungsmittel.

The "Biosphere home farming" concept generates food and cooking gas, while filtering water. The concept supplements a families nutritional needs by generating several hundred calories a day in the form of fish, root vegetables, grasses, plants and algae. Unlike conventional hydroponic nurseries this system incorporates a methane digester than produces heat and gas to power lights, similarly algae produces hydrogen and the root plants produces oxygen, which is fed back to fish. CO_2 is pumped into the plants. It is a closed loop interdependent system. The system uses waste water and non-consumable household matter and delivers food in return.

Product
Deodr
Kleider-Auffrischer
Clothes freshener

Design
Scenario Lab
Wu Kun-chia
Jhudong Township, Hsinchu County, Taiwan

Manufacturer
Chung-shan Institute of Science & Technology
Armament bureau, MND
Tao-Yuan, Taiwan

Deodr, eine Kombination aus fotokatalytischer Licht-röhre und Konvektionsgebläse, entfernt unange-nehme Gerüche aus Kleidern und lässt sie wieder frisch riechen – so kann man seine Sachen bequem auffrischen, ohne sie zu waschen. Der Verzicht auf Wasser und Waschmittel ist gut für Umwelt und Kleidung; das Auffrischen ist viel schonender als Waschen. Die Anwendung ist leicht: Man hängt die Kleider einfach in den Schirm und stellt das Steuer-gerät auf Start. Alle unangenehmen Gerüche wie z. B. Parfümrückstände sind im Nu verschwunden. Deodr entfernt jedoch nur Gerüche; zur Fleckentfer-nung ist Waschen unumgänglich.

Offering a convenient way to freshen up clothes with-out washing them, Deodr combines the effects of a photocatalyst light tube and fan-induced convection to remove unpleasant smells from clothes and make them smell fresh. Avoiding the use of water and laun-dry detergent has benefits for the environment as well as the clothes. This freshening process is much more gentle on fabrics than washing. Using Deodr is easy. Just hang the clothes within the lampshade and set the controller to start. Any unpleasant smells, such as perfume residue, will be removed quickly. While Deodr will remove odors, washing is still required for stain removal.

Product
TOYOTA i-REAL
Individuelle Mobilität
Personal mobility

Design
TOYOTA MOTOR CORPORATION
Toyota City, Aichi, Japan

Manufacturer
TOYOTA MOTOR CORPORATION
Toyota City, Aichi, Japan

TOYOTA i-REAL steht nach PM, i-unit und i-swing für die nächste Phase von Toyotas Personal Mobility – urbaner, emissionsfreier Fortbewegung. Der Name „REAL" deutet an, dass wir auf eine baldige Serienfertigung hoffen. Die originelle Vermählung von Mobilität mit modernster Robotertechnik im kompakten Gehäuse ist echt japanisch. Bei langsamer Fahrt verkürzt sich der Radstand, und man kann zwischen den Fußgängern auf Augenhöhe bei einem Minimum an Platzbedarf hindurchmanövrieren. Fährt man schneller, verlängert sich der Radstand, was durch einen niedrigeren Schwerpunkt für bessere Fahreigenschaften sorgt.

TOYOTA i-REAL represents the next stage of Toyota's personal mobility development with zero-emission urban transportation following the PM, i-unit and TOYOTA i-swing. The name "REAL" symbolizes our hope for commercialization in the near future. TOYOTA i-REAL is the realization of Japanese originality, through the harmonization of mobility and state-of-the-art robotics in a compact body. In low-speed mode, the wheelbase shortens to allow it to maneuver naturally among pedestrians, at eye level within a minimum space. In high-speed mode, the wheelbase lengthens to provide a lower center of gravity and better driving performance.

Product
GREENKITCHEN
Entwicklungskonzept
Design concept

Design
Whirlpool Corporation
European Design Team
Varese/Biandronno, Italy

Manufacturer
Whirlpool Corporation
Varese/Biandronno, Italy

GREENKITCHEN ist das neue Konzept der Whirlpool Corporation. Durch bewusstes, nachhaltiges Nutzerverhalten ermöglicht es eine Reduzierung der Energiekosten um bis zu 70%. Revolutionär ist die Vernetzung von Geräten zur optimalen Energie- und Ressourcennutzung. GREENKITCHEN passt an, reduziert und recycelt; verbraucht wird nur, was gebraucht wird. Die Nachbildung natürlicher Kreisläufe reduziert Abfall und optimiert Ressourcen. Die Verbindung von organischen Formen, Beleuchtung, Klängen und interaktiven Elementen schafft ein System überlegter und intelligenter Anwendungen in einem sorgsam gestalteten Umfeld.

GREENKITCHEN is the latest design concept from Whirlpool Corporation. It offers an informed user experience for sustainable living and savings of up to 70% on energy bills. Its real innovation is the linking of products as networked solutions which optimize energy and resources. GREENKITCHEN adapts, reduces and recycles, using only what is needed. Adapting to the environment, it reduces waste and optimizes resources, recreating cycles of nature in kitchen processes. It combines organic forms, lighting, sound and interactive elements to offer a system of discreet and intelligent appliances in a sensitively landscaped environment.

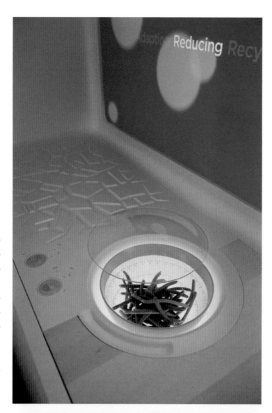

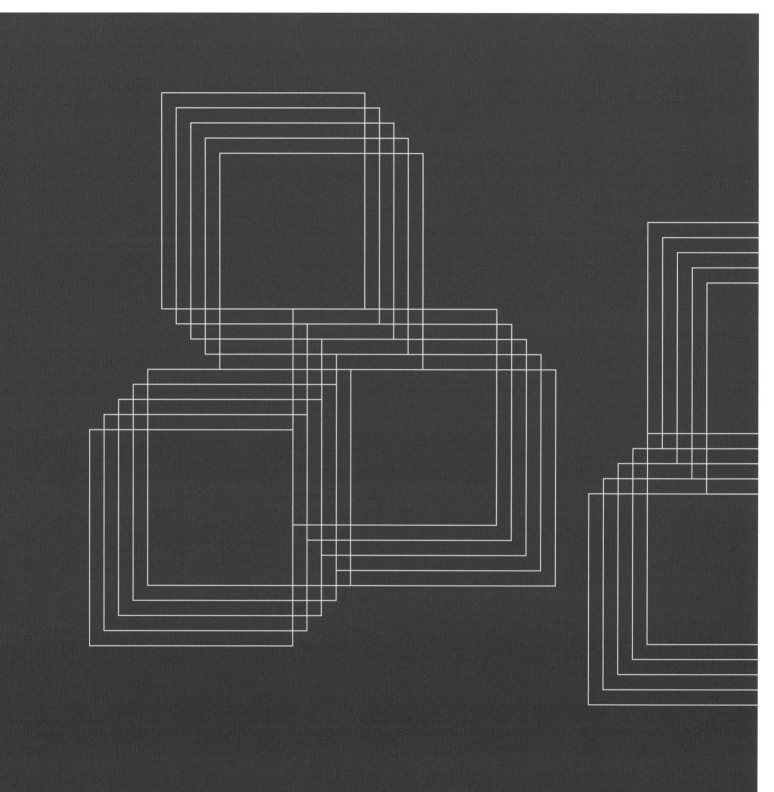

iF Industrie Forum Design e.V.
List of iF e.V. Members
Article of Association

iF Industrie Forum Design e.V. Members

Vorstände / Board

1. Ernst Raue, Deutsche Messe AG,
 1. Vorsitzender / Chairman iF Hannover
2. Norbert Bargmann, Messe München GmbH,
 München
3. Christoph Böninger, brains4design GmbH,
 München
4. Prof. Fritz Frenkler, f / p design GmbH,
 München
5. Ralph Wiegmann, iF Hannover,
 Geschäftsführendes Vorstandsmitglied /
 Executive Member of the Board, Hannover

Geschäftsführender Vorstand / Managing Director

Ralph Wiegmann, iF Hannover

Ehrenmitglieder / Honorary Members

1. Knut Bliesener, Hannover
2. Sepp D. Heckmann, Hannover
3. Karl-Heinz Krug, Düsseldorf
4. Prof. H. Lindinger, Hannover
5. Herbert H. Schultes, Fürstenfeldbruck

Firmenmitglieder / Corporate members

AL-KO Geräte GmbH	Ichenhauserstraße 14	89359	Kötz
ARGUZ GmbH publishing	Mittelstraße 50	33602	Bielefeld
Ars Nova Collection	Salzstraße 10	49326	Melle
Artemide GmbH	Hans-Böckler-Straße 2	58730	Fröndenberg
B / S / H Bosch und Siemens Hausgeräte GmbH	Carl-Wery-Straße 34	81793	München
BASF SE	G-KTS/EPD-H 612	67056	Ludwigshafen
BEGA Gantenbrink-Leuchten	Hennenbusch 1	58708	Menden
BEST COMPANY VIDEO GmbH	Boulevard der EU 7	30539	Hannover
BMW AG	Knorrstraße 147	80788	München
Braun GmbH	Frankfurter Straße 145	61476	Kronberg
BREE Collection GmbH & Co. KG	Gerberstraße 3	30916	Isernhagen
Carpet Concept	Bunzlauer Straße 7	33719	Bielefeld
ClassiCon GmbH	Sigmund-Riefler-Bogen 3	81829	München
Crown Gabelstapler GmbH & Co. KG	Moosacher Straße 52	80809	München
Daimler AG	Werk 059, HPC X800	71059	Sindelfingen
design report – Blue C. Verlag	Ernst-Mey-Straße 8	70771	Leinfelden-Echterdingen
designafairs GmbH	Rosenheimer Straße 145 b / EG	81671	München
Deutsche Messe AG	Messegelände	30521	Hannover
Die Neue Sammlung, Pinakothek der Moderne	Türkenstraße 15	80333	München
EnBW AG	Durlacher Allee 93	76131	Karlsruhe
EnBW AG	Durlacher Allee 93	76131	Karlsruhe
F. W. OVENTROP GmbH & Co. KG	Paul-Oventrop-Straße 1	59939	Olsberg
FESTO AG & Co. KG	Ruiter Straße 82	73734	Esslingen
GEZE GmbH	Reinhold-Vöster-Straße 21–29	71229	Leonberg
GHM Gesellschaft für Handwerksmessen GmbH	Willy-Brandt-Allee 1	81829	München
Gira Giersiepen GmbH & Co. KG	Dahlienstraße	42477	Radevormwald

Grohe AG	Feldmühleplatz 15	40545	Düsseldorf
häfelinger + wagner design gmbh	Türkenstraße 55–57	80799	München
Hansgrohe AG	Auestraße 5–9	77761	Schiltach
HBK Braunschweig	Johannes-Selenka-Platz 1	38118	Braunschweig
Heidelberger Druckmaschinen AG	Kurfürsten-Anlage 52–60	69115	Heidelberg
HEWI Heinrich Wilke GmbH	Postfach 1260	34442	Bad Arolsen
Hiller Objektmöbel GmbH & Co. KG	Kippenheimer Straße 6	77971	Kippenheim
IBM Deutschland GmbH	Pascalstraße 100	70569	Stuttgart
iF International Forum Design GmbH	Messegelände	30521	Hannover
Interstuhl Büromöbel GmbH & Co. KG	Brühlstraße 21	72469	Meßstetten-Tieringen
Isaria Corporate Design AG	Gewerbepark Aich 7–9	85667	Oberpframmern
JAB Teppiche Heinz Anstoetz KG	Dammheider Straße 67	32052	Herford
Kermi GmbH	Pankofen-Bahnhof 1	94447	Plattling
Kochan & Partner GmbH	Hirschgartenallee 25	80639	München
Köttermann GmbH & Co. KG	Industriestraße 2–10	31311	Uetze
LOEWE OPTA GmbH	Industriestraße 11	96317	Kronach
Merten GmbH	Fritz-Kotz-Straße 8	51674	Wiehl
Messe München GmbH	Messegelände	81823	München
Niedersächsisches Ministerium für Wirtschaft, Technologie u. Verkehr	Friedrichswall 1	30159	Hannover
Nils Holger Moormann GmbH	An der Festhalle 2	83229	Aschau
OCTANORM-Vertriebs-GmbH	Raiffeisenstraße 39	70794	Filderstadt
Panasonic Design Company	1–15 Matsuo-cho		Kadoma-city, Osaka 571-8504
Patentanwalt European Design Attorney	Flüggenstraße 13	80639	München
Philips GmbH	Lübeckertordamm 5	20099	Hamburg
Poggenpohl Möbelwerke GmbH	Poggenpohl Straße 1	32051	Herford
PRODESIGN	Turmstraße 39	89231	Neu-Ulm
RITTO GmbH	Rodenbacher Straße 15	35708	Haiger
Sedus Stoll AG	Brückenstraße 15	79761	Waldshut-Tiengen
Seibel Designpartner GmbH	Industriestraße 5	40822	Mettmann
Sennheiser electronic GmbH & Co. KG	Am Labor 1	30900	Wedemark
Siemens AG	Wittelsbacherplatz 2	80333	München
Sony Ericsson Mobile Communications AB		SE-221 88	Lund
Steelcase Werndl AG	Georg-Aicher-Straße 7	83026	Rosenheim
Storck Bicycle GmbH	Carl-Zeiss-Straße 4	65520	Bad Camberg
TRILUX GmbH + Co. KG	Heidestraße 4	59759	Arnsberg
TROIKA domovari GmbH	Nisterfeld 11	57629	Müschenbach
Viessmann Werke GmbH Co. KG	Viessmannstraße 1	35108	Allendorf/Eder
Volkswagen AG	Brieffach 1701, Berliner Ring 2	38436	Wolfsburg
wiege Entwicklungsgesellschaft GmbH	Hauptstraße 81	31848	Bad Münder
Wilkhahn	Fritz Hahne Straße 8	31848	Bad Münder
WINI Büromöbel GmbH & Co. KG	Auhagenstraße 79	31863	Coppenbrügge
wodtke GmbH	Rittweg 55–57	72070	Tübingen-Hirschau
Yokogawa Electric Corporation	2-9-32 naka-cho		Mushashino-shi, Tokyo, 180-8750
Zumtobel Lighting GmbH	Schweizer Straße 30	6850	Dornbirn

Designagenturen/Design studios or Designers

artcollin	Ickstattstraße 26/Rgb	80469	München
.molldesign	Turmgasse 7	73525	Schwäbisch Gmünd
B:SiGN Werbeagentur GmbH	Ellernstraße 36	30175	Hannover
bgp design/Braake Grobe Partnerschaft	Lindenstraße 10	70563	Stuttgart
brains4design GmbH	Sandstraße 33	80335	München
brodbeck design	Schillerstraße 40 c	80336	München
DDC Deutscher Designer Club e. V.	Leerbachstraße 57	60322	Frankfurt am Main
D'ART Visuelle Kommunikation GmbH	Adlerstraße 41	70199	Stuttgart
Design House co., Ltd	1F., No. 2, Alley 25, Lane 118, Wusing St., Sinyi District	R.O.C.110	Taipei
design studio hartmut s. engel	Monreposstraße 7	71634	Ludwigsburg
Design Tech	Zeppelinstraße 53	72119	Ammerbuch
designfunktion GmbH	Schleißheimer Straße 141	80797	München
DRWA Das Rudel Werbeagentur	Erbprinzenstraße 11	79098	Freiburg
Eda Event Design Agentur GmbH	Gut Mönchhof, Quettinger Straße 187	51381	Leverkusen
f/p design GmbH	Mauerkicherstraße 4	81679	München
fön,design_	Schiltachstraße 40	78713	Schramberg
Fuenfwerken Design AG	Taunusstraße 52	65183	Wiesbaden
GDC-Design	Krugstraße 12	90419	Nürnberg
GUTE GESELLSCHAFT FÜR STRATEGIE, DESIGN UND KOMMUNIKATION MBH	Grafenberger Allee 126	40237	Düsseldorf
H H Schultes Design Studio	Rodelbahnstraße 1	82256	Fürstenfeldbruck
i/i/d Institut für Integriertes Design	Am Speicher XI, Abtlg.7, Boden 3	28217	Bremen
identis GmbH	Bötzinger Straße 36	79111	Freiburg
INOID DesignGroup	Reutlingerstraße 114	70597	Stuttgart
Landschaftsarchitektin BDLA DWB	Bauerstraße 19	80796	München
MEDIADESIGN HOCHSCHULE FÜR DESIGN	Berg am Laim-Straße 47	81673	München
Meisterschule für Mode	Roßmarkt 15	80331	München
Network! Werbeagentur GmbH	Sandstraße 33	80335	München
Nova Design Co., Ltd.	Tower C, 8F, No. 96, Sec. 1, Xintai 5th Rd.	Xizh City	Taipei Country 221
OCO-Design O. K. Nüsse	An der Kleimannbrücke 79	48157	Münster
Olaf Hoffmann Industrial Design	Dachauer Straße 44 a	80355	München
Philips International BV Philips Design	Building HWD, Emmasingel 24	5600 MD	Eindhoven
Pilotfish GmbH	Schleissheimer Straße 6	80333	München
Polvan Design Ltd.	Cemil Topuzlu cad. 79/2 Caddebostan	34170	Istanbul
rahe+rahe design	Konsul-Smidt-Straße 8c	28217	Bremen
S + F Architektur + Design	Straße der Nationen 5, Expo-Park Ost	30539	Hannover
SAINT ELMO'S Multichannel Creativity	Kaulbachstraße 4	80539	München
SCHOLZ & VOLKMER GmbH	Schwalbacher Straße 76	65183	Wiesbaden
Strategy & Marketing Institute GmbH	Lange-Hop-Straße 19	30559	Hannover
Studio Laeis	Marienburger Straße 32	50968	Köln
Taipei Base Design Center	2Fl., 1. No. 49, Sec. 5, Chenggung Rd.,	114	Taipei
TRICON Design AG	Bahnhofstraße 26	72138	Kirchentellinsfurt

VDID/DDV	Markgrafenstraße 15	10969	Berlin
Weinberg & Ruf	Martinsstraße 5	70794	Filderstadt

Einzelmitglieder/Individual members

Andreas Gantenhammer	Meerbuscher Straße 64–78	40670	Meerbusch
Andreas Thierry	Arthur-Kutscher-Platz 1/VII	80802	München
Bibs Hosak-Robb	Mendelssohnstraße 31	81245	München
Christoph Eschke	Admiralitätstraße 10	20459	Hamburg
Christoph Rohrer	Tölzerstraße 2c	81379	München
Dr. Helga Huskamp	Schlottnauerstraße 10	81541	München
Thomas Biswanger	Probierlweg 47	85049	Ingolstadt
Eberhard Schlegel	Am Kapellenweg 4	88525	Dürmentingen
Gabriel Weber	Orffstraße 35	80637	München
Gerd Bulthaup	Chamissostraße 1	81925	München
Hildegund Lichtwark	Pfarrer-Linzbach-Straße 1	52388	Nörvenich
Jiro Katsuta	Elsternweg 46	47804	Krefeld
Josef Hasberg	Lokenbach 8–10	51491	Overath
Michael Grüter	Hainholzstraße 17	31158	Hagenburg
Nenad Dordevic	Türkenstraße 103	80799	München
Peter Hartmann	Fasaneriestraße 10	80636	München
Prof. Gunnar Spellmeyer	c/o Fachhochschule Hannover Expo Plaza 2	30539	Hannover
Prof. Martin Topel	Fuhlrottstraße 10, Gebäude I, Ebene 16, Raum 76	42119	Wuppertal
Sebastian Le Peetz	Osterstraße 43 a	30159	Hannover
Thomas Bade	Im Knick 9	31655	Stadthagen

Satzung des Vereins „iF – Industrie Forum Design e.V."

§ 1 Name und Sitz des Vereins

1. Der Verein trägt den Namen „iF – Industrie Forum Design e.V.".
2. iF – Industrie Forum Design ist im Vereinsregister eingetragen.
3. Der Verein hat seinen Sitz in Hannover.

§ 2 Zweck des Vereins

Der Verein verfolgt den Zweck der Förderung und Akzeptanz von Design als Teil der Wertschöpfungskette und als kulturelles Element der Gesellschaft. Die bewusste Gestaltung von Produkten und Lebensräumen für den privaten und öffentlichen Bereich sowie von benutzerfreundlichen Softwareanwendungen betrachtet der Verein als seine gesellschaftspolitische und kulturelle Aufgabe. Vereinsziele sind:

1. Die Anerkennung der Designleistung zur Erreichung von Unternehmenszielen und zur Sicherung von wirtschaftlichem Erfolg;
2. Die Organisation von Wettbewerben, Ausstellungen, Konferenzen, Vortragsveranstaltungen und weiteren Aktivitäten;
3. Die Veröffentlichung von Publikationen als Grundlage für Diskussionen;
4. Die Stärkung des Bewusstseins für Design in der Öffentlichkeit;
5. Das Angebot eines Forums zur Kommunikation auf neutraler Ebene;
Der Verein ist mit seinen Aktivitäten regional, national und international präsent.

§ 3 Geschäftsjahr

Das Geschäftsjahr ist das Kalenderjahr.

§ 4 Mitgliedschaft

1. Jede natürliche oder juristische Person kann Mitglied im iF e.V. werden. Der schriftliche Aufnahmeantrag wird von der Geschäftsführung geprüft und von ihr entschieden – in Zweifelsfällen beschließt der Vorstand mit einfacher Mehrheit über die Aufnahme des Mitglieds. Die Ablehnung der Aufnahme braucht nicht begründet zu werden.
2. Der Verein hat neben Mitgliedern auch Ehrenmitglieder. Ehrenmitglieder sind Persönlichkeiten, die sich im besonderen Maße um die Förderung und das Ansehen des „iF – Industrie Forum Design e.V." Verdienste erworben haben. Sie können durch einstimmigen Beschluss der Mitgliederversammlung zu Ehrenmitgliedern ernannt werden und haben in der Mitgliederversammlung kein Stimmrecht.
3. Die Mitgliedschaft endet durch
a) Austritt, der dem Verein gegenüber zu erklären ist. Der Austritt kann nur durch schriftliche Erklärung zum Ende eines jeden Geschäftsjahres mit dreimonatiger Frist erklärt werden,
b) Ausschluss aus dem Verein, über den der Vorstand einstimmig beschließt,
c) Tod eines Mitglieds.

§ 5 Organe

Die Organe des Vereins sind:

1. die Mitgliederversammlung
2. der Vorstand
3. die Geschäftsführung

§ 6 Mitgliederversammlung

1. Die Mitgliederversammlung ist zuständig für:
a) Entgegennahme des Jahresberichts des Vorstandes und des Berichts der Rechnungsprüfer,
b) Wahl des Vorstands,
c) Entlastung des Vorstands und der Geschäftsführung,
d) Satzungsänderungen,
e) Auflösung des Vereins,
f) Verwendung des Vermögens bei Auflösung des Vereins,
g) die Verwendung des jährlichen Gewinnvortrages bzw. die Behandlung eines Verlustes,
h) Entscheidung über neue Aktivitäten des Vereins,
i) Festsetzung des Jahresmitgliedsbeitrages,
j) Wahl der Ehrenmitglieder.
2. Jährlich ist eine ordentliche Mitgliederversammlung durchzuführen, zu der alle Mitglieder des Vereins eingeladen werden und in der insbesondere über das abgelaufene Geschäftsjahr, über den Rechnungsabschluss und das Ergebnis der Rechnungsprüfung zu berichten ist.
3. Die Mitgliederversammlung wird vom Vorsitzenden des Vorstandes mit einer Frist von mindestens einer Woche schriftlich unter Angabe der Tagesordnung einberufen. Die Tagesordnung der Mitgliederversammlung setzt der Vorsitzende des Vorstandes oder ein anderes von ihm benanntes Vorstandsmitglied fest. Anträge einzelner Mitglieder zur Tagesordnung können nachträglich auf die Tagesordnung gesetzt werden, wenn die Mitgliederversammlung es einstimmig beschließt.
4. Außerordentliche Mitgliederversammlungen können jederzeit vom Vorsitzenden des Vorstandes einberufen werden, wenn ein wichtiger Grund vorliegt. Die Einberufung muß erfolgen, wenn dies von mindestens $1/3$ der Mitglieder schriftlich beantragt wird. Die Einberufungsfrist beträgt 2 Tage. In Eilfällen können die Einladungen telefonisch oder per Fax erfolgen.
5. Die Mitgliederversammlung wird von dem Vorsitzenden des Vorstandes, im Falle seiner Verhinderung durch ein von ihm bestimmtes anderes Vorstandsmitglied geleitet.
6. Die ordnungsgemäß einberufene Mitgliederversammlung ist beschlussfähig, wenn außer dem Versammlungsleiter mindestens drei weitere stimmberechtigte Mitglieder anwesend sind.

7. Jedes Mitglied hat in der Mitgliederversammlung eine Stimme. Beschlüsse der Mitgliederversammlung werden mit einfacher Mehrheit der bei der Abstimmung anwesenden stimmberechtigten Mitglieder gefaßt, soweit diese Satzung nicht etwas anderes bestimmt. Ein Beschluss über die Verwendung des Gewinnvortrages bzw. die Behandlung eines Verlustes bedarf einer Mehrheit von 80% der bei der Abstimmung anwesenden stimmberechtigten Mitglieder. Stimmberechtigte Mitglieder können sich in der Mitgliederversammlung vertreten lassen, wobei auch die Übertragung des Stimmrechts auf den Vertreter zulässig ist. Bei Stimmengleichheit entscheidet die Stimme des Versammlungsleiters.

8. Eilbeschlüsse können im Umlaufverfahren schriftlich gefaßt werden.

9. Zu einem Beschluss über eine Änderung der Satzung ist eine Mehrheit von $3/4$ der Stimmen der erschienenen stimmberechtigten Mitglieder erforderlich.

10. Die gefaßten Beschlüsse werden in einem Protokoll erfasst, das vom Protokollführer und dem Leiter der Mitgliederversammlung unterschrieben werden muß. Jedem Mitglied ist eine Niederschrift des Protokolls der Mitgliederversammlung zuzustellen.

§ 7 Vorstand

1. Der Vorstand des Vereins besteht aus dem 1. Vorsitzenden sowie maximal sechs weiteren Mitgliedern. Die Vorstandsmitglieder werden von den Mitgliedern auf die Dauer von vier Jahren gewählt. Sie verbleiben bis zur Neuwahl im Amt. Die Wahlen können aus wichtigem Grund auf der Mitgliederversammlung widerrufen werden.

2. Der Verein wird gerichtlich und außergerichtlich im Rahmen des Vereinszwecks durch den 1. Vorsitzenden vertreten. Der 1. Vorsitzende ist berechtigt, für Einzelaufgaben Dritten Vollmacht zu erteilen.

3. Der Vorstand unterstützt die Geschäftsführung bei der Leitung des Vereins und beschließt über alle Vereinsangelegenheiten, soweit diese nicht der Mitgliederversammlung vorbehalten sind. Der Vorstand kann weitere zur Verwaltung des Vereins erforderlichen Personen wählen und entscheidet über sämtliche Einnahmen und Ausgaben des Vereins.

4. Über Aktivitäten besonderer Art und die Höhe der damit verbundenen Kosten beschließen nach Vorlage des Vorstandes die Mitglieder in der Mitgliederversammlung.

5. Die Mitgliederversammlung kann dem Vorstand eine Geschäftsordnung geben, nach der die Geschäfte des Vereins zu führen sind.

§ 8 Geschäftsführung

Der Vorstand bestellt eine Geschäftsführung. Diese führt die laufenden Aufgaben des Vereins nach Richtlinien des Vorstands durch. Sie ist auch zur Entscheidung über die Aufnahmeanträge der neuen Mitglieder bevollmächtigt. Die Geschäftsführung hat den Vorstand über alle Vereinsangelegenheiten von Bedeutung zu unterrichten. Sie ist an die Weisungen des Vorstandes gebunden und hat den Vorstand in allen wichtigen Angelegenheiten vorher zu konsultieren.

§ 9 Mitgliedsbeiträge

Der Jahresmitgliederbeitrag wird durch die Mitgliederversammlung bestimmt und staffelt sich zur Zeit wie folgt:

– Unternehmen: mindestens 600,– Euro
– Designer/Designbüros: mindestens 300,– Euro
– Privatpersonen: mindestens 150,– Euro

§ 10 Revision

Mit der Rechnungsprüfung wird die Revision der Deutsche Messe AG bzw. eine Wirtschaftsprüfungsgesellschaft beauftragt. Über das Revisionsergebnis ist in der ordentlichen Mitgliederversammlung zu berichten.

§ 11 Auflösung des Vereins

1. Ein Beschluss auf Auflösung des Vereins bedarf einer Mehrheit von $3/4$ der stimmberechtigten Mitglieder, wobei die Mitgliederversammlung nur beschlussfähig ist, wenn mindestens $2/3$ der stimmberechtigten Mitglieder anwesend sind.

2. Bei Auflösung oder Aufhebung des Vereins oder bei Wegfall des jetzigen Zwecks fällt das Vermögen, soweit es die eingezahlten Kapitalanteile der Mitglieder und den gemeinen Wert der von den Mitgliedern geleisteten Sacheinlagen übersteigt, an eine Körperschaft des öffentlichen Rechts zwecks Verwendung für kulturelle oder soziale Zwecke. Beschlüsse über die künftige Verwendung des Vermögens dürfen erst nach Einwilligung des Finanzamtes ausgeführt werden.

3. Die die Auflösung beschließende Mitgliederversammlung entscheidet über die Verwendung des Vereinsvermögens mit $3/4$ Mehrheit.

§ 12 Überschüsse, Ausgaben, Buchführung

1. Etwaige Gewinne des Vereins dürfen nur für steuerbegünstigte Zwecke der Satzung verwendet werden. Die Mitglieder erhalten keine Gewinnanteile und in ihrer Eigenschaft als Mitglieder auch keine sonstigen Zuwendungen aus Mitteln des Vereins.

2. Es darf keine Person durch Verwaltungsaufgaben, die dem Zweck des Vereins fremd sind, mittels unverhältnismäßig hoher Vergütungen begünstigt werden.

3. Der Nachweis für die Mittelverwendung ist durch eine ordnungsgemäße Buchführung zu gewährleisten.

Hannover, 5. Juni 2008

Ernst Raue
Vorsitzender

Articles of Association of "iF – Industrie Forum Design e.V."

Article 1. Name and registered office of the Association
1. The name of the Association is "iF – Industrie Forum Design e.V.".
2. iF – Industrie Forum Design is listed in the Register of Associations (Vereinsregister).
3. The Association's registered office is in Hannover, Germany.

Article 2. Object of the Association
The object of the Association is to support and gain acceptance for design as a link in the value chain and as a cultural component of society. The Association considers the targeted design of products, public and private living spaces, and user-friendly software applications as constituting its own civic and cultural mission. The Association aims to:
1. Recognize design achievements that help companies achieve their business goals and cement their economic success
2. Organize competitions, exhibitions, conferences, lectures, and other events
3. Issue publications to serve as the basis for discussions
4. Bolster the public's awareness of design
5. Provide a forum for objective dialogue on design-related issues.
The Association's activities give it a regional, national, and international presence.

Article 3. Financial year
The financial year corresponds to the calendar year.

Article 4. Membership
1. Any natural person or legal entity may become a member of the Association. Executive Management shall examine and decide on membership applications, which are to be submitted in writing. In cases where Executive Management is unsure, the Board of Management shall decide on whether to grant membership by means of a simple majority vote. The Association is not required to justify a negative decision on membership.
2. In addition to members, the Association also consists of honorary members.
Honorary members are individuals who have been particularly meritorious in their support of "iF – Industrie Forum Design". They may be elected to honorary membership by way of a unanimous resolution passed at the General Meeting. They are not entitled to vote at the General Meeting.

3. Membership shall end
a) Through resignation, which must be declared to the Association in writing. This declaration requires a minimum of three months' advance notice before the end of the financial year, and takes effect at the end of the financial year.

b) By way of expulsion upon a unanimous resolution by the Board of Management.
c) At the time of a member's death.

Article 5. Official bodies
The Association's official bodies are:
1. The General Meeting
2. The Board of Management
3. Executive Management

Article 6. General Meeting
1. The General Meeting is responsible for:
a) Receiving the reports of the Board of Management and the independent auditors
b) Electing the Board of Management
c) Approving the actions of the Board of Management and the Executive Management
d) Changing the Articles of Association
e) Dissolving the Association
f) Using the Association's assets in the event that it should be dissolved
g) Using the annual profits or handling of any loss
h) Setting the annual membership fee
i) Electing honorary members
2. A regular General Meeting will be held annually. All members of the Association shall be invited to attend the General Meeting. The agenda of the regular General Meeting will, in particular, include reports on the preceding financial year, on the Association's financial statements, and on the results of the auditing of accounts.
3. General Meeting shall be called in writing by the Chairperson of the Board of Management, with a minimum of one week's advance notice and with such notice containing a meeting agenda. The agenda of the General Meeting is set by the Chairperson of the Board of Management or by another member of the Board of Management appointed by the Chairperson. Topics requested by individual members may be added to the agenda if the General Meeting gives its unanimous consent.
4. The Chairperson of the Board of Management may call an extraordinary General Meeting if an important reason exists for doing so. A meeting of this kind must be called if it has been requested in writing by at least one third of all members. Two day's advance notice is required. In urgent cases, invitations may be transmitted by telephone or fax.
5. General Meetings shall be presided over by the Chairperson of the Board of Management or, in the event that he or she should be prevented from doing so, by another member of the Board of Management appointed by the Chairperson.
6. A General Meeting that has been properly called has a quorum if, in addition to the individual presiding over the Meeting, at least three other members in possession of voting rights are present.

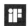

7. Each member has one vote at the General Meeting. Unless otherwise stipulated in these Articles, resolutions of the General Meeting shall be passed by way of a simple majority of those members present and entitled to vote. Passing a resolution on the appropriation of profit carried forward or the treatment of a loss requires a majority of 80 percent among the voting members present. Members entitled to vote may appoint a proxy to attend the General Meeting in their place, including a proxy voting right. In the of a tie, the deciding vote shall be cast by the individual presiding over the Meeting.

8. Urgent resolutions may be passed by round-robin procedure.

9. Resolutions on amendments to the Articles of Association shall require a three-quarters majority vote by the attending members who are eligible to vote.

10. Approved resolutions must be recorded in writing and signed by both the individual presiding over the Meeting and the keeper of the minutes. All members shall receive a copy of the minutes of the General Meeting.

Article 7. Board of Management

1. The Association's Board of Management consists of the Chairperson and a maximum of six other members. The members of the Board of Management will be elected by the members of the Association for a term of four years. They shall remain in office until new elections take place. Elections may be revoked at General Meetings for good cause.

2. The Association will be represented in and out of court by the Chairperson of the Board of Management, who shall be permitted to delegate a power of attorney to third persons in individual cases.

3. The Board of Management shall support Executive Management in the running of the Association and shall decide on all matters concerning the Association, providing that the right to such decision-making is not reserved by the General Meeting. The Board of Management may elect other individuals required to assume administrative tasks and will decide on all of the Association's income and expenditures.

4. At the General Meeting, the members will decide on special activities and related expenditures as presented by the Board of Management.

5. The General Meeting may provide the Board of Management with rules of procedure governing the Association's operation.

Article 8. Executive Management

The Board of Management shall appoint the executive management, which will be charged with executing the ongoing tasks of the Association in accordance with the guidelines issued by the Board of Management. Executive Management is authorized to make decisions on membership applications for new members. Executive Management shall inform the Board of Management about all significant matters affecting the Association. Executive Management shall follow all instructions issued by the Board of Management und shall consult the Board of Management in advance regarding all important matters.

Article 9. Membership fees

The annual membership fee will be set at the General Meeting and is currently as follows:

– Companies:	600 Euro minimum
– Designers and design studios:	300 Euro minimum
– Individuals:	150 Euro minimum

Article 10. Auditing

Accounting control will be assigned to Deutsche Messe AG's auditing department or to an independent auditor. The results of auditing will be reported at the regular General Meeting.

Article 11. Dissolution of the Association

1. A resolution to dissolve the Association shall require a three-fourths majority vote by the members who are entitled to vote, provided that at least two thirds of the members entitled to vote are present at the General Meeting.

2. Upon dissolution or annulment of the Association or in the event that the current object of the Association should cease to be applicable, any assets exceeding the capital shares deposited by the members and the fair market value of non-cash capital contributions made by members shall go to a public corporation that will use the assets for cultural or community welfare purposes. Resolutions on the future application of such assets may only be acted upon subsequent to consent thereto by the tax authorities.

3. The General Meeting which resolves to dissolve the Association shall pass a resolution on the application of the Association's assets by way of a three-fourths majority vote.

Article 12. Profits, expenditures, accounting

1. Any profits produced by the Association shall be used exclusively for the tax-privileged purposes of these Articles of Association. Members shall not receive shares of profit, nor shall they, in their capacity as members, receive any other forms of bestowal from Association funds.

2. No individual may be favored by receiving disproportionately high remuneration for administrative tasks not in keeping with the object of the Association.

3. Proof that the Association's funds are being used properly shall be guaranteed by way of adequate and orderly accounting procedures.

Hannover, June 5, 2008

Ernst Raue
Chairman

0–9

240design
Room No.406, 23-4
Inokuchidai-2chome
Hiroshima City, 733-0844 Japan
Phone +81.82.278.7235
● Band 1, 409

3M Svenska AB
Ernst Hedlunds Väg 35
780 41 Gagnef, Sweden
Phone +46.24162452
www.speedglas.com
▲ Band 2, 320

3T Cycling srl
Via Papa Giovanni XXIII 1
24040 Madone, Italy
Phone +39.0354.943451
▲ Band 1, 81
● Band 1, 81

5.5 designers
80 rue du Faubourg Saint Denis
75010 Paris, France
Phone +33.1.48008350
www.cinqcinqdesigners.com
● Band 1, 331

A

A. & J. Stöckli AG
Ennetbachstrasse 40
8754 Netstal, Switzerland
Phone +41.55.64555.55
▲ Band 2, 62
● Band 2, 62

Acer Inc.
8F, No.88, 1st Sec., Hsin Tai Wu Road
221 Taipei Hsien, Taiwan
Phone +886.2.26961234
▲ Band 1, 291
● Band 1, 291

Achilles Associates bvba
Borchtstraat 30
2800 Mechelen, Belgium
Phone +32.15.410272
Fax +32.15.421423
www.achilles.be
● Band 2, 377

ACO Haustechnik
Im Gewerbepark 11c
36457 Stadtlengsfeld, Germany
Phone +49.36965.819301
▲ Band 2, 174
● Band 2, 174

Acute Ideas Co., Ltd
3F, No.11, Lane 35, Jihu Road
Taipei 114, Taiwan
Phone +886.2.8751.4868
www.acuteideas.com
▲ Band 2, 302
● Band 2, 302

A-DATA Technology
18F, No.258, Lian Cheng Road
Chung Ho City, Taipei 235, Taiwan
Phone +886.2.8228.0886
Fax +886.2.8228.0887
www.adata.com.tw
▲ Band 1, 328
● Band 1, 328

Adiri, Inc.
2248 Park Blvd.
Palo Alto, CA 94306, USA
Phone +16502690296
▲ Band 1, 72

ag Licht
Dechenstraße 12
53115 Bonn, Germany
Phone +49.228.908980
www.aglicht.de
● Band 1, 403

ag4 media facade GmbH
GKD – Gebr. Kufferath AG
Am Kölner Brett 8
50825 Köln, Germany
Phone +49.221.912732.0
Fax +49.221.138660
www.mediafacade.com
● Band 2, 254

AIPTEK International Inc.
No.19 Industry East Road 4
Hsinchu 300, Taiwan
Phone +886.3.5678138
Fax +886.3.5771363
www.aiptek.com.tw
▲ Band 1, 212
● Band 1, 212

airbone
111 Tzengfu Lane, Tzengtsuo Tsuen
Changhua 504, Taiwan
Phone +886.4.7686511
Fax +886.4.7686516
www.airbone.com.tw
▲ Band 1, 85
● Band 1, 85

Airfel Heating and Cooling System
Hurriyet Mah. E5 yan yol uzere, Kartal
34876 Istanbul, Turkey
Phone +90.216.4532700
Fax +90.216.6710600
www.airfel.com
▲ Band 2, 209

AISIN SEIKI Co., Ltd.
Design Dept.
2-1, Asahi-machi
Kariya, Aichi 448-8650, Japan
Phone +81.566.24.9766
Fax +81.566.24.9372
www.aisin.com
▲ Band 1, 133
● Band 1, 133

Alfred Kärcher GmbH & Co. KG
Alfred-Kärcher-Straße 28–40
71364 Winnenden, Germany
Phone +49.7195.142827
www.kaercher.de
▲ Band 1, 116–117, 157
▲ Band 2, 236
● Band 1, 116, 157
● Band 2, 236

ALTO LIGHTING CO. Ltd.
Tae-Seung Bldg.
Seoul 135-894, South Korea
Phone +82.2.546.3471
Fax +82.2.515.3471
www.alto.co.kr
● Band 1, 391–393

Amie Design Limited
155 Jervois Road
Herne Bay Auckland, New Zealand
Phone +61.9.361.6941
www.merinokids.com
▲ Band 1, 142
● Band 1, 142

Ammunition LLC
1500 Sansome Street,
Roundhouse One
San Francisco, CA 94111, USA
Phone +14156321170
● Band 1, 297

AmorePacific
181, 2-ga Hangang-ro Yongsan-gu
Seoul, 140-777, South Korea
Phone +82.2.709.5479
▲ Band 2, 303
● Band 2, 303

AmorePacific
138 Spring St., 3rd Floor
New York, NY 10012, USA
▲ Band 1, 125

Animalltag
Rua Antonio Carlos Ferraz de Salles,
95-Marada Deuses
13563-306 São Carlos - SP, Brazil
Phone +55.16.33623362
Fax +55.16.33623366
www.animalltag.com.br
▲ Band 2, 382

AnMo Electronics Corp
5F-1, No.76, Sec.2
Hsinchu 300, Taiwan
Phone +886.3.5357868.10
Fax +996.3.5358098
www.anmo.com.tw
▲ Band 2, 378
● Band 2, 378

Apple, Inc.
1 Infinite Loop, MS: 302-1ID
Cupertino, CA, 95014 USA
Phone +1.408.9749202
www.apple.com
▲ Band 1, 154–155, 231, 252, 290
● Band 1, 154–155, 231, 252, 290

Arcam
Pembroke Avenue, Waterbeach
Cambridge CB5 9QR, United Kingdom
Phone +44.122.3863384
www.arcam.co.uk
▲ Band 1, 218
● Band 1, 218

Arcelik A.S. Industrial Design Team
Endustriyel Tasarim Yoneticiligi
34950 Istanbul, Turkey
Phone +90.216.5858472
▲ Band 2, 45
● Band 2, 45

archicult gmbh
breunig architekten
Mainleitenstraße 33
97299 Zell am Main, Germany
Phone +49.931.46883.0
Fax +49.931.46883.11
www.archicult.de
● Band 2, 265

archicult rhein-main
Atelier für Kommunikation im Raum
Bahnhofstraße 20
64673 Zwingenberg, Germany
Phone +49.6251.84808.0
Fax +49.6251.84808.18
www.archicult.de
● Band 2, 265

Arco Meubelfabriek b.v.
PO Box 11
7100 AA Winterswijk, Netherlands
Phone +31.543.546579
Fax +31.543.521395
www.arco.nl
▲ Band 1, 427
● Band 1, 427

ARRI AG
Türkenstraße 89
80799 München, Germany
Phone +49.89.38091452
www.arri.com
▲ Band 1, 394
● Band 1, 394

Artefakt
Liebigstraße 50–52
64293 Darmstadt, Germany
Phone +49.6151396700
www.artefakt.de
▲ Band 2, 192–193
● Band 2, 192–193

Art-Kon-Tor
Hainstraße 1
07745 Jena, Germany
Phone +49.3641.88770
● Band 2, 299

ARTPHERE Co., Ltd.
8-4 ChuoCho
Toyookashi Hyogo
Prefecture 668-0033, Japan
Phone +81.796.23.5408
Fax +81.796.23.5418
www.artphere.com
▲ Band 1, 141
● Band 1, 141

Arzberg-Porzellan GmbH
Fabrikweg 41
95706 Schirnding, Germany
Phone +49.9233.403168
Fax +49.9233.403267
www.arzberg-porzellan.com
▲ Band 2, 124
● Band 2, 124

asa designers limited
2 Durlston Road
Kingston upon Thames KT2 5RT,
United Kingdom
Phone +44.20.8549.5452
www.asadesigners.com
● Band 1, 121, 218

Ashcraft Design
821 N.Nash Street
El Segundo, CA 90245, USA
Phone +1.310.6408330
Fax +1.310.6408333
www.ashcraftdesign.com
● Band 1, 219, 322

astec gmbh
design beschlaege
Sigmaringerstraße 84
72458 Albstadt, Germany
Phone +49.7431.1340.11
Fax +49.7431.1340.19
www.astec-design.de
▲ Band 2, 216
● Band 2, 216

ASUSTek Computer Inc.
ASUS DESIGN
15, LI-Te Road, Peitou
Taipei 112, Taiwan
Phone +886.2.2894.3447
Fax +886.2.2896.0062
www.asus.com
● Band 1, 299

ASUSTek Computer Inc.
15, LI-Te Road, Peitou
Taipei 112, Taiwan
Phone +886.2.2894.3447
Fax +886.2.2896.0062
www.asus.com
▲ Band 1, 299, 335
● Band 1, 335

at-design
Flugplatzstraße 111
90768 Fürth, Germany
Phone +49.911.239808.0
Fax +49.911.239808.29
www.atdesign.de
● Band 2, 361

Atelier Oï
Ch. du Signolet 3
2520 La Neuveville, Switzerland
Phone +41.32.75156.66
Fax +41.32.75156.55
www.atelier-oi.ch
● Band 1, 429, 456

Augustin Produktentwicklung
Tengstraße 45
80786 München, Germany
Phone +49.89.2730690
Fax +49.89.2730690
www.augustin.net
● Band 1, 82

AUTHENTICS GmbH
Am Ölbach 28
33334 Gütersloh, Germany
Phone +49.5241.9405533
Fax +49.5241.94059533
www.authentics.de
▲ Band 1, 140
▲ Band 2, 122

AVerMedia Information, Inc.
5F, No.135, Jian Yi Road
Chung Ho 235, Taiwan
Phone +886.2.22263630.3818
Fax +886.2.2226.8751
www.avermedia.com/avervision
▲ Band 1, 176
● Band 1, 176

AZZURRA SANITARI IN
CERAMICA S.P.A.
Via Civita Castellana SNC
1030 Castel Santelia, Italy
Phone +39.761.518155
Fax +39.761.514560
www.azzurraceramica.it
▲ Band 2, 172

B
B/S/H
Carl-Wery-Straße 34
81739 München, Germany
Phone +49.89.45903613
Fax +49.89.45903614
▲ Band 2, 14–15
● Band 2, 14–15

Bachorski Design
Bachorski Kirchhoff GbR
Maria-Goeppert-Straße 1
23562 Lübeck, Germany
Phone +49.451.989957.90
Fax +49.451.989957.88
www.bachorski-design.de
● Band 2, 407

Ballendat Design
Maximilianstraße 15
84359 Simbach am Inn, Germany
Phone +49.8571.605660
www.ballendat.de
● Band 1, 437

Baltensweiler AG
Luzernerstrasse 75
6030 Ebikon, Switzerland
Phone +41.41.429.00.30
www.baltensweiler.ch
▲ Band 1, 384
● Band 1, 384

basalte
Dorpsstraat 5a
9052 Gent, Belgium
Phone +32.9.3857838
Fax +32.9.3296695
www.basalte.be
▲ Band 2, 234

basysPrint by Punch Graphix
Duwijckstraat 17
2500 Lier, Belgium
Phone +32.3.4431311
Fax +32.3.4431309
www.basysprint.com
▲ Band 2, 377

Bauerfeind AG
Triebeser Straße 16
07937 Zeulenroda-Triebes, Germany
Phone +49.36628.663167
Fax +49.36628.663154
www.bauerfeind.com
▲ Band 2, 270, 312

BDI – Busscar Design Industrial
Rua Augusto Bruno Nielson, 345
89219-580 Joinville - SC, Brazil
Phone +55.47.34411347
● Band 1, 61

BEE DESIGN INC.
No.2, Lane 302, Sec.2, Tihwa St.
Taipei City 103, Taiwan
Phone +886.2.25971687
Fax +886.2.25980597
● Band 2, 151

BEGA · Produktgestaltung
Hennenbusch 1
58708 Menden, Germany
Phone +49.2373.966329
www.bega.de
▲ Band 1, 388–390
● Band 1, 388–390

BenQ Corporation
No.16 Jihu Road, Neihu
Taipei 114, Taiwan
Phone +886.2.2658.8880
Fax +886.2.2656.7395
▲ Band 1, 253
● Band 1, 253

Berghoff Worldwide
Boterbosstraat 6-1
3550 Heusden-Zolder, Belgium
Phone +32.13.35.87.46
Fax +32.13.35.87.47
www.berghoffworldwide.com
▲ Band 2, 125
● Band 2, 125

Antonio Bernardo
Jardim Botânico 635, 10° andar
22470-050 Rio de Janeiro - RJ, Brazil
Phone +55.21.3874.7070
Fax +55.21.3874.7050
www.antoniobernardo.com.br
▲ Band 1, 126
● Band 1, 126

Bernhardt
1839 Morganton Blvd. SW
Lenoir, NC 28645, USA
Phone +1.828.7596268
▲ Band 1, 369

DESIGN EXCELLENCE BRAZIL

Creative by its own nature.

The Design Excellence Brazil program has been supporting Brazilian entries on the iF Design Awards since 2003. The results are more than 700 finalist projects and over 110 awards, displaying to the world all the creativity and excellence of Brazilian design.

www.designbrasil.org.br/debrazil

DESIGN
excellence
BRAZIL

iF
product
design
award
2009

Organized by: CENTRO DE DESIGN PARANÁ

Sponsored by: ApexBrasil
BRAZILIAN TRADE AND INVESTMENT PROMOTION AGENCY

 PBD
Programa Brasileiro do Design

 Ministry of Development Industry and Foreing Trade

 BRASIL
BRAZILLIAN GOVERNMENT

bfs batterie füllungs systeme GmbH
Mitterweg 9–11
85232 Bergkirchen, Germany
Phone +49.8131.36400
Fax +49.8131.364099
www.bfsgmbh.de
▲ Band 2, 392
● Band 2, 392

Bluelounge Design
32 S.Raymond Ave. No. 9
Pasadena, CA 91105, USA
Phone +1.626.3180512
Fax +1.626.6283287
www.bluelounge.com
▲ Band 1, 365
● Band 1, 365

bluequest Product Engineering GmbH
Grundweg 5
64331 Weiterstadt, Germany
Phone +49.6150.17248
Fax +49.6150.17247
www.bluequest.de
● Band 2, 348

BMC Trading AG
Sportstrasse 49
2540 Grenchen, Switzerland
Phone +41.32.65414.54
Fax +41.32.65414.55
www.bmc-racing.com
▲ Band 1, 74–75

BMW AG
Knorrstraße 147
80788 München, Germany
Phone +49.89.382.14014
Fax +49.89.382.43696
www.bmw.de
▲ Band 1, 48–51, 53, 90–91

BMW Design Studio Motorrad
Knorrstraße 147
80788 München, Germany
Phone +49.89.382.14014
Fax +49.89.382.43696
www.bmw.de
● Band 1, 49, 90–91

BMW Designworks USA
2201 Corporate Center Drive
California, CA 00011-233, USA
Phone +55.80.5499 9590
www.designworksusa.com
● Band 2, 220

BMW Group Design
Knorrstraße 147
80788 München, Germany
Phone +49.89.382.14014
Fax +49.89.382.43696
www.bmw.de
● Band 1, 48, 50–51, 53

BODUM AG
Kantonsstrasse 100
6234 Triengen, Switzerland
Phone +41.41.935.4500
www.bodum.com
▲ Band 2, 195
● Band 2, 195

Prof. Michael Boehm
Matterhornstraße 95
14129 Berlin, Germany
Phone +49.262418848
www.sahm.de
● Band 2, 143

Bosch Lawn and Garden Ltd.
Suffolk Works
Stowmarket IP14 1EY, United Kingdom
Phone +44.1449.742070
▲ Band 1, 115
● Band 1, 115

Bosch Power Tools,
Accessory Business Unit
Scintilla AG
4501 Solothurn, Switzerland
Phone +41.32.686.3654
Fax +41.32.686.7158
www.bosch.ch
▲ Band 2, 329

BOWA-electronic GmbH
Heinrich Hertz Straße 4–10
72810 Gomaringen, Germany
Phone +49.7072.60020
www.bowa.de
▲ Band 2, 284

Brandes en Meurs industrial design
Kerkstraat 19 C
3581 RA Utrecht, Netherlands
Phone +31.30.2310206
www.brandesenmeurs.nl
● Band 2, 330–332

Brandis&Farenski Industrial Design
Johannisstraße 3
90419 Nürnberg, Germany
Phone +49.911.9336970
www.brandisfarenski.de
● Band 1, 123

Brau Union Österreich AG
Poschacherstraße 35
4020 Linz, Austria
Phone +43.664.8382234
▲ Band 2, 126

Brennwald Design
Feldstraße 133
24105 Kiel, Germany
Phone +49.431.334515
Fax +49.431.334516
www.brennwald-design.de
● Band 1, 221

brinell gmbh
Humboldtstraße 30
76131 Karlsruhe, Germany
Phone +49.721.18035590
Fax +49.721.18035599
www.brinell-style.com
▲ Band 1, 321
● Band 1, 321

Brinno Inc.
4F-1, No.392, Sec.1, Nei-Hu Road,
Nei-Hu District
Taipei 114, Taiwan
Phone +886.2.8751.0306
Fax +886.2.8751.0549
www.brinno.com
● Band 2, 394

brodbeck design
Schillerstraße 40c
80336 München, Germany
Phone +49.89.51266586
Fax +49.89.51266583
www.brodbeckdesign.de
● Band 1, 266

Brother Industries, Ltd.
1-1-1, Kawagishi, Mizuho-ku
Nagoya 467-8562, Japan
Phone +81.52.824.2452
▲ Band 1, 134
● Band 1, 134

Brunner GmbH
Im Salmenkopf 10
77866 Rheinau, Germany
Phone +49.7844.40249
Fax +49.7844.40248
www.brunner-group.com
▲ Band 1, 366

BSN medical GmbH
Quickbornerstraße 24
20253 Hamburg, Germany
Phone +49.40.4909909
▲ Band 2, 271

BT Products
Svarvargatan 8
595 81 Mjölby, Sweden
Phone +46.142.86000
▲ Band 2, 415

BULO
office furniture
Blarenberglaan 6
2800 Mechelen, Belgium
Phone +32.15.282828
Fax +32.15.282829
www.bulo.com
▲ Band 1, 368
● Band 1, 368

burmeister industrial design
Markgrafstraße 5
30419 Hannover, Germany
Phone +49.511.16998680
www.burmeister-id.de
● Band 2, 211

Büro für Konstruktion & Gestaltung
Hauptstraße 16
93464 Tiefenbach, Germany
Phone +49.9673.9140244
www.hagenkluge.de
● Band 2, 393

busk+hertzog i/s
Gunlögsgade 1, St
2300 Copenhagen, Denmark
Phone +45.325.01552
Fax +45.325.01542
www.busk-hertzog.dk
● Band 1, 460

Busscar Ônibus S.A.
Rua Augusto Bruno Nielson, 345
89219-580 Joinville – SC, Brazil
Phone +55.47.34411347
Fax +55.47.34411015
▲ Band 1, 61

Busse Design + Engineering GmbH
Nersinger Straße 18
89275 Elchingen, Germany
Phone +49.7308.811499
Fax +49.7308.811499
www.busse-design.com
● Band 2, 358

by-number
Uhrevej 3, Uhre
6064 Jordrup, Denmark
Phone +45.755.06090
www.by-number.com
▲ Band 1, 457

C
C Creative Inc.
4-15-5-202, Minami Aoyama,
Minatoku
Tokyo 107-0062, Japan
Phone +81.3.5771.7200
www.c-creative.net
● Band 2, 293

C. Josef Lamy GmbH
Grenzhöfer Weg 32
69123 Heidelberg, Germany
Phone +49.6221.843147
Fax +49.6221.843121
www.lamy.de
▲ Band 1, 374

CACAU Design Industrial
Calçada dos Antares, 272-Sala 04
06541-065 São Paulo - SP, Brazil
Phone +55.11.3067.5970
www.cacaudesign.com.br
● Band 2, 86

Canal Plus
1 Place du Spectacle
92 863 Issy Les Moulineaux, France
Phone +33.1.171.351832
▲ Band 1, 213

Canon Inc.
30-2, Shimomaruko 3-chome,
Oh-ta-ku
Tokyo 146-8501, Japan
Phone +81.3.3758.2111
www.canon.jp
▲ Band 1, 166, 316
● Band 1, 166, 316

Cappellini
Via Milano, 28
22066 Mariano Comense, Italy
Phone +39.031.759111
Fax +39.031.763322
▲ Band 1, 434

CASIO COMPUTER CO., Ltd.
Product Development HQ.
Design Center
1-6-2 Honmachi Shibuya-ku
Tokyo 151-8543, Japan
Phone +81.3.5334.4829
▲ Band 1, 167
● Band 1, 167

Catalyst Design Group
252 Church Street
3121 Richmond, Australia
Phone +61.3.9428.6352
Fax +61.3.9428.6897
● Band 1, 83–84, 385, 408

Catlike
Pje. Sant Felip
8006 Barcelona, Spain
Phone +34.93.7065408
● Band 1, 78

Catlike
Doctor Trueta 17, PO Box 502
30510 Yecla, Murcia, Spain
Phone +34.96.8752087
Fax +34.96.8752290
www.catlike.es
▲ Band 1, 78
● Band 1, 78

CDC Corporate Design Catalano
Strada Prov.le Falerina Km 7.200
1034 Fabrica di Roma, Italy
Phone +39.761.5661
Fax +39.761.574304
www.catalano.it
● Band 2, 190

Cebien Co., Ltd.
27-32 Munhyeongri Opoeup
Gwangjusi
464-894 Gyeonggi-do, South Korea
Phone +82.31.765.3110
Fax +82.31.765.3113
www.cebien.com
▲ Band 2, 166

Ceramica Catalano srl.
Strada Provinciale Falerina Km 7.200
1034 Fabrica Di Roma, Italy
Phone +39.761.5661
Fax +39.761.574304
www.catalano.it
▲ Band 2, 190

C. F. Møller Architects
Europaplads 2, 11
8000 Aarhus C, Denmark
Phone +45.87.305300
www.cfmoller.com
● Band 2, 233

Champtek Inc.
5/F, No. 2, Alley 2, Shih-Wei Lane,
Chung Cheng Rd., Hsin Tien City
Taipei 231, Taiwan
Phone +886.2.2219.2385
www.champtek.com
▲ Band 2, 394
● Band 2, 394

ChauhanStudio
264 Acton Lane
London W4 5DJ, United Kingdom
Phone +44.208.9956657
www.chauhanstudio.com
● Band 1, 280

Chelles & Hayashi Design
Rua Áurea, 2
04015-070 São Paulo - SP, Brazil
Phone +55.11.5573.3470
www.design.ind.br
● Band 2, 87

Chung-shan Institute of Science &
Technology Armament bureau, MND
P.O. Box90008-8-11, Lung-Tan
Tao-Yuan 32599, Taiwan
Phone +886.2.26739638
▲ Band 2, 436

CITAQ Co., Ltd.
6 IF., Hanjing Bldg., Changping Road
Shantou 515000, China
Phone +86.7.5488845120
Fax +86.7.5488845109
www.citaqpos.com
▲ Band 1, 345
● Band 1, 345

color inc.
No.105 maisonAX, 4-14-19 jingumae
Tokyo 150-0001, Japan
Phone +81.3.3408.1361
Fax +81.3.3408.1361
www.color-81.com
● Band 1, 278, 363

Combat Electric Co., Ltd
No.2, Lane 255, Sec. 2,
Jhongshan Road
Banciao City, Taipei Country 220,
Taiwan
Phone +886.2.29648877
Fax +886.2.29641970
▲ Band 2, 151

Conacord
Seilerweg 10
59556 Lippstadt, Germany
Phone +49.2941.956120
▲ Band 2, 398

CONCORD GmbH
Industriestraße 25
95346 Stadtsteinach, Germany
Phone +49.9225.955026
Fax +49.9225.955055
www.concord.de
▲ Band 1, 59

Constructa-Neff Vertriebs GmbH
Carl-Wery-Straße 34
81739 München, Germany
Phone +49.89.45904233
Fax +49.89.45904237
▲ Band 2, 28–34, 50–53, 60, 68,
77–79, 83, 94–96, 115
● Band 2, 28–34, 50–53, 60, 68,
77–79, 83, 94–96, 115

Continental AG
Technology Center
Jädekamp 30
30419 Hannover, Germany
Phone +49.511.9763828
www.conti-online.com
▲ Band 1, 57
● Band 1, 57

Cooler Master Co., Ltd.
9F., No 786, Chung-Cheng Road
Chung-Ho City, Taipei Hsien 235,
Taiwan
Phone +886.2.32340050.207
www.coolermaster.com
▲ Band 1, 346
● Band 1, 346

Corallo Co., Ltd.
857-32 Bang bae 4 dong , Seocho-gu
Seoul 137-837, South Korea
Phone +82.2.532.2725
Fax +82.2.532.2788
www.corallo.co.kr
● Band 2, 166

Corpus-C Design Agentur
Kaiserstraße 168–170
90763 Fürth, Germany
Phone +49.911.2177379.0
Fax +49.911.2177379.99
www.corpus-c.de
● Band 2, 300–301

Coza Utilidades Plásticas Ltda
Av. Alberto Bins, 392/304
90030-140 Porto Alegre - RS, Brazil
Phone +55.54.21015600
www.radararquitetos.com.br
▲ Band 1, 375
● Band 1, 375

CRE8-designstudio
5F-1, No.477, Sec 2, Tiding Blvd.
Taipei 114, Taiwan
Phone +886.2.8797.5000
Fax +886.2.8797.8315
www.cre8-designstudio.com
● Band 1, 305

Crown Equipment Corp.
14 West Monroe Street
New Bremen, OH 45869, USA
Phone +14196292311
www.crown.com
▲ Band 2, 413

Crown Gabelstapler GmbH & Co. KG
Moosacher Straße 52
80809 München, Germany
Phone +49.89.930020
www.crown.com
● Band 2, 413

Cyphics Co., Ltd.
3F, Erujin Bldg., 37-8, Jamwon-Dong
Seoul 137-905, South Korea
Phone +82.2.549.7210
Fax +82.2.549.7240
www.cyphics.com
● Band 1, 284

D
Dadam Design Associates Inc.
1618-2 Seocho-dong, Seocho-gu
Seoul 137-070, South Korea
Phone +82.2.581.6430
Fax +82.2.581.6435
www.dadam.com
● Band 1, 351
● Band 2, 230

DAIKO ELECTRIC Co., Ltd.
PLCT
1-23, Kawata-4chome
Higashi-Osaka City 578-0905, Japan
Phone +81.72.962.8418
Fax +81.72.962.8425
● Band 1, 382

DAIKO ELECTRIC Co., Ltd.
6-48, 1-Chome, Sumida
Higashi-Osaka 578-0912, Japan
Phone +81.72.9653487
▲ Band 1, 382, 409

Dallmer GmbH & Co. KG
Wiebelsheidestraße 25
59757 Arnsberg, Germany
Phone +49.2932.9616174
Fax +49.2932.9616222
www.dallmer.de
▲ Band 2, 173
● Band 2, 173

Danese
34 Via Antonio Canova
20145 Milan, Italy
Phone +39.02.34939634
▲ Band 1, 436

Das Ding
Jan Stobbaertslaan 37-6
1030 Brussel, Belgium
Phone +32.49.8501890
www.dasding.be
● Band 1, 71, 135

Decameron Design
Rua Bragança Paulista 346
04727-000 São Paulo - SP, Brazil
Phone +55.11.56411528
Fax +55.11.56414525
www.decamerondesign.com.br
▲ Band 1, 472

DECATHLON
4 boulevard du Mons
59650 Villeneuve d'Ascq, France
Phone +33.6.22.71.31.14
www.oxylane-group.com
▲ Band 1, 68, 92, 95–104, 110
● Band 1, 68, 92, 95–104, 110

Deck 5
Dix Frankowski Noster Steber
Max-Keith-Straße 11
45136 Essen, Germany
Phone +49.201.2697670
Fax +49.201.2697679
www.deck5.de
● Band 2, 296–297

DEDON GmbH
Zeppelinstraße 22
21337 Lüneburg, Germany
Phone +49.4131.22447544
Fax +49.4131.22447637
www.dedon.de
▲ Band 1, 440–441, 450, 478
● Band 1, 440–441, 450, 478

Dell Inc.
One Dell Way PS-4
Round Rock, TX 78682, USA
Phone +1.512.7281957
▲ Band 1, 211, 296–297, 325, 336, 356
● Band 1, 211, 296–297, 325, 336, 356

Delmedica Investments
7 Temasek Boulevard, No.06-01
Suntec Tower 1
38987 Singapore, Singapore
Phone +65.64153102
Fax +65.64153108
▲ Band 2, 287

Delta Light nv
Muizelstraat 2
8560 Wevelgem, Belgium
Phone +32.56.435.735
Fax +32.56.435.736
www.deltalightcom
▲ Band 1, 405
● Band 1, 405

Demirden Design
Turnacibasi Sok. Nese Apt.No.9/7
34433 Istanbul, Turkey
Phone +90.212.2452563
Fax +90.212.2448943
www.demirden.com
● Band 1, 431
● Band 2, 135

DenTek Oral Care, Inc.
307 Excellence Way
Maryville, TN 37801, USA
Phone +1.865.9831300
Fax +1.865.9838073
▲ Band 2, 286

DesfiacocO d.e.s.i.g.n.
R. Cel. Manoel Alves do Amaral, 125
82520-340 Curitiba – PR, Brazil
Phone +55.41.30275239
▲ Band 2, 84
● Band 2, 84

Design 3
Schaarsteinwegsbrücke 2
20459 Hamburg, Germany
Phone +49.40.378793.00
Fax +49.40.378793.09
www.design3.de
● Band 1, 190–192, 275
● Band 2, 381

design AG
Neupförtner Wall 21
33378 Rheda Wiedenbrück, Germany
Phone +49.5242.982115
● Band 2, 398

DESIGN DEUTSCHE
59 Liuhe Road
Kaohsiung 802, Taiwan
Phone +886.9.88154992
www.designdeutsche.com
● Band 2, 379–380

Design Inverso
Conselheiro Arp, 80-América
89204-600 Joinville – SC, Brazil
Phone +55.47.3028.7767
www.designinverso.com.br
● Band 2, 85

Design Management
Siemens AG, Industry Sector
Gleiwitzerstraße 555
90475 Nürnberg, Germany
Phone +49.911.8954200
Fax +49.911.8955400
www.siemens.com/automation
● Band 2, 359–361

Design Nicklas
Kielortallee 16
20144 Hamburg, Germany
Phone +49.40.41498255
● Band 1, 233

Design Partners
IDA Business Park
Bray, Co Wicklow, Ireland
Phone +35.312828913
Fax +35.312863236
www.designpartners.com
● Band 2, 127

Design Tech
Zeppelinstraße 53
72119 Ammerbuch, Germany
Phone +49.7073.9189.0
Fax +49.7073.9189.16
www.designtech.eu
● Band 2, 264, 276, 397

designaffairs GmbH
Konrad-Zuse-Straße 12
91052 Erlangen, Germany
Phone +49.9131.977948.10
Fax +49.9131.977948.20
www.designaffairs.com
● Band 2, 305

DesignGoth
Banpo-dong
Seoul 137-805, South Korea
Phone +82.2.5947279
Fax +82.2.5947280
www.designgoth.com
● Band 1, 215

Designit A/S
Klosterport 4
8000 Aarhus C, Denmark
Phone +45.70.277700
www.designit.dk
● Band 1, 139

designmu
B2 Sinsumiha Bldg.
Seoul 137-927, South Korea
Phone +82.2.522.9261
● Band 2, 256

design-people
Graven 24b
8000 Aarhus C, Denmark
Phone +45.70.22.64.62
Fax +45.86.18.06.82
www.design-people.dk
● Band 1, 224–225

designship
Heimstraße 29
89073 Ulm, Germany
Phone +49.731.28046
Fax +49.731.27380
www.designship.de
● Band 1, 371
● Band 2, 399

Deutsche Post AG
Charles-de-Gaulle-Straße 20
53113 Bonn, Germany
Phone +49.228.1820
www.deutschepost.de
▲ Band 2, 250

Deutsches Zentrum für
Luft- und Raumfahrt
Münchner Straße 20
82234 Wessling, Germany
Phone +49.8153.281075
www.dlr.de/rm
▲ Band 2, 424

development engineering GmbH
Egmatinger Straße 3
85667 Oberpframmern, Germany
Phone +49.8093.9036.0
Fax +49.8093.9036.20
www.moving-children.de
▲ Band 1, 82
● Band 1, 82

DFG
Deutsche Fernsprecher GmbH
Temmlerstraße 5
35039 Marburg, Germany
Phone +49.6421.402401
Fax +49.6421.402400
▲ Band 1, 266

Dialogform GmbH
Wallbergstraße 3
82024 Taufkirchen, Germany
Phone +49.89.6128251
Fax +49.89.6128253
www.dialogform.de
● Band 2, 416, 417

Friedr. DICK GmbH & Co. KG
Esslinger Straße 4–10
73779 Deizisau, Germany
Phone +49.7153.8170
Fax +49.7153.817219
www.dick.de
▲ Band 2, 130
● Band 2, 130

DID INSTITUTE, Inc.
2-12-5, Kichijoji-Honcho,
Musashino-shi
Tokyo 180-0004, Japan
Phone +81.422.21.9207
● Band 1, 320

die haptiker GmbH
Bergstraße 12
82024 Taufkirchen b. München,
Germany
Phone +49.89.510869.40
Fax +49.89.510869.42
www.die-haptiker.de
● Band 2, 359

Die Hausmacher
Otto-Hahn-Straße 127
40591 Düsseldorf, Germany
Phone +49.211.7302010
● Band 2, 221–222

Dietz Joppien Architekten AG
Schaumainkai 69
60596 Frankfurt am Main, Germany
Phone +49.69.96244960
● Band 2, 262

Stefan Diez Industrial Design
Geyerstraße 20
80469 München, Germany
Phone +49.89.20245394
Fax +49.89.20245395
www.stefan-diez.com
● Band 1, 140, 430, 432

D-Link Corporation
No.289, Sinhu 3rd Road, Neihu District
Taipei 114, Taiwan
Phone +886.2.66000123.5412
▲ Band 2, 223
● Band 2, 223

DLR
Münchener Straße 20
82234 Wessling, Germany
Phone +49.8153.281300
Fax +49.8153.281134
▲ Band 2, 383

DOK54 ApS
Uhrevej 3, Uhre
6064 Jordrup, Denmark
Phone +45.75.506090
www.dok54.dk
● Band 1, 457

Dominox Design Ltda.
Rua Passa Tempo, 440
30310-760 Belo Horizonte - MG, Brazil
Phone +55.31.32235794
▲ Band 1, 471

Aloys F. Dornbracht GmbH & Co. KG
Armaturenfabrik
Köbbingser Mühle 6
58640 Iserlohn, Germany
Phone +49.2371.4330
Fax +49.5426949239
www.dornbracht.com
▲ Band 2, 184

Doro
Magistratsvägen 10
22643 Lund, Sweden
Phone +46.46.2805080
www.doro.com
▲ Band 1, 251

Dräger Medical AG & Co. KG
Moislinger Allee 53–55
23542 Lübeck, Germany
Phone +49.451.8820
www.draeger.com
▲ Band 2, 300–301

Dräger Safety AG & Co. KGaA
Revalstraße 1
23560 Lübeck, Germany
Phone +49.451.882.0
www.draeger.com
▲ Band 2, 407

Dt. Steinzeug Cremer & Breuer AG
Servaisstraße
53347 Alfter-Witterschlick, Germany
Phone +49.2283.911562
▲ Band 2, 191
● Band 2, 191

DUCK IMAGE CO., Ltd.
No.51-3 Sanguang Lane
Taichung 406, Taiwan
Phone +886.4.2236.0089
www.duckimage.com.tw
● Band 1, 118, 120, 212, 357

DUCK IMAGE CO., Ltd.
Room 301, 195-52, Sec.4,
Zhongxing, Chutung
Hsinchu 310, Taiwan
Phone +886.3.591.5073
www.duckimage.com.tw
● Band 2, 232, 432–433

Duravit AG
Werderstraße 36
78132 Hornberg, Germany
Phone +49.7833.70359
Fax +49.7833.707359
www.duravit.de
▲ Band 2, 194

Dyson GmbH
Lichtstraße 43b
50825 Köln, Germany
Phone +49.221.50600149
▲ Band 2, 245

Dyson Ltd.
Tetbury Hill
Malmesbury, Wiltshire SN16 ORP,
United Kingdom
Phone +44.166.68272000
● Band 2, 245

E
eb Co., Ltd.
14th F., Ace Hign-End Tower, 235-2,
Guro-Dong, Guro-Gu
Seoul 152-050, South Korea
Phone +82.2.6220.3006
Fax +82.2.6220.5001
www.ebwide.com
▲ Band 2, 246

EBF Capacetes
Rua Crisólita, 145
13347-060 Indaiatuba - SP, Brazil
Phone +55.19.3935.2589
www.ebfcapacetes.com.br
▲ Band 1, 62

Eckstein Design
Theo Prosel Weg 14
80797 München, Germany
Phone +49.89.38380710
Fax +49.89.38380790
www.eckstein-design.com
● Band 2, 385

EDF Recherche & Dévelopment
Département Ener BAT
Avenue des Renardièrs
77818 Moret sur Loing, France
Phone +33.01.607361
● Band 2, 211

eer architectural design
Terdekdelleweg 27
3090 Overijse, Belgium
Phone +32.2.6880189
Fax +32.2.6881189
www.eerdesign.com
● Band 1, 406

egg design
Dogok-dong
Seoul 135-270, South Korea
Phone +82.2.3462.9741
Fax +82.2.3462.9745
www.eggdesign.co.kr
▲ Band 2, 400
● Band 2, 400

Eidenbenz Industrial Design Est.
Poska 2
9495 Triesen, Liechtenstein
Phone +423.392.30.10
● Band 2, 210

Elastique. We design.
Moltkestraße 127
50674 Köln, Germany
Phone +49.221.35503450
Fax +49.221.35503459
www.elastique.de
▲ Band 1, 364
● Band 1, 364

ELBA Bürosysteme GmbH & Co. KG
Maybachstraße 2
45891 Gelsenkirchen, Germany
Phone +49.209.97604142
www.elba.com
▲ Band 1, 372

ELECOM Co., Ltd.
Osaka-Midousuji Bldg.
Chuouku, Osaka 541-8765, Japan
Phone +81.6.6229.2727
www.elecom.co.jp
▲ Band 1, 326, 334
● Band 1, 326, 334

Electrolux Dienstleistungs GmbH
Industrial Design Center – Nürnberg
Fürtherstraße 246
90429 Nürnberg
www.electrolux.de
● Band 2, 97–98

Electrolux Home Products
Corporation N.V.
Zaventem, Belgium
Phone +32.911.3231173
www.aeg-hausgeräte.de
▲ Band 2, 97–98

Elesa S.p.A.
Technical Department
Via Pompei 29
20052 Monza, Italy
Phone +39.03.928111
www.elesa.com
▲ Band 2, 401
● Band 2, 401

elmar flötotto
Am Ölbach 28
33334 Gütersloh, Germany
Phone +49.5241.9405315
www.elmarfloetotto.de
▲ Band 1, 458

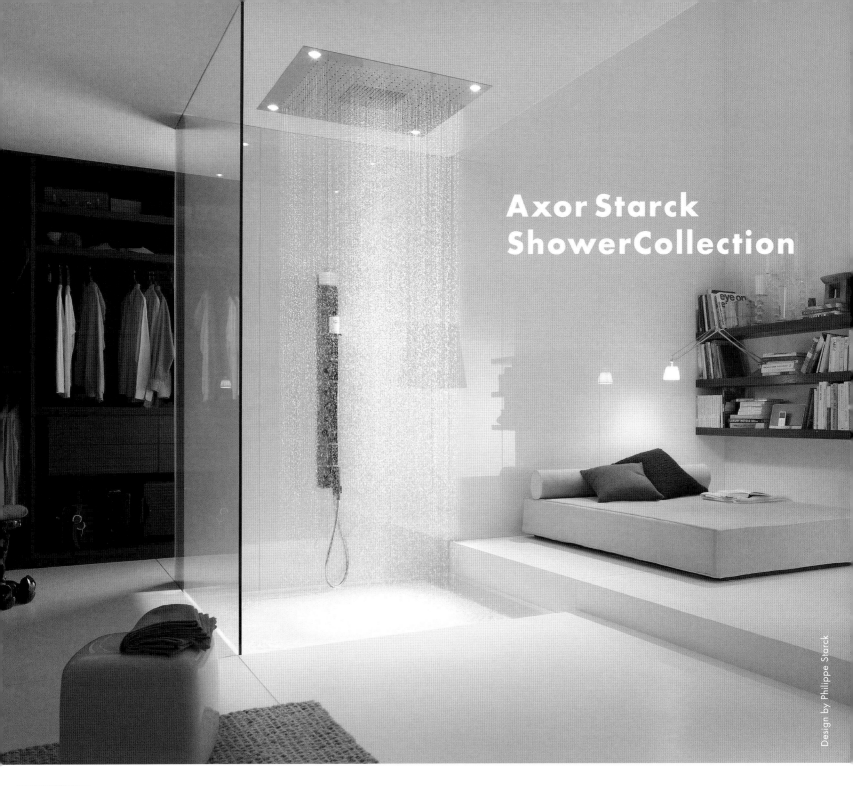

Axor Starck
ShowerCollection

Design by Philippe Starck

Haute Couture für die Dusche.

Mehr Informationen auf www.axor-design.com

EnBW
Vertriebs- und Servicegesellschaft
Kronenstraße 26
70173 Stuttgart, Germany
Phone +49.711.1281034
Fax +49.711.1281222
www.enbw.com
▲ Band 1, 349

Enthoven Associates Design
Consultants
Lange Lozanastraat 254
2018 Antwerpen, Belgium
Phone +32.32.035300
www.ea-dc.com
● Band 2, 119, 333

ERBE Elektromedizin GmbH
Waldhörnlestraße 17
72072 Tübingen, Germany
Phone +49.7071.7550
www.erbe-med.com
▲ Band 2, 314

ERCO
Brockhauser Weg 80–82
58507 Lüdenscheid, Germany
Phone +49.2351.551203
▲ Band 1, 407

ergon3
Westendstraße 147
80339 München, Germany
Phone +49.89.4808810
www.ergon3.de
▲ Band 2, 229, 237
● Band 2, 229, 237, 360

Ergonomidesign
Missionsvagen 24
167 33 Bromma, Sweden
Phone +46.8.506.67.200
www.ergonomidesign.com
● Band 1, 251
● Band 2, 320–321

Eschenbach Optik GmbH
Andernacher Straße 29b
90411 Nürnberg, Germany
Phone +49.911.36000
▲ Band 1, 123

Essential Design
143 South Street
Boston, MA 2111, USA
Phone +1.617.3386057
Fax +1.617.3386058
www.essential-design.com
● Band 1, 241, 336

ETAP NV
Produktentwicklung
Antwerpsesteenweg 130
2390 Malle, Belgium
Phone +32.3.210.02.11
www.etaplighting.com
▲ Band 1, 406

Etel Marcenaria
Gabriel Monteiro da Silva 1834
01442-001 São Paulo, Brazil
Phone +55.11.30641266
▲ Band 1, 451

ETERNIT AG
Eternitstrasse
8867 Niederurnen, Switzerland
Phone +41.55.5171111
www.eternit.ch
▲ Band 1, 459

Ethicon Endo-Surgery
4545 Creek Road
Cincinnati, OH 45242, USA
Phone +1.513.3377101
▲ Band 2, 306
● Band 2, 306

Eton Corporation
1015 Corporation Way
Palo Alto, CA 94303, USA
Phone +1.650.3353012
▲ Band 1, 229

EVA DENMARK A/S
Maaloev Teknikerby 18–20
2760 Maaloev, Denmark
Phone +45.367.32074
Fax +45.367.07411
www.evaDenmark.com
▲ Band 1, 112
▲ Band 2, 128, 142

Evonik Degussa GmbH
Paul-Baumann-Straße 1
45772 Marl, Germany
Phone +49.2365.49 9337
▲ Band 1, 449
● Band 1, 449

EXPOTECHNIK Heinz Soschinski GmbH
Aarstraße 176
65232 Taunusstein, Germany
Phone +49.6128.26992
Fax +49.6128.269100
www.expotechnik.com
▲ Band 2, 247–248

EYE-D Designed Innovation
Nijverheidsweg 1d–e
6651 KS Druten, Netherlands
Phone +31.487.585835
Fax +31.487.518273
www.eye-ddi.com
● Band 2, 394

F
F&L Design
via Isonzo 1
22078 Turate (CO), Italy
Phone +39.02.967.191
Fax +39.02.967.50859
www.unifor.it
● Band 1, 376

Fahrenheit Design
1970 Rawhide Drive
Round Rock, TX 78681, USA
Phone +1.512.3412242
● Band 1, 336

Faltmann
Laubisrütistrasse 52
8712 Stäfa, Switzerland
Phone +41.44.9282500
www.faltmann.ch
▲ Band 2, 249

Faro Design Ltda.
Fabricio Pillar 33
90450-040 Porto Alegre - RS, Brazil
Phone +55.51.33331715
Fax +55.51.33214282
www.farodesign.com.br
▲ Band 1, 473
● Band 1, 473

Faurecia Design Studio France
2, rue Hennape
92735 Nanterre cedex, France
▲ Band 2, 426
● Band 2, 426

Faurecia Design Studio Germany
Faureciastraße 1
76767 Hagenbach, Germany
Phone +49.5721.702703
● Band 2, 426

Faurecia Design Studio USA
2050 Auburn Road
Auburn Hills, MI 48326, USA
● Band 2, 426

Fawoo Technology
364 Samjeong-dong, Bucheon
Tecnopark, Suite 102-905
Bucheon 421-809, South Korea
Phone +82.326212923
Fax +82.326212940
www.fawoo.com
▲ Band 1, 421
● Band 1, 421

Felder KG
KR-Felder-Straße 1
6060 Hall in Tirol, Austria
Phone +43.5223.585030
www.felder.at
▲ Band 2, 350

feldmann+schultchen design studios
Himmelstraße 10–16
22299 Hamburg, Germany
Phone +49.40.510000
www.fsdesign.de
● Band 2, 123

Ferm b.v.
Postbus 3015
8003 CD Zwolle, Netherlands
Phone +31.38.385.2525
Fax +31.38.385.5077
www.ferm.com
▲ Band 2, 330–332

Festo AG & Co. KG
Ruiter Straße 82
73734 Esslingen, Germany
Phone +49.711.3474703
Fax +49.711.347544703
www.festo.com
▲ Band 2, 334–339
● Band 2, 334–339

FESTOOL GmbH
Wertstraße 20
73240 Wendlingen, Germany
Phone +49.7024.80420689
Fax +49.7024.80420727
www.festool.com
▲ Band 2, 369–370, 386, 391

Fischer Möbel GmbH
Dieselstraße 6
73278 Schlierbach, Germany
Phone +49.7021.72760
Fax +49.7021.727640
www.fischer-moebel.de
▲ Band 1, 476

Fishman
340-D Fordham Road
Wilmington, MA 1887, USA
Phone +1.978.9889199
Fax +1.978.9880770
www.fishman.com
▲ Band 1, 241

Fontana-Hunziker Design Office
Obere Bahnhofstrasse 62
8640 Rapperswil, Switzerland
Phone +41.55.5340080
www.fontana-hunziker.com
● Band 2, 249

Format Tresorbau GmbH & Co. KG
Industriestraße 10–24
37235 Hessisch-Lichtenau, Germany
Phone +49.5602.939602
Fax +49.5602.939720
www.format-tresorbau.de
▲ Band 1, 373
● Band 1, 373

Formation Design Group
555 Dutch Valley Road
Atlanta, GA 30324, USA
Phone +1.404.8851301
Fax +1.404.8851302
www.formationdesign.com
● Band 2, 413

formidable design
Kirchbergstraße 23a
85402 Braunschweig/Kranzberg,
Germany
Phone +49.8166.9955.52
Fax +49.8166.9955.53
www.formidable.de
● Band 1, 362

FRACKENPOHL POULHEIM
Im Stavenhof 20
50668 Köln, Germany
Phone +49.221.7158528
www.tfap.de
● Band 1, 113

FRATELLI GUZZINI S.p.A.
Contrada Mattonata, 60
62019 Recanati, Italy
Phone +39.071.9891
Fax +39.071.989363
www.fratelliguzzini.com
▲ Band 2, 129

Freecom Technologies BV
Laan van Zuid Hoorn 14
2289 De Rijswijk, Netherlands
Phone +31.70.3367686
Fax +31.70.3367688
www.freecom.com
▲ Band 1, 324

Nils Frederking
Lehderstraße 74–79
13086 Berlin, Germany
Phone +49.1776118925
www.nils-frederking.de
● Band 1, 428

Freudenberg Haushaltsprodukte KG
Vileda Professional
Mallaustraße 72
68217 Mannheim, Germany
Phone +49.6218.773164
Fax +49.6218.7735164
www.vileda.com
▲ Band 2, 387

fries & zumbühl
Industrial Design
Lessingstrasse 13
8002 Zürich, Switzerland
Phone +41.43.3335330
www.frieszumbuehl.ch
● Band 1, 426, 458–459

FROLI Kunststoffwerk GmbH & Co. KG
Liemker Straße 27
33758 Schloß Holte-Stukenbrock,
Germany
Phone +49.5207.95000
Fax +49.5207.95.00.61
www.froli.com
▲ Band 1, 454
● Band 1, 454

Frost A/S
Bavne Allé 6E
8370 Hadsten, Denmark
Phone +45.8761.0032
Fax +45.8761.0034
www.frostdesign.dk
▲ Band 1, 460

FSB
Franz Schneider Brakel GmbH + Co KG
Nieheimer Straße 38
33034 Brakel, Germany
Phone +49.5272.608105
Fax +49.5272.608312
▲ Band 2, 242, 257
● Band 2, 242, 257

FUJITSU DESIGN Ltd.
4-1-1, Kamiodanaka
Kawasaki-shi 211-8588, Japan
Phone +81.44.754.3476
● Band 1, 294

FUJITSU Ltd.
4-1-1, Kamiodanaka, Nakahara-ku
Kawasaki-shi 211-8588, Japan
Phone +81.44.433.5490
▲ Band 1, 294

Fujitsu Siemens Computers GmbH
Mies-van-der-Rohe-Straße 8
80807 München, Germany
Phone +49.89.620604435
Fax +49.89.620603294435
www.fujitsu-siemens.com
▲ Band 1, 293
▲ Band 2, 277
● Band 2, 293
● Band 2, 277

Funnyworks
Unit B-3213, Doosan We've pavilion,
Seongnam City 463-843, South Korea
Phone +82.31.785.3775
Fax +82.31.785.3776
www.fworks.co.kr
● Band 1, 453

fuseproject
528 Folsom Street
San Francisco, CA 94105, USA
Phone +1.415.9081492712
● Band 1, 143, 213, 369, 407, 436
● Band 2, 251–252, 431

FUTEC AG engineering
Selzacherstrasse 32
2545 Selzach, Switzerland
Phone +41.32.641.35.60
● Band 1, 74–75

G
Gaggenau Hausgeräte GmbH
Carl-Wery-Straße 34
81739 München, Germany
Phone +49.89.4590.2927
www.gaggenau.com
▲ Band 2, 27, 35–36, 49, 54, 61,
99–100, 116–117
● Band 2, 27, 35–36, 49, 54, 61,
99–100, 116–117

GazinCreate Co., Ltd.
4F-A No.29 Sec.3 ChunShan N.Road
Taipei 104, Taiwan
Phone +886.2.25921742
Fax +886.2.25923748
www.kedo.com.tw
▲ Band 2, 120

GE Healthcare
283, rue de la minière
78533 Buc Cedex, France
Phone +33.1.30704947
Fax +33.1.30709850
www.ge.com
▲ Band 2, 278
● Band 2, 278

Geberit International AG
Schachenstrasse 77
8645 Jona, Switzerland
Phone +41.55.2216100
www.geberit.com
▲ Band 2, 210

Genesis-design GmbH
Ponkratzstraße 67
80995 München, Germany
Phone +49.89.31221820
www.genesis-design.de
● Band 2, 383

Getama Danmark A/S
Holmmarkvej 5
9631 Gedsted, Denmark
Phone +45.98.645300
www.getama.dk
▲ Band 2, 258

GEWISS SPA
Via A. Volta, 1
24069 Cenate Sotto-Bergamo, Italy
Phone +39.35.946111
Fax +39.35.946250
www.gewiss.com
▲ Band 1, 420
▲ Band 2, 253
● Band 1, 420
● Band 2, 253

Roberto Giacomucci
Via Podesti, 54
60122 Ancona, Italy
Phone +33.367.55949
● Band 2, 137

Gira Giersiepen GmbH & Co. KG
Dahlienstraße
42477 Radevormwald, Germany
Phone +49.2195.602.0
Fax +49.2195.602339
www.gira.de
▲ Band 2, 225–227
● Band 2, 225–227

GKD – Gebr. Kufferath AG
ag4 media facade GmbH
Metallweberstraße 46
52353 Düren, Germany
Phone +49.2421.803.0
Fax +49.2421.803.227
www.creativeweave.de
▲ Band 2, 254

Glamü GmbH
Mobilstraße 2
79423 Heitersheim, Germany
Phone +49.7634.520.0
● Band 2, 174

GMC-I Messtechnik GmbH
Südwestpark 15
90449 Nürnberg, Germany
Phone +49.911.8602152
Fax +49.911.8602669
www.gossenmetrawatt.com
▲ Band 2, 385

Carsten Gollnick
Product Design / Interior Design
Bülowstrasse 66
10783 Berlin, Germany
Phone +49.30.21235856
Fax +49.30.21235857
www.gollnick-design.de
● Band 1, 127

GREENLAWN GARDEN
PRODUCTS CO.
7-7Fl., No.32, Chenggong Road, Sec.1
Taipei 115, Taiwan
Phone +886.2.2653.6600
Fax +886.2.2651.2277
http://greenlawn.myweb.hinet.net
▲ Band 1, 114
● Band 1, 114

Greggersen Gasetechnik GmbH
Bodestraße 27–29
21013 Hamburg, Germany
Phone +49.40.7393570
www.greggersen.de
▲ Band 2, 283

Konstantin Grcic Industrial Design
Schillerstraße 40
80336 München, Germany
Phone +49.89.55079995
Fax +49.89.55079996
www.konstantin-grcic.com
● Band 1, 433

Frank Greiser
Neupförtner Wall 21
33378 Rheda-Wiedenbrück, Germany
Phone +49.5242.982115
● Band 1, 475

Grohe AG
Feldmühleplatz 15
40545 Düsseldorf, Germany
Phone +49.211.91303221
Fax +49.211.91303921
www.grohe.com
▲ Band 2, 165, 186, 189,
196–197, 199
● Band 2, 165, 186, 189,
196–197, 199

Grundig Intermedia GmbH
Beuthener Straße 41
90471 Nürnberg, Germany
Phone +49.911.7037706
www.grundig.com
▲ Band 1, 204
● Band 1, 204

GS E&C
Gs Yeokjeon Tower, 537,
Namdaemun-ro, Joong-gu
Seoul 100-753, South Korea
Phone +82.2.2005.1114
www.gsconst.co.kr
▲ Band 1, 391–393
▲ Band 2, 255–256
● Band 1, 391–393
● Band 2, 76, 255–256

H
H.-D. SCHUNK GmbH & Co.
Spanntechnik KG
Lothringer Straße 23
88512 Mengen, Germany
Phone +49.7572.76141034
Fax +49.7572.76141039
www.schunk.com
▲ Band 2, 358

Habto Design
Rua Evaristo da Veiga, 95-Centro
20031-040 Rio de Janeiro – RJ, Brazil
Phone +55.21.9619.9621
www.habto.com
● Band 1, 470

Hang Zhou Onondo Appliances Inc.
by Joyoung
No.52, Road No.22, Economic and
Technological Development Area
Hang Zhou 310018, China
Phone +86.057181639126
▲ Band 2, 138

HANKOOK TIRE Ltd.
647-15 Yeoksam-dong
Seoul 135-723, South Korea
Phone +82.2.2222.1365
Fax +82.2.2222.1942
www.hankooktire.com
▲ Band 1, 55–56
● Band 1, 55–56

HANLIX Int'l Co., Ltd.
No.398, Sec.1, Jhongsing Road
Changhua County 509, Taiwan
Phone +886.47997699
Fax +886.47989995
www.hanlix.com
▲ Band 1, 124
● Band 1, 124

Hansaton Akustik GmbH
Stückenstraße 48
22081 Hamburg, Germany
Phone +49.40.2980110
Fax +49.40.29801128
www.hansaton.de
▲ Band 2, 310

Hansgrohe AG
Auestraße 5–9
77761 Schiltach, Germany
Phone +49.7836.51.0
Fax +49.7836.51.1300
www.hansgrohe.com
▲ Band 2, 167, 185, 187–188, 200

Harman Consumer Group, Inc.
8500 Balboa Boulevard
Northridge, CA 91329, USA
Phone +1.818.8953349
Fax +1.818.8959104
www.harman.com
▲ Band 1, 219

HAZET-WERK GmbH & Co. KG
Güldenwerther Bahnhofstraße 25
42857 Remscheid, Germany
Phone +49.2191.792251
Fax +49.2191.792499
www.hazet.de
▲ Band 2, 340
● Band 2, 340

Heidelberg Industrial Design
Speyerer Straße 4
69115 Heidelberg, Germany
Phone +49.6221.923326
Fax +49.6221.923329
www.design.heidelberg.com
● Band 2, 341

Heidelberg Postpress
Deutschland GmbH
Brahestraße 8
4347 Leipzig, Germany
Phone +49.6221.923326
Fax +49.6221.923329
www.heidelberg.com
▲ Band 2, 341

HEINE Optotechnik GmbH
Kientalstraße 7
82211 Herrsching, Germany
Phone +49.8152.380
www.heine.com
▲ Band 2, 282

Held+Team
Rehmstraße 3a
22299 Hamburg, Germany
Phone +49.40.4807075
www.helddesign.de
● Band 2, 279–285, 298

Helix Akantus Formgestaltung
GmbH & Co. KG
Am Mittelhafen 42–44
48155 Münster, Germany
Phone +49.251.97910.0
Fax +49.251.762277
www.akantus.de
● Band 2, 235

HELIX DESIGN
No.398, Sec.1, Jhongsing Road,
Shengang Township
Changhua 509, Taiwan
Phone +886.9.10458581
Fax +886.4.7989995
www.hanlix.com
● Band 1, 124

Henssler & Schultheiss
Fullservice Productdesign GmbH
Weissensteiner Straße 28
73525 Schwäbisch Gmünd, Germany
Phone +49.7171.927420
● Band 1, 463

Herbert Schultes Design
Rodelbahnstraße 1
82256 Fürstenfeldbruck, Germany
Phone +49.8141.530899
Fax +49.8141.530906
● Band 2, 194

Jonathan Herrle
Krausnickstraße 7
10115 Berlin, Germany
Phone +49.30.70240061
www.j-zwei.de
● Band 2, 422–423

Burkhard Heß
Suhrsweg 14
22305 Hamburg, Germany
Phone +49.40.6902807
● Band 1, 452

Hettich Marketing- & Vertriebs
GmbH & Co. KG
Vahrenkampstraße 12–16
32278 Kirchlengern, Germany
Phone +49.5223.77.0
▲ Band 1, 461–463
● Band 1, 461–462

Hewlett Packard
20555 SH 249
Houston, TX 77070, USA
Phone +1.281.5189958
www.hp.com
▲ Band 1, 332–333
● Band 1, 332–333

Hewlett Packard
10955 Tantau Ave
Cupertino, CA 95014, USA
Phone +1.541.7403988
▲ Band 1, 292, 298

Hilti Corporation
Feldkircherstrasse 100
9494 Schaan, Liechtenstein
Phone +423.234.2111
▲ Band 2, 322–328
● Band 2, 322–328

Hirschmann Laborgeräte
GmbH & Co. KG
Hauptstraße 7–15
74246 Eberstadt, Germany
Phone +49.713.451119
Fax +49.713.4511 90
www.hirschmannlab.de
▲ Band 2, 307

Hitachi Koki Co. Ltd.
1060 Takeda
HitaChinaka-City 312-8502,
Ibaraki-Pref., Japan
Phone +81.29.276.0326
www.hitachi-koki.co.jp
▲ Band 2, 342–343
● Band 2, 342–343

Holmegaard A/S
Slotemarken 1
2970 Hørsholm, Denmark
Phone +45.45.886633
▲ Band 2, 154–155
● Band 2, 154–155

HOLZAMMER
Kunststofftechnik GmbH
Am Ursprung 9
92369 Sengenthal, Germany
Phone +49.9181.295.0
Fax +49.9181.295.34
www.holzammer.de
▲ Band 2, 313

Horn/Majewski/Design
Horn & Majewski GbR
Bischofsweg 56
01099 Dresden, Germany
Phone +49.351.89960160
● Band 1, 355

Hostek Technologies Inc.
No. 51-3, San Kuang Lane, Beitun
District
Taichung 406, Taiwan
Phone +886.4.2236.2231
▲ Band 1, 120

Huawei Technologies
Haukadalsgatan 3
16494 Stockholm, Sweden
Phone +46.7.09264
▲ Band 1, 250, 275–276
● Band 1, 275

Huawei Technology Co., Ltd
No.7 Vision Software Park
Shenzhen 518057, China
Phone +867.5536836518
● Band 1, 344

Hubco Automotive Ltd.
iDesign
46 Parkhouse Road
8443 Christchurch, New Zealand
Phone +64.3.348.8828
Fax +64.3.348.1682
www.prorack.co.nz
▲ Band 1, 58
● Band 1, 58

Humanscale
11 E. 26th Street
New York, NY 10010, USA
Phone +1.800.4000625
Fax +1.212.7257545
www.humanscale.com
▲ Band 1, 410
● Band 1, 410

hymer-idc GmbH & Co. KG
Blücherstraße 32
75177 Pforzheim, Germany
Phone +49.7231.9568411
Fax +49.7231.9568410
www.hymer-idc.de
● Band 1, 60

Hyundai Engineering & Construction
Hyundai E&C Bldg, 140-2, Kye-dong
Seoul 110-920, South Korea
Phone +82.2.746.2680
Fax +82.2.746.4858
www.hdec.kr
▲ Band 2, 428–430
● Band 2, 428–430

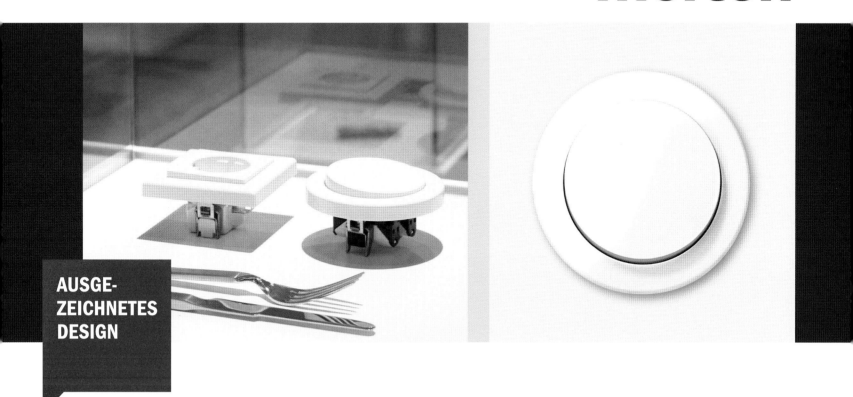

Hyundai Heavy Industries
Techno Design Institute
Mabuk-dong giheung-gu
Yongin-si 446-716, Gyeonggi-do,
South Korea
Phone +82.31.289.5367
▲ Band 2, 384
● Band 2, 384

HYUNDAI
TELECOMMUNICATION CO. Ltd.
Hyundai telecom Bldg., 4273-12,
Shingil-dong, Youngdeungpogu
Seoul 150-050, South Korea
Phone +82.2.2240.9121
Fax +82.2.2240.9100
www.hyundaitel.com
▲ Band 2, 230

I
I CONCI s.r.l. Unipersonale
Via Davide Albertario 30
61032 Bellocchi di Fano (PU), Italy
Phone +39.072.1855140
Fax +39.072.1854974
www.iconci.it
▲ Band 2, 177

IBM Corporation
3039 Cornwallis Rd
Research Triangle Park,
NC 27709, USA
Phone +1.919.5433151
● Band 1, 337–338

IBM Corporation
New Orchard Rd
Armonk, NY 10504, USA
Phone +1.914.4991900
▲ Band 1, 337–339

Icon 7 Inc.
8F, 475 Tiding Blvd., Sec. 2, Neihu
Taipei 114, Taiwan
Phone +886.2.8797.2577
www.icon7.com
▲ Band 1, 305

iConn Tecnologia
Rua Teixeira da Silva, 344, Paraíso
04002-031 São Paulo - SP, Brazil
Phone +55.11.32532044
www.iconn.com.br
▲ Band 2, 244

Ideas-Denmark
Brondbytoften 14
2605 Brondby, Denmark
Phone +45.33.455756
www.ideas-Denmark.com
▲ Band 2, 133
● Band 2, 133

IDEO
100 Forest Avenue
Palo Alto, CA 94301, USA
Phone +1.650.2893400
Fax +1.650.2893707
www.ideo.com
● Band 1, 302, 323

Ideo GmbH
Hochbrückenstraße 6
80331 München, Germany
Phone +49.89.3834670
Fax +49.89.3834670
www.ideo.com
● Band 1, 125, 293

iDesign Solutions
Level 1, 47 Mandeville Street,
Riccarton
PO Box 80087
Christchurch, New Zealand
● Band 1, 58

iGuzzini illuminazione
Via Mariano Guzzini 37
62019 Recanati, Italy
Phone +39.71.75881
www.iguzzini.com
▲ Band 1, 404

IKA-WERKE GMBH & CO.KG
Janke und Kunkel Straße 10
79219 Staufen, Germany
Phone +49.7633.831968
Fax +49.7633.831550
www.ika.de
▲ Band 2, 308
● Band 2, 308

ILIO
Turnacibasi Sok. Nese Apt.No.9/7,
Beyoglu
34433 Istanbul, Turkey
Phone +90.212.2512824
Fax +90.212.2448943
www.ilio.eu
▲ Band 1, 431
▲ Band 2, 135

Industrial Design Center
of Haier Group
No.1 Haier Road
Qingdao 266101, China
Phone +86.5.3288939923
www.haier.com
▲ Band 2, 63, 101, 198
● Band 2, 63, 101, 198

Industrial Technology Research
Institute
Bldg. 64, 195, Sec. 4, Chung Hsing
Rd., Chutung
Hsinchu 31040, Taiwan
▲ Band 2, 232, 432–433
● Band 2, 432–433

Ingersoll Rand Security Tech. A/S
Mirabellevej 3
8930 Randers NØ, Denmark
Phone +45.86.427522
www.randi.ingersollrand.com
▲ Band 2, 233

InnoDesign Inc.
61-3 Nonhyeon-dong, Gangnam-gu
Seoul 135010, South Korea
Phone +82.2.2017.4760
Fax +82.2.2017.4700
www.innodesign.com
● Band 1, 306–307

Innoman Inc.
61-3 Nonhyeon-dong, Gangnam-gu
Seoul 135010, South Korea
Phone +82.2.2017.4796
Fax +82.2.2017.4721
www.inno.co.kr
▲ Band 1, 306–307

Instituto Terressência
Rua Monte das Oliveiras n° 619
81825-180 Curitiba - PR, Brazil
Phone +55.51.98580993
www.terressencia.org.br
▲ Band 2, 304

Interstil
Liebigstraße 1–3
33803 Steinhagen, Germany
Phone +49.5204.913630
www.interstil.de
▲ Band 1, 475
● Band 1, 475

invenio GmbH Engineering Services
Eisenstraße 9
65428 Rüsselsheim, Germany
Phone +49.6142.899247
www.invenio.net
● Band 1, 372

IPEVO
3F, No.53, Bo-ai Road
Taipei 100, Taiwan
Phone +886.2.5550.8686
Fax +886.2.2382.0420
www.ipevo.com
▲ Band 1, 270
● Band 1, 270

ITALDESIGN
Via A. Grandi 25
10024 Moncalieri (Torino), Italy
Phone +39.11.6893311
● Band 1, 170

Itautec
Rua Wilhem Winter 301
13213000 Jundiaí – SP, Brazil
Phone +55.11.4531.9407
Fax +55.11.4531.9294
www.itautec.com
▲ Band 2, 243
● Band 2, 243

iTronics Co., Ltd.
Samsung technopark 305,
Wonchon-Dong 471
Suwon 443-824, South Korea
Phone +82.31.217.1063
Fax +82.31.217.1067
www.itronics.co.kr
▲ Band 1, 284

IXI s.r.l.
Via Carlo Bazzi 51
20141 Milano, Italy
Phone +39.2.89503021
Fax +39.2.89501462
www.ixisrl.com
● Band 1, 122

J
JAB TEPPICHE HEINZ ANSTOETZ KG
Dammheider Straße 67
32052 Herford, Germany
Phone +49.5221.77450
Fax +49.5221.77489
www.jab.de
▲ Band 1, 443–444

Jamo Denmark Aps
Ølandsvej 18
8800 Viborg, Denmark
Phone +45.99.767676
www.jamo.com
▲ Band 1, 224–225

JASPER MORRISON Ltd.
51 Hoxton Square
London N1 6PB, United Kingdom
Phone +44.2.077392522
www.jaspermorrison.com
● Band 2, 141

Johnson Electric
Saia-Burgess Halver GmbH
Weißenpferd 9
58553 Halver, Germany
Phone +49.2353.911.0
Fax +49.2353.911299
www.johnsonelectric.com
▲ Band 2, 354–355

Jonas Hultqvist Design
Citadellsvägen 23
211 18 Malmö, Sweden
Phone +46.706.792629
www.jonashultqvistdesign.se
● Band 1, 105

Josef Haunstetter Sägenfabrik KG
Im Tal 6 1/2
86179 Augsburg, Germany
Phone +49.8218.88871
Fax +49.8218.88874
www.haunstetter-saegenfabrik.de
▲ Band 2, 393

Joseph Vögele AG
Neckarauer Straße 168–228
68146 Mannheim, Germany
Phone +49.6218.1050
Fax +49.6218.105461
www.voegele-ag.de
▲ Band 2, 416–417

K
Martin Kahrs
Hermelingerstraße 12
28205 Bremen, Germany
Phone +49.89.208039347
www.combox.info
▲ Band 1, 477
● Band 1, 477

Kaindl Flooring GmbH
Kaindlstraße 2
5071 Wals/Salzburg, Austria
Phone +43.662.85883560
www.kaindl.com
▲ Band 1, 448
● Band 1, 448

Kaldewei
Beckumer Straße 33–35
59229 Ahlen, Germany
Phone +49.2382.785233
Fax +49.2382.785255
www.kaldewei.com
▲ Band 2, 169
● Band 2, 169

KÄSCH GmbH
Dorfstraße 2
85737 Ismaning, Germany
Phone +49.89.92989882
Fax +49.89.9612741
www.kaesch.net
▲ Band 2, 170
● Band 2, 170

KID Industrial design
1041/23 Soi Nailert Plenchit Rd.
10330 Bangkok, Thailand
Phone +66.2.559.2586
● Band 1, 474

King & Miranda Design S.r.l.
Via Savona 97
20144 Milano, Italy
Phone +39.02.48953851
www.kingmiranda.com
● Band 2, 203

Kiska GmbH
St. Leonharder Straße 2
5081 Anif, Austria
Phone +43.6246.734880
www.kiska.at
● Band 1, 52
● Band 2, 126, 328

Ralf Kittmann
Lönsstraße 9A
13125 Berlin, Germany
Phone +49.179.5199234
www.ralfkittmann.de
● Band 2, 422–423

KMC Chain Industrial Co., Ltd.
No.41, Chung Shan Road,
Hsin Hua Town
Tainan County 712, Taiwan
Phone +886.6.5900711
Fax +886.6.5801251
www.kmcchain.com
▲ Band 1, 80
● Band 1, 80

Knoend
427 Bryant St.
San Francisco, CA 94107, USA
Phone +1.415.2527662
Fax +1.415.2527348
www.knoend.com
▲ Band 1, 435
● Band 1, 435

Knog Pty Ltd.
252 Church Street
3121 Richmond, Australia
Phone +61.3.9428.6352
Fax +61.3.9428.6897
www.knog.com.au
▲ Band 1, 83–84, 385, 408

KODAS Design
Seochodong
Seoul 137-070, South Korea
Phone +82.2.585.8936
Fax +82.2.585.8938
www.kodasdesign.com
● Band 2, 246

Köhler & Wilms Products GbR
Kreishausstraße 11
32051 Herford, Germany
Phone +49.5221.1021889
● Band 2, 191

KOKUYO FURNITURE CO., Ltd.
6-1-1 Oimazato-minami
Osaka 537-8686, Japan
Phone +81.6.6976.0411
Fax +81.6.6972.9412
www.kokuyo.co.jp
▲ Band 1, 367
● Band 1, 367

Köra-Packmat Maschinenbau GmbH
Gewerbestraße 4
78667 Villingendorf, Germany
Phone +49.741.9283.0
Fax +49.741.9283.80
www.koera-packmat.de
▲ Band 2, 399

KT
17 Woomyeon-dong, Secho-gu
Seoul 137-792, South Korea
Phone +82.2.5266780
Fax +82.2.5266643
www.kt.com
▲ Band 1, 215

KTM Sportcar Produktion GmbH
Maggstraße 20
8042 Graz, Austria
Phone +43.316.405005
▲ Band 1, 52

Kuhn Rikon AG
Neschwilerstrasse 4
8486 Rikon, Switzerland
Phone +41.52.3960278
www.kuhnrikon.ch
▲ Band 2, 136
● Band 2, 136

Kunsthochschule Weißensee
Bühringstraße 20
13086 Berlin, Germany
Phone +49.30.47705244
www.kh-berlin.de
▲ Band 2, 422–423

Kurz Kurz Design
Productdesign Consulting
Engelsberg 44
42697 Solingen, Germany
Phone +49.212.336983
www.kurz-kurz-design.de
● Band 1, 397

Kverneland Group
Nuenenseweg 165
5567 KP Geldrop, Netherlands
Phone +31.40.289.33.00
▲ Band 2, 412

kymo GmbH
Karlstraße 32
76133 Karlsruhe, Germany
Phone +49.721.9614020
Fax +49.721.96140299
www.kymo.de
▲ Band 1, 446–447

L
LaCie
33 Blvd. General Martial Valin
75015 Paris, France
Phone +33.1.58495754
www.lacie.com
▲ Band 1, 331, 352

Laerdal Medical AS
Tanke Svilandsgate 30
4002 Stavanger, Norway
Phone +47.515.11760
www.laerdal.com
▲ Band 2, 309
● Band 2, 275, 309

Eva Langhans
Bunsenstraße 6
76135 Karlsruhe, Germany
Phone +49.721.784952
● Band 1, 446

Laufen Bathrooms AG
Wahlenstrasse 46, Verwaltung
4242 Laufen, Switzerland
Phone +41.61.7657612
Fax +41.61.7613660
www.laufen.com
▲ Band 2, 176

Lei Yueh Enterprise Co., Ltd.
3F, No.16, Section 2
Chung Yang South Road,
Beitou Taipei 112, Taiwan
Phone +886.2.2894.1226
Fax +886.2.2894.3315
www.leiyueh.com
▲ Band 1, 414
● Band 1, 414

Leica Geosystems
Heinrich-Wild-Strasse
9435 Heerbrugg, Switzerland
Phone +41.71.7273170
www.leica-geosystems.com
▲ Band 2, 363

LEICHT Küchen AG
Gmünderstraße 70
73550 Waldstetten, Germany
Phone +49.7171.402153
Fax +49.7171.402300
www.leicht.com
▲ Band 2, 156
● Band 2, 156

LengyelDesign
Rellinghauser Straße 332
45136 Essen, Germany
Phone +49.201.89536.0
www.lengyel.de
● Band 2, 250

interstuhl

Das schönste an einer Kopie ist, es gibt immer nur ein Original. Silver.

Silver. Einmalig echt. Product-Design: Hadi Teherani AG, Hans-Ullrich Bitsch, Ulrich Nether | Vom Sitzen verstehen wir mehr. Interstuhl · Brühlstraße. 21 D-72469 Meßstetten-Tieringen · Phone: +49-7436-871-0 · Fax +49-7436-871-110 · info@interstuhl.de · www.interstuhl.de · www.silver-chair.net

Lepper Schmidt Sommerlade
Hegelsbergstraße 21
34127 Kassel, Germany
Phone +49.561.8900536
● Band 1, 366

LG Electronics Inc.
GS Gangnam Tower. 679
Yeoksam-dong, Gangnam-gu
Seoul 135-985, South Korea
Phone +82.2.2005.3616
Fax +82.2.2005.3115
www.lge.com
▲ Band 1, 188–189, 202, 254–256
▲ Band 2, 102
● Band 1, 188–189, 202, 254–256
● Band 2, 102

LG-Nortel Co., Ltd.
GStower 679 Yoksam-dong,
Kangnam-gu
Seoul 135-985, South Korea
Phone +82.2.3777.1114
Fax +82.2.2005.2129
www.lg-nortel.com
▲ Band 1, 281

Li, Jianye
3/F Philips Building, 5# HKSP
Shatin, Hong Kong
Phone +852.6.7079005
www.labexp.blogspot.com
▲ Band 2, 159
● Band 2, 159

Lia Siqueira
Rua Lopes Quintas 642
22460-010 Rio de Janeiro, Brazil
Phone +55.21.25408646
● Band 1, 451

Lin, Tiger
No.161-60, Kong-Chen Road
Chin-Sui Town, Taichung County 436,
Taiwan
Phone +886.937737933
● Band 2, 371–372

LINDBERG
Bjarkesvej 30
8230 Aabyhoj, Denmark
Phone +45.87.444000
www.lindberg.com
▲ Band 1, 137
● Band 1, 137

Lite-On Technology Corp.
21F, 392 Ruey Kuang Rd, Neihu
Taipei 114, Taiwan
Phone +886.2.879828886500
▲ Band 1, 144

Loc8tor Limited
Devonshire House,
404-406 Finchley Road
London NW2 2HZ, United Kingdom
Phone +44.207.4311111
www.loc8tor.com
▲ Band 1, 121
● Band 1, 121

Loewe AG
Industriestraße 11
96317 Kronach, Germany
Phone +49.9261.990
www.loewe.de
▲ Band 1, 190–192

Loofenlee Co., Ltd.
654-3 11th FL.Plaza Buildig
Yeoksam-dong, Gangnal-gu
Seoul 135080, South Korea
Phone +82.5.574488
www.loofen.com
▲ Band 2, 121
● Band 2, 121

Lothar Böhm GmbH
Grosse Elbstraße 281
22767 Hamburg, Germany
Phone +49.40.3910080
● Band 2, 271

LTS Licht und Leuchten GmbH
Waldesch 24
88069 Tettnang, Germany
Phone +49.7542.9307
www.lts-online.de/httpdocs/index.php
▲ Band 1, 398
● Band 1, 398

Lumini
Ferreira Viana 786
04761-010 São Paulo - SP, Brazil
Phone +55.11.3437.5555
Fax +55.11.3437.5556
www.lumini.com.br
▲ Band 1, 386, 396
● Band 1, 386, 396

LUNAR Europe GmbH
Baaderstraße 41
80469 München, Germany
Phone +49.89.13927620
Fax +49.89.13927621
www.lunar-europe.com
● Band 2, 277

Lundgaard & Tranberg Arkitekter
Pilestræde 10, 3
1112 København K, Denmark
Phone +45.33.910717
www.ltarkitekter.dk
● Band 2, 258

Lyra Bleistiftfabrik GmbH
Willstätter Straße 54-56
90449 Nürnberg, Germany
Phone +49.911.6805.0
▲ Band 1, 362

M

MAGNA STEYR
Fahrzeugtechnik AG & Co. KG
Liebenauer Hauptstraße 317
8041 Graz, Austria
Phone +43.316.4042325
Fax +43.316.4044918
www.magnsteyr.com
▲ Band 2, 427
● Band 2, 427

Magppie Retail Ltd.
400 GD ITL North Ex. Towers, A-9,
Netaji Subhash Place, Pitampura
Delhi 110088, India
Phone +91.11.27353566
▲ Band 2, 137

Industrie Design
Marco Meier
Bergstraße 182
51519 Odenthal, Germany
Phone +49.2174.894753
www.design-berater.de
● Band 2, 354–355

manzana
Wittebroodhof 30a
9052 Gent, Belgium
Phone +32.495.239652
www.manzana.net
● Band 2, 234

Maquet Cardiopulmonary AG
Lotzenäckerstraße 25
72379 Hechingen, Germany
Phone +49.7478.921209
www.maquet.com/cardiopulmonary
▲ Band 2, 276

Megabox Design e Soluções
Av. São Sebastião , No.1213 Centro
83420-000 Curitiba - PR, Brazil
Phone +55.41.3672.3663
www.megaboxdesign.com.br
● Band 2, 382

Metabowerke GmbH
Metabo-Allee 1
72622 Nürtingen, Germany
Phone +49.7022.722261
Fax +49.7022.722731
www.metabo.de
▲ Band 2, 345–347

Meyerhoffer Inc.
1241 Main Street
Montara, CA 94037, USA
Phone +1.650.4550061
www.meyerhoffer.com
● Band 2, 201

Miele & Cie. KG
Carl-Miele-Straße 29
33332 Gütersloh, Germany
Phone +49.5241.894191
Fax +49.5241.4140
www.miele.de
▲ Band 2, 12, 103–105, 118, 388–390
● Band 2, 12, 103–105, 118, 388–390

Mindsailors, Starline Polska
Sp. z o.o.
Wielka 8/2
61-774 Poznan, Poland
Phone +48.61.8530714
www.mindsailors.com
● Band 1, 329

Mirae Company
Baekseok-Dong
Cheonan-Si 330-220, South Korea
Phone +82.41.621.5070
www.mirae.com
▲ Band 2, 375

Mitac International Corp.
6TH FL., NO. 187, SEC. 2, TIDING BL
Taipei 114, Taiwan
Phone +886.2.2627.1188
www.mitac.com
▲ Band 1, 242, 283
● Band 1, 242, 283

ML Magalhaes
Rua Maria Rodrigues, 65 – Olaria
21031-490 Rio de Janeiro – RJ, Brazil
Phone +55.21.2560.5446
www.mlmagalhaes.com.br
▲ Band 1, 470

.molldesign
Turmgasse 7
73525 Schwäbisch-Gmünd, Germany
● Band 1, 145

Mo.T.I.S. GmbH
Blücherstraße 32
75177 Pforzheim, Germany
Phone +49.7231.9568411
Fax +49.7231.9568410
www.motis.org
▲ Band 1, 60

Mobi
Yalova Yolu 14. km. Sanayi Cad.
16335 Bursa, Turkey
Phone +90.224.267.06.48
Fax +90.224.267.06.51
www.mobi.com.tr
▲ Band 1, 439
● Band 1, 439

MobiSolution Co., Ltd.
848-16, Gupyeong-dong
Gumi-city, Gyeongbuk 730-300,
South Korea
Phone +82.54.474.2254
Fax +82.54.474.2251
www.mobifren.com
▲ Band 1, 272
● Band 1, 272

Motorola Enterprise Mobility
1 Motorola Plaza
Holtsville, NY 11742, USA
Phone +1.631.7384660
www.business.motorola.com
▲ Band 2, 402
● Band 2, 402

Motorola Government & Public Safety
8000 W. Sunrise Blvd.
Plantation, FL 33322, USA
Phone +1.954.7235063
Fax +1.954.7238004
http://business.motorola.com/MO-
TOA4/index.html
● Band 1, 285

Motorola, Inc.
1303 E Algonquin Road, Fl.4
Schaumburg, IL 60196, USA
Phone +1.312.3310242
Fax +1.847.5380223
www.motorola.com/government
▲ Band 1, 285

MOZART AG
Schmalzgraben 15
42655 Solingen, Germany
Phone +49.212.2209130
Fax +49.212.208663
www.mozart-blades.de
▲ Band 2, 348

Mueller Eletrodomésticos
Rua Fritz Lorenz, 1481
89120-000 Timbó - SC, Brazil
Phone + 55.47.3281.2040
www.mueller.ind.br
▲ Band 2, 87

Mundial S.A.
Visconde de Pelotas, 360
91030-530 Gravataí - RS, Brazil
Phone +55.11.37413669
Fax +55.11.37413669
www.mundial-sa.com.br
▲ Band 2, 86

N
Naoto Fukasawa Design
5-17-20-4, Jingumae
Tokyo 150-0001, Japan
Phone +81.3.54683677
Fax +82.3.54683678
● Band 1, 210, 374

Native Design Ltd
5 Garden Walk
London EC2A 3EQ, United Kingdom
Phone +44.20.7033.4888
www.native.com
● Band 1, 243

NEC Corporation
1753, Shimonumabe, Nakahara-Ku
Kawasaki, Kanagawa 211-8666, Japan
Phone +81.44.455.8043
Fax +81.44.455.8123
▲ Band 1, 265

NEC Design Ltd.
Shinagawa Seaside East Tower, 4-12
Tokyo 140-0002, Japan
Phone +81.3.5463.3565
● Band 1, 265

NEC Display Solutions GmbH
Landshuter Allee 12-14
80637 München, Germany
Phone +49.89.99699.216
www.nec-display-solutions.com
▲ Band 1, 210

NEC Display Solutions Ltd.
686-1, Nishioi, Oi-machi
Kanagawa 258-8533, Japan
Phone +81.465.85.2330
Fax +81.465.85.2438
▲ Band 1, 303
● Band 1, 303

Hulusi Neci
Hurriyet Mah. E5 yanyol uzeri
34876 Istanbul, Turkey
www.necidesign.com
● Band 2, 209

nendo
2-2-16-5F Shimomeguro
Tokyo 153-0064, Japan
Phone +81.3.6661.3750
Fax +81.3.6661.3751
www.nendo.jp
● Band 1, 434

New | Comunicação 360
Rua Antonio de Albuquerque 273
30112-010 Belo Horizonte - MG, Brazil
Phone +55.31.21082225
www.new360.com.br
● Band 1, 471

Nichetto & Partners s. a. s.
Via BanChina dell'Azoto, 15/D
30175 Porto Marghera, Venezia, Italy
Phone +39.041.925825
Fax +39.041.5090278
● Band 2, 129

Josef Niedermeier
Hesseloherstraße 3
80802 München, Germany
Phone +49.179.5224666
www.j-zwei.de
● Band 2, 422–423

Nikon Corporation
Shinagawa-ku Nishi-ohi 1-6-3
140-8601 Tokyo, Japan
Phone +81.3.3773.7350
www.nikon.com
▲ Band 1, 170
● Band 1, 170

NOA GbR
Bendstraße 50-52
52066 Aachen, Germany
Phone +49.241.972001.0
Fax +49.241.972001.20
www.noa.de
● Band 2, 131

Nódesign
Rua Harmonia, 789
05435-000 São Paulo - SP, Brazil
Phone +55.41.38148939
www.nodesign.com.br
● Band 1, 472

Nokia
Keilalahdentie 2–4
45 Espoo, Finland
Phone +358.71.8008000
▲ Band 1, 267–269
● Band 1, 267–269

Nordwind Energieanlagen GmbH
Lindenstraße 63
17033 Neubrandenburg, Germany
Phone +49.3957616531
▲ Band 2, 357

NOSE AG Design Intelligence
Hardturmstrasse 171
8005 Zürich, Switzerland
Phone +41.44.277.57.60
Fax +41.44.277.57.12
www.nose.ch
● Band 1, 74–75
● Band 2, 247–248

npk design
Noordeinde 2 d
2311 CD Leiden, Netherlands
Phone +31.71.5141341
Fax +31.71.5130410
www.npk.nl
● Band 2, 349

NTEC
745, Banpo-dong, Seocho-gu
Seoul 137-040, South Korea
Phone +82.2.3218.7661
www.ntec.co.kr
▲ Band 2, 76
● Band 2, 76

Nurus A.S.
Büyükdere cad. Karakol sok. No.2,
Levent
34330 Istanbul, Turkey
Phone +90.212.2696300
Fax +90.212.2799979
www.nurus.com
▲ Band 1, 438

Nusharp Inc.
No.13, 32nd Road,
Taichung Industrial Park
Taichung 407, Taiwan
Phone +886.4.2355.1133
www.nusharp.com.tw
▲ Band 2, 371–372

Nya Nordiska Textiles GmbH
An den Ratswiesen 4
29451 Dannenberg, Germany
Phone +49.5861.809400
Fax +49.5861.80912
www.nya.com
▲ Band 1, 464–469
● Band 1, 464–469

O

o.d.m. design & marketing ltd.
Rm 2701, Saxon Tower, 7 Cheung
Shun St., Cheung Sha Wan, Hong Kong
Phone +852.36052127
Fax +852.22429083
www.odm-design.com
▲ Band 1, 109
● Band 1, 109

Oce Technologies Bv
PO box 101
5900 MA Venlo, Netherlands
Phone +31.77.359.2407
www.oce.com
▲ Band 2, 403
● Band 2, 403

O-D Works Inc.
He 131-1, Oki-machi, Komatsu-shi
Ishikawa 923-0861, Japan
Phone +81.761.24.0906
● Band 1, 320

Odenwälder Kunststoffwerke
Gehäusesysteme GmbH
Friedrich-List-Straße 3
74722 Buchen, Germany
Phone +49.6281.404150
Fax +49.6281.404170
www.okw.com
▲ Band 2, 404

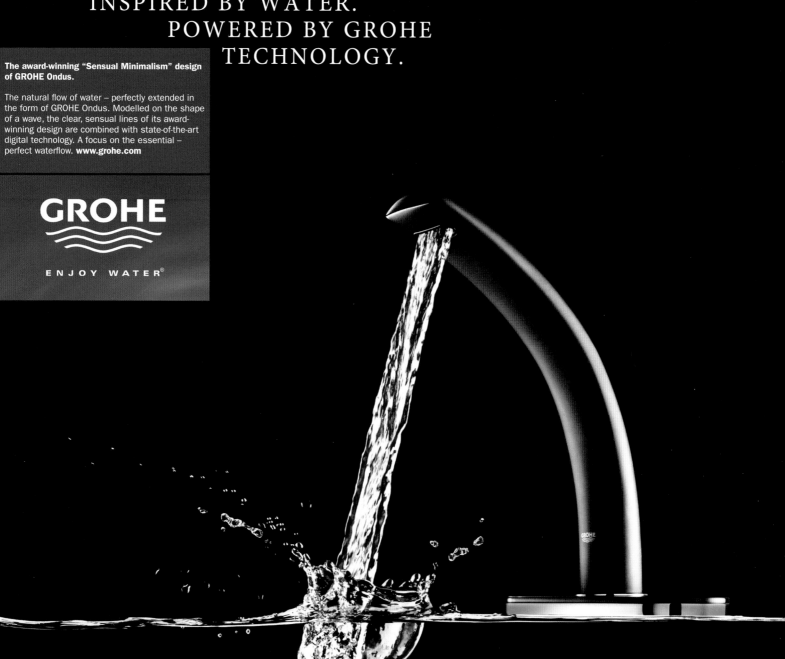

INSPIRED BY WATER.
POWERED BY GROHE
TECHNOLOGY.

The award-winning "Sensual Minimalism" design of GROHE Ondus.

The natural flow of water – perfectly extended in the form of GROHE Ondus. Modelled on the shape of a wave, the clear, sensual lines of its award-winning design are combined with state-of-the-art digital technology. A focus on the essential – perfect waterflow. **www.grohe.com**

GROHE

ENJOY WATER®

Olympus Imaging Corporation
2951 Ishikawa-cho
Hachioji Tokyo 192-8507, Japan
Phone +81.42.642.2111
● Band 1, 173

Olympus Imaging Corporation
Wendenstrasse
20097 Hamburg, Germany
Phone +49.40.23773.4165
Fax +49.40.23773.5457
www.olympus-europa.com
▲ Band 1, 173

Olympus Winter + Ibe GmbH
Kuehnstraße 61
22045 Hamburg, Germany
Phone +49.40.669660
▲ Band 2, 280–281, 285

OMRON HEALTHCARE Co., Ltd.
24, Yamanouchi Yamanoshita-cho,
Ukyo-ku
Kyoto 615-0084, Japan
Phone +81.75.322.9322
www.healthcare.omron.co.jp
▲ Band 2, 292–293

One Laptop per Child
One Cambridge Center
Cambridge, MA 2142, USA
Phone +1.617.8884518
● Band 2, 431

ORNAMIN Kunststoffwerke
W. Zschetzsche GmbH & Co. KG
Kuckuckstraße 20a–26
32427 Minden, Germany
Phone +49.5718.880875
www.ornamin-provita.com
▲ Band 2, 273
● Band 2, 273

Ortovox Sportartikel GmbH
Rotwandweg 5
82024 Taufkirchen, Germany
Phone +49.89.666740
▲ Band 1, 113

Oscar Tusquets Blanca
Cavallers 50
8034 Barcelona, Spain
Phone +34.93.206.5580
www.tusquets.com
● Band 1, 442

Otis Elevator Korea
7F, Kukdong Bldg. 60-1
Seoul 100-705, South Korea
Phone +82.2.6007.3392
Fax +82.2.6007.3479
www.otis.com
▲ Band 2, 214
● Band 2, 214

Otto Bock HealthCare GmbH
Max-Näder-Straße 15
37115 Duderstadt, Germany
Phone +49.5527.8481218
Fax +49.5527.8481502
www.ottobock.de
▲ Band 2, 272, 294–295
● Band 2, 272, 294–295

OXO International
601 West 26th Street, Suite 1050
New York, NY 10001, USA
Phone +1.212.2423333
▲ Band 2, 149

P
Pacific Cycles, Inc.
236, Hsia Chuan Tze, Yung An,
Hsin Wu
Taoyuan 327, Taiwan
Phone +886.3.4861231
Fax +886.3.4861215
www.pacific-cycles.com
▲ Band 1, 73
● Band 1, 73

PADO S/A
Rua do Sol, 84 - Parque Maracanã
86185-670 Cambé - PR, Brazil
Phone +55.43.3249.1100
Fax +55.43.3249.1100
www.pado.com.br
▲ Band 2, 220

Panasonic Corporation
Design Company
1-15, Matsuo-cho
Kadoma City, Osaka 571-8504, Japan
Phone +81.6.6905.4094
▲ Band 1, 132, 171–172, 180–182,
196, 206, 209, 216–217, 234,
300–301, 387
● Band 1, 132, 171–172, 180–182,
196, 206, 209, 216–217, 234,
300–301, 387

Panasonic Corporation
4-3-1 Tsunashima-higashi, Kohoku-ku
Yokohama 223-8639, Japan
● Band 2, 259

Panasonic Electric Works Co., Ltd.
1048 Kadoma
Osaka 571-8686, Japan
Phone +81.6.6908.0102
Fax +81.6.6906.4579
▲ Band 1, 395, 411–412
▲ Band 2, 231
● Band 1, 395, 411–412
● Band 2, 231

Panasonic System Solutions Company
4-3-1 Tsunashima-higashi, Kohoku-ku
223-8639 Yokohama, Japan
▲ Band 2, 259

Pano Logic Corporation
1350 Willow Rd., No.201
Menlo Park, CA 94025, USA
Phone +1.650.7996388
▲ Band 1, 341

Parrot
174 quai de Jemmapes
75010 Paris, France
Phone +33.1.48.036093
Fax +33.1.48.037008
www.parrot.com
▲ Band 1, 179, 273–274
● Band 1, 179, 274–274

PATRICK FREY Industrial Design
Ratswiese 18
30453 Hannover, Germany
Phone +49.511.3378791
Fax +49.511.3378792
www.patrick-frey.com
● Band 2, 122

Paulmann Licht GmbH
Quezinger Feld 2
31832 Springe, Germany
Phone +49.5041.998256
www.paulmann.de
▲ Band 1, 413
● Band 1, 413

Paulo Dias Design
Rua Guilherme Pugsley, 1468, ap 21
80620-000 Curitiba - PR, Brazil
Phone +55.41.32434961
www.terressencia.org.br
● Band 2, 304

PC Cox Limited
Turnpike Industrial Estate
Newbury RG14 2LR, United Kingdom
Phone +44.163.5264500
Fax +44.163.5264555
www.pccox.co.uk
▲ Band 2, 376
● Band 2, 376

PDD Group Ltd.
85-87 Richford Street
London W6 7HJ, United Kingdom
Phone +44.20.87351111
www.pdd.co.uk
● Band 2, 311

pearl creative industrial design
Königsallee 57
71636 Ludwigsburg, Germany
Phone +49.7141.4887490
www.pearlcreative.com
● Band 2, 157

Pentagram
387 Tehama Street
San Francisco, CA 94103, USA
Phone +1.415.8960499
● Band 1, 296, 356

PFU Limited
Nu 98-2, Unoke, Kahoku-shi
Tokyo 929-1192, Japan
Phone +81.76.283.1212
www.pfu.fujitsu.com
▲ Band 1, 320

PFU TECHNOCONSUL Limited
Nu 98-2, Unoke, Kahoku-shi
Ishikawa 929-1192, Japan
Phone +81.76.283.8600
● Band 1, 320

Philips Electronics
5 Science Park East Avenue
Shatin, Hong Kong
Phone +852.2.4896797
▲ Band 1, 304
● Band 1, 304

Philips Design
Emmasingel 24
5611 AZ Eindhoven, Netherlands
Phone +31.40.2759066
www.design.philips.com
▲ Band 2, 435
● Band 1, 136, 153, 184–187, 199,
214, 222, 228, 230, 282, 416
● Band 2, 275, 286–291, 435

Philips Healthcare Cardiac Care
2301, 5th Ave, Suite 200
Seattle, WA 98121-1825, USA
● Band 2, 275

Philips Design Seattle
2301, 5th Ave, Suite 200
Seattle, WA 98121, USA
● Band 2, 309

Phoenix Design GmbH & Co. KG
Kölner Straße 16
70376 Stuttgart, Germany
Phone +49.7119559760
www.phoenixdesign.de
● Band 2, 167, 187–188, 200, 215,
225, 227, 307

Pilotfish GmbH
Schleissheimer Straße 6
80333 München, Germany
Phone +49.89.12021894
Fax +49.89.12021899
www.pilotfish.eu
● Band 2, 310

Pilotfish Inc.
5F-1, No.501 Section 2, Tiding Blvd.
NeiHu Taipei, Taiwan
Phone +886.2.26591226
Fax +886.2.26598524
www.pilotfish.eu
● Band 2, 310

Pioneer Design Corporation
4-1, Meguro 1-Chome, Meguro-ku
Tokyo 153-8654, Japan
Phone +81.3.3495.9990
Fax +81.3.3495.5087
www.pioneer.jp
▲ Band 1, 195, 197, 226
● Band 1, 195, 197, 226

piu products
Max-Keith-Straße 33
45136 Essen, Germany
Phone +49.201.8965295
Fax +49.201.8965398
www.piuproducts.com
● Band 2, 387

Plank Collezioni srl.
Via Nazionale 35
39040 Ora (BZ), Italy
Phone +39.047.1803500
Fax +39.047.1803599
www.plank.it
▲ Band 1, 433

Plantronics
Gildenweg 7
50354 Hürth, Germany
Phone +49.2233.399319
▲ Band 1, 271

Plantronics Design
345 Encinal Street
Santa Cruz, CA 95060, USA
Phone +1.831.4587700
● Band 1, 271

plato.designgroup
Pappenheimstraße 9
80335 München, Germany
Phone +49.89.54506676
www.plato.designgroup.de
● Band 2, 350

Polar Electro Oy
Professorintie 5
90440 Kempele, Finland
Phone +358.8.5202.100
Fax +358.8.5202.331
www.polar.fi
▲ Band 1, 106
● Band 1, 106

Poly-clip System GmbH & Co. KG
Westerbachstraße 45
60489 Frankfurt a. M., Germany
Phone +49.69.7806341
www.polyclip.com
▲ Band 2, 351

Polyconcept Hong Kong Ltd.
CP Centrum für Prototypenbau GmbH
Straßburger Allee 15
41812 Erkelenz, Germany
Phone +49.2431.96350
▲ Band 2, 123

polyform Industrie Design
Pappenheimstraße 9
80335 München, Germany
Phone +49.89.596181
www.polyform-design.de
● Band 2, 404

Neil Poulton
3 Passage Turquetil
75011 Paris, France
Phone +33.1.40242022
www.neilpoulton.com
● Band 1, 352

Power Quotient International Co., LTD.
14F, No. 16, Jian Ba Road
Chung Ho City, Taipei 235, Taiwan
Phone +886.2.8226.5288
Fax +886.2.8226.3999
http://www.pqi.com.tw
▲ Band 1, 350
● Band 1, 350

Produktdesign
Tesseraux+Partner
Wilhelm-Staab-Straße 5
14467 Potsdam, Germany
Phone +49.331.2016777
● Band 2, 28–34, 50, 25–53, 68,
226, 228

Profit Master Displays Inc.
6151 Powers Perry Road Suite 625
Atlanta, GA 30339, USA
Phone +1.770.9841400
▲ Band 2, 251

Proform Design
Seehalde 16
71364 Winnenden, Germany
Phone +49.7195.919100
www.proform-design.de
● Band 2, 324–327

PROTOOL GmbH
Wertstraße 20
73240 Wendlingen, Germany
Phone +49.7024.80420609
www.protooll.de
▲ Band 2, 366–368

PULS Design und Konstruktion
Nieder-Ramstädter Straße 247
64285 Darmstadt, Germany
Phone +49.6151.428768.13
www.puls-design.de
● Band 2, 274, 351

Q

Qisda Corporation
18 Jihu Road, Neihu
Taipei 114, Taiwan
Phone +886.2.2799.8800
Fax +886.2.2656.6258
www.qisda.com
▲ Band 1, 201, 318, 342–343, 415

QisDesign
18 Jihu Road, Neihu
Taipei 114, Taiwan
Phone +886.2.27998800
● Band 1, 201, 318, 342–343, 415

qixen-p design
Dubravnaya 36, ap 336
125368 Moscow, Russian Federation
Phone +79169986831
www.qixen-p.com
● Band 1, 108

Questto Design
Rua Cotoxó 303-cj 38
05021-000 São Paulo - SP, Brazil
Phone +55.11.3875.5552
www.questtodesign.com.br
● Band 1, 62
● Band 2, 244

R

R.STONE INTERNATIONAL Ltd.
2/F Eton Tower
Causeway Bay Hong Kong,
Hong Kong
Phone +852.82084200
Fax +852.23685093
www.hand3.net
▲ Band 1, 119, 277
● Band 1, 119, 277

RASTAL GmbH & Co. KG
Rastal-Straße 1
56203 Höhr-Grenzhausen, Germany
Phone +49.2624.16192
Fax +49.2624.16215
www.rastal.com
▲ Band 2, 134
● Band 2, 134

raumplus GmbH & Co. KG
Dortmunderstaße 35
28199 Bremen, Germany
Phone +49.421.579500
www.raumplus.de
▲ Band 1, 452

Reigncom Limited
7F Iriver House, 902-5
Seoul 137-842, South Korea
Phone +82.2.30191700
Fax +82.2.30197578
www.reigncom.com
▲ Band 1, 236–237, 353–354
● Band 1, 236–237, 353–354
▲ Band 2, 434
● Band 2, 434

repaBAD GmbH
Bosslerstraße 13–15
73240 Wendlingen, Germany
Phone +49.7024.941117
Fax +49.7024.9411917
www.repabad.com
▲ Band 2, 168

Revo Technologies Ltd.
The Inox Building
Lanark ML11 7SR, United Kingdom
Phone +44.1555.66.61.61
Fax +44.1555.66.33.44
www.revo.co.uk
▲ Band 1, 238
● Band 1, 238

Ricoh Co., Ltd.
Corporate Design Center
3-2-3, Shin-Yokohama
Yokohama-shi 222-8530, Japan
Phone +81.45.4771769
● Band 1, 174–175

Ricoh Europe (Netherlands) B.V.
P.O. Box 114
1180 AC Amstelveen, Netherlands
Phone +31.20.5474141
Fax +31.20.5474222
▲ Band 1, 174–175

Rightning, Inc.
2-21-21 Nishiazabu
Tokyo 106-0031, Japan
Phone +81.3.3406.1337
Fax +81.3.3406.1338
www.rightning.com
▲ Band 1, 327
● Band 1, 327

RK DESIGN Optik GmbH
Forchenrain 11/2
71263 Weil der Stadt, Germany
Phone +49.7033.544826
Fax +49.7033.544828
www.rk-design.de
▲ Band 1, 128
● Band 1, 128

Robert Bosch Hausgeräte GmbH
Postfach 830101
81701 München, Germany
Phone +49.89.4590.02
Fax +49.89.4590.4250
www.bosch-hausgeraete.de
▲ Band 2, 19–26, 37–44, 47–48,
55–59, 64–67, 69–74, 80–82, 88–92,
106–109, 139
● Band 2, 19, 21–26, 37–44, 47–48,
55–59, 64–67, 69–74, 80–82, 88–92,
106–109, 139

Auf die inneren Werte kommt es an. Und die erkennt man am ausgezeichneten Design.

The excellent exterior design speaks of the qualities within.

VIESSMANN

climate of innovation

Robert Bürkle GmbH
Stuttgarter Straße 123
72250 Freudenstadt, Germany
Phone +49.7441.58307
▲ Band 2, 397

Rohde AG
Industriestraße 9
37176 Nörten-Hardenberg, Germany
Phone +49.5503.9860.0
Fax +49.5503.9860.11
www.rohde-technics.com
▲ Band 2, 352, 353
● Band 2, 352, 353

Rokitta, Produkt & Markenästhetik
Kölner Straße 38a
45481 Mühlheim a.d. Ruhr, Germany
Phone +49.208.8992770
Fax +49.208.8992779
www.rokitta.de
● Band 2, 270, 312

Roland Corporation
2036-1 Nakagawa, Hosoe-cho,
Kita-ku
Hamamatsu, Shizuoka 431-1304,
Japan
Phone +81.53.523.1109
Fax +81.53.523.0257
www.roland.com
▲ Band 1, 146
● Band 1, 146

Ronald Schmitt Tische GmbH
Gretengrund 3
69412 Eberbach, Germany
Phone +49.6271.9490
www.ronald-schmitt.com
▲ Band 1, 437

rose plastic AG
Rupolzer Straße 53
88138 Hergensweiler, Germany
Phone +49.8388.9200.27
Fax +49.8388.9200.58
www.rose-plastic.de
▲ Band 2, 405
● Band 2, 405

Rosendahl A/S
Slotsmarken 1
2970 Hørsholm, Denmark
Phone +45.45.88.6633
▲ Band 2, 140
● Band 2, 140

Roset Möbel GmbH
Industriestraße 51
79194 Gundelfingen, Germany
Phone +49.761.5920913
Fax +49.761.581518
www.ligne-roset.de
▲ Band 1, 428

Röthlisberger AG
Gewerbestrasse 7
3535 Schüpbach, Switzerland
Phone +41.34.4977287
Fax +41.34.4977270
www.roethlisberger-ag.ch
▲ Band 1, 426

Röthlisberger Schreinerei AG
Sägeweg 11
3073 Gümligen, Switzerland
Phone +41.31.9502140
Fax +41.31.9502149
www.roethlisberger.ch
▲ Band 1, 429, 455–456

Royal Philips Electronics
Emmasingel 24
5611 AZ Eindhoven, Netherlands
Phone +31.40.2759066
Fax +31.40.2759059
www.design.philips.com
▲ Band 1, 136, 153, 184–187,
199, 214, 222, 228, 230, 275, 282,
288–291, 416

Ryohin Keikaku Co., Ltd.
4-26-3 Higashi-Ikebukuro, Toshima-k
Tokyo 170-8424, Japan
Phone +81.3.3988.4028
www.muji.co.jp
▲ Band 1, 383
▲ Band 2, 141
● Band 1, 383

S
S. Siedle & Söhne
Telefon- und Telegrafenwerke
Bregstraße 1
78120 Furtwangen, Germany
Phone +49.7723.63274
www.siedle.de
▲ Band 2, 218
● Band 2, 218

Sahm GmbH & Co. KG
Westerwaldstraße 13
56203 Höhr-Grenzhausen, Germany
Phone +49.2624.18848
www.sahm.de
▲ Band 2, 143

SAMSUNG C&T
8th Fl., Samsung C&T Bldg., 1321-20
137-857 Seoul, South Korea
Phone +82.2.2145.7288
www.secc.co.kr
▲ Band 2, 164, 183
● Band 2, 164, 183

Samsung Electronics
14th Fl., Jungang-Ilbo Bldg.7
Soonwha-dong, Jung-gu
Seoul 100-759, South Korea
Phone +82.2.750.9237
Fax +82.2.750.9425
▲ Band 1, 159–160, 257–260, 295,
308–310
▲ Band 2, 13, 110, 208
● Band 1, 159–160, 257–260, 295,
308–310
● Band 2, 13, 110, 208

Samsung Electronics America, Inc.
(SEA)
Ridge Jield Park
New Jersey, NJ 07660, USA
▲ Band 1, 302

Samsung Fiber Ceramic
1522-3, Song-Jung dong, Gang-su gu
618-817 Busan, South Korea
Phone +82.51.831.9990
Fax +82.51.831.9343
www.sfceramic.com
▲ Band 2, 171

SAMSUNG S1
8th Fl., S1 Bldg., 168, Soonhwa-dong
Seoul 100-130, South Korea
Phone +82.2.2131.8582
Fax +82.2.2131.8589
www.s1.co.kr
▲ Band 2, 219
● Band 2, 219

SAMSUNG TECHWIN CO., Ltd.
17F., Joong-Ang Ilbo Bldg. Soonhwa
Chung-Ku 100-759, Seoul,
South Korea
Phone +82.2.750.7683
www.samsungtechwin.co.kr
▲ Band 1, 163–165
● Band 1, 163–165

SANYO Electric Co, Ltd.
Advanced Design Center
1-1, Sanyo-cho, Daito City
Osaka 574-8534, Japan
Phone +81.72.870.6383
Fax +81.72.870.6010
www.sanyo.co.jp/design
● Band 1, 207

SANYO Electric Co., Ltd.
Advanced Design Center
222-1, Kaminaizen, Sumoto-city
Hyogo 656-8555, Japan
Phone +81.799.23.2840
Fax +81.799.23.2929
www.sanyo.co.jp/design
● Band 1, 130–131

SANYO Electric Co., Ltd.
Advanced Design Center
7F SANYO Hdqrs.Building One
Osaka 570-8677, Japan
Phone +81.3.6414.8593
Fax +81.3.6414.8703
www.sanyo.com
● Band 1, 69

SANYO Electric Co., Ltd.
ADC IID Design Labo.
IID-201A, 2-4-5, ikejiri
Tokyo 154-0001, Japan
Phone +81.3.5779.4155
Fax +81.3.3418.8358
www.sanyo.co.jp/design
● Band 1, 200

SANYO Electric Co., Ltd.
5-5, Keihan-Hondori 2-Chome
Moriguchi City
Osaka 570-8677, Japan
Phone +81.6.6991.1181
www.sanyo.com
▲ Band 1, 69, 130–131, 200, 207

Carl Sauter
Pianofortemanufaktur GmbH & Co. KG
Max-Planck-Straße 20
78549 Spaichingen, Germany
Phone +49.7424.94820
Fax +49.7424.948238
www.sauter-pianos.de
▲ Band 1, 145
● Band 1, 145

Scala Design
Wilf-Hirth-Straße 23
71034 Böblingen, Germany
Phone +49.7031.226908
Fax +49.7031.227809
● Band 2, 345–347

Scandinavian Eyewear AB
Grashagsgatan 11
551 11 Jönköping, Sweden
Phone +46.36.305300
www.scandinavianeyewear.se
▲ Band 1, 129
● Band 1, 129

Scenario Lab
Room 415, Building 53
Jhudong Township, Hsinchu County
31040, Taiwan
Phone +886.3.5820245
Fax +886.3.5835908
www.scenariolab.com.tw/blog
● Band 2, 436

Schaub & Oshiro
Via Cola Montano, 40
20159 Milano, Italy
Phone +49.1773638327
● Band 1, 447

School of Design, Hunan University
Lushan South Road
410082 Changsha, Hunan, China
Phone +867.318822418
● Band 1, 144

Schüco International KG
Geschäftsbereich Schüco Design
In der Lake 2
33829 Borgholzhausen, Germany
Phone +49.5425.12152
Fax +49.5425.12155
www.schueco.de/industrieautomation
▲ Band 2, 356
● Band 2, 356

Schumann
Büro für industrielle Formentwicklung
Angelsachsenweg 72
48167 Münster, Germany
Phone +49.251.1365555
Fax +49.251.136.5556
www.schumanndesign.de
● Band 2, 357

Schweizer Design Consulting
Heusteigstraße 19
70182 Stuttgart, Germany
Phone +49.711.8069770
www.schweizerdesign.com
● Band 1, 372

Seagate Technology
100 Mathilda Place, Branded Solutions
Sunnyvale, CA 94086, USA
Phone +1.408.3282072
Fax +1.408.3282184
▲ Band 1, 322

Sedus Stoll AG
Brückenstraße 15
79761 Waldshut, Germany
Phone +49.7751.84263
Fax +49.7751.84360
www.sedus.de
▲ Band 1, 371

SEIKO EPSON CORPORATION
80 Harashinden, Hirooka
Shiojiri-shi, Nagano-ken 399-0785,
Japan
Phone +81.263.53.5390
www.epson.com
● Band 1, 311–315, 319

SEIKO EPSON CORPORATION
4897 Shimauchi
Matsumoto-shi
Nagano-ken 390-8640, Japan
Phone +81.263.48.1391
www.epson.com
● Band 1, 208

SEIKO EPSON CORPORATION
3-3-5 Owa,
Suwa-shi
Nagano-ken 392-8502, Japan
Phone +81.266.52.3131
www.epson.com
▲ Band 1, 208, 311–312, 313–315, 319

Sennheiser Electronic GmbH & Co. KG
Am Labor 1
30900 Wedemark, Germany
Phone +49.5130.600235
www.sennheiser.de
▲ Band 1, 221, 233

SensoMotoric Instruments GmbH
Warthestraße 21
14513 Teltow, Germany
Phone +49.3328.395510
www.smivision.com
▲ Band 1, 355

Sensorial Material Lab Corporation
No.51-3, San Kuang Lane, Beitun
District
Taichung 406, Taiwan
Phone +886.4.2236.0089
▲ Band 1, 357

SENZ Umbrellas BV
Rotterdamseweg 145
2628 EA Delft, Netherlands
Phone +31.15.2855022
Fax +31.15.2852526
www.senzumbrellas.com
▲ Band 1, 70
● Band 1, 70

Seoul Commtech Co., Ltd.
448-11, Seongnae 3 dong
Gangdong-Gu
Seoul 134-033, South Korea
Phone +82.2.2225.6000
www.scommtech.com
▲ Band 1, 279
● Band 1, 279

ServoClean
Tulpenweg 21
89607 Emerkingen, Germany
Phone +49.7393.954970
● Band 2, 313

SGW Electronics Ltd
No.68 Guowie Road
Shenzhen, China
Phone +867.5525736666
www.sgwglobal.com
▲ Band 1, 280

Shenzhen Huawei Communication
Technologies Co., Ltd.
No.6, Vision software High Tech S9
Shenzhen 518057, China
Phone +86.755.28780808
www.huawei.com
▲ Band 1, 344

Shibasaki Schumann & Co., Ltd.
No.10, Lane 26, Sec 6, Sinyi Road
Taipei 11086, Taiwan
Phone +886.2.2726.3581
Fax +886.2.2726.6581
www.shibasakischumann.com
▲ Band 1, 138
● Band 1, 138

Shimano Inc.
3-77 Oimatsu-cho
Oska 590-8577, Japan
Phone +31.341272259
www.shimano.com
▲ Band 1, 79
● Band 1, 79

SICK AG
Erwin-Sick-Straße 1
79183 Waldkirch, Germany
Phone +49.7681.2025278
www.sick.com
▲ Band 2, 344

sieger design GmbH & Co. KG
Schloss Harkotten
48336 Sassenberg, Germany
Phone +49.5426.94920
www.sieger-design.com
● Band 2, 184

Siemens AG Healthcare Sector
Allee am Röthelheimpark 2
91052 Erlangen, Germany
Phone +49.9131.842873
▲ Band 2, 305
● Band 2, 305

Siemens AG, Industry Sector
Gleiwitzerstraße 555
90475 Nürnberg, Germany
Phone +49.911.8954208
Fax +49.911.8955400
www.siemens.com/automation
▲ Band 2, 359–361

Siemens Electrogeräte GmbH
Carl-Wery-Straße 34
81739 München, Germany
Phone +49.89.45902389
Fax +49.89.45902958
www.siemens-hausgeraete.de
▲ Band 2, 16–18, 75, 111–114,
144–145
● Band 2, 16–18, 75, 111–114

SIG Combibloc Systems GmbH
Rurstraße 58
52441 Linnich, Germany
Phone +49.2462.792958
Fax +49.2462.79172958
www.sigcombibloc.com
▲ Band 2, 406

Signature
Achtstraße 67-69
55765 Birkenfeld, Germany
Phone +49.6782.140
▲ Band 2, 262

SIGNCE
Am Tucherpark 4
80538 München, Germany
Phone +49.89.3866790
Fax +49.89.38667911
www.signce.eu
● Band 2, 363

Silit-Werke GmbH & Co. KG
Neufraer Straße 6
88499 Riedlingen, Germany
Phone +49.7371.189.0
Fax +49.7371.189.1260
www.silit.de
▲ Band 2, 132, 146–147, 248
● Band 2, 147

SilVER SEIKO
28-7, Kamiochiai 2-chome,
Shinjuku-ku
Tokyo 161-8501, Japan
Phone +81.3.5332.7627
Fax +81.3.5332.7622
▲ Band 1, 278, 363

Simplon Fahrrad GmbH
Oberer Achdamm 22
6971 Hard, Austria
Phone +43.5574.72564.26
▲ Band 1, 76
● Band 1, 76

Sip-Well
Technologielaan 3
1840 Londerzeel, Belgium
Phone +32.78052053
Fax +32.052890891
www.sipwell.com
▲ Band 2, 119

Sirona Dental Systems GmbH
Fabrikstrasse 31
64625 Bensheim, Germany
Phone +49.6251.162267
www.sirona.de
▲ Band 2, 274

SK Engineering & Construction
SKEC Building Design Team
Seoul 110-300, South Korea
Phone +82.2.3700.8525
Fax +82.2.3499.2400
www.skec.co.kr
● Band 2, 171

Skantherm Wagner GmbH & Co. KG
Lümernweg 188a
33378 Rheda-Wiedenbrück, Germany
Phone +49.5242.9381.10
Fax +49.5242.9381.37
www.skantherm.de
▲ Band 2, 235

hamburg.
hannover.
weimar.
munich.
kyoto / japan.

competence in the matter of universal design.

www.ud-germany.de
info@ud-germany.de

universal design©

Skil Europe BV
Konijnenberg 60
4825 BD Breda, Netherlands
Phone +31.76.5795000
Fax +31.76.5810558
www.skil.nl
▲ Band 2, 349

SKS-Kinkel Elektronik GmbH
Im Industriegebiet 9
56472 Hof, Germany
Phone +49.2661.98088.0
Fax +49.2661.98088200
www.sks-kinkel.de
▲ Band 2, 228

Smart Design
601 W. 26th Street, Suite 1820
New York, NY 10001, USA
Phone +1.212.8078150
www.smartdesignworldwide.com
● Band 1, 317
● Band 2, 149

SMC CORPORATION
Akihabara UDX 15F, 4-14-1,
Sotokanda, Chiyoda-ku
Tokyo 101-0021, Japan
www.smc-pneumatik.de
▲ Band 2, 362
● Band 2, 362

SNA Europe
Tallbacksvägen 2
745 82 Enköpping, Sweden
Phone +46.171.227.00
Fax +46171479889
www.snaeurope.com
▲ Band 2, 321

SOBEY
North Ganlu Garden 25
Peking 100025, China
Phone +860.1.01350106
▲ Band 1, 340

Sonos
Hoge Naarderweg 5
1217AB Hilversum, Netherlands
Phone +31.356.260533
www.sonos.com
▲ Band 1, 152

Sony Corporation
1-7-1 Konan Minato-ku
Tokyo 108-0075, Japan
Phone +81.3.6748.4604
www.sony.net/design
▲ Band 1, 156–158, 161–162,
168–169, 177–178, 183, 194, 198,
205, 223, 232, 235, 330
● Band 1, 156–158, 161–162,
168–169, 177–178, 183, 194, 198,
205, 223, 232, 235

Sony Creativeworks Corporation
4-10-18 Takanawa Minato-ku
Tokyo 108-0074, Japan
Phone +81.3.5792.3005
www.sonycreativeworks.co.jp/index.
html
● Band 1, 330

Sony Ericsson
Mobile Communications AB
Nya Vattentornet
SE221-88 Lund, Sweden
Phone +46.767.621251
www.sonyericsson.com
▲ Band 1, 261–263
● Band 1, 261–263

Sottsass Associati
Via Melone 2
20121 Milano, Italy
Phone +39.2.72016090
www.sottsass.it
● Band 1, 401

SPANNAGEL.DESIGN
Büro für Industriedesign
Engelbertstraße 21
50674 Köln, Germany
Phone +49.221.240049.7
Fax +49.221.240049.8
www.spannageldesign.de
● Band 2, 168

SPERIAN Eye Face Protection
10 Thurber Blvd.
Smithfield, RI 2917, USA
Phone +1.401.7572330
▲ Band 2, 364–365
● Band 2, 365–365

Squareone GmbH
Talstraße 66
40217 Düsseldorf, Germany
Phone +49.211.15924960
● Band 2, 396

Staatlicher Hofkeller Würzburg
Residenzplatz 3, Rosenbachpalais
97070 Würzburg, Germany
Phone +49.931.3050920
Fax +49.931.3050933
www.hofkeller.de
▲ Band 2, 265

Starline International Group Ltd.
Room 1818-19, 18/F, Nan Fung
Commerc., Centre, 19 Lam Lok Str.,
Kowloon Bay, Hong Kong, Hong Kong
Phone +852.2.3888255
Fax +852.2.3888255
www.starline.hk
▲ Band 1, 329

Philippe Starck
18/20, rue du Faubourg du Temple
75011 Paris, France
Phone +33.148.075454
Fax +33.148.075465
www.starck.com
● Band 2, 185

STEINEL
Vertrieb GmbH
Dieselstraße 80–84
33442 Herzebrock-Clarholz, Germany
Phone +49.5245.448242
Fax +49.5245.448197
www.steinel.de
▲ Band 1, 397

Stelton A/S
Christianshavns Kanal 4
1406 Copenhagen K, Denmark
Phone +45.39.458831
Fax +45.39.622350
www.stelton.com
▲ Band 1, 139

Stiebel Eltron
Dr.-Stiebel-Straße
37603 Holzminden, Germany
Phone +49.5531.70295582
Fax +49.5531.70297582
www.stiebel-eltron.de
▲ Band 2, 211–212

Stöckel Söhne GmbH
Dorfstraße 14
23701 Eutin, Germany
Phone +49.4521.2377
Fax +49.4521.4709
www.stoeckel-soehne.de
▲ Band 2, 150

Storm Design
Hovmosevej 17
3400 Hillerød, Denmark
Phone +45.48.26.30.60
● Band 2, 128

Ströer Out-Of-Home Media AG
--- media for mobile people ---
Ströer Allee 1
50999 Köln, Germany
Phone +49.223.68846536
Fax +49.223.68846337
www.stroeer.com
▲ Band 2, 260–261
● Band 2, 260–261

Studio Hannes Wettstein AG
Seefeldstrasse 303
8008 Zürich, Switzerland
● Band 2, 329

Studio Paretaia
Architektur - Design - Konzepte
Felix-Dahn-Straße 66 A
70597 Stuttgart, Germany
Phone +49.711.7657765
www.paretaia.de
● Band 1, 373

Studio Vertijet
Harz 5a
06108 Halle, Germany
Phone +49.345.2905844
● Band 1, 443

Studio Wagner: Design
Mainzer Landstraße 220
60327 Frankfurt, Germany
Phone +49.69.92870574
Fax +49.69.92870575
www.wolf-udo-wagner.com
● Band 1, 476

Studiomartino.5
Via Pasquale S. Mancini 2
196 Roma, Italy
Phone +39.06.32110841
Fax +39.06.3202098
www.studiomartino5.it
● Band 2, 177

STUDIOWERK DESIGN
Forellenstraße 11
82266 Inning, Germany
Phone +49.8143.1869
www.studiowerk-design.de
● Band 2, 366–370, 386, 391

Supersymetrics
Unterdorfstrasse 15
9443 Widnau, Switzerland
Phone +43.55.723901390
● Band 1, 402

Suunto/Mottoform
Valimotie 7
1510 Vantaa, Finland
Phone +358.9.875.870
▲ Band 1, 107
● Band 1, 107

Swiss Axe
Rijfstraat 11
2018 Antwerpen, Belgium
Phone +32.3.2321090
Fax +32.3.2343374
www.swissaxe.be
▲ Band 2, 333

Swyst Product Development LLC
81 Park Ave
Arlington, VA 2476, USA
Phone +1.781.6088979
● Band 1, 325

SylvainWillenzDesignStudio
Studio:14 Rue Raphaël
1070 Bruxelles, Belgium
Phone +32.2.521.43.16
Fax +32.2.522.40.95
● Band 1, 324

Symo NV
Dirk Martensstraat 13
8200 Brugge, Belgium
Phone +32.50.320795
www.sywawa.com
▲ Band 1, 71, 135

synapsis design GmbH
Teckstraße 56
70190 Stuttgart, Germany
Phone +49.711.2621131
www.synapsisdesign.com
● Band 2, 344

T
t+t Netcom
Elektrastraße 6
81925 München, Germany
Phone +49.89.9292790
▲ Band 2, 396

Taco Lab llc
25th Street
San Francisco, CA 94114, USA
Phone +1.415.9947035
www.tacolab.com
▲ Band 1, 108

Taiwan Kurim Enterprises Co., Ltd.
No.39, 36 Pei Lane, Sec.3, Ming She
Taichung Hsien 428, Taiwan
Phone +886.4.25651199
▲ Band 1, 118

Tangerine & Partners
Unit 9 Blue Lion Place, 237 Long Lane
London SE1 4PU, United Kingdom
Phone +82.11.443.0966
www.tangerine.net
● Band 2, 164, 183

Taurus Design
Die Agentur für Gestaltung
Kalkofen 6
58638 Iserlohn, Germany
Phone +49.2371.52020
Fax +49.2371.5859
www.taurus-design.de
● Band 2, 212

TEAMS Design GmbH
Kollwitzstraße 1
73728 Esslingen, Germany
Phone +49.711.3517650
www.teamsdesign.com
● Band 1, 349
● Band 2, 132, 146, 148

Tecnolumen GmbH & Co.KG
Lötzener Straße 2–4
28207 Bremen, Germany
Phone +49.421.4304170
Fax +49.421.4986685
www.tecnolumen.de
▲ Band 1, 399
● Band 1, 399

TEDES.Designteam GmbH
Neues Gässchen 1
91154 Roth, Germany
Phone +49.9171.88102
Fax +49.9171.88103
www.tedes-designteam.de
● Band 2, 373

TentLED
Havenstraat 68
1271 AG Huizen, Netherlands
Phone +31.35.533.4856
▲ Band 1, 111

Terra First Design (TFD)
6F, 570-7 Chung-Won B/D
135-891 Seoul, South Korea
Phone +82.2.511.3141
Fax +82.2.549.9680
www.tfdesign.co.kr
● Band 1, 281

Terraillon
57 Blvd. de la republique
BP73 78403 Chatou, Cedex, France
Phone +33.130154150
Fax +33.130154151
www.terraillon.com
▲ Band 2, 127

The Neat Company
3401 Market Street, Suite 120
Philadelphia, PA 19104, USA
Phone +1.215.3823300
www.neatco.com
▲ Band 1, 317

therefore Limited
2 Scala Street
London W1T 2HN, United Kingdom
Phone +44.2.079279940
www.therefore.com
● Band 1, 239–240

Thermaltake Technology Co., Ltd.
4F, No.268, Sec.3, Beishen Road
Taipei County 222, Taiwan
Phone +886.2.26626501
▲ Band 1, 347–348
● Band 1, 347–348

Thomas Hofmann
Entwicklung interaktiver Medien
Moltkestraße 94
45138 Essen, Germany
Phone +49.201.5078393
Fax +49.201.7490384
www.thomashofmann.net
● Band 2, 406

Thonet GmbH
Michael-Thonet-Straße 1
35066 Frankenberg, Germany
Phone +49.6451.508160
Fax +49.6451.508168
▲ Band 1, 430, 432

Tiga
1201/71 Srivara Town in Town,
Lad Phrao 94 Rd. Wangthonglang
10310 Bangkok, Thailand
Phone +66.2.559.2586
Fax +66.2.559.2587
▲ Band 1, 474

Tilo Wüsthoff Industrial Design
Pullacher Platz 6
81371 München, Germany
Phone +49.89.724039.11
www.tilo-wuesthoff.de
● Band 2, 424

Tim Oelker Industrial Design
Venusberg 30
20459 Hamburg, Germany
Phone +49.40.85157085
Fax +49.40.85157086
www.timoelker.de
● Band 2, 150

Tisca Textil GmbH & Co. KG
Werkstraße 5
6712 Thüringen, Austria
Phone +43.5550.2311.0
Fax +43.5550.2311.25
www.tisca.at
▲ Band 1, 445
● Band 1, 445

Tivoli Audio, LLC.
70 Fargo Street, 9th Floor,
Seaport Center
Boston, MA 2210, USA
Phone +1.617.3450066
www.tivoliaudio.com
▲ Band 1, 220

Tobias Berneth Industrial Design
Ståltrådsvägen 32
16868 Stockholm, Sweden
Phone +46.709264112
www.tobiasberneth.com
● Band 1, 250, 276

Tobias Grau GmbH
Siemensstraße 35 b
25462 Rellingen, Germany
Phone +49.4101.3700
Fax +49.4101.3701000
www.tobias-grau.com
▲ Band 2, 213
● Band 2, 213

Tom DeVesto
70 Fargo Street, 9th Floor
Boston, MA 2210, USA
Phone +1.617.3450066
● Band 1, 220

Tomoko Azumi
t. n. a. design studio
Unit7 Haybridge House
London E5 9NB, United Kingdom
Phone +44.20.8880.0031
Fax +44.20.8880.0697
www.tnadesignstudio.co.uk
● Band 1, 455

TomTom International b. v.
Oosterdoksstraat 114
1011 DK Amsterdam, Netherlands
Phone +31.20.757.5000
www.tomtom.com
▲ Band 1, 239–240, 243

Tong Yang Magic Co., Ltd.
TYLI Bldg, 10F No. 185-10, Euljiro-2(i),
Jung-Gu, Seoul 100-845, Korea
Seoul 100-845, South Korea
Phone +82.2.319.0423
Fax +82.2.319.0179
www.magic.co.kr
▲ Band 2, 93
● Band 2, 93

Tonon & C. SpA
Via Diaz 22
33044 Manzano, Italy
Phone +39.0432740740
Fax +39.0432740770
www.tononitalia.com
▲ Band 1, 442

Tools Design
Rentemestervej 23A
2400 Copenhagen, Denmark
Phone +45.38194114
www.toolsdesign.com
● Band 1, 112
● Band 2, 142

Simply outstanding.

product
design
award

communication
design
award

design
award
china

material
award

packaging
award

concept
award

Tork
SCA Tissues Europe
Bäckstensgatan 5, Mölndal
SE-405 03 Göteborg, Sweden
Phone +46.706.10.40.11
www.sca-tork.com
▲ Band 2, 201

Toshiba Corporation
1-1, Shibaura 1-Chome
Tokyo 105-8001, Japan
Phone +81.3.3457.4051
● Band 2, 158

Toshiba Home Appliances Corporation
2-2-15, Sotokanda, Chiyoda-ku
Tokyo 101-0021, Japan
Phone +81.3.3257.5864
www.toshiba.co.jp/tha
▲ Band 2, 158

TOTO Ltd.
1-1, Nakashima 2-chome
Kokurakita-ku,
Kitakyushu, Fukuoka 802-8601, Japan
Phone +81.93.951.2052
▲ Band 2, 178–182
● Band 2, 178–182

Toyota Industries Corporation
2-1, Toyoda-cho
Kariya, Aichi 448-8671, Japan
Phone +81.566.22.2511
www.toyota-industries.com
▲ Band 2, 414
● Band 2, 414

Toyota Material Handling Europe
Product Planning
Svarvargatan 8
595 81 Mjölby, Sweden
Phone +46.14288502
www.toyota-forklifts.eu
● Band 2, 415

TOYOTA MOTOR CORPORATION
1, Toyota-cho
Toyota City , Aichi 471-8572, Japan
Phone +81.565.72.1609
www.toyota.co.jp/en/index.html
▲ Band 1, 54
▲ Band 2, 425, 437
● Band 1, 54
● Band 2, 425, 437

Tretorn Sweden AB
Garnisonsgatan 51
251 09 Helsingborg, Sweden
Phone +46.42.19.71.05
www.tretorn.com
▲ Band 1, 105

Tricon Design AG
Bahnhofstraße 26
72138 Kirchentellinsfurt, Germany
Phone +49.7121.680870
Fax +49.7121.6808720
www.tricon-design.de
● Band 2, 314

TRILUX GmbH & Co. KG
Heidestraße 4
59759 Arnsberg, Germany
Phone +49.2932.301264
Fax +49.2932.301391
www.trilux.de
▲ Band 2, 296–297

Trumpf Medizin Systeme
GmbH & Co. KG
Benzstraße 8
82178 Puchheim, Germany
Phone +49.89 809070
www.trumpf-med.com
▲ Band 2, 279, 298–299

TRUMPF Werkzeugmaschinen
GmbH & Co. KG
Johann-Maus Straße 2
71254 Ditzingen, Germany
Phone +49.7156.30330791
www.trumpf.com
▲ Band 2, 373

Tsann Kuen Enterprise Co., Ltd.
5F, No.331, Sec.1, Ti-Ding Blvd.,
Taipei 114, Taiwan
Phone +886.2.77203999
Fax +886.2.27911718
▲ Band 1, 244
● Band 1, 244

Tupperware Corporation
14901 S.Orange Blossom Trail
Orlando, FL 32837, USA
Phone +1.407.8471907
Fax +1.407.8471905
www.tupperware.com
● Band 2, 153

Tupperware France S.A.
Route de Monts
37300 Joue-Les-Tours, France
Phone +33.2.476810.00
Fax +33.2.476810.01
www.tupperware.com
▲ Band 2, 152

Tupperware General Services N.V.
Wijngaardveld 17
9300 Aalst, Belgium
Phone +32.53.727542
Fax +32.53.727540
www.tupperware.com
▲ Band 2, 153
● Band 2, 152

U
U. I. Design Co., Ltd.
4F-A No.29 Sec.3 ChunShan N.Road
Taipei 104, Taiwan
Phone +886.2.25921742
Fax +886.2.25923748
www.kedo.com.tw
● Band 2, 120

U10 Inc.
4F-2, No.16, Sec.6, Minquan East
Road, Nei Hu District
Taipei 114, Taiwan
Phone +886.2.87919382
● Band 2, 138

PAOLO ULIAN
Via san Leonardo, 250
54037 Marina di Massa, Italy
Phone +49.585.870039.
● Band 2, 172

Ultimate Hydroforming
42450 Yeargo Drive
Sterling Heights, MI 48314, USA
Phone +1.586.2542300108
▲ Band 2, 252

ünal&böler
Caferaga Mah. Rusenaga Sok.
34710 Istanbul, Turkey
Phone +90.216.4187180
Fax +90.216.3475914
www.ub-studio.com
● Band 1, 438

Uniflex S. r. l.
Via dell'Industria, 1
33086 Montereale Valcellina, Italy
Phone +39.04.27734411
● Band 1, 117

Unifor Design
via Isonzo 1
22078 Turate (CO), Italy
Phone +39.02.967.191
Fax +39.02.967.50.859
www.unifor.it
▲ Band 1, 370, 376
● Band 1, 370

Union SB International Co., Ltd.
1102 Windstone, 275-2,
Yangjae-dong, Seocho-gu
Seoul 137-130, South Korea
Phone +82.10.6203.3142
● Band 2, 183

unit-design gmbh
Holbeinstraße 25
60596 Frankfurt am Main, Germany
Phone +49.69.66057880
● Band 2, 262

V

Vaillant GmbH
Berghauser Straße 40
42859 Remscheid, Germany
Phone +49.2191.18.2869
www.vaillant.de
▲ Band 2, 217
● Band 2, 217

VAN Furniture Co., Ltd.
126 Maesan-Ri Opo-Eup
Gwangju-City 464-893, South Korea
Phone +82.31.7680502
Fax +82.31.7977218
www.vankids.co.kr
▲ Band 1, 453

VanBerlo strategy+design
Beemdstraat 29
5653 MA Eindhoven, Netherlands
Phone +31.40.2929090
Fax +31.40.2929099
www.vanberlo.nl
● Band 1, 111
● Band 2, 263, 315, 412

Vibringe B. V.
Weerdsingel WZ 16 bis
3513 BA Utrecht, Netherlands
Phone +31.20.3453846
▲ Band 2, 315

VICON Motion Systems Ltd.
14 Minns Business Park, West Way
Oxford OX2 0JB, United Kingdom
Phone +44.1865.261800
Fax +44.1865.240527
www.vicon.com
▲ Band 2, 311

Victor Company of Japan, Ltd.
12, 3-chome, Moriya-cho,
Kanagawa-ku
Yokohama, Kanagawa 221-8528,
Japan
Phone +81.45.450.2430
Fax +81.45.450.2441
▲ Band 1, 193, 203
● Band 1, 193, 203

Viessmann Werke GmbH & Co. KG
Viessmannstraße 1
35107 Allendorf/ Eder, Germany
Phone +49.6452.702298
Fax +49.6452.705298
www.viessmann.com
▲ Band 2, 215

View Design
Samseong-dong
Seoul 135-090, South Korea
Phone +82.2.557.9217
Fax +82.2.557.9260
www.view-design.co.kr
● Band 2, 375

Vistapark GmbH
Viehhofstraße 119
42117 Wuppertal, Germany
Phone +49.202.2427500
● Band 2, 217

Volkswagen AG
Berliner Ring
38440 Wolfsburg, Germany
Phone +49.536.190
www.volkswagen.de
▲ Band 1, 46–47
● Band 1, 46–47

VOODOO
10955 Tantau Ave
Cupertino, CA 95014, USA
Phone +1.408.8736358
www.voodoopc.com
● Band 1, 292, 298

VOVO CORPORATION
6F Samwon Bld, 1329-8 Seocho-dong,
Seocho-gu
Seoul 137-858, South Korea
Phone +82.2.5230631
Fax +82.2.5230630
www.vovoceramic.com
▲ Band 2, 175
● Band 2, 175

W

W. L. Gore & Associates GmbH
Aiblinger Straße 60
83620 Feldkirchen-Westerham,
Germany
Phone +49.8063.8010
Fax +49.8063.801556
www.gorebikewear.com
▲ Band 1, 87–89, 93
● Band 1, 87–89, 93

Wanke S. A.
Marechal Floriano Peixoto, 284
89130-000 Indaial - SC, Brazil
Phone +55.47.3301.2511
www.wanke.com.br
▲ Band 2, 85

Adam Wehsely-Swiczinsky
Hollandstraße 9
1020 Wien, Austria
Phone +43.699.19425831
● Band 2, 295

WeLL Design
Uraniumweg 27
3542 AK Utrecht, Netherlands
Phone +31.30.2985832
www.welldesign.com
● Band 2, 376

Wera Werk Hermann Werner GmbH
Korzerter Straße 21–25
42349 Wuppertal, Germany
Phone +49.202.40.45.217
Fax +49.202.40.45.268
www.wera.de
▲ Band 2, 374
● Band 2, 374

WERMA Signaltechnik
GmbH + Co. KG
Dürbheimer Straße 15
78604 Rietheim-Weilheim, Germany
Phone +49.7424.9557183
▲ Band 2, 264
● Band 2, 264

Christian Werner
Industrial Design
Am Aarbach 14
21279 Höllenstedt/Appel, Germany
Phone +49.4165.212614
● Band 1, 444

Western Digital
20511 Lake Forest Drive
Lake Forest, CA 92630-7741, USA
▲ Band 1, 323

Whipsaw, Inc.
434 South 1st Street
San Jose, CA 9513, USA
Phone +1.408.2979771
● Band 1, 72, 229, 341

Whirlpool Corporation
Global Consumer Design
Localita Cassinetta
21024 Varese / Biandronno, Italy
Phone +39.033.2757594
www.whirlpoolcorp.com
▲ Band 2, 46, 438
● Band 2, 46, 438

White-ID
vormals Fourhead productdesign
Vordere Schmiedgasse 36-1
73525 Schwäbisch Gmünd, Germany
Phone +49.7171.877184
Fax +49.7171.877185
www.white-id.de
● Band 1, 59

Wiel Arets
D'Artagnanlaan 29
6213 Maastricht, Netherlands Antilles
Phone +31.43.3512200
● Band 2, 176

WIKA
Alexander Wiegand GmbH & Co. KG
Alexander-Wiegand-Straße
63911 Klingenberg, Germany
Phone +49.9372.132.0
Fax +49.9372132406
www.wika.de
▲ Band 2, 381

Jean Michel Wilmotte
68, Rue du Faubourg Saint-Antoine
75012 Paris, France
Phone +33.1.53022222
● Band 1, 404

Wistron NeWeb Corporation
No.10-1, Li-hsin Road1
Hsinchu 300, Taiwan
Phone +886.3.6667799
www.wneweb.com
▲ Band 1, 264
● Band 1, 264

WMF AG
Eberhardstraße
73312 Geislingen, Germany
Phone +49.7331.25.8816
Fax +49.7331.25.8997
www.wmf.de
▲ Band 2, 131

Wonders Industrial
Development(ShenZhen)Co., Ltd.
Doss industrial Zone, Qiping Road
ShenZhen 518110, China
Phone +86.75527520646
Fax +86.75527520228
www.dossav.com
▲ Band 1, 227
● Band 1, 227

Woongjin Coway Co., Ltd.
Euljiro2-Ga
Seoul 100-844, South Korea
Phone +82.2.2172.3728
Fax +82.2.2172.3667
▲ Band 2, 202
● Band 2, 202

WOONGJINST
3F Daerung Techno Town 7, 489-11,
Gasan-dong Geumcheon-gu
Seoul 153-774, South Korea
Phone +82.2.2081.9300
Fax +82.2.2081.9300
www.wjst.co.kr
▲ Band 1, 351

WPS Parking Systems B. V.
Hoevenweg 11
5652 AW Eindhoven, Netherlands
Phone +31.40.250.91.11
▲ Band 2, 263

X
XL PLUS Design
Mo Gan Shan Road 50 4a-205
Shanghai 200060, China
Phone +86.21.62984733
Fax +82.21.62984736
www.xlplusdesign.com
● Band 1, 340

X-Technology R+D Swiss GmbH
Samstagernstrasse 45
8832 Wollerau, Switzerland
Phone +41.44.7860375
Fax +41.44.7860304
www.x-bionic.com
▲ Band 1, 86, 94
● Band 1, 86, 94

Y
Y Studios LLC
1125 Cortland Avenue
San Francisco, CA 94110, USA
Phone +1.415.2060622
www.ystudios.com
● Band 1, 152

Y Water
5737 Venice Blvd.
Los Angeles, CA 90019, USA
Phone +1.310.5932440
www.ywater.us
▲ Band 1, 143

YAKKAY A/S
Skudehavnsvej 36 B
2100 Copenhagen, Denmark
Phone +45.392.02299
www.yakkay.com
▲ Band 1, 77
● Band 1, 77

YAYA Tech
No.2, Alley 19, Lane 550, Nanda Road
Hsing-Chu 300, Taiwan
Phone +886.3.5330298.668
Fax +886.3.5238615
www.yayatech.com
▲ Band 2, 379–380

YKK CORPORATION
Shinjuku Maynds Tower, 28Гl.
Tokyo 151-0053, Japan
Phone +81.65288065289
www.ykkfastening.com
▲ Band 1, 122
● Band 1, 122

YS design Inc.
1-6-4-7, Otemae, Chuo-ku
Osaka 540-0008, Japan
Phone +81.6.6944.9161
● Band 2, 292

Z
ZEBEX INDUSTRIES INC.
B1-1 No.207 Sec.3, Beisin Road,
Sindian
Taipei County 23143, Taiwan
Phone +886.2.89132598
Fax +886.2.89132596
www.zebex.com
▲ Band 2, 395
● Band 2, 395

Zehnder GmbH
Comfosystems
Almweg 34
77933 Lahr, Germany
Phone +49.7821.586273
Fax +49.7821.586226
www.zehnder-online.de
▲ Band 2, 221–222

Zehnder Group Produktion Gränichen
Oberfeldstrasse 2
5722 Gränichen, Switzerland
Phone +41.62.8551546
www.zehndergroup.com
▲ Band 2, 203

Zeitform-Design GmbH
Neuenreuth 13
95336 Mainleus, Germany
Phone +49.9229.975174
www.zeitform-design.de
▲ Band 2, 224
● Band 2, 224

Zumtobel Lighting GmbH
Schweizer Straße 30
6851 Dornbirn, Austria
Phone +43.55.723901574
www.zumtobel.com
▲ Band 1, 400–403
● Band 1, 400–403

Zweibrüder Optoelectronics GmbH
Kronenstraße 5–7
42699 Solingen, Germany
Phone +49.2125.948164
▲ Band 1, 417–419
● Band 1, 417–419